Building Information Modeling

André Borrmann • Markus König • Christian Koch •
Jakob Beetz

Editors

Building
Information
Modeling

Technology Foundations
and Industry Practice

 Springer

Editors
André Borrmann (iD)
Chair of Computational Modeling and
Simulation
Technical University of Munich
München, Germany

Markus König
Lehrstuhl für Informatik im Bauwesen
Ruhr-Universität Bochum
Bochum, Germany

Christian Koch
Chair of Intelligent Technical Design
Bauhaus-Universität Weimar
Weimar, Germany

Jakob Beetz
Chair of Design Computation
RWTH Aachen University
Aachen, Germany

ISBN 978-3-030-06536-2 ISBN 978-3-319-92862-3 (eBook)
https://doi.org/10.1007/978-3-319-92862-3

This Springer imprint is published by the registered company Springer Nature Switzerland AG
The registered company address is: Gewerbestrasse 11, 6330 Cham, Switzerland

Preface

Building Information Modeling (BIM) represents the consistent and continuous use of digital information across the entire lifecycle of a built facility, including its design, construction and operation. This idea was originally proposed by researchers in the 1980s, but has only reached technical maturity in recent years and is now being successively adopted by the industry across the globe. The implementation of BIM technology profoundly changes the way architects and engineers work and drives the digital evolution of the AEC industry.

BIM is based on the consistent use and re-use of digital data and helps to raise productivity while lowering error rates as mistakes can be detected and resolved before they become serious problems. Important benefits lie in the direct use of the models for different analysis and simulation tools and the seamless handover of data for the operation phase. Today, powerful and sophisticated software products are available that provide the technical foundation for realizing BIM-based construction projects. The real challenge, however, lies in creating the right models and applying the right tools in the most beneficial way, as well as in developing and establishing the corresponding workflows and processes. In addition, BIM adoption requires changes in legal practices and remuneration. These are currently the main hurdles that hinder its broader uptake.

If we look at the degree of BIM adoption in practice, we can see that in the USA, BIM was already introduced in the mid-2000s and since then has been consistently intensified. Accordingly, large parts of the American AEC industry already use BIM methods in daily practice. In Asia, Singapore and South Korea are among the most advanced countries worldwide with a long history in establishing BIM working methods and corresponding governmental BIM roadmaps and BIM guidelines. Europe's forerunners are the Scandinavian countries: Finland began conducting a number of BIM pilot projects as early as 2001. Based on the success of these projects, the Finnish Senate decided in 2007 to make BIM mandatory for all its projects. BIM is accordingly widespread in the Finnish industry today. Norway and Sweden have taken similar steps and have reached a correspondingly high degree of BIM adoption. Another very influential development is the UK BIM initiative started by the British government in 2011, which has resulted in BIM

becoming mandatory for all centrally procured Government projects from 2016 onward. The degree of BIM penetration reached in all the above countries shows the success of the top-down impulses given by the respective governments and the public authorities.

In many other European countries, the introduction of BIM methods is advancing. The Netherlands, Germany, France, and Spain, among others, have established governmental BIM roadmaps. These go hand in hand with activities by the European Union including an update of the Public Procurement Directive which now allows public clients to stipulate digital working practices. Another important EU initiative is the EU BIM Task Force which aims to establish a common European network for aligning the use of Building Information Modeling in public construction works. At the same time, efforts to establish BIM standards have been significantly intensified at international, European and national levels.

In short, the shift towards model-based working practices has gained huge momentum around the world in recent years and the AEC industry across the globe is undergoing a fundamental transition from conventional paper-based workflows to digitized ones. Directing and implementing this transition requires sound knowledge of both the capabilities of BIM as well as its limitations.

It is the editors' strong conviction that in order to properly understand and apply BIM methods to beneficial effect, fundamental knowledge of its key principles is paramount. The book complements the discussion of theoretical foundations with reports from the industry on currently applied best practices. The book is written both for experts in the construction industry as well as students of Architecture and Construction Engineering programs.

The content is organized in six parts:

- Part I discusses the technological basics of BIM and addresses computational methods for the geometric and semantic modeling of buildings as well as methods for process modeling.
- Part II covers the important aspect of the interoperability of BIM software products and describes in detail the standardized data format Industry Foundation Classes. It sheds light on the different classification systems, discusses the data format CityGML for describing 3D city models and COBie for handing over data to clients. It also gives an overview of BIM programming tools and interfaces.
- Part III is dedicated to the philosophy, the organization and the technical implementation of BIM-based collaboration, and discusses the impact on legal issues including construction contracts.
- Part IV covers a wide range of BIM use cases in the different life-cycle phases of a built facility, including the use of BIM for design coordination, structural analysis, energy analysis, code compliance checking, quantity take-off, prefabrication, progress monitoring and operation.
- Part V, a number of design and construction companies report on the current state of BIM adoption by means of practical BIM projects, and discuss the approach taken for the shift towards BIM including the hurdles taken.
- Finally, Part VI summarizes the book's content and provides an outlook on future developments.

We thank all the authors for their valuable contributions. Without them, this book would not have been possible. We would particularly like to thank Simon Vilgertshofer and Martin Slepicka for their extraordinary application in the technical coordination of the book and the careful typesetting of the chapters. We also thank our proofreaders Julian Reisenberger and Robert Kurth for their excellent service.

We wish our readers an insightful journey through the world of BIM.

München, Germany André Borrmann
Bochum, Germany Markus König
Weimar, Germany Christian Koch
Aachen, Germany Jakob Beetz
May 2018

Contents

34 BIM at STRABAG... **555**

Konstantinos Kessoudis, Jochen Teizer, Frank Schley,
Alexander Blickle, Lynn Hiel, Nikolas Früh, Martin Biesinger,
Martin Wachinger, Arnim Marx, Alexander Paulitsch,
Benjamin Hahn, and Jan Lodewijks

Part VI Summary and Outlook

35 Conclusions and Outlook **571**

André Borrmann, Markus König, Christian Koch, and Jakob Beetz

Acronyms

ADE	Application Domain Extension
AEC	Architecture Engineering Construction
AIA	American Institute of Architects
AP	Application Protocol
API	Application Programming Interface
BC	British Code
BCF	BIM Collaboration Format
BEP	BIM Execution Plan
BIM	Building Information Modeling
BOM	Bill of Materials
BPMN	Business Process Model and Notation
BREEAM	Building Research Establishment Environmental Assessment Methodology
bS	buildingSMART
bSDD	buildingSMART Data Dictionary
CAD	Computer-Aided Design
CAFM	Computer-Aided Facility Management
CAM	Computer-Aided Manufacturing
CAQM	Computer-Aided Quality Management
CDE	Common Data Environment
CIC	Construction Industry Council
CIM	Computer Integrated Manufacturing
CIS	CIMSteel Integration Standards
COBie	Construction-Operations Building Information Exchange
COINS	Construction Objects and INtegration of Processes and Systems
CSCW	Computer-supported collaborative work
DMS	Document Management System
DXF	Drawing Interchange Format
EBOM	Engineering Bill Of Materials
EIR	Employer's Information Requirements or Exchange Information Requirements (Chap. 13)

ER	Exchange Requirement
ERP	Enterprise Resource Planning
EU	European Union
FM	Facility Management
gbXML	Green Building XML
GIS	Geographic Information System
GML	Geography Markup Language
GTDS	Global Testing and Documentation Server
GUID	Globally Unique Identifier
HVAC	Heating Ventilation Air Conditioning
IAI	International Alliance for Interoperability
ICAM	Integrated Computer Aided Manufacturing
IDEF	Icam DEFinition for Function Modeling
IDM	Information Delivery Manual
IFC	Industry Foundation Classes
IFD	International Framework for Dictionaries
IGES	Initial Graphics Exchange Specification
INSPIRE	Infrastructure for Spatial Information in the European Community
IPD	Integrated Project Delivery
ISO	International Organization for Standardization
KML	Keyhole Markup Language
LD	Linked Data
LEED	Leadership in Energy and Environmental Design
LoD	Level of Detail
LOD	Level of Development
LOG	Level of Geometry
LOI	Level of Information
LOMD	Level of Model Definition
MBOM	Manufacturing Bill Of Materials
MVD	Model View Definition
NBS	National Building Specification
OOM	Object-Orientated Modeling
OWL	Web Ontology Language
PDM	Product Data Management
PLM	Product Lifecycle Management
PM	Process Management
PPP	Public Private Partnership
PSet	PropertySet
QTO	Quantity Take-Off
RDF	Ressource Description Framework
RFC	Request for Change
RFI	Request for Information
RFID	Radio Frequency Identification
SB	Space Boundary
SDAI	Standard Data Access Interface

SIG	Special Interest Group
SPARQL	Simple Protocol and RDF Query Language
STEP	Standard for the Exchange of Product Model Data
UML	Unified Modeling Language
URL	Uniform Resource Locator
VDC	Virtual Design and Construction
W3C	World Wide Web Consortium
WBS	Work Breakdown Structure
XDR	XML Data Reduced
XML	Extensible Markup Language
XSD	XML Schema Definition

Chapter 1
Building Information Modeling: Why? What? How?

André Borrmann ⓘ, Markus König, Christian Koch, and Jakob Beetz

Abstract Building Information Modeling is based on the idea of the continuous use of digital building models throughout the entire lifecycle of a built facility, starting from the early conceptual design and detailed design phases, to the construction phase, and the long phase of operation. BIM significantly improves information flow between stakeholders involved at all stages, resulting in an increase in efficiency by reducing the laborious and error-prone manual re-entering of information that dominates conventional paper-based workflows. Thanks to its many advantages, BIM is already practiced in many construction projects throughout the entire world. However, the fragmented nature of the construction industry still impedes its more widespread use. Government initiatives around the world play an important role in increasing BIM adoption: as the largest client of the construction industry in many countries, the state has the power to significantly change its work practices. This chapter discusses the motivation for applying BIM, offers a detailed definition of BIM along with an overview of typical use cases, describes the common BIM maturity grades and reports on BIM adoption levels in various countries around the globe.

A. Borrmann (✉)
Chair of Computational Modeling and Simulation, Technical University of Munich, München, Germany
e-mail: andre.borrmann@tum.de

M. König
Chair of Computing in Engineering, Ruhr University Bochum, Bochum, Germany
e-mail: koenig@inf.bi.rub.de

C. Koch
Chair of Intelligent Technical Design, Bauhaus-Universität Weimar, Weimar, Germany
e-mail: c.koch@uni-weimar.de

J. Beetz
Chair of Design Computation, RWTH Aachen University, Aachen, Germany
e-mail: j.beetz@caad.arch.rwth-aachen.de

© Springer International Publishing AG, part of Springer Nature 2018
A. Borrmann et al. (eds.), *Building Information Modeling*,
https://doi.org/10.1007/978-3-319-92862-3_1

1

1.1 Building Information Modeling: Why?

In the last decade, digitalization has transformed a wide range of industrial sectors, resulting in a tremendous increase in productivity, product quality and product variety. In the Architecture, Engineering, Construction (AEC) industry, digital tools are increasingly adopted for designing, constructing and operating buildings and infrastructure assets. However, the continuous use of digital information along the entire process chain falls significantly behind other industry domains. All too often, valuable information is lost because information is still predominantly handed over in the form of drawings, either as physical printed plots on paper or in a digital but limited format. Such disruptions in the information flow occur across the entire lifecycle of a built facility: in its design, construction and operation phases as well as in the very important handovers between these phases.

The planning and realization of built facilities is a complex undertaking involving a wide range of stakeholders from different fields of expertise. For a successful construction project, a continuous reconciliation and intense exchange of information among these stakeholders is necessary. Currently, this typically involves the handover of technical drawings of the construction project in graphical manner in the form of horizontal and vertical sections, views and detail drawings. The software used to create these drawings imitate the centuries-old way of working using a drawing board.

However, line drawings cannot be comprehensively understood by computers. The information they contain can only be partially interpreted and processed by computational methods. Basing the information flow on drawings alone therefore fails to harness the great potential of information technology for supporting project management and building operation. A key problem is that the consistency of the diverse technical drawings can only be checked manually. This is a potentially massive source of errors, particularly if we take into account that the drawings are typically created by experts from different design disciplines and across multiple companies. Design changes are particularly challenging: if they are not continuously tracked and relayed to all related plans, inconsistencies can easily arise and often remain undiscovered until the actual construction – where they then incur significant extra costs for ad-hoc solutions on site. In conventional practice, design changes are marked only by means of revision clouds in the drawings, which can be hard to detect and ambiguous.

The limited information depth of technical drawings also has a significant drawback in that information on the building design cannot be directly used by downstream applications for any kind of analysis, calculation and simulation, but must be re-entered manually which again requires unnecessary additional work and is a further source of errors. The same holds true for the information handover to the building owner after the construction is finished. He must invest considerable effort into extracting the required information for operating the building from the drawings and documents and enter it into a facility management system. At each of

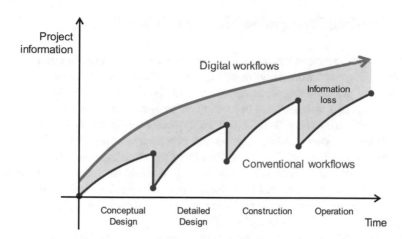

Fig. 1.1 Loss of information caused by disruptions in the digital information flow. (Based on Eastman et al. 2008)

these information exchange points, data that was once available in digital form is lost and has to be laboriously re-created (Fig. 1.1).

This is where Building Information Modeling comes into play. By applying the BIM method, a much more profound use of computer technology in the design, engineering, construction and operation of built facilities is realized. Instead of recording information in drawings, BIM stores, maintains and exchanges information using comprehensive digital representations: the building information models. This approach dramatically improves the coordination of the design activities, the integration of simulations, the setup and control of the construction process, as well as the handover of building information to the operator. By reducing the manual re-entering of data to a minimum and enabling the consequent re-use of digital information, laborious and error-prone work is avoided, which in turn results in an increase in productivity and quality in construction projects.

Other industry sectors, such as the automotive industry, have already undergone the transition to digitized, model-based product development and manufacturing which allowed them to achieve significant efficiency gains (Kagermann 2015). The Architecture Engineering and Construction (AEC) industry, however, has its own particularly challenging boundary conditions: first and foremost, the process and value creation chain is not controlled by one company, but is dispersed across a large number of enterprises including architectural offices, engineering consultancies, and construction firms. These typically cooperate only for the duration of an individual construction project and not for a longer period of time. Consequently, there are a large number of interfaces in the ad-hoc network of companies where digital information has to be handed over. As these information flows must be supervised and controlled by a central instance, the onus is on the building owner to specify and enforce the use of Building Information Modeling.

1.2 Building Information Modeling: What?

A Building Information Model is a comprehensive digital representation of a built facility with great information depth. It typically includes the three-dimensional geometry of the building components at a defined level of detail. In addition, it also comprises non-physical objects, such as spaces and zones, a hierarchical project structure, or schedules. Objects are typically associated with a well-defined set of semantic information, such as the component type, materials, technical properties, or costs, as well as the relationships between the components and other physical or logical entities (Fig. 1.2). The term Building Information Modeling (BIM) consequently describes both the process of creating such digital building models as well as the process of maintaining, using and exchanging them throughout the entire lifetime of the built facility (Fig. 1.3).

The US National Building Information Modeling Standard defines BIM as follows (NIBS 2012):

> Building Information Modeling (BIM) is a digital representation of physical and functional characteristics of a facility. A BIM is a shared knowledge resource for information about a facility forming a reliable basis for decisions during its life-cycle; defined as existing from earliest conception to demolition. A basic premise of BIM is collaboration by different stakeholders at different phases of the life cycle of a facility to insert, extract, update or modify information in the BIM to support and reflect the roles of that stakeholder.

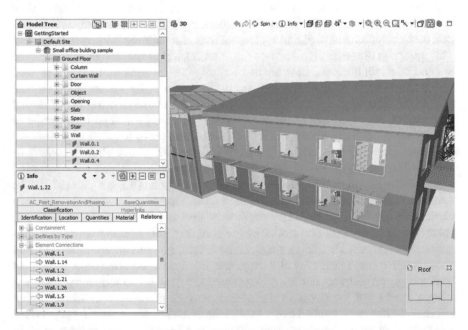

Fig. 1.2 A BIM model comprises both the 3D geometry of each building element as well as a rich set of semantic information provided by attributes and relationships

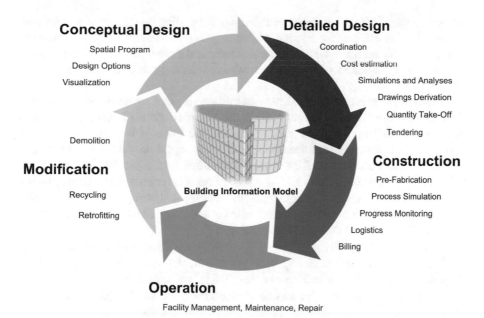

Conceptual Design

Spatial Program

Design Options

Visualization

Demolition

Modification

Recycling

Retrofitting

Building Information Model

Detailed Design

Coordination

Cost estimation

Simulations and Analyses

Drawings Derivation

Quantity Take-Off

Tendering

Construction

Pre-Fabrication

Process Simulation

Progress Monitoring

Logistics

Billing

Operation

Facility Management, Maintenance, Repair

Fig. 1.3 The concept of Building Information Modeling relies on the continuous use and low-loss handover of digital information across the entire lifecycle of a built facility. (© A. Borrmann, reprinted with permission)

The BIM concept is not new. Indeed, research papers about the creation and employment of virtual building models were first published in the 1970s (Eastman et al. 1974). The term Building Information Modeling was used for the first time in 1992 by the researchers van Nederveen and Tolman (1992). However, the widespread dissemination of the term was initiated by the software company Autodesk which used it the first time in a White Paper published in 2003 (Autodesk 2003). In recent years, a large range of software products with powerful BIM functionalities have been published by many different vendors, and the concept which originated in academic research has now become established industry practice.

The most obvious feature of a Building Information Model is the three-dimensional geometry of the facility under design or construction, which provides the basis for performing clash detection and for deriving consistent horizontal and vertical sections (Fig. 1.2). It is important to note, however, that 3D geometry on its own is not sufficient to provide a really capable digital representation. One of the major characteristics of a Building Information Model is its capability to convey semantics. This means that all its objects possess a meaning, i.e. they are instances of object types such as a Wall, Column, Window, Door and so on. These objects combine a parametrized 3D geometry representation with additional descriptive properties and their relationships to other elements in the model. Working with objects is a prerequisite for using the model for any kind of analysis,

including quantity take-off, structural analysis or building performance simulations. In addition, object-based modeling is also required for deriving drawings that are compliant with norms and regulations for technical drawings which often employ abstract or symbolized representations which cannot be produced from the 3D geometry alone.

There is no universally applicable definition of what information a Building Information Model must provide. Instead, the concrete information content depends heavily on the purpose of the model, i.e. the use cases it is created to support (Kreider et al. 2010). Indeed, the intended BIM use cases provide a very important point of departure for the BIM project execution and must be defined at the beginning of the project. Table 1.1 lists some of the most common uses cases (the list is by no means exhaustive). For example, PennState has developed a comprehensive use case scheme which comprises 32 detailed uses cases across the four phases Plan, Design, Construct and Operate (PennState 2013).

In typical BIM projects, multiple BIM models are used across the project phases, each of which tailored to the specific phase and use cases to be implemented. Figure 1.4 shows a typical example of the BIM information flow.

The following sections give an overview on the typical BIM applications in the different phases of a construction project. Part IV of this book is entirely dedicated to BIM use cases: each of its chapters addresses a different use case in great detail.

1.2.1 BIM in the Design Development Phase

BIM provides a large number of advantages for the design and engineering process. Compared to conventional 2D processes, one of the most significant advantages of using BIM is that most of the technical drawings, such as horizontal and vertical sections, are derived directly from the model and are thus automatically consistent with each other. Clash detection between the different partial models makes it possible to identify and resolve conflicts between the design disciplines at an early stage. BIM also facilitates the integration of computations and simulations in a seamless way, as a lot of input information about the building's geometry and material parameters can be taken directly from the model. A wide range of simulations, including structural analysis, building performance simulation, evacuation simulation, or lightning analysis, are then usable in the design process. In addition, the model can be checked for compliance with codes and regulations; currently mostly semi-automated, but in future with a higher degree of automation. Finally, the model data can be used to compute a very precise quantity take-off, providing the basis for reliable cost estimations and improving accuracy in the tendering and bidding process.

Applying BIM in the planning process results in shifting the design effort to earlier phases, as illustrated in Fig. 1.5. In conventional planning processes, the main design and engineering effort occurs in the later detailed design phases, sometimes even during the actual construction phase. As a result, the detailed coordination of

Table 1.1 A selection of the most widespread BIM use cases

Use case	Description
Technical visualization	Visualization of the 3D model as basis for project meetings and for public relations
Coordination of the specialist disciplines	Merging of discipline models into a coordination model at regular intervals, collision detection and systematic conflict resolution
Derivation of technical drawings	Derivation of the major parts of the design and construction drawings
BIM-based simulations and analyses	Use of the BIM model as input for various simulation and analysis tools, including structural analysis, energy performance simulation, daylight analysis, computational fluid dynamics, etc.
Cost estimation	BIM-based quantity take-off as basis for cost estimation
Tendering	BIM-based quantity take-off for creating the Bill of Quantities required for tendering construction works
Construction process modeling (4D modeling)	Linkage of individual components of the BIM model with the corresponding processes of the construction schedule
Simulation of the cost progress (5D modeling)	Linkage of the 4D model with costs for fabricating and/or purchasing the corresponding building components
Progress monitoring	Creation and update of a 4D model for reflecting and monitoring the construction progress
Billing and controlling	Billing and controlling based on the progress monitoring BIM model
Issue and defects management	Use of the BIM model for documenting construction defects and tracking their removal
Building operation and maintenance	Handover of BIM data to the client and subsequent take-over into facility management systems for operation and management

design disciplines, the integration of analysis and simulation tools and consequently a comprehensive assessment of the building design only occurs at a relatively late point in the overall process. At this point, however, the possibilities for design changes are more limited and also more costly to implement.

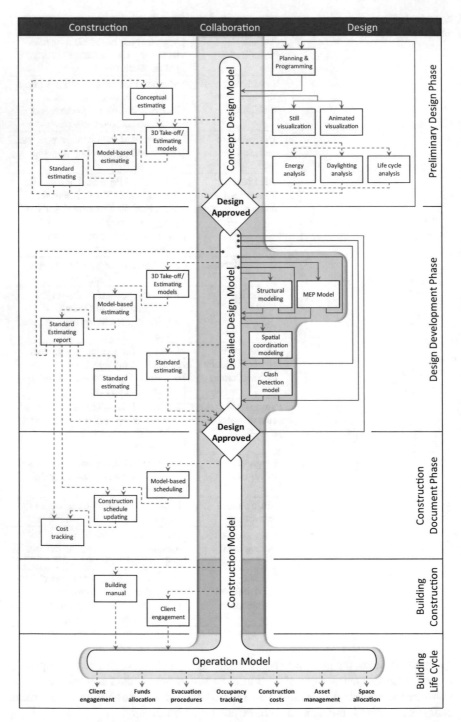

Fig. 1.4 BIM use cases and their mutual dependencies across the different phases of a construction project. (Based on Joseph 2011)

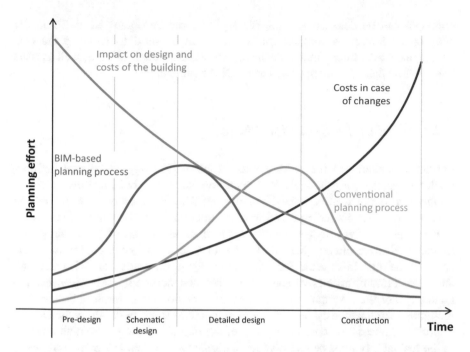

Fig. 1.5 Building Information Modeling shifts planning effort and design decisions to earlier phases. This makes it possible to influence the design, performance and costs of the resulting facility before design changes start to become costly to implement. (Based on MacLeamy 2004)

In a BIM-based planning process, by contrast, much of this planning effort can be brought forward to the early design phases by building up a comprehensive digital building model. The ability to plan coordination requirements in detail and to employ computational analyses in the early design phases makes it possible to evaluate the impact of design decisions more comprehensively and to identify and resolve possible conflicts early on, significantly decreasing the effort required at later phases and improving the overall design quality.

1.2.2 BIM in the Construction Phase

The application of BIM offers significant advantages not only for the design of a built facility, but also for preparing and executing its actual construction. Providing the digital building model as part of the tendering process makes it possible to determine the services required and costs for the contractors when preparing the bid and also facilitates precise billing at a later stage. By means of a 4D Building Information Model, which associates the individual building components with the scheduled construction times, the construction sequence can be validated, spatial

collisions can be detected and the site logistics can be organized. A 5D model additionally integrates cost information and can be used to simulate the cost development over time. Finally, the invoicing of construction work, as well as issue management can also be supported using BIM methods.

1.2.3 BIM in the Operation Phase

Further advantages of the BIM method result from using the digital building model across the comparatively long operation phase of a built facility. A critical prerequisite is the well-organized handover of BIM information from the design team to the owner, including all relevant information from the construction phase. If the owner receives high-value digital information instead of 'dead' drawings, he can feed them directly into his facility or asset management systems. In the case of buildings, this means that information about room sizes, HVAC, electricity and telecommunication is directly accessible and does not need to be entered manually. For the operation of a building, information about the installed devices including maintenance cycles and warranty conditions are particular valuable. An important aspect is the constant upkeep of the digital building model; all changes in the real facility must be recorded in its digital twin. When larger renovations or modifications are required at a later date, the building model provides an excellent basis for the necessary design activities. When the built facility reaches the end of its life cycle and is going to be demolished, the digital twin provides detailed information about the materials used in its construction, in order to plan their environmentally-sound recycling or disposal.

1.2.4 Level of Development

Building design is a process of continuous development, elaboration and refinement. In conventional planning processes, the drawing scale provides a well-established means for describing the geometric resolution required for a certain project stage which implicitly defines the degree of elaboration, maturity and reliability of the design information to be delivered. As there is no scale in the world of digital models, an analogy had to be found for reflecting the concept of geometric resolution and degree of elaboration.

After the initially used term "Level of Detail" (as used in neighboring domains) was deemed misleading as it puts too much emphasis on the geometric appearance, the term "Level of Development" (LOD) was coined and is now in widespread use. An LOD defines both the required geometric detail (also denoted as Level of Geometry – LOG) as well as the required alphanumeric information (also denoted as Level of Information – LOI). An LOD defines the extent of information provided

but also gives an indication of its maturity and reliability. In most cases, an LOD can be associated with a specific design phase.

The US-American BIMForum has defined six standardized LODs (100, 200, 300, 350, 400, 500) and published an extensive catalog depicting the geometric part of the LODs for typical building components (BIMForum 2017). This document, however, provides only minimal specifications regarding the LOI, as the required alphanumeric information depends heavily on the type of construction project and the respective BIM use cases. A more detailed description of the LOD concept is provided in Chap. 6.

LOD requirements typically form part of the Employer's Information Requirements (EIR) defined by the client at the beginning of the project (see Sect. 1.3.3 and Chap. 13).

1.3 Building Information Modeling: How?

1.3.1 Little BIM vs. BIG BIM, Closed BIM vs. Open BIM

The shift from conventional drawing-based workflows to model-based ones requires significant changes in both internal company workflows as well as cross-company processes. To avoid unduly unsettling the basic functioning of established workflows, a stepwise transition is recommended. Accordingly, different technological levels of BIM implementation are distinguished.

The simplest differentiation is expressed by the terms "BIG BIM" and "little bim" (Jernigan 2008). Here, little bim describes the application of a specific BIM software by an individual stakeholder to realize a discipline-specific design task. Typically, software is used to create a building model and derive the drawings which are then fed into the conventional process. The building model is not used across different software packages and is not handed over to other stakeholders. This BIM implementation is, therefore, an insular solution within one design discipline, with all external communications taking place using drawings. Although, implementing "little bim" can offer efficiency gains, the big potential of comprehensively using digital building information remains untapped.

By contrast, BIG BIM involves consistently model-based communications between all stakeholders and across the entire lifecycle of a facility (Fig. 1.3). For the data exchange and the coordination of the model-based workflows, digital technologies such as model servers, databases or project platforms are employed in a comprehensive manner.

Alongside the extent of BIM usage is the question of whether software products from just one vendor are employed ("Closed BIM") or whether open vendor-neutral data formats are utilized to allow data to be exchanged between products by different software vendors ("Open BIM"), see Fig. 1.6. Although some software companies on the market provide a large range of software products required for the design,

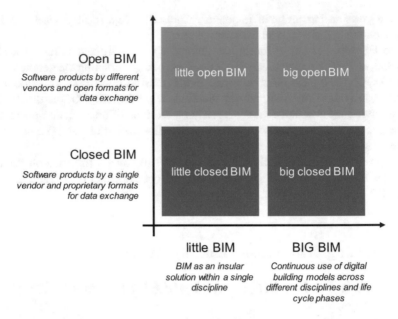

Fig. 1.6 The terms "little BIM" and "BIG BIM" describe the extent of BIM usage. The terms "Closed BIM" and "Open BIM" distinguish between the exclusive use of software products from a single vendor and the use of open, vendor-neutral data exchange formats. (Based on Liebich et al. 2011)

construction and operation of built facilities, there will always be a need to exchange data with other products that either serve a specific purpose or are used by other stakeholders in the overall process. The variety of software systems in use is usually a product of the many disciplines involved and the distribution of tasks across different companies.

Although achieving high-quality data exchange using neutral formats is a challenge, there is no alternative. In 2004, the US National Institute of Standards and Technology published a study which quantified the costs caused by poor software interoperability in the capital sector at 15.8 billion US$ per year (Gallagher et al. 2004).

To overcome this enormous economic waste and significantly improve data exchange between software products in the AEC industry, the *International Alliance for Interoperability* was founded in 1994 by a number of software vendors, users and public authorities across the world. In 2003, it was renamed *buildingSMART* for marketing reasons. The international non-profit organization succeeded in defining a vendor-independent data format for exchanging comprehensive digital building models. The resulting object-oriented data model named *Industry Foundation Classes (IFC)* provides very rich data structures covering almost all aspects of built facilities. In 2013, the data format was adopted as an ISO standard (ISO 2013) and it

now forms the basis for many national guidelines that stipulate the implementation of Open BIM. Chapter 5 provides detailed information about this format.

Despite much progress in recent years, BIM data exchange using the IFC format still does not work perfectly, i.e. data loss and misinterpretation still occurs from time to time. Both the definition of neutral formats as well as their correct implementation is a technically challenging task but there are promising signs that the remaining problems will be solved very soon if the software vendors are serious about pursuing this goal. This depends to a large degree on how much market demand (e.g. from public owners) there is for the implementation of Open BIM. If we consider the negative effects of an overwhelming dominance of a single software vendor, realizing Open BIM is definitely worth the effort.

1.3.2 BIM Maturity Levels

The construction industry cannot realize the big transition to fully-digitized model-based working procedures – i.e. BIG Open BIM – in one go. Instead, a more appropriate approach is to introduce the new technology and the accompanying changes in processes step by step. To illustrate this, the UK BIM Task Group developed the BIM Maturity Model which defines four discrete levels of BIM implementation (Fig. 1.7).

Level 0 describes conventional working practice based on 2D CAD and the exchange of paper-based drawings. Level 1 comprises the partial 3D modeling of the facility (mostly for complex geometries) while most of the design is still realized

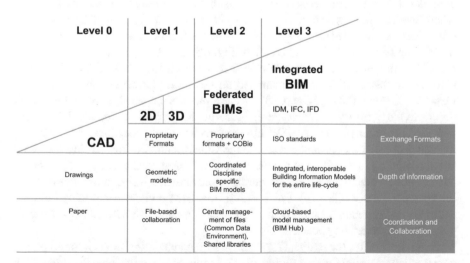

Fig. 1.7 The BIM Maturity Ramp of the UK BIM Task Group (Bew and Richards 2008) defines four discrete levels of BIM maturity. Since April 2016, the British Government is mandating Level 2 for all public construction projects. (© A. Borrmann, reprinted with permission)

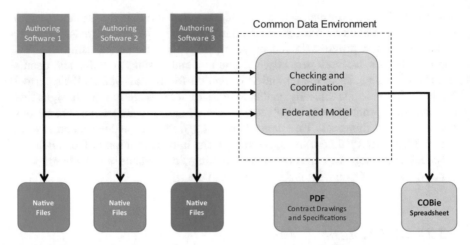

Fig. 1.8 In BIM Level 2, the workflow uses native files from the individual specialist planners that are regularly integrated into a common data model for verifying and coordinating the different trades. From this model, a contractually agreed set of 2D plans and specifications are derived and saved as PDF files. An important role is played by COBie spreadsheets that contain information on a building and its technical installations in a structured form for transferring to the client. (© A. Borrmann, reprinted with permission)

by means of 2D drawings. Here, data exchange is realized through sending and receiving individual files, and a central project platform is not employed.

Level 2 is defined by the use of BIM software products for authoring digital building models, however, each of the various disciplines involved develops its own model. Their mutual consistency is ensured by periodic coordination sessions, where the individual sub-models are brought together and checked for clashes or other discrepancies. This approach is known as the federated models approach since the sub-models are only loosely coupled (Fig. 1.8). 2D drawings are mostly derived from BIM models. Data exchange is still realized on the basis of files (in native formats), however, all files are managed on a central platform called a Common Data Environment (CDE) (Chap. 15). A CDE records the status of each file which describes the maturity of the contained information as well as the level of access provided for other parties. A CDE also enforces formal procedures for changing the status of a file. A particular role has the COBie standard for handing over data about a building to the client at regular intervals. COBie does not support geometry, but facilitates the transmission of purely alphanumeric information relevant for the operation phase (Chap. 9). For handing over BIM models comprising both 3D geometry and semantics, open standards are not demanded on BIM Level 2. Instead, proprietary formats may be used.

From April 2016, the British Government began mandating Level 2 for all public construction projects (Cabinet Office 2011). To this end, detailed specifications have been published, most importantly PAS1192-2:2013 "Specification for information management for the capital/delivery phase of construction projects using building

information modeling" and PAS1192-3:2014 "Specification for information management for the operational phase of assets using building information modeling" as well as the BIM protocol to be used as an appendix of legal contracts and the Digital Plan of Work which defines what information is required at which project stage (PAS 1192-2 2013).

Level 3, which is targeted for the future, is based on the concept of a fully integrated BIM. It is based on the implementation of BIG Open BIM, i.e. ISO standards are employed for data exchange and process descriptions, and deeply integrated digital models are used throughout the entire lifecycle. Cloud services are used for managing project data so that data is continuously and consistently maintained over the building's life cycle.

1.3.3 BIM Project Execution

An important prerequisite for the successful realization of BIM projects are legally binding agreements addressing model contents, model qualities and workflows, in particular for the handover of building models to the owner. General contractual specifications are typically provided by a contract appendix that defines the applied terminology as well as global responsibilities. The British Construction Industry Council (CIC) has published a template called the BIM protocol that serves this purpose (CIC 2013).

In this context, the Employer's Information Requirements (EIR) and the BIM Execution Plan (BEP) play a very important role. Both documents are developed specifically for the respective construction project and form part of the contractual agreements. In the EIR, which forms part of the tendering documents, the client declares the objectives of applying BIM in the project and how the digital processes shall be executed. It contains detailed specifications on responsibilities, handover dates and procedures, as well as data exchange formats. The content of the models to be delivered is specified through well-defined LODs for each element type including detailed lists of attributes.

In the Pre-Award BEP, bidders (potential contractors) describe how they plan to meet the requirements of the EIR. The BEP is refined into a more detailed document after the contract is awarded. A number of templates have been published for both the EIR and BEP by different institutions (AEC UK 2012a,b; Richards et al. 2013; CIC 2013; PennState 2011).

General specifications for BIM project execution have been provided by the British PAS 1192-2:2013 as part of the UK BIM mandate. It forms the basis for ISO 19650 which is currently in development. More details about BIM project execution and management are provided in Chap. 13.

1.3.4 BIM Roles and Professions

The introduction of BIM brings with it numerous new tasks and responsibilities for the management and coordination of digital building models. This means not only that there are new roles in the project team, but also new professions. The most important roles are that of the BIM Manager, the BIM Coordinator and the BIM Modeler. Currently, there are no broadly agreed descriptions of these roles.

Most guidelines accord the BIM Manager a strategic role in the company, responsible for guiding the transition towards digital practices and for developing guidelines regarding workflows, model contents and best practices. The BIM Coordinator, by contrast, is a role assigned on a per-project basis, and is responsible for coordinating the specialist disciplines, merging sub-models, checking model contents and applying quality control in order to meet the client's demands. The BIM modeler is an engineer or architect responsible for developing the model.

Figure 1.9 shows the responsibilities of the BIM Manager, the BIM Coordinator and the BIM Modeler, as defined by the UK AEC BIM Protocol (AEC UK 2012a).

The guidelines of the British Construction Industry Council (CIC), however, define the role of the Information Manager as a person with similar responsibilities to the aforementioned BIM Coordinator (CIC 2013), but with a slightly higher-level perspective. According to the guidelines, this role is not responsible for coordinating the discipline-specific partial models, but for defining and monitoring data exchange processes as well as performing quality control regarding the model delivery, i.e. checking model contents and enforcing their handover in time. The British Building Research Establishment (BRE) accordingly defines the Information Manager as an "organizational representative appointed by the employer or asset owner, who is responsible for establishing governance and assuring data and information flow to

Role	Strategic						Management				Production	
	Corporate Objectives	Research	Process + Workflow	Standards	Implementation	Training	Exceution Plan	Model Audit	Model Coordination	Content Creation	Modelling	Drawing Production
BIM Manager	Y	Y	Y	Y	Y	Y	Y	N	N	N	N	N
BIM Coordinator	N	N	N	N	N	Y	Y	Y	Y	Y	Y	N
BIM Modeler	N	N	N	N	N	N	N	N	N	Y	Y	Y

Fig. 1.9 Responsibilities of the BIM manager, BIM coordinator and BIM modeler. (Based on AEC UK 2012a)

and from the common data environment (CDE) during the design, construction, operation and maintenance, and disposal or decommissioning of a built asset." (BRE 2017).

1.4 State of BIM Adoption

The degree of BIM adoption and BIM maturity varies across the world. In some countries, the introduction of the BIM methods is already quite advanced. Singapore, Finland, Korea, the USA, UK and Australia are among the pioneers. In all these countries, the government and its subsidiary authorities play a key role in demanding and fostering the introduction of BIM.

As far back as 2004, Singapore already made it obligatory to submit construction documents for public construction projects via an internet platform (Khemlani 2005). This included the submission of Building Information Models in the vendor-neutral IFC format. The digital building models are subsequently checked for conformance with codes and guidelines, e.g. regarding fire safety. BIM penetration in the Singaporean construction sector is accordingly very advanced. The BIM guidelines of the Building and Construction Authority (BCA) were already published in a second edition in 2013 (BCA Singapore 2013).

Since 2007, public authorities in Finland have required the use of digital building models for all public projects with projected costs in excess of 1 million Euros (Senate Properties 2007). Since then, comprehensive experience in the execution of BIM projects has been gathered which has been anchored in the "Common BIM requirements", a set of guidelines that were published in 2012 (RTS 2012). In general, Finnish BIM requirements for data handover to the public client require the use of the vendor-neutral IFC format.

In the US, major governmental building owners, such as the General Service Administration (GSA) and the US Army Corps of Engineers (USACE) have required the use of BIM methods for project execution for many years (GSA 2007). USACE has published a comprehensive BIM roadmap and provides templates for BIM authoring tools as well as contract requirements on their website (USACE 2012). Also large private owners are increasingly demanding BIM in their construction projects. The National Institute of Building Sciences (NIBS) has published the National BIM standard (NIBS 2012) which basically bundles a set of standards defined elsewhere, including the international data exchange standards IFC and COBie, the BIMforum LOD specifications, the US CAD standards, and the PennState BIM use cases, among others. The first version of NBIMS-US came out as far back as 2007, the most recent version 3 was published in 2015.

An important role for the practical implementation of BIM is played by the American Institute of Architects (AIA). For example, it provides a set of templates for contractual agreements in BIM projects. Together with the Associated General Contractors (AGC), AIA supports the BIMForum, the US chapter of BuildingSMART International. As its most important activity, BIMForum publishes

a comprehensive Level of Developments specification in a yearly update cycle (BIMForum 2017). The specification, which was provided for the first time in 2013, has been used as a basis for many BIM projects across the entire world.

Apart from these US-wide efforts, there are a wide range of BIM standards and guidelines at different governmental and administrative levels, e.g. from the state level down to the local level of individual cities. One example is the BIM guidelines of New York City (NYC DDC 2012).

A particularly remarkable example is the construction strategy of the British government which was initiated in 2011 with the declared objective of reducing costs and lowering the carbon footprint of construction projects through the consequent use of BIM methods and technologies. The UK government also aims to put the British construction industry "at the vanguard of a new digital construction era and position the UK to become the world leaders in BIM", in order to acquire a significant competitive advantage on the international market. The key aspect of the 2011 UK construction strategy was to demand "fully collaborative 3D-BIM" for all centrally procured construction projects from 2016 onwards, which corresponds to BIM Level 2 as defined in Sect. 1.3.2. At the time of writing, the goal has been mostly met. This is supported by an annual BIM survey which reported a significant increase in the adoption of BIM methods by the UK construction industry over the past few years.

To achieve this, a BIM Task Group was appointed to coordinate the creation of necessary standards and guidelines. One of the most important standards developed is the aforementioned Publicly Available Specification PAS 1192-2 "Specification for information management for the capital/delivery phase of construction projects using building information modeling". The document describes the general execution of BIM projects including the purposes and required contents of both the Employer's Information Requirements (EIR) and the BIM Execution Plan (BEP), and introduces the concept of Data Drops where at defined project stages information is handed over to the client (see Chap. 18). Currently, however, the PAS requires only the handover of alphanumeric information using the vendor-neutral format COBie (see Chap. 9). The use of IFC for implementing full Open BIM, i.e. including 3D building geometry, is not yet obligatory, i.e. proprietary formats can also be applied.

The PAS makes stipulations at a mostly generic level and leaves details such as the model contents and required LOG/LOI to the arrangements of the individual construction project. This includes the Digital Plan of Work (DPoW) that defines the deliverables required at each stage of a construction project including the levels of geometry, data and documentation. To support clients in the definition of the deliverables, an online toolkit has been developed (NBS 2015). The consistent use of the British classification system Uniclass is an important aspect in this regard (see Chap. 8). Another important component of the UK BIM initiative is the National BIM Library which provides a large number of BIM objects of products from different manufacturers with pre-defined property sets, for direct use in diverse BIM authoring tools (NBS 2014). Templates for contractual agreements have also been developed by the Construction Industry Council (CIC) as well as the AEC UK Consortium and are provided online free of charge (CIC 2013; AEC UK 2012a,b).

Many other European countries have started initiatives for implementing BIM in the public construction sector. Some of them already require the use of BIM, others plan to do so very soon. Among the most advanced countries are Finland (RTS 2012), Sweden (BIM Alliance 2015), Norway (Staatsbyg 2013) and the Netherlands (Rijksgebouwendients 2013).

France initiated its "Plan de transition numérique du bâtiment" (PTNB) in 2014 (Delcambre 2014) with significant investments to support the transition towards digital technologies. The PTNB published a roadmap in 2015 (PTNB 2015), a BIM guide specifically addressing the needs of the building owners in 2016 (PTNB 2016), and a standardization strategy in 2017 (PTNB 2017). Meanwhile, the French chapter of bSI called "MediaConstruct" has published a comprehensive BIM guide describing BIM processes, BIM use cases and BIM contents (Mediaconstruct 2016). The French region of Burgundy had deployed BIM models for managing building operations across 135 sites consisting majorly of high schools way back in 2004. Today, the regional council works exclusively within a BIM-based process for construction, maintenance and building operations.

In Germany, the Ministry of Transport published a BIM Roadmap in 2015 which defines the mandatory use of BIM methods for all federal infrastructure projects from 2020 onwards (BMVI 2015). In this context, significant standardization work is being carried out (VDI 2014), guidelines and templates for EIR and BEP are being developed, and a number of BIM pilot projects are being conducted. The German approach is remarkable in that BIM is first becoming mandatory for the infrastructure sector before being adopted for public house building. The Deutsche Bahn, as one of the largest infrastructure construction clients, plays a particularly important role and has published detailed BIM guidelines (Deutsche Bahn 2017) and achieved a significant level of BIM adoption in its projects. The European railway companies are currently establishing alliances for collaborating in the field of BIM for railways.

In Spain, a steering committee was established in 2015 and a provisional timetable has been set, with recommended use of BIM in public sector projects by March 2018, mandatory use in public construction projects by December 2018 and mandatory use in infrastructure projects by July 2019. Also Austria and Switzerland have started intensive work on BIM standardization (Austrian Standards 2015; Bauen digital Schweiz 2018).

In the European Union, an important prerequisite for the introduction of national BIM mandates is their compliance with EU legislation. In this regard, the EU Public Procurement Directive was updated in 2014 to allow public clients to stipulate digital working practices (European Parliament 2014): "For public works contracts and design contests, Member States may require the use of specific electronic tools, such as building information, electronic modeling tools or similar". At the same time, European standardization work has begun and Technical Committee 442 "Building Information Modeling" has been established in the Centre Européen de Normalisation (CEN). As one of its first steps, the committee adopted the international standards ISO 16739 (Industry Foundation Classes) and ISO 29481 (Information Delivery Manual) as European standards. All CEN standards must be

implemented by the EU member states as national standards. Another important initiative on the EU level is the EU BIM Task Force which aims to establish a common European network for aligning the use of Building Information Modeling in public works. One of the first outcomes of the task force is the publishing of the "BIM Handbook for Owners" in 2017 (EU BIM Task Force 2017).

In Asia, besides Singapore, South Korea and China are the most advanced countries with respect to BIM adoption. Korea has a long tradition of using BIM and already published its first BIM roadmap in 2010. The first BIM guidelines were published in 2011 and have been frequently updated since then. They included details on how BIM models should be developed incrementally throughout the design and construction phases and define the minimum requirements for various use cases, such as design review, 3D coordination, and cost estimation. Since 2016, the Korean government is mandating BIM for all public construction projects over 50 billion Won. Currently, they are focusing on including the infrastructure sector in the BIM mandate.

China started to develop BIM guidelines and standards in 2001 (Liu et al. 2017). In 2011, the Ministry of Housing and Urban-Rural Development (MOHURD) released the "Outline of Development of Construction Industry Informatization (2011–2015)", which emphasized BIM as a core technology to support and improve the construction industry. In 2016, MOHURD issued an updated version of their "Outline of Development of Construction Industry Informatization (2016–2020)" that proposes enhancing the integrative applications of information technologies like BIM, big data, etc. However, according to Liu et al. (2017) and Jin (2015), the main barriers to the successful adoption of BIM in China are cultural resistance; the low cost of manpower; the lack of domestic BIM data exchange standards, evaluation criteria and BIM project implementation standards; along with the lack of qualified BIM professionals.

The BIM implementation strategy of Australia is mainly influenced and driven by the pioneering UK efforts. In 2012, "The National Building Information Modeling Initiative (NBI)" report was published as a strategy for the "the focused adoption of BIM and related digital technologies and process for the Australian built environment sector" (Australian Parliament 2016). With regard to BIM in infrastructure, in 2016, the Standing Committee on Infrastructure, Transport and City of the Commonwealth of Australia released the "Report on the inquiry into the role of smart ICT in the design and planning of infrastructure" (buildingSMART Australasia 2012). In this report the committee recommends the Government to "[…] require BIM to LOD500 on all major infrastructure projects exceeding 50 million AUS$ in cost and receiving government funding […]".

1.5 Summary

Building Information Modeling is an information management method for construction projects based on the consequent use of digital models across the entire lifecycle of a built facility. The models comprise both the 3D geometry of the

building components as well as a comprehensive set of semantic information, including function, materials and relationships between the objects. A BIM model provides a high-level digital representation of the real building and forms an optimal basis for computational applications. The actual content of a BIM model depends on the BIM use case and the project phase it is applied in. Typical BIM use cases include visualization, design coordination, drawing generation, quantity take-off, progress monitoring and facility management. The application of BIM methods provides significant benefits when compared with conventional drawing-based processes resulting in more efficient processes, reduced errors in the building design and construction, and improved transparency of the construction process, which ultimately helps to reduce costs and risks with respect to time and budget overruns.

Each BIM use case implies different demands regarding the level of geometric detail and the level of information provided by the model, often subsumed under term Level of Development which has become an important concept when defining BIM requirements. The actual creation of BIM content and its processing for implementing the uses cases is achieved using a variety of different software applications. It is important to note that BIM is an information management method and not a single software product. Accordingly, data exchange between the involved BIM systems is of utmost importance. Here, we can distinguish between the Closed BIM approach, where products by only one vendor or its proprietary interfaces are applied, and the Open BIM approach, which is based on vendor-neutral, standardized data formats such as the Industry Foundation Classes. Both approaches have their own advantages and challenges.

Thanks to the availability of modern software applications, technological barriers for introducing BIM hardly exist. At the same time, however, the use of BIM requires significant changes to working processes and procedures. Due to the strong fragmentation of the construction industry, the impetus for applying BIM must come from the clients who must stipulate and foster the application of BIM methods. The public sector plays a particular role in this regard as, on the one hand, it has sufficient power to change the working practices of the construction sector, and on the other is bound to precise regulations regarding the procurement of design and construction services. The experiences in the countries with the most advanced BIM adoption have shown that a strong political will is required to drive the digitalization of the construction sector.

References

AEC UK. (2012a). *AEC (UK) BIM Protocol*. AEC (UK) CAD & BIM Standards, UK. Retrieved from https://aecuk.wordpress.com/documents/. Accessed 9 Dec 2017.
AEC UK. (2012b). *AEC (UK) BIM Protocol – BIM Execution Plan V2.0*. AEC (UK) CAD & BIM Standards, UK. Retrieved from https://aecuk.wordpress.com/documents/. Accessed 9 Dec 2017.

Australian Parliament. (2016). *Smart ICT report on the inquiry into the role of smart ICT in the design and planning of infrastructure.* Report of the Standing Committee on Infrastructure, Transport and City. Sydney: The Parliament of the Commonwealth of Australia.

Austrian Standards. (2015). *Building Information Modeling.* Vienna: Austrian Standards Institute. Retrieved from https://www.austrian-standards.at/infopedia-themencenter/infopedia-artikel/building-information-modeling-bim/. Accessed 9 Dec 2017.

Autodesk. (2003). *Building Information Modeling.* San Rafael: Autodesk Inc. Retrieved from http://www.laiserin.com/features/bim/autodesk_bim.pdf. Accessed 9 Dec 2017.

Bauen Digital Schweiz. (2018). *Stufenplan Schweiz – Digital Planen, Bauen und Betreiben.* Retrieved from: https://bauen-digital.ch/assets/Downloads/free4all/BdCH-Stufenplan-web.pdf

BCA Singapore. (2013). *Singapore BIM guide V2.* Singapore: Building and Construction Authority. Retrieved from https://www.corenet.gov.sg/general/bim-guides/singapore-bim-guide-version-20.aspx. Accessed 9 Dec 2017.

Bew, M., & Richards, M. (2011). *BIM maturity model, strategy paper for the government construction client group.* London: Department of Business, Innovation and Skills. Retrieved from: https://www.cdbb.cam.ac.uk/Resources/ResoucePublications/BISBIMstrategyReport.pdf. Accessed 9 Dec 2017.

BIM Alliance. (2015). *BIM alliance Sweden website.* Stockholm. Retrieved from http://www.bimalliance.se. Accessed 9 Dec 2017.

BIMForum. (2017). *Level of development specification version 2017.* BIMForum. Retrieved from http://bimforum.org/lod/. Accessed 9 Dec 2017.

BMVI. (2015). *Roadmap for digital design and construction, federal ministry of transport and digital infrastructure.* Berlin. Retrieved from https://www.bmvi.de/SharedDocs/EN/publications/road-map-for-digital-design-and-construction.html. Accessed 9 Dec 2017.

Building Research Establishment. (2017). *BRE BIM terminology.* Watford. Retrieved from https://www.bre.co.uk/bim-terminology.jsp. Accessed 9 Dec 2017.

buildingSMART Australasia. (2012). *National building information modelling initiative* (Vol. 1). Strategy: A strategy for the focussed adoption of building information modelling and related digital technologies and processes for the Australian built environment sector, Report to the Department of Industry, Innovation, Science, Research and Tertiary Education, Sydney.

Cabinet Office. (2011). *Government Construction Strategy.* London: Cabinet Office. Retrieved from https://www.gov.uk/government/publications/government-construction-strategy. Accessed 9 Dec 2017.

CIC. (2013). *Building information model (BIM) protocol – Standard protocol for use in projects using building information models.* London: Construction Industry Council. Retrieved from http://cic.org.uk/download.php?f=the-bim-protocol.pdf. Accessed 9 Dec 2017.

Delcambre, B. (2014). *Mission numérique du bâtiment.* Rapport, Ministère du Logement, de l'Égalité des territoires et de la Ruralité, Paris. Retrieved from http://www.batiment-numerique.fr/uploads/PDF/rapport-mission-numerique-batiment-vf.pdf. Accessed 9 Dec 2017.

Deutsche Bahn. (2017). *Vorgaben zur Anwendung der BIM-Methodik.* Retrieved from http://www1.deutschebahn.com/sus-infoplattform/start/Vorgaben_zu_Anwendung_der_BIM-Methodik.html. Accessed 9 Dec 2017.

Eastman, C., Fisher, D., Lafue, G., Lividini, J., Stoker, D., & Yessios, C. (1974). *An outline of the building description system.* Institute of Physical Planning, Carnegie-Mellon University. Retrieved from http://eric.ed.gov/?id=ED113833. Accessed 9 Dec 2017.

Eastman, C., Teicholz, P., Sacks, R., & Liston, K. (2008). *BIM handbook: A guide to building information modeling for owners, managers, designers, engineers and contractors.* Hoboken: John Wiley & Sons.

EU BIM Task Force. (2017). *Handbook for the introduction of building information modelling by the European public sector.* Bruxelles: EU BIM Task Force. Retrieved from http://www.eubim.eu/handbook/. Accessed 9 Dec 2017.

European Parliament. (2014). *Directive 2014/24/EU of the European Parliament and of the Council of 26 February 2014 on Public Procurement and Repealing Directive 2004/18/EC.* Bruxelles: European Parliament.

Gallagher, M., O'Connor, A., Dettbar, J., & Gilday, L. (2004). *Cost analysis of inadequate interoperability in the US capital facilities industry (NIST GCR 04-867)*. Gaithersburg: National Institute of Standards and Technology.

GSA. (2007). *GSA BIM guide series*. Washington, DC: General Service Administration. Retrieved from www.gsa.gov/bim. Accessed 9 Dec 2017.

ISO 16739. (2013). *Industry Foundation Classes (IFC) for data sharing in the construction and facility management industries*. Geneva: International Organization for Standardization.

Jernigan, F. E. (2008). *BIG BIM – Little BIM: The practical approach to building information modeling: Integrated practice done the right way!* (2nd ed.). Salisbury: 4 Site Press.

Jin R., Tang L., & Fang K. (2015). Investigation into the current stage of BIM application in China's AEC industries. *WIT Transactions on the Built Environment, 145*, 493–503. https://doi.org/10.2495/BIM150401

Joseph, J. (2011). *BIM titles and job descriptions: How do they fit in your organizational structure?* Autodesk University 2011.

Kagermann, H. (2015). Change through digitization – Value creation in the age of industry 4.0. *Management of Permanent Change*, 23–45. https://doi.org/10.1007/978-3-658-05014-6_2

Khemlani, L. (2005). *CORENET e-PlanCheck: Singapore's automated code checking system*. AECbytes Website: http://www.novacitynets.com/pdf/aecbytes_20052610.pdf. Accessed 9 Dec 2017.

Kreider, R., Messner, J., & Dubler, C. (2010). Determining the frequency and impact of applying BIM for different purposes on building projects. In *Proceedings of the 6th International Conference on Innovation in Architecture, Engineering and Construction (AEC)* (pp. 1–10). Retrieved from http://bim.psu.edu/uses/Freq-Benefit/BIM_Use-2010_Innovation_in_AEC-Kreider_Messner_Dubler.pdf. Accessed 9 Dec 2017.

Liebich, T., Schweer, C.-S., & Wernik, S. (2011). Auswirkungen der Planungsmethode Building Information Modelling (BIM) auf die Leistungsbilder und Vergütungsstrukturen für Architekten Architekten und Ingenieure sowie auf die Vertragsgestaltung (in German), Final Report, Research Initiative ZukunftBAU, Federal Institute for Research on Building, Urban Affairs and Spatial Development, Bonn.

Liu, B., Wang, M., Zhang, Y., Liu, R., & Wang, A. (2017). Review and prospect of BIM policy in China. *IOP Conference Series: Materials Science and Engineering, 245*. http://doi.org/10.1088/1757-899X/245/2/022021

MacLeamy, P. (2004). *Collaboration, integrated information and the project lifecycle in building design, construction and operation*. Retrieved from http://www.lcis.com.tw/paper_store/paper_store/CurtCollaboration-20154614516312.pdf. Accessed 9 Dec 2017.

Mediaconstruct. (2016). *Guide méthodologique pour des conventions de projets en BIM*. Retrieved from http://www.mediaconstruct.fr/travaux/guide-de-convention-bim. Accessed 9 Dec 2017.

NBS. (2014). *NBS national BIM library*. Newcastle Upon Tyne, UK: National Building Specification (NBS). Retrieved from http://www.nationalbimlibrary.com/. Accessed 9 Dec 2017.

NBS. (2015). *NBS BIM toolkit*. Newcastle Upon Tyne, UK: National Building Specification (NBS). Retrieved from https://toolkit.thenbs.com/. Accessed 9 Dec 2017.

van Nederveen, G. A., & Tolman, F. P. (1992). Modelling multiple views on buildings. *Automation in Construction, 1*(3), 215–24. https://doi.org/10.1016/0926-5805(92)90014-B

NIBS. (2015). *National BIM standard United States version 3*. Washington, DC: National Institute of Building Sciences. Retrieved from http://www.nationalbimstandard.org/. Accessed 9 Dec 2017.

NYC DDC. (2012). *BIM guide*. New York: New York City department of design and construction. Retrieved from http://www1.nyc.gov/site/ddc/resources/publications.page. Accessed 9 Dec 2017.

PAS 1192-2. (2013). *Specification for information management for the capital/delivery phase of construction projects using building information modelling*. London: The British Standards Institution.

PennState. (2011). *BIM project execution planning guide V2.1*. State College: The Computer Integrated Construction Research Group, The Pennsylvania State University. Retrieved from http://bim.psu.edu/Project/resources/default.aspx. Accessed 9 Dec 2017.

PennState. (2013). *BIM uses within the BIM project execution plan*. State College: The Computer Integrated Construction Research Group, The Pennsylvania State University. Retrieved from http://bim.psu.edu/uses/. Accessed 9 Dec 2017.

PTNB. (2015). *Operational roadmap*. Paris: Plan Transition Numerique dans le Batiment. Retrieved from http://www.batiment-numerique.fr/uploads/PDF/Feuille%20de%20route %20PTNB_EN_002%20(1).pdf. Accessed 9 Dec 2017.

PTNB. (2016). *Guide de Recommandation à la maîtrise d'ouvrage*. Paris: Plan Transition Numerique dans le Batiment. Retrieved from http://www.batiment-numerique.fr/uploads/DOC/PTNB%20-%20Guide%20Methodo%20MOA.pdf. Accessed 9 Dec 2017.

PTNB. (2017). *Stratégie française pour les actions de pré-normalisation et normalisation BIM appliquées au bâtiment*. Paris: Plan Transition Numerique dans le Batiment. Retrieved from http://www.batiment-numerique.fr/uploads/DOC/PTNB%20-%20FdR %20Normalisation%202017.pdf. Accessed 9 Dec 2017.

Richards, M., Churcher, D., Shillcock, P., & Throssell, D. (2013). *Post contract-award building information modelling (BIM) execution plan (BEP)*. Construction Project Information Committee. Retrieved from http://www.cpic.org.uk/cpix/cpix-bim-execution-plan/. Accessed 9 Dec 2017.

Rijksgebouwendients. (2013). *Rgd BIM standard*. The Netherlands: Rijksgebouwendients. Retrieved from http://www.rijksvastgoedbedrijf.nl/english/expertise-and-services/b/building-information-modelling-bim. Accessed 9 Dec 2017.

RTS. (2012). *Common BIM requirements 2012*. Helsinki: The Building Information Foundation RTS. Retrieved from http://www.en.buildingsmart.kotisivukone.com/3. Accessed 9 Dec 2017.

Senate Properties. (2007). *Senate properties' BIM requirements*. Helsinki: Senate Properties.

Staatsbyg. (2013). *BIM manual V 1.2.1*. Staatsbyg. Retrieved from http://www.statsbygg.no/Files/publikasjoner/manualer/StatsbyggBIM-manual-ver1-2-1eng-2013-12-17.pdf. Accessed 9 Dec 2017.

USACE. (2012). *The US army corps of engineers roadmap for life-cycle BIM (2012 Edition)*. Washington, DC: US Army Corps of Engineers. Retrieved from https://cadbimcenter.erdc.dren.mil/default.aspx?p=a&t=1&i=13. Accessed 9 Dec 2017.

VDI. (2014). *Agenda building information modeling – VDI-Richtlinien zur Zielerreichung*. Düsseldorf: Verein Deutscher Ingenieure. Retrieved from http://www.vdi.de/technik/fachthemen/bauen-und-gebaeudetechnik/querschnittsthemen-der-vdi-gbg/koordinierungskreis-bim/. Accessed 9 Dec 2017.

Part I
Technological Foundations

Chapter 2
Principles of Geometric Modeling

André Borrmann and **Volker Berkhahn**

Abstract The three-dimensional geometry of a building is a vital prerequisite for Building Information Modeling. This chapter examines the principles involved in representing geometry with a computer. It details explicit and implicit approaches to describing volumetric models as well as the basic principles of parametric modeling for creating flexible, adaptable models. The chapter concludes with an examination of freeform curves and surfaces and their underlying mathematical description.

2.1 Geometric Modeling in the Context of BIM

A Building Information Model contains all the relevant information needed for the planning, construction and operation of a building. The three-dimensional description of the geometry of a building is one of the most important aspects without which many BIM applications would not be possible. The availability of a model in three dimensions offers significant advantages over conventionally drawn plans:

- The planning and construction of the building can be undertaken using a 3D model rather than separate plans and sections. Drawings are then generated from the 3D model, ensuring that the separate drawings always correspond and remain consistent with one another. This almost entirely eradicates a common source of errors, especially when alterations are made to the plans. But a three-dimensional geometric model on its own is not sufficient for generating plans that conform with current standards. Further semantic information also needs to be provided, for example denoting the construction type or material, as building

A. Borrmann (✉)
Chair of Computational Modeling and Simulation, Technical University of Munich, München, Germany
e-mail: andre.borrmann@tum.de

V. Berkhahn
Institute for Risk and Reliability, Leibniz University Hannover, Hannover, Germany
e-mail: berkhahn@irz.uni-hannover.de

© Springer International Publishing AG, part of Springer Nature 2018
A. Borrmann et al. (eds.), *Building Information Modeling*,
https://doi.org/10.1007/978-3-319-92862-3_2

plans are commonly represented in a symbolic or simplified form, which cannot be generated from the 3D geometry alone.

- With a 3D model, collision analyses can be conducted to determine whether parts of a model or building elements within a model overlap. In most cases this indicates a planning error or oversight. The detection of such collisions is especially important for coordinating the work of different trades, for example when planning wall openings and penetrations for plumbing, ducts or other technical installations (see Chap. 18).

- A 3D model facilitates easy quantity take-off as quantities can be calculated directly from the volume and surface area of the model elements. Further special rules are typically still required to conform to standards, e.g. simplified quantity approximations (see Chap. 23).

- The availability of the building geometry in 3D is essential for associated calculation and simulation methods (see Chaps. 19 and 20). The necessary mechanical or physical model can often be generated directly from the geometric model, obviating the need to laboriously re-enter geometric data in a parallel system and the associated risk of entry errors. Many simulation methods, however, require simplifications to the model or model transformations to function effectively. Structural analyses, for example, are often calculated using dimensionally-reduced models.

- 3D models make it possible to compute photo-realistic visualizations of building designs (renderings) including shadows and surface reflections (see Fig. 2.1). This is particularly relevant for communications with clients and helps architects assess the spatial qualities and lighting conditions of their designs. For photo-realistic visualization, information on the materials and their surface qualities is also required in addition to the 3D geometry.

Fig. 2.1 A 3D model serves as the basis for a rendering to create a photo-realistic impression of a building design. (© C. Preidel, reprinted with permission)

The digital representation of the three-dimensional geometry of a building design is therefore one of the most fundamental aspects of Building Information Modeling. To properly understand the capabilities of modeling tools and exchange formats, one needs to know the basic principles of computer-aided geometric modeling, as described in this chapter. In addition, this chapter also introduces parametric modeling as a means of creating flexible geometries that can be easily adapted to meet new boundary conditions. The chapter concludes with an overview of modeling freeform curves and surfaces, which are gaining increasing relevance in building constructions.

A key determining factor for the capabilities of a BIM modeling tool is the quality of the geometric modeling kernel used. This is a software component that provides support for elementary data structures and operations for representing and processing geometric information. The same geometric modeling kernels is often used for several related software packages, and sometimes even licensed for use by other software vendors. Two examples of commonly-used geometric modeling kernels include ACIS (Spatial 2015) and ParaSolid (Siemens 2015).

2.2 Solid Modeling

There are two fundamentally different approaches to modeling the geometry of three-dimensional bodies: *Explicit modeling*, which describes a volume in terms of its surface, and is therefore often also known as Boundary Representation (BRep). *Implicit modeling* by contrast employs a sequence of construction steps to describe a volumetric body, and is therefore commonly termed a procedural approach. Both methods are used in BIM software and in the corresponding data exchange formats, and both are part of the IFC specification (see Chap. 5). The following section describes each in turn.

2.2.1 Explicit Modeling

2.2.1.1 Boundary Representation Methods

Boundary Representation is the most common and widespread method for describing three-dimensional bodies using a computer. The basic principle involves defining a hierarchy of boundary elements. Typically, this hierarchy comprises the elements *Body, Face, Edge* and *Vertex*. Each element is described by elements from the level beneath, i.e. the body is described by its faces, each face by its edges, each edge by a start and end vertex. This system of relationships defines the *topology* of the modeled body, and can be described with the help of a graph (see Fig. 2.2), which is known as the *vertex-edge-face graph*, or vef graph.

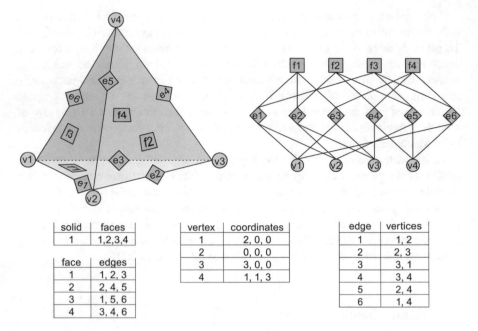

solid	faces
1	1,2,3,4

face	edges
1	1, 2, 3
2	2, 4, 5
3	1, 5, 6
4	3, 4, 6

vertex	coordinates
1	2, 0, 0
2	0, 0, 0
3	3, 0, 0
4	1, 1, 3

edge	vertices
1	1, 2
2	2, 3
3	3, 1
4	3, 4
5	2, 4
6	1, 4

Fig. 2.2 A simple BRep data structure containing the information necessary to describe a pyramid. The Vertex-Edge-Face-Graph describes the relationship between the vertices, edges and faces, and therefore the topology of the body. (© S. Vilgertshofer, reprinted with permission)

This topological information must then be augmented with geometric dimensions to fully describe the body. If a geometric body has only straight edges and flat surfaces, geometric information is only required for the nodes, i.e. the coordinates of the vertices. If the geometric kernel permits curved edges and surfaces, geometric information describing their shape or curvature is also required. This is described below in more detail in Sect. 2.4.

The data structure used to describe topological information usually takes the form of lists of variable length. The body refers to the faces that enclose it, the surfaces to the edges that bound it, and each edge to its start and end vertices.

This data structure is, however, only suitable for describing simple bodies without cut-outs or openings. To describe more complex volumes, the data model must be extended. Figure 2.3 shows the object-oriented data model of the ACIS modeling kernel (Spatial 2015), which is used by a variety of CAD and BIM software applications. With this data model, a *Body* can be comprised of several so-called *Lumps* that are not connected to one another. These *Lumps* are in turn described by several *Shells*, which make it possible for volumes with one or more openings or cut-outs. *Shells* can be comprised of any number of *Faces*, which in turn are described by one or more *Loops* that bound the faces. Because several loops are permitted per face, it is possible to define faces with holes, which are a prerequisite for modeling openings, recesses and holes.

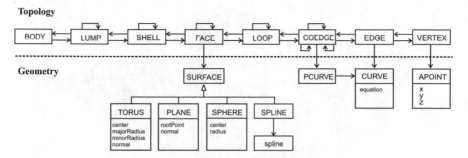

Fig. 2.3 The data model of the ACIS geometric modeling kernel

A further characteristic of this model is that loops do not refer directly to edges but to so-called *CoEdges* that have a consistent orientation to the respective face. These then refer to the actual *Edges*, which in turn are defined by their start and end Vertices. The bottom section of the figure shows the geometric information that can be associated with the faces, edges and vertices.

The resulting data model is extremely powerful, and can be used to describe almost any arbitrary body. It is implemented in the ACIS data exchange format, which is supported by several BIM systems, and is replicated in a slightly modified form in the IFC data model (see Chap. 5).

2.2.1.2 Triangulated Surface Modeling

A much-simplified variant of boundary representation is the description of the surface of a body as a triangle mesh. While curved surfaces cannot be described precisely, they can be approximated by choosing a finer mesh size to achieve the desired degree of accuracy. Triangulated surface modeling is often used in visualization software, for describing the surface of a terrain (see Fig. 2.4), or as input for numerical calculations and simulations. The description of curved surfaces as multiple faces requires much more storage capacity than analytical descriptions (see Sect. 2.4).

The underlying data structure commonly takes the form of a so-called *Indexed Face Set*. Here the coordinates of the vertices are stored as an ordered and numbered (indexed) list. The triangular faces are then defined by the indexes within the point list. This method avoids the repeated (redundant) storage of point coordinates and possible resulting geometry errors (gaps, overlaps) resulting from imprecisions.

The *Indexed Face Set* is a simple data structure and therefore robust and quick to process. It is used in several geometry data formats such as VRML, X3D and JT, as well as in the BIM IFC data structure (see Chap. 5). The commonly-used STL geometry format is likewise based on a triangulated description of bodies but, unlike the Indexed Face Set, stores the explicit coordinates of each individual triangle. This results in larger data sets and the lack of topological information in the STL format

Fig. 2.4 Digital terrain models are usually modeled as triangulated surface meshes. (© S. Vilgertshofer, reprinted with permission)

means that the derived geometry can contain errors, such as gaps between faces or overlapping sections of the individual triangles.

2.2.2 Implicit Modeling

Implicit methods for modeling geometries store the history of the creation of a modeled 3D body. As such they are known as procedural methods. They represent an alternative approach to the explicit methods described above, which store just the result of a what may have been a long and complex modeling process.

In CAD and BIM systems, a hybrid approach is often used in which the individual modeling steps of the construction history are recorded for the user while the system makes snapshots of the resulting explicit description of the geometry to reduce computational load and improve display times.

2.2.2.1 Constructive Solid Geometry

A classical approach to the procedural description of 3D geometries is the *Constructive Solid Geometry* (CSG) method, which employs predefined basic objects – so-called primitives –, such as cubes, cylinders or pyramids and combines them using Boolean operators such as union, intersection or difference to create more complex objects. This process of combination results in a construction tree that describes the generation of the 3D body (see Fig. 2.5). The dimensions of the basic

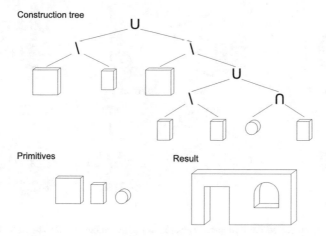

Fig. 2.5 The CSG method is based on the combination of solids using the Boolean operators union, intersection and difference. (© S. Vilgertshofer, reprinted with permission)

bodies are usually parametrized so that they can be easily adapted to the respective application.

While a relatively large spectrum of bodies can be constructed using CSG, the use of a small number of simple objects is often too limiting. As such, the pure CSG method is only rarely used, although it is supported by the IFC data model and other systems for data exchange purposes.

Many 3D CAD and BIM systems have adopted the principle of Boolean operators and extended their functionality significantly by making it possible to apply them to any previously modeled 3D object. This offers a powerful means of intuitively modeling complex three-dimensional objects. In the field of BIM, the definition of subtraction solids plays an important role in the modeling of openings and penetrations.

2.2.2.2 Extrusion and Rotation Methods

Many CAD and BIM systems provide the ability to generate 3D geometries by extrusion or rotation (Fig. 2.6). With these methods, a 2D geometry (typically a closed surface) is moved along a path or 3D curve defined by the user to create a 3D solid.

When the path along which the shape is drawn is straight, the results is an *Extrusion*, when curved a *Sweep*. Using a dedicated setting, the user can define whether the 2D profile remains parallel to its original plane or whether it turns to remain perpendicular to the path over the length of the path. Extrusion methods are used in building construction to generate beams with a constant or variable profile. A rotation volume is similar to an extrusion except that the 2D surface is rotated around an axis defined by the user.

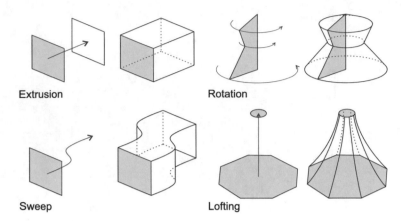

Fig. 2.6 Extrusion and rotation methods for creating solid bodies. (© S. Vilgertshofer, reprinted with permission)

Lofting is a variant of the above in which several cross-sections are defined and positioned one behind the other in space. The cross-sections can differ in size and shape from one another. The CAD or BIM system generates a body out of these cross-sections, interpolating the sections between them.

Extrusion and rotation functionality for generating 3D bodies is provided in many BIM tools, and is included in the IFC data format.

2.2.3 A Comparison of Explicit and Implicit Methods

With respect to data exchange, implicit methods have several advantages over explicit representations, most notably the ability to trace the modeling steps, the ability to easily modify the transferred geometry by editing the construction steps and a much smaller quantity of data to transfer. A major proviso in the data exchange of implicit model descriptions is, however, that the target system must support and be able to precisely reproduce all the operations used to generate the model geometry in the source system. This makes the implementation of a data exchange interface considerably more complex for the software producer.

The ability to edit the construction steps in implicitly modeled geometries requires the automatic reconstruction of the building element. Although this rarely needs any manual interaction from the user, it can be computationally intensive for complex elements. In addition, editing a construction step can prevent later construction steps from being executed properly so that these may also need editing.

In the case of explicitly modeled geometries, only direct editing is possible. One can manipulate specific control points to ensure the continuity of surfaces or to adapt the shape of surfaces to match the respective requirements.

2.3 Parametric Modeling

An exceptionally important trend in the building sector is parametric modeling (Pottman et al. 2015), with which it is possible to define a model using dependencies and constraints. The result is a flexible model that can be quickly and easily adapted to meet new or changing conditions.

Parameters can be as simple as geometric dimensions, for example the height, width, length, position and orientation of a cuboid. Relationships between parameters, so-called dependencies, can be defined with user-definable equations. This can be used, for example, to ensure that all walls in a story have the same height as the story-height. If the height of the story is changed, all wall heights change accordingly.

The concept of parametric CAD systems originated from the field of mechanical engineering, where it has been used since the 1990s. These systems used an approach based on parametrized sketches. The user would create an 2D drawing (the sketch) comprising all the desired geometric elements in proportions that roughly corresponded to the final object. These geometric elements would then be assigned constraints in the form of geometric constraints or dimensional constraints (Fig. 2.7). Geometric constraints can, for example, define that two lines must meet at their ends, that two lines are perpendicular to one another or parallel to one another. Dimensional constraints, on the other hand, define only dimensional values such as length, distance or angle. Equations can be defined to define relationships between different parameters (Fig. 2.8). This parametrized sketch then serves in the next step as a basis for an extrusion or rotation operation that generates the final parametrized three-dimensional body. Such bodies can then be combined with one another using CSG operations. So-called features can also be added to the final bodies, for example the application of a chamfer or the boring of holes. These features comprise a series of geometric operations, each controllable via their own parameters.

The combination of parametrized sketches and procedural geometric descriptions is an extremely powerful mechanism for defining flexible 3D models that affords users a high degree of freedom as well as precise control of the generated model.

This form of parametric modeling is not currently supported by BIM products. At present, only pure 3D modeling tools such as SolidWorks, CATIA and Siemens NX provide this functionality, but without support for semantic modeling. One exception is Digital Project by Gehry Technologies that comprises a fully parametric

Fig. 2.7 User interface for defining parametric geometries in Autodesk AutoCAD

Fig. 2.8 Right: a parametric sketch with defined geometric and dimensional constraints. Left: Using a parameter manager, it is possible to specify equations that define the relationship of parameters to one another. In the example shown, the parameter constraints ensure that the square and circle always bound the same area

modeling kernel augmented with a catalog of building-related construction elements that detail their semantic structure.

At present, BIM tools implement the concept of parametric modeling with a limited degree of flexibility. Parametric definitions are applied at two different levels: the level of the creation of parametrized building element types and the level of the orientation and positioning of building elements within a specific building model.

To create parametrized object types (typically called "families"), reference planes and/or axes are first defined and their position specified with the help of distance parameters. Here too, the relationship between parameters can be defined with the help of equations. The resulting bodies can then be generated with their edges or faces aligned with respect to the reference plane.

When creating the building model itself, the user cannot generate new parameters but only specify values already defined in the families or for the respective project. It is, however, possible to define the following constraints when aligning construction elements:

- Orientation: Construction elements must be arranged either horizontally or vertically to one another or to a reference plane.
- Orthogonality: Construction elements remain perpendicular to one another.
- Parallelism: Construction elements remain parallel to one another.
- Connection: Two construction elements are always connected.
- Distance: The distance between two construction elements remains constant.
- Same-size dimensions: Two dimensions specified by the user must be the same size.

While the implementation of parametric systems is more limited in comparison with defining the building geometry, it can still provide a sufficiently high degree of flexibility while keeping the model dependencies manageable.

Fig. 2.9 Definition of a construction element family in Revit, showing how dimensions are linked to parameters

BIM products that support this kind of parametric modeling include Autodesk Revit (Fig. 2.9), Nemetschek Allplan, Graphisoft ArchiCAD and Tekla Structure.

2.4 Freeform Curves and Surfaces

Bodies with straight edges and surfaces are easily represented using boundary representation (BRep method). The conceptual design of more sophisticated and complex architectural designs can, however, also require the modeling of arbitrarily curved edges and surfaces. These curved geometries are known as freeform curves and surfaces. Freeform geometries are described with the help of parametric representations which, compared to approximations (e.g. polygon triangulation), make it possible to model a curve or surface with absolute precision. The data volume required for the parametric description of freeform geometries is also much less than that needed for approximated methods.

The following section outlines the principle methods for describing curved surfaces, and how these surfaces are represented.

2.4.1 Freeform Curves

Freeform curves are also known as splines. These are curves that are comprised of a series of polynomials. To ensure the overall curve is smooth, the joins between

Fig. 2.10 Continuity
conditions at the join between
two curves.
(© S. Vilgertshofer, reprinted
with permission)

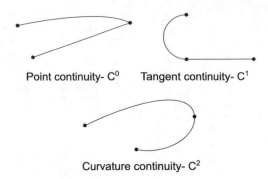

Point continuity- C^0 Tangent continuity- C^1

Curvature continuity- C^2

the segments of the curve must satisfy given continuity conditions. There are three different stages of continuity which are termed C^0-, C^1- and $C^2 - continuity$ (see Fig. 2.10).

- $C^0 - continuity$ stands for point continuity and means that two curves are connected without a break between them.
- $C^1 - continuity$ stands for tangent continuity and means that two curves are connected at a point and share a common tangent direction at the join point.
- $C^2 - continuity$ stands for curvature continuity and means that two curves are connected at a point, share a common tangent direction and a common curvature at the join point.

Freeform curves are described mathematically as parametric curves. The term "parametric" derives from the fact that the three coordinates in space are the function of common parameters (commonly termed u). These parameters span a given value range (typically 0 to 1) and the evaluation of the three functions produces the path of the curve in the space.

The most common types of freeform curves are Bézier curves, B-splines and NURBS. All three types are defined by a series of control points: the first and last of these lie on the curve, while those in-between are only approximated by the curve. Moving a control point changes the arc of the curve, making it possible to adjust curves intuitively in the computer interface. The control points form a characteristic polygon, the first and last segments of which determine the tangents for the start and end points of the curve.

Mathematically all three curve types are the sum of the multiplication of the control points with the basis function. These basis functions are different for each of the three curve types. As such they are fundamental to determining the shape of the different curves and are described as follows:

Bézier curves The basis functions for Bézier curves (see Fig. 2.11) consist of Bernstein polynomials. The degree p of the resulting curves is determined by the number of control points n where $p = n - 1$. This means, however, that curves with a large number of control points result in a very high degree polynomial. In addition, control points are not isolated from each other: changing the position of one, therefore has global impact on the entire course of the curve.

Fig. 2.11 A Bézier curve described by four control points. (© S. Vilgertshofer, reprinted with permission)

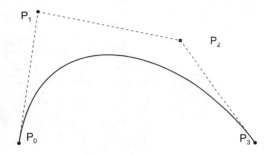

B-splines B-splines were developed to overcome the limitations of Bézier curves. The primary advantage is that the degree of the curve can be defined largely independently of the number of control points. It needs only remain beneath the number of control points ($p < n$). As such, it is possible to combine the smoothness of low degree polynomials (typically $p = 3$) with a higher number of control points. To achieve this, the B-spline is comprised of piecewise sections polynomials of a chosen degree, whereby the continuity $c = p - 1$ at the join point. The basis for this is a hierarchical basis function that is recursively defined.

NURBS Non-Uniform Rational B-splines (NURBS) are based on B-splines but additionally make it possible to assign a weighting to each control point (Piegl and Tiller 1997). This makes it possible to further influence the course of the curve, which is necessary to precisely represent regular conical sections (circles, ellipses, hyperboles). Consequently, NURBS are the standard means for describing curves and are implemented by many BIM systems and geometric modeling kernels.

2.4.2 Freeform Surfaces

Freeform surfaces add an additional dimension to the description of freeform curves. For this a second parameter is introduced, typically given as v, that also spans a predefined value range. The combination of all specified values of u and all specified values of v produces the desired freeform surface.

As with the description of curves, one also differentiates between Bézier surfaces, B-spline surfaces and NURBS surfaces. The respective advantages and disadvantages of these curve types apply equally to the corresponding surfaces. As such, NURBS surfaces are by far the most flexible type of freeform surfaces, and can be used to precisely model spherical and cylindrical surfaces. Figure 2.12 shows a NURBS surface and its corresponding network of control points.

Larger surfaces are generally assembled out of a series of individual "patches" with a set mathematical description. Where the patches adjoin one another, continuity conditions need to be satisfied. The most common continuity condition is $C^2 - continuity$, i.e. that the patch surfaces meet without changing the curvature of the surface.

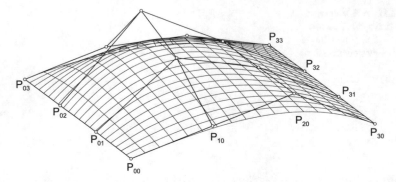

Fig. 2.12 NURBS patch with a field of 4 × 4 control points. (© S. Vilgertshofer, reprinted with permission)

2.5 Further Reading

The field of geometric modeling is extensive and complex and this chapter only presents a basic overview. Readers interested in more detailed aspects of geometric modeling can find out more from the following literature:

Pottman et al. (2007) provide a good overview of the different forms of geometric modeling with a discussion of their relevance for and impact on architectural design. Mortenson (2006) has become a standard work on computer-aided geometric modeling, now available in its third edition. Shah and Mantyl (1995) have also authored a standard work that focuses on parametric modeling with an in-depth discussion of the underlying mathematics and data structures. With respect to the mathematical description of freeform surfaces, the NURBS book by Piegl and Tiller (1997) is highly recommended.

2.6 Summary

Geometric modeling is an important basis for modeling buildings digitally. The representation of a building as a 3D volumetric model makes it possible to derive consistent plans and sections, to determine possible collisions between construction elements, to automate quantity take-off and to pass data on to calculation and simulation systems.

There are two principle approaches to geometric modeling. The explicit description of the model surfaces known as Boundary Representation, which is modeled by a hierarchy of boundary relationships between body, face, edge and vertex. A special variant of this is the triangulated description of model surfaces. The implicit method, by contrast, is a procedural approach that describes the history of the creation of the modeled body. Typical methods include Constructive Solid Geometry and extrusion

and rotation methods. As both explicit and implicit geometric description methods have specific advantages and disadvantages, many BIM systems employ a hybrid approach in which the user models a body using the implicit procedural method and the system internally takes a snapshot of the resulting explicit description at each point in the history of its description. Both approaches are also used for BIM data exchange formats.

Parametric modeling makes it possible to assign parameters, dependencies and constraints to geometric models. This results in flexible models that can be quickly and easily adapted to meet changing boundary conditions. Parametric approaches are always based on implicit methods of describing geometry.

Freeform curves are mathematically described as parametric curves. Three coordinates in spaces are defined as a function of common parameters that are defined within a predefined value range. The computation of the three functions produces the path of the curve. Control points can be used to intuitively control the shape of the freeform curve. Depending on the definition of the underlying basis functions, one differentiates between Bézier, B-spline and NURBS curves. This same differentiation also extends to freeform surfaces, resulting in Bézier, B-spline and NURBS surfaces. Complex surfaces can be created by assembling a series of so-called patches making sure that they satisfy given continuity conditions at their joins.

References

Mortenson, M. E. (2006). *Geometric modeling* (3rd ed.). New York: Industrial Press.

Piegl, L., & Tiller, W. (1997). *The NURBS book* (2nd ed.). Berlin: Springer-Verlag.

Pottmann, H., Asperl, A., Hofer, M., & Kilian, A. (2007). *Architectural geometry*. Exton, PA: Bentley Institute Press.

Pottman, H., Eigensatz, M., Vaxman, A., & Wallner, J. (2015). Architectural geometry. *Computers & Graphics, 47*, 145–164.

Shah, J. J., & Mäntylä, M. (1995). *Parametric and feature-based CAD/CAM – Concepts, techniques and applications*. New York: Wiley.

Siemens. (2015). *Parasolid 3D geometric modelling engine*. Retrieved from http://www.plm. automation.siemens.com/de_de/products/open/parasolid/. Accessed on 12 Jan 2018.

Spatial. (2015). *ACIS library reference specification*. Retrieved from http://doc.spatial.com/qref/ ACIS/html/ Accessed on 12 Jan 2018.

Chapter 3
Data Modeling

Christian Koch and Markus König

Abstract When modeling buildings and infrastructure systems using a computer, it is not sufficient to look solely at geometric data; semantic data also has to be considered. This includes, for example, data about construction methods, materials and the functions of rooms. In order to properly describe and structure this type of information, several different data modeling concepts are currently being applied. This chapter introduces the most essential data modeling notations and concepts, such as entities and objects, entity types and classes, attributes, relationships and associations, aggregations and compositions as well as specialization and generalization (inheritance). Finally, we examine current and future challenges related to data modeling within the AEC/FM domain.

3.1 Introduction

In computer science the term **semantics** describes the meaning of data or information. On the one hand, a random sequence of integer numbers, for example, can include rich informational content, but neither meaning nor semantics. On the other hand, an experienced architect or engineer may know that a dashed line in a construction drawing usually represents a hidden edge of a building component. The meaning, or semantics, of this type of information or notation is well-defined and well-known.

When modeling building data, one might ask why it is not sufficient to solely describe the three-dimensional geometry of a building or infrastructure element (see Chap. 2). The answer: Because it lacks essential, semantic data to comprehensively describe it, such as data about the construction methods used, the materials

C. Koch (✉)
Chair of Intelligent Technical Design, Bauhaus-Universität Weimar, Weimar, Germany
e-mail: c.koch@uni-weimar.de

M. König
Chair of Computing in Engineering, Ruhr-Universität Bochum, Bochum, Germany
e-mail: koenig@inf.bi.rub.de

© Springer International Publishing AG, part of Springer Nature 2018
A. Borrmann et al. (eds.), *Building Information Modeling*,
https://doi.org/10.1007/978-3-319-92862-3_3

employed, the functions of rooms and spaces, and maintenance procedures. For this reason, the semantics of building and infrastructure components play a significant role, in addition to their geometry.

The design, construction and operation of a real building or infrastructure facility involves complex information and relationships that we need to structure and store in a computer in order to solve certain tasks. With this in mind, a digital building model represents a computer-based abstraction of a real facility focusing on a simplified and reduced extract of the entire set of all available information. A practical advantage of the digital support of complex design, construction and maintenance tasks is the ability to subsequently focus on certain selected aspects: digital building models permit an appropriate overview of a naturally very complex and unmanageable system. With the aid of digital building models, information can be digitally collected, structured, analyzed, summarized, compared and assessed in order to support the design, planning, construction and operation of a real facility.

In general, there are several different types of digital models. First, there are reproduction models, for example, in geography (digital terrain models, digital maps), in biology and medicine (digital body and anatomical models), in economics (digital economic activity models) and in sociology (digital models for group dynamics), all of which try to create a digital replicate of existing reality. Second, there are prototypical models, which virtually represent a desired part of future reality that has not been realized yet. In addition to digital designs of mobile phones, cars, airplanes and ships, these also include digital models in architecture, engineering, construction and facility management, so called digital building models or Building Information Models. Furthermore, there are hybrid model types, e.g. in software engineering and development (application models, data models, process models). With regard to Building Information Modeling, digital building models play a significant role in the context of computer-aided design and engineering software as well as in the context of data exchange formats (see Chap. 5).

This chapter provides a general description of the sequence and way in which data models are created to map reality. We introduce the most essential data modeling notations and concepts that will be used in subsequent chapters. Finally, we examine current and future challenges associated with data modeling within the AEC/FM domain.

3.2 Workflow of Data Modeling

The workflow of data modeling is divided into two successive processes: conceptualization and realization/implementation (Booch et al. 2007) (Fig. 3.1). In the first step, a part of reality is abstracted as a conceptual data model (e.g. a building data model), which scopes and structures the domain by representing types of significant items (entity types, classes, see Sect. 3.4.1), their properties (attributes, see Sect. 3.4.2) as well as relationships (associations, see Sect. 3.4.3) among them.

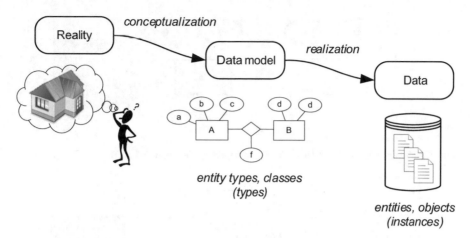

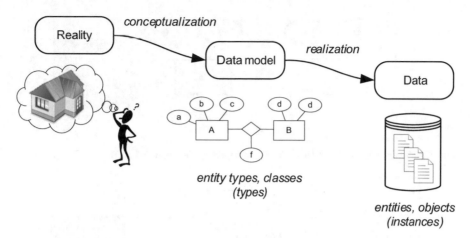

entity types, classes
(types)

entities, objects
(instances)

Fig. 3.1 The procedure of data modeling: reality – data model – data

In the second step, this conceptual model is realized for a particular case (e.g. a specific building model), defining specific instances of the real world (entities, objects) in the form of actual data (e.g. tables, numbers, texts, etc.) stored in a physical file or database.

3.3 Data Modeling Notations and Languages

There are several notations for conceptual data modeling. These notations are needed and used to graphically or alphanumerically define the data modeling concepts introduced in the subsequent section (Sect. 3.4). In this section we introduce Entity Relationship Diagrams (ERD), the Unified Modeling Language (UML) and the Extensible Markup Language (XML).

3.3.1 Entity Relationship Diagrams (ERD)

Entity Relationship Diagrams graphically describe **Entity Relationship Models (ERM)** that were first introduced by Chen (1976). ERM are based on relational theory and can be implemented directly in a Relational Database (Codd 1990). They represent a specific domain in terms of Entity types (classification of things) and Relationships among instances of these types. Several different symbols are used to depict the concepts of Entity type (A, B), Attribute (a, b, c, d, e, f) and Relation *(R)* (Fig. 3.2).

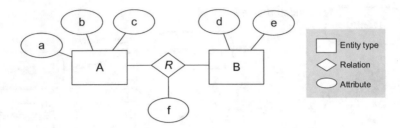

Fig. 3.2 Abstract Entity Relationship Diagram depicting the main data modeling concepts

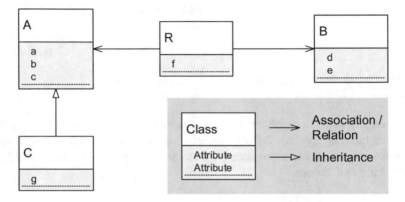

Fig. 3.3 Abstract UML class diagram depicting the main data modeling concepts

3.3.2 Unified Modeling Language (UML)

The Unified Modeling Language (UML) is an internationally standardized notation
(ISO/IEC 19505) that uses texts and symbols to graphically describe **object-
oriented models (OOM)** in several different aspects or diagrams (Booch et al.
2005). The most important diagram type is a Class Diagram. Class diagrams
represent structured views of a specific domain depicting the concepts of Class
(type) (A, B, C, R), Attribute (a, b, c, d, e, f, g), Association (\rightarrow) and Inheritance
(\rightarrow) (Fig. 3.3).

 Although UML is quite powerful, the variety of different diagram types and
notations sometimes seems overwhelming. To make full sense of this modeling lan-
guage, detailed knowledge of UML is necessary, requiring corresponding training.
A similar modeling language for object-oriented data models is EXPRESS, which
is introduced in Chap. 5 along with a discussion of the standardized building data
model Industry Foundation Classes (IFC).

3.3.3 *Extensible Markup Language (XML)*

XML, the Extensible Markup Language is a structured markup language for text documents, standardized by the World Wide Web Consortium (W3C, www.w3.org). XML documents are both human-readable and machine-readable. With regard to data modeling, XML can be used to both define a data model (XML schema file) and hold the actual data (XML data file). Figure 3.4 illustrates how common data modeling concepts can be implemented in XML, both in terms of the data model (Fig. 3.4, left) and the data (Fig. 3.4, right).

The XML specification defines the syntax that XML documents have to follow (Harold 2004). Elements in an XML document are delimited by a pair of tags (an opening and closing tag), similar to the markup in an HTML document, and can be structured hierarchically. As opposed to HTML, which has a fixed set of pre-defined tags (e.g. `<H1>`...`</H1>`), XML permits the creation of elements and corresponding tags as needed to structure data. For example, an element `<Wall>`...`</Wall>` can be used to describe a wall, and a sub-element `<width>`...`</width>` can define its width.

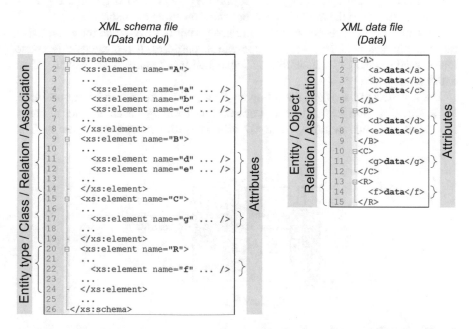

Fig. 3.4 Abstract XML schema file (left) and data file (right) depicting the main data modeling concepts

3.4 Data Modeling Concepts

The following simplified example, depicted in Fig. 3.5, illustrates the main data modeling concepts using the three different notations ERD, UML and XML. In order to model and eventually determine the bearing capacity of a wall, a simplified data model is created: a wall with two openings, resting on solid ground, is exposed to loading.

3.4.1 Entities and Entity Types

An **entity** (or **object**, **instance**) is a specific data item of interest within the real world. It can be either a physical or tangible item, for example a wall, a column or a slab, or can represent a non-physical or notional thing, for example a room, a load or a task. Each entity is defined by its identity and its condition or state.

In our example, the following entities are used to abstract reality: the wall W1, the opening O1, the opening O2, the support S1 and the load L1 (see Fig. 3.5). Figure 3.6 illustrates the individual entities that constitute our example.

An **entity type** (or **class**) classifies and groups entities that share the same structure and characteristic (e.g. shape, appearance, purpose). It represents a template that is used to create specific entities. Consequently, an entity is an instance of an entity type.

For our example, we need the following four entity types to model our problem: **Wall**, **Opening**, **Support** and **Load**. For example, entity W1 is an instance of entity type **Wall** and both entities O1 and O2 originate from entity type **Opening**. The

Fig. 3.5 Example wall model

Fig. 3.6 Symbolized entities (objects)

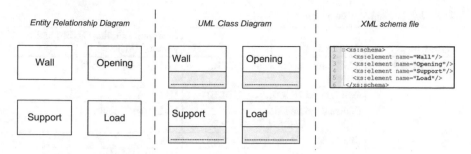

Fig. 3.7 Entity types in Entity Relationship Modeling (left), Classes in object-oriented modeling (center), and corresponding XML schema file (right)

respective ER and UML diagrams as well as the corresponding XML schema file are depicted in Fig. 3.7.

3.4.2 Attributes

As mentioned above, an entity is characterized by its identifier or identity (id) and by its attributes. **Attributes** model the properties of an entity, and the actual information and data associated with it. Entities of the same entity type share the same attributes, but differ in terms of their individual attribute values. Attributes are therefore defined within an entity type and have a name and a data type. The data type specifies the kind of information to be stored and the corresponding value range. In general, one distinguishes between primitive (atomic) types, composite types and data structures. **Primitive types** usually include

- Integer numbers
- Real numbers (floating point numbers)
- Boolean or logical values
- Characters

Composite types are compounds of a primitive data type, for example, a text composed of a sequence of characters, or an **array** of values of the same primitive type (e.g. an array of integer numbers). In contrast to an array, an **enumeration** defines distinct values of the same primitive data type. The actual data value of an enumeration is one of the defined values (Table 3.1).

A **data structure** captures several different data types as one item. The data types used, in turn, can be primitive or composite types or other data structures. Table 3.1 lists a few examples of data types.

For our example, we can define several attributes for our entity types (classes) and assign specific attribute values for our entities (objects). Figures 3.8, 3.9 and 3.10

Table 3.1 Examples of data types

Type category	Data type	Example definitions (DEF) and values (VAL)
Primitive types	Integer number (INT, INTEGER, LONG)	VAL: $-123, 0, 2, 875$
	Real number (FLOAT, DOUBLE)	VAL: $-1.234, 1.234e02$
	Boolean/logical value (BOOL, BOOLEAN, LOGICAL)	VAL: true (0), false (1)
	Character (CHAR, CHARACTER)	VAL: "a", "1", "α", "@", "\leq"
Composite types	Text (STRING)	VAL: "abc", "123", "a1@_x"
	Enumeration (ENUM, ENUMERATION)	DEF: Color := {blue, green, red, yellow}; VAL: Color.green
	Array, series or sequence (ARRAY), finite index-based series of values of the same primitive data type	DEF: 3D_Vector := ARRAY(1..3) of DOUBLE; VAL: [-1.23, 4.56e-5, 123.45]
Data structures	Entity or Class (ENTITY, CLASS), finite number of attributes of different data types (primitive or composite type, data structure)	DEF: ENTITY/CLASS Date := {day:INT, month:INT, year:INT}; VAL: {15, 2, 2012}
	List or sequence (LIST), (in-)finite index-based series of values of the same data type or structure	DEF: List_of_Openings := LIST of CLASS(Opening); VAL: [O1, O2, O3]
	Set (SET), (in-)finite unsorted set of values of the same data type or structure	DEF: Set_of_Openings := SET of CLASS(Opening), VAL: {O2, O1, O3}

illustrate both the conceptual modeling aspect (data model) and the realization or implementation aspect (data).

3.4.2.1 Relationship Modeling

The Entity Relationship Diagram in Fig. 3.8 depicts the data model (left). In addition to the entity types **Wall**, **Opening**, **Support** and **Load**, several corresponding attributes are defined. For example, the entity type **Opening** defines the attributes *id, width, height, posX, posY* and *type*. The data types of the attributes are usually not specified explicitly. The right-hand side of Fig. 3.8 shows data tables that realize the data of the five entities in our example. These tables can be stored, for example, in a Relational Database (Codd 1990). Each entity type is represented by a table. The table columns represent attributes of the respective entity type, and the rows in each table represent a specific entity in the example model. For example, the opening entity O1 is defined in the first row of the table **Opening** with the following attribute values in the corresponding columns: *id = O1, width = 1.26, height = 1.385, posX = 2.99, posY = 0.874* and *type = "Window"*.

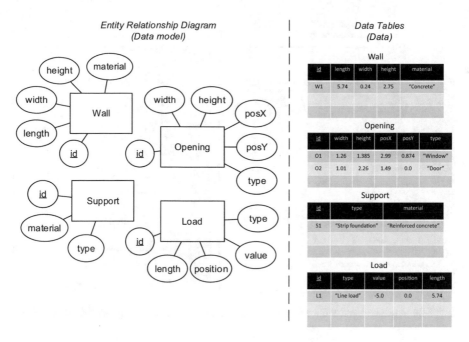

Fig. 3.8 Attributes in Entity Relationship Modeling: data model (left) and data (right)

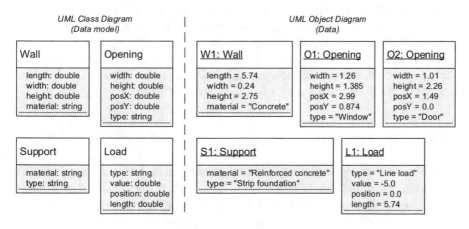

Fig. 3.9 Attributes in object-oriented modeling: data model (left) and data (right)

3.4.2.2 Object-Oriented Modeling

Similar to Entity Relationship Modeling, Fig. 3.9 depicts the UML Class Diagram (data model) and the UML Object Diagram (data) using the object-oriented modeling approach. As with the entity types, the classes in our data model are **Wall**, **Opening**, **Support** and **Load**. The UML Class Diagram also shows the corresponding attributes and their data types. For example, the class **Opening**

<div style="text-align:center">

XML schema file
(Data model)

XML data file
(Data)

</div>

```
1  <xs:schema>
2    <xs:element name="Wall">
3      <xs:complexType>
4        <xs:sequence>
5          <xs:attribute name="id" type="xs:string"/>
6          <xs:element name="length" type="xs:decimal"/>
7          <xs:element name="width" type="xs:decimal"/>
8          <xs:element name="height" type="xs:decimal"/>
9          <xs:element name="material" type="xs:string"/>
10       </xs:sequence>
11     </xs:complexType>
12   </xs:element>
13
14   <xs:element name="Opening">
15     ...
16   </xs:element>
17
18   <xs:element name="Support">
19     <xs:complexType>
20       <xs:sequence>
21         <xs:attribute name="id" type="xs:string"/>
22         <xs:element name="type" type="xs:string"/>
23         <xs:element name="material" type="xs:string"/>
24       </xs:sequence>
25     </xs:complexType>
26   </xs:element>
27
28   <xs:element name="Load">
29     ...
30   </xs:element>
31 </xs:schema>
```

```
1  <Wall id="W1">
2    <length>5.74</length>
3    <width>0.24</width>
4    <height>2.75</height>
5    <material>Concrete</material>
6  </Wall>
7  <Opening id="O1">
8    <width>1.26</width>
9    <height>1.385</height>
10   <posX>2.99</posX>
11   <posY>0.874</posY>
12   <type>Window</Door>
13 </Opening>
14 <Opening id="O2">
15   <width>1.01</width>
16   <height>2.26</height>
17   <posX>1.49</posX>
18   <posY>0.0</posY>
19   <type>Door</Door>
20 </Opening>
21 <Support id="S1">
22   <type>Strip foundation</type>
23   <material>Reinforced concrete</material>
24 </Support>
25 <Load id="L1">
26   <type>Linear load</type>
27   <value>-5.0</value>
28   <position>0.0</height>
29   <length>5.74</length>
30 </Load>
```

Fig. 3.10 Attributes in XML data modeling: data model (left) and data (right) modelled as either xs:attribute or xs:element

defines the following attributes: *width, height, posX, posY* (all using the data type *double*), and *type* (data type *string*). The right-hand side of Fig. 3.9 shows the UML Object Diagram containing the data in our example: five objects W1, O1, O2, S1 and L1 and, analogous to the data tables in Fig. 3.9 (right), the attribute values of these objects. For example, the window object O1 is characterized by *width = 1.26, height = 1.385, posX = 2.99, posY = 0.874 and type = "Window"*.

3.4.2.3 XML Data Modeling

In XML, the data model of our example is specified in an XML schema (Fig. 3.10, left) while the actual data is stored in an XML data file (Fig. 3.10, right). Entity types (classes) in the data model are commonly represented as XML elements (see lines 2, 14, 18, 28 in Fig. 3.10, left) while attributes can be defined either as XML sub-elements (xs:element) or XML attributes (xs:attribute). The difference becomes evident when looking at the corresponding XML data file (Fig. 3.10, right). An XML element is a block including an opening and a closing tag (e.g. line 2), whereas an XML attribute models additional information within an opening tag (e.g. line 1).

When defining an XML element and its attributes in the schema, both the attribute name (name) and the data type (type) have to be specified. For example, the attribute *length* of the entity type **Wall** is described by the name="length" and the type="xs:decimal" (see line 6 in XML schema). The actual data of our

example is implemented in the XML data file (Fig. 3.10, right). Each entity or object is represented by an XML element, e.g. <u>W1</u>: lines 1–6, <u>O1</u>: lines 7–13. While the identifier (id) of an entity is encoded as an XML attribute, the entities' attributes are encoded as XML elements. For example, the window entity <u>O1</u>, defined in lines 7–13, has the `id=O1`, `width=1.26` (line 8), `height=1.385` (line 9), etc.

3.4.3 Relations and Associations

Relations and associations are modeling concepts that describe relationships or interdependencies between entities and objects. Relations and associations need to be modeled, for example, if one entity carries information that is needed by another entity (data dependency).

Most commonly, so-called **binary relations** are considered that model the relationship between exactly two entities (objects). In this context, **cardinalities** (or multiplicities) determine how many entities (objects) on one side correlate with how many entities (objects) on the other side. In addition, one also distinguishes between **directed** (or uni-directional) and **undirected** (or bi-directional) associations. The former means only one entity (object) "knows" about the other one, while the latter means that both entities (objects) involved "know" each other.

3.4.3.1 Entity Relationship Modeling

In Entity Relationship Modeling, relations are modeled explicitly by defining **relations** using the diamond symbol in Entity Relationship Diagrams. Similar to entity types, relations can have attributes to further specify and describe the relation. In our example, an entity of type **Wall** relates to other entities of the following types: **Opening, Support** and **Load**. Figure 3.11 (left) depicts this by introducing the relations **contains, carries** and **rests**.

Cardinalities are specified and depicted at the entity types and can have either exact values (e.g. 1) or a range of potential values (min, max). According to

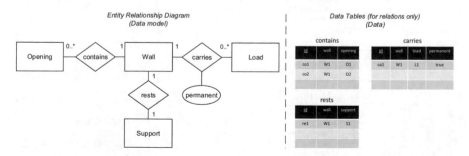

Fig. 3.11 Associations in Entity Relationship Modeling: relations and cardinalities. Data model (left) and data (right)

Fig. 3.11, left, for example, exactly one (1) wall (an entity of type Wall) *contains* any number (0..*) of openings and, vice versa, none to several (0..*) opening(-s) can be contained in exactly one (1) wall. Notably, the **contains** relation defines that any opening can only be contained in exactly one wall. Moreover, the Entity Relationship Diagram in Fig. 3.11 shows that one (1) wall rests on exactly one (1) support and can *carry* several number (0..*) of loads, and, vice versa, exactly one (1) support is the bearing for exactly one (1) wall, and any number (0..*) of loads act on exactly one (1) wall.

In Entity Relationship Modeling one can add attributes to the relations to add more semantics. For example, the Entity Relationship Diagram presented in Fig. 3.11 (left) shows the attribute *permanent* assigned to the Relation *carries* to indicate whether a certain load is permanent or temporary.

The data tables depicted on the right in Fig. 3.11 show the realization of the exemplified relations. The table **contains** reveals two instances (co1, co2) that describe the two Wall-Opening relationships in our example, in particular, the relation between the wall entity W1 and the opening entity O1, and the relation between the wall entity W1 and the opening entity O2. The table **carries** shows that the wall entity W1 carries the load entity L1, which is a permanent load indicated by the attribute value `true`.

3.4.3.2 Object-Oriented Modeling

In object-oriented modeling using UML, associations between objects are defined by means of **Attributes** (see Table 3.1), either by directly referencing the class of the associated object or by referencing a so-called **Association Class**. Association classes describe the relationship explicitly, similar to relations in ERM, allowing additional information to be attached, e.g. additional properties.

In our example, the **Wall** object is associated with other objects of the classes **Opening**, **Load**, and **Support**. The UML Class Diagram in Fig. 3.12 (left) illustrates this. Associations are depicted by solid lines between the classes. Similar to ERD,

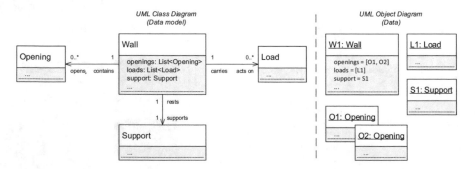

Fig. 3.12 Associations in object-oriented modeling: binary associations, cardinalities and roles. Data model (left) and data (right)

corresponding cardinalities and descriptions are presented at the respective end of the lines. For example, exactly one (1) wall object is associated with any number (0..*) of openings. This association is defined in the class **Wall** as the attribute *openings*, which is of type List<Opening> to store the associated openings in a list. Analogously, the association between the classes **Wall** and **Load** is defined. As depicted in Fig. 3.12 (left), the **Wall–Support** association is modeled by means of the attribute *support* of type **Support**.

The UML Object Diagram depicted in Fig. 3.12 (right) presents the realization of the associations between the objects in our example. In contrast to Fig. 3.9, in Fig. 3.12 additional attributes and their values are added to the respective object diagrams. For example, the wall object W1 is associated with the two opening objects O1 and O2 implemented by the attribute value [O1, O2].

In Fig. 3.13 (top), a dedicated association class **Carries** is used to explicitly model the association between wall objects and load objects in order to add additional information (semantics) to this relationship (Fig. 3.13, top). This information is modeled as the attribute *permanent* using the data type Boolean (see Table 3.1). It determines whether the loading acts permanently (true) or temporary (false). With the aim of implementing this part of the data model into object-oriented software, the association class needs to be resolved. This means that the initial association between **Wall** and **Load** resolves in the new class **Carries** and the two associations **Wall–Carries** and **Carries–Load**, including corresponding new attributes. This is depicted in Fig. 3.13 (bottom).

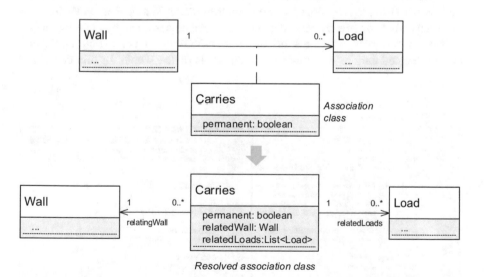

Fig. 3.13 Association class in object-oriented modeling (top) and its resolution (bottom)

3.4.3.3 XML Data Modeling

In XML data modeling, associations (relations) are commonly modeled using attributes that store references to the associated entities. With regard to our example, the associations **Wall–Opening**, **Wall–Load** and **Wall–Support** can be modeled as new attributes (XML elements) of the entity type **Wall**, namely *relatedOpenings*, *relatedLoads* and *relatedSupport* (Fig. 3.14, left). Since a wall entity can be associated with several (0..*) opening entities and load entities, the data type of *relatedOpenings* and *relatedLoads* is set to be a list of text items (stringList) to store a list of entity identifiers (id). For this reason, the XML schema needs to define the new type stringList as a list (xs:list, Fig. 3.14, left, line 10) of text items (xs:string, Fig. 3.14, left, line 10).

Figure 3.14 (right) depicts the actual data to model the associations. It shows that wall entity W1 has two related opening entities O1 and O2 (line 2), one related load entity L1, and one related support entity S1. In order to specify the identifiers of our entities, the XML data file uses XML attributes, for example <Opening id="O1"> in line 7.

3.4.4 Aggregations and Compositions

Aggregation and **Composition** are special kinds of associations. In contrast to (simple) associations, aggregations and composition model **Whole-Part relationships** between entities or objects. Such dependencies can be described by the relation "is-part-of" or "consists-of". One entity or object represents the whole (aggregate) and the aggregated entities or objects represent parts of the whole. In this context, a

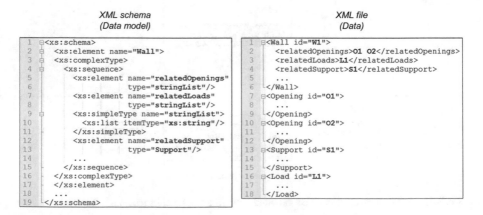

Fig. 3.14 Associations in XML data modeling: binary associations modeled as attributes. Data model (left) and data (right)

composition defines some kind of "strong" aggregation where parts of the whole cannot exist without the whole.

Entity Relationship Modeling, in general, does not provide a means of defining aggregations and composition explicitly. In object-oriented modeling, on the other hand, there are dedicated concepts and symbols in UML class diagrams that support the definition of aggregations and compositions.

Given the relationship between a construction company and its employees, the employees can exist independently of the existence of the company. In this case, the association **Company–Employee** is preferably modeled as an **aggregation**. The UML class diagram depicted in Fig. 3.15 shows that a company consists of at least one (1) or many (*) employees, and that an employee is part of at least one (1) or several (*) companies. An aggregation in a UML class diagram is symbolized using an empty diamond symbol at the end towards the whole. The realization of aggregations in terms of actual data is equivalent to the implementation of simple aggregations.

In our previous wall example, it is assumed that the wall consists of several, but at least one (1..*), wall layers. This aggregation can sensibly be modeled as a **composition**, because individual wall layers, such as an insulation layer, cannot exist without the wall as a whole. This is illustrated in the UML class diagram depicted in Fig. 3.16. A composition is symbolized using a full (solid) diamond symbol at the end towards the whole, in this case the wall. Moreover, the class **WallLayer** defines attributes that represent each layer's thickness and material.

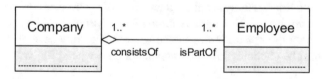

Fig. 3.15 Aggregation in object-oriented modeling: a company (aggregate) consists of employees (parts)

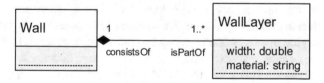

Fig. 3.16 Composition in object-oriented modeling: a wall (composite, whole) consists of several wall layers (parts)

3.4.5 Specialization and Generalization (Inheritance)

Relationships between entities types or classes play an important role in describing the semantics of data models. In this context there is another essential data modeling concept called **Inheritance**. This concept is sometimes also referred to as **Specialization and Generalization**. Inheritance allows data models to define specialized entity types/classes (sub-classes, child classes) and generalized entity types/classes (super-classes, parent classes). The idea is that sub-classes can **inherit attributes** (properties) of associated super-classes while defining additional attributes to create a specialization of the super-class. Vice-versa super-classes represent generalizations of associated sub-classes. This concept permits the creation of a **hierarchical classification system** (taxonomy) within a data model.

In Entity Relationship Modeling there is generally no way to model inheritance relations between entity types. In object-oriented modeling and XML data modeling, on the other hand, the concept of inheritance can be used to create a hierarchical classification structure.

3.4.5.1 Object-Oriented Modeling

In object-oriented modeling, inheritance can be classified as **Single Inheritance** or **Multiple Inheritance**. Single inheritance means that every sub-class is associated with exactly one super-class. In this case the inheritance graph becomes a tree structure. In contrast, multiple inheritance allows a sub-class to have multiple associated super-classes. This case is known to be problematic as conflicts arise when a sub-class inherits attributes of the same name from several super-classes. This issue must be explicitly taken into consideration when programming software tools.

Coming back to our previous wall example, the objects O1 and O2 have the same properties, but differ in terms of the type of the opening. So far, this difference has been modeled by the attribute *type* in class **Opening** (see Fig. 3.9). With this solution, however, only the object itself knows whether it represents a window or a door; the data model does not reveal this semantic information. A more suitable way of classifying openings is offered by the inheritance concept. In this context, an opening represents a generalization of windows and doors. Consequently, by means of inheritance two new classes **Window** and **Door** are introduced that both are specializations of the super-class **Opening**. The attribute *type* is then no longer needed. Also, assuming a door is always positioned at the bottom of a wall *(posY=0)*, the attribute *posY* need only be specified in class **Window** and can be neglected in class **Door**. This is shown in the UML class diagram in Fig. 3.17 (left). An inheritance relation is symbolized using an open arrow pointing towards the super-class (e.g. Opening) emphasizing generalization. The corresponding UML object diagram (Fig. 3.17, right) depicts the actual data objects O1 and O2 as instances of the sub-classes **Window** and **Door** respectively.

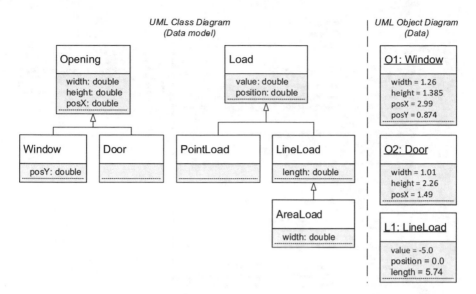

Fig. 3.17 Inheritance in object-oriented modeling: data model (left) and data (right)

A further example is the modeling and classification of loads. With regard to ultimate limit state design, loads are distinguished into different types. One classification criteria, for example, could be the load's geometric extent. Point loads usually act on a structure at a single point, whereas line loads and area loads affect a structure along a line or across an area, respectively. Figure 3.17 (left) illustrates the hierarchical classification structure between the classes **Load**, **PointLoad**, **LineLoad** and **AreaLoad**. It can be seen that all types of loads are characterized by the attributes *value* and *position*, which are defined in the super-class **Load**. Specializations of the class **Load** are the class **LineLoad** with an additional attribute *length*, and the class **AreaLoad** with a further additional attribute *width*. This means that, for example, the class **AreaLoad** inherits the attributes *value* and *position* from class **Load** and the attribute *length* from class **LineLoad** and itself defines a fourth attribute *width*. In our wall example, the load object L1 is actually an instance of the class **LineLoad** and, respectively, has three attribute values for *value*, *position* and *length* (Fig. 3.17, right).

3.4.5.2 XML Data Modeling

In XML data modeling, the inheritance concept is established by means of complex type **extensions** that represent specializations. In order to model the inheritance relationship between the classes **Load**, **LineLoad** and **AreaLoad** as depicted in Fig. 3.18, for example, we can define a base complex type **LoadType** (Fig. 3.18, lines 3–9) to represent loads in general. To create a specialization of this another

<div style="text-align:center">XML schema
(Data model)</div>

<div style="text-align:center">XML file
(Data)</div>

```
 1  <xs:schema>
 2    ...
 3    <xs:complexType name="LoadType">
 4      <xs:sequence>
 5        <xs:attribute name="id" type="xs:string"/>
 6        <xs:element name="value" type="xs:decimal"/>
 7        <xs:element name="position" type="xs:decimal"/>
 8      </xs:sequence>
 9    </xs:complexType>
10    <xs:complexType name="LineLoadType">
11      <xs:complexContent>
12        <xs:extension base="LoadType">
13          <xs:element name="length" type="xs:decimal"/>
14        </xs:extension>
15      </xs:complexContent>
16    </xs:complexType>
17    <xs:complexType name="AreaLoadType">
18      <xs:complexContent>
19        <xs:extension base="LineLoadType">
20          <xs:element name="width" type="xs:decimal"/>
21        </xs:extension>
22      </xs:complexContent>
23    </xs:complexType>
24    <xs:element name="Load" type="LoadType"/>
25    <xs:element name="LineLoad" type="LineLoadType"/>
26    <xs:element name="AreaLoad" type="AreaLoadType"/>
27  </xs:schema>
```

```
1  <LineLoad id="L1">
2    <value>-5.0</value>
3    <position>0.0</position>
4    <length>5.74</length>
5  </LineLoad>
```

Fig. 3.18 Inheritance in XML data modeling: data model (left) and data (right)

complex type **LineLoadType** is defined as an extension of the type LoadType (Fig. 3.18, lines 10–16). Subsequently, the LineLoadType can be further extended when defining the **AreaLoadType** (Fig. 3.18, lines 17–23) to represent area loads. These type definitions are then used to specify the type of our actual XML elements, namely **Load**, **LineLoad** and **AreaLoad**, as depicted in Fig. 3.18 in lines 24–26. The corresponding XML data representing the line load in our previous wall example is shown in Fig. 3.18 (right).

3.5 Challenges of Data Modeling in AEC/FM

Reducing the complexity of real world phenomena is critical when developing data models for the AEC/FM industry. In this regard, the data modeling concepts presented above for Entity Relationship Modeling, object-oriented modeling and XML data modeling reveal a significant advantage when compared to imperative, declarative and functional modeling paradigms. However, many use cases in AEC/FM require very detailed models, for example, when creating realistic real-time visualizations of buildings or infrastructure systems. In this context, it can be very challenging to decide on the **Level of Detail** or **Level of Information** (see Chap. 6), i.e. to determine to what extent a building or infrastructure component needs to be disaggregated in order to digitally support a certain task. For example, is it sufficient to represent a door by its frame and leaf, or is it necessary to model the

casing, the jamb, the lock and the door handle in detail? Similarly, how detailed do relationships have to be specified within a data model. For example, is it necessary to introduce a new sub-class in a data model to improve the overall model structure? In summary, such decisions have to be made thoughtfully and carefully as the complexity of a data model quickly increases the more detail one includes in it (Booch et al. 2007).

Another important challenge relates to the **modeling of different views** or perspectives on one and the same object. For instance, an architect cares about the final color of a reinforced concrete wall when assessing the aesthetic properties of a building. For a structural engineer, however, the color is irrelevant, while material properties such as the Young's modulus are of much greater importance. In this context, one must decide whether it is sensible to create a single holistic data model that captures all different aspects and views (see Chap. 5), or perhaps is it more advisable and expedient to create separate partial data models first, which are linked together later on. Strategies for addressing this particular challenge are presented in Chaps. 6 and 10 of this book.

3.6 Summary

The design, construction and operation of a built facility involves complex information and relationships that are to be covered within building information models. Next to geometry, these digital models capture semantic data, for example, data about construction methods and sequences, materials and functions of spaces.

Using dedicated data modeling notations and data modeling concepts, semantic building data is scoped, classified, structured and specified in data models in order to digitally support decisions during the life-cycle of a built facility. Presented notations are Entity Relationship Diagrams (ERD), Unified Modeling Language (UML) and Extensible Markup Language (XML). Based on a simple example, these modeling notations are employed to graphically and alphanumerically express and describe the modeling concepts, such as entities (objects) and entity types (classes), attributes, relations and associations, aggregation and composition, specialization and generalization (inheritance).

Finally, it is concluded that it is very challenging to decide on an appropriate Level of Detail and Level of Information when modeling semantic building data (see Chap. 6). Moreover, different views of different stakeholders on the same item or objects further complicate the definition of a generally accepted data model for buildings and infrastructure facilities (see Chaps. 5, 6 and 10).

References

Booch, G., Rumbaugh, J., & Jacobson, I. (2005). *The unified modeling language user guide* (2nd ed.). Upper Saddle River: Adisson-Wesley.

Booch, G., Maksimchuk, R., Engle, M., Young, B., Conallen, J., & Houston, K. (2007). *Object oriented analysis and design with applications* (3rd ed.). Upper Saddle River: Adisson-Wesley.

Chen, P. (1976). The entity-relationship model – Toward a unified view of data. *ACM Transactions on Database Systems 1*(1), 9–36.

Codd, E. F. (1990). *The relational model for database management* (2nd ed.). Reading: Addison-Wesley.

Harold, E. R., & Means, W. S. (2004). *XML in a nutshell* (3rd ed.). Beijing: O'Reilly.

Chapter 4
Process Modeling

Markus König

Abstract An important part of the BIM methodology is the consideration of processes that create, modify, use or pass on digital building information. The planning and coordination of such BIM processes is one of the many important tasks of a BIM manager. It defines which tasks are to be executed by which persons in what order. In particular, the individual interfaces must be clearly specified. A lean and transparent process definition helps support the introduction of BIM methods significantly. This chapter provides an introduction to formal process modeling, including the modeling languages Integration Definition for Function Modeling (IDEF) and Business Process Model and Notation (BPMN), which are widely used today in the field of BIM process modeling.

4.1 Introduction

An important part of the BIM methodology is to consider the processes that create, modify or pass on digital building information. Since, as a rule, many specialist planners and individual companies are involved in these processes, they must be carefully coordinated. For major construction projects, this process landscape can become very complex. The process landscape for BIM-based project management includes processes related to planning, communication, data exchange, controlling, execution and management. A successful implementation of BIM technologies must describe all these processes and their interactions in a systematic and correct manner. Apart from defining the size of each process, their possible dynamic extension or revision as well as their inclusion in corresponding process sequences plays an important role. Often, it is not possible to conclusively define all processes at the beginning of a project. It is, therefore, imperative to continuously supervise, adjust and improve processes over the course of a project. These constraints, along

M. König (✉)
Chair of Computing in Engineering, Ruhr-Universität Bochum, Bochum, Germany
e-mail: koenig@inf.bi.rub.de

© Springer International Publishing AG, part of Springer Nature 2018
A. Borrmann et al. (eds.), *Building Information Modeling*,
https://doi.org/10.1007/978-3-319-92862-3_4

with new technological possibilities, must be adequately considered in an integral and goal-oriented approach to building process modeling.

Building Information Modeling thus not only involves the introduction of new technologies but also implies a reorganization or optimization of project management and related processes. By defining transparent processes, integrated and cooperative operations are made possible. BIM methods also enable entirely new forms of management for diverse building information (see Chap. 14) and these, in turn, have implications for the design of processes and how specialist planners can interact. Process management frequently differs depending on the type of project execution, legal constructs and project size. Therefore, in addition to the identification of possible BIM technologies, the scale of process support should be considered with respect to individual project requirements. BIM methods and tools can be used successfully only when all involved processes are properly coordinated.

Process modeling is an essential task of the BIM manager (see Chap. 16). BIM process modeling sets out in principal which tasks should be executed by which people using which tools in what order. In particular, each interface must be well defined. In addition to determining the type of data exchange, the amount of data, the chronology and task responsibilities, corresponding approval processes must also be specified and planned. A lean and transparent process definition can therefore greatly facilitate the introduction of BIM methods.

Modeling processes in the construction industry can, of course, be applied independently of the BIM method. In fact, processes in the life cycle of a building are already being planned today at a very detailed and systematic level. Also, in other industries and sectors of the economy, very extensive definitions and coordination of production and information processes are being carried out. At this point it is worth mentioning the diverse literature available on process management (for example Weske 2012; Dumas et al. 2013). Coordinated and well-documented processes are also an essential element of quality management according to ISO 9001. The greatest obstacles in adapting processes lies in overcoming traditional, more function-oriented, hierarchical organizational structures that often prevail in project management in the construction industry (see Gadatsch 2012). In particular, in projects involving many participants from different companies, the center of focus is often not the overall, holistic process, but rather each single task in the context of a participant's own area of responsibility. This functional organization hinders communication between the different parties and cross-disciplinary issues are often not addressed properly. In process modeling, greater emphasis is given to the processes and sub-processes needed to tackle complex engineering problems: the processes are adapted to meet the requirements of each project and not necessarily the needs of individual companies. Figure 4.1 shows the difference between the functional organization of a company as opposed to the process-oriented requirements in the project execution. A construction project is handled by different departments of different companies. These companies have different

Fig. 4.1 Project requirements versus functional organizational structures

internal organizational structures and processes. Since these only rarely match, a seamless transition of data is not possible resulting in so-called "media breaks."

This process-oriented mindset is an essential basis of Building Information Modeling. At the same time, the availability of new BIM technologies and BIM methods can further automate and even optimize processes used in the construction industry. This implies that the introduction of BIM methods in a project must be carried out hand in hand with a reorganization of the corresponding project processes. It is often not enough to organize only the exchange of digital data; instead, all cooperation within the project needs to be restructured. Consequently, new services within project management are necessary, such as BIM managers who must reorganize and coordinate processes in line with BIM guidelines. For these reasons, this chapter will present an introduction to formal modeling and the software support of processes and their (partial) automatic implementation using Building Information Modeling. This introduction provides an initial insight into implementing BIM-based process modeling.

4.2 Workflow Management

The systematic and partially automated exchange of information between different organizational units to perform a task is often referred to as a so-called workflow. Automation in this sense means that, for example, on completion of a task further specified actions (sending an email, changing the status or converting data to a specific format, for instance) are automatically triggered. The term workflow is widely used in the automation of business processes. Scheer et al. (2004) define a

Fig. 4.2 Processes, roles, data and tools are the key elements of an automatable workflow

business process as the exemplary description of tasks (or functions) to be performed with respect to content or temporal dependency, possibly distributed across several organizational units. Also, a distinction must be made between internal business processes, industry standard processes (for example, public tender) and overall project-specific processes.

This section focuses on the project-specific interactions between different companies and planners involved in a project. Where documents and information are a central aspect and their exchange can be readily supported by appropriate IT tools, the concept of workflow can be used. According to Gadatsch (2012), a workflow is a formally described process that can be entirely or partially automated and involves temporal, technical and resource requirements that are required for automatic control at an operational level (Fig. 4.2). The individual steps are actually carried out by persons or application programs. The introduction of BIM methods facilitates their support using IT. In the following, "workflow" will be used when information between participating companies and planners are exchanged in a structured and transparent manner.

Workflow management usually encompasses all tasks involved in the modeling, configuration and simulation of workflows as well as the computer-aided execution and control of workflows. In particular, the IT implementation of a workflow using suitable software systems is a key goal of workflow management. To this end, as already mentioned, structured processes and structured data are essential (see Fig. 4.3). The structuring of data in the context of Building Information Modeling will be discussed in Chaps. 6 and 8. The structuring of processes for project management and their modeling will be addressed below. Further information on workflow management can be found, for example, in van der Aalst and van Hee (2004) and Gadatsch (2012).

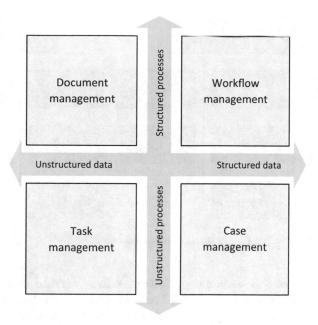

Fig. 4.3 Workflow management requires structured processes and structured data

4.3 Process Modeling

As part of process modeling, all essential elements that are necessary to perform individual tasks need to be formally described and clearly displayed. In recent decades, a variety of approaches for modeling processes have been developed. Often, different views are used for different aspects. In many approaches, a distinction is made between process views, organizational views and information views (cf. Österle 2013; Kunze and Weske 2016; Scheer et al. 2004; Gadatsch 2012), and often others.

In principle, all tasks, processes, responsibilities, editors, tools and information are presented in individual views. The elements under consideration and the diverse views can be described with the help of formal methods, often using graphical notation or chart languages. Figure 4.4 presents a selection of current chart languages. Today, civil engineering projects often use the Integration Definition for Function Modeling (IDEF), extended event-driven process chains (EPC) or the Business Process Model and Notation (BPMN). Of course, other modeling approaches for describing processes for BIM methods can be used. More information on chart languages can be found in the literature (for example, Kunze and Weske 2016; Scheer et al. 2004; Gadatsch 2012).

This chapter considers only IDEF and BPMN diagrams, as many modeling software systems are available that already support these modeling languages, both in research and practice. Furthermore, many of these modeling software systems

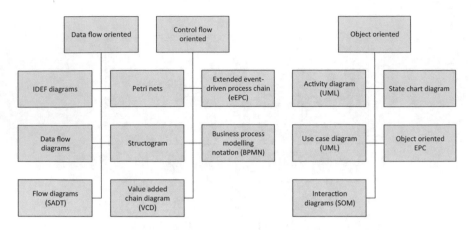

Fig. 4.4 Graphic modeling approaches. (Based on Gadatsch 2012)

also assist the user in developing processes using graphical specifications. In particular, the option to use BPMN in the context of workflow management systems as an implementation language and to transfer to the Business Process Execution Language (BPEL) is an important criterion for use in construction projects.

4.3.1 Integration Definition for Function Modeling

Integration Definition for Function Modeling (IDEF) was developed in the late 1970s by the US Air Force. The two basic essential elements for modeling processes are defined in the IDEF0 method, with a little-used extension for modeling workflows (IDEF3). IDEF0 diagrams include only activity boxes and arrows, the arrows representing any type of object or information. The orientation of the arrows with respect to the activity boxes can have various meanings, as illustrated in Fig. 4.5.

In Fig. 4.6, a possible process flow for automated clash detection using digital building models is shown. The IDEF0 method is well suited for simple processes and connecting only a few related objects. However, if a large number of persons are involved and the data exchange needs to be described in great detail, then other modeling approaches are certainly more suitable. The IDEF0 method is especially widespread in the United States within the BIM community, however, automating IDEF0 using workflow management systems is not considered.

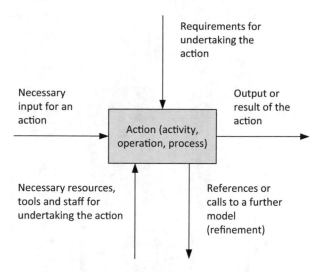

Fig. 4.5 Basic elements of IDEF0 and their meaning

4.3.2 Business Process Modeling and Notation

The Business Process Model and Notation (BPMN) is a standardized graphical specification language for modeling business processes and workflows. It is maintained and developed by the Object Management Group (OMG), a leading standardization organization in information technology specifying, for example, the Unified Modeling Language (UML) and other international authoritative standards. In many areas, BPMN already is the standard. The buildingSMART Alliance uses this specification language for the formalization of processes in the field of Building Information Modeling (see Chap. 6). BPMN provides various icons to document processes and their use, including flow objects, pools and swim lanes, connecting objects and artifacts. These individual elements will be briefly described below. Detailed information can found in the relevant literature on BPMN (for example, Allweyer 2012; Kossak et al. 2015).

4.3.2.1 Flow Objects

Flow objects describe the activities, the decision points or coordination points (gateway) and the events within a process. An activity in general describes a job to be done. A non-divisible activity is called a task. An activity that is composed of sub-activities or sub-tasks is referred to as sub-process. The corresponding symbols are shown in Fig. 4.7.

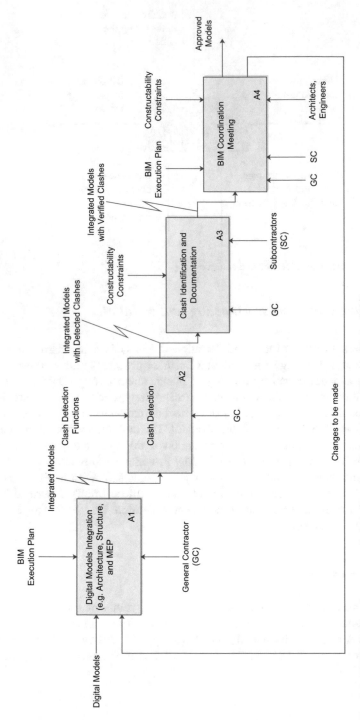

Fig. 4.6 IDEF0 diagram for automated clash detection. (Adapted from Wang and Leite 2012)

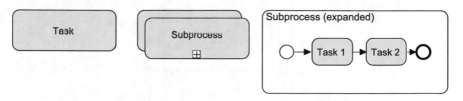

Fig. 4.7 BPMN symbols for activities

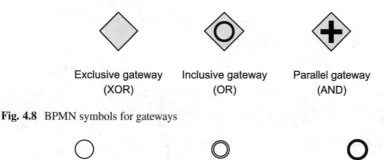

Fig. 4.8 BPMN symbols for gateways

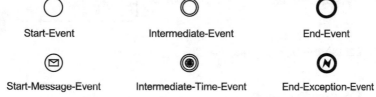

Fig. 4.9 BPMN symbols for events

The flow of a process can be controlled with the help of decision points (split/fork) and coordination points (join/merge), (Fig. 4.8). Note the correct recombination of alternative and parallel processes is particularly important.

Events represent essentially external events that have an impact on the process under consideration. An event may, for example, start a single activity or terminate an entire process. Figure 4.9 shows some examples of events.

4.3.2.2 Pools and Swim Lanes

All activities or partial processes are executed under the responsibility of a single person or company. A so-called pool describes an organization or a company. A pool can be viewed as a container for a set of activities that need to be processed by the parties. A lane is a subdivision of a pool extending over the entire length. This allows individual responsibilities, roles or people to be represented in an enterprise (Fig. 4.10).

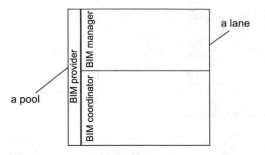

Fig. 4.10 BPMN symbols for pools and swim lanes

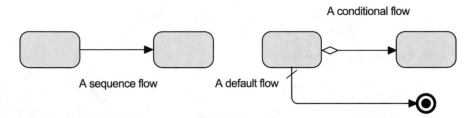

Fig. 4.11 BPMN symbols for sequence flows

4.3.2.3 Connecting Objects

The sequence of activities (sequence flow) and flow of information (message flow) are described with the help of connections. The links between activities describe the logical order and usually involves no time period (Fig. 4.11). Deadlines are described with the help of external events which can, in turn, trigger other activities.

The sequence of activities is defined for one participant only. Two or more activities between different pools are not allowed. However, so-called information flows can be defined between two different pools that can trigger further activities (Fig. 4.12).

4.3.2.4 Artifacts

With the help of so-called artifacts, additional information can be described, in particular to organize the flow of information in the field of Building Information Modeling. For example, the data format, the level of detail and the contents of a building model can be specified using artifacts. The more accurate these artifacts are, the better complex processes can be monitored and controlled. In principle, there are two ways to define artifacts. First, data objects can be defined and attached to activities and connections. By drawing an arrow, we can specify whether a data object is being used or required or whether it must be generated (Fig. 4.13).

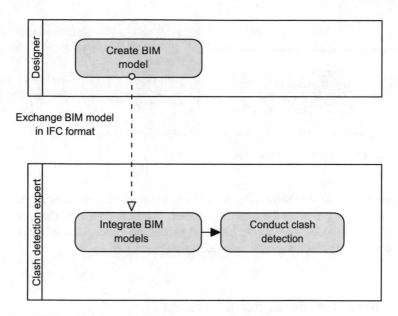

Fig. 4.12 BPMN symbols for message flows

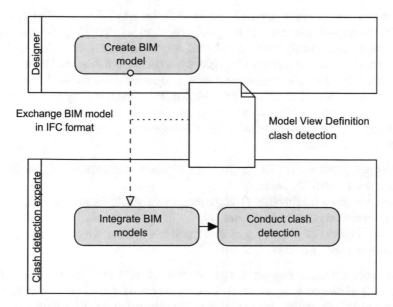

Fig. 4.13 BPMN symbols for data objects

With annotations, more information can be provided to users of BPMN. An annotation is a verbal piece of information and can be assigned to any element. Frequently, annotations are used to explain individual activities or to document possible problems during execution. Figure 4.14 shows how an annotation can be

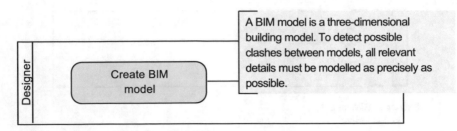

Fig. 4.14 BPMN symbols for annotations

attached to an activity. BPMN diagrams have been used very successfully to model BIM processes. Based on the resulting process diagram, data exchange points and corresponding model contents can be clearly specified. Often, the exchange of data can be augmented with a model view definition (see Chap. 6).

4.4 Workflow Management Systems

A workflow can be implemented in many different ways. The simplest approach is to let participants use their existing tools and data sources. Communications are then done conventionally with paper-based messages, emails or central exchange platforms. Control is manually managed by a designated responsible person. In many areas (for example, banks, insurance companies or authorities), the defined processes have been instantiated in a workflow management system for a long time now, where a workflow engine executes, controls and monitors the processes (Fig. 4.15). The introduction of workflow management systems places focus on the following objectives:

- improved process transparency through efficient status determination and the documentation of decisions;
- increased process reliability through standardized and fixed processes and the documentation of user interactions;
- the availability and processing of information is increased by minimizing media breaks and access control.

For more extensive support, a central database and the direct connection of different applications is required. A looser connection can also be implemented, in which only information on the status of the planned activities is reported. Thus, the workflow is only supervised at a high level and the actual exchange of data or the data management itself is not centralized. The various implementations of a so-called worklist handler are shown in Fig. 4.16. These functionalities are, in fact, provided by many project management systems currently available (see Chap. 14).

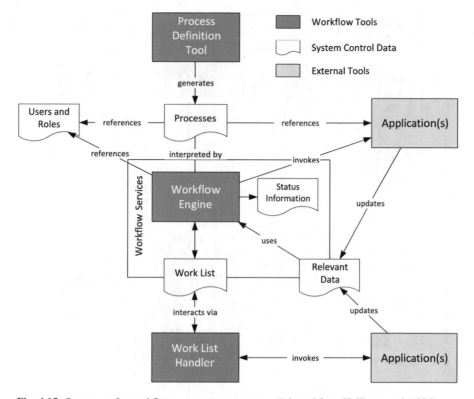

Fig. 4.15 Structure of a workflow management system. (Adapted from Hollingsworth 1995)

The increasing provision of central BIM servers and new planning tools, will result in the increasing use of workflow management systems in the construction industry. Despite all the technical possibilities, the essential foundation is still the correct and detailed description of all processes.

4.5 Execution Processes

The definition, structuring, analyzing and execution control of processes is one of the main tasks of production planning and project management. For this purpose, the critical path method is often used in practice. As this method is widely known, we will not elaborate further here on the individual elements and methods of the critical path method but instead refer the reader to the relevant literature (for example East 2015). Instead, we will discuss some specific possibilities.

Since building information modeling provides much more comprehensive information, projects can be planned more precisely and in more detail much earlier. Furthermore, production planning and logistics can be analyzed in detail with the

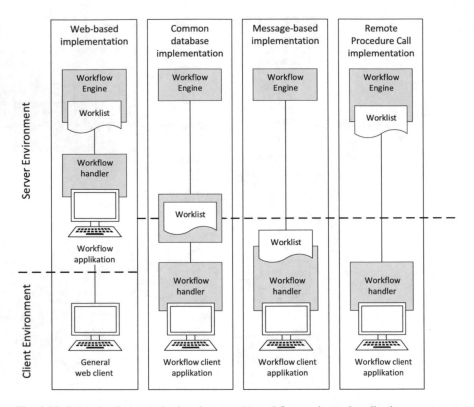

Fig. 4.16 Example of communications between the workflow engine and application system

help of special simulation tools. With very extensive construction schedules (for example, with thousands of transactions), the critical path method soon becomes too unwieldy. The definition of individual activities and relationships is very costly, clarity decreases sharply and adjustments are very prone to error. Another disadvantage is that specific information, such as resources, delivery dates, documents and other constraints can be described only with great difficulty. However, this information is necessary for a realistic and robust design planning.

For these reasons, the process models based on IDEF0 or BPMN are also used in detailed process planning (Benevolenskiy et al. 2012). This is usually done using so-called process templates that describe generalized construction methods. Since there are currently no standardized process templates, they are often defined specifically within corporations and projects. These process templates are then used for the preparation of construction schedule plans. Linking the operations with personnel, equipment and logistical constraints then allows the implementation of models for simulating project execution. Corresponding approaches have been successfully validated in the context of research projects (Scherer and Schapke 2011) and will certainly gain importance in the future of construction practice.

4.6 Summary

Process modeling and workflow management are, in relation to the description of business processes, established techniques to organize and coordinate tasks, people and data. For a successful BIM-based project management, transparent specifications for processing and exchange are particularly important. It must be clear which information is created, edited or approved by which person(s). Transparent processes are also extremely important for quality assurance and traceability. The focus, therefore, is on data flow and data exchange. Aspects of interoperability (Chap. 5), the definition of model contents (Chap. 6) and possibilities of model-based collaboration (Chap. 14) must be observed. It is, therefore, difficult to develop standardize BIM processes, since the composition of teams, the technical possibilities and also BIM objectives can vary, depending on the project. This has given rise to the developing role of the so-called BIM manager (Chap. 16), whose job it is to take over the preparation, coordination and control of BIM processes. The continuous updating and adjustment of defined processes is also important to identify and resolve potential problems early on. Although BIM processes might look different in each project, it makes sense to develop standardized processes. For example, BIM processes for public tendering and procurement could be implemented by projects, to facilitate the simple testing and evaluation of digital building models from different vendors.

References

Allweyer, T. (2012). *BPMN 2.0: Introduction to the standard for business process modeling* (2nd updated and revised edition, 2016). Norderstedt: Books on Demand.

Benevolenskiy, A., Roos, K., Katranuschkov, P., & Scherer, R. J. (2012). Construction processes configuration using process patterns. *Advanced Engineering Informatics, 26*(4), 727–736.

Dumas, M., Rosa, M. L., Mendling, J., & Reijers, H. A. (2013). *Fundamentals of business process management*. Berlin: Springer.

East, W. (2015). *Critical path method (CPM) tutor for construction planning and scheduling*. McGraw-Hill Education. Retrieved from https://books.google.de/books?id=-fIeBgAAQBAJ

Gadatsch, A. (2012). *Grundkurs Geschäftsprozess-Management: Methoden und Werkzeuge für die IT-Praxis: Eine Einführung für Studenten und Praktiker* (7th ed.). Wiesbaden: Springer Vieweg Verlag.

Hollingsworth, D. (1995). *Workflow management coalition: The workflow reference model*. [Online]. www.wfmc.org. Accessed on 15 June 2018.

Kossak, F., Illibauer, C., Geist, V., Kubovy, J., Natschläger, C., Ziebermayr, T., Kopetzky, T., Freudenthaler, B., & Schewe, K. D. (2015). *A rigorous semantics for BPMN 2.0 process diagrams*. Springer. Retrieved from https://books.google.de/books?id=M1eEBgAAQBAJ

Kunze, M., & Weske, M. (2016). *Behavioural models: From modelling finite automata to analysing business processes*. Springer. Retrieved from https://books.google.de/books?id=HH4EDQAAQBAJ

Österle, H. (2013). *Business in the information age: Heading for new processes*. Berlin/Heidelberg: Springer. Retrieved from https://books.google.de/books?id=poXnCAAAQBAJ

Scheer, A. W., Abolhassan, F., & Jost, W. (2004). *Business process automation: ARIS in practice*. ARIS in practice. Springer. Retrieved from https://books.google.de/books?id=EzSsnTECsMMC

Scherer, R. J., & Schapke, S.-E. (2011). A distributed multi-model-based management information system for simulation and decision-making on construction projects. *Advanced Engineering Informatics, 25*(4), 582–599. http://dx.doi.org/10.1016/j.aei.2011.08.007

van der Aalst, W., & van Hee, K. M. (2004). *Workflow management: Models, methods, and systems*. Cooperative information systems. MIT Press. Retrieved from https://books.google.de/books?id=O1xW1_Za-I0C

Weske, M. (2012). *Business process management: Concepts, languages, architectures* (2nd ed.). Berlin/Heidelberg: Springer.

Wang, L., & Leite, F. (2012). Towards process-aware building information modelling for dynamic design and management of construction processes. In *Proceedings of the 19th Annual Workshop of the European Group for Intelligent Computing in Engineering (EG-ICE)*. Herrsching: Technische Universität München.

Part II
Interoperability in AEC

Chapter 5
Industry Foundation Classes: A Standardized Data Model for the Vendor-Neutral Exchange of Digital Building Models

André Borrmann ⓘ, Jakob Beetz, Christian Koch, Thomas Liebich, and Sergej Muhic

Abstract The Industry Foundation Classes (IFC) provide a comprehensive, standardized data format for the vendor-neutral exchange of digital building models. Accordingly, it is an essential basis for the establishment of Big Open BIM. This chapter describes in detail the structure of the data model and its use for the semantic and geometric description of a building and its building elements. The chapter concludes with a discussion of the advantages and disadvantages of the IFC data model.

5.1 Background

The idea of Building Information Modeling is based on the consistent use of a comprehensive building model as a basis for all data exchange operations (see Chap. 1). This avoids the need to manually re-enter data or information already created, and reduces the accompanying risk of errors. In addition to the numerous data exchange scenarios between participants in the planning process, this principle

A. Borrmann (✉)
Chair of Computational Modeling and Simulation, Technical University of Munich, München, Germany
e-mail: andre.borrmann@tum.de

J. Beetz
Chair of Design Computation, RWTH Aachen University, Aachen, Germany
e-mail: beetz@caad.arch.rwth-aachen.de

C. Koch
Chair of Intelligent Technical Design, Bauhaus-Universität Weimar, Weimar, Germany
e-mail: c.koch@uni-weimar.de

T. Liebich · S. Muhic
AEC3 Deutschland GmbH, Munich, Germany
e-mail: tl@aec3.de; sm@aec3.de

© Springer International Publishing AG, part of Springer Nature 2018
A. Borrmann et al. (eds.), *Building Information Modeling*,
https://doi.org/10.1007/978-3-319-92862-3_5

also enables building data to be transferred digitally to the contractors in the building phase, and on completion for the "handover" of building data to the client or operator of the building.

A wide range of software tools already exist for the numerous different tasks involved in planning buildings, for example for the geometric design of the building, for undertaking a range of analyses and simulations (structural design, heating requirement, costing, etc.), for operating the building (facility management) as well as other applications such as those detailed in Part IV of this book. These tools address different tasks and application areas, and for the most part serve their purpose well.

A problem, however, is that many of these tools are still *islands of automation* (Fig. 5.1), i.e. have no or only limited support for data exchange between the separate applications. Consequently, data and information that already exists in digital form needs to be re-entered manually, which is laborious and prone to introducing new errors.

To remedy this situation, a data exchange format is required that makes it possible to transport building data between software products with as little data loss as possible. Such a format must set out uniform, unequivocal descriptions of geometric information that are clear in their meaning and therefore not open to

Fig. 5.1 Islands of automation in construction. The image was created in 1998 (© Matti Hannus, reprinted with permission)

misinterpretation (see Chap. 2). A further important aspect is the detailed description of semantic information, including the classification of building components within a common hierarchy of types, the description of the relationships between them and the definition of their relevant properties (material, building times, etc. see Chap. 3).

This is where the term interoperability comes into play, which means the loss-free exchange of data between software products by different vendors. What differentiates the building sector from many other industries is the wide range of different products in use and number of software vendors in the market. In other industries (for example automobile and aircraft manufacturing), the main manufacturers stipulate which software products their suppliers must use. At the same time, large, global software manufacturers provide complete solutions for these industries that cover many parts of the design and engineering processes. It is more straightforward for these software manufacturers to ensure interoperability between their own software products, because they can design their own proprietary formats and methods without needing to go through lengthy and complex standardization procedures.

Compared with such stationary industrial applications, the building sector has several different boundary conditions that make it more difficult to achieve the goal of loss-free data exchange:

- A building's design and its construction are typically undertaken by different companies
- Building planning typically has several phases that are often undertaken by different planning offices
- Numerous different specialist planners are involved, each of which are separate companies.
- The building industry is very fragmented with numerous small and medium-sized companies. Statistics for Europe show that 93% of construction companies have fewer than 10 employees.
- Collaborations between different companies are typically ad-hoc partnerships for the duration of a project rather than long-term working relationships with well-defined processes and responsibilities.

In short, the building industry is characterized by a highly fragmented process with numerous different and independent participants. This means that lots of different tools are used and therefore uniform standards are difficult to enforce. At the same time, public authorities are required to be vendor-impartial, i.e. are not allowed to specify the use of certain software products when putting work out to tender. Likewise, public and private clients should not become too dependent on any one software producer to avoid vendor lock-in.

As a result, it has become common practice to specify widely-used proprietary formats for many typical data exchange scenarios in order to achieve a degree of predictable, i.e. pseudo-standardized interoperability. These formats are mostly used for 2D geometry formats augmented with a limited degree of semantic information, for example an agreed layer structure.

Proprietary formats are not conducive to realizing the BIG BIM goal of a consistent, high-quality digital building information model for the entire building process (see Chap. 1). In most cases, proprietary data formats are tailored to specific application scenarios and not designed to cover the full range of different data exchange scenarios in the BIM context nor the necessary depth of information. As such, to achieve the goal of BIG BIM, it became clear that a vendor-neutral, open and standardized data exchange format was needed.

This approach, while undoubtedly better in the long term, is more difficult and more protracted to put into practice. The international organization buildingSMART has dedicated many years to the development of the Industry Foundation Classes (IFC) as an open, vendor-neutral data exchange format. This is a complex data model with which it is possible to represent both the geometry and semantic structure of a building model using an object-oriented approach. The building is broken down into its building components on the one hand and its spaces on the other, both of which are described in detail along with the interrelationships between them. Thanks to its comprehensive data structure, it can be used for almost any data exchange scenario in the life cycle of a building. The IFC data model is immensely important for implementing BIM concepts and is the basis of many standardization initiatives at an international, European and national level. It is described in detail in this chapter.

The process of establishing a neutral data exchange format is, however, lengthy. While the current Version 4 of the IFC can be considered largely mature and ready for use as a standard, it can only be used in practice once the different software vendors have implemented it as an import and export interface. The quality of the implementation of such interfaces is crucial for its take-up in the industry. In the past, errors in these import and export modules led to data errors or even data loss, impacting on the reputation and market acceptance of the IFC data format.

One reason for the inadequate implementation of the import and export functionality by software vendors is also the complexity of the IFC data model. For example, it is possible to represent 3D geometry in an IFC model in several different ways. For software vendors, this means that they need to support all geometric representation methods to offer full IFC compatibility, which is an immense implementation task.

To overcome this hurdle, buildingSMART introduced the concept of Model View Definitions (MVD) that define which parts of an IFC data model need to be implemented for a specific data exchange scenario. The underlying methods and concepts are discussed in more detail in Chap. 6. Consequently, the Model View Definitions form the basis for certifying the compatibility of software products with the IFC standard. The corresponding certification procedure is presented in Chap. 7.

5.2 History of the IFC Data Model

As far back as the late 1980s, researchers had already begun investigating ways to improve the exchange of data in the building and construction sector. The idea of

"product modeling" as a means of digitally describing a product and its components, both in terms of their geometry as well as scmantic structure, stems from this time (Eastman 1999).

Methods for exchanging data between different CAD systems first began to be developed in the 1970s to meet a need among major interest groups, such as the US Ministry of Defense and the German Association of the Automotive Industry (VDA), for a common interface for loss-free data exchange. These first data exchange formats, some of which are still in use today (such as the IGES Initial Graphics Exchange Specification), were mostly limited to the exchange of geometric data. Continuing efforts to improve standardization culminated in the 1980s in the development of STEP, a Standard for the Exchange of Product model data. Through Technical Committee 184, Sub-Committee 4 "Industrial Data" (ISO TC 184/SC 4) of the International Organization for Standardization (ISO), a series of different sub-norms were united in the ISO 10303 Standard, developed by a broad alliance of stakeholders from various industrial sectors. In addition to setting out an agreed framework for describing product data representation schemas ISO 10303-11, the family of 10303 standards included graphical notation methods, the definition of file formats for instances (serialization) in different syntactic variants, and uniform information processing interfaces. It also details semantic aspects of the individual product categories. Various industrial sectors grouped relevant product and data exchange scenarios into so-called Application Protocols (APs). Alongside object models for oil drilling platforms, airplane, automotive and ship components, a separate object model for buildings – Application Protocol for Building Elements Using Explicit Shape Representation – were developed.

For many stakeholders, however, the procedure for reaching a consensus on a common approach to modeling building data and its exchange was too long-winded: the bureaucratic framework for standardization under the auspices of the ISO was felt to be holding back developments in the then prospering construction industry. Spurred on by a series of (often EU-funded) research projects and the needs of the industry, a group of engineering offices, construction firms and software manufacturers, most notably Autodesk, decided to collaborate in the foundation of the International Alliance for Interoperability (IAI) in 1995 to speed up the process of standardization. The organization, which re-branded itself in 2005 as "buildingSMART", currently has 19 regional chapters, including the German "buildingSMART e.V.". More than 800 organizations, companies and institutes are now members of buildingSMART and promote the development of standards on behalf of the industry as a whole. A first version 1.0 of these standards was issued in 1997 as the "Industry Foundation Classes – IFC" and version 1.5.1 was the first to be implemented in dedicated construction software applications (Laasko and Kiviniemi 2012).

Since the first version, numerous revisions and extensions have followed (see Fig. 5.2), which vendors then implemented shortly afterwards in their respective products. These standards were published independently of the ISO as a vendor-neutral standard and made freely available at no cost. Unlike other proprietary, vendor-specific object models, such as Autodesk's popular DWG and ARX formats,

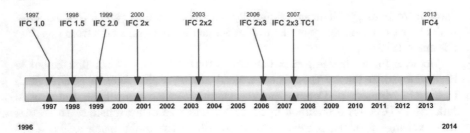

Fig. 5.2 Version history of the IFC format

there are no licensing fees for using the IFC model. As a consequence, numerous software products have since implemented the IFC model. Today there are more than 160 implementations of the standard in individual software products, with most widespread support for version 2×3, although this is gradually being replaced by IFC 4 (as of late 2017) (BuildingSMART 2013a). The subsequent incorporation of the IFC in ISO Standard 16739 (2013) also fueled its adoption among public authorities, and in many countries it has now become an obligatory data exchange format for construction tendering and approval procedures.

In recent years, the IFC has become the definitive format for realizing Open BIM. It is already supported by numerous BIM software applications, ranging from BIM modeling tools to structural computation tools and thermal performance analysis tools to software for facility management.

Thanks to the open definition of the data structure and the neutrality of the IFC format, it has become the basis of almost all public sector initiatives that prescribe the use of BIM for public building projects. Pioneering initiatives have been made in Singapore, Finland, Norway, the USA and Great Britain.

The open data format means that data will continue to be legible many years into the future. This is especially important given the longevity of buildings, which typically spans several decades or more.

Currently the IFC data model focuses on the description of buildings. Extensions for describing other built structures, such as civil engineering infrastructure, are currently in development.

5.3 EXPRESS: A Data Modeling Language for the IFC Standard

Although the development of the IFC evolved independently of the ISO standardization body and the STEP procedure, it shares much of the same underlying technology, most notably the data modeling language EXPRESS which is defined in part 11 of the STEP standard (ISO 10303-11 2004).

EXPRESS is a declarative language with which one can define object-oriented data models (Schenck and Wilson 1993). That means it follows the object-oriented

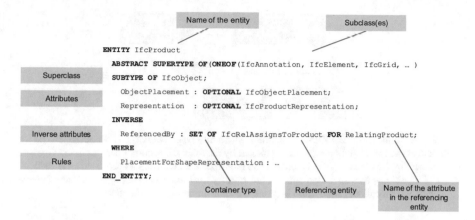

Fig. 5.3 Definition of an entity type using the data modeling language EXPRESS

principles described in Chap. 3, such as the abstraction of objects in the real world into classes (called entities in EXPRESS) which can have attributes and be related to other classes.

EXPRESS employs the construct of an entity type[1] as an equivalent to classes in object-oriented theory. For each entity type, attributes and relationships to other entity types can be defined. EXPRESS also implements the object-oriented concept of inheritance, enabling attributes and relationships to apply similarly to sub-types.

A relationship (association) between an object of Type A and an object of Type B is expressed by giving entity Type A an attribute from the type of Entity B. A special characteristic of the EXPRESS standard is the ability to explicitly define inverse relationships. In this case, no new information is modeled; just a relationship in the reverse direction.

A further special aspect is that aggregation datatypes – list, array, set and bag – are defined as part of the language, making it easier to define relationships with groups of objects. This construct of abstract datatypes makes it possible to define superclasses without these needing to be explicitly instantiated.

EXPRESS offers the possibility to define algorithmic conditions using an optional WHERE block as a means of describing rules for data consistency. The WHERE block contains Boolean expressions that have to evaluate as true for the respective instance to be deemed valid.

Figure 5.3 shows an excerpt of a data model from the IFC standard defined using EXPRESS.

The select type in EXPRESS offers an additional method, alongside inheritance hierarchies, for assigning several entity types to a higher-level construct. This can in turn serve as a placeholder, for example when defining the type of an attribute. An

[1] In this chapter, the use of the term *class* is synonymous with *entity type*.

Fig. 5.4 Example of an EXPRESS-G diagram. The entity type *Person* is an abstract supertype for both entity types *Male* and *Female*. This is shown by the thick connecting lines. A circle at the end of a connecting lines denotes the direction of an inheritance relationship. A person has the attribute *name* of type *string* as well as two optional attributes: *father* and *mother* of type *Male* and *Female* respectively. The optional connection is denoted by the dashed connecting line

example from the IFC data model is the select type *IfcUnit*, which provides a choice between the types *IfcDerivedUnit*, *IfcNamedUnit* and *IfcMonetaryUnit*.

Attributes that can only contain specific values from a selection of predefined strings are modeled in EXPRESS with the help of the Enumeration Type. For example, *IfcBooleanOperator* can be either UNION, INTERSECTION or DIFFERENCE.

In addition to this textual notation, EXPRESS also offers a means of modeling data graphically. The corresponding graphical notation language is called EXPRESS-G. Figure 5.4 shows an example of the elements of the graphical language.

It is important to remember that EXPRESS is designed for defining a data model (also known as a schema). It is not possible to describe concrete instances of the data model using EXPRESS. Various different methods can be used for this, of which a STEP Physical File (defined in STEP part 21) is most common. Other options include the use of XML instances or storing data in a database. More information on this is provided in Sect. 5.11.

5.4 Organization in Layers

The IFC data model is both extensive and complex. To improve its maintainability and extensibility, it is therefore structured into several layers (Fig. 5.5). The general principle is that elements in the upper layers can reference elements in the layers below but not vice versa. This ensures that the core elements remain independent.

5.4.1 Core Layer

The Core Layer contains the most elementary classes of the data model. They can be referenced by all the layers above. These classes define the basic structures, key

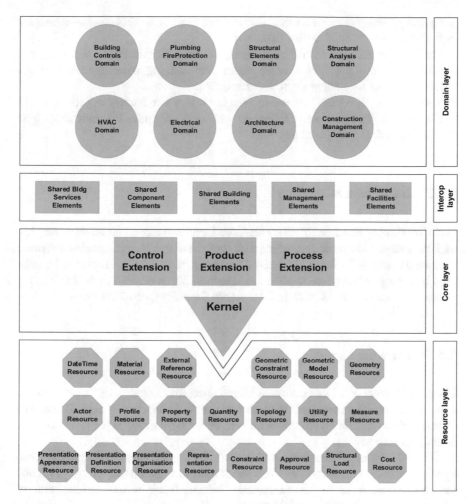

Fig. 5.5 The layers of the IFC data model. (Source: IFC Documentation, ©buildingSMART, reprinted with permission)

relationships and general concepts which can then be re-used and defined more precisely by classes in the upper layers.

The Kernel schema represents the core of the IFC data model and comprises basic abstract classes such as *IfcRoot, IfcObject, IfcActor, IfcProcess, IfcProduct, IfcProject, IfcRelationship*. Based on these are three scheme extensions *Product Extension, Process Extension* and *Control Extension* which are also part of the Core Layer.

The *Product Extension* schema describes the physical and spatial objects of a building and their respective relationships. It comprises the subclasses of *IfcProduct* such as *IfcBuilding, IfcBuildingStorey, IfcSpace, IfcElement, IfcBuildingElement,*

IfcOpeningElement as well as the relationships classes *IfcRelAssociatesMaterial*, *IfcRelFillsElement* and *IfcRelVoidsElement*.

The *Process Extension* schema comprises classes for describing processes and operations. It also provides a basic means for defining dependencies between process elements for linking them with resources.

The *Control Extension* defines the basic classes for control objects such as *IfcControl* and *IfcPerformanceHistory* as well as possibilities for allocating these objects to physical and spatial objects.

5.4.2 Interoperability Layer

The *Shared Layer* lies directly above the Core Layer and represents an interoperability layer between the basic core of the data model and the domain-specific schemes. Here classes are defined that are derived from classes in the Core Layer and can be used by a range of different application schemes, for example, important building element classes such as *IfcWall*, *IfcColumn*, *IfcBeam*, *IfcPlate*, *IfcWindow*.

5.4.3 Domain Layer

The domain-specific schemes contain highly specialized classes that only apply to a particular domain. They form the leaf nodes in the hierarchy of inheritance. The classes defined in this layer cannot be referenced by another layer or by another domain-specific schema.

The IFC4 defines domains for architecture, building control, construction management, electrical systems, heating, ventilation and air conditioning, plumbing and fire protection as well as structural elements (such as foundations, pylons, reinforcement, etc.) and structural analysis.

5.4.4 Resource Layer

At the lowest level, the *Resource Layer*, are schemes that provide basic data structures that can be used throughout the entire IFC data model.

The classes in this layer do not derive from *IfcRoot* and therefore have no identity of their own (see Sect. 5.5.1). Unlike entities in other layers, they cannot exist as independent objects in an IFC model but have to be referenced by an object that instantiates a subclass of *IfcRoot*.

Of these, the most important resource schemes include:

- Geometry Resource: contains basic geometric elements such as points, vectors, parametric curves, swept surfaces (see Sect. 5.7, see also Chap. 2).

- Topology Resource: contains all classes for representing the topology of a solid (see Sect. 5.7, see also Chap. 2).
- Geometric Model Resource: contains all classes for describing geometric models such as *IfcCsgSolid*, *IfcFacetBrep*, *IfcSweptAreaSolid* (see Sect. 5.7, see also Chap. 2).
- Material Resource: contains elements for describing materials (see Sect. 5.6.4).
- Utility Resource: provides elements for describing the ownership and version history (History) of IFC objects.

In addition to these, the resource layer also includes a whole series of further schemes, such as Cost, Measure, DateTime, Representation, etc. that we shall not deal with here.

5.5 Inheritance Hierarchy

As in any object-oriented data model, inheritance hierarchy plays a crucial role in the IFC. It defines specialization and generalization relationships and therefore which attributes of which classes can be inherited by other classes. Figure 5.6 shows part of the IFC inheritance hierarchy.

The inheritance hierarchy follows a semantic approach: the meaning of objects is the basis for modeling inheritance relationships. Here we shall concentrate on the most important classes of the IFC inheritance hierarchy.

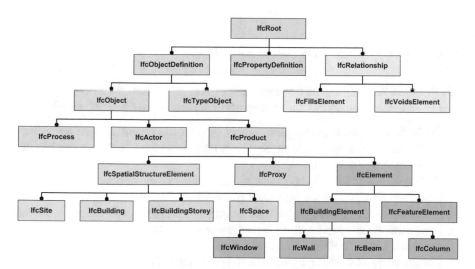

Fig. 5.6 Part of the IFC data model showing the most important entities in the upper layers of the inheritance hierarchy. (© A. Borrmann, reprinted with permission)

5.5.1 IfcRoot and Its Direct Subclasses

The starting point and root of the inheritance tree is the class *IfcRoot*. All entities, with the exception of those in the resource layer, must derive directly or indirectly from *IfcRoot*. This class provides basic functionality for uniquely identifying an object using a Globally Unique Identifier (GUID), for describing ownership and the origin of an object and to map the history of changes made to it (identity of the originator and other actors, its version history etc.). In addition, every object can be given a name and description.

Directly derived from *IfcRoot* are the classes *IfcObjectDefinition*, *IfcProperty-Definition* and *IfcRelationship*, which represent the next level in the inheritance hierarchy.

The class *IfcObjectDefinition* is an abstract superclass for all classes that represent physical objects (e.g. building elements), spatial objects (e.g. openings and spaces), or conceptual elements (e.g. processes, costs, etc.). It also includes definitions for describing those involved in the building project. The three subclasses of *IfcObjectDefinition* are *IfcObject* (individual objects in the building project), *IfcTypeObject* (object type) and *IfcContext* (general project information).

The class *IfcRelationship* and its subclasses describe objectified relationships. This decouples the semantic of a relationship from the object attributes so that relationship-specific properties can be saved directly with the related object. This concept is discussed in detail in Sect. 5.6.

The class *IfcPropertyDefinition* defines those properties of an object that are not already part of the IFC data model. This aspect is detailed in Sect. 5.8.

5.5.2 IfcObject and Its Direct Subclasses

An *IfcObject* represents an individual object (a thing) as part of a building project. It is as an abstract superclass for six important classes of the IFC data model:

- *IfcProduct* – a physical (tangible) object or a spatial object. *IfcProduct* objects can be assigned a geometric shape representation and are positioned within the project coordinate system.
- *IfcProcess* – a process that occurs within a building project (planning, construction, operation). Processes have a temporal dimension.
- *IfcControl* – an object that controls or limits another object. Controls can be laws, guidelines, specifications, boundary conditions or other requirements that the object has to fulfill.
- *IfcResource* – describes the use of an object as part of a process.
- *IfcActor* – a human participant involved in the building project.
- *IfcGroup* – an arbitrary aggregation of objects.

This subdivision into the areas product, process, control element and resource corresponds to the principal approach to modeling business processes developed back in the 1980s by the IDEF initiative.

5.5.3 IfcProduct and Its Direct Subclasses

IfcProduct is an abstract representation of all objects that relate to a geometric or spatial context. All classes used to describe a virtual building model are subclasses of *IfcProduct*. These can be used to describe both physical objects as well as spatial objects. *IfcProduct* objects can be assigned a geometric shape representation and a location (see Sect. 5.7).

The subclass *IfcElement* is the superclass for a whole series of important basic classes including *IfcBuildingElement*, which is the superclass for all building elements such as *IfcWall*, *IfcColumn*, *IfcWindow* etc.

The *IfcSpatialElement* class, by comparison, is used to describe non-physical spatial objects. Its respective subclasses include *IfcSite*, *IfcBuilding*, *IfcBuilding-Storey* and *IfcSpace*. The organisation of a corresponding relationship structure between these elements is described in Sect. 5.6.2.

The *IfcProduct* subclass *IfcProxy* serves as a placeholder for representation objects that do not correspond to any of the semantic types so that they can still be defined in the IFC model, and if necessary be assigned a geometric representation. *IfcProduct* has further subclasses for describing objects that are embedded within a spatial context, for example *IfcAnnotation*, *IfcGrid* and *IfcPort*.

5.6 Object Relationships

5.6.1 General Concept

Object relationships are an important part of the IFC data model. In fact, the IFCs powerful functions for detailing relationships between objects can be seen as one of its key qualities. The ability to describe relationships, along with the semantic classification of objects, is a fundamental aspect of an "intelligent" building information model that not only records building elements as isolated bodies but highlights their function and interaction with other objects. Typical relationships can be whole/part relationships (Meronymy, "the south wing is part of the overall building"), connections ("the floor slab is connected to the column") or type definitions ("Beam with an HE-A 140 profile").

The IFC data model follows the principle of objectified relationships (see also Sect. 3.3.2). That means that semantically relevant relationships between objects are not formed by direct association but instead with the help of a special intermediary

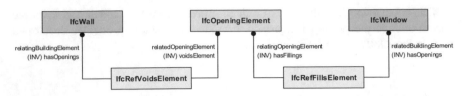

Fig. 5.7 The principle of objectified relationships illustrated using the example of a wall, opening and window

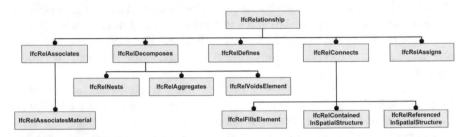

Fig. 5.8 The inheritance hierarchy of relationship classes in the IFC data model

object that represents the relationship itself (see Fig. 5.7). An important principle of data modeling that has been implemented in the IFC is that the forward relationship (the defined attribute) is always made from the relationship object and points to the related objects. The corresponding attributes of the relationship object always have names according to the schema *related... Element* and *relating... Element*. The reverse path from the related objects to the relating objects can be navigated using corresponding inverse attributes.

Relationship objects are always instances of a subclass of *IfcRelationship*. The inheritance tree of the object relationships is shown in Fig. 5.8. The element *IfcRelationship* is the root and every relationship can have an informal description that details the precise purpose for using this relationship.

The following six relationship types serve specific basic functions in the IFC data model:

- IfcRelAssociates – serves to relate an external source of information (such as classifications, libraries or documents) to an object or its properties.
- IfcRelDecomposes – serves as a means of representing concepts of composed objects. The decomposition relationship denotes a whole/part hierarchy with the ability to navigate from the whole to the parts and vice versa. Its subclasses include *IfcRelNests* (the nested parts have an order) and *IfcRelAggregates* (the aggregated parts have no order) and *IfcVoidsElement* (opening relationship).
- IfcRelDefines – links an object instance with a Property Set Definition (Sect. 5.8) or a Type Definition (Sect. 5.9)
- IfcRelConnects – describes a connection between two objects.
- IfcRelDeclares – represents the link between an object, its defined properties and the respective context.

- IfcRelAssigns – represents a generalization of "link" relationships between object instances.

The purpose and application of the individual relationship types will be discussed in the following sub-sections.

5.6.2 Spatial Aggregation Hierarchy

An important underlying concept for the description of buildings using IFC is the representation of aggregation relationships between spatial objects on the different hierarchical levels. All classes with spatial semantics inherit attributes and properties from the class *IfcSpatialStructureElement*. These are *IfcSite* which describes the building site, *IfcBuilding* to represent the building, *IfcBuildingStorey* for representing a particular story and *IfcSpace* for the individual rooms and corridors. *IfcSpatialZone* introduces a further method for representing general spatial zones that does not correspond to the default building structure taking into account a functional consideration. Instances of these classes are related to one another via relationship objects of the type *IfcRelAggregates*.

Figure 5.9 shows an example of how spatial hierarchy can be represented in an IFC model. At the top of the hierarchy is the *IfcProject* object that describes the context within which the information about the project as a whole is represented. Important in this context is the use of the attribute *CompositionType* on the aggregated *IfcSpatialStructureElement* which is used to define whether the element is part of a whole (PARTIAL) or simply an embedded element (ELEMENT). For example, sections of buildings are generally modeled as *IfcBuilding* with the *CompositionType* attribute set to PARTIAL.

The data model itself does not define which hierarchy levels may be linked to which other hierarchy levels via aggregation relationships. However, some informal rules do apply, for example that the resulting graph must be acyclic and that elements on a lower level cannot encompass objects from a higher level. The correctness and consistency of the information stored is the responsibility of the respective software program.

To model which building elements lie in which spatial objects, instances of the relationship class *IfcRelContainedInSpatialStructure* are used (see Fig. 5.10). In most cases building elements are linked to stories. However, one must be careful to observe that one building element can only be assigned to a single spatial object per *IfcRelContainedInSpatialStructure* at any one time. Should a building element be linked to several stories (for example a multistory facade element), it should be linked to all other instances via the relationship *IfcReferencedInSpatialStructure* (see Fig. 5.10).

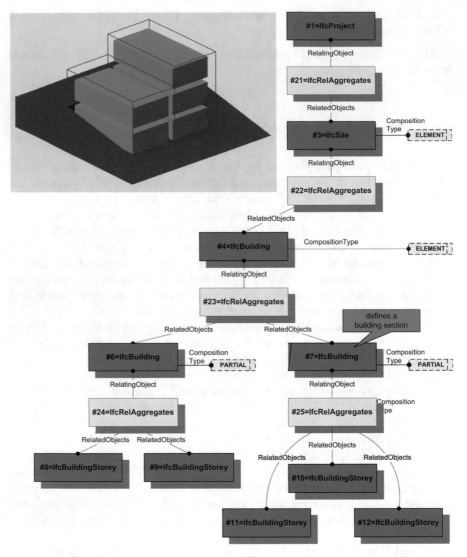

Fig. 5.9 Example of the structure of a hierarchical aggregation relationship between spatial objects in the IFC model (instance diagram). (Source: IFC Documentation. ©buildingSMART, reprinted with permission)

5.6.3 Relationships Between Spaces and Their Bounding Elements

Numerous applications in the BIM context require a link between a spatial object and the objects that bound the space, such as walls, floor and ceiling. For example, programs for calculating quantities (see Chap. 19) or for computing the energy

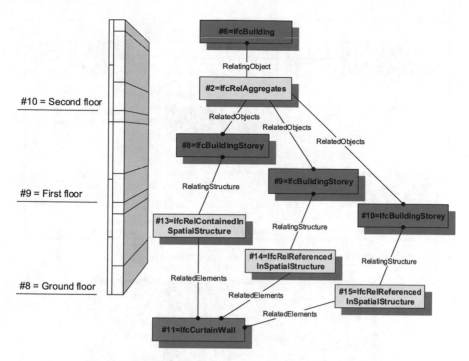

Fig. 5.10 Example of the use of the relationship *IfcRelContainedInSpatialStructure* and *IfcRef-erencedInSpatialStructure* to describe spatial relationships to a multistory wall element. (Source: IFC Documentation. ©buildingSMART, reprinted with permission)

demand (see Chap. 17). To model such relationships, the IFC data model includes the relationship class *IfcRelSpaceBoundary* (Weise et al. 2009). The attribute *RelatingSpace* refers to the spatial object while *RelatedBuildingElement* refers to the respective bounding element (see Fig. 5.11).

In addition, it is possible to link a relationship object to an actual object using the class *IfcConnectionGeometry* which describes the surface where the space meets the building element. This can be invaluable for certain calculations and simulations.

Space Boundaries are always described from the perspective of the spatial object. One differentiates between two key levels of Space Boundaries (Fig. 5.12):

- Level 1 Space Boundary: boundaries of a space disregarding any changes in building elements or spaces on the other side.
- Level 2 Space Boundary: boundaries of a space taking into account changes in building elements or spaces on the other side:

 - Level 2, Type A: On the other side of the boundary is a space.
 - Level 2, Type B: On the other side of the boundary is a building element.

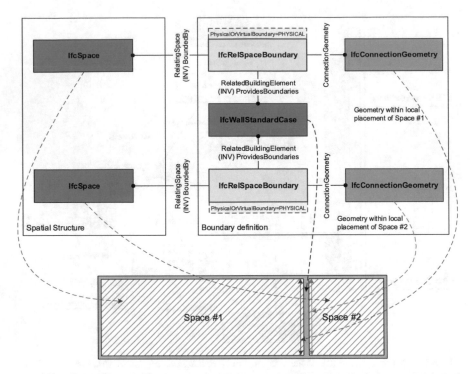

Fig. 5.11 The relationships between a spatial object and the bounding elements are represented using instances of the relationship class *IfcRelSpaceBoundary*. (Source: IFC Documentation. ©buildingSMART, reprinted with permission)

A more precise definition of space boundaries can be made using application-specific model view definitions as the requirements for the respective situations vary considerably (see Liebich 2009).

5.6.4 Specifying Materials

The specification of materials is an important part of a digital building model. Without information on the materials of each building element it would not be possible to automatically calculate quantities of materials required. Calculations and simulations such as for structural analyses or energy demand calculations likewise require information about the materials used along with their respective parameters. A further important aspect of the IFC model is the ability to represent building elements comprised of several materials. A typical example is a wall with several layers of different materials.

Materials are specified using the relationship class *IfcRelAssociatesMaterial* linked to a building element (an arbitrary subclass of *IfcElement*). The attribute

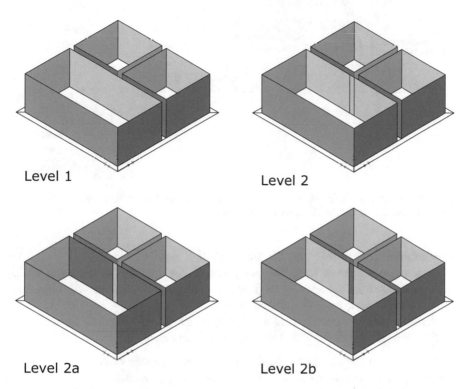

Fig. 5.12 Differences between the space boundaries on Level 1, Level 2a and Level 2b. On Level 1, the boundary of the spaces is modeled without taking into account changes in building elements or spaces on the other side of the boundary. Level 2 takes these into account and subdivides the surfaces accordingly. Level 2 Type A shows all surfaces with a space on the other side, Level 2 Type B all surfaces with a building element on the other side. (Source: IFC Documentation. ©buildingSMART, reprinted with permission)

RelatingMaterial typically refers to an object of the class *IfcMaterialDefinition*, which can have several subclasses, the most important of which are described here:

- *IfcMaterial*: the basic entity for describing a material.
- *IfcMaterialConstituent*: describes the material as part of a building element. The material attribute itself refers to an *IfcMaterial* object. The attribute Name is used to unequivocally attribute the material to the respective building element, more precisely to the respective part of the element via *IfcShapeAspect*.
- *IfcMaterialConstituentSet*: describes a set of *IfcMaterialConstituent* objects. Each of these objects is assigned to a part of the building element. For example: a window is comprised of the glazing and the frame. The window is modeled as a building element and associated with an *IfcMaterialConstituentSet* which in turn contains two *IfcMaterialConstituent* objects, one for the frame and the other for the glazing.

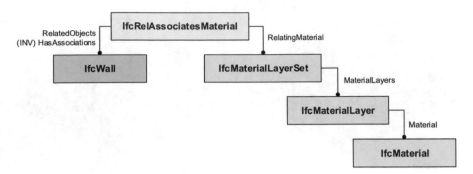

Fig. 5.13 Example for linking a building element comprised of multiple layers with its materials using the relationship class *IfcRelAssociatesMaterial*

- *IfcMaterialLayer*: describes the material of a layer of a multilayer building element. The attribute *LayerThickness* denotes the thickness of the layer, while the attribute Material refers to an *IfcMaterial* object. The attribute *IsVentilated* is set to true if the layer is a ventilated cavity.
- *IfcMaterialLayerSet*: describes a set of *IfcMaterialLayer* objects. Instances of this class are associated with a multilayer building element (see Fig. 5.13).

Composite materials are modeled using the relationship class *IfcMaterialRelationship*, with which it is possible to represent aggregation relationships. The attribute *RelatedMaterials* refers to the individual components while the attribute *RelatingMaterial* refers to the composite material.

The class *IfcMaterial* includes the attribute *Name* as a means of specifying a unique name and can also accommodate classifying materials according to an external classification system by linking it with *IfcExternalReferenceRelationship*.

In addition, material parameters can also be linked to one or more objects of the type *IfcMaterialProperties*, which can be referenced via the inverse attribute *HasProperties*. The class *IfcMaterialProperties* describes a set of material properties in the form of a name-value list (see Sect. 5.8). A series of predefined property sets already exist, for example for mechanical properties (*Pset_MaterialMechanical*), optical properties (*Pset_MaterialOptical*), thermal properties (*Pset_MaterialThermal*), and parameters for energy demand calculations (*Pset_MaterialEnergy*). Specific parameter sets have been developed for common materials such as concrete, steel and wood.

Using the *IfcMaterial*, presentation information can also be associated with a building element. The inverse attribute *HasRepresentation* is applied to an object of type *IfcMaterialDefinitionRepresentation*, which defines the line type and thickness as well as hatching (for 2D drawings) or information necessary for rendering the surface of the material (for 3D presentations).

5.7 Geometric Representations

5.7.1 Division Between Semantic Description and Geometric Representation

The IFC data model makes a strict division between the semantic description and its geometric representation. The semantic representation is the defining aspect: all objects within a building project are initially described as a semantic identity and can then be linked with one or more geometric representations (Fig. 5.14). The concept of identity is therefore linked only to a semantic object, and not its geometric representation.

The ability to link distinct geometric representations with an object addresses the need for distinct geometric representations for distinct application scenarios. For example, visualization programs usually only need a simple triangulated geometric description while BIM modeling tools need good quality Brep (boundary representation) or CSG (constructive solid geometry) descriptions in order to be able to make changes to the model. It is also possible to link a 2D representation with a semantic object so that drawings can be stored within an IFC model to be compliant with standards.

The problem of maintaining consistency between the distinct representations must be dealt with by the modeling programs as the IFC data model does not include such functionality.

5.7.2 Forms of Geometric Description

The IFC model implements a broad range of the geometric models presented in Chap. 2. This section focuses on the most important geometric representations.

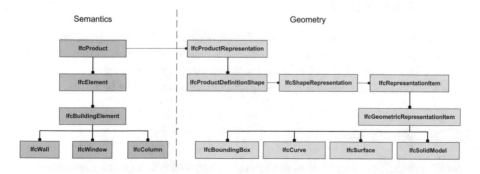

Fig. 5.14 The IFC data model makes a strict division between the semantic structure and geometric description. This affords the flexibility to link one or more geometric representations with a semantic object

All the classes needed for geometric modeling belong to one of the three schemes *Geometric Model Resource, Geometry Resource,* or *Topology Resource.* In the majority of cases, the definitions and data structures correspond exactly to those set out in part 42 of the STEP standard, and in the case of indexed geometry descriptions from the X3D standard (ISO/IEC 19775-1 2004).

All geometry classes inherit from the abstract superclass *IfcGeometricRepresentationItem.* Its subclasses can be grouped into classes for representing curves (*IfcCurve* and its subclasses), classes for describing surfaces in space (*IfcSurface* and its subclasses) and classes for representing solids (*IfcSolidModel* and its subclasses). The dimensions are specified using the *Dim* attribute in the class *IfcGeometricRepresentationItem.*

5.7.2.1 Points, Vectors, Directions

The entity types *IfcCartesianPoint, IfcCartesianPointList, IfcVector* and *IfcDirection* are used to define points, vectors and directions.

5.7.2.2 Curves in 2D and 3D

To model line objects, the entity type *IfcCurve* and its subclasses *IfcBoundedCurve, IfcConic,* and *IfcLine* are used. Freeform curves can also be modeled using the class *IfcBSplineCurve* (see also Chap. 2). The *IfcCompositeCurve* can be used to model complex curves comprised of several curved sections.

In addition to 3D geometric representation, the IFC data model explicitly supports the storage of 2D representations for plan drawings. In such cases, the dimensionality of the respective *IfcCurve* objects must be set to 2. This approach can be used to model profiles for extrusion and other similar operations.

5.7.2.3 Bounding Box

The Bounding Box is a highly simplified geometric representation for three-dimensional objects that is commonly used only as a placeholder, or in combination with a more detailed description. Using the class *IfcBoundingBox* one can define a corner point and three edge lengths for the respective dimensions of the box.

5.7.2.4 Surface Model

Surface models offer a means of describing composite surfaces comprised of several sub-surfaces. They are used to describe broad surfaces (such as a terrain) or very flat surfaces (such as metal sheeting). 3D solids can also be described via their surfaces. An advantage of this method over Brep modeling is its simpler data structure; a

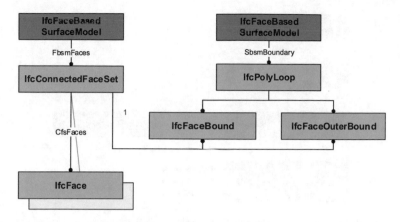

Fig. 5.15 Entities used to describe surface models

disadvantage is the limited ability to verify the correctness of the modeled solid, for example incorrect intersections (e.g. gaps or overlaps) between faces.

The IFC data model supports two different variants of surface models (Fig. 5.15). The *IfcFaceBasedSurfaceModel* makes it possible to model simple bodies without holes or cavities while the *IfcShellBasedSurfaceModel* can be used to model solids with cavities or holes through the use of any number of *IfcShell* objects. These shell objects can be either open shells (*IfcOpenShell*) or closed shells (*IfcClosedShell*).

5.7.2.5 Triangulated Surface Descriptions/Tessellation

A widely used method for describing geometric forms is the use of triangulated nets. This very general and simple form of geometric representation can be interpreted by nearly all visualization software applications. Its main limitations are that curved surfaces are not represented precisely but approximated into triangular facets, that they are data intensive and that many applications offer only limited support for editing them. As such, this geometric representation is not always the most suitable form for building geometries. One area where triangulated surfaces excel is for the description of digital terrain models (DTMs).

For such uses, the IFC data model provides the class *IfcTriangulatedFaceSet*. This is derived from the class *IfcTessellatedFaceSet* that represents the general principle of tessellated surfaces, i.e. polygons with an arbitrary number of edges. *IfcTessellatedFaceSet* is not derived from *IfcSolidModel* but instead inherits from *IfcTesselatedItem*.

The IFC model implements the *Indexed Face Set* approach described in Chap. 2. The class *IfcTriangulatedFaceSet* refers via the Coordinates attribute to an object of type *IfcCartesianPointList3D* which describes a list of points (Fig. 5.16). A further attribute, *CoordIndex*, describes the index of the three vertices for each triangle. The

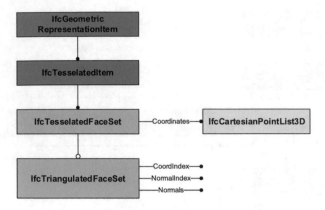

Fig. 5.16 Data structure for the representation of triangulated surfaces

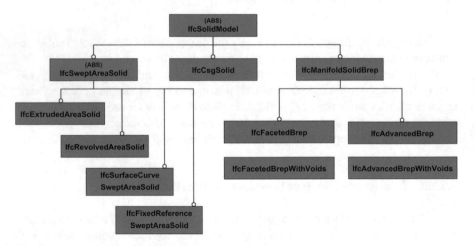

Fig. 5.17 The IFC data model provides a number of different ways to model volumetric bodies (solids)

normals for each triangle can be optionally specified using the *Normals* attribute. In addition, it is possible to link color values or textures with the index values.

5.7.2.6 Solid Modeling

The IFC data model supports a number of different ways of modeling 3D solids. These are represented by the abstract superclass *IfcSolidModel* and its subclasses *IfcCsgSolid*, *IfcManifoldSolidBRep*, *IfcSweptAreaSolid* and *IfcSweptDiskSolid* (see Fig. 5.17). This section describes each of these approaches in detail.

5.7.2.7 Boundary Representation

The most powerful and flexible approach to modeling geometric solids is through
Boundary Representation (Brep). The two subclasses of *IfcManifoldSolidBrep*,
IfcFacetedBrep and *IfcAdvancedBrep* implement the typical Brep data structure, as
described in Chap. 2. *IfcFacetedBrep* is limited to flat surfaces while *IfcAdvanced-
Brep* can model surfaces with curved edges.

Both Brep types are, however, limited to the description of shells, making them
unsuitable for modeling geometric objects with cavities and holes. To model these
kinds of objects, the corresponding subclasses *IfcFactedBrepWithVoids* or *IfcAd-
vancedBrepWithVoids* should be used which extend their respective superclasses by
providing the ability to specify several closed shell objects (Fig. 5.17).

For the modeling of solids with flat surfaces, the class *IfcFacetedBrep* is used
(Fig. 5.18). The basis of this is an *IfcFacetedBrep* object, the *Outer* attribute of

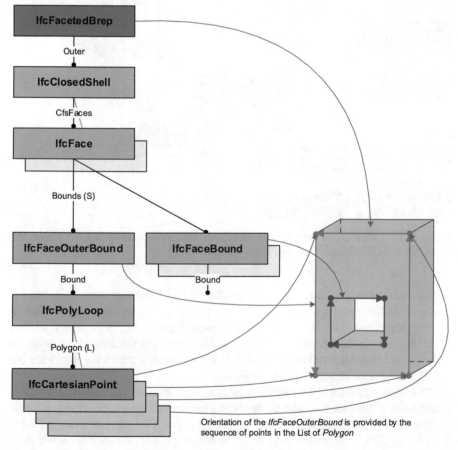

Fig. 5.18 Data structure for representing solids with flat surfaces and straight edges. (Source: IFC
Documentation. ©buildingSMART, reprinted with permission)

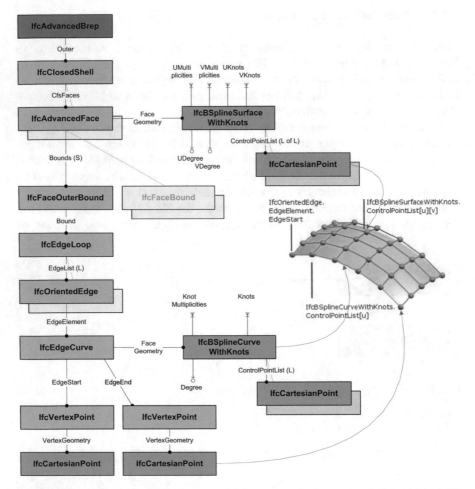

Fig. 5.19 Data structure for representing solids with curved surfaces and edges. (Source: IFC Documentation. ©buildingSMART, reprinted with permission)

which references an object of type *IfcClosedShell* which in turn references a series of *IfcFace* objects. Each of these *IfcFace* objects can have any number of bounding surfaces modeled using *IfcFaceBound*. Each *IfcFaceBound* object refers to an *IfcLoop* object which describes a list of points (the vertices of the solid). It is important that each object (point, edge) is not instantiated more than once but merely referenced several times as required.

The data structure for describing solids with curved surfaces extends this basic topological data structure by providing elements for modeling the geometric progression of surfaces and edges (Fig. 5.19). The basis for this is the class *IfcAdvancedBrep*. As above, this is linked to an *IfcClosedShell* object which in turn refers to surface objects of type *IfcAdvancedFace*. Unlike the *IfcFace* objects

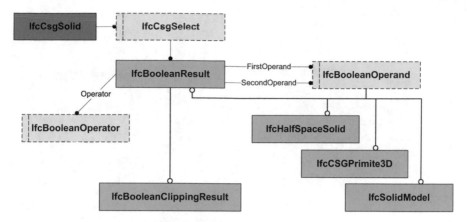

Fig. 5.20 Data structure for describing solids using the CSG approach

described above, these include an explicit geometric description. This can be a NURBS surface modeled as an *IfcBSplineSurface*. Objects with this class refer to the corresponding control points and must specify all the necessary parameters to describe a NURBS surface (see Chap. 2). To model the (curved) progression of edges, these can be linked to *IfcBSplineCurve* objects, which in turn reference the corresponding control points and parameters.

5.7.2.8 Constructive Solid Geometry

As described in Chap. 2, the Constructive Solid Geometry (CSG) approach models solids by combining predefined basic solid objects (primitives) using Boolean operations such as union, intersection and difference. The IFC data model provides the class *IfcCsgPrimitive3D* with its subclasses *IfcBlock*, *IfcRectangularPyramid*, *IfcRightCircularCone*, *IfcRightCircularCylinder* and *IfcSphere*.

The class *IfcBooleanResult* is used to model the results of the combination operations (Fig. 5.20). This class provides an *Operator* attribute which can have one of three values – UNION, INTERSECTION, or DIFFERENCE – along with the attributes *FirstOperand* and *SecondOperand* which refer to the two operands. The operands can be of type *IfcSolidModel*, *IfcHalfSpaceSolid*, *IfcCsgPrimitive3D* or *IfcBooleanResult*. CSG models are described exclusively by the latter two classes. The class *IfcBooleanResult* can be used recursively to define a tree-like structure. What makes this data structure especially powerful is the ability to use instances of any subclass of *IfcSolidModel* as an operand, for example solids that have been defined elsewhere by extrusion.

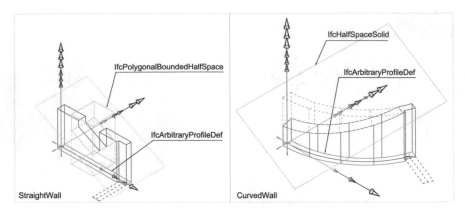

Fig. 5.21 Clippings are often used to model the slanted tops of walls that meet diagonal surfaces. (Source: IFC Documentation. ©buildingSMART, reprinted with permission)

5.7.2.9 Clipping

Clipping can be used to model solids that are cut off by a plane. Clipping is implemented as a special variant of the CSG approach. The first operand is always a volumetric solid (*IfcSolidModel*) and second operand is a so-called half-space solid (*IfcHalfSpaceSolid*), that is defined along a plane and in one direction. The operator is always DIFFERENCE. Clippings can occur anywhere as a node in a CSG tree, and are used, for example, to model the slanted tops of walls that meet diagonal surfaces (see Fig. 5.21).

5.7.2.10 Rotation, Extrusion and Swept Solids

The IFC data model also provides a means for modeling 3D solids as the result of the rotation or extrusion of a 2D profile (Fig. 5.22) through the class *IfcSweptArea-Solid* and its subclasses *IfcExtrudedAreaSolid*, *IfcRevolvedAreaSolid*, *IfcFixedRef-erenceSweptAreaSolid*, and *IfcSurfaceCurveSweptAreaSolid*. In addition, there is also the class *IfcSweptDiskSolid*, which inherits directly from *IfcSolidModel*.

The basis for each operation is the definition of a profile in the form of an *IfcProfileDef* object referenced by the *SweptArea* attribute. The most common subclass of *IfcProfileDef* is *IfcArbitraryClosedProfileDef*, which defines a closed profile by referencing an arbitrary *IfcCurve* object.

Through the use of the class *IfcExtrudedAreaSolid*, this profile can be used as a basis for an extrusion operation along a given direction (*ExtrudedDirection* attribute) for a specified distance (*Depth* attribute). Using the class *IfcRevolvedArea-Solid*, the profile is instead rotated around a given axis (*Axis* attribute) for a specified angle (*Angle* attribute).

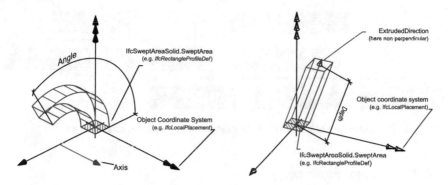

Fig. 5.22 The geometric representations *IfcRevolvedAreaSolid* and *IfcExtrudedAreaSolid*. (Source: IFC Documentation. ©buildingSMART, reprinted with permission)

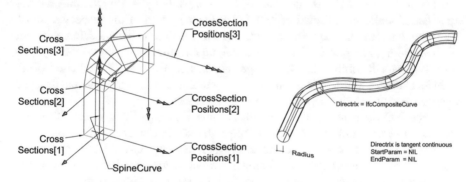

Fig. 5.23 The geometric representations *IfcSectionedSpine* and *IfcSweptDiskSolid*

The class *IfcFixedReferenceSweptAreaSolid* can be used to model an object as the result of the sweeping of a profile along a given curve in space (*Directrix* attribute). A key characteristic of this representation is that the profile does not twist during the sweep but remains orientated on reference to the fixed reference vector (*FixedReference* attribute).

Using instances of the class *IfcSectionedSpine* it is possible to describe objects that result from the linear interpolation between a series of successive profiles (Fig. 5.23 left). The attribute refers to an *IfcCompositeCurve* object which describes the path as a composite curve, the segments of which lie between two profiles. The *CrossSections* attribute refers to a list of profiles whose positions are defined by the attribute *CrossSectionPositions*.

The class *IfcSweptDiskSolid* is not derived from *IfcSweptArea* but directly from *IfcSolidModel*. The underlying profile is always a circular disc which follows the path of a curve through space (*Directrix* attribute) as shown in Fig. 5.23 (right). Unlike *IfcFixedReferenceSweptAreaSolid* the circular profile does not maintain a fixed orientation but turns with the path of the sweep so that it is always perpendicular to the path of the curve.

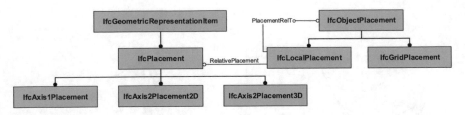

Fig. 5.24 The inheritance hierarchy of entities for describing location relationships

5.7.3 Relative Positioning

Geometric modeling in the IFC data model is strongly oriented around the use of a local coordinate system. As such the corners of a wall object, for example, are not specified globally but in relation to the coordinate system of the respective story. The story's coordinates are, in turn, modeled in relation to the coordinate system of the building, and so on. This hierarchical organization of the coordinate system affords greater flexibility should changes occur. For example, if the height of an individual object in the building needs to be modified, only one value needs to be changed, and all relative coordinates remain unchanged.

In the IFC data model, this concept is known as *Local Placement*. The IFC includes a series of classes for this purpose that all inherit from *IfcObjectPlacement* (Fig. 5.24). The class *IfcLocalPlacement* is derived from *IfcObjectPlacement* and provides two attributes: the optional attribute *PlacementRelTo* refers to the *IfcObjectPlacement* that the parent coordinate system provides. If this is not set, the respective object is positioned absolutely within the global coordinate system. The attribute *RelativePlacement* refers to an *IfcAxis2Placement* object that defines the transformation between the parent coordinate system and the embedded local coordinate system. This transformation can be either in 2D (*IfcAxis2Placement2D*) or 3D (*IfcAxis2Placement3D*).

Figure 5.25 shows how *IfcAxis2Placement3D* works. The location of the origin of the local coordinate system in relation to the parent coordinate system is defined using the *Location* attribute. Any rotation of the local coordinate system is specified by two vectors: the *Axis* vector defines the direction of the local z-axis while the *RefDirection* vector defines the direction of the local x-axis. Both vectors must be perpendicular to each other. The class *IfcAxis2Placement2D* works the same way but for 2D coordinate systems. Here only one rotation needs to be given, namely the attribute *RefDirection*.

There is a close relationship between the hierarchy of the *IfcLocalPlacement* objects and the aggregation hierarchy of the spatial objects (see also Sect. 5.6.2). The convention is that only the *IfcSite* object is positioned within the global coordinate system. All elements beneath this in the spatial hierarchy are positioned as a local placement with respect to the respective parent object (Fig. 5.26).

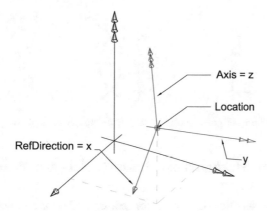

Fig. 5.25 The functioning of relative positioning using an *IfCAxis2Placement3D*

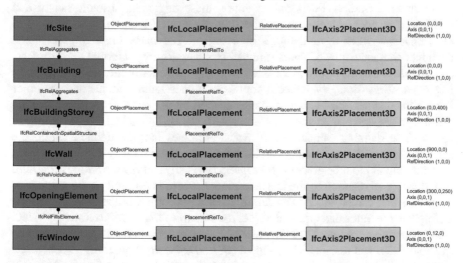

Fig. 5.26 Relationship between LocalPlacement and aggregation hierarchy of the building object

In addition to the aforementioned method of local placement, there is also the ability to use a grid as a basis for aligning objects. The class *IfcGrid* provides a very flexible means of defining grids. The predefined grid types include rectangular, radial and triangular grid layouts (Fig. 5.27) but entirely irregular grids can also be defined. The actual placement is undertaken using the class *IfcGridPlacement* and its attribute *PlacementLocation* which refers to a node in the underlying grid (*IfcVirtualGridIntersection*).

Fig. 5.27 Different forms of grids on which building elements can be placed

5.8 Extension Mechanisms: Property Sets and Proxies

Several key characteristics of objects, for example of door and wall elements, can be defined directly within a schema of the IFC model with the help of attributes in an entity definition. For standard doors, these might the absolute height and width of the door, which can be specified by the attributes *OverallWidth* and *OverallHeight* when instantiating a door object. The many other important and desirable characteristics of doors (fire safety class, security, thermal performance, etc.) would make the already extensive schema unnecessarily bloated and slow its implementation. Similarly, it would not be possible to include all the unforeseen or international standardized characteristics needed by various users without making changes to the schema. To address this problem, the IFC model takes a two-pronged approach to defining characteristics: static attributes that are defined within the schema along with dynamically created properties. Such properties can be defined with the help of the subclasses of *IfcProperty* (typically *IfcPropertySingleValue*) and added freely as required to the instance model. There is no limit to the number of properties that can be added. The definition of a new object property is defined via a simple name-value datatype-unit tuple, for example: "Name: 'FireRating'; Value: 'F30'; Datatype: 'IfcLabel'". Individual *IfcProperty* definitions are grouped into an *IfcPropertySet* and assigned to an object (*IfcRelDefinesByProperties*). A schematic overview of these two primary mechanisms for defining properties is shown in Fig. 5.28.

Software vendors need only implement the basic entity of the properties, for example *IfcPropertySingleValue* with the attributes 'Name', 'NominalValue' 'Type' and 'Unit' in order to provide a generally applicable template mechanism in their application. This extension mechanism for property definitions is supplemented by the placeholder entity *IfcProxy* which makes it possible to also define the semantic meaning of a class dynamically (i.e. "in run-time"). This provides the IFC with a meta-model that permits numerous semantic extensions, making it possible to cover a wide range of application scenarios independently of the implementation. This flexibility is desirable for many scenarios where special objects and properties are not defined in the schema, for example because they have limited general applicability. German building codes, acoustics simulations or vendor-specific product properties are not general enough to warrant their definition in a globally applicable data schema, but can nevertheless be created within a model as needed

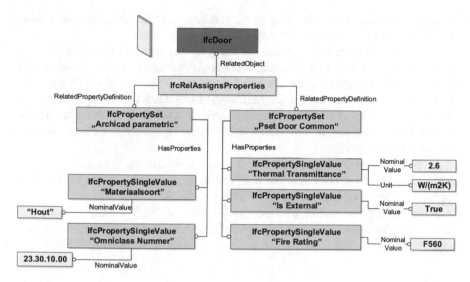

Fig. 5.28 Example use of properties. Left: Ad hoc properties assigned at the level of the instance, Right: Properties from a standardized *PropertySet*

in a standard-compliant form that can be transported and read by software. If the recipient/receiving software is unable to interpret a property (for example the value "FireRating" for the attribute instance "Name") in its respective context, it can simply leave it as is.

The disadvantage of this dynamic approach and the external definition of semantics is the potential for the creation of large numbers of arbitrary objects and properties by different parties for the same purpose: what one user defines as "FireRating" may be "FireResistanceClass" for another. To help minimize multiple occurrences (which was the original dilemma that the IFC tries to address in order to improve interoperability) users and developers have jointly attempted to voluntarily standardize the most common properties.

Instead of anchoring these within the schema, they are made available as separate files, embedded within the model documentation, on the website of the buildingSMART organization. These *PropertySet* definitions are saved as straightforward XML-format files with the naming scheme "Pset_*.xml", for example "Pset_DoorCommon.xml". Many object classes such as typical building elements (roof, wall, column, etc.) have extensive collections of such standardized properties. The door classes *IfcDoor* and *IfcDoorType*, for example, have, in addition to the *Pset_DoorCommon* collection with 16 properties (e.g. "AcousticRating" and "FireExit"), further property sets including *Pset_DoorWindowGlazingType* and *Pset_DoorWindowShadingType* covering door glazing and shading properties.

Together with the door-specific properties for the door frame, door case and door leaf and the general properties that apply to all building elements (environmental

aspects, guarantee and service properties, vendor-specific information, etc.), more than 135 further properties are available for describing doors.

As the administration and upkeep of the growing amount of additional information in individual files has become increasingly ineffective, the buildingSMART organization began with version 2 × 3 to incorporate the standardized *PropertySet*-Definitions into the database of the buildingSMART Data Dictionary (bSDD, see also Chap. 8) for better administration. Alongside the master definitions in English, many properties are now also available in other languages such as German, French, Japanese and Chinese.

A further means of extending the IFC model is by making direct references to properties in external classification and product libraries such as the bSDD. This approach is described in a section of its own in Chap. 8.

Future developments, for example in the field of the "Semantic Web", will introduce further means of dynamic property generation and more flexible extension possibilities.

5.9 Typification of Building Elements

To describe building elements that occur frequently within a project (beams with a certain profile, internal doors, light fittings, etc.) more efficiently, the IFC model supports the concepts of reusable types. To begin with, a "template" of an element is defined which can then be instantiated and adapted accordingly. As a result, only the data that is different needs to be adapted, for example the spatial location of the object or its relationship to a neighboring building element ("Door in a wall", "Beam resting on a column") while the other basic parameters remain unchanged. The IFC model supports typification in two different places:

Semantic typification: An *IfcTypeObject* is assigned to an object using the *IfcRel-DefinesByType* relationship. Before a concrete object is instantiated, a collection of properties is defined and grouped in *IfcPropertySets* (see Sect. 5.8) and then applied via the attribute *HasPropertySets* to the type that will be valid for all object instances of that type, such as the fire rating of a door. All concrete instances of an *IfcDoor* object that are assigned via *IfcRelDefinesByType* to this *IfcTypeObject* will then have the same fire rating class. This mechanism is shown schematically in Fig. 5.29. The type properties can, however, be adapted for each instance of an object. A door, that has been assigned the property "FireRating" is "F30" through a door type, can be assigned the same "FireRating" with a higher rating "F60" at the level of the instance. This value that applies to the individual instance overrides or replaces the original "F30" value of the type object.

Geometric typification, i.e. the recurrence of a geometric representation of an object can be modeled in the IFC model using the concept of *IfcMappedItems* (see Fig. 5.30). In a manner similar to the block concept of most CAD programs,

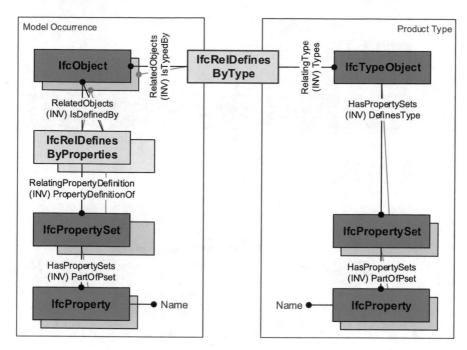

Fig. 5.29 Semantic typification of an object. (Source: IFC Documentation. ©buildingSMART, reprinted with permission)

a geometric representation of the form (*IfcShapeRepresentation*) is first created and stored together with a local coordinate system in an *IfcRepresentationMap* object. This is then, as with the semantic *IfcPropertySets*, assigned to an *IfcTypeObject*, for example a door type. When a new door instance is created, the *IfcRepresentationMap* is then referenced. The spatial position of the element instance is then determined using a local transformation (*IfcCartesianTransformationOperator*). With the help of this transformation it is also possible to change not only the position and rotation of an instance but also its scale. In practice, however, this is rarely undertaken as it can easily lead to inconsistencies and simple changes in scale are not parametric, i.e. increasing the width of a window also increases the size of the profiles and the window handle rather than maintaining their size and repositioning them accordingly as would happen with a true parametric object.

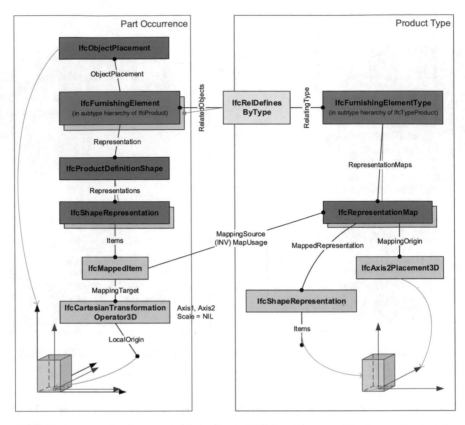

Fig. 5.30 Example for the use of object types in IFC – an instance object is associated with a type object containing a geometric representation, which is mapped to the instance object using the *MappedItem* concept. (Source: IFC Documentation. ©buildingSMART, reprinted with permission)

5.10 Example: HelloWall.ifc

The following section uses a simple example of a wall with a window to show how a building is modeled using the IFC and saved in the file *HelloWall.ifc*.[2] Figure 5.31 shows the example model in an IFC viewer. The IFC file is saved in the alphanumeric file format defined in part 21 of the STEP standard ISO 10303-21. An IFC file is structured in two sections: (1) a HEADER section with information about the file, and (2) a DATA section with the project information. Internal file object identifiers are denoted in the STEP21 file format by a natural number prefixed by a #-sign.

[2]The example is available online from: http://www.buildingsmart-tech.org/implementation/get-started/hello-world/example-1

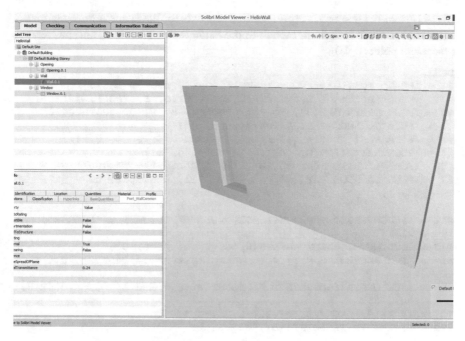

Fig. 5.31 Example model HelloWall.ifc

The first line denotes that the physical file adheres to the format defined in STEP-Standard ISO 10303 Part 21. The HEADER section follows immediately thereafter. The file description (FILE_DESCRIPTION) indicates the model view definition to which the IFC file complies (see also Chap. 6), in this case the Coordination View with additional elements according to the Quantity Take-off view. The entry FILE_NAME specifies the file name, the creation time of the file, the file creator and the organization to which the creator belongs, the name of the application, and the name of the authorizing user. Finally, the version of the IFC schema is specified, in this case Version IFC 2×3.

```
ISO-10303-21;
HEADER;
FILE_DESCRIPTION (('ViewDefinition [CoordinationView,
QuantityTakeOffAddOnView]'), '2;1');
FILE_NAME ('HelloWall.ifc', '2014-10-20T17:02:56',
    ('Architect'), ('Building Designer Office'), 'My IFC tool',
    'My IFC tool', 'Simon Sample);
FILE_SCHEMA (('IFC2X3'));
ENDSEC;
```

The file data section follows the header and contains information about the project. To begin with the IFC project (#1) is given a globally unique identifier (0YvctVUKr0kugbFTf53O9L) as the root element in an IFC exchange file for the coordination view. In addition, details on the past user history (#2), the basic units

(#7–#19) and the geometric representation contexts for the shape representations in the file (#20–#22) are given, including precision factor (0.00001) and the relative placement point (0,0,0).

```
DATA;
#1  = IFCPROJECT('0YvctVUKr0kugbFTf5309L', #2, 'Default Project',
      'Description of Default Project', $, $, $, (#20), #7);
#2  = IFCOWNERHISTORY(#3, #6, $, .ADDED., $, $, $, 1217620436);
#3  = IFCPERSONANDORGANIZATION(#4, #5, $);
#4  = IFCPERSON('ID001', 'Sample', 'Simon', $, $, $, $, $);
#5  = IFCORGANIZATION($, 'MF', 'Testco', $, $);
#6  = IFCAPPLICATION(#5, '0.10', 'My IFC tool', 'TA 1001');
#7  = IFCUNITASSIGNMENT((#8, #9, #10, #11, #15, #16, #17, #18,
      #19));
...
#11 = IFCCONVERSIONBASEDUNIT(#12, .PLANEANGLEUNIT., 'DEGREE',
      #13);
#12 = IFCDIMENSIONALEXPONENTS(0, 0, 0, 0, 0, 0, 0);
#13 = IFCMEASUREWITHUNIT(IFCPLANEANGLEMEASURE(1.745E-2), #14);
...
#20 = IFCGEOMETRICREPRESENTATIONCONTEXT($, 'Model', 3, 1.000E-5,
      #21, $);
#21 = IFCAXIS2PLACEMENT3D(#22, $, $);
#22 = %IFCCARTESIANPOINT((0., 0., 0.));
```

The next section defines the project structure. This example shows a three level project structure, created by exactly one site (#23), one building (#29), and one building story (#35). The position of the building site is given within the global coordinate system located at 24° 28′ 0″ north, 54° 25′ 0″ west. The local coordinate system of the building site is positioned at the origin (0.0, 0.0, 0.0) with no rotation (#24–#28). Both the building and the building story are positioned relative to the building site with no rotation or offset (#30–#34 and #36–#40).

```
#23 = IFCSITE('3rNg_N55v4CRBpQVbZJoHB', #2, 'Default Site',
      'Description of Default Site', $, #24, $, $, .ELEMENT.,
      (24, 28, 0), (54, 25, 0), $, $, $);
#24 = IFCLOCALPLACEMENT($, #25);
#25 = IFCAXIS2PLACEMENT3D(#26, #27, #28);
#26 = IFCCARTESIANPOINT((0., 0., 0.));
#27 = IFCDIRECTION((0., 0., 1.));
#28 = IFCDIRECTION((1., 0., 0.));
#29 = IFCBUILDING('0yf_M5JZv9QQXly4dq_zvI', #2,
      'Default Building', 'Description of Default Building',
      $, #30, $, $, .ELEMENT., $, $, $);
#30 = IFCLOCALPLACEMENT(#24, #31);
#31 = IFCAXIS2PLACEMENT3D(#32, #33, #34);
#32 = IFCCARTESIANPOINT((0., 0., 0.));
#33 = IFCDIRECTION((0., 0., 1.));
#34 = IFCDIRECTION((1., 0., 0.));
#35 = IFCBUILDINGSTOREY('0C87kaqBXF$xpGmTZ7zxN$', #2,
      'Default Building Storey',
      'Description of Default Building Storey', $, #36, $, $,
      .ELEMENT., 0.);
```

```
#36 = IFCLOCALPLACEMENT (#30, #37);
#37 = IFCAXIS2PLACEMENT3D (#38, #39, #40);
#38 = IFCCARTESIANPOINT ((0., 0., 0.));
#39 = IFCDIRECTION ((0., 0., 1.));
#40 = IFCDIRECTION ((1., 0., 0.));
```

The section that follows defines the project structure hierarchy of the project levels defined above by placing them in an aggregation relationship (see also Chap. 3). The building (#29) comprises one building story (#35), one building (#29), the building site (#23) and the project (#1). A hierarchy of spatial relationships is likewise defined (#44) within which the wall (#45) and window (#124) are assigned to the building story (#35), in this case the only one in this model.

```
#41 = IFCRELAGGREGATES ('2168U9nPH5xB3UpDx_uK11', #2,
      'BuildingContainer', 'Container for BuildingStories',
      #29, (#35));
#42 = IFCRELAGGREGATES ('3JuhmQJDj9xPnAnWoNb94X', #2,
      'SiteContainer', 'Container for Buildings', #23, (#29));
#43 = IFCRELAGGREGATES ('1N1_BIjGLBke9u_6U3IWlW', #2,
      'ProjectContainer', 'Container for Sites', #1, (#23));
#44 = IFCRELCONTAINEDINSPATIALSTRUCTURE ('2O_dMuDnr1Ahv28oR6ZVpr',
      #2, 'Default Building', 'Contents of Building Storey',
      (#45, #124), #35);
```

The section that follows defines the creation of the actual wall object of type *IfcWallStandardCase* (#45) positioned relative to the building story (#46 points to #36). Two different geometric representations are defined for the wall (#51). The wall axis is defined as a two-dimensional curve (#79) comprised of a polyline (#80) from (0.0, 0.15) to (5.0, 0.15), and the three-dimensional volumetric solid is defined as a "SweptSolid" (#83, #84). This solid is the product of the extrusion of the footprint (#85) described by a closed polyline (#86). The extrusion is in the vertical direction (0.0, 0.0, 1.0) (#96) with a height of 2.30 m (#84).

```
#45 = IFCWALLSTANDARDCASE ('3vB2YO$MX4xv5uCqZZG05x', #2,
      'Wall xyz', 'Description of Wall', $, #46, #51, $);
#46 = IFCLOCALPLACEMENT (#36, #47);
#47 = IFCAXIS2PLACEMENT3D (#48, #49, #50);
#48 = IFCCARTESIANPOINT ((0., 0., 0.));
#49 = IFCDIRECTION ((0., 0., 1.));
#50 = IFCDIRECTION ((1., 0., 0.));
#51 = IFCPRODUCTDEFINITIONSHAPE ($, $, (#79, #83));
#79 = IFCSHAPEREPRESENTATION (#20, 'Axis', 'Curve2D', (#80));
#80 = IFCPOLYLINE ((#81, #82));
#81 = IFCCARTESIANPOINT ((0., 1.500E-1));
#82 = IFCCARTESIANPOINT ((5., 1.500E-1));
#83 = IFCSHAPEREPRESENTATION (#20, 'Body', 'SweptSolid', (#84));
#84 = IFCEXTRUDEDAREASOLID (#85, #92, #96, 2.300);
#85 = IFCARBITRARYCLOSEDPROFILEDEF (.AREA., $, #86);
#86 = IFCPOLYLINE ((#87, #88, #89, #90, #91));
#87 = IFCCARTESIANPOINT ((0., 0.));
#88 = IFCCARTESIANPOINT ((0., 3.000E-1));
#89 = IFCCARTESIANPOINT ((5., 3.000E-1));
#90 = IFCCARTESIANPOINT ((5., 0.));
```

```
#91 = IFCCARTESIANPOINT((0., 0.));
#92 = IFCAXIS2PLACEMENT3D(#93, #94, #95);
#93 = IFCCARTESIANPOINT((0., 0., 0.));
#94 = IFCDIRECTION((0., 0., 1.));
#95 = IFCDIRECTION((1., 0., 0.));
#96 = IFCDIRECTION((0., 0., 1.));
```

The next section defines the wall layers and their materials. The wall in the example has a single layer (#77) of thickness 0.3 m made of the material "Reinforced concrete C30/37". This material layer is placed in the middle of the wall axis (#79) as expressed by the negative offset of −0.15 m (#75).

```
#74 = IFCRELASSOCIATESMATERIAL('2zeggBjk9A5wcc3k9CYqdL', #2, $,
      $, (#45), #75);
#75 = IFCMATERIALLAYERSETUSAGE(#76, .AXIS2., .POSITIVE.,
      -1.500E-1);
#76 = IFCMATERIALLAYERSET((#77), $);
#77 = IFCMATERIALLAYER(#78, 3.000E-1, $);
#78 = IFCMATERIAL('Reinforced concrete C30/37');
```

The definition of alphanumeric properties such as dimensions and quantity information follows. For these a property set (*IfcPropertySet*, #52) and an element quantity set (*IfcElementQuantity*, #64) are defined and attached to the wall by means of relationship objects (*IfcRelDefinesByProperties*, #63 and #73). Lines #53 to #63 define properties such as "ThermalTransmittance" (#58) while lines #65 to #72 specify values for measurements and quantities such as the gross volume (#69). The names "Pset_WallCommon" and "BaseQuantities" indicates that these properties and quantities information are defined as part of the IFC specification.

```
#52 = IFCPROPERTYSET('18RtPv6efDwuUOMduCZ7rH', #2,
      'Pset_WallCommon', $, (#53, #54, #55, #56, #57, #58,
      #59, #60, #61, #62));
...
#58 = IFCPROPERTYSINGLEVALUE('ThermalTransmittance',
      'ThermalTransmittance', IFCREAL(2.400E-1), $);
...
#61 = IFCPROPERTYSINGLEVALUE('LoadBearing', 'LoadBearing',
      IFCBOOLEAN(.F.), $);
...
#63 = IFCRELDEFINESBYPROPERTIES('3IxFuNHRvBDfMT6_FiWPEz', #2, $,
      $, (#45), #52);
#64 = IFCELEMENTQUANTITY('10m6qcXSj0Iu4RVOK1omPJ', #2,
      'BaseQuantities', $, $,
      (#65, #66, #67, #68, #69, #70, #71, #72));
#65 = IFCQUANTITYLENGTH('Width', 'Width', $, 3.000E-1);
#66 = IFCQUANTITYLENGTH('Length', 'Length', $, 5.);
...
#69 = IFCQUANTITYVOLUME('GrossVolume', 'GrossVolume', $, 3.450);
...
#73 = IFCRELDEFINESBYPROPERTIES('0cpLgxVi9Ew8B08wF2Ql1w', #2, $,
      $, (#45), #64);
```

The next section defines the creation of an opening object of type *IfcOpeningElement* (#97) relative to the local coordinate system of the wall (#98 points to

#46). A geometric representation (#103) is defined for the opening object as a three-dimensional "SweptSolid" (#110, #111) and the opening object (#97) is related via *IfcRelVoidsElement* (#109) to the wall (#45), indicating that the opening is to be subtracted from the wall.

```
#97  = IFCOPENINGELEMENT('2LcE70iQb51PEZynawyvuT', #2,
         'Opening Element xyz', 'Description of Opening', $,
         #98, #103, $);
#98  = IFCLOCALPLACEMENT(#46, #99);
#99  = IFCAXIS2PLACEMENT3D(#100, #101, #102);
#100 = IFCCARTESIANPOINT((9.000E-1, 0., 2.500E-1));
#101 = IFCDIRECTION((0., 0., 1.));
#102 = IFCDIRECTION((1., 0., 0.));
#103 = IFCPRODUCTDEFINITIONSHAPE($, $, (#110));
#109 = IFCRELVOIDSELEMENT('3lR5koIT51Kwudkm5eIoTu', #2, $, $,
         #45, #97);
#110 = IFCSHAPEREPRESENTATION(#20, 'Body', 'SweptSolid',
         (#111));
#111 = IFCEXTRUDEDAREASOLID(#112, #119, #123, 1.400);
#112 = IFCARBITRARYCLOSEDPROFILEDEF(.AREA., $, #113);
...
```

Here too a set of measurements and quantities is defined (#104) and associated with the opening object (#97) by means of a relation #108.

```
#104 = IFCELEMENTQUANTITY('2yDPSWYWf319fWaWWvPxwA', #2,
         'BaseQuantities', $, $, (#105, #106, #107));
#105 = IFCQUANTITYLENGTH('Depth', 'Depth', $, 3.000E-1);
#106 = IFCQUANTITYLENGTH('Height', 'Height', $, 1.400);
#107 = IFCQUANTITYLENGTH('Width', 'Width', $, 7.500E-1);
#108 = IFCRELDEFINESBYPROPERTIES('2UEO1blXL9sPmb1AMeW7Ax', #2,
         $, $, (#97), #104);
```

Finally, the creation of the window object of type *IfcWindow* (#124) is defined and positioned relative to the local coordinate system of the opening (#125 points to #98). A three-dimensional geometric representation (#130) is defined for the object as a "SweptSolid" (#150, #151). This solid is created by extruding the footprint (#152) described as a closed polyline (#153). The window object (#124) is given a *IfcRelFillsElement* (#131) relationship to the opening (#97), indicating that the opening is to be filled with the window.

```
#124 = IFCWINDOW('0LV8Pid0X3IA3jJLVDPidY', #2, 'Window xyz',
         'Description of Window', $, #125, #130, $, 1.400,
         7.500E-1);
#125 = IFCLOCALPLACEMENT(#98, #126);
#126 = IFCAXIS2PLACEMENT3D(#127, #128, #129);
#127 = IFCCARTESIANPOINT((0., 1.000E-1, 0.));
#128 = IFCDIRECTION((0., 0., 1.));
#129 = IFCDIRECTION((1., 0., 0.));
#130 = IFCPRODUCTDEFINITIONSHAPE($, $, (#150));
#131 = IFCRELFILLSELEMENT('1CDlLMVMv1qw1giUXpQgxI', #2, $, $,
         #97, #124);
#150 = IFCSHAPEREPRESENTATION(#20, 'Body', 'SweptSolid',
         (#151));
```

```
#151 = IFCEXTRUDEDAREASOLID(#152, #159, #163, 1.400);
#152 = IFCARBITRARYCLOSEDPROFILEDEF(.AREA., $, #153);
#153 = IFCPOLYLINE((#154, #155, #156, #157, #158));
...
```

As with the wall above, alphanumeric properties (#132) and quantities and measurements (#146) are defined for the window and related to it via the relationship objects (*IfcRelDefinesByProperties*, #145 and #149). Lines #133 to #144 specify properties and values, such as "ThermalTransmittance" (#139) while lines #147 and #148 define measurement values, in this case the height (#147) and breadth (#148) of the window.

The penultimate line marks the end of the project data section (DATA) of the IFC file and the final line the end of the entire ISO standard file.

```
#132 = IFCPROPERTYSET('0fhz_bHU54xB$tXHjHPUZl', #2,
       'Pset_WindowCommon', $, (#133, #134, #135, #136, #137,
       #138, #139, #140, #141, #142, #143, #144));
...
#139 = IFCPROPERTYSINGLEVALUE('ThermalTransmittance',
       'ThermalTransmittance', IFCREAL(2.400E-1), $);
...
#145 = IFCRELDEFINESBYPROPERTIES('2fHMxamlj5DvGvEKfCk8nj', #2,
       $, $, (#124), #132);
#146 = IFCELEMENTQUANTITY('0bB_7AP5v5OBZ90TDvo0Fo', #2,
       'BaseQuantities', $, $, (#147, #148));
#147 = IFCQUANTITYLENGTH('Height', 'Height', $, 1.400);
#148 = IFCQUANTITYLENGTH('Width', 'Width', $, 7.500E-1);
#149 = IFCRELDEFINESBYPROPERTIES('0FmgI0DRX49OXL_$Wa2P1E', #2,
       $, $, (#124), #146);$
ENDSEC;
END-ISO-10303-21;
```

5.11 ifcXML

The descriptive language of the IFC schema is EXPRESS (ISO 10303-11 2004), a data modeling language specially developed for product modeling. As mentioned earlier, the accompanying exchange format for model instances is defined in part 21 of the STEP specification. When the IFC was first developed, the XML format (developed by W3C 2015) which is now very popular, was not available.

From the early 2000s onwards the eXtensible Markup Language XML, a simpler and optimized version of the SGML standard, began to gain popularity. Many development tools were introduced and XML became a mainstream language for formally describing structured data.

As a consequence, buildingSMART were asked to also provide IFC data in XML format. From 2001 onwards, a number of different approaches to translating the EXPRESS schema into an XML compatible form were developed as a means of creating valid IFC XML documents:

- 2001 – the first version of an XML translation of the IFC 2.0 schema as an XDR (XML Data Reduced) schema definition. The translation rule from EXPRESS to XDR was a private development.
- 2002 – the first version of an XML translation of the IFC 2.0 schema as an XSD (XML Schema Definition). Here too the translation rule from EXPRESS to XSD was a private development that was later adopted as a proposal by the ISO Group ISO/TC 184/SC 4 for a general standard for mapping EXPRESS to XSD.
- 2005 – a new method for XML translation of the IFX2 × 2 schema according to the developmental stage (working draft) of the ISO 10303:28-ed2 standard which was developed for the standard-compliant translation of EXPRESS to XSD. A default configuration was chosen which, however, led to very large XML data files.
- 2007 – the same methodology, this time for the IFC2 × 3 schema.
- 2013 – a newly developed version of ifcXML was developed as part of the development of IFC4 in which the transfer from IFC EXPRESS to XSD is compliant to the final version of ISO 10303-28:ed2 using an optimized configuration of the mapping rules. XSD definitions were given alongside the EXPRESS definition in the official IFC4 documentation. The new configuration of the ISO 10303-28:ed2 rules is much more efficient and this method is often known as Simple ifcXML.

As a rule, the XML serialization of IFC data has exactly the same depth of information as the Part-21 serialization. IFC XML data can be validated against the online ifcXML XSD schema. Only detailed validation against the validation rules available in EXPRESS is not possible as the scope of the XSD language is not sufficient to translate these rules. Another limitation is that inverse attributes are not included in the ifcXML schema.

Due to the additional XML syntax, ifcXML files are significantly larger than a regular ifc file for the same information content. In the earlier ifcXML conversions (up to IFC2 × 3), ifcXML files were typically 6–8 times larger than an ifc file, but with the newer simple ifcXML convention in IFC4 they are now approximately 2–3 times larger.

5.12 Summary

The IFC data model is an open, mature and internationally standardized data model. It permits the exchange of digital building models beyond the limits of functionality of individual applications and between various software vendors and supports a diverse range of application scenarios.

With the IFC data model it is possible to model buildings digitally in great detail including the comprehensive semantic description of a building, the modeling of all building elements and spaces as well as the reciprocal relationships between them. Each semantic building object can have one or more geometric representations

associated with it, making it possible to cater for the different needs for presenting building information geometrically.

The IFC data model is an extremely powerful and also very complex data model. That has the advantage that buildings can be described very completely and in different ways. But it also has disadvantages. For example, different planning stages may require different geometric representations, for example a surface model or a finite element net, each of which can be modeled differently. A typical stumbling block is the modeling of a continuous external wall as opposed to story-wise in individual sections. Both variants are possible, and even sensible for different application scenarios, but they can rarely be derived from one another or described parallel to one another.

This complexity requires a considerable effort for software vendors that wish to make their products compatible with the IFC standard. Many software vendors therefore only offer partial support for the data model in their import and export modules. To avoid incompatibilities as a result of this, buildingSMART introduced the concept of Model View Definitions (MVD, described in Chap. 6), with which it is possible to specify which parts of the IFC data model must be implemented for specific data exchange scenarios. Accordingly, MVDs are also the basis for certifying IFC compatibility: software products are not certified for the entire data schema but only for specifically defined sections.

Despite the formal mechanisms of the data scheme and the MVDs, the model's flexibility is still so complex that further agreements are necessary to achieve homogeneous and compatible implementations. These so-called "Implementers' Agreements" can contain extensive sets of agreements, but are increasingly being described in semi-automated test procedures and therefore becoming part of the certification of software products. This is expected to lead to further improvements in the quality and reliability of IFC data, as described in detail in Chap. 7.

Despite the complexity of the data model and the problems this brings with it, the IFC data format plays a key role in the path towards Big Open BIM. On the one hand, a neutral, open format is the only way to ensure vendor-neutrality and true, sustainable data continuity. And on the other hand, rules governing the provision of BIM models must specify an open format in order to avoid skewing the competition in favor of specific software vendors. Last but not least, the usefulness of the long-term archiving of digital data from the monitoring of a building's operation can only be reliably guaranteed if this information is available in an open, well-documented format that is not dependent on an individual manufacturer's specific format. Similar attempts to make data available in the long term in a vendor-neutral format can be observed in other industrial sectors such as the automotive industry and in aerospace technology. As a consequence, some national organizations have decided to specify the use of the IFC format for public building projects, including public authorities in Singapore, the Netherlands and Finland. Similar developments are expected to follow in the near future in the USA, Great Britain and in the Scandinavian countries. In the long term, therefore, one can expect to see the IFC standard play an important role in the search for a legally-binding digital equivalent

to paper-based, rubber-stamped and hand-signed planning documents at a national and European level.

The standardization organization buildingSMART offers all its members, whether individuals, companies or public authorities and organizations, extensive opportunities to participate and contribute to the IFC, and with it numerous opportunities to influence the quality and future development of the standards.

Among these future developments, outlined in part in the Technical Committee's "Roadmap 2020", are ways of integrating complementary standards and models such as the IDM/MVD (see Chap. 6), bSDD (see Chap. 8) and BCF (see Chap. 13) as well as improvements to the quality of implementation through more stringent certification procedures (see Chap. 7). Further developments are also underway in the field of extending geometric representations, for example through the support of point clouds, the improved support of model servers and the dynamization of semantic extensions and distributed instance models using Semantic Web Technologies such as the Resource Description Framework (RDF). To improve model consistency, it would be desirable in the long term to parametrize objects to remedy the currently lacking connection between an attribute (such as the "OverallWidth" of a door) and its geometric representation. Similarly, links to existing standards from the field of Geo-information (CityGML, LandXML, etc.) as well as model extensions for infrastructure objects such as bridges and tunnels or streets and railway tracks are currently being actively developed.

References

BuildingSMART. (2013a). *IFC and related data model standards documentation*. Retrieved from http://www.buildingsmart-tech.org/. Accessed on 26 Sept 2017.
BuildingSMART. (2013b). *Industry Foundation Classes, version 4, documentation*. Retrieved from http://www.buildingsmart-tech.org/ifc/IFC4/final/html/. Accessed on 10 Feb 2018.
Eastman, C. (1999). *Building product models: Computer environments supporting design and construction*. Boca Raton: CRC Press.
ISO 10303-21. (2002). *Industrial automation systems and integration – Product data representation and exchange – Part 21: Implementation methods: Clear text encoding of the exchange structure*. Geneva: International Organization for Standardization.
ISO 10303-11. (2004). *Industrial automation systems and integration – Product data representation and exchange – Part 11: Description methods: The EXPRESS language reference manual*. Geneva: International Organization for Standardization.
ISO 16739. (2013). *Industry Foundation Classes (IFC) for data sharing in the construction and facility management industries*. Geneva: International Organization for Standardization.
ISO/IEC 19775-1. (2004). *Information technology – Computer graphics and image processing – Extensible 3D (X3D)*. Geneva: International Organization for Standardization.
Laakso, M., & Kiviniemi, A. (2012). The IFC standard – A review of history, development and standardization. *ITcon Journal of Information Technology in Construction, 17*, 134–161. Retrieved from http://www.itcon.org/data/works/att/2012_9.content.01913.pdf. Accessed on 10 Apr 2018.
Liebich, T. (2009). *IFC 2x edition 3 model implementation guide*. Retrieved from http://www.buildingsmart-tech.org/implementation/ifc-implementation/ifc-impl-guide. Accessed on 10 Apr 2018.

Schenck, D. A., & Wilson, P. R. (1993). *Information modeling the EXPRESS way.* Oxford University Press, Oxford, UK.

W3C. (2015). *XML standard, Word Wide Web consortium (W3C).* Retrieved from http://www.w3.org/standards/xml/. Accessed on 10 Apr 2018.

Weise, M., Liebich, T., See, R., Bazjanac, V., & Laine, T. (2009). *IFC implementation guide: Space boundaries for thermal analysis.* BuildingSMART. Retrieved from http://www.buildingsmart-tech.org/downloads/accompanying-documents/agreements. Accessed on 10 Apr 2018.

Chapter 6
Process-Based Definition of Model Content

Jakob Beetz, André Borrmann ⓘ, and Matthias Weise

Abstract The Industry Foundation Classes (IFC) data model provides a comprehensive, vendor-neutral standard for the description of digital building models. However, the IFC only concerns the data structure. To be truly useful in the context of planning processes, additional specifications are necessary that determine who provides which information when and to whom. To support this, the buildingSMART organization introduced the Information Delivery Manual (IDM) standard. This standard makes it possible to organize data exchange processes in a graphical notation, and to subsequently derive exchange requirements (ER) for data exchanges occurring in this process. The technical implementation of these exchange requirements takes the form of a Model View Definitions (MVD) that accurately specify which entities, attributes and properties may or should be used in a particular exchange. This chapter provides a detailed introduction to the IDM mechanisms. The chapter concludes with an introduction to the concepts of levels of development (LOD).

6.1 Overview

The standard data model formats introduced in the preceding chapters, such as the Industry Foundation Classes (IFC) are targeted at capturing complete, all-encompassing information regarding all aspects of a building (all-in-one). This

J. Beetz (✉)
Chair of Design Computation, RWTH Aachen University, Aachen, Germany
e-mail: beetz@caad.arch.rwth-aachen.de

A. Borrmann
Chair of Computational Modeling and Simulation, Technical University of Munich, München, Germany
e-mail: andre.borrmann@tum.de

M. Weise
AEC3 Deutschland GmbH, Munich, Germany
e-mail: mw@aec3.de

© Springer International Publishing AG, part of Springer Nature 2018
A. Borrmann et al. (eds.), *Building Information Modeling*,
https://doi.org/10.1007/978-3-319-92862-3_6

means they are both very complex but also never entirely complete due to the notion of 'reduction' (Stachoviak); see Chap. 1. For example, for structural calculations, statements about the color of the wall finish are as superfluous. Likewise, the detailed geometric description of a piece of furniture is irrelevant for the calculation of the energy consumption of a building. On the other hand, generic exchange models often lack the necessary information for specific use cases. For example, generic models rarely contain the fire resistance properties of crucial construction elements needed for fire safety calculations, or finite element meshes needed for structural simulations, or all the material properties required for cost estimation. Often, it is desirable, to focus and restrict the information captured in a model to particular aspects, processes or stakeholder views. This can be achieved by so-called partial or aspect models that apply restrictions and constraints to information models such as the IFC.

In this chapter, we examine different approaches that allow the process-specific applications of such mechanisms for building information models.

6.2 Information Delivery Manuals and Model View Definitions

As discussed in Chap. 5, the IFC data model is very extensive. The wealth of information that can be captured in attributes, properties and at a geometric level often exceeds the intended use at a particular stage in the life cycle of a building project. In addition, the flexibility of the IFC model, although on the whole desirable, can make it difficult to capture and retrieve information in an appropriate form for other scenarios. To avoid difficulties arising from this, it is necessary to agree on uniform and standardized means to further specify the contents expected from a building model instance. These specifications regulate *which* information is delivered by *whom*, *when*, and to *which* recipient. To address this, the buildingSMART organization developed IDM/MVD frameworks (buildingSMART 2012, 2013). This helps reduce room for interpretation and makes it easier to implement specific use cases and application areas. The framework distinguishes content-related requirements captured in *Information Delivery Manuals (IDM)* and technical implementations and mappings of these requirements in the form of *Model View Definitions (MVD)*. Information Delivery Manuals capture quality assurance agreements in a uniform, standardized way. Their creation and use are specified in the ISO 29481 (2016).

The technical implementation of these agreed requirements in the form of partial IFC Models is based on the Model View Definition standard. Figure 6.1 schematically depicts the phases with their respective intermediary results: First stakeholders, actors and their respective roles are determined (1). In a second step, processes are captured in the form of diagrams according to the Business Process Modeling Notation (BPMN; see Chap. 4) referred to as Process Maps (PM) (2).

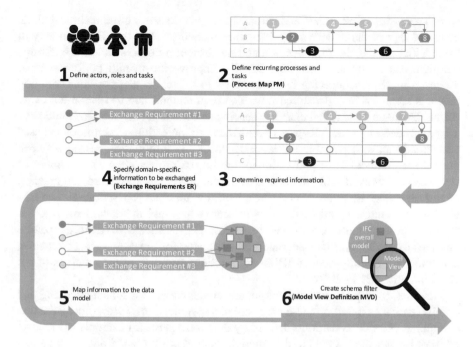

Fig. 6.1 Overview of the IDM/MVD method used for the IFC based exchange of information

The interfaces determining the exchange of information are defined in (3), after which they are formalized in (4) and mapped to the IFC model in a fifth step (5). The formal notation of capturing these exchanges using the dedicated mvdXML meta model concludes the process and results in (6) a use-case specific Model View Definition (MVD). Before starting this procedure, participants should agree on the scope of the effort and define clearly the intended improvements they intend to achieve. Consequently, the following requirements are essential:

1. Creation of an overview of the sub-processes of the planning process for the specific situation. Elaboration of these sub-processes using a standardized formalization notation referred to as *Process Maps (PM)*
2. Creation of a formal program of data exchange specifications referred to as *Exchange Requirements (ER)*
3. Mapping of these information aspects onto a data model like the Industry Foundation Classes, referred to as *Model View Definitions (MVD)*

The first two tasks (PM, ER) are undertaken by domain experts who have good knowledge and experience of past projects, general conventions, and best practices in the respective fields. The respective documents and information artifacts can be created using simple technical means such as general-purpose diagram editors,

word processing applications and spreadsheets and do not require technical skills or knowledge of the underlying information models such as the IFCs. Already in these initial phases, the formalization and notation of processes and data exchange definitions at a low level can significantly improve the overall performance of a consortium by encouraging team members to reflect on and consider common business scenarios in a structured way. The requirements can be elaborated using natural language such as "all elements serving as boundaries for spaces should have a thermal coefficient" or "all spaces should have an indication of their intended use" and already make it possible to manually check the information passed between parties even without IT support. Depending on the project phase, the number of stakeholders involved, and the number of partial processes considered, the creation of such Exchange Requirements can be a laborious task that is best done as a collaborative effort, allowing all participants to share and re-use the documents in order to establish commonly agreed best practices. The buildingSMART organization provides extensive tutorial materials and templates for creating such documents, and a number of fully-fledged IDMs are publicly available in the archives of the BLIS initiative (BLIS 2014).

However, to implement semi-automated model audits, for model-checking and quality assurance based on these requirements specifications, further formalization is required. For this, constraints defined by domain experts, for example in the form of spreadsheets, are mapped to data models such as the IFCs and documented in a form that can be implemented in computer tools. These exchange requirements are bundled into so-called Model View Definitions (MVD) that specify what parts of the large IFC meta-model (classes, attributes, properties and relationships) are required for a specific purpose. Whether the specified information should be included in an IFC partial model is determined by an additional rule set based on process-oriented domain-specific requirements. The overall goal of this step is to transfer user exchange requirements into a machine-readable form that can be processed by software tools such as modelers and model checkers implemented by software vendors. Specifying Exchange Requirements needs a good understanding of both the domain-specific requirements as well as technical knowledge of the underlying data model.

The relationship between domain-specific requirements independent of the IFC data model (Process Map + Exchange Requirements) to its technical implementation based on IFC is shown in Fig. 6.2. The information contained in the overall IFC model is narrowed down to what is required for a specific exchange using Model View Definitions. Through the application of additional restrictions, it is possible to define the precise information needed for particular exchange requirements.

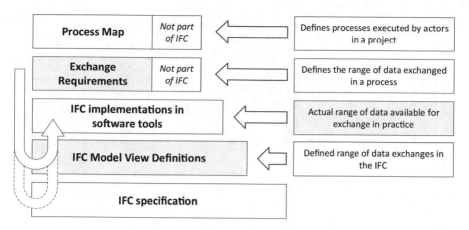

Fig. 6.2 Mutual coverage of Process Maps, Exchange Requirements, Model Views and the IFC model

6.2.1 Process Maps

To obtain an overview of the partial processes under consideration for a particular exchange, and to organize different information exchange scenarios, process diagrams are created using the Business Process Model and Notation (BPMN) (see Chap. 4). These structure a number of process properties:

- Actors and their relationships (who transmits information to whom)
- Dependencies regarding the order of partial processes (when is information transmitted)
- Documents or partial models being used (what is transmitted)

For example, we can map the relationships between the actors "client", "architect", and "energy consultant" for the energy consumption use case based on an initial design created by the architect, the owner commissions an energy estimation from the energy consultant as illustrated in Fig. 6.3. The actors agree that in addition to external data sets such as climate data, energy costs and the relevant calculation methods (such as ISO 6946, or BREEAM (BREEAM 2017) and LEED (LEED 2017) in later stages), a building model in IFC format is also required. The resulting Process Map defines a clear structure for the requirements and the assignment of responsibilities for information exchange scenarios throughout all process steps. This detailed elaboration is necessary as the requirements for model content differ significantly in different situations.

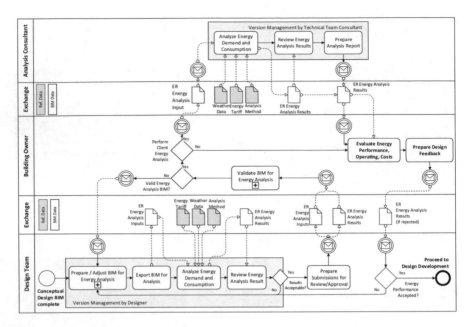

Fig. 6.3 A Process Map captures the processes that are relevant in a given business use case and identifies data exchanges along with their relevant Exchange Requirements (ER). This serves as a basis for the corresponding MVDs. The Process Map shown here in abbreviated form is taken from the Concept Design Phase Energy Analysis IDM, developed jointly by GSA (USA), Byggforsk (Norway) and Senatii (Finland)

6.2.2 Exchange Requirements

Exchange Requirements set out the information needed for a handover in the data models in a semi-formal tabular form. The items are structured by building element and determine the necessary properties such as optional/required entry, data type, unit, value ranges, relationships to other elements etc. (Fig. 6.4). These Exchange Requirement documents facilitate both discussion between stakeholders and serve as a preparatory step for the formalized, machine-readable definition of model views.

6.2.3 Model View Definitions

Process Maps and Exchange Requirements describe what is needed for data exchange in different scenarios. If the exchanged information is based on an IFC model, the respective partial models can be formalized as a Model View Definition (MVD). With the help of additional rules, one can determine which information is necessary and which is optional. The result is a description of requirements

Type of Information	Information Needed	Required	Optional	Data Type	Units
	○ Construction type (e.g. wall type, door type, window type, shading device type, etc.) Window constructions from Window 6, opaque constructions from ASHRAE Fundamentals.	X		String	n/a
	○ Classification - UniFormat (reference to a classification -- see below)		X	String	n/a
	○ 3D Geometry	X		IFC Geometry	varies
	○ Exterior or Interior Element (i.e. Is Exterior)	X		Boolean	n/a
	○ Link to Space Boundary	X		Relationship	n/a
Building Elements *(Opaque- Wall, Roof, Floor, Ceiling, Door)*	Added to the list above, the following properties should be included for opaque building elements (e.g. walls, floors, ceilings, roofs, doors, etc.):				
	○ Link to Material Layer Set	X		String	n/a
Building Elements *(Glazing- Curtain Wall, Glazed door, Skylight, Window)*	Added to the Building Elements list above, assigns thermal information to building elements to enable energy analysis. The following properties should be included for glazed building elements (e.g. windows, curtain walls, glazed doors, and skylights):				
	○ Window Assembly Exterior Surface Color of Glass (clear, bronze, silver, gold, copper, blue,		X	Enum	n/a

Fig. 6.4 In an IDM, Exchange Requirements are captured in a user-friendly way. Here, required and optional information items are specified for each object type. In this excerpt from the IDM Concept Design Phase Energy Analysis, a particular construction type is specified. Such descriptions are formalized further in later stages, see Sect. 6.2.3

at the schema level that is applicable for the respective instance models in the concrete use case. A MVD is a technical means of checking the validity of instance models for a particular exchange scenario. Specifications in a Model View range from the definition of required Property Sets to restrictions on allowable forms of geometry representations. The latter is of particular importance in concrete data exchange scenarios as the Industry Foundation Classes model can accommodate a great variety of different geometric representations (see Chap. 5) while real-world scenarios require only one or two. Limiting the availability of geometric representations, e.g. to faceted meshes rather than parametric NURBS surfaces, can also reduce the functionality requirements for downstream software tools. Additionally, such MVDs form an excellent basis for the certification of IFC implementations in software tools (see Chap. 7).

Version 2 × 3 of the Industry Foundation Classes contains the following predefined MVDs (buildingSMART 2014):

- Coordination View: contains all building information for the exchange between the three major disciplines architecture, structural engineering and MEP. Receiving software applications can modify the content.
- Quantity Take-Off Add-on: contains additional quantities for building elements and spaces that are only implicitly contained in the general model. For example, in the generic Coordination View model, the height of a wall is only captured in the geometric representation whereas the Quantity Take-Off Add-on also captures an explicit height attached to the element.
- Space Boundary Add-on: contains additional, explicit boundary descriptions for spaces that are required, for example, for MEP planning.
- 2D Annotation Add-on: contains additional elements for handing over 2D geometry, annotations, dimensioning and remarks.

- Structural Analysis View: contains information such as physical models and loads that are necessary for the structural analysis.
- Basic Facility Management Handover View.

These predefined views usually form the basis for the certification of software products and their ability to correctly import or export IFC data sets (see Chap. 7). Alongside these common predefined views, the new view definition models for IFC 4, based on the mvdXML standard, are going to play an increasingly important role. To basic forms, the Reference View and the Transfer View can be distinguished:

- The Reference View is mainly intended to support the coordination and merging of partial models and domain models for purposes such as collision detection based on geometric information. Changes are created in the respective authoring tools and made available through exports.
- In the Design Transfer View, the complete model is handed over and changes are made in the shared model.

The definition of a Model View is often done in a two-step process: First, special MVD-diagrams are created in which the required data items from the model are color coded. Here, "concepts" are used, that combine the use of attributes as well as relations across multiple instances. The concepts are defined in such a way that they are reusable across different MVDs. The combination of several simple concepts into more complex concepts is a further principle for the creation of Model Views. The introduction of concepts helps avoid the overly fine-grained production of views at an attribute level and supports the reuse of partial views and their implementation in software tools.

Typical examples for concepts are "GUID", "Name" and "Building Element Assignment". The use of corresponding concepts is shown in Fig. 6.5. An excerpt of an MVD diagram for the entity IfcBeam in the context of the MVD *Energy Analysis* is shown in Fig. 6.6. The diagram specifies for example how the fire resistance of each beam has to be provided. Furthermore, it defines that only the concepts *Brep*, *Swept Solid* and *Clipped Solid* may be used for its geometric representation (see Chap. 5 for further information).

In a second step such MVD diagrams are transferred into the machine-readable format mvdXML, which describes Model Views using an XML Schema (Chipman et al. 2012). In addition to the graphical description described earlier, further concepts such as links, if-then-else relations and conditions as well as arithmetic calculations can be captured as formal rules. Software tools for the creation of mvdXML definitions are presently comparatively rare, but will in future be more widespread. Increasing awareness of the necessity of such formalizations, along with an increase in specifications and the standardization of enabling technologies, will lead to an increase in the use of quality assurance tools for building information data sets. The creation of ad-hoc, project-specific Exchange Requirements would pave the way for semi-automated checks of information exchanges alongside

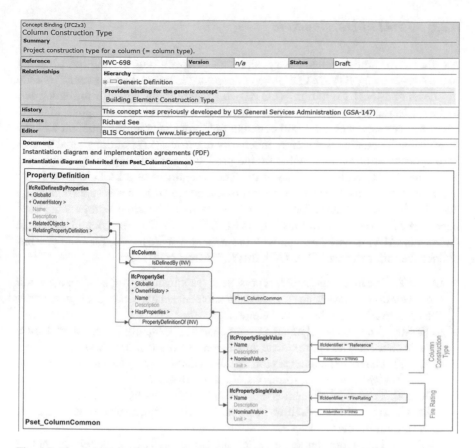

Fig. 6.5 The definition of the concept "Column Construction Type" describes the assignment of a construction type and a fire rating to an IfcColumn. This concept is used, for example, in the Energy Analysis View Definition

Fig. 6.6 An MVD diagram defines for an ENTITY which concepts are an required par of a particular MVD. This figure shows the diagram of the IfcBeam in the Concept Design to Energy Analysis MVD. The definition of corresponding Column Construction Type is provided in Fig. 6.5

existing semi-formal agreements and manual model checks. An important step is the creation and maintenance of re-usable concepts that can be used by end users and modified for the specific organization or project needs.

6.2.4 Level of Development

An alternative and complementary approach to specifying design and planning requirements using IDM/MVD is the concept of "Level of Development" (LOD) or "Level of Model Definition" (LOMD) for determining which information has to be delivered by whom at which stage. This concept is analogous to scale drawings: A scale such as 1:200 contains only approximate information and the information it contains is therefore inherently uncertain; a detail drawing at a scale 1:10 contains information suitable for the production of building components with a high degree of precision and accuracy. The assignment of a LOD to a model or building components allows the recipient of the information to assess its reliability. To achieve this, standards for the levels of detail of building components have been created in various countries, e.g. (AEC UK 2012). The American Institute of Architects (AIA) in collaboration with the American BIMforum, for example, has defined the following six LODs (AIA 2013; BIMforum 2013):

- LOD 100: The model element is represented graphically by a symbol or a generic representation. Information specific to the element such as costs per square meter can be derived from other model elements.
- LOD 200: The model element is represented graphically in the model by a *generic* element with approximate dimensions, position and orientation.
- LOD 300: The model element is represented graphically by a *specific* object that defines its size, dimension, form, position and orientation.
- LOD 350: The model element is represented graphically by a *specific* object that defines its size, dimension, form, position and orientation as well as its interfaces to other building systems.
- LOD 400: The model element is represented graphically by a *specific* object that defines its size, dimension, form, position and orientation along with information regarding its production, assembly and installation.
- LOD 500: The model element has been validated on the construction site including its size, dimension, form, position and orientation.

Figure 6.7 the different levels of development of a steel column and its interfaces. LOD definitions are not related primarily to IFC models but can also be implemented with proprietary models by software vendors. Combinations of the LOD concept with the vendor-independent IFC model include the Australian NATSPEC National BIM Guide (NATSPEC 2011). In this standard, extensive spreadsheets are provided by the so-called NATSPEC BIM Object/Element matrix that provide specifications for IFC model contents for each respective LOD (Fig. 6.8). In current business practice, contractual agreements between stakeholders include information on which LOD has to be delivered. Depending on the local standard, this matrix is referred to as a "Model Progress Specification", "Model Element Table" or "LOD Table". The LOD concept is of particular value for model-based collaboration across organizational boundaries and for contractual agreements concerning model content and quality. In future, we can expect to see further formalizations of LOD and their inclusion in norms and standards.

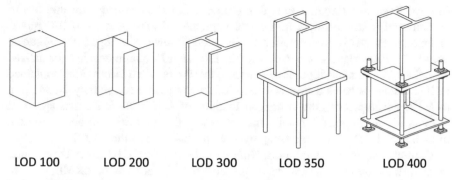

LOD 100 LOD 200 LOD 300 LOD 350 LOD 400

Fig. 6.7 Different Levels of Development as defined by the American Institute of Architects (AIA). In this example a steel column including its connection to the lower building elements is shown. LOD 500 is left out

Column	BIM Object or Element		General Information Use
	Item Catergory - **Column**		Building System
	Description: A 2D and 3D element. An relatively vertical element most commonly attributed to the structural support system for a building. Columns may be located on the exterior or interior of a building . A column may be a non-structural decorative element only.		Item System Category - Uniformat
Level of Development AIA Document E202 - 2008 Developed by Graphisoft 2001	**Information Category** for Information Item (See Master Information Tab)	**Information Item** (Information about the specific object or element)	**IFC Support**
LOD 100 - Conceptual			
Overall Building Massing Indicative of Area, Height, Volume, Location, and Orientation.	Building Program & Project Meta Data	Facility ID	IfcColumn->IfcBuilding.Name
	Building Program & Project Meta Data	Facility Name	IfcColumn->IfcBuilding.LongName
	Building Program & Project Meta Data	Facility Description	IfcColumn->IfcBuilding.Description
	Physical Properties of BIM Objects & Elements	Overall Length	IfcColumn->IfcQuantityLength.Name="Length"
	Physical Properties of BIM Objects & Elements	Overall Width	IfcColumn->IfcQuantityLength.Name="Width"
	Physical Properties of BIM Objects & Elements	Overall Height	IfcColumn->IfcQuantityLength.Name="Depth"
	Physical Properties of BIM Objects & Elements	Overall Area	IfcColumn->IfcQuantityArea.Name="GrossSurfaceArea"
	Physical Properties of BIM Objects & Elements	Overall Volume	IfcColumn->IfcQuantityVolume.Name="GrossVolume"
	GeoSpatial and Spatial Location of Objects &	Position Type	IfcColumn.ObjectPlacement
LOD 200-Approximate Geometry			
Generalized Systems or Assemblies with Approximate Quantities, Size, Shape, Location, , and Orientation.	GeoSpatial and Spatial Location of Objects &	Zone/Space Name	IfcColumn->IfcZone.LongName (new in IFC2x4)
	Manufacturer Specific Information Requirements	General Type	IfcColumnType.Name + IfcClassificationReference
	Costing Requirements	Value Based Costing (i.e. Cost SqFtg)	IfcColumn->IfcCostValue.CostType="Estimated" + UnitBasis
	Sustainable Material LEED or Other	LEED Items per Quantity Values	IfcColumn->IfcEnvironmentalImpactValue or IfcPropertySet with local LEED agreement
	Program/Space Compliance or Validation	Program Room Requirements	IfcColumn->IfcSpace - IfcSpace has IfcConstraint
	Code Compliance/ Occupant Safety	Egress Requirement	IfcColumn->IfcSpace - IfcSpace has IfcConstraint
	Code Compliance/ Occupant Safety	Circulation Requirement	IfcColumn->IfcSpace - IfcSpace has IfcConstraint
	Phases Time Sequencing & Schedule	Order of Project Milestones	IfcProject->IfcTask.IsMilestone->IfcRelSequence + assign IfcColumn->IfcRelAssignsToP
LOD 300-Precise Geometry			
Specific Assemblies that are Accurate in Terms of Size, Shape, Location, Quantity, and Orientation .	Physical Properties of BIM Objects & Elements	Nominal Size	
	Physical Properties of BIM Objects & Elements	Mass	IfcColumn->IfcQuantityWeigth.Name="GrossWeigth"
	Physical Properties of BIM Objects & Elements	Connections	- physical fasteners -
	Physical Properties of BIM Objects & Elements	Capacity	IfcColumn->IfcPset_ColumnCommon with Property.Name="LoadBearing"
	Physical Properties of BIM Objects & Elements	Perimeter	IfcColumn->IfcQuantityLength.Name="GrossPerimeter"
	Manufacturer Specific Information Requirements	Type	IfcColumnType
	Manufacturer Specific Information Requirements	Material	IfcColumnType->IfcMaterial.Name
	Manufacturer Specific Information Requirements	Availability	

Fig. 6.8 The reduced excerpt from the BIM Object/Element Matrix of the Australian NATSPEC standard shows the different levels of development of a building element along with its required parameters and maps these into the IFC model

6.3 Summary

For the organization of model-based collaboration it is essential to determine which stakeholders should receive which information at what level of detail at a certain moment in the planning process. The Information Delivery Manual (IDM) method requires that underlying business processes be structured in a Process Map (PM) and that the necessary information for handovers between project participants is identified. Specifications are created for these information transmissions in the

form of Exchange Requirements that define the kind of information that has to be delivered to the recipient in order to continue with the process. If IFC model instances are used as an information carrier, Model View Definitions (MVDs) can be specified in a subsequent step to capture the Exchange Requirements in a formalized way. Such MVDs make it possible to ensure that the required information contained in IFC models is handed over and help reduce the model complexity. In addition to MVD developments, the American Institute of Architects (AIA) has specified "Levels of Development" (LOD) that represent the maturity and accuracy of a model. Such LODs can also be employed with other models than the IFC.

Current semi-formal graphical methods for the creation of IDM/MVD will soon be augmented by more formal and expressive formats, such as mvdXML, that are completely machine-processable. As such, we can expect to see more widespread use of IDMs for recurring scenarios as well as their standardization at national and international levels in the coming years.

References

AEC UK. (2012). *AEC (UK) BIM protocol – Implementing UK BIM standards for the architectural*. Engineering and construction industry. Retrieved from http://aecuk.files.wordpress.com/2012/09/aecukbimprotocol-v2-0.pdf. Accessed Nov 2017.

AIA. (2013). *AIA contract document G202-2013, building information modeling protocol form*. Washington, DC: American Institute of Architects.

BIMforum. (2013). *Level of development specification*. Retrieved from http://bimforum.org/wp-content/uploads/2013/08/2013-LOD-Specification.pdf. Accessed Nov 2017.

BLIS. (2014). *IFC solutions factory – The model view definition site*. BLIS project. Retrieved from http://www.blis-project.org/IAI-MVD/. Accessed Nov 2017.

Building Research Establishment Environmental Assessment Methodology. Retrieved from http://www.breeam.com. Accessed Nov 2017.

buildingSMART. (2012). *An integrated process for delivering IFC based data exchange*. Retrieved from http://iug.buildingsmart.org/idms/methods-and-guides/Integrated_IDM-MVD_ProcessFormats_14.pdf. Accessed Nov 2017.

buildingSMART. (2013). *Construction operations building information exchange, MVD definition for IFC4*. Retrieved from http://docs.buildingsmartalliance.org/MVD_COBIE/. Accessed Nov 2017.

buildingSMART. (2014). *Model view definition summary*. Retrieved from http://www.buildingsmart-tech.org/specifications/ifc-view-definition/summary. Accessed Nov 2017.

Chipman, T., Liebich, T., & Weise, M. (2012). *Specification of a standardized format to define and exchange model view definitions with exchange requirements and validation rules*. buildingSMART. Retrieved from http://www.buildingsmart-tech.org/downloads/accompanying-documents/formats/mvdxml-documentation/mvdXML_V1-0.pdf. Accessed Nov 2017.

ISO 29481. (2016). *Building information models – Information delivery manual*. Geneva, Switzerland: International Organization for Standardization.

Leadership in Energy and Environmental Design by U.S. Green Building Council (USGBC). Retrieved from https://new.usgbc.org/leed. Accessed Nov 2017.

NATSPEC. (2011). *NATSPEC national BIM guide*. NATSPEC, Australien. Retrieved from http://bim.natspec.org/index.php/natspec-bim-documents/national-bim-guide. Accessed Nov 2017.

Chapter 7
IFC Certification of BIM Software

Rasso Steinmann

Abstract The Industry Foundation Classes (IFC) data model, developed by buildingSMART, is an important data standard for the exchange of data between BIM process partners. For reliable and consistent data exchange in practice, the IFC import and export functionality of BIM software must function correctly and reliably. Assessment and certification by an independent party offers a way to ensure a consistently high standard of data exchange. To this end, buildingSMART developed and implemented a certification procedure. This chapter discusses the aims of certification, the different expectations of certification, the procedure and its relevance for BIM in general. To conclude, the chapter looks at possible further BIM certificates (modeling quality of BIM data, BIM knowledge, BIM processes) that go beyond assessing just the data exchange interfaces of BIM software packages.

7.1 The Aims of buildingSMART Software Certification

The central focus of buildingSMART is the development of data formats for exchanging information in projects using the BIM methodology. The most well-known format developed by buildingSMART is the Industry Foundation Classes (IFC) format, a semantic product data model for comprehensively describing entire buildings (see Chap. 5). Numerous BIM software applications have implemented data import and export interfaces for this format, and buildingSMART has developed a corresponding certification procedure to ensure the quality, reliability and standard of data exchange. buildingSMART has also developed other data formats in addition to the IFC, but currently the IFC is the only format with a corresponding certification procedure.

The primary aim of certification is to ensure and attest a high standard of data exchange using the IFC format. For users of BIM software applications, certification

R. Steinmann (✉)
Department 02 – Civil Engineering, University of Applied Sciences Munich, Munich, Germany
e-mail: steinmann@iabi.eu

© Springer International Publishing AG, part of Springer Nature 2018
A. Borrmann et al. (eds.), *Building Information Modeling*,
https://doi.org/10.1007/978-3-319-92862-3_7

serves as an indicator of the software vendor's interest in providing good support for the IFC format.

The certification procedure also helps software vendors maintain their own quality assurance processes. The vendors can follow the progress they are making via a web-based certification platform (see Sect. 7.3.3), which is especially useful for international software companies with teams working in different countries. The online test cases are based on many years' experience of manual testing and therefore serve as reliable tests of real scenarios. Software vendors can also access hundreds of IFC files provided by other vendors.

7.2 Expectations of Software Certification

A central aspect of any certification scheme is what it can demonstrate, and therefore what users can expect from it. No certification scheme can guarantee completely error-free operation. As such, any certification scheme is a cost-benefit balance: how much effort is involved to secure a certain benefit and at what point does the work involved exceed the economic benefit.

A comparison of IFC software certification with quality assurance procedures in the automobile industry illustrates the issues that arise with certification. A product or vehicle safety test cannot guarantee trouble-free operation, or that a safety-relevant component won't fail shortly after testing, for example due to material fatigue. A safety certificate reflects empirical experience that a specific safety-relevant component, after checking according to a defined procedure, is very likely to perform reliably under normal use until the next testing deadline. Numerous examples and product recalls by manufacturers show that product or vehicle certification cannot cover all eventualities that arise in practice. Significant investment is made in cases where reliable performance is paramount for human safety, but in other cases, certification is often a question of economic benefit.

Software vendors, like automobile manufacturers, have extensive internal quality assurance systems of their own (see Fig. 7.1). Cars, for example, once ready for production, are subject to various vehicle safety and crash tests (e.g. TÜV, NCAP New Car Assessment Program). Nevertheless, car magazines and automobile associations often discover severe defects or shortcomings in their own subsequent tests – for example the infamous elk avoidance test.

The situation is similar for the software certification of IFC data exchange interfaces where the buildingSMART certification procedure is the equivalent to a product safety test or an NCAP crash test. Other independent tests by users and public or private bodies can reveal problems with specific usage scenarios that buildingSMART certification does not cover. These tests are useful, and the sum of these various independent tests contributes to the overall quality.

buildingSMART has many years of experience of IFC software certification: in its first implementation, the assumption was that software vendors would ensure a sufficiently high standard as part of their own quality assurance processes. Version 1

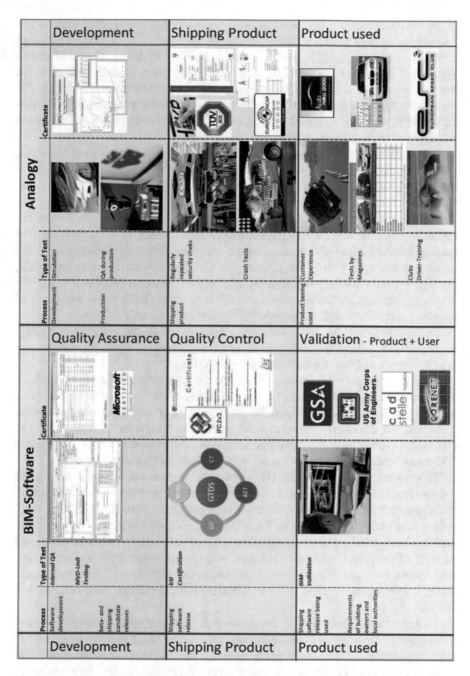

Fig. 7.1 Analogy between buildingSMART software certification and automobile quality assurance. (© R. Steinmann, reprinted with permission)

of the IFC certification (last used in 2005) employed a certification that was in principle analogous to ISO 9000 procedure and evaluated only whether a software producer had the capacity to develop a good quality IFC data exchange interface. The actual quality of the interface was tested only on a random basis. It soon became apparent that this approach was not sufficient. Some software vendors did not devote the necessary attention while others genuinely interested in creating a high-quality interface struggled with developing suitable test scenarios and robust test environments (Kiviniemi 2008).

The buildingSMART user groups were disappointed with the results of Version 1. While the quality of IFC interfaces in some products improved markedly, overall user acceptance was hampered by the inadequate data exchange interfaces of other software products.

In September 2008, buildingSMART commissioned Dr Thomas Liebich and the author to develop Version 2 of the certification that aimed to evaluate the actual quality standard of an IFC data exchange interface. Once the concept had been developed and agreed on by the buildingSMART committee, the company AEC3, the iabi Institute at Munich University of Applied Sciences and the Institute for Applied Informatics at Karlsruhe Institute of Technology (KIT) were commissioned to implement the concept and conduct audits for the first certifications.

The results speak for themselves: the improvement in the quality of IFC data exchange interfaces of the software systems that underwent Version 2 certification is both marked and verifiable (BuildingSmart 2015a).

But were users equally convinced? While the improvements were widely praised, there was still critical feedback. On the one hand, as one would expect, problems arose in practice in areas not covered by the tests in the certification procedure. More often than not, the software vendors were quick to respond with software patches to resolve these situations. A more general problem, however, was that users expected IFC data exchange to do things not explicitly defined in its technical remit.

This is a wider problem that all IFC specialists are aware of, but most users might not be. The IFC data model can be used to describe a building and its constituent components, but in most communications between participants in the BIM process, only a small fraction of the entire model is required (see Chap. 6). Every communication has a specific purpose that refers to a particular part of the data model that covers that scenario. Certification tests can only cover defined application scenarios. Users, however, assume that certification also covers their own particular scenario, which may lie outside typical use cases – and are understandably disappointed when it does not.

To draw on our analogy with the automobile industry: no-one would dream of driving a car with a lowered chassis through off-road terrain. Likewise, an all-terrain vehicle with chunky tires is not going to speed past a sports car on the motorway. Drivers know what to expect from these types of vehicles. In IFC data exchange, users lack such background knowledge and consequently often assume that IFC covers all situations, regardless of how specific they may be.

7.3 The Principles of IFC Software Certification

7.3.1 IDM and MVD

To consistently describe BIM processes and the accompanying information exchange requirements, buildingSMART developed a standardized method called the Information Delivery Manual (IDM, ISO 29481, see Chap. 6). This predefined uniform structure and method for presenting process models enables users to develop, agree on and accurately document their BIM processes. The corresponding technical counterpart to the individual IDM specifications are so-called Model View Definitions (MVD) that define the specific sub-elements of the overall IFC data model that can support the specific exchange requirements of the IDMs (see Chap. 6 and Fig. 7.2).

MVDs can therefore serve as technical specifications for software vendors that wish to support IFC. In the user interface of the IFC import/export facility of BIM software, the user should have a choice of relevant MVDs. However, because users are usually unaware of MVDs, the user interface needs to use terms that describe the underlying MVDs in more user-friendly terms, for example that describe the purpose of the data exchange.

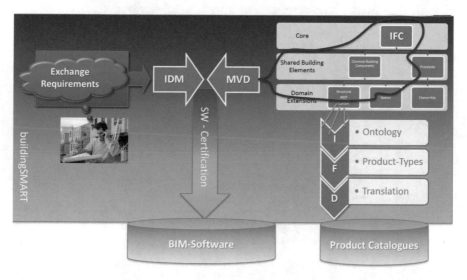

Fig. 7.2 The relationship between IDM, MVD, IFC and IFD. (© R. Steinmann, reprinted with permission)

7.3.2 Test Descriptions and Calibration Files

MVDs also serve as the basis for defining the framework for software certification. They essentially set the bar to be reached. The test cases are built around them, and they serve as a template for checklists that the systematic tests support.

Further important documents for certification include test descriptions for the export tests and calibration files for import tests (see Fig. 7.3). The test descriptions describe precisely how BIM programs need to model building components as well as entire buildings for export as IFC files.

To discover specific problems and identify their causes, large building models are not very helpful due to their complexity. Instead, small test scenarios – so-called unit tests – are used that define specific cases and can be used to systematically test a wide variety of variants. Considerable experience is required to develop tests so that they can reveal potential defects and problems in the implementation. For

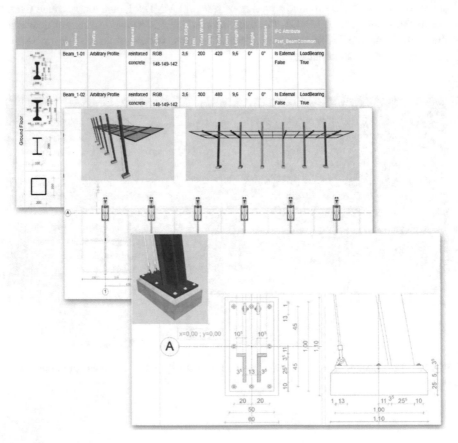

Fig. 7.3 Example test case description

Version 2 of the software certification procedures, buildingSMART were able to draw on their years of experience with Version 1 and the input provided by users as well as by software vendors interested in improving the overall standard of IFC interface implementations on the market.

In addition to these specific test cases, models of entire buildings are also used for testing to see how a software package performs when dealing with large data sets.

The exported IFC files generated as a product of these test descriptions are then used, after thorough checking, as calibration files for the import tests. The IFC specification works in a way that even when processing the test descriptions correctly, IFC data from different software will never be entirely identical. While the geometry should be, as far as possible, visually identical, the IFC permits different representations in the data structure (see Chap. 5). As such, the collection of IFC files exported from different programs is a valuable repository for the importing programs because it allows them to test the full extent of different IFC files on the market and the permitted variations.

7.3.3 GTDS Web Platform

This certification method has several inherent challenges, for which a web-based application was developed. The Global Testing and Documentation Server[1] (GTDS, see Fig. 7.4) developed at the iabi Institute at Munich University of Applied Sciences functions according to the following principles:

1. A wide range of test descriptions must be developed by experts and made available for testers to use as required. The participants are located around the world in different time zones. Tests must exist for all IFC areas described by the MVDs. To provide this functionality, a web-based database application was established for developing the tests, making them available in a structured manner, and for testing, all with the necessary transparency.
2. Exported IFC files should, as far as possible, be tested automatically. A validation tool was developed and integrated into the GTDS that automatically validates IFC files against the technical specification when uploaded.
3. As the automatic testing of IFC files cannot cover everything that needs testing, exhaustive manual testing is also undertaken. The results of these tests are documented in detail at the level of the individual IFC structures. A checklist containing all the main components of IFC2×3 would have more than 700 entries, and paging back and forth through such a long list would be very time-consuming and error-prone. Each test scenario is therefore automatically

[1]GTDS-Certification Platform for IFC2×3: http://gtds.buildingsmart.org

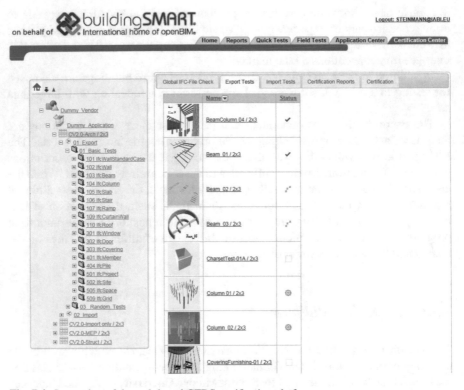

Fig. 7.4 Screenshot of the web-based GTDS certification platform

packaged with only a focused checklist with a cross-section of the IFC model, MVD and the IFC elements present in the actual scenario.

4. On registration, each software application applying for certification is assigned a specific set of test cases that match the corresponding MVD and needs to be supported.

5. During the preparation phase, the software vendors can add staff to their closed area of the GTDS to undertake tests, document the results and follow their progress. This functionality is particularly valuable for large teams with members across the globe.

6. The auditors verify the software vendors' results using independent tests and document their results in the GTDS alongside the testing undertaken by the software vendor who, in turn, can follow the progress of auditing and respond to them as required.

7. Once a software vendor declares a test case closed, the team of auditors are automatically notified by the GTDS so that they can begin auditing.

8. Evaluation tools show an overview of the progress of testing for all the registered BIM applications.

9. An integral billing tool monitors the ongoing costs of certification.

10. Once the certification process is complete, the system automatically generates a report with the test results. The application is then automatically listed in the public registry of successfully certified BIM applications on the buildingSMART homepage where the final certification report is also published (BuildingSmart 2015b).

7.4 The Process of Software Certification

The certification workflow involves the testers and developers of the software vendor as well as independent auditors. There are two principle processes requiring certification: export and import certification. Alongside the certifications tests, regular teleconferences take place in which software vendors can ask questions and exchange experiences.

7.4.1 Export Certification

1. For export certification, the first step is to develop tests that cover all the IFC components relevant to a specific MVD and contain numerous variations to simulate as many of the cases that might occur in practice as possible.
2. These test cases must then be modeled by the software producers, and the result exported as an IFC file which is then uploaded to the GTDS platform.
3. The uploaded file is automatically validated against the specification by an integral validation tool.
4. Files that validate successfully must also be manually checked by the software producers against a compiled checklist of criteria specific to the test case.
5. Once a software vendor officially declares their IFC file error-free, the independent auditors are automatically notified.
6. The auditors then manually evaluate the IFC file using a variety of own methods, such as using it in different BIM applications, and document their results in detail in the GTDS. The precompiled checklists help to ensure every IFC component is individually checked and evaluation tools log the process to verify this. It is quite common for auditors to help software vendors locate the cause of errors.
7. When no more errors are found, the test case is deemed successfully passed. The progress of the certification procedure is logged by evaluation tools that show how many test cases are awaiting testing or are in testing by the software vendors and auditors, as well as how many have passed testing or been rejected.
8. Once all test cases have been successfully completed, the team of auditors and the buildingSMART business management team must give final approval before the export certification process is deemed officially completed. The certification is published automatically on the buildingSMART homepage, and the software vendor receives a corresponding certificate.

7.4.2 Import Certification

The import certification workflow uses the successfully certified files from the export certification process as calibration files. For this certification, it is not possible to test automatically, and all tests must, therefore, be conducted manually. The following workflow results:

1. The software vendors download the calibration file from the GTDS for importing into their application. The vendors are supplied with corresponding test descriptions so that they can verify what they should have received. Here too, a precompiled check-list accompanies each test case.
2. Once approximately 20% of the test cases have been completed, an initial pre-audit is conducted to give the software vendor an indication of the direction for further testing.
3. In the audits, the software vendors must demonstrate which content from the calibration file is imported into their software. Using the relevant functions of the application, the received content is visualized in the application in both graphical as well as alphanumerical form.
4. The audits are conducted by independent auditors (at least two) as well as representatives from the software producer to avoid false assessments resulting from incorrect use of the software. The audits can take place as meetings or as web-conferences. In the case of extensive audits, meetings are more effective as all-day web-conferences become very tiring and are ultimately less efficient.
5. Once all test cases have been successfully completed, the remainder of the process is identical to the procedure described above for export certification.

7.5 Further Aspects of Software Certification

7.5.1 Costs

The certification fee depends on the work involved in developing the test cases and undertaking the tests. The vendor must also pay a proportional contribution towards the ongoing development and maintenance of the GTDS platform and automatic validation tools. The work involved depends on the MVD used and on whether export and/or import certification is undertaken.

7.5.2 Transparency and Reproducibility

An important aspect of an independent certification process is that the results can be verified and are reproducible. The procedure described above and the GTDS platform ensure that the entire process is documented and transparent. All

participants can see what was tested when and what the result was. If there are any doubts, the certification can be checked by an authorized supervisor.

7.5.3 The Role of mvdXML

mvdXML was not available when this certification procedure was initially developed. To automatically select the relevant IFC elements required for certification according to a particular MVD, it soon became clear that a method such as what we know today as mvdXML was desirable. At the time a more involved method using Excel tables stored in a database tool was used and incorporated into the GTDS platform. This is no longer necessary for future certifications thanks to the availability of the mvdXML format (see Chap. 5).

7.5.4 The Importance of Software Certification for BIM

The certification procedure described in this chapter has led to a lasting improvement in the quality of IFC data exchange interfaces, which in turn is an essential basis for successfully exchanging data between participants in BIM processes. A second, equally important factor, however, is the quality with which BIM data is modeled, and that depends on the competency of the users of BIM software. To improve this, various approaches exist ranging from training programs for users to model-checking tools that verify modeled data, the establishment of BIM process standards in organizations as well as contractually agreed expectations.

7.6 Outlook

At the time of writing, all major BIM applications and several others supporting IFC Version 2 × 3 and Coordination view 2.0 have been certified. In the meanwhile, a new certification scheme 3.0 has been established by buildingSMART for certifying IFC4 supporting applications.

There are some significant improvements in the certification scheme 3.0:

- The GTDS web based platform, used for IFC2×3 certification, is running on Oracle database technology and it turned out that under increasing load one had to experience performance issues. Also scalability turned out to become an issue in the foreseeable future.

Fig. 7.5 Screenshot of the cloud-based b-Cert certification platform

- Therefore, iabi developed the new cloud based platform[2] "b-Cert" running on Azure technologies (see Fig. 7.5). It basically provides similar functionality as GTDS, but with better performance, it is scalable and has a state-of the-art UI and provides better usability. It also offers an API for a direct programmer's access and it supports BCF (BIM Collaboration Format) for issue management over the BCF-web service.
- IFC4 started with two MVDs from the beginning:

 - The Reference View (RV), which basically is covering the initial idea of the Coordination View (CV) of IFC2×3. However, the IFC2×3-CV over the years became overloaded with model transfer requirements. Therefore, the IFC4-RV is coming back to the roots of the initial idea of coordination and got rid of model transfer aspects. With this it is more focused on the purpose of coordination and a bit simpler than the former IFC2×3-CV.
 - The Design Transfer View (DTV), which is covering aspects of exchanging models, so that they can be used/evaluated by other applications for specific purposes, is more focused on transferring specific BIM-information between applications and therefore, in parts is more enhanced than the former IFC2×3-CV.

[2]b-Cert Certification Platform for IFC4: http://b-cert.org

- In the meanwhile, mvdXML became available, which makes MVDs machine-readable. mvdXML can be used for many purposes, e.g. as a filter for an IFC-supporting application with a wide scope. For the certification, mvdXML is used to define the content of each test case, which then can drive the b-Cert-UI for the test-case-specific audit.
- The new partner Apstex replaced KIT for providing a new automated checking tool. This development makes intense use of mvdXML, by actually generating specific checking tools for each test case. This approach also makes it easier to use the scalable resources of cloud technology, when many automated checks are running at the same time in parallel.

Based on the long experience with the IFC2×3-CV, the Exchange Requirements for the IFC4-RV are clear. Therefore, the certification process for IFC4-RV could be set up and started in the meanwhile. However, it turned out, that the Exchange Requirements for the IFC4-DTV are not yet defined in detail. There are two alternatives to handle this:

1. Run the certification on the basis of a more general specification of the DTV and decide for each application which scope of support makes sense for its functionality and what likely would be expected by the users. This would result into a certification with green (supported), yellow (partly supported) and red (not supported) checkmarks, as it was done in the IFC2×3-CV certification. However, users criticized that this is too difficult to handle in practice, especially when matching the transfer capabilities between applications.
2. Define the Exchange Requirements for the IFC4-DTV more precisely and focused on specific exchange purpose. Consequently, an application could pass such certifications with green checkmarks only. Since the user group of buildingSMART opted for this alternative, the work to be done is to elaborate typical standard Exchange Requirements for the IFC4-DTV. As soon as this is available, also the certifications for this MVD can be started.

buildingSMART also develops other data standards in addition to the IFC:

- The buildingSMART Data Dictionary (bSDD), an implementation of the International Framework for Dictionaries (IFD, see Fig. 7.2) sets outs terms and structures that can be used as a basis for standardized product catalogs (see Chap. 8). In future implementations, both these product catalogs, as well as the data derived from them, must be certified.
- In 2013, the BIM Collaboration Format (BCF) was developed, with updates since then, as a data format and simultaneous web service with which model-related BIM issues can be communicated (e.g. collisions, problems, requirements, etc.). The standard-compliant support of BCF must also be certified.

In addition to the certification of IT applications, a need for further certificates has also been identified. These include:

- Certification of BIM qualification programs as an attest of the professional competency of BIM participants. A prerequisite for this is recognized training

guidelines that set out not only the knowledge required but also the roles and responsibilities of participants in the BIM process as well as the hours of experience required. Such training guidelines serve as a framework for developing training programs and as a basis for their accreditation. Only qualifications obtained from accredited training programs can be considered reliable. At the time of writing buildingSMART just started such a certificate based on a commonly developed Learning Outcome Framework.

- BIM data certification verifies the quality of BIM models exchanged between different BIM participants. Rather than assessing the quality of the data exchange interface systems, this certification examines the quality of the model produced by the user. As described above, so-called "exchange requirements" are defined in IDMs to support data communication between process stages. Where a sufficiently high quality of data exchange is important, for example to be able to fulfill contractual obligations, participants can require independent certification of the correct structure and completeness of BIM model data.

- BIM process certification can be used to demonstrate that a company has the capabilities and competencies to implement BIM processes at a defined quality. The ISO 9000 certification program already assesses whether a company is able in principle to attain a certain level of quality, but without actually checking the actual quality level. While the certificates mentioned above verify the quality standards of actual software, people and data, the BIM process certificate provides an indication of whether suitable boundary conditions for a successful BIM workflow exist. A prerequisite for these certificates is the description of BIM processes and procedures and the establishment of generally recognized standards. These standards, in turn, represent a further important basis for defining the content of BIM qualification programs.

At the time of publication, these and other certificates are currently under discussion in different contexts. In some countries, the first legally-binding standards are even being developed that could serve as a basis for these certificates. buildingSMART will continue to facilitate and mediate ongoing developments and international dialogue.

7.7 Summary

This chapter has provided a detailed motivation for the certification of IFC import and export functionalities of BIM software products. Only with a formal certification process, the implementation quality reaches a level where the AEC industry's expectations regarding open BIM model exchange can be met. The chapter described in detail the certification procedures, both in the past as well as in current practice, and introduced the technical platforms underlying the certification workflow. The role of mvdXML for a formal definition of both, exchange scenarios as well as test cases, was highlighted and the challenges associated especially with more recently defined MVDs were discussed.

References

BuildingSMART. (2015a). *Software certification process*. Retrieved from http://www. buildingsmart.org/compliance/software-certification/. Accessed on 10 Apr 2018.

BuildingSMART. (2015b). *Certified software*. Retrieved from http://www.buildingsmart.org/ compliance/certified-software/. Accessed on 10 Apr 2018.

Kiviniemi, A. (2008). IFC certification process and data exchange problems. In *Proceedings of the 2008 ECPPM Conference*. Taylor & Francis. https://doi.org/10.1201/9780203883327.ch57

Chapter 8
Structured Vocabularies in Construction: Classifications, Taxonomies and Ontologies

Jakob Beetz

Abstract Structured vocabularies are an important means of defining and structuring the meaning of concepts and terms used in the building industry to ensure their consistent use by all stakeholders over the life cycle of a construction. In their traditional form as text documents and tables they are designed for use by domain experts to facilitate the creation and use of unambiguous specifications, requirement documents and mutual agreements. In their digital, machine-readable form, they can be used in a Building Information Modeling context for the semantic annotation of model objects to further enhance exchange and interoperability in data exchange scenarios. This chapter introduces the fundamental concepts, application areas and technical implementations of such terminologies and structured vocabularies.

8.1 Introduction

In circa 15 BC the engineer, architect and scholar Marcus Vitruvius Pollio published "De architectura", the first major compendium of knowledge on the built environment of its time. These "Ten Books on Architecture" comprised a comprehensive collection of the state of the art of building and planning and covered a broad spectrum of knowledge ranging from the microscopic ingredients of concrete to connection details of masonry and timber structures, ventilation and heating systems, and the aesthetic configuration of pillars and columns to large-scale infrastructural artifacts including roads, sewage and water systems and the layout of cities and defensive structures. The opus survived medieval times in the form of manual copies and for centuries was the most important universal reference on building practice in many parts of the world. In the Renaissance, more than fourteen hundred years after its initial publication, the "Libri Decem" were augmented with rich illustrations and examples. Emerging printing technologies accelerated its

J. Beetz (✉)
Chair of Design Computation, RWTH Aachen University, Aachen, Germany
e-mail: beetz@caad.arch.rwth-aachen.de

© Springer International Publishing AG, part of Springer Nature 2018
A. Borrmann et al. (eds.), *Building Information Modeling*,
https://doi.org/10.1007/978-3-319-92862-3_8

155

propagation in an age in which building and the construction trade were flourishing. Numerous translations of the Latin original were made, and it acquired an additional role as a dictionary between languages.

The days in which the entire body of knowledge on architecture, engineering and construction could be compiled into ten books passed as new discoveries, inventions and enhancements rapidly multiplied the quantity of available information. The 'master builder' of old, the polymath who could design and engineer an entire structure independently, now had to specialize. This diversification of knowledge resulted in a need to collaborate among domain experts in ever more specialized disciplines and, in turn, to an increasing need for unambiguous classifications, clear definitions and glossaries, reliable specifications and sets of clear rules by which to conduct these increasingly complex interactions.

Today, structured vocabularies play an increasingly important role. Next to their traditional role as an aid for structuring and facilitating communication between experts, they also serve new purposes. "Intelligent" functionalities in automation systems and interoperability in information exchange processes require rigid, machine-readable formalization of knowledge. To this end, the **semantics** (meaning) of a **concept** can be captured in layers of increasing complexity that will be introduced in this chapter.

Since the early days of computer science, the field of **Knowledge Representation** (KR) (Studer et al. 1998) emerged from the broader domain of **Artificial Intelligence** to address the challenge of formalizing knowledge in machine readable ways. In the beginning, academic discussions were dominated by visionary plans of an all-encompassing 'strong' AI that aimed to make all of humankind's knowledge available to machines in order to allow them to make 'independent' discoveries and decisions. After an initial wave of success stories, including the CyC project (Lenat and Guha 1989), disillusionment followed. In its weaker forms, however, knowledge modeling has today achieved remarkable results in the fields of medicine, pharmacology, chemistry and material sciences by harnessing automated methods to help deal with the complexity of knowledge. Methods and tools from the field of knowledge modeling play a vital part in **linked data and knowledge** and thus have great potential to address a domain as inherently multi-disciplinary as building and construction.

8.2 Applications of Structured Vocabularies

Dictionaries, classification systems and ontologies such as the buildingSMART Data Dictionary (bSDD) (buildingSMART 2015), or Uniclass2 (CPIC 2015) system can be used in different ways to enhance reliable collaboration between stakeholders by providing unambiguous definitions of terms and concepts. For example, relations and links between different object instances (a specific door or wall in a building design and its respective model) and their respective classification items ("the class of all external doors") can be created and introduced into the model.

A traditional application for 2D drawings are layer standards, such as ISO 13567-1:1998, where groups of elements, such as external walls, doors or technical equipment, are placed on common layers of a CAD model and thus represent a structured approach to information management. However, the granularity and usability of such approaches are limited due to the sheer amount of information (many layers) and the limitation of allocating object to categories (only one layer per object instance).

The introduction of object-oriented concepts (Chap. 3) makes it possible to assign meaning in much finer and more sophisticated ways, for example by combining general functional categories ("internal doors") with other typological categories ("sliding door").

The annotation of individual objects facilitates the partial automation of specific application areas, for example quantity take-off, specification documents and cost estimation.

Classifications are inherent to most building models in the form of object and attribute definitions (see Chap. 3). To a certain degree, these can be represented in a vendor-independent way, for example using the common Industry Foundation Classes (IFC) (see Chap. 5). However, such models can only contain a limited, finite set of definitions i.e. they can model only a part of 'reality'. To capture and use additional aspects of a domain, cultural context or 'universe of discourse' in a building model, the use of traditional and existing classification systems is vital in practice. Local standards and building codes (e.g. OmniClass 21-02 20 50 10 "Exterior Entrance Doors"), such as the OmniClass and UniClass are an important part of best or mandatory practices. Such systems vary from country to country, require the involvement of various disciplines (fire safety, building services etc.) and are constantly evolving. For building information models, flexible, adaptable and yet interoperable technologies are needed that can capture and incorporate these heterogeneous classification systems.

An important function of such interoperable structured vocabularies for the semantic annotation of objects is their use in building product databases (see Fig. 8.1) which will soon make it possible to conduct vendor-independent searches for building products. Dictionaries, classifications and ontologies are an important facilitator for unambiguous definitions and data exchange. Textual descriptions of products written for humans are usually only available in semi-formal and natural language formats, and are severely limited in terms of machine readability which results in limited search and query capabilities. The shared classification of objects and their properties in a machine-readable form facilitates better, more structured searches and comparisons of design solutions based on their functional requirements. Furthermore, structured vocabularies allow the modular and dynamic extension of building model schemas such as the IFC without increasing the complexity and extents of the base model.

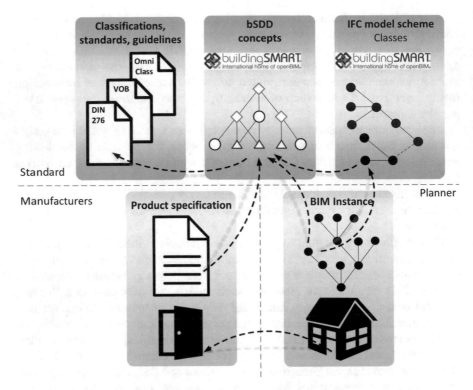

Fig. 8.1 Linking of building models, classifications and manufacturer data with the buildingS-MART Data Dictionary (bSDD) and IFC instances

8.3 Foundations of Structured Vocabularies

Depending on their intended use, structured vocabularies and classification systems can be created and used in different forms. The more detailed and precisely a knowledge domain needs to be captured, the more intricate the required methods and technologies are. This section introduces different approaches and their applications in practice, starting from simple dictionaries to taxonomies and finally fully-fledged ontologies.

8.3.1 Shared Dictionaries

Nomenclatures, **glossaries** and **terminologies** that are shared among a single or multiple domains are basic forms of structured vocabularies. These comprise lists of commonly agreed technical terms and their definitions, usually arranged in a specific order, e.g. alphabetically, and sometimes also in one or more languages. Next to the

customary spelling (**syntax**) of individual (technical) terms they often also contain short definitions of the **meaning** (**semantics**) of the underlying **concepts**. Additional media, such as illustrations, help to scope the space of possible interpretations of the concept and to distinguish them from one another.

Dictionaries containing multiple languages can be transferred into simple data models that can already be used in automation scenarios. A simple application area of such dictionaries is the translation of building product catalogs, service descriptions or bid tender documents in international projects. In addition, they can be used for the semi-automatic translation of software tools. Instead of hard-coding terms into user interfaces and component libraries, natural language terms are stored in separate dictionaries and added to the tool dynamically at runtime.

8.3.2 Classification Systems

Dictionaries and glossaries consist of punctual summaries of terms and concepts. Through classification systems and taxonomies they are related to each other, thereby creating additional structure. The classification of a single building component, such as a column, can be achieved using different categories, aspects or facets, for example according to its function ("load-bearing"), its form ("cylindrical") its orientation ("vertical"), material ("concrete") or its domain ("structural column" vs. "architectural column"). Depending on the type of axis and discriminator, different relationships between the nodes (concepts and terms) are chosen.

One of the most common relationship types is **specialization** in which concepts are related to each other in terms of being more general or specific: an "I-beam" can be seen as a special form of a "steel beam" which is a special form of a "structural element". Such specialization relationships are often represented by simple natural language terms such as "is-a". When many concepts are related to each other using the same relationship type, the result is a tree structure. Next to such specialization trees, other relationship types are employed in building and construction such as part-whole relationships, which are referred to as "partonomies". A convenient way to manage different facets are classification tables that group trees of different relationship types.

An important fundamental classification of functions, elements and processes in building and construction was proposed in the 1950s by the Swedish "Samarbet-skomtten for Byggnadsfragor" SfB (committee for building matters) (Giertz 1982). Today, this classification system still serves as the basis of many classifications in other countries such as OmniClass and UniClass. Relevant applications and further details are discussed in Sect. 8.4.

8.3.3 Ontologies

Basic classification tables of concepts are limited to single relationship types, such as specialization, i.e. they are ordered along a single axis (general-specific). Using ontologies, several relationship types and aspects can be represented in a common model. Both, the classical definition of the concept ontology (Greek: "discourse on that which is") as well as the modern computer science definition ("explicit specification of a conceptualisation") (Gruber 1993) include dictionaries and taxonomies as a simple form of ontology. In practice, however, the concept of an "ontology" is often reserved for more expressive knowledge models. In fully-fledged ontologies, relations are often used that are rarely represented based on principles provided by formal logic, that make it possible to draw conclusions (inferences) based on statements or facts (axioms), e.g.

1. All buildings have entrances.
2. A hospital is a building.
⇒ All hospitals have entrances.

This principle can be used to define models that can be checked for consistency using the underlying formal logic, and from which new facts can be inferred. A multitude of formal logics and languages are available that enable the creation of knowledge models of varying complexity. When complex modeling constructs and logics are used, and models become large, the computational complexity can quickly become high and the logic system can become even undecidable.

In computational ontology models, a distinction is made between the T-Box (terminology) and the A-Box (assertions). Like the notions of classes and instances in object-oriented programming (see Chap. 3), concepts ("hospital") and their properties are modeled separately from their instances ("John Hopkins Hospital, Baltimore"). In addition to purely descriptive statements, rule-based languages are often used to provide additional modeling capabilities. For example, simple if-then conditions can be modeled that can be used for automatic code checking (see also Chaps. 6 and 18).

8.4 Technical Implementations of Structured Vocabularies

8.4.1 Classification Tables

A traditional method of implementing classification systems and other structured vocabularies uses table and hierarchical numeration systems. A basic example is the numbering system of the Omniclass classification. The hierarchical levels of specialization regarding the functionality of buildings are given in "Table 11 – Construction Entities by Function" and are organized on four levels, reflected in the columns of the number code: "11-12 00 00 Educational Facility" is the general

category of which "11-12 24 00 Higher Education Facility" and "11-12 23 11 University" are specializations. The British UniClass table makes it possible to describe combinations such as "Ee_25_25>Sp_35_10_08" for all interior walls (Ee_25_25) in birthing rooms (Sp_35_10_08).

8.4.2 ISO 12006 and bSDD

The three parts of ISO 12006 provide a framework for the definition of classification systems at an international level. Derived from the Swedish SfB system (see Sect. 8.3.2), it is referred to as the "International Framework for Dictionaries" (IFD) and is an official standard of the buildingSMART organisation. In part 2 of this standard (ISO 12006-2:2001), a central conceptual framework is provided for concepts such as "construction result", "process" and "resource". This framework, however, only provides a general recommendation for possible classifications that it can describe. An overview of the framework is shown in Fig. 8.2.

Part III of the ISO provides a tangible data model for capturing building-relevant terms (ISO 12006-3:2007). A fundamental part of the structure of this model is the ability to attach multilingual labels and descriptions to all concepts. Here, the relevant identification of a concept is provided by a Globally Unique Identifier (GUID) and not its term in a particular language (e.g. "door knob" or "Türgriff").

When this data structure is instantiated and annotated with terms and descriptions in multiple languages, an international dictionary is created that forms the basis for international collaboration and interoperability. The reference implementation of this data model, created and maintained by the buildingSMART organization, is the "buildingSMART Data Dictionary" (bSDD) which currently contains some 60,000 concepts in multiple languages.

Since version 2×4 of the IFC model, the bSDD also serves as a central repository for the standardized PropertySet (PSet) extensions where each individual property is represented by a concept in the bSDD. The different relationship types between concept nodes (specialization, part-whole-relationships etc.) together with the ability to link these concepts to other normative documents, building codes etc. make the bSDD a valuable body of knowledge that will gain increasing importance in future. Figure 8.3 shows a screenshot of a web-based interface for browsing and searching the contents of the dictionary. To reduce complexity and filter information relevant to a particular use case, the notion of "contexts" makes it possible to scope associated codes and concept hierarchies to a particular local standard.

8.4.3 Semantic Web and Linked Data

A fundamental problem in structuring knowledge and information for automated processing is the heterogeneity of technical representations. In the past, different

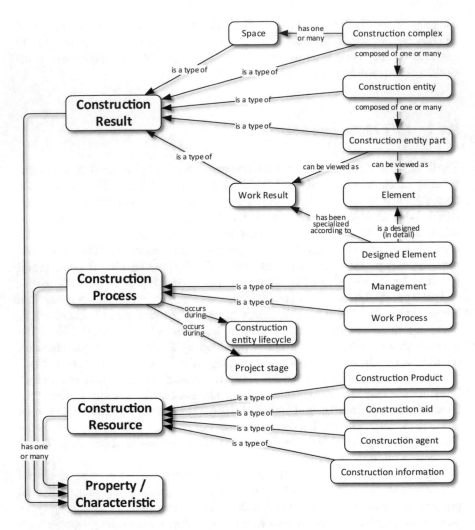

Fig. 8.2 Schematic overview of part 2 of ISO 12006, which constitutes the original conceptual basis of numerous classification systems and the buildingSMART Data Dictionary

vocabularies, classification systems, conceptual models and ontologies have been created and presented using different modeling languages, data formats and interfaces. Up to now, considerable effort has been invested by both software vendors and users to access and harness relevant classification systems. These efforts impose severe obstacles to facilitating the semantically unambiguous exchange of information in the building industry.

To address such interoperability problems, methods and technologies for the distributed modeling of and access to information resources were developed that are referred to as the **Semantic Web** initiative (Berners-Lee et al. 2001). The core

Fig. 8.3 Browser interface of the buildingSMART Data Dictionary (bSDD). The image shows the descriptions of the concept "door", its specifications and properties (*bottom*) and any applicable standards and regulations (*right*)

idea is to standardize generic means of modeling and representing knowledge and information that enables their uniform, decentralized creation, and the publication and linking of resources in a global network. At the core of this standardization effort under the umbrella of the World Wide Web consortium (W3C), the **Resource Description Framework** (RDF) (W3C 2014), is the ability to capture atomic statements in any model in the form of a triple consisting of a subject, predicate and object. Each of these components is identified by a Uniform Resource Identifier (URI), the most common form of which is the network-address URL (Uniform Resource Locator), which has the inherent ability to distribute and link information across network structures. This allows the reuse of concepts, properties, models and instance data even across domain boundaries. Basic concepts of information and knowledge modeling such as "Class", "Property" and "Data Value" are provided by standardized vocabularies such as the RDF Schema (RDFS), the Web Ontology Language (OWL) or the Simple Knowledge Organization System (SKOS) to allow their

universal reuse (Allemang and Hendler 2011). For building-relevant classifications, this means that the concept "external door", its properties "burglary resistance" and its value "Security Class 4 (RC 4) rating according to EN 1627:2011" can be defined, described, published and used in unambiguous ways. Each partner in the communication process and the software tools they use "understands" these the same way without the risk of different interpretations of the semantics or the error-prone handling of its syntax.

In building and construction, a number of vocabularies, classifications and ontologies exist that have been developed using these technologies. The free classification structure FreeClass provides approximately 2,800 concepts pertaining to building materials that are available in 8 languages. This vocabulary has been used to create product catalogs of approximately 70,000 building products by 90 manufacturers in Austria that can be accessed, searched and indexed by search engines in a uniform way (Radinger et al. 2013). The global networking of such data sets is summarized by the notion of **Linked Data** (cf. Chap. 10). In addition to general purpose data sets, such as the semantically annotated form of the Wikipedia corpus, DBPedia (DBPedia 2014; Auer et al. 2007) and Yago (Suchanek et al. 2007), building relevant vocabularies such as the Getty Arts and Architecture Thesaurus (AAT)(Getty 2015) are also available.

The integration and linking of building-related classification systems and building information models using the standardized, established and widespread technologies of the semantic web are an important building block for opening the insular information silos of the building industry to wider, interoperable engineering and business solutions.

8.5 Summary

The structured vocabularies, application areas and technical implementations introduced in this chapter are gaining increasing importance in many use case scenarios of the building industry, and are already an indispensable part of building information modeling technology. Their main purpose is to serve the unambiguous exchange of information by all stakeholders in the building process by providing clear definitions of concepts and terms. Augmenting static models such as Industry Foundation Classes, a prime application area is the annotation of spatial structures, their components and elements. The digitization and machine-readability of building codes, norms and specifications is progressing rapidly and is used in many business practices already today. New developments in the areas of the Semantic Web and Linked Data will further accelerate the integration and dynamic composition of semantically rich information resources in digital building models.

References

Allemang, D., & Hendler, J. (2011). *Semantic web for the working ontologist: Effective modeling in RDFS and OWL*. Waltham, MA: Morgan Kaufmann/Elsevier.

Auer, S., Bizer, C., Kobilarov, G., Lehmann, J., Cyganiak, R., & Ives, Z. (2007). Dbpedia: A nucleus for a web of open data. In *ISWC/ASWC 2007: Proceedings of the 6th International The Semantic Web and 2nd Asian Conference on Asian Semantic Web Conference* (LNCS, Vol. 4825, pp. 722–735).

Berners-Lee, T., Hendler, J., & Lassila, O. (2001). The semantic web. *Scientific American, 284*(5), 28–37.

buildingSMART. (2015). *buildingSMART data dictionary – ISO 12006-3 based ontology for the building and construction industry*. Retrieved from http://bsdd.buildingsmart.org/. Accessed Mar 2018.

CPIC – Construction Project Information Committee. (2015). *Uniclass2 classification tables*. Retrieved from http://www.cpic.org.uk/uniclass2/. Accessed Mar 2018.

DBPedia. (2014). *The DBpedia knowledge base*. Retrieved from http://dbpedia.org. Accessed Mar 2018.

Getty. (2015). *The Getty research institute art & architecture thesaurus*. Retrieved from http://www.getty.edu/research/tools/vocabularies/aat/. Accessed Mar 2018.

Giertz, L. (1982). SFB and its development 1950–1980. CIB/SFB International Bureau/Foras Forbartha Distributor, Dublin.

Gruber, T. (1993). A translation approach to portable ontology specifications. *Knowledge Acquisition, 5*(2), 199–220.

ISO 12006-2. (2001). *Building construction – Organization of information about construction works — Part 2: Framework for classification of information*. Geneva, Switzerland: International Organization for Standardization.

ISO 12006-3. (2007). *Building construction – Organization of information about construction works — Part 3: Framework for object-oriented information*. Geneva, Switzerland: International Organization for Standardization.

ISO 13567-1. (1998). *Technical product documentation – Organization and naming of layers for CAD — Part 1: Overview and principles*. Geneva, Switzerland: International Organization for Standardization.

Lenat, D. B., & Guha, R. V. (1989). *Building large knowledge-based systems: Representation and inference in the CYC project*. Boston, MA: Addison-Wesley Longman Publishing Co., Inc.

Radinger, A., Rodriguez-Castro, B., Stolz, A., & Hepp, M. (2013). BauDataWeb: The Austrian building and construction materials market as linked data. In *I-SEMANTICS 2013: Proceedings of the 9th International Conference on Semantic Systems*, Graz, Austria (pp. 25–32). ACM.

Studer, R., Benjamins, V. R., & Fensel, D., (1998). Knowledge engineering: Principles and methods. *Data & Knowledge Engineering, 25*(1–2), 161–197.

Suchanek, F. M., Kasneci, G., & Weikum, G. (2007). Yago: A core of semantic knowledge. In *Proceedings of the 16th International Conference on World Wide Web*, Alberta, Canada (pp. 697–706). ACM.

W3C. (2014). *RDF 1.1 concepts and abstract syntax*. W3C recommendation 25 Feb 2014. Retrieved from http://www.w3.org/TR/rdf11-concepts/. Accessed Mar 2018.

Chapter 9
COBie: A Specification for the Construction Operations Building Information Exchange

Kevin Schwabe, Maximilian Dichtl, Markus König, and Christian Koch

Abstract The Construction Operations Building information exchange (COBie) is a specification that evolved from the idea of Computer Aided Facility Management (CAFM). The specification describes processes and information requirements which streamline the handover of specific data from the design and construction phases to the facility's operation and maintenance (FM). Until now, the handover comprises a bulk of paper or e-paper documents, but extracting FM relevant information from these documents is considered to be tedious work. Therefore, the key idea of COBie is to incrementally gather and systematically store relevant information in a digital form as soon as they emerge in the project. To realize an effective data exchange and to guarantee market neutrality, the COBie specification suggests open formats, such as Extensible Markup Language (XML), SpreadsheetML or the IFC STEP format. These formats are meant for system-to-system data exchange. However, the implementation status of COBie is still at early stages. In practice, the creation of COBie deliverables is seen as problematic, due to wrong understanding of end users as well as insufficient software implementation. This ultimately lowers the acceptance among practitioners. Nevertheless, the potential benefit for the employer can be significant, if further technical and practical improvements are achieved.

9.1 Introduction

In the course of planning and constructing buildings a multitude of information emerges before the commissioning of the built facility. If this information was properly stored, it could significantly simplify the operation, maintenance and the monitoring of assets within a facility. Traditionally, information about construction

K. Schwabe (✉) · M. Dichtl · M. König
Chair of Computing in Engineering, Ruhr-Universität Bochum, Bochum, Germany
e-mail: kevin.schwabe@rub.de; maximilian.dichtl@rub.de; koenig@inf.bi.rub.de

C. Koch
Chair of Intelligent Technical Design, Bauhaus-Universität Weimar, Weimar, Germany
e-mail: c.koch@uni-weimar.de

© Springer International Publishing AG, part of Springer Nature 2018
A. Borrmann et al. (eds.), *Building Information Modeling*,
https://doi.org/10.1007/978-3-319-92862-3_9

projects is provided by means of construction drawings and other paper documents. However, the handover of a bulk of information stored as paper or e-paper documents from the contractors to the employer's facility management, facility operations or facility maintenance (FM) has shown several disadvantages. One of the greatest challenges is the manual extraction of FM-relevant information from an information pool that is considerably larger than needed. Since large building projects include thousands or even tens of thousands of documents this manual information extraction is very time consuming (WBDG 2016) and prone to errors.

Even if the information is retrieved within a reasonable timeframe it still has to be transcribed from the paper document to machine-readable digital information for further processing in Computer Aided Facility Management (CAFM) software. Moreover, relevant information may not be transmitted even though it was generated during the precedent phases. Hence, unnecessary additional working hours, due to the gathering of information that already exists, are inevitable. In consequence the optimization of this information exchange process can lead to a significant reduction of errors as well as to time and cost savings, especially for the employer.

This forms the starting point for the Construction Operations Building Information Exchange (COBie) specification. COBie defines a hierarchical data structure for the efficient building information exchange from the preoperation phase to the FM. COBie data mainly provides non-geometric building information, collected during the design and construction phase by different actors incrementally. This forms a subset of model data and thus, a subset of the Industry Foundation Classes (IFC, see Chap. 5), which can be represented by a Model View Definition (MVD, see Chap. 6, buildingSMART 2013). After the handover of information from the construction to the Operations and Maintenance phase (O&M) the FM keeps on feeding information into the CAFM software. Due to this process the FM-relevant information is up-to-date at every phase and enables the FM to work efficiently.

The use of COBie should be contractually specified to clarify the responsibilities of information collection, as well as to concretize the Level of Information (LOI) by the employer. As a consequence, the contractors will know when and where to collect and store which information. A number of different software applications such as planning, commissioning, operations, maintenance and asset management software already support COBie.

COBie, published by the US Army Corps of Engineers in 2007, is part of standards such as the National Building Information Modeling Standard (NBIMS) of the USA and the British code of practice BS 1192-4:2014 (Lea et al. 2015). The effective use of the COBie specification has been demonstrated by several public and commercial projects (East 2012). Several other information exchange projects are also available apart from COBie.

9.2 Information Exchange Projects in the NBIMS

Not only the information exchange between design, construction and facility management is important during the lifecycle of a construction project. On that account, there are additional projects, for example in the NBIMS, that specify standards how information regarding a specific subject area should be exchanged.

An information exchange project should always consist of a statement of requirements which is expressed using the IDM-Method (Information Delivery Manual-Method, see Chap. 6) and the resulting technical specification (East 2016a). This specification is a subset (MVD) of the IFC standard (ISO 16739, buildingS-MART 2013). COBie, for example, is integrated in the NBIMS as a MVD called the Facility Management Handover Model View Definition. Furthermore, in many cases there is a need of a dictionary to clarify the nomenclature of the involved information exchange partners. Therefore, the National Information Exchange Model (NIEM) was created in the US and a COBieLite-XML version of it was developed (East 2013a). The date reliability of projects can be significantly streamlined using the information exchange projects. An assortment of information projects already rooted in the NBIMS include (NIBS 2015; East 2016a)

- Construction Operations Building information exchange (COBie),
- Life-Cycle information exchange (LCie),
- Heating, Ventilation, and Air Conditioning information exchange (HVACie),
- Electrical information exchange (Sparkie),
- Water System information exchange (WSie) and
- Building Programming information exchange (BPie).

For instance, for WSie the requirements of geometric location and properties of (1) piping components, (2) control components and (3) mixing/transformation components were identified. Hence, the modeling of a sink in WSie has to include a potable hot and cold water connection as well as a wastewater connection (East 2013b). For further information see East (2016a) and NIBS (2015).

9.3 Workflows and Technologies Behind COBie

9.3.1 Identify Requirements

The incremental gathering of information by the involved actors has to be specified as mandatory by the employer before the project starts and the specific LOI should be included into the contract. To realize the information exchange efficiently the Information Delivery Manual (IDM) can be used. Among others, the IDM identifies business processes with their associated input and output information requirements (Data Drops). Based on the IDM the COBie specification defines business processes. These processes interconnect the contractor's supply chain management with the

owner representative's quality assurance process. For that purpose the COBie standard suggests the following nine processes (East 2012)

1. identify submittals requirements,
2. define submittal schedule,
3. transmit submittal,
4. approve submittal,
5. install equipment,
6. commission equipment,
7. provide warranties,
8. provide spare parts sources and
9. transmit handover information.

The processes as well as the worksheets are ordered according to the time at which the information appears in the project and hence they can be processed consecutively. Every relevant process is described in a business process diagram using the Business Process Model and Notation (BPMN) and is further explained for each process step (East 2012). Figure 9.1 shows an extraction of the second COBie-process (define submittal schedule).

This process begins with the approved submittal register produced in the previous process which includes a list of all items that have to be submitted by the contractor. In the example considered here, the contractors receive the register to be able to use the submittal requirements in their internal construction scheduling methods, e.g., a Critical Path Method (CPM). As a result, the contractor adds dates for item approval, item transmittal, material on-site and further general information such as author's contact information to the register. The COBie specification therefore provides a specific structure and notation (Table 9.1). Not shown in Fig. 9.1, but contained in the standard are the approval process of the Owner's Representative,

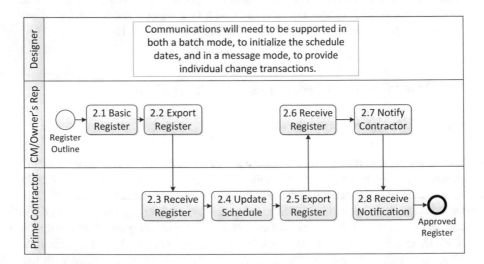

Fig. 9.1 Define submittal schedule process map. (Based on East 2012)

Table 9.1 Submittal schedule data requirement according to East (2012)

Name	Type	Reqd/Opt	Description
RegisterItemID	String	ReadOnly	Project-specific ID
RegisterScheduleCPMTask	String	Reqd.	Construction schedule link
RegisterScheduleSubmitBy	Date	Reqd.	Planned date for item transmittal
RegisterScheduleApproveBy	Date	Reqd.	Needed date for item approval
RegisterScheduleDeliveryBy	Date	Reqd.	Needed date for on-site material
RegisterScheduledBy	Contact	Reqd.	Author's contact information
RegisterScheduledOn	Date	Reqd.	Date action taken

the integration of sub-contractors and the modification of the register over time. For further information about the other processes the authors recommend the COBie specification (East 2012).

9.3.2 COBie File Formats

The COBie specification does not invent or define a new technology for data exchange. It simply takes existing technologies and applies them to the process of data exchange during project handover. The corresponding technologies are open exchange formats (IFC) and subsets of IFC data (MVD). However, four years have passed until the idea of COBie (in 2007) was finally realized as the Facility Management Handover Model View in cooperation with the buildingSMART alliance (in 2011) (East et al. 2013). The MVD narrows down the large amount of information within an IFC model to a small portion by filtering mostly non-geometric data. The export of geometry specific entities, such as IfcBeam or IfcColumn, is optional and can be included in specific cases if needed (East et al. 2013). Since the COBie specification was designed to be interoperable it can be realized using different file formats, such as IFC (buildingSMART 2013), XML, or SpreadsheetML. All formats are designed for system-to-system exchange and are not meant for direct user interference (WBDG 2016). COBie files contain information about

- maintenance,
- operations and
- asset management

and this information is provided at different project stages mainly by designers and contractors (East 2012). That implies that the information is gathered and entered progressively in small portions by different actors into a *COBie deliverable*. COBie deliverables are files that have to deliver certain data at a certain point in time. It represents the FM relevant information for a single facility. Typically transmitted information includes, for example, the room allocation plan, types of devices, manufacturers, serial numbers, maintenance intervals or warranty information

(East 2012). In addition, a COBie deliverable usually contains an appendix of e-documents such as product specifications, user manuals, maintenance instructions or technical drawings. Besides the traditional IFC formats STEP and ifcXML, this MVD allows the use of SpreadsheetML, which can be interpreted by common spreadsheet software, for example Microsoft Excel. This decision has both positive and negative impact on the practicability of COBie. Advantages and disadvantages as well as problems considering software implementation will be explained and discussed in Sect. 9.5.

9.3.3 Workflow of Data Transfer

The following description of the COBie data transfer concentrates on the spreadsheet format, because it is easier to visualize and it has gained the highest popularity among practitioners so far (Yalcinkaya and Singh 2016). In general, before data is exchanged, specific requirements have to be met. One necessary aspect is the contractually binding specification of dates and responsibilities for the gathering and delivery of COBie data. Therefore, it is important that the use of COBie is contractually agreed upon so that the additional effort can be financially compensated and dates and responsibilities will be held. In a real project this can be accomplished by defining COBie deliverables in the master information delivery plan (MIDP). If the COBie deliverables are defined at different stages of the project, the process of data exchange can be successful. Figure 9.2 shows the schematic process of data exchange within a fictitious construction project in a process map. The example shows the three main phases of a construction project: design, construction and operation. During all of these stages relevant data is gathered and added to a COBie file. This file will be exchanged and expanded throughout the whole project. In the example during design phase spatial data (e.g., rooms, zones etc.) is exported to a file. During construction phase the company installing components of HVAC and inventory will expand the file with additional data. At the beginning of the operations phase the facility managers will import the file and enrich it with maintenance schedules and other maintenance related information with the help of CAFM. This data can then be accessed during operations phase.

The two magnifying glasses in Fig. 9.2 symbolize that the targets to be magnified, in this case the COBie files, will be explained in further steps. The colored numbers show in which specific step they will be described. The building model of the accompanying example project consists of the *Duplex Apartment*. This building model is an openly accessible model provided by NIBS (East 2016b) for open research and testing purposes.

File 1:

The first file (1) to be examined includes data that has been gathered during or after the design phase. The actual file in spreadsheet format is depicted in Fig. 9.3. In the

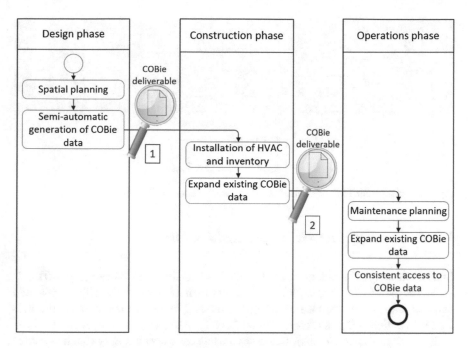

Fig. 9.2 Schematic process map of data delivery in a construction project

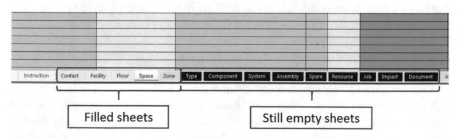

Fig. 9.3 Example file 1: COBie spreadsheet export after design phase

file the sheets contain spatial data, for example in sheets such as *Space* or *Zone*. The other sheets contain no data, for example sheets such as *Component* or *System*.

File 2:

The second file (2) to be examined includes data gathered during or after the construction phase. The actual file can be seen in Fig. 9.4. Existing sheets are still filled with the spatial data from the design phase. But now the additional sheets *Type*, *Component* and *System* are filled with information about the built-in inventory.

There are still empty sheets that have to be filled, such as *Spare* or *Job*. These sheets are filled at the beginning of and during the operations phase, when the facility managers have finished the maintenance plan to ensure the accessibility of the data throughout the operation of the facility.

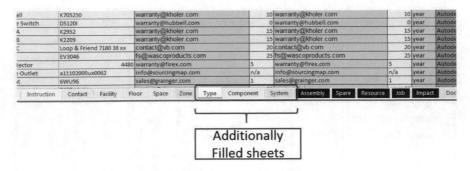

Fig. 9.4 Example file 2: COBie spreadsheet export after construction phase

9.3.4 Content of a COBie Spreadsheet File

In the following the structure of the spreadsheet version is explained (Fig. 9.5).

The core of a COBie spreadsheet file consists of 18 worksheets with internal and external links. As can be seen from Fig. 9.5 the building information transmitted via a COBie deliverable is structured hierarchically. A *Facility* is composed of *Floors* which contain *Spaces* (rooms). Those spaces can form specific *Zones* such as a zone rented by an enterprise as office space or a surgical ward in a hospital. The worksheet *Type* characterizes superordinate items such as different door types (e.g., doors of a certain fire protection class), which are represented as instances in the worksheet *Component*. Those components can form a system such as the heating system of an apartment. Hence, all the components that form a system are mapped in the *System* worksheet.

Operations and maintenance jobs, such as a boiler inspection interval, are represented in the *Job* worksheet. Furthermore, resources such as tools (ladder), materials (boiler chemicals) or trainings for the personnel (basic electricity course) needed to complete the job are specified. Resources are described in the *Resource* worksheet and information about spare parts may be obtained from the *Spare* worksheet. The worksheets highlighted in green boxes link their information to all the other sheets which are affected by the information. The columns *SheetName* and *RowName* are used as a composed key.

An internal link is a connection between information in the worksheets, for instance floor, space and zone. A zone **Apartment** C is composed of various spaces such as kitchen, living room, bathroom etc. It is linked through the column *SpaceNames* with those spaces, for example the kitchen **C301**, which itself is linked again through the column *FloorName* to the floor **Level 3** (see Fig. 9.6). Items such as doors (worksheet *Component*), which are installed between two spaces (kitchen C301, living room C302) are linked in the same way, but the link key is then composed of two spaces separated with a comma (see Fig. 9.5). Links to documents in the appendix are also declared as internal links, whereas external links contain, e.g., information gained in external software (Fig. 9.5).

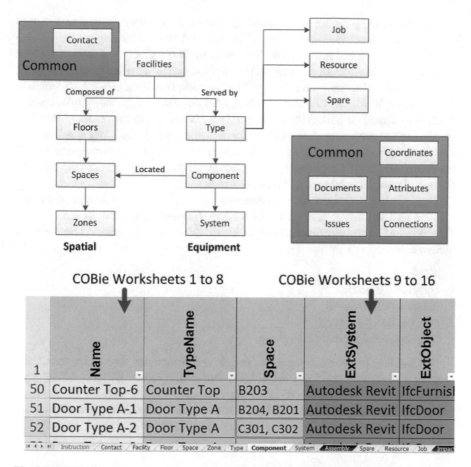

Fig. 9.5 COBie data structure and content. (Modified from AEC Digital Solutions 2015)

Fig. 9.6 Color coding and internal links across sheets (extract)

For a better overview and understanding of the information, a COBie spreadsheet can contain a specific color coding (Figs. 9.5 and 9.6) according to the characteristics of the entered information. Yellow symbolizes sheets and columns which contain required information, whereas information that is specified as required in the contract (Master Information Delivery Plan) is marked as light green. References to other sheets/pic lists or to external sources are colored orange and purple respectively. Additional columns colored in gray may be added to the standard template sheets, such as product specific data, region specific requirements and specifications determined by the employer. In the worksheet *Introduction* a short explanation of the above mentioned functionalities is given. For further understanding the data, the supported querying and sorting functions can be used.

The COBie spreadsheet file also matches information with project phases in the *Introduction* worksheet and hence provides a framework for the instant of time at which FM relevant information can be meaningfully collected. These phases include:

- all phases,
- early design phase,
- detailed design phase,
- construction phase and
- operations and maintenance phase.

For instance, information regarding people and companies involved in the COBie process (*Contact* sheet) should be entered during all phases, whereas information about floors and spaces (*Floor* and *Space* worksheet) are entered in the early design phase. The COBie Responsibility Matrix (East 2016c) is a template for the specification of responsibilities for the worksheets and columns and also provides the schema of the COBie spreadsheet.

9.3.5 File Format COBieLite

COBieLite is an Extensible Markup Language (XML) document schema that was designed for software to software information exchange and is a National Information Exchange Model (NIEM) conformant format. Hence it is mostly attractive to software designers who want to include a COBie im- and export in their products. Due to the lean structure of the format the term Lite was included into COBieLite. It is free of unnecessary spreadsheet visualization information and due to its child-parent nesting computationally less expensive than the COBie spreadsheet version (Bogen and East 2016).

The COBieLite XML Schema Definition (XSD) cobielite.xsd (Bogen and East 2016) specifies the structure of a COBieLite XML file. Hence elements defined

in the schema may be used in the instances which are the COBieLite XML files. Furthermore, the namespace core.xsd defines the nomenclature of the elements in a COBieLite file. The location of a schema (link to webpage) should be included into the XML file to enable, for instance, XML-parsers to load the XML file if the underlying schema is not yet known by the parser. The information depth of a COBie file should not be dependent upon the file format, meaning that COBie files of the same project and instant of time should include the same information, even though they are of different format. Hence, the before described structure of information is nearly the same in the different formats. Only the technical implementation of the information differs.

9.3.6 Structure and Content of a COBieLite File

The following example is an extract of the *Medical Clinic* COBieLite and spread-sheet deliverable. This building model is another openly accessible model provided by NIBS (East 2016b). In the upper left corner of Fig. 9.7 the first lines of the *Component* sheet in the spreadsheet file are shown. The component **AC Unit Type 1 AC-1** is a type of **AC Unit Type 1** and located in the space **1B21**.

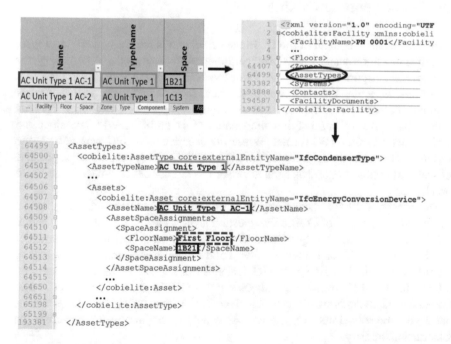

Fig. 9.7 Extract of the Medical Clinic COBieLite deliverable (handover) (East 2016b)

The same information can be delivered using COBieLite. The main structure of a COBieLite deliverable is depicted in the upper right corner of Fig. 9.7. There are less XML elements at the first and second hierarchical level than worksheets in the COBie spreadsheet version because the information of the other worksheets is nested into the higher levels. For example, the Type sheet is represented by the XML element *AssetTypes* (Fig. 9.7 at the bottom). In this element not only the type elements can be found. Components which belong to a special type are nested as child elements into the *AssetTypes*. In this example the information of the component **AC Unit Type 1 AC-1** is nested into the type **AC Unit Type 1**. The *SpaceAssignment* specifies the location of the component. The dots in the figure represent omitted parts of the XML file (for basic understanding) such as *AssetAttributes* and *AssetDocuments*.

The exchange of this deliverable does not differ from the exchange of a COBie spreadsheet version, meaning that the XML file contains the same data and is filled incrementally in each project phase similar to its spreadsheet counterpart. This means that the choice of format should have no impact on the content. However, the way of creating the file may depend on the quality of export implementation in the particular software.

9.4 Implementation Status

While the technical content of the COBie specification is relatively well developed, the implementation status of COBie compliant software products necessary for the consistent export of COBie data is not yet on the same level. This may root within the respective software company. Either lack of ambition, skill or money to implement consistent export functionalities for open data exchange formats at this time result in unsatisfying file quality. This problem is known since the implementation of the IFC format. While the acceptance of IFC was poor in the beginning, it is now highly accepted among interdisciplinary practitioners, because software export and import has been improved. A similar development is predicted for COBie.

The acceptance of a technology is strongly related to the simplicity of its application. In the case of COBie the question is: how easy is it to produce a useful COBie file? To answer the question and to give a status quo of the acceptance of COBie, buildingSMART United Kingdom and Ireland performed a survey among practitioners in 2014 (buildingSMART UK and IRL 2016). The results can be seen in Fig. 9.8. Only 12% of the respondents say that COBie is easy to produce, while 88% of the respondents are disagreeing. To conclude, there are still certain problems that have to be solved until COBie will be widely spread and welcome across the construction industry.

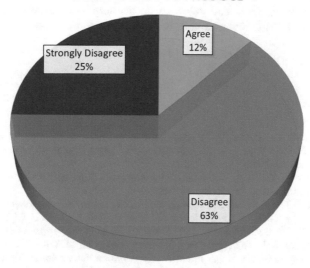

COBIE IS EASY TO PRODUCE

Fig. 9.8 Survey about production of COBie files in United Kingdom (buildingSMART UK and IRL 2016)

9.5 Summary

The general idea of COBie has been widely accepted in the facility management sector. However, the realization into practice is still at early stages. This is mostly due to the misunderstanding of the different file formats. In particular, the SpreadsheetML format gives the impression that data manipulation is to be performed within spreadsheet software such as Microsoft Excel. But the actual purpose of exchange formats is not more than system to system data exchange. Still, the user-friendliness and experience of working with Excel has seduced users to thinking that the result of COBie is an Excel file. Thus, the manipulation of data is often mistakenly performed using Excel. Recent research has shown that complex dependencies between cells and sheets exceed the cognitive capacity of the human brain (Yalcinkaya and Singh 2016). Therefore, the intention of reducing errors during data exchange remains unsolved. This makes the superficial convenience of using known spreadsheet software to be inconvenient in reality. This contributes to the argument stated in Sect. 9.4 that the technology behind COBie is less of a problem than the false application in practice.

All of these problems combined leave the creation of COBie deliverables to be tedious work. This ultimately lowers the acceptance among practitioners. Even more frustrating for the contractors who put a lot of work into delivering demanded COBie data is that changes in the model are not directly applied to the COBie file and vice versa (Hannell 2016).

In practice the demand of COBie often cannot be satisfied. Therefore, a lot of research is in progress and needs to be accomplished to solve the problems mentioned above. This includes both the technical optimization and the practical implementation.

References

AEC Digital Solutions. (2015). *AEC digital solutions portfolio: COBie/Level 2 BIM*. Retrieved 10 Apr 2018, from https://www.slideshare.net/AEC_Digital_Solutions/aec-digital-solutions-portfoliocobielevel-2-bim

Bogen, C., & East, E. W. (2016). *COBieLite: A lightweight XML format for COBie data*. Retrieved 10 Apr 2018, from https://www.nibs.org/?page=bsa_cobielite

buildingSMART. (2013). *Construction operations building information exchange: MVD for IFC4*. Retrieved 10 Apr 2018, from http://docs.buildingsmartalliance.org/MVD_COBIE/

buildingSMART United Kingdom and Ireland. (2016). *Judging the performance of level 2 BIM*. Retrieved 10 Apr 2018, from http://www.bre.co.uk/enews/bre/bsUKI/bsUKI_jun14.html

East, E. W. (2012). *Construction-operations building information exchange (COBie)*, buildingSMART alliance, National Institute of building Sciences, Washington, DC. http://www.nibs.org/?page=bsa_cobie (cited 27 Sept 2017)

East, E. W. (2013a). *Life cycle information exchange (LCie)*, buildingSMART alliance, National Institute of building Sciences, Washington, DC. http://www.nibs.org/?page=bsa_lcie (cited 27 Sept 2017)

East, E. W. (2013b). *Water system information exchange (WSie)*, buildingSMART alliance, National Institute of building Sciences, Washington, DC. http://www.nibs.org/?page=bsa_wsie (cited 27 Sept 2017)

East, E. W. (2016a). *Information exchange projects*. Retrieved 27 Sept 2017, from https://www.nibs.org/?page=bsa_infoexchange

East, E. W. (2016b). *Common building information model files and tools*. Retrieved 27 Sept 2017, from https://www.nibs.org/?page=bsa_commonbimfiles

East, E. W. (2016c). *COBie responsibility matrix*. Retrieved 27 Sept 2017, from http://projects.buildingsmartalliance.org/files/?artifact_id=4093

East, E. W., Nisbet, N., & Liebich, T. (2013). Facility management handover model view. *Journal of Computing in Civil Engineering, 27*(1), 61–67. https://doi.org/10.1061/(ASCE)CP.1943-5487.0000196

Hannell, A. (2016). *COBie is already an outdated method of data management*, Retrieved 5 Dec 2017, from http://www.bimplus.co.uk/people/cobie-already-outdated-method-data-management/

Lea, G., Ganah, A., Goulding, J., & Ainsworth, N. (2015). Identification and analysis of UK and US BIM standards to aid collaboration. In: L. Mahdjoubi, C. Brebbia, & R. Laing (Eds.), *BIM 2015* (pp. 505–516). Southampton: WIT Press

NIBS. (2015). *National BIM Standard – United States version 3*. Retrieved 10 Apr 2018, from https://www.nationalbimstandard.org/

WBDG. (2016). *Construction-operations building information exchange (COBie)*. Retrieved 10 Apr 2018, from: https://www.wbdg.org/resources/cobie.php

Yalcinkaya, M., & Singh, V. (2016). Evaluating the usability aspects of construction operation building information exchange (COBie) standard. In *Proceedings of the CIB World Building Congress*, Tampere. https://www.researchgate.net/publication/303811016_Evaluating_the_Usability_Aspects_of_Construction_Operation_Building_Information_Exchange_COBie_Standard

Chapter 10
Linked Data

Pieter Pauwels, Kris McGlinn, Seppo Törmä, and Jakob Beetz

Abstract In this chapter, an overview of the current state of the art, future trends and conceptual underpinnings of Linked Data in the field of Architecture and Construction is provided. A short brief introduction to the fundamental concepts of Linked Data and the Semantic Web is followed by practical applications in the building sector that include the use of OpenBIM information exchange standards and the creation of dynamic model extensions with external vocabularies and data sets. An introduction into harnessing the Linked Data standards for domain-specific, federated multi-models and the use of well-established query and reasoning mechanisms to address industry challenges is introduced. The chapter is concluded by a discussion of current developments and future trends.

10.1 Introduction

A wide range of domain experts are involved in the design, planning, construction and maintenance of the built environment. This requires close cooperation between the different experts and constant exchange and integration of heterogeneous information resources throughout all life cycle stages. The information these

P. Pauwels (✉)
Department of Architecture and Urban Planning, Ghent University, Ghent, Belgium
e-mail: pipauwel.pauwels@ugent.be

K. McGlinn
Trinity College Dublin, School of Computer Science and Statistics, O'Reilly Institute, Dublin 2, Ireland
e-mail: Kris.McGlinn@adaptcentre.ie

S. Törmä
VisuaLynk Oy, Espoo, Finnland
e-mail: seppo.torma@visualynk.com

J. Beetz
Chair of Design Computation, RWTH Aachen University, Aachen, Germany
e-mail: beetz@caad.arch.rwth-aachen.de

© Springer International Publishing AG, part of Springer Nature 2018
A. Borrmann et al. (eds.), *Building Information Modeling*,
https://doi.org/10.1007/978-3-319-92862-3_10

181

stakeholders generate and process, stem from a variety of sources and is obtained, generated and transformed using a variety of data sources and software tools. Hence, interoperability is a crucial aspect to facilitate the business processes of the industry. This central aspect of Building Information Modeling is addressed – among others – by specialized data exchange models such as the IFC (see Chap. 5), the process-driven formalization of tool-independent Exchange Requirements (Chap. 6) or the definition of common data environments (Chap. 15), and forms the basis of collaboration (Chap. 14) and coordination (Chap. 13). To date however, much of the data exchanged as well as the formal description of information, for example as a meta model schema (Chap. 3) or knowledge model (Chap. 8), all come with their own data formats, are communicated mostly through files and are only loosely and implicitly related to each other. The Linked Data concept addresses these important aspects by providing concepts and technical standards to overcome these inhibiting factors for information exchange. In this chapter, the fundamental concepts of Linked Data and their applications in the building industry are introduced.

10.2 Concepts of Linked Data and the Semantic Web

The origins of Linked Data can be traced back to the invention of the World Wide Web (WWW) and the Semantic Web (Berners-Lee 2001). Where in the WWW, only a single *generic* type of hyperlink reference exists (the "href" element in the HTML standard), that for example connects one word with a section in another hypertext document, the Semantic Web uses links that are *specialized* and attributed with additional meaning. As such, the researchers and practitioners aiming to build a semantic web, set out to make the human-readable WWW also machine-readable. Whereas a human was required to follow the hyperlinks in the WWW, now a machine would be able to trace the links between data, hence building a semantic web of data.

Similar to the notions of "entities" and "classes" related by "associations" in ERM and OOM (see Chap. 3), information artifacts are described using "concepts" that are related with "properties" to model information in the form of statements. A statement consists of a triple of three Resources referred to as Subject, Predicate and Object. For example, the statement "Wall 1 is connected to Wall 2" can be expressed as

$$\text{"Wall_1"} \rightarrow \text{"isConnectedTo"} \rightarrow \text{"Wall_2"}.$$

By adding additional statements about the same resource "Wall_1", information can be accumulated, e.g.

$$\text{"Wall_1"} \rightarrow \text{"hasLayer"} \rightarrow \text{"Brick_1"}$$

or

$$\text{"Wall_1"} \rightarrow \text{"isLoadbearing"} \rightarrow \text{"True"}.$$

Multiple statements form graphs in which subject resources, such as "Wall_1", form nodes and predicate resources, like "hasLayer", form labeled edges. Altogether, this results in a world wide directed labeled graph.

An important ingredient in these fundamental concepts of Linked Data is that any of the three resources Subject, Predicate and Object can be published anywhere in an accessible network (like the WWW) as long as they can be uniquely identified using standard unique web referencing techniques (Uniform Resource Identifiers – URIs). Like this, resources can be linked to each other not only within the realm of a single model or file, but across file boundaries and networks. This applies to both instance data sets as well as data schemas and vocabularies. It enables the assembly of data models and meta models from distributed partial models on an object level. For concrete data such as information about a particular building, statements about a building element like a wall can be linked together from partial models. For example, the structural engineer contributes the statement that the wall is load bearing, the architect determines the composition of the wall layers, and so forth (see Fig. 10.1).

On a meta model level, this means that different schemas for data models can be reused and integrated using common technologies. This makes the interoperability of the many heterogeneous domain models and information bits used in the construction industry much easier. In other industries and knowledge domains, the linking, reuse and integration of different vocabularies and data sets has been rapidly growing in recent years and has lead to a vast web of interconnected information resources referred to as Linked (Open) Data (LOD or LD). To ensure this, a number of widely accepted technologies has been standardized by the World Wide Web consortium (W3C) that is referred to as the "Semantic Web Stack", as illustrated in Fig. 10.2.

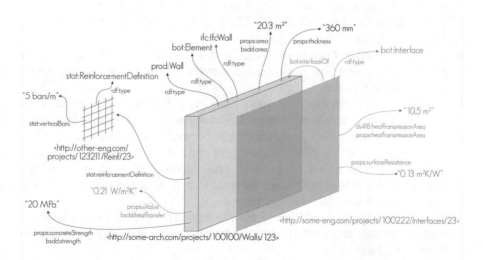

Fig. 10.1 Illustration of how one wall can be semantically described by many people, each one adding its own layer of information (bot, prod, ifc, stat, . . .) (Rasmussen 2017)

Fig. 10.2 Illustration of the Semantic Web stack showing the different technology standards enabling Linked Data and the Semantic Web. Lower tiers show the commonly shared technologies such as URIs, Unicode and XML, which are also used in hypertext documents for the World Wide Web. The Resource Description Framework (RDF) and the schema for modeling vocabularies for taxonomies (RDFS), ontologies (OWL) and Rules (RIF, SWRL) together with the query language SPARQL form the core. They form the basis of the more conceptual layers around Logic, Proof and Trust. (© J. Beetz, reprinted with permission)

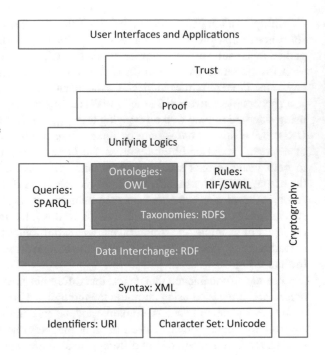

10.3 Technology: The Semantic Web Stack

Linked Data and the Semantic Web consist of a number of integrated technologies that are standardized by the W3C.

- *Uniform Resource Identifiers (URI)* form the backbone of the WWW by providing means to address resources. Their most common form is the Uniform Resource Locator (URL).
- *eXtensible Markup Language (XML)* is the common Markup Language to describe file content (see also Chap. 3), provide simple data types, and can be used as a syntax format.
- The *Resource Description Framework (RDF)* is a data model that specifies the use of triples to form statements as well as additional concepts such as lists, bags, sets and containers. Even though RDF can be written in the form of an XML document (RDF/XML), other formats such as Turtle or JSON-LD can be used to serialize RDF into files. Larger RDF data sets are often stored in specialized databases referred to as triple stores (or quad stores), that can be accessed, linked and queried over regular network structures.
- The *Resource Description Framework Schema (RDFS)* provides a vocabulary to capture concepts as classes, create sub-class relations and specify possible data types and value ranges.
- The *Web Ontology Language (OWL)* provides a modeling vocabulary that extends RDFS with formal logic concepts (Description Logics – DL) to define

additional constraints such as cardinalities or value restrictions. OWL is rooted in earlier Knowledge Engineering vocabularies and enables logical inference (reasoning).

- Similar to SQL for relational databases, the *Simple Protocol and RDF Query Language (SPARQL)* defines a query language to create, read, update and delete data from RDF data sets in a standardized way.
- The *Rule Interchange Format (RIF)* and *Semantic Web Rule Language (SWRL)* can be used to define rules for concepts and their relations in an IF–THEN form.

The main principles lie in the possibility to interlink heterogeneous information resources using the URI, XML and RDF tiers of the stack. The ability to define classes and subclasses of concepts using RDFS and OWL allows to standardize vocabularies (shared conceptualization – Gruber 1993). Furthermore, SPARQL, OWL, RDFS, SWRL, and RIF provide strong mechanisms for querying and reasoning with data. Linking, querying and reasoning are primarily enabled because of the strong reliance on methods from the fields of knowledge engineering and Artificial Intelligence (AI), and more particularly through the use of Description Logics (DL).

Knowledge is organized into three different compounds: rules, concepts, and assertions (see Fig. 10.3). The Terminology Box (TBox) captures conceptual classes with additional restrictions such as "All buildings must have at least one door". This is similar to the concepts of a formal data model schema. Concrete instances of such concepts are captured in the Assertion Box (ABox) as the 'known facts' of a particular Universe of Discourse (UoD). Additional rules in a Rule Box (RBox) allow to further extend the inferences that can be drawn from the ABox and TBox information (IF-THEN rules).

This complete setup (TBox, ABox, RBox) enables generic theorem proofing machines to "understand" the meaning of concepts and negotiate between hetero-geneous systems. The idea of the Semantic Web is to capture information in a way so that not only human readers can make sense of the underlying semantics, but also interconnected machines "understand" what information is being used for. This "Web of Meaning" was introduced in a seminal article in the Scientific American in 2001 (Berners-Lee 2001).

This Semantic web approach to the organization of information, including ABox, RBox, and TBox, faces a number of fundamental challenges including complexity, fragility regarding the rigidness of the underlying models, the necessary processing time, decidability and the usability. The approach in which machine-interpretable information is interconnected in a more agile manner, is referred to as "Linked Data", and this approach is in very active use across many different domains (health-care, biology, publications, media, geography, and so forth). In recent years, many vocabularies and other data sets have been published for public access in order to be reused and help to collectively build up a body of knowledge in different domains.[1]

[1]Linked Open Vocabularies, http://lov.okfn.org/dataset/lov/, accessed November 2017.

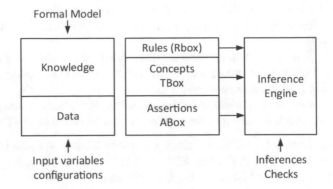

Fig. 10.3 The logic-based layers of the Semantic Web stack allow generic inference machines to draw conclusions from the knowledge model (TBox), the facts asserted about concrete instances (ABox) (e.g. about a particular building) and additional rules (RBox). (© J. Beetz, reprinted with permission)

This is referred to as the Linked Open Data cloud depicted in Fig. 10.4. At its center, the vocabulary most often referenced and linked to other vocabularies is the Linked Data representation of the WikiPedia called DBPedia.

10.4 Linked Data in AEC/FM

To enable the use of Linked Data principles with domain-specific Building Information Models, the information generated by common BIM tools must be represented with the suitable data formats. Until recently, the IFC data exchange model (see Chap. 5) was only available in its native STEP EXPRESS and Step Physical File Formats (SPFF) and could not be accessed and processed using common Linked Data technologies. Data from the building domain was hidden in information silos that are unfamiliar to other engineering domains. Efforts to translate both the data schema and instance models (Beetz et al. 2009; Pauwels and Terkaj 2017) have led to the joint international standardization of ifcOWL, the Ontology Web Language representation of the Industry Foundation Classes under the umbrella of the buildingSMART standardization organization (buildingSMART International 2016). Modeling constructs employed in the specification of the IFC model defined in the EXPRESS language (ENTITY, Attributes, data types etc.) are translated into equivalents from the RDF(S) and OWL modeling vocabularies (Class, ObjectProperty, DatatypeProperty, domains, ranges, etc.) resulting in an OWL meta model for buildings. Based on these schema mappings, instance models exported from standard IFC-enabled industry tools can be represented as RDF Linked Data without loss of information.

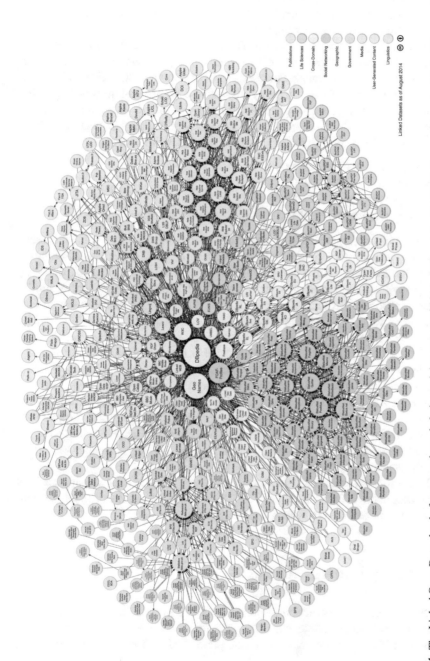

Fig. 10.4 The Linked Open Data cloud of connected vocabularies and data sets as of 2014. At the center, the DBPedia vocabulary is a Linked Data version of the WikiPedia corpus. (© 2014 Linking Open Data cloud diagram, by Andrejs Abele, John P. McCrae, Paul Buitelaar, Anja Jentzsch and Richard Cyganiak, reprinted under CC-BY-SA license. http://lod-cloud.net/)

This work has been further elaborated on. More specifically, several development initiatives have focused on making the ifcOWL ontology, or the IFC ontology, simpler, more modular, and extensible. Some of these works have started from the ifcOWL ontology itself, converting it directly into a simpler form, or adding a simpler version on top (Pauwels and Roxin 2016; de Farias et al. 2015). In this case, the majority of the contribution lies in the automatic inference and generation of alternative constructs that are simpler to query for a developer in the client side. Other development initiatives focus strongly on building a set of ontologies in inspiration from IFC, rather than generating it directly from IFC. In this case, main contributions happen in the W3C Community Group on Linked Building Data (LBD).[2] This group works actively on the creation, publication and maintenance of:

1. Building Topology Ontology (BOT)
2. Product Ontology (PRODUCT)
3. Properties Ontology (PROPS)
4. Geometry Ontology (GEOM)

These four ontologies capture the essence of most of the IFC data sets, namely geometry, building topology, products, and their properties. Modularity, extensibility, and simplicity are at the core of these ontologies. The BOT ontology hereby serves as a key ontology, with just about 7 OWL classes and a similar number of properties (Rasmussen et al. 2017). This ontology captures the core of IFC (building topology), making it available as one of many modules (extensible, modular). In contrast to IFC, this ontology can easily be extended into any domain, then often attracting Facility Management (FM) cases and energy performance modeling cases. The BOT ontology can naturally be extended by the PRODUCT ontologies, which captures the semantics of any tangible object in a building, in combination with the PROPS ontologies. This ontology is closely related to the buildingSMART Data Dictionary (bSDD) and ongoing work around product data in general in Europe. The GEOM ontology allows to capture 3D building data, yet it remains to be seen to what extent one needs to have a fully semantic version of purely syntactical 3D geometry.

All the above work forms the basis for a number of use cases and applications that are described in Sects. 10.5, 10.6 and 10.7. More references to use cases and applications can be found in Pauwels et al. (2017b).

10.5 Multiple Interlinked Models

The design work in construction projects is divided into discipline-oriented tasks relying on discipline-specific expertise and tools. According to the prevailing processes, different designs aim to be completed and utilized independently, and

[2]https://www.w3.org/community/lbd/, accessed November 2017.

therefore there cannot be any real dependencies – for instance, links or other semantically meaningful references – across the models even if they describe different aspects of same objects. For instance, a structural model specifies the implementation-level design of the same walls and slabs that have already been specified from a usage-oriented perspective in an architectural model, but there are still no links from those structural elements to corresponding architectural elements. This is true even when the structural model has been created using the architectural model as a reference model at the background. A reason to the continuing lack of interlinking is the missing information system infrastructure that could allow models to refer to outside information in a live manner, enabling tools to utilize it efficiently.

Due to the missing of interlinking, a common approach to facilitate collaboration across interrelated models is to combine them into a common data environment (see Chap. 15) in the form of coordination or design transfer models. Models stemming from different expert tools, from e.g. architectural, structural or MEP are geometrically superimposed on to each other and checked for clashes, correct element alignment, inconsistencies or other issues. The relations between elements in different models are typically only implicit and cause problems for example by occupying the same physical space when they should not (e.g., structural and mep models) or failing to occupy the same spaces (e.g., structural and architectural).

As changes during the design and planning process are inevitable and occur regularly for example due to changing requirements or iterative design improvements, relations between elements have to be reintroduced into the combined models time and again. Changes to one partial model require to identify the changes and replace the old version of the entire model with the new one and the combination has to be made anew. If corresponding objects would be linked across different models, the management of changes could be approached in a more incremental manner, by looking which objects have changed in a model and how these changes can be projected over the links to other models. Repeated full-model comparisons would be avoided and fine-grained coordination during a design process enabled.

There have been different approaches to sharing interlinked models. First, as a generalization of a file exchange paradigm, there are proposals to share interlinked models in a *container* – for instance, in a file archive such as a zip package. In addition to the model files, the container would include linksets that connect object identifiers across models. Two well-known designs of a container exchange paradigm are Multi Models (Fuchs et al. 2011) and the COINS initiative.[3] Second, as the centralized repositories have become a more common medium for sharing building data, a need to deal with interlinking has also emerged. One approach is *object fusion* (van Berlo 2012) but often more general linking is needed to support complex many-to-many relations between objects. Third, the standardized Linked Data technologies can be used to link models and other building data in a decentralized manner, preserving the data ownership and digital sovereignty of the

[3]http://coinsweb.nl/, accessed March 2018.

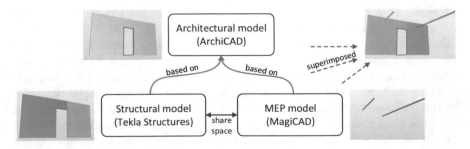

Fig. 10.5 Relationships of three models: architectural, structural and MEP. (© S. Törmä, reprinted with permission)

owner to authorize users and determine the terms and conditions for data use (Törmä 2013, 2014).

The concept of such linked models is to relate objects representing the same physical design artifacts with additional relations that explicitly state which partial domain aspects they represent. Starting from an architectural model, a structural model adds new aspects such as loads or material properties to a model. Figure 10.5 shows a small example of three interrelated models, each containing a couple of elements and specific relations between the models. The example is further elaborated and extended in Fig. 10.6 that shows different parties – owner, architect, structural engineer, and so on – and the respective models they create, such as requirements models, architectural model, and structural model. It also shows the cross-model linking between the elements in the models. For instance, the architectural "Wall1" is decomposed into two structural wall objects "Precast1" and "Precast2" (with the geometry illustrated in Fig. 10.5), for example as precast concrete elements and an "implements" property defined in a linking vocabulary is used to explicitly qualify the relation between the two aspects of the same physical object. Similarly, a ventilation duct "Duct1" modeled in the MEP model as part of a ventilation system serving a particular space in the architectural model requires an opening "Void2" in the "Precast1" provided in the structural model.

All relations are kept separate from the domain models that have been exported by legacy tools in *link sets* that are maintained independently. All links are two-directional, that is, they can be followed from subject to object and vice versa.

Using common Linked Data technologies and formats, the *federated overall model* can be queried and processed using standardized languages and available tools such as SPARQL to e.g. "Get all objects in the linked structural and MEP model that are affected by the relocation of a wall in the architectural model and depending elements such as openings". Or the architect can ponder a possibility of a design change and would like to know "Has the architectural wall Wall1 already been fabricated?" This kind of information is available following the links between the objects in Fig. 10.6.

Even though at present no commercial systems are available that fully support such interlinked models, the upcoming Information Container Data Drop standard

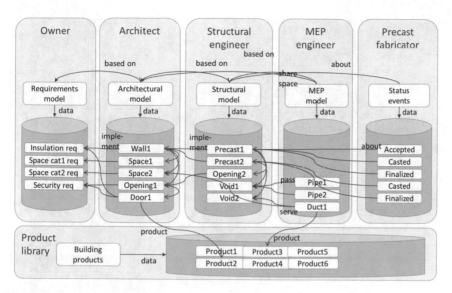

Fig. 10.6 Interlinked models using specialized relationships (implements, serves, spatial overlaps). (© S. Törmä, reprinted with permission)

(ISO 21597) will define object-level links between different models, documents and data sets using Linked Data technology. A wall instance captured in an ifcOWL model can be directly linked to a Linked Data representation of a cost estimation spreadsheet, the results of a structural analysis and the audit trail of a requirement document pertaining to sound insulation.

10.6 Dynamic, Semantic Model Extensions

One of the biggest opportunities of Linked Data technology is the possibility to easily integrate different data sets, schema and vocabularies using a common set of generic technologies. For Building Information Models, this means for example, that additional extensions on both instance and schema level can be dynamically integrated without having to overhaul the entire underlying models: Currently, many industry-led initiatives are underway to extend the IFC model with additional infrastructural domain meta models for bridges, roads, tunnels and railways. Using STEP technologies, this requires significant additions to the IFC schema. This increases the complexity of the schema, and the process of integrating these extensions takes a long period of time for the centralized coordination and standardization of these efforts. It also requires many implementers of software tools to adapt to new editions of the schema even though the respective extension is out of scope of their product.

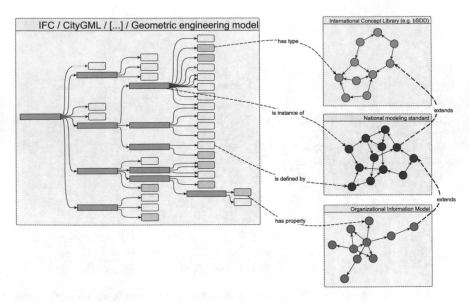

Fig. 10.7 Dynamic model extensions with decentralized Linked Data vocabularies provided by international, local and project-specific concept and object type libraries. (© J. Beetz, reprinted with permission)

Using Linked Data, such extensions can be achieved in a modular way by dynamically linking to vocabularies that can be developed in a decentralized fashion. Further extensions for example to address national standards and regulations or even project-based information requirements that only affect a limited number of stakeholders can be created and used using the same mechanisms without requiring one-of-a-kind tools for their implementation. Generic parts useful in many scenarios such as geometry, are augmented with semantic information from modular vocabularies as depicted in Fig. 10.7. Existing classification systems, taxonomies and ontologies described in Chap. 8 can be used to semantically enrich model objects using common ways to develop, publish, access and process them without having to implement dedicated interfaces like web-service APIs.

Outside of vocabularies and data sets specifically meant for the semantic extension of building information models, a wide range of information structured vocabularies to capture relevant data is available to semantically enrich building data throughout all life-cycle phases of built structures. Some examples (by domain) include:

• **Product Domain:** The GoodRelations Ontology supports describing the types and properties of products and services on the Semantic Web, allowing businesses to semantically define information such as their company, product descriptions, price, store location and shipment information. The freeClass Ontology builds on GoodRelations to provide detailed information for the building and

construction industry, such as building materials. These have been successfully linked to building material vendors (Radinger et al. 2013).

- **Geometry and Spatial Domain:** GeoSPARQL (Open Geospatial Consortium) is an Open Geospatial Consortium (OGC) standard which not only defines a vocabulary for representing geospatial data on the Semantic Web, but also specifies an extension to the SPARQL query language for processing geospatial data. It can support the description of geolocation, as well as simple geometries (2D polygons) to describe, for example, a buildings footprint. Extensions to IFC using GeoSPARQL and Well-Known Text (WKT) have been shown to support integration of geolocation and can potentially provide a means for interlinking based upon geolocation (McGlinn et al. 2017). CityGML describes not only geometry (using the Graphical Modeling Language), but also attributes and semantics of different kinds of 3D city objects, such as roads, tunnels, bridges, etc.[4] Buildings can also be described at five Levels of Detail (LoD). At its most detailed level, this includes descriptions of rooms, furniture, openings and installations (lamps, radiators). In most cases, CityGML is modeled for the external appearance of the building, at LoD2, and is then used to interlink with large city models. The exploration of linking with detailed BIM standards like IFC is an active area of research (Karan and Irizarry 2015; Donkers et al. 2015; Deng et al. 2016).
- **Sensor Domain:** The *Sensor, Observation, Sample and Actuator* (SOSA) and the *Semantic Sensor Network Ontology* (SSN) provide vocabularies to describe sensors and observations that can be used across different domains including energy efficient buildings, Smart Homes and Building Automation Systems as an interoperable alternative to proprietary, vendor-specific formats (SSN 2011; SSN Ontology). SOSA provides a set of core concepts, which are re-used by SSN, but act as minimal interoperability fall-back to help broaden the audience of a standard which is complex to pick up for non-experts.
- **Automation Domain:** The *Smart Appliances REFerence* ontology (SAREF)[5] provides a means to connect different standards, protocols and data models in the domain of smart appliances and can be used for vendor-independent building control scenarios. It has several extensions, including an extension towards building devices based on IFC (SAREF4BLDG Poveda-Villalon and Garcia Castro 2017). The DogONT Ontology was originally designed to support device/network independent description of intelligent domotic environments, including both "controllable" and architectural elements. Today it supports residential, building, and factory automation solutions (Bonino and Russis 2018).
- **Observations and Measurements Domain:** The aforementioned SOSA supports modeling of observations and measurements, as well as samples which are common in scientific observations. QUDT, the *Quantities, Units, Dimensions and Types* vocabulary, originally developed by NASA, provides a universal engi-

[4]https://www.citygml.org/, accessed November 2017.

[5]http://ontology.tno.nl/saref/, accessed November 2017.

neering vocabulary to capture measurements. It enables automated conversions between different measurements.

- **Energy Domain:** The *Architecture and Building Physics Information* for energy related aspects is based on the Green Building XML (gbXML) standard. gbXML is a popular choice for exchanging data required for building energy simulation. Compared to IFC, gbXML has better support for thermal characteristics that are necessary for energy modeling.[6]

- The *Getty Arts and Architecture Thesaurus (AAT)* provides tens of thousands of concepts mostly pertaining to historical buildings and art.

10.7 Querying and Reasoning

For many industry use cases, also those listed in Sects. 10.5 and 10.6, strong reliance on query and reasoning engines is present. Yet, one particular set of the cases outlined by Pauwels et al. (2017b) specifically requires highly efficient query and reasoning languages, namely, checking requirements and checking compliance to building codes.

In such cases, there is a high need to search, filter and validate information in complex and large building information models. While a number of languages, systems and tools have been tailored to the specific needs of the building industry, they are often tied to vendor-specific data formats and cannot be easily extended. For Linked Data, a number of generic query and rule languages are available.

Similar to the Structured Query Language SQL for relational databases, SPARQL has been standardized by the W3C organization and is implemented in many software tools such as graph databases and libraries. Other than SQL, SPARQL is a graph query language, that matches patterns in RDF graphs rather than retrieving information from tables. A basic query in SPARQL is built like this:

```
<prefixes> SELECT <variables> WHERE <pattern>
```

where `<prefixes>` indicate vocabularies that are used with their abbreviations during the query, `<variables>` store the results that should be returned and `<pattern>` is the pattern in the graph that should be matched. Such queries can be efficiently run on dedicated databases called triple or quad stores, that allow to be accessed over networks. The following example query lists the first 100 entries of buildings that have more than 100 floors as they are listed in WikiPedia:

[6]https://www.auto.tuwien.ac.at/downloads/thinkhome/ontology/BuildingOntologyShared Vocabulary.owl, accessed November 2017.

Listing 10.1 Example SPARQL code

```
SELECT DISTINCT ?building, ?name, ?floors
WHERE
{
    ?building a dbo:Building .
    ?building dbo:floorCount ?floors .
    ?building rdfs:label ?name
    FILTER(LANGMATCHES(LANG(?name),''en''))
    FILTER (?floors >= 100)
}
LIMIT 100
```

While some such databases are publicly available such as the DBPedia SPARQL endpoint with more than 3 billion triples, access to sensitive and project-relevant data can also be restricted to authorized roles, or only made accessible within a company's intranet.

Rule languages like SWRL, RIF and other languages like N3 can be employed to encode IF-THEN rules (RBox) that allow to capture parts of building regulations, technical Exchange Requirements or model checking procedures to validate instance models with generic query and reasoning engines. Successful applications include model checking against the Norwegian Statsbygg and Dutch Rijksgebouwendienst BIM norms (Zhang et al. 2015). A comparative study on the scalability and performance of different rule and query languages has been made by Pauwels et al. (2017a). The results of these experiments are promising and international working groups are looking into possibilities to harmonize rule checking systems using established rule languages to augment current implementations based on custom implementations (see Chap. 22).

10.8 Summary

Across industries, Linked Data is recognized as an important set of fundamental methods and technologies to address interoperability and information exchange challenges. The use of universal information identifiers, generic data formats, transfer protocols and higher-level constructs such as conceptual modeling vocabularies founded on formal logics as well as universal query and rule languages are important building blocks to address the specific challenges of an industry that is suffering from a lack of interoperability. Even though the field of Linked Building Data is relatively young, promising results have been achieved and have gained attention well beyond the academic circles.

References

Beetz, J., Van Leeuwen, J., & de Vries, B. (2009). IfcOWL: A case of transforming EXPRESS schemas into ontologies. *Artificial Intelligence for Engineering Design, Analysis and Manufacturing, 23*(1), 89–101.

Berners-Lee, T., Hendler, J., & Lassila, O. (2001). The semantic web. *Scientific American, 284*(5), 35–43.

Bonino, D., & De Russis, L. (accepted – 2018). DogOnt as a viable seed for semantic modeling of AEC/FM. *The Semantic Web Journal.*

buildingSMART International. (2016). *ifcOWL ontology (IFC4)*. Retrieved from http://www. buildingsmart-tech.org/ifcOWL/IFC4 (Accessed Nov 2017).

de Farias, T., Roxin, A., & Nicolle, C. (2015). IfcWoD, semantically adapting IFC model relations into OWL properties. In *Proceedings of the 32nd International CIB W78 Conference*, Eindhoven (pp. 175–185).

Deng, Y., Cheng, J. C. P., & Anumba, C. (2016). Mapping between BIM and 3D GIS in different levels of detail using schema mediation and instance comparison. *Automation in Construction, 67*, 1–21.

Donkers, S., Ledoux, H., Zhao, J., & Stoter, J. (2015). *Automatic conversion of IFC datasets to geometrically and semantically correct CityGML LOD3 buildings*. Trans. GIS, 2015.

Fuchs, S., Kadolsky, M., & Scherer, R. J. (2011). Formal description of a generic multi-model. In *Proceedings of the 20th IEEE International Workshops on Enabling Technologies: Infrastructure for Collaborative Enterprises (WETICE)* (pp. 205–210). IEEE.

Gruber, T. R. (1993). A translation approach to portable ontology specifications. *Knowledge Acquisition, 5*(2), 199–220.

Karan, E. P., & Irizarry, J. (2015). Extending BIM interoperability to preconstruction operations using geospatial analyses and semantic web services. *Automation in Construction, 53*, 1–12.

McGlinn, K., Debruyne, C., McNerney, L., & O'Sullivan, D. (2017). Integrating building information models with authoritative Irish geospatial information. In *Proceedings of the 13th International Conference on Semantic Systems*.

Open Geospatial Consortium. (2012). *GeoSPARQL – A geographic query language for RDF data*. Retrieved from http://www.opengeospatial.org/standards/geosparql (Accessed Nov 2017).

Pauwels, P., & Roxin, A. (2016). SimpleBIM: From full ifcOWL graphs to simplified building graphs. In *Proceedings of the 11th European Conference on Product and Process Modelling (ECPPM)* (pp. 11–18).

Pauwels, P., & Terkaj, W. (2017). EXPRESS to OWL for construction industry: Towards a recommendable and usable ifcOWL ontology. *Automation in Construction, 63*, 100–133. http:// dx.doi.org/10.1016/j.autcon.2015.12.003

Pauwels, P., de Farias, T. M., Zhang, C., Roxin, A., Beetz, J., De Roo, J., & Nicolle, C. (2017). A performance benchmark over semantic rule checking approaches in construction industry. *Advanced Engineering Informatics, 33*, 68–88. https://doi.org/10.1016/j.aei.2017.05.001

Pauwels, P., Zhang, S., & Lee, Y.-C. (2017). Semantic web technologies in AEC industry: A literature review. *Automation in Construction, 73*, 145–165. https://doi.org/10.1016/j.autcon. 2016.10.003

Poveda-Villalon, M., & Garcia Castro, R. (2017). *SAREF extension for building devices*. Retrieved from https://w3id.org/def/saref4bldg

Radinger, A., Rodriguez-Castro, B., Stolz, A., & Hepp, M. (2013). BauDataWeb: The Austrian building and construction materials market as linked data. In *Proceedings of the 9th International Conference on Semantic Systems* (pp. 25–32). ACM. http://doi.org/10.1145/2506182. 2506186

Rasmussen, M. H. (2017). *Linked buiding data*. Presentation in the buildingSMART International Standards Summit, London.

Rasmussen, M. H., Pauwels, P., Hviid, C. A., & Karlshøj, J. (2017). Proposing a central AEC ontology that allows for domain specific extensions. In *Proceedings of the Joint Conference on Computing in Construction (JC3)* (pp. 237–244).

Semantic Sensor Network Ontology. (2011). *W3C semantic sensor network incubator group.* Retrieved from https://www.w3.org/2005/Incubator/ssn/ssnx/ssn (Accessed Nov 2017).

Semantic Sensor Network Ontology. (2017). W3C Recommendation 19 Oct 2017. Retrieved from https://www.w3.org/TR/vocab-ssn/ (Accessed Nov 2017).

Törmä, S. (2013). Semantic linking of building information models. In *IEEE Seventh International Conference on Semantic Computing (ICSC).*

Törmä, S. (2014). Web of building data – Integrating IFC with the web of data. In A. Mahdavi, B. Martens, & R. Scherer (Eds.), *eWork and eBusiness in architecture, engineering and construction: ECPPM 2014* (pp. 141–147). Vienna, Austria: CRC Press.

Van Berlo, L. A. H. M., Beetz, J., Bos, P., Hendriks, H., & van Tongeren, R. C. J. (2012). Collaborative engineering with IFC: New insights and technology. In *Proceedings of the 9th European Conference on Product and Process Modelling*, Iceland.

Zhang, C., Beetz, J., & Weise, M. (2015). Interoperable validation for IFC building models using open standards. *ITcon, 20*, 24–39. Special Issue.

Chapter 11
Modeling Cities and Landscapes in 3D with CityGML

Ken Arroyo Ohori, Filip Biljecki, Kavisha Kumar, Hugo Ledoux, and Jantien Stoter

Abstract CityGML is the most important international standard used to model cities and landscapes in 3D with extensive semantics. Compared to BIM standards such as IFC, CityGML models are usually less detailed but they cover a much greater spatial extent. They are also available in any of five standardized levels of detail. CityGML serves as an exchange format and as a data source for visualizations, either in dedicated applications or in a web browser. It can also be used for a wide range of spatial analyses, such as visibility studies and solar potential. Ongoing research will improve the integration of BIM standards with CityGML, making improved data exchange possible throughout the life-cycle of urban and environmental processes.

11.1 Introduction

Municipalities and other governmental organizations are increasingly using 3D city and landscape models to maintain and plan the environment (see Fig. 11.1 for an example). These models contain 3D data about urban objects such as buildings, roads, and waterways, and the data is collected, maintained and used in applications for urban planning and environmental simulations. Examples of such applications are estimating the shadows cast by buildings and vegetation, simulations of floods and noise propagation, and predicting exposure of roof surfaces to sunlight to assess the potential of installing solar panels. An overview of applications of 3D city

K. Arroyo Ohori (✉) · K. Kumar · H. Ledoux · J. Stoter
3D Geoinformation, Faculty of the Built Environment and Architecture, Delft University of Technology, Delft, The Netherlands
e-mail: g.a.k.arroyoohori@tudelft.nl; k.kavisha@tudelft.nl; h.ledoux@tudelft.nl; j.e.stoter@tudelft.nl

F. Biljecki
Department of Architecture, School of Design & Environment, National University of Singapore, Singapore, Singapore
e-mail: filip@nus.edu.sg

© Springer International Publishing AG, part of Springer Nature 2018
A. Borrmann et al. (eds.), *Building Information Modeling*,
https://doi.org/10.1007/978-3-319-92862-3_11

Fig. 11.1 A subset of The Hague in CityGML, containing terrain and buildings. Cities are increasingly investing in CityGML datasets and are releasing them as open data. (Data courtesy of the City of The Hague. © F. Biljecki, reprinted with permission)

models is available in Biljecki et al. (2015). The most prominent international standard to define the content of 3D city and landscape models is CityGML (Open Geospatial Consortium 2012; Gröger and Plümer 2012). The standard was established in 2008 by the Open Geospatial Consortium (OGC) and is an application independent information model and exchange format for 3D city and landscape models. It models semantics, geometry, topology and the appearance of objects. The standard is supported by an increasing number of vendors who provide import and export functionalities as well as viewers. CityGML database implementations are also available.

This chapter gives an explanation of the standard while addressing its main principles. The chapter is structured as follows:

- Brief overview of the main principles of the standard (Sect. 11.2)
- The principle of Level of Detail (LoD) in CityGML (Sect. 11.3)
- Validation of CityGML datasets (Sect. 11.4)
- Viewing CityGML data over the web (Sect. 11.5)
- Applications of 3D city models (Sect. 11.6)
- BIM and 3D GIS Integration: IFC and CityGML (Sect. 11.7)
- BIM and 3D GIS Integration: gbXML and CityGML (Sect. 11.8)
- Concluding remarks (Sect. 11.9)

11.2 What Is CityGML? A Short Introduction

CityGML was originally developed by the members of the Special Interest Group 3D (SIG 3D) of the initiative Geodata Infrastructure North-Rhine Westphalia (GDI NRW) in Germany. However, it is now an open standard developed and maintained by the Open Geospatial Consortium (OGC).

CityGML defines ways to describe the geometry and attributes of most of the common 3D features and objects found in cities, such as buildings, roads, rivers, bridges, vegetation and city furniture. These can be supplemented with textures and/or colors to give a better impression of their appearance. Specific relationships between different objects can also be stored using CityGML, for example that a building is composed of three parts, or that a building has a both a carport and a balcony. CityGML defines different standard levels of detail (LoDs) for 3D objects. These make it the possible to represent objects for different applications and purposes (Sect. 11.3).

The types of objects stored in CityGML are grouped into different modules. These are:

- **Appearance**: textures and materials for other types
- **Bridge**: bridge-related structures, possibly split into parts
- **Building**: the exterior and possibly the interior of buildings with individual surfaces that represent doors, windows, etc.
- **CityFurniture**: benches, traffic lights, signs, etc.
- **CityObjectGroup**: groups of objects of other types
- **Generics**: other types that are not explicitly covered
- **LandUse**: areas that reflect different land uses, such as urban, agricultural, etc.
- **Relief**: the shape of the terrain
- **Transportation**: roads, railways and squares
- **Tunnel**: tunnels, possibly split into parts
- **Vegetation**: areas with vegetation or individual trees
- **WaterBody**: lakes, rivers, canals, etc.

It is possible to extend this list with new classes and attributes by defining Application Domain Extensions (ADEs). See Sect. 11.6.

11.2.1 Implementation

In its most common implementation, which is the one generally used to disseminate and exchange data, CityGML datasets consist of a set of text files (XML files) and possibly some accompanying image files that are used as textures. Each text file can represent a part of the dataset, such as a specific region, objects of a specific type (such as a set of roads), or a predefined LoD. The structure of a CityGML file is a hierarchy that ultimately extends down to individual objects and their attributes.

Each of these objects have a geometry described using the Geography Markup Language (GML) 3.2.1 (OGC 2012).

Another important implementation of CityGML is the 3D City Database (3D City DB) (3D City Database 2017). It is an open source database schema that implements the CityGML standard on top of a standard spatial relational database (Oracle and PostGIS). The 3D City DB content can be exported into KML, COLLADA, and glTF formats for visualization in a broad range of applications such as Google Earth, ArcGIS, and the WebGL-based Cesium Virtual Globe.

11.2.2 Geometry

Since CityGML is an application schema for GML, all geometries supported by GML are supported by CityGML with one exception: while GML allows the use of non-linear geometries, CityGML uses only linear geometries. Areal features are represented as triangles and polygons, while volumetric geometries are represented as a boundary representation scheme (*b-rep*) using triangles/polygons.

For representing the exterior of a building, the natural choice is a gml:Solid (without interior shells) because it is a volumetric object that must be watertight. Using a gml:Solid, however, implies that the exterior envelope is a 2-manifold, and while the vast majority of buildings can be modeled this way, there are buildings whose exterior envelope is a self-tangent. For these, a gml:Solid should not be used, and its exterior boundary must instead be stored as a gml:MultiSurface, i.e. an unstructured set of surfaces. Another important rule is that the orientation of the surfaces of a gml:Solid must be consistent. A complete list of properties can be found in Ledoux (2013).

11.3 LoD in CityGML

3D city models may be derived at different levels of detail (LoDs), depending on the acquisition technique and intended application of the data (Kolbe 2009). CityGML supports storing multiple representations, and differentiates between them by defining five LoDs depending on the geometric and semantic complexity of the model (Fig. 11.2).

For buildings, the following LoDs are described. **LoD0** is a footprint containing its elevation and optionally a polygon representing the roof edges. Such models represent the transition from 2D to 3D GIS but do not contain volumetric features. **LoD1** is a block model that is usually derived by extruding a footprint to a uniform height (Arroyo Ohori et al. 2015). LoD1 models are used for a wide range of applications, such as computational fluid dynamics (Amorim et al. 2012). and can be acquired automatically with a number of different techniques, such as using existing data in cadastral databases or analyzing point clouds derived from

Fig. 11.2 CityGML datasets at different LoDs: LoD1 (top left), LoD2 (top right), LoD3 (bottom left), and LoD4 (bottom right). (Data courtesy of: Kadaster, AHN, City of Rotterdam, and Karlsruhe Institute of Technology. © F. Biljecki, reprinted with permission)

airborne laser scanning. Due to their favorable balance between usability and easy of acquisition, LoD1 models are popular and widely available (Biljecki et al. 2018). **LoD2** includes a generalized roof shape and larger roof superstructures, making them useful, for example, for rooftop solar potential estimations (Bremer et al. 2016). They are usually obtained using photogrammetric techniques, and may be derived automatically (Haala and Kada 2010). **LoD3** is a detailed architectural model containing roof overhangs, openings, and other façade details. Models at LoD3 are usually obtained by converting data from BIM models or using terrestrial laser scanning (Donkers et al. 2016). The presence of windows and other details makes them useful for applications such as energy simulations (Previtali et al. 2014; Monien et al. 2017). The most detailed LoD in CityGML is **LoD4**, which is an LoD3 containing indoor features such as rooms and furniture. LoD4 marks the boundary between GIS and BIM. Datasets modeled at LoD4 are useful for spatial analyses that integrate both outdoor and indoor features, for example the simulation of floods for predicting damage to buildings (Amirebrahimi et al. 2016), or for navigation purposes (Vanclooster et al. 2016; Kim and Wilson 2014).

While many spatial analyses are possible with any of these LoDs, data at finer LoDs is usually of a higher accuracy and produces more reliable results in a spatial analysis (Biljecki et al. 2018). However, these benefits come at a cost, as datasets modeled at high LoDs require more laborious acquisition approaches.

In CityGML, alongside the geometric content, each LoD implies a certain level of semantic information (Stadler and Kolbe 2007). For example, in LoD2 the geometry may be classified into *RoofSurface*, *GroundSurface*, and *WallSurface* among others, which is not possible at LoD1. Nevertheless, CityGML is flexible and

it does not necessitate semantics, e.g. an LoD2 with only geometry and no semantic differentiation is still valid (Biljecki et al. 2016).

11.4 Validation of CityGML Datasets

Collecting geographical data about existing physical objects, which can be done with different acquisition devices (laserscanners, cameras, total-stations), is prone to errors. These errors often propagate to errors in the constructed 3D objects, e.g. objects missing part of a roof, a bridge not connected to the shore, two houses slightly overlapping, houses "floating" a few centimeters above the ground, etc. Such errors are problematic for various reasons: (1) they hinder interoperability as non-watertight solids can make it impossible to convert from one format to another; (2) several spatial operations require valid datasets, e.g. the volume of a non-watertight solid cannot be computed making it unusable for some applications (Steuer et al. 2015); (3) errors such as duplicate surfaces or wrongly oriented surfaces in visualizations of datasets cause artifacts that distract the user.

The validation of a CityGML dataset ensures that it conforms to the standardized specifications and definitions as given in Open Geospatial Consortium (2012). In general, five aspects of data quality should be ensured (OGC 2016; van Walstijn 2015):

1. schema conformance;
2. geometry;
3. semantics;
4. conformance requirements;
5. application-specific rules.

Tools for the first aspect – verifying whether the structure of a GML file conforms to the schemas – are readily available, and this can be considered a solved problem in practice. An open-source tool that can be used is *Apache Xerces*.[1]

Validating geometry means checking whether a given 3D primitive respects the standardized definitions. For a typical volumetric primitive, a `Solid`, several errors are possible, e.g. duplicate bounding surfaces, non-watertight boundary, intersecting surfaces, etc. This too has been solved and details of the methodology are available in Computer-Aided Civil and Infrastructure Engineering 28(9) (Ledoux 2013), along with an open-source implementation.[2] However, (City)GML datasets contain more 3D primitives, since primitives can be combined into either *aggregates* or *composites*; see Fig. 11.3.

[1] http://xerces.apache.org
[2] https://github.com/tudelft3d/val3dity

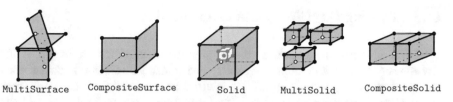

Fig. 11.3 3D geometric primitives used in CityGML. (© H. Ledoux, reprinted with permission)

An aggregate is an arbitrary collection of primitives of the same dimensionality that is simply used to bundle together geometries; the topological relationships between the primitives are not prescribed. GML has classes for each dimensionality (`Multi*`), of which the most relevant in our context are `MultiSurface` (often used for the geometry of a building) and `MultiSolid`. A composite of dimension d is a collection of d-dimensional primitives whose union forms a valid d-dimensional primitive. The most relevant example in our context is a `CompositeSolid`, which is often used to represent the volumetric part of a building in CityGML. At present software implementations that are capable of validating such 3D primitives are lacking.

The features in CityGML can have semantics, for instance each of the surfaces used to represent a building can be a semantic class (e.g. roof, wall, window, etc.), which defines its real-world meaning. Depending on the LoD, a semantic surface in a building can be one of nine classes. While it is impossible to validate with 100% certainty the semantics of the surfaces of a building, it is possible to infer it from the orientation of a surface (Boeters et al. 2015; Wagner et al. 2015).

Conformance requirements refer to statements made in the international standard document (Open Geospatial Consortium 2012) that cannot be directly implemented. They require the translation of a concept, expressed in natural language, into verifiable functions. An example is that if a building is one homogeneous volume it should be represented as one `Building`, but different `BuildingParts` should be used if the roof types or if the number of stories differ, or if the addresses are different. The validation of these requirements requires either extra knowledge (information about the addresses in the area) or specifying what different roof types means.

Application-specific rules are rules that are not specified in the standard, but that are required in practice. One example is that a building can be required to have a ground floor to form a volume.

Applications of 3D city models (see Sect. 11.6) may be affected by missing information and/or inconsistencies in the data, which are not specified in the standard: for instance, that a volume of a building can only be computed if it is modeled by a solid (with a ground floor). CityGML specifies that buildings can be represented as a `MultiSurface`, but in such cases all applications requiring volumes will not be possible without additional processing. Another example is to ensure consistent attributes (e.g. codes) of buildings when estimating their energy demand. Such inconsistencies may result in errors when the data is used across different software packages.

11.5 Viewing CityGML Data Over the Web

CityGML presents an appealing solution for the storage and exchange of 3D city models because it combines geometry and semantics in a single data model. However, efficiently visualizing 3D geometries and semantic information stored in CityGML is complex. A number of desktop viewers are available for the local visualisation of CityGML data such as *FZK Viewer*, *FME Data Inspector* and *azul*. However, the visualization of CityGML models on the web is still a challenging area since CityGML is designed for the representation of 3D city models and not for presenting or visualizing 3D city models directly on the web.

Among other issues, large CityGML XML files often cannot be rendered directly in a web browser due to memory constraints. Sometimes 3D data cannot be visualized because the user does not have the right browser plug-ins.

Visualizing CityGML over the web requires separating the geometric information from the semantic information in the commonly used 3D graphics formats and using these formats to visualize the model. Several 3D graphical standards such as X3D,[3] KML[4]/COLLADA,[5] etc. can be used but it should be noted that when CityGML data is converted to those formats for visualizing data over the web, the rich semantics of CityGML are often lost.

X3D (Extensible 3D) is an XML-based, open 3D data format that is used for representing 3D scenes in a web environment and is the successor to VRML[6] (Virtual Reality Modeling Language). Several studies have been undertaken to visualize CityGML data over the web browser using X3D. Mao and Ban (2011) developed a framework for the online visualization of CityGML models. In his approach, 3D scenes are generated from CityGML data based on the geometric and semantic information, and are then viewed in the web browser using X3DOM. Supporting the importance of X3D, Prieto et al. (2012) introduced a framework for the visualization of CityGML data over the web (without any dependency on plug-ins) using X3D and W3DS (Web 3D Service).

KML (Keyhole Markup Language) is a file format used to display geographic data in an Earth browser such as Google Earth. KML focuses on geographic visualization, including annotation of maps and images, and version 2.2 has been adopted as an OGC implementation standard. Although KML is not designed for 3D visualization, it uses COLLADA for 3D modeling. *COLLADA* (COLLAborative Design Activity) is an XML-based open standard for the representation and exchange of 3D assets between applications. It focuses on the exchange of geometric data and 3D scenery. KML/COLLADA is designed for an Earth browser, while X3D

[3] http://www.web3d.org/x3d/what-x3d

[4] https://developers.google.com/kml/

[5] https://www.khronos.org/collada/

[6] http://gun.teipir.gr/VRML-amgem/spec/index.html

is a better choice for presenting 3D city models online due to its compatibility with HTML and good support in popular browsers such as Firefox or Chrome.

With advances in the development of 3D web-based applications, virtual globes have emerged as a new medium for visualizing and interacting with geographic information. They offer users the ability to freely move around in a virtual environment by changing the viewing angle and position. To develop cross-platform and cross-browser applications, several WebGL based virtual globes have been developed, such as Cesium JS,[7] OpenWebGlobe[8] or WebGLEarth.[9] *Cesium*, for example, is an open-source JavaScript library to create 3D virtual globes as well as 2D maps on a web browser. However, Cesium does not directly support rendering of CityGML data. In a preprocessing step, CityGML can be converted to KML using 3D City DB, which is used for visualization in the Cesium globe (Chaturvedi et al. 2015). With 3D City DB, it is possible to export the geometric information of the 3D city models to an interoperable format such as KML/COLLADA. This is more suitable for visualization purposes than CityGML (Fig. 11.4). Semantic information can be retrieved from the 3D City DB using a Web Feature Service. Cesium also supports rendering 3D models in its native format glTF[10] (GL Transmission

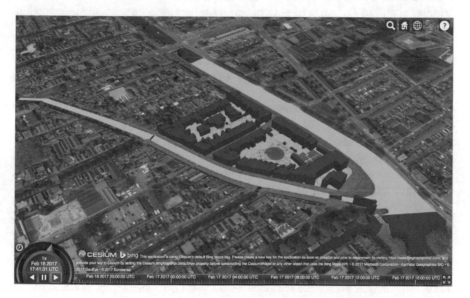

Fig. 11.4 3D city model of a part of Delft rendered over Cesium in KML/COLLADA format. (© K. Kumar, reprinted with permission)

[7]http://cesiumjs.org/

[8]http://www.openwebglobe.org

[9]http://www.webglearth.org/

[10]https://github.com/KhronosGroup/glTF

Format). Collada2gltf & obj2glft[11] are two tools that convert COLLADA & OBJ models to glTF for use with Cesium.

11.6 Applications of 3D City Models

3D city models are nowadays used for many different purposes. A recent study identified 29 use cases in dozens of application domains where 3D city models are used (Biljecki et al. 2015). These use cases range from large-scale studies to micro analyses focused at the level of buildings. For example, 3D city models stored in CityGML (but also other formats) may be used in energy planning (Agugiaro 2016), change detection (Pedrinis et al. 2015), facilitating property taxation (Çağdaş 2013), calculating the sky view factor (Brasebin et al. 2012), visibility studies (Wrózyński et al. 2016), and thermal simulations (Zucker et al. 2016).

Each of these applications may require specific semantic data. One such application is the analysis of building heating energy consumption, which requires data such as building function, number of occupants, and refurbishment information (Nouvel et al. 2017). Due to its structure and support for such semantic information, CityGML constitutes a powerful platform for use in support applications.

While CityGML enables storing a number of generic attributes, such as the year of construction of a building, it is meant as a generic standard for modeling topographic features. Hence, it is not always possible to store semantic information required by certain applications.

Such domain-specific information can be modeled in CityGML either by generic classes or by the definition of an extra formal schema based on the CityGML schema definitions. These schemas are called CityGML Application Domain Extensions (ADE). The approach of defining an extra formal schema makes it possible to define new classes, their relationships and attributes and is ideal for applications that require a large number of new features.

Examples of ADEs to support particular applications are the Immovable Property Taxation (Çağdaş 2013), Noise (Open Geospatial Consortium 2012), and Energy (Nouvel et al. 2015) ADEs. ADEs can also be modeled to support the needs of a specific domain or context like the IMGeo (Information Model for large-scale Geographical Information) ADE in the Netherlands (van den Brink et al. 2013a,b). This ADE models additional attributes to all CityGML classes for specific use as national 3D standard. The IMGeo ADE also adds 2D geometry to each class to establish a link to the 2D reference data set, i.e. the geometries in 3D extend features that are modeled in the 2D large-scale map. It also adds additional attributes, see Fig. 11.5.

[11]https://cesiumjs.org/convertmodel.html

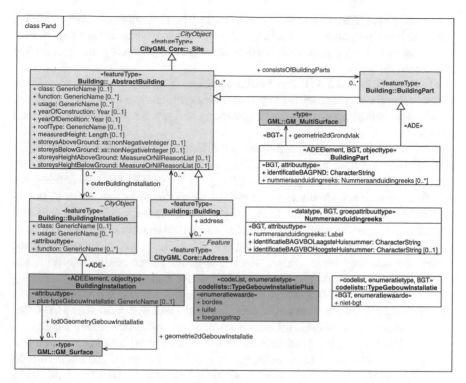

Fig. 11.5 The UML diagram of IMGeo ADE for the CityGML class Building (*Pand* in Dutch). The yellow parts are from the CityGML standard; the rest is additional information in the application domain extension. (© Geonovum, reprinted with permission)

11.7 BIM and 3D GIS Integrations: IFC and CityGML

BIM and 3D GIS have some overlap as they both model buildings. However, BIM focuses on the range from a building down to the individual components used in its construction, while 3D GIS focuses on anything from a single building up to entire cities and countries, including both man-made and natural features. This means that BIM data almost always contains much more detail than GIS data, but it also has a much more limited extent.

Because both domains model buildings and constructions, it is widely acknowledged in both GIS and BIM that the integration of their data is mutually beneficial and a crucial step forward for future 3D city modeling. Detailed BIM data can be used to feed GIS data, providing comprehensive data for the interior of buildings – including parts that would otherwise be hidden – and avoiding having to create new building models from scratch when data already exist. At the same time, the extensive coverage and free availability of GIS data is helpful as context and

georeference for BIM data, enabling architects and managers to see how a building relates to its surroundings. In addition, both types of models can be used to perform a very large number of spatial analyses (e.g. water, noise, air quality, energy, building and construction).

However, BIM and 3D GIS data differ significantly in their modeling paradigms and software tools, as exemplified by their main open standards, IFC and CityGML. These differ in their approach to model geometry and semantics as well as their level of detail.

For instance, IFC geometries follow three different representation paradigms (i.e. CSG, Sweep Volumes and *b-rep*), while volumetric geometries in CityGML are solely represented with *b-rep*. Individual objects in an IFC file (i.e. entities) are usually designed individually and have their own coordinate system, while objects in a CityGML file are usually modeled together using the same coordinate system. IFC geometries are mostly representations of a set of *volumes* but CityGML generally models the visible *surfaces* of a building (Fig. 11.6). IFC models are often created during the building design phase, which can differ significantly from how it is eventually constructed, while CityGML models are usually created by measuring an already existing building. These differences are just a few that illustrate the very different modeling paradigms of IFC and CityGML, and in turn BIM and 3D GIS.

Many researchers and practitioners have studied how to best share information between BIM and GIS, including models that combine both approaches (El-Mekawy et al. 2012), the (automatic) generalization of detailed BIM data for GIS use (Geiger et al. 2015), adding more detail to GIS 3D datasets (Boeters et al. 2015), and the creation of automatic converters between IFC and CityGML (Donkers et al. 2016). Up to now, solutions for BIM and 3D GIS data integration have only been partial since it is very complex to reconcile all their differences. Even standard GIS

Fig. 11.6 Two modeling paradigms: (left) boundary representation as used in CityGML, (center and right) space-filling representation as used in IFC. (© K. Arroyo Ohori, reprinted with permission)

software features such as georeferencing can be a problem in practice with IFC files. This makes it very hard to share 3D information among different users throughout the life-cycle of urban and environmental processes (from planning, design and construction to maintenance).

The two domains of 3D GIS and BIM are increasingly intersecting: BIM methodologies are applied to infrastructural works, city models are becoming more detailed, Smart City concepts require integrated approaches to city infrastructure, and sustainability objectives require approaches that operate at multiple levels of detail. This will focus further attention to the many yet unresolved challenges in integrating 3D GIS and BIM data, such as the automatic conversion of models, the inclusion of appropriate semantics, and the preparation of models for various types of spatial analyses.

11.8 BIM and 3D GIS: BIM gbXML and CityGML

At present, IFC and CityGML are the two most popular standards for modeling 3D objects in the BIM & 3D GIS domains. As mentioned in Sect. 11.7, a lot of work has already been done in transforming IFC to CityGML and vice versa. But there is also another BIM standard that is relevant for the BIM/3DGIS integration: gbXML.

gbXML[12] (green building XML) is a comparatively new BIM standard that is gaining industry support from leading BIM authoring and analysis software vendors like Bentley and Autodesk. It is an XML-based BIM standard that facilitates the transfer of building information between different BIM models and engineering environmental analysis tools and extensive coverage of the characteristics required for the building energy domain. The gbXML schema comprises nearly 400 elements and attributes for storing information related to building geometry, weather data, spaces, thermal zones, surface adjacency information, etc. (Sokolov and Crosby 2011). The schema is based on the notion of Analytical Space in which a space represents a volume enclosed by surfaces. In a building, every closed volume is an analytical space which is modeled as a shell geometry (see Fig. 11.7b). Building components such as walls, roofs, and floors are modeled as analytical surfaces (see Fig. 11.7c).

While CityGML is presently the best standard for modeling the geometric-semantic relations of 3D city objects, it cannot, unlike gbXML, be used directly as input by energy simulation tools. An interesting topic for future research will therefore be to develop a formal framework for the geometric-semantic transformation of 3D city objects between the two standards, gbXML and CityGML. By transforming 3D objects from CityGML to gbXML, significant time can be saved during energy simulations as it will not be necessary to recreate the building geometry within the simulation interface. In current practice, gbXML-based BIM

[12]http://www.gbxml.org/

Fig. 11.7 (**a**) gbXML building model (Source:gbxml.org) (**b** and **c**) Spaces in a gbXML building model with and without exterior walls. (© K. Kumar, reprinted with permission)

models are used exclusively to derive the thermal properties of building elements (e.g. thermal conductivity and specific heat), which are then directly used by energy simulation tools.

11.9 Summary

This chapter provided an explanation of and background information on CityGML as an international standard for modeling cities and landscapes. It is the dominant standard for 3D city and landscape models, and is widely adopted by researchers and industry alike. An important feature of CityGML is that it models 3D data so that it can be used beyond 3D visualization. As such, the data can be used in spatial analyses, e.g. to better understand the physical environment or to better predict the impact of interventions on the environment, whether foreseen (such as a new road) or unforeseen (emissions from a toxic cloud). Since CityGML models similar features to BIM standards, it will be interesting to see how both standards could be better aligned to make improved data exchange possible. For a successful integration, it is important to acknowledge the differences in each domain, semantically, geometrically and in their level of detail. Overcoming these differences is still a challenge. This is also true for other domains: it is expected that the main challenge for 3D city modeling in the coming years will be data integration: not only between BIM and CityGML, but also above and below ground, between voxel and vector, sensors, bathymetry and digital terrain models, etc. This can

potentially result in one digital view of the built environment that can support a wide variety of applications: a point on the horizon that many governmental organizations are looking towards. This project has received funding from the European Research Council (ERC) under the European Union's Horizon 2020 research and innovation program (grant agreement No 677312 UMnD).

References

3D City Database. (2017). *(3D city DB: The CityGML database).* Retrieved from http://www. 3dcitydb.org/

Agugiaro, G. (2016). Energy planning tools and CityGML-based 3D virtual city models: Experiences from Trento (Italy). *Applied Geomatics, 8*(1), 41–56.

Amirebrahimi, S., Rajabifard, A., Mendis, P., & Ngo, T. (2016). A BIM-GIS integration method in support of the assessment and 3D visualisation of flood damage to a building. *Journal of Spatial Science, 61*(2), 317–350.

Amorim, J. H., Valente, J., Pimentel, C., Miranda, A. I., & Borrego, C. (2012). Detailed modelling of the wind comfort in a city avenue at the pedestrian level. In: Leduc, T., Moreau, G., Billen, R. (Eds.), *Usage, usability, and utility of 3D city models – European COST action TU0801* (pp. (03,008)1–6). EDP Sciences, Nantes.

Arroyo Ohori, K., Ledoux, H., & Stoter, J. (2015). A dimension-independent extrusion algorithm using generalised maps. *International Journal of Geographical Information Science, 29*(7), 1166–1186.

Biljecki, F., Stoter, J., Ledoux, H., Zlatanova, S., & Çöltekin, A. (2015). Applications of 3D city models: State of the art review. *ISPRS International Journal of Geo-Information, 4*(4), 2842–2889.

Biljecki, F., Ledoux, H., & Stoter, J. (2016). An improved LOD specification for 3D building models. *Computers, Environment and Urban Systems, 59*, 25–37.

Biljecki, F., Heuvelink, G. B. M., Ledoux, H., & Stoter, J. (2018). The effect of acquisition error and level of detail on the accuracy of spatial analyses. *Cartography and Geographic Information Science, 45*(2), 156–176. https://doi.org/10.1080/15230406.2017.1279986

Boeters, R., Arroyo Ohori, K., Biljecki, F., & Zlatanova, S. (2015). Automatically enhancing CityGML LOD2 models with a corresponding indoor geometry. *International Journal of Geographical Information Science, 29*(12), 2248–2268.

Brasebin, M., Perret, J., Mustière, S., & Weber, C. (2012). Measuring the impact of 3D data geometric modeling on spatial analysis: Illustration with Skyview factor. In: T. Leduc, G. Moreau, & R. Billen (Eds.), *Usage, usability, and utility of 3D city models – European COST action TU0801* (pp. (02,001)1–16). EDP Sciences, Nantes.

Bremer, M., Mayr, A., Wichmann, V., Schmidtner, K., & Rutzinger, M. (2016). A new multi-scale 3D-GIS-approach for the assessment and dissemination of solar income of digital city models. *Computers, Environment and Urban Systems, 57*, 144–154.

Çağdaş, V. (2013). An application domain extension to CityGML for immovable property taxation: A Turkish case study. *International Journal of Applied Earth Observation and Geoinformation, 21*, 545–555.

Chaturvedi, K., Yao, Z., & Kolbe, T. H. (2015). Web-based exploration of and interaction with large and deeply structured semantic 3D city models using html5 and webgl. In *Wissenschaftlich-Technische Jahrestagung der DGPF und Workshop on Laser Scanning Applications* (Vol. 3).

Donkers, S., Ledoux, H., Zhao, J., & Stoter, J. (2016). Automatic conversion of IFC datasets to geometrically and semantically correct CityGML LOD3 buildings. *Transactions in GIS, 20*(4), 547–569.

El-Mekawy, M., Östman, A., & Hijazi, I. (2012). A unified building model for 3D urban GIS. *ISPRS International Journal of Geo-Information, 1*(3), 120–145.

Geiger, A., Benner, J., & Haefele, K. H. (2015). Generalization of 3D IFC building models. In M. Breunig, M. Al-Doori, E. Butwilowski, P. V. Kuper, J. Benner, & K. H. Haefele (Eds.), *3D geoinformation science* (pp. 19–35). Cham: Springer.

Gröger, G., & Plümer, L. (2012). CityGML – interoperable semantic 3D city models. *ISPRS Journal of Photogrammetry and Remote Sensing, 71*, 12–33.

Haala, N., & Kada, M. (2010). An update on automatic 3D building reconstruction. *ISPRS Journal of Photogrammetry and Remote Sensing, 65*(6), 570–580.

Kim, K., & Wilson, J. P. (2014). Planning and visualising 3D routes for indoor and outdoor spaces using CityEngine. *Journal of Spatial Science, 60*(1), 179–193.

Kolbe, T. H. (2009). Representing and exchanging 3D city models with CityGML. In: S. Zlatanova & J. Lee (Eds.), *3D geo-information sciences* (pp. 15–31). Berlin/Heidelberg: Springer.

Ledoux, H. (2013). On the validation of solids represented with the international standards for geographic information. *Computer-Aided Civil and Infrastructure Engineering, 28*(9), 693–706.

Mao, B., & Ban, Y. (2011). Online visualization of 3D city model using CityGML and X3DOM. *Cartographica: The International Journal for Geographic Information and Geovisualization, 46*(2), 109–114.

Monien, D., Strzalka, A., Koukofikis, A., Coors, V., & Eicker, U. (2017). Comparison of building modelling assumptions and methods for urban scale heat demand forecasting. *Future Cities and Environment, 3*(2). https://doi.org/10.1186/s40984-017-0025-7

Nouvel, R., Kaden, R., Bahu, J. M., Kaempf, J., Cipriano, P., Lauster, M., Benner, J., Munoz, E., Tournaire, O., & Casper, E. (2015). Genesis of the CityGML energy ADE. In: J. L. Scartezzini (Ed.), *Proceedings of the International Conference on CISBAT 2015 Future Buildings and Districts – Sustainability from Nano to Urban Scale*, LESO-PB, EPFL (Lausanne) (pp. 931–936).

Nouvel, R., Zirak, M., Coors, V., & Eicker, U. (2017). The influence of data quality on urban heating demand modeling using 3D city models. *Computers, Environment and Urban Systems, 64*, 68–80.

OGC. (2012). OGC geography markup language (GML) – Extended schemas and encoding rules 3.3.0. Open Geospatial Consortium.

OGC. (2016). OGC CityGML quality interoperability experiment. Open Geospatial Consortium inc., document OGC 16-064r1.

Open Geospatial Consortium. (2012). OGC city geography markup language (CityGML) encoding standard 2.0.0. Technical report.

Pedrinis, F., Morel, M., & Gesquiére, G. (2015). Change detection of cities. In M. Breunig, M. Al-Doori, E. Butwilowski, P. V. Kuper, J. Benner, & K. H. Haefele (Eds.), *3D geoinformation science* (pp. 123–139). Cham: Springer.

Previtali, M., Barazzetti, L., Brumana, R., Cuca, B., Oreni, D., Roncoroni, F., & Scaioni, M. (2014). Automatic façade modelling using point cloud data for energy-efficient retrofitting. *Applied Geomatics, 6*(2), 95–113.

Prieto, I., Izkara, J. L., & del Hoyo, F. J. D. (2012). Efficient visualization of the geometric information of CityGML: Application for the documentation of built heritage. In B. Murgante, O. Gervasi, S. Misra, N. Nedjah, A. M. A. C. Rocha, D. Taniar, & B. O. Apduhan (Eds.), *International Conference on Computational Science and Its Applications* (pp. 529–544). Berlin/Heidelberg: Springer.

Sokolov, I., & Crosby, J. (2011). *Utilizing gbXML with AECOsim building designer and speedikon*.

Stadler, A., & Kolbe, T. H. (2007). Spatio-semantic coherence in the integration of 3D city models. *The ISPRS Annals of the Photogrammetry, Remote Sensing and Spatial Information Sciences, XXXVI-2/C43*, 8.

Steuer, H., Machl, T., Sindram, M., Liebel, L., & Kolbe, T. H. (2015). Voluminator—approximating the volume of 3D buildings to overcome topological errors. In F. Bacao, M. Y. Santos, & M. Painho (Eds.), *AGILE 2015* (pp. 343–362). Cham: Springer.

van den Brink, L., Stoter, J., & Zlatanova, S. (2013a). Establishing a national standard for 3D topographic data compliant to CityGML. *International Journal of Geographical Information Science, 27*(1), 92–113. http://dx.doi.org/10.1080/13658816.2012.667105

van den Brink, L., Stoter, J., & Zlatanova, S. (2013b). UML-based approach to developing a CityGML application domain extension. *Transactions in GIS, 17*(6), 920–942.

van Walstijn, L. (2015). *Requirements for an integral testing framework of CityGML instance documents.* Master's thesis, Institute of Geodesy and Geoinformation Science, Technische Universitaet, Berlin.

Vanclooster, A., Van de Weghe, N., & De Maeyer, P. (2016). Integrating indoor and outdoor spaces for pedestrian navigation guidance: A review. *Transactions in GIS, 20*(4), 491–525.

Wagner, D., Alam, N., Wewetzer, M., Pries, M., & Coors, V. (2015). Methods for geometric data validation of 3D city models. *Int Arch Photogramm Remote Sens Spatial Inf Sci, XL-1-W5*, 729–735.

Wróżyński, R., Sojka, M., & Pyszny, K. (2016). The application of GIS and 3D graphic software to visual impact assessment of wind turbines. *Renewable Energy, 96*, 625–635.

Zucker, G., Judex, F., Blöchle, M., Köstl, M., Widl, E., Hauer, S., Bres, A., & Zeilinger, J. (2016). A new method for optimizing operation of large neighborhoods of buildings using thermal simulation. *Energy and Buildings, 125*, 153–160.

Chapter 12
BIM Programming

Julian Amann, Cornelius Preidel, Eike Tauscher, and André Borrmann (iD)

Abstract This chapter describes different possibilities for programming BIM applications with particular emphasis on processing data in the vendor-neutral Industry Foundation Classes (IFC) exchange format. It describes how to access data in STEP clear text encoding and discusses the differences between early and late binding. Given the increasingly important role of ifcXML in the exchange of IFC data, the chapter also examines different access variants such as SAX (Simple API for XML) and DOM (Document Object Model), and discusses the different geometry representations of IFC and their interpretation. Furthermore, the chapter gives a brief overview of the development of add-ins as a means of allowing existing software to be adapted to user-specific needs. The chapter ends with a brief overview of cloud-based platforms and a short introduction to visual programming.

12.1 Introduction

As described in earlier chapters, a wide range of different software products have been developed to serve specific tasks in the construction industry, with new software tools emerging all the time. To make efficient use of these tools in the value-added chain, data exchange at a high semantic level is paramount. Today, this is increasingly achieved using open data formats such as the Industry Foundation Classes (IFC) (see Chap. 5). To use information contained in an IFC instance file, it needs to be accessed using the respective programming language. This chapter outlines the different methods and practices.

J. Amann (✉) · C. Preidel · A. Borrmann
Chair of Computational Modeling and Simulation, Technical University of Munich, München, Germany
e-mail: julian.amann@tum.de; cornelius.preidel@tum.de; andre.borrmann@tum.de

E. Tauscher
Chair of Computing in Civil Engineering, Bauhaus-Universität Weimar, Weimar, Germany
e-mail: eike.tauscher@uni-weimar.de

12.2 Procedures for Accessing Data in the STEP Format

The most commonly used format for the storage of IFC instance file is STEP Clear
Text Encoding (ISO 10303-21 2016), also known as STEP P21. Techniques for
reading and writing STEP files can be categorized into two key approaches: early
binding and late binding.

12.2.1 Early Binding

With the early binding approach, the entities of the EXPRESS schema in the STEP
P21 file are mapped to the target programming language (host language) using a
suitable mapping method. Early bindings make it possible to map the STEP file to
entities of the host language, i.e. to read a STEP file, and subsequently to convert the
host entities back into a STEP file, i.e. to write a STEP file. While it is theoretically
possible to implement a early binding manually, it is not recommended for the IFC
data model due to the large number of entities (several hundred) and accompanying
risk of introducing programming errors through manual implementation.

From a technical viewpoint, a code generator is used that takes an EXPRESS schema as input and
produces entities (e.g. classes) of the host language as output. This mapping and
the associated code generation need only be performed once for a given EXPRESS
schema, and need only be repeated if the underlying EXPRESS schema changes.
In the case of the IFC, this is comparatively rare and when changes are made, a
new version number for the corresponding EXPRESS schema is issued (e.g. IFC4,
IFC2×3 TC1, IFC2×3, IFC2×2, etc.).

From a technical viewpoint, if several different IFC schema versions need to
be supported in parallel, each version requires its own separate early binding.
Figure 12.1 shows an overview of the early binding process. The code generator
generates a corresponding mapping for each entity in the target programming
language, e.g. for the C++ programming language, a C++ class called IfcAddress

Fig. 12.1 Scheme of an early binding. For each entity, a corresponding class is created for the
target programming language

is generated for the EXPRESS entity IfcAddress. There are no standardized rules for mapping EXPRESS entities to a programming language, and the developer of the code generator therefore has a free hand. In object-oriented programming languages, EXPRESS entities are typically mapped to classes, inheritance is implemented with the inheritance syntax, and references are realized with pointers, smart pointers (pointers that deal with memory management) or references in the target programming language.

A code generator needs to be able to parse the EXPRESS grammar by means of a lexer that generates tokens from the input symbols of the STEP file, processes them using a parser to create a syntax tree and then validates the syntax of the respective EXPRESS schema for correctness. The code generator should ideally be able to produce a valid mapping for the target language in one step from the EXPRESS schema without any manual intervention. In practice, however, not all code generators are able to convert any valid EXPRESS schema and may need a pre-processing step or additional manual effort up front. IfcOpenShell[1] is an example of a code generator for the target programming language C++, while the JSDAI library[2] can be used for the programming language Java.

The following listing shows the use of the TUM Open Infra Platform Early Binding EXPRESS generator[3] with the IFC4 schema:

```cpp
// create a model
ifc_model = shared_ptr<Ifc4Model>(new Ifc4Model());
// ...

// create a point with the coordinates (9,10)
shared_ptr<IfcCartesianPoint> pnt =
    std::make_shared<IfcCartesianPoint>(id++);
ifc_model->insertEntity(pnt); // add point to model
// set coordinates of point
pnt->m_Coordinates.push_back(
    std::make_shared<IfcLengthMeasure>(9.0)
);
pnt->m_Coordinates.push_back(
    std::make_shared<IfcLengthMeasure>(10.0)
);
// ...

// write a STEP P21 file
shared_ptr<IfcStepWriter> step_writer =
    std::make_shared<IfcStepWriter>()
std::stringstream stream;
stream.precision(20);
step_writer->writeStream(stream, ifc_model);
std::ofstream myFile("MyFile.ifc");
myFile<<stream.str().c_str();
```

[1] https://github.com/IfcOpenShell/IfcOpenShell/tree/master/src/ifcexpressparser
[2] http://www.jsdai.net
[3] https://bitbucket.org/tumcms/oipexpress

The program creates an instance of the entity IfcCartesianPoint with the coordinates (9.0, 10.0). Subsequently, an IfcStepWriter object is created, which is used to convert the generated model (ifc_model) to a STEP P21 file.

12.2.2 Late Binding

In contrast to early binding, late binding uses a fixed interface called the standard data access interface (SDAI). The SDAI is an application programming interface (API) that provides a defined set of functions and methods to read and write STEP files, and is standardized in abstract form in the ISO 10303-22 standard (ISO 10303-22 1998). In addition, the STEP standard defines three different bindings for three different programming languages: Part 23 (ISO 10303-23 2000) defines a C++ binding, part 24 a C binding, and part 27 a Java binding. Bindings for other software languages, such as C#, have been implemented by other software vendors which, while not standardized, are based on the standardized bindings.

The following examples use the C binding of the SDAI, but the principles are transferable to other bindings. In the C binding, all variable names, constants, alias types (typedef) and function names start with the prefix sdai. SDAI operations are always executed in the scope of an SDAI session. The data of a STEP file is stored in a SDAI model, which is also part of a SDAI repository. The following listing illustrates the use of the C-SDAI API:

```
SdaiSession session = sdaiOpenSession(); // open a new session

// open a new repository
SdaiRepo repository = sdaiOpenRepositoryBN(session,
                                            "MyFile.ifc");

// create a model
int ifcModelId = sdaiCreateModelBN(0, "MyModelName", "IFC4.exp");

// create a point with the coordinates (9,10)
int ifcCartesianPointId =
    sdaiCreateInstanceBN(ifcModelId, "IfcCartesianPoint");
int ifcCoordinatesId =
    sdaiCreateAggrBN(ifcCartesianPointId, "Coordinates");
sdaiAdd(ifcCoordinatesId, sdaiREAL, 9.0);
sdaiAdd(ifcCoordinatesId, sdaiREAL, 10.0);
sdaiSaveChanges(ifcModelId);
sdaiCloseRepository(repository);
sdaiCloseSession(session);
```

The above program, as before, produces an IfcCartesianPoint entity, which is stored in a STEP file.

While with early binding an equivalent for each entity of the EXPRESS schema is created in the host programming language, this intermediate code generation step is not necessary when using a late binding. The late binding approach can therefore

respond flexibly to changes in the EXPRESS schema. This is achieved using a generic approach that allows both the instantiation and access to entities based on the underlying EXPRESS schema during program runtime.

To accomplish this, however, the interface must frequently be called with strings used as parameters, which denote, for example, which entity should be created, which attribute should be read or which function should be executed. This requires in-depth knowledge of the underlying EXPRESS schema, not least because the automatic code completion functionality of modern development environments cannot help here. In addition, this is problematic from a programming perspective because, for example, syntax errors within such a string are not recognized by the compiler and thus only come to light when the program is run.

The handling of IFC files using the SDAI is much more difficult since the same entities with the same attributes, inheritance hierarchies and relations in the host language are not available as they are with early binding, and therefore cannot be checked during compiling to reliably exclude such errors. In theory, a key advantage of the SDAI is that an SDAI implementation from one vendor can be swapped with another, as they are standardized. In practice, however, this is not always as straightforward because some vendors integrate advanced SDAI functions into their APIs that are not part of the standard.

Table 12.1 shows a (non-exhaustive) overview of different libraries that can be used to read or write STEP and IFC files.

Table 12.1 Overview of common STEP/IFC libraries

Name	Language	License	STEP	IFC	Visualization	URL of website
IfcPlusPlus	C++	MIT	No	Yes	Yes	https://github.com/ifcquery/ifcplusplus
IfcOpenShell	C++/Python	OSGPL	No	Yes	Yes	http://ifcopenshell.org/
JSDAI	Java	AGPL v3	Yes	No	No	http://www.jsdai.net/
xBIM Toolkit	C#	CDDL	No	Yes	Yes	https://github.com/xBimTeam
IFC Tools Project	Java/C#	CC BY-NC 4.0 DE	Yes	Yes	Yes	http://www.ifctoolsproject.com
IFC Engine	C++/C#	Proprietary	Yes	Yes	Yes	http://rdf.bg/ifc-engine-dll.php
STEPcode	C++/Python	BSD	Yes	Yes	No	http://stepcode.org/mw/index.php/STEPcode
ifc-dotnet	C#	BSD	No	Yes	No	https://code.google.com/p/ifc-dotnet/

12.3 Accessing XML Encoded IFC Data

In recent years, the Extensible Markup Language (XML) has established itself as a standard and cross-industry approach for describing schemas and instance data. Both Microsoft's .NET framework and Java Standard Edition include an XML parser for handling XML files. There are numerous libraries for C++ for reading and writing XML files, for example, the Qt library or the Xerces C++ XML parser, which is particularly suitable for very large XML files. In short, support for reading and creating XML documents or the availability of middleware for this task is much better for XML than for STEP.

Starting with version 4 of the IFC standard, an XML schema is also available as an equivalent to the EXPRESS schema. XML Schema Definition (XSD) is used as the description language. This defines the structure of XML instance files and allows them to be validated against the corresponding schema. Most major frameworks include XSD validators for this purpose.

Although from a programming standpoint, data access via XML is easier to implement using XML for the reasons mentioned above, it is currently far less widespread than its STEP counterpart. This can be attributed in part to the historical development of IFC, which was based on STEP and the data modeling language EXPRESS. A further reason is the size of ifcXML files, which are often multiple times larger than their STEP counterparts due to the XML tag syntax (see Chap. 5). ifcXML4 has improved on this through the definition of a more compact representation which may help the XML mapping of IFC data gain popularity in future. However, it must be noted that the XML schema of the IFC contains none of the inverse attributes, rules or functions included in the original IFC EXPRESS schema.

There are three commonly used approaches to reading and writing XML files: SAX, DOM and class generators.

SAX (Simple API for XML) was initially a Java library for sequentially reading XML documents. The software architecture of the original SAX implementation has become the de-facto standard and found its way into numerous other frameworks. Figure 12.2 shows a small part of the class QtXmlDefaultHandler of the Qt-SAX framework. Object-oriented programming languages usually offer a base classes or interface (cf. QtXmlDefaultHandler) which can be tailored by the developer via

QXmlDefaultHandler
+startDocument()
+endDocument()
+startElement(namespaceURI : String, localName : String, qName : String, atts : QXmlAttributes)
+endElement(namespaceURI : String, localName : String, qName : String)
+characters(ch : String)

Fig. 12.2 Class diagram that shows a small part of the Qt SAX framework. The member methods of the class QtXmlDefaultHandler are incomplete

inheritance to serve a custom purpose. The SAX parser reads the XML document and invokes the appropriate method upon finding a specific XML element. For example, parsing the root tag invokes the `startDocument` method, while the `endDocument` method is called at the end. XML elements are treated in a similar fashion, calling `startElement` or `endElement` at the start or end of the element respectively. The SAX parser is, however, only capable of verifying whether an XML file is valid or not while reading it.

Like SAX, the DOM (Document Object Model) is a common method for accessing XML and is likewise supported in multiple frameworks. The following listing shows the use of DOM in Qt:

```
QDomDocument doc; // create a DOM document
QDomProcessingInstruction header = // create XML header
    doc.createProcessingInstruction("xml",
                                    "version=\"1.0\"");
doc.appendChild(header); // Add XML header to DOM document
QDomElement root = doc.createElement("root");
root.setAttribute("version", getApplicationVersionString());
doc.appendChild(root);

// save entity
QDomElement xmlAlignments = doc.createElement("Alignments");
root.appendChild(xmlAlignments);

QFile file(filename.c_str()); // save XML file
file.open(QIODevice::WriteOnly))
QTextStream ts(&file);
ts << doc.toString();
```

The last approach is the equivalent of an early binding method for XML. Here too, multiple tools are available for generating a class hierarchy from an XML schema and providing read/write methods for the respective XML file. This approach has the same advantages and disadvantages as STEP-based early binding.

12.4 Interpretation of IFC Geometry Information

Alongside semantic information, geometric information plays an important role in IFC-based data exchange, due to the relevance of geometry in the design, construction and operation of buildings. It is essential that all software tools correctly interpret this data when visualizing or processing the geometric information contained in an IFC file. While most available geometry models support the export of geometric information into the IFC format (see Chap. 5), the provision of import functionalities is more complex because software systems need to support all geometric representation methods defined by the exchange requirements (see Chap. 6).

A large part of the IFC geometry descriptions is based on definitions in the ISO standard 10303-42 (ISO 10303-42 2014). IFC version 4 supports the following approaches of geometry descriptions (see Chap. 2 for more details):

- *Constructive Solid Geometry (CSG)*: Solids formed by the result of Boolean operators – union, difference or intersection – on two or more solids.
- *Half-space solids*: Solids which are bounded on one side by a surface.
- *Extrusion bodies*: Solids produced by extrusion of a surface along a vector, one or more polylines, curves, splines or other mathematical functions.
- *Boundary Representation*: Solid bodies described by means of the surfaces delimiting them.
- *Tessellated objects*: Sets of triangulated surfaces.
- *Geometric groups*: Groups of geometric elements that do not have a topological structure, such as 2D or 3D points, lines, curves, surfaces.
- *Non-Uniform Rational B-Splines (NURBS)*: Representation of surfaces based on B-splines.

In the following, two of the above models are presented in more detail to illustrate the complexity of interpreting geometry.

Geometric models are divided into two primary categories: evaluated (or explicit) and non-evaluated (or implicit) models. Evaluated models are relatively easy to interpret since all geometric information relevant to the representation or further processing is explicitly available within the IFC data model. The Brep representation used in IFC can be taken as an example for such a model. All vertices of a body are already present with the correct coordinates and need no further calculation. The limiting surfaces (faces) result from the topological relationship between the vertices and edges.

Non-evaluated geometry models require the execution of sometimes complex geometric operations, because the implicit geometric information for representing an object must first be processed. An example of this is CSG modeling.

The basis of a CSG model, as described in detail in Chap. 2, is its so-called construction tree. It describes the construction history of the arising object, with the result of all Boolean operations at the root of the tree. The primitive bodies are located at the leaves of the tree, and are combined by the inner nodes of the tree using regularized Boolean set operations.

The calculations required to produce the final geometric bodies can be very complex. Different calculation models exist for different methods: for example, if the operands are provided as triangulated surface bodies, the calculation can be performed according to Laidlaw et al. (1986) and Hubbard (1990). This method effectively checks all triangles of each operand against each other for intersection. If two triangles intersect, new triangles are formed by the cutting edge. The triangles of both operands are then classified depending on whether they are within the other body, outside the other body, on the surface of the other body with the same surface normal, or on the surface of the other body with opposing surface normal. After classification, the triangles are merged using the respective Boolean operator as shown in Table 12.2.

Table 12.2 Classification of triangles for area selection for the resulting body as a function of the Boolean operation (* = triangles with inverted orientation)

Operation	Triangles from A				Triangles from B			
	Within B	Outside of B	Same normal	Reverse normal	Within A	Outside of B	Same normal	Reverse normal
$A \cup B$	No	Yes	Yes	No	No	Yes	No	No
$A \cap B$	Yes	No	Yes	No	Yes	No	No	No
$A \setminus B$	No	Yes	No	Yes	Yes*	No	No	No

Table 12.3 A selection of libraries which can convert different geometric representations into a triangle representation

Name	Language	License	URL of website
OpenCASCADE	C++	LGPL	http://opencascade.org
Carve	C++	MIT	https://github.com/Vertexwahn/carve
csg.js	JavaScript	BSD	http://evanw.github.io/csg.js/
GTS	C++/Python	LGPL	http://gts.sourceforge.net

In this case, not only geometric primitives (spheres, cones, cylinders, etc.) can be found on the leaves, but also arbitrary complex solids. The only prerequisite is that it be a valid body, i.e. that two surfaces adjoin on each body edge. This procedure is often used in IFC models, for example to "cut" openings in walls or ceilings.

Table 12.3 shows a brief selection of different libraries that can convert different geometric representations into a triangle representation. In many cases, these libraries are not limited to a certain programming language, because bindings are available that permit the use of other programming languages, such as Java or C#.

12.5 Add-In Development for Commercial BIM Applications

Numerous software applications used for or in conjunction with Building Information Modeling provide a means of implementing add-ins and plugins to extend their functionality. Add-ins can typically be written in various programming languages such as C++ or languages within Microsoft's .Net framework (C#, VisualBasic.Net, J# etc.).

This section briefly outlines the development of a simple C# add-in for Autodesk Revit. Full documentation and details for programmers on developing a Revit add-in is available on the Autodesk website.[4]

Microsoft Visual Studio can be used to program a C#-based Revit extension. Usually, the first step is to create a class library as a new project. If access to the Revit API is required, the class has to reference the corresponding Revit libraries (RevitAPI.dll and RevitAPIUI.dll). It is also important to use the correct target framework: the .Net version used in Visual Studio – e.g. 2.0, 3.0, 3.5, 3.5 Client Profile or 4 – must match that used by Revit (a common pitfall). The following is a minimal add-in for Revit:

```
using System;
using System.Collections.Generic;
using System.Linq;
```

[4]https://www.autodesk.com/

```
using Autodesk.Revit.DB;
using Autodesk.Revit.DB.Architecture;
using Autodesk.Revit.UI;
using Autodesk.Revit.UI.Selection;
using Autodesk.Revit.ApplicationServices;
using Autodesk.Revit.Attributes;

[TransactionAttribute(TransactionMode.Manual)]
[RegenerationAttribute(RegenerationOption.Manual)]
public class Lab1PlaceGroup : IexternalCommand
{
  public Result Execute(
    ExternalCommandData commandData,
    ref string message,
    ElementSet elements)
  {
    UIApplication uiApp = commandData.Application;
    Document doc = uiApp.ActiveUIDocument.Document;

        // here you can use the revit API

    return Result.Succeeded;
  }
}
```

In addition to this library, an add-in XML manifest file must be created to define the global settings of the add-in and saved under `Autodesk\Revit\Addins\2014\`. Revit will then automatically load the add-in on start-up and it can be used via the toolbar. Further information can be found in the documentation.

12.6 Cloud-Based Platforms

Several companies offer so-called cloud-based platforms that enable developers to develop cloud-based applications based on these platforms. Table 12.4 gives some examples of such cloud-based platforms.

These cloud-based platforms build on RESTful web services. REST has the advantage that it can be used from almost every programming language since it needs only to send HTTP requests encoded with JSON or XML messages. This means it is straightforward to use these services within an application that is programmed in C++, C#, Java, Ruby, Java Script or any other similar powerful

Table 12.4 Some examples of cloud-based platforms

Provider	Name	URL of website
Autodesk	Autodesk Forge	https://forge.autodesk.com/
Nemetschek	BIM+	https://bimplus.net/
Trimple	Tekla BIMsight	http://www.teklabimsight.com/

programming language. Besides this, sometimes high-level APIs are provided for different programming languages to make programming more comfortable for software developers.

The previously mentioned platforms allow to store data like IFC files, photographs, any files such as for example Word Documents, Excel Sheets or scanned PDFs. Besides data management, also view capabilities are provided. There is a 3D viewer available on all the above-named platforms that is also running directly in a web browser that allows inspecting your data in real time.

Besides this, each platform offers different APIs. For instance, Autodesk Forge offers a Reality Capture API that makes it possible to convert photographs to a textured 3D model. For more details consider the corresponding documentation of these platforms.

12.7 Visual Programming

In recent years, Visual Programming Languages (VPL) have made inroads into the field of digital construction. Users can employ these languages as a tool to make repetitive work or the creation of variants and their evaluation a lot easier without the need for detailed programming knowledge (Chao 2016; Cooper et al. 2000).

A visual language is defined as a formal language with visual syntax and semantics. It describes a system of signs and rules on the syntactic and semantic level with the help of visual elements, which are more readily understandable for non-professional programmers. Visual programming languages are often referred to as flow-based, since they represent complex structures as a flow of information (Hils 1993).

Typically, the user interface of visual language applications comprises a canvas that serves as a basic workspace, and a library of individual components (nodes). Nodes are placed on the campus and arranged and linked to one another by so-called edges or wires (see Fig. 12.3). The resulting system can be stored as a graph system and passed on to other project participants or documented accordingly.

An essential distinguishing characteristic between different visual programming languages is the level of granularity. This granularity describes how finely the individual functionalities are resolved, i.e. whether functions within a node are entirely encapsulated or whether each sub-step is available and visible as a separate node. Encapsulation (low granularity) reduces the number of elements present on the workspace and contributes to the clarity, handling and comprehensibility of the overall system. At the other end of the scale (fine granularity), the resulting canvas is a more detailed representation of the information process in which the user can access and adapt each individual step as required.

Visual programming languages are controversial, particularly among programmers. The most commonly stated disadvantage is that programs created with a VPL rarely meet the high requirements of a professional programming environment. Furthermore, more complex situations, such as recursion, can often not be implemented

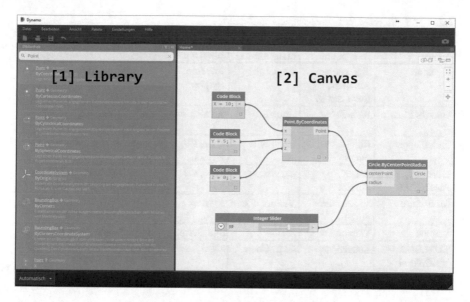

Fig. 12.3 Typical environment of a visual programming language: [1] Library containing the usable node elements, and [2] the workspace canvas. As an example, the interface of Autodesk Dynamo is shown

or are hard to understand. A common argument is that users who design processes using a visual language should also be able to describe the information process with a conventional textual programming language (Chao 2016).

On the other hand, VPLs are more user-friendly and make it easier for inexperienced users to get started with programming. Due to its abstract representation, it is easier for people without programming knowledge to understand and therefore to achieve results more quickly. Images can communicate ideas more simply and more clearly, and aid visual comprehension and remembering, not least also because there are no language barriers (Shu 1988). A study by Cataraci and Santucci (1995) attests to the user-friendliness of visual languages using an example based on the common query language SQL.

In digital construction, VPLs are mainly used in two application areas: for generative purposes to generate geometric as well as semantic information, or for checking or querying information on existing models. In some VPL-based applications and environments the boundaries between the two are fluid and clear classification is not always possible. Most of the visual programming environments provide the ability for developers to extend libraries with their own functions to extend a program's functionality or field of application (Kurihara et al. 2015). Table 12.5 shows an overview of common visual programming languages.

Table 12.5 Selected VPL environments and libraries

Name	Application	Manufacturer	Programming Interface	URL
Dynamo	Standalone; Autodesk Revit add-in	Autodesk	C#, Iron Python	http://dynamobim.org/
Google Blocky	Web-Based	Google	JavaScript	https://developers.google.com/blockly/
Grasshopper3D	Rhinoceros3D plug-in	Open-Source	C++, C#, Python	http://www.grasshopper3d.com/
Grasshopper3D ArchiCAD	ArchiCAD plug-in	Graphisoft	C++, C#	https://www.graphisoft.com/archicad/rhino-grasshopper/
Marionette	Vectorworks plug-in	Vectorworks	Python	http://www.vectorworks.net/training/marionette
Scratch	Web-based	MIT	JavaScript	https://scratch.mit.edu/
TUM.CMS. VplControl	Standalone	CMS Chair	C#	https://github.com/tumcms/TUM.CMS.VPLControl

12.8 Summary

This chapter provided a brief overview of ways to read and write IFC files. Presently, the most common format for exchanging IFC data uses STEP clear text encoding, which is standardized in Part 21 (ISO 10303-21 2016) of the STEP standard.

The difference between the early binding approach, in which the entities of the EXPRESS schema are mapped to entities of a high-level language, and the late binding approach, in which a generic, data-model-independent interface is used to access instance data, is explained and their respective advantages and disadvantages discussed. A key advantage of the early binding approach is that the majority of programming errors can be detected at compile time. A key disadvantage is that the class structure has to be generated in the host language using a code generator, and that this process must be repeated every time a schema changes. An alternative to using STEP-Part 21 to communicate IFC data is to use the XML-based format ifcXML. The SAX and DOM methods provide a means for the programmatic implementation of accessing IFC data as XML. The popularity and widespread support of the XML format means that it is likely that ifcXML will become an increasingly important means of communicating IFC data in future.

An important aspect of processing IFC data is the interpretation of geometric information. IFC data models present a challenge because they support very different means of geometric representations, including implicit representations. These must normally be processed and converted into a triangle network to render the geometry and make it available for further processing.

Where the existing possibilities offered by the vendor-neutral IFC and corresponding BIM tools are not sufficient, it is possible to extend commercially available software applications by developing add-ins or use cloud-based platforms providing additional functionality.

Finally, Visual Programming Languages (VPL) represent a new genre of programming tools that make it possible for AEC professionals to develop customized BIM solutions, without in-depth programming skills being required.

References

Cataraci, T., & Santucci, G. (1995). Are visual query languages easier to use than traditional ones? An experimental proof. In M. A. R. Kirby, A. Dix, & J. E. Finlay (Eds.), *People and Computers X: Proceedings of HCI'95, Hudders-Field* (Cambridge programme on human-computer interaction). Cambridge: Cambridge University Press.

Chao, P.-Y. (2016). Exploring students' computational practice, design and performance of problem-solving through a visual programming environment. *Computers & Education, 95,* 202–215.

Cooper, S., Dann, W., & Pausch, R. (2000). Alice. A 3-D tool for introductory programming concepts. *Journal of Computing Sciences in Colleges, 15*(5), 107–116.

Hils, D. D. (1993). *A visual programming language for visualization of scientific data.* Urbana: University of Illinois at Urbana-Champaign.

Hubbard, M. (1990). *Constructive solid geometry for triangulated polyhedra.* Department of Computer Science, Brown University, Providence, Rhode Island 02912, CS-90-07.

ISO 10303-22:1998. (1998). *Industrial automation systems and integration – Product data representation and exchange – Part 22: Implementation methods: Standard data access interface.* Geneva: Standard, International Organization for Standardization.

ISO 10303-23:2000. (2000). *Industrial automation systems and integration – Product data representation and exchange – Part 23: Implementation methods: C++ language binding to the standard data access interface.* Geneva: Standard, International Organization for Standardization.

ISO 10303-42:2014. (2014). *Industrial automation systems and integration – Product data representation and exchange – Part 42: Integrated generic resource: Geometric and topological representation.* Geneva: Standard, International Organization for Standardization.

ISO 10303-21:2016-03. (2016). *Industrial automation systems and integration – Product data representation and exchange – Part 21: Implementation methods: Clear text encoding of the exchange structure.* Geneva: Standard, International Organization for Standardization.

Kurihara, A., Sasaki, A., Wakita, K., & Hosobe, H. (2015). A programming environment for visual block-based domain-specific languages. *Procedia Computer Science, 62,* 287–296.

Laidlaw, D., Trumbore, B., & Hughes, J. (1986). Constructive solid geometry for polyhedral objects. In *Proceedings of SIGGRAPH'86, Computer Graphics, 2.* New York: ACM.

Shu, N. C. (1988). *Visual programming.* New York: Van Nostrand Reinhold.

Part III
BIM-Based Collaboration

Chapter 13
BIM Project Management

Markus Scheffer, Hannah Mattern, and Markus König

Abstract Building Information Modeling (BIM) is characterized by a well-structured creation and exchange of information. In the last years, the term has also been referred to as "Better Information Management". Due to the high amount of involved parties, which by nature hold contradicting views and interests, the organization of information requirements represents a key factor in the context of project management. The major challenge and chance, lies in improved project and information management achieved by applying BIM and thus, producing and using high-quality information. This chapter presents roles and perspectives to be considered in the building life cycle. Information Requirements and related Information Models are introduced to organize the resulting production of information and its exchange during different project stages. The concept is based on the methodology presented in ISO 19650.

13.1 Introduction

Starting to consider the use of Building Information Modeling (BIM) during a construction project should begin with the question: Which aspects do I want to improve in my project by using BIM methods? Consequently, the answer to this question automatically generates a branch of more open issues, e.g.:

- How will BIM methods influence the overall project structure?
- Which project actors are concerned by using BIM methods?
- How to organize different project actors in order to fulfill the project goals in the most efficient manner?

As above described questions refer to different aspects and boundary conditions of a construction project (see Fig. 13.1), it soon becomes obvious that the digiti-

M. Scheffer (✉) · H. Mattern · M. König
Chair of Computing in Engineering, Ruhr-Universität Bochum, Bochum, Germany
e-mail: markus.scheffer@rub.de; hannah.mattern@rub.de; koenig@inf.bi.rub.de

© Springer International Publishing AG, part of Springer Nature 2018
A. Borrmann et al. (eds.), *Building Information Modeling*,
https://doi.org/10.1007/978-3-319-92862-3_13

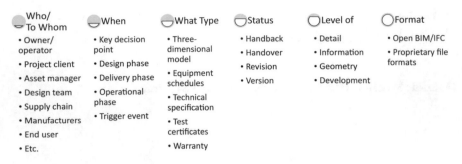

Fig. 13.1 Questions related to the project information flow

zation of construction projects requires a clear definition and structure between involved actors. In the best case, produced information can be reused in project phases covering the whole life cycle of an asset.

In 2014, the European Parliament decided to support public clients by demanding a digital information management in construction projects (European Parliament 2014): "For public works contracts and design contests, Member States may require the use of specific electronic tools, such as building information, electronic modeling tools or similar". Simultaneously, European standardization projects have started within the Working Group 215 of the "Centre Européen de Normalisation (CEN)". First steps comprise the adaptation of ISO 16739 (Industry Foundation Classes, Chap. 5) and ISO 29481 (Information Delivery Manual, Chap. 6) on a European level which need to be transferred to national standards of the EU member states.

In all phases of a construction project, decision making should always be based on the best set of available information. An efficient asset and project management requires access to up-to-date and accurate information when necessary. Consequently, quality assurance needs to be considered before starting the planning and construction process.

To achieve an improvement of the project efficiency and construction quality, information and collaboration management should be defined in advance. On the one hand, the formal structure of the project needs to be defined as strict as possible to assure productive and traceable workflows. On the other hand, regulations should be flexible enough to enable rearrangements of the project teams even during the project progress. Further, an established BIM supporting project structure should be transferable to other projects.

Resulting concepts and principles are transparently described in ISO 19650 which was accessible as a draft version as of October 2017 (ISO 19650-1 2017). This international standard provides a framework to manage information including exchanging, recording, versioning and organizing. In this context, the whole asset life cycle is addressed comprising the majority of involved roles (asset owner/operator, project client, asset manager, design team, construction supply chain, equipment manufacturer, a system specialist, regulator and end-user). Part 2 of ISO 19650 (ISO

19650-2 2017) focuses on project and information management during the delivery phase.

According to ISO 19650, using BIM methods becomes more beneficial if a BIM supporting project structure is implemented by the project stakeholders or client using a top-down approach. A well-structured information flow becomes highly relevant when data is delivered to the client ("data drops"). Provided that the information management structure is transparently defined by the stakeholders, the increased information quality supports the client at key decision points.

13.2 Participants and Perspectives

During the life cycle of a construction project including the asset phase, different project participants hold varying views on the information requirements and data environments. These different perspectives have to be respected within the project structure as well as in documents used to described the information flow. Generally, the ISO 19650 defines different perspectives that evolve in the asset life cycle. The first and global view on a project is from a political and social point of view, which has to ensure that the project goals match with the needs of the society. This global perspective in general does not affect the information structure for construction projects but may generate the needs for a special building structure.

The asset owners perspective is a strategic and profit driven, global perspective on the project. Disregarding specific information about the construction methods or detailed project schedules, this perspective focuses on the business plan and life cycle cost analyses and defines the expected benefits of an asset. This perspective is based on case-by-case decision and analyses, and represents the information requirements needed to run a business.

The purpose of the asset user perspective is to fulfill the needs of the owner's business plan with the right quantities and capacities. This is done by defining the asset information requirements which defines the strategic information requirements. Still, this only happens in the conceptual stage of the information management without generating content.

With a strong focus on the project success, the user perspective during the project delivery phase must target on complying with the schedule and budget of the construction project. Adequate generation of popular content like organigrams, schedules or construction plans, contributes to a high quality of information at various stages of the project phase.

Clearly structured information requirements translate the owner perspective into the project perspective. Thus, different project delivery teams providing sub-models and information can be merged and used during the whole asset life cycle. Key decision points and related data drops require a definition of quality and quantity of relevant information. Both need to be implemented within the project processes in advance to support the decision finding process. Thus, key decision points need to be defined covering the whole asset life cycle (Fig. 13.2) to describe a

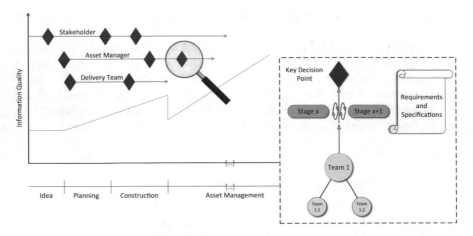

Fig. 13.2 Key decision points and data drops over the asset life cycle based on ISO 19650-1 (2017)

clear and structured information flow between different project participants and phases. Information exchange should always be based on the proper information requirements. The following section describes methods to clearly structure and process information requirements during a dynamically evolving project with different roles and perspectives.

13.3 Information Requirements and Models

The prevalence and exchange of information varies according to project phases and defined key decision points. ISO 19650 generally differentiates between the definition of information requirements, the planning for information delivery and the delivery of information in the form of information models. Information requirements are created by the project client and serve as a valuable information source at key decision points. The content and structure of information models have to correspond to the respective requirements. Information models may cover different aspects at the described phases of a project. In the context of a building project, an information model may comprise 3D models, equipment schedules, technical specifications or test certificates. To structure information exchange processes over the asset life cycle, a differentiation between project "delivery phase" and "asset management phase" is proposed.

Figure 13.3 shows the relation between information requirements and information models produced and used over the asset life cycle. The horizontal division of the figure represents the different views on the asset which decisively influence requirements and the resulting information models. A detailed description of the different aspects can be found in the following section.

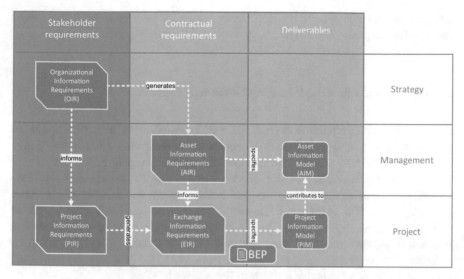

Fig. 13.3 Information management throughout the asset life cycle based on ISO 19650-1 (2017)

13.3.1 Organizational Information Requirements

Organizational Information Requirements (OIR) represent a specification for data and information by the asset owner or operator to achieve their organizational objectives. OIR might be based on strategic asset management, portfolio planning, regulatory duties or policy making. Concerning the building life cycle, the asset management phase shows a decisive influence on lifespan and resulting costs. Thus, OIR mainly influence Asset Information Requirements. However, as information from Project Information Models need to be handed over to the Asset Information Model, the OIR are also considered when defining requirements concerning the Project Information Model (PIM).

13.3.2 Project Information Requirements/Model

Project Information Requirements (PIR) aim at supporting the answer to high level strategic objectives within involved organizations. PIR refer to a particular built asset project. They are generated from both the client's project management process and the asset owner or operator's asset management process.

The Project Information Model (PIM) supports the project delivery phase and represents an important input source of the AIM. During project delivery, the PIM might be used for clash detection, scheduling or cost estimation. A PIM generally provides geometric information, location of equipment, details of installed systems

which are highly relevant for the AIM. Furthermore, PIMs serve as a valuable means for auditing purposes, e.g. maintenance work and documentation.

13.3.3 Asset Information Requirements/Model

Asset Information Requirements (AIR) define those pieces of information needed to answer the above described OIR. AIR should be expressed in such a way that they can incorporated into asset management works, appointments or instructions.

The resulting Asset Information Model (AIM) supports the strategic and day-to-day asset management processes and mainly refers to interests of the asset owner/operator. The AIM may integrate documentation, non-graphical data as well as graphical models (PAS 1192-2 2013). Common AIM content comprises equipment registers or cumulative maintenance costs and dates. In addition; a former existing AIM might also serve as an information source for PIM (e.g., by delivering pre-existing asset information as basis of the project brief).

13.3.4 Exchange Information Requirements

Exchange Information Requirements (EIR)[1] are specified by the appointing party and regulate data and information that the appointed party is expected to meet during the handover. EIR mostly cover PIR, but might also include requirements given in the AIR. As the nature of building projects is characterized by sub-appointments, EIR received by an appointed party might be sub-divided and passed on to any sub-appointment and thus, cover the resulting supply chains.

13.3.5 Information Requirements Over the Asset Life Cycle

Figure 13.4 summarizes requirements described above and transfers their creation to the different phases of an asset. To increase the quality of information for all project participants and at each stage of the project, the consistency of the requirements needs to be guaranteed.

[1] In this chapter, the abbreviation EIR is used for Exchange Information Requirements and not for Employer's Information Requirements as in the other chapters.

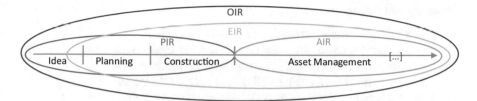

Fig. 13.4 Application range of information requirements throughout the asset life cycle

13.3.6 BIM Execution Plan

The BIM Execution Plan (BEP) is generated according to the PIR and explains how the information management aspects of the project will be carried out by the delivery team. Thus, the BEP defines processes to create information models that correspond to the client's EIR. In general, a differentiation is made between "pre-appointment" and "post-appointment" or "post-contract award" BEP. The pre-appointment BEP focuses on the delivery team's proposed approach to information management, and their capability and capacity to manage information [ISO]. As part of the initial BEP, a Project Implementation Plan (PIP) shall be submitted by each organization. The PIP might be based on templates (e.g., Construction Project Information Exchange (CPIx) Protocol) used to assess the suppliers' building information management, the suppliers' information technology and the suppliers' resources. According to PAS 1192-2 (2013), the contents of the pre-contract BEP shall consist of everything requested in the EIR plus the following aspects:

- the project implementation plan (PIP)
- project goals for collaboration and information modeling;
- major project milestones consistent with the project program, and
- project information model (PIM) deliverable

Due to the dynamic nature of construction projects, the BEP is being developed and expanded continuously within the team. The contents of the post-contract award BEP shall consist of everything requested in the EIR plus the following information (ISO 19650-1 2017):

Management:

1. roles, responsibilities and authorities;
2. major project milestones consistent with the project program;
3. project information model deliverable strategy (for example the Construction Industry Council (CIC) Schedule);
4. survey strategy including the use of point clouds, light detecting and ranging (LIDAR) or global navigation satellite systems (GNSS);
5. existing legacy data use;
6. approval of information; and
7. PIM authorization process;

Planning and documentation:

1. revised PIP confirming the capability of the supply chain;
2. agreed project processes for collaboration and information modeling;
3. agreed matrix of responsibilities across the supply chain;
4. Task Information Delivery Plan (TIDP; see Sect. 13.3.7); and
5. Master Information Delivery Plan (MIDP; see Sect. 13.3.8);

The standard method and procedure:

1. the volume strategy;
2. PIM origin and orientation (which may also be geo-references to the earth's surface using a specified projection);
3. file naming convention;
4. layer naming convention, where used;
5. agreed construction tolerances for all disciplines;
6. drawing sheet templates;
7. annotation, dimensions, abbreviations and symbols; and
8. attribute data;

The IT solutions:

1. software versions;
2. exchange formats; and
3. process and data management systems.

13.3.7 Task Information Delivery Plan

According to PAS 1192-2 (2013), the Task Information Delivery Plan (TIDP) represents an internal document used within the different planning teams. Each team compiles its own TIDP including relevant milestones. These shall be used to convey the responsibility for delivery of each supplier's information.

- Milestones within each TIDP shall be aligned with the design and construction programs to produce the MIDP (see Sect. 13.3.8).
- For each deliverable, the TIDP is used to indicate the team member responsible or to note that such responsibility has yet to be allocated.
- The TIDPs show how responsibility for the preparation of project documents transfers from one team member to another.

A TIDP helps to take account of the required sequence of model preparation for any work packages used in the project.

13.3.8 Master Information Delivery Plan

The MIDP lists the information deliverables for the project, including but not limited to models, drawings or renditions, specifications, equipment schedules, room data sheets. The MIDP shall be managed via change control and developed in accordance with the team members' TIDPs (PAS 1192-2 2013).

13.4 Collaborative Production of Information

The draft version of ISO 19650 specifies information management processes focusing on the exchange of information between an AIM and PIM at the start and end of a project. Figure 13.5 shows the collaborative production of information according to commonly applied supply chains covering design, construction and asset management. At every key decision point, the client needs to be provided with the required information which is checked for consistency with the EIR.

The resulting supply chains include complex team structures and diverse tasks. As information may be stored and exchanged in different types of media, a container-based collaboration method is advisable. An information container is more generic than a 3D model file as it may comprise written documents, schedules and tables or aggregates of information sources (e.g., folders or files). More details on a container-based working strategy can be found in Sect. 13.5.

13.4.1 Information Management in the Project Delivery Phase

Part 2 of ISO 19650 (ISO 19650-2 2017) specifies the above described structure explicitly focusing on the delivery phase of assets. Furthermore, the standard comprises a strategy to define a commercial and collaborative environment used by (multiple) appointed parties. The standard divides the delivery phase of an asset into the following stages:

- Phase 1: Assessment and need
- Phase 2: Invitation to tender
- Phase 3: Tender response
- Phase 4: Appointment
- Phase 5: Mobilization
- Phase 6: Collaborative production of information
- Phase 7: Information model delivery
- Phase 8: Project close-out (end of delivery phase)

In the following, the overall definitions and project structure as described in the sections above are applied in terms of information management during the delivery

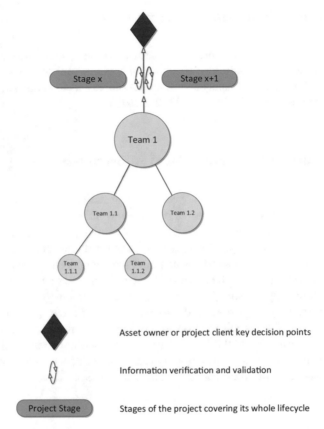

Fig. 13.5 Collaborative information management at key decision points based on ISO 19650-1 (2017)

phase. Special focus lies on structure and components according to Fig. 13.3. Further, elementary aspects are explained in the full version of the standard. When analyzing project-specific assessment and need (Phase 1), the appointing party shall establish the project information requirements (PIR) which are strongly influenced by Organizational Information Requirements (OIR) derived from the strategic level (see Fig. 13.6). Defining PIRs should cover aspects like project scope, purpose of information use or number of key decision points throughout the delivery phase. Related definitions to be made in Phase 1 comprise project milestones, information standard, reference information and shared resources as well as an information protocol. Summing up these results, the appointing party shall establish a common data environment (CDE) which serves the overall project needs. According to ISO 19650-1, container- based information management should be supported. Provided that the CDE is in place prior to issuing the invitation to tender, information can be shared with tendering organizations in a secure and well-structured manner.

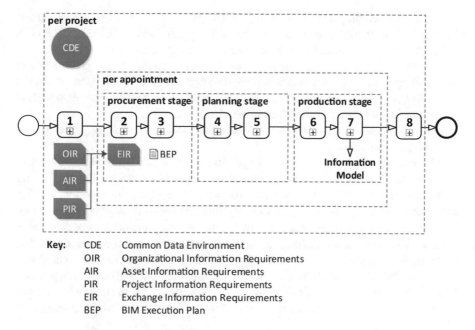

Fig. 13.6 Information management processes in the delivery phase according to ISO 19650-2 (2017)

Phase 2 refers to the invitation to tender. According to the defined PIR, the appointing party shall establish their exchange information requirements (EIR) to be met by the appointed party during the appointment. To define appropriate EIRs, OIRs, AIRs as well as PIRs need to be considered (see Fig. 13.6). Furthermore, the level of definition, including level of detail (LoD) and level of information (LoI), needs to be established. Guidelines set in the EIR comprise acceptance criteria for each information requirement, dates of information delivery and supporting information to interpret the given requirements and related acceptance criteria.

A pre-appointment BIM Execution Plan (BEP) is established by each delivery team and submitted in the tender response (Phase 3). The individual BEPs should include information on

- team members (name, CV, role in the team)
- the team's information delivery strategy,
- the proposed spatial division
- a high-level responsibility matrix
- the delivery team's proposed information production methods and procedures
- any proposed additions or amendments to the project information standard
- a complete schedule of software (including versions), hardware and IT infrastructure used by the team

Besides developing a project-specific BEP, the team's mobilization plan covers information on configuring and testing the delivery team's (distributed) CDE and its connectivity to the project CDE (if provided by the appointing party).

During the appointment, the delivery team's BEP is confirmed in agreement with each sub-appointed party, which might require updating the BEP. Concurrently, the appointed party shall establish their EIR for each sub-appointed party. Resulting documents need to be revised and completed.

Phase 5 mainly focuses on the mobilization of resources including information technology and CDE.

Phase 6 describes the collaborative production of information which is aggregated in the PIM. In this context, production comprises checking the availability of reference information and shared resources, generating information, quality assurance checking and finally, reviewing information and approval for sharing. Due to the involvement of multiple teams, information production is performed in parallel. Exchange and revision processes are supported by the chosen CDE. The resulting information is delivered in Phase 7. The information model is submitted for appointed party authorization, which includes review and authorizing tasks. Provided that the submitted PIM adheres to the specified EIR, the model is accepted by the appointing party. Otherwise, corrections need to be made by the appointed party.

Phase 8 represents the project close-out. Besides archiving the CDE, information stored in the PIM are filtered and transferred to the AIM.

Phases 6 and 7 comprise the production of information which is commonly divided into different delivery teams. An appointed leading team might delegate tasks to sub-appointed parties. To guarantee an efficient production and exchange along the resulting supply chain, the definition of project and task information management roles is proposed.

13.4.2 Roles During the Production of Information

Figure 13.7 explains the responsibilities assigned to the different roles during the collaborative production of information. Information Authors are responsible for developing constituent parts of the information model in connection with specific tasks. Thus, information authors are experts in their field and produce technically correct deliverables. The main responsibility of the Task Information Manager is to direct the production of information along the supply chain. In this context, project-specific standards, methods and procedures need to be fulfilled. The Interface Manager supports collaboration between appointed parties and within the single teams. This task comprises managing spatial coordination and proposing resolutions to coordination clashes. Another aspect of this role is the coordination and configuration of information as well as information exchange in different formats. After the deliverables have been produced by the Information Authors, the Task Information Manager needs to confirm that information which is still

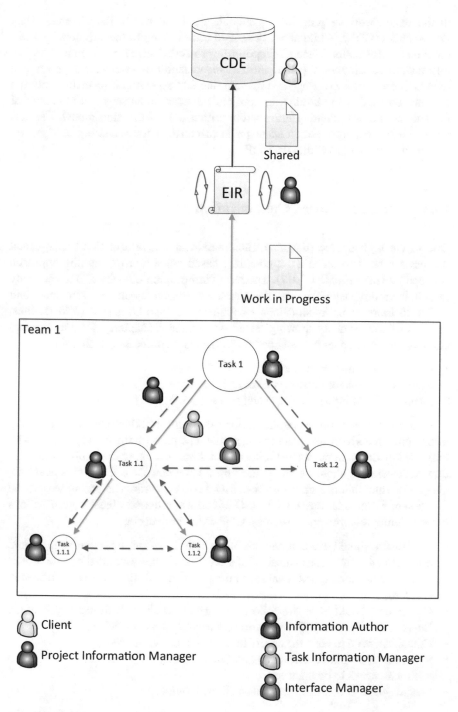

Fig. 13.7 Project and information management roles in the delivery phase according to ISO 19650-2:2017-02

in the stage "work in progress" is suitable for issue within the Common Data Environment (CDE). While above described roles belong to the appointed parties, the Project Information Manager supports the project client. This role defines project information requirements (PIR). Further responsibilities comprise supporting a reliable information exchange and maintaining and receiving information into the information model. In addition, the Project Information Manager is in charge of integrating and coordinating information within the information model. Furthermore, the Project Information Manager is responsible for accepting or rejecting information exchanges within the CDE.

13.5 Container-Based Collaboration

Due to the high degree of human intervention in the information management processes related to an asset, a container-based collaborative working approach is proposed (ISO 19650-1 2017). The term "information container" does not only refer to three-dimensional model files but also to written documents, schedules, and tables. In more complex situations, containers can also be nested (folders, files, sections of files such as drawing layers or document chapters). Container-based collaboration comprises project-specific management processes, such as

- definition of information content,
- agreed protocols for version control and
- management of information use and access.

Above mentioned processes are applied to all information containers evolving during project delivery and asset management. Focusing on the delivery phase with multiple key decision points and related data drops, checking the applied Information Requirements should be supported by a Common Date Environment (CDE, Chap. 15). International standards like ISO 19650 describe the structure and the function of a container-based CDE. ISO 19650-2 summarizes basic considerations when defining requirements towards a CDE at the project start:

- Containers should have a unique ID which is based upon an agreed and documented convention comprised of a number of fields separated by a delimiter; each field to be assigned a value from an agreed and documented codification standard;
- Containers should have the following attributes assigned: Suitability (status), Revision (and version), Classification (in accordance with ISO 12006-2)
- Containers need to have the ability to transition between states;
- Recording the name of user and date when container revisions transition between each state needs to be managed.
- Secure access at container level needs to be provided.

13.6 Summary

As BIM stresses collaboration among a high number of involved parties with heterogeneous views and interests, project management plays a significant role. A clear definition of roles and responsibilities enables a successful use of BIM technically realized by a common data environment (CDE), and supports a mutual understanding of roles and work flows. Thus, a collaborative production and management of information increases the benefit for all participants. The value and use of information may be expanded from the pre-planning to the asset management phase.

Due to the manifold options of project structures, management processes need to be independent from the procurement route or form of contract which is applied. In this context, standardized processes and definitions help ensure the same form and quality, enabling information to be used and reused without change or interpretation. Following the guidelines described in this chapter, the client is provided with reliable information at key decision point of the project, which is a prerequisite for making beneficial decisions from a long-term point of view.

References

European Parliament. (2014). *Directive 2014/24/EU of the European Parliament and of the Council of 26 February 2014 on public procurement and repealing Directive (2004/18/EC).* Luxembourg: Office for Official Publications of the European Communities.

ISO 19650-1. (2017). *Organization of information about construction works – Information management using building information modelling – Part 1: Concepts and principles.* Geneva, Switzerland: International Organization for Standardization.

ISO 19650-2. (2017). *Organization of information about construction works – Information management using building information modelling – Part 2: Delivery phase of assets.* Geneva, Switzerland: International Organization for Standardization.

PAS 1192-2. (2013). *Specification for information management for the capital/delivery phase of construction projects using building information modelling.* London, UK: British Standards Institution.

Chapter 14
Collaborative Data Management

Sven-Eric Schapke, Jakob Beetz, Markus König, Christian Koch,
and André Borrmann (iD)

Abstract The design, construction and operation of buildings is a collaborative process involving numerous project participants who exchange information on an ongoing basis. Many of their working and communication processes can be significantly improved by using a uniformly structured building information model. A centralized approach to the administration of model information simplifies coordination between project participants and their communications and makes it possible to monitor the integrity of the information as well as to obtain an overview of project progress at any time. Depending on which model information from which project phases and/or sections need to be worked on by which partners, different forms and means of cooperation can be employed. This chapter presents different methodical approaches, practical techniques and available software systems for cooperative data administration. It discusses the different information resources and possible forms of cooperation for model-based collaboration and explains the underlying technical concepts, such as concurrency checking and versioning along with rights and permissions management. Several different software systems available for

S.-E. Schapke (✉)
think project! GmbH, Munich, Germany
e-mail: sven-eric.schapke@thinkproject.com

J. Beetz
Chair of Design Computation, RWTH Aachen University, Aachen, Germany
e-mail: beetz@caad.arch.rwth-aachen.de

M. König
Chair of Computing in Engineering, Ruhr-Universität Bochum, Bochum, Germany
e-mail: koenig@inf.bi.rub.de

C. Koch
Chair of Intelligent Technical Design, Bauhaus-Universität Weimar, Weimar, Germany
e-mail: c.koch@uni-weimar.de

A. Borrmann
Chair of Computational Modeling and Simulation, Technical University of Munich, München, Germany
e-mail: andre.borrmann@tum.de

© Springer International Publishing AG, part of Springer Nature 2018
A. Borrmann et al. (eds.), *Building Information Modeling*,
https://doi.org/10.1007/978-3-319-92862-3_14

251

cooperative data administration are also presented. The chapter concludes with a brief look at future developments and the challenges still to be faced.

14.1 Introduction

The design and construction of buildings is a highly collaborative process involving numerous participants. Clear communications between these participants, which are vital to successfully completing the projects, is still primarily based on 2D drawings today. For complex building projects, this form of information exchange is, however, both time consuming and prone to errors. The monitoring, coordination and agreement of changes is not automatically supported. The introduction of digital building information models with agreed workflows and processes offers an effective way of supporting and improving different forms of collaboration. Information needed from the various project participants can be kept up to date and made immediately available in a shared information space, which can be semi-automatically verified and monitored for inconsistencies. Iterative planning cycles are kept short, project progress is easier to monitor and control, and communications between all participants are more reliable as everyone has access to the same information. The transition to more effective and efficient computer-supported collaborative systems does, however, require fundamental changes to the way we work compared with paper-based work processes.

This chapter shows how collaboration as well as the coordination of planning processes can be significantly improved through cooperative data management. While Chap. 15 discusses the specific concept of the Common Data Environment and the underlying standards BS PAS 1192-2 (2013) and ISO19650 providing a high-level perspective on cross-enterprise collaboration on the basis of federated models, this Chapter discusses technical solutions not only for CDE-compliant work but also for more intense forms of collaboration including synchronous model editing. To begin with, we look at fundamental concepts of shared information spaces as well as Computer-Supported Collaborative Work (CSCW). In the first section, we present the basic principles of BIM-based information resources and their processing methods, and in the second, we look at fundamental aspects of cooperative data management.

In the following we present an overview of the different available technologies and their applications. The third section discusses software tools that support the various concepts and methods of collaborative working, the different approaches they take in supporting these concepts, and their respective requirements. Finally, we conclude the chapter with a critical consideration of the current state of the art and take a look at future developments and research in the field.

14.2 BIM Information Resources

The basis of every data management task is clearly addressable and formally uniform amount of data, known as data sets, data objects or *information resources*. Data management systems describe these information resources with the help of metadata to make them easier to capture, organize, find and use. In model-based collaboration processes, first structured information resources, such as object-oriented 3D building models, need to be managed. These can happen at different levels of aggregation, for example at the level of a building element, of groups of elements, or of entire models. At the same time, building projects always also involve a degree of semi-structured information resources, for example text, images or drawings. While these may be created and edited using software applications, they are only interpreted by the user in their respective context.

14.2.1 Metadata

The basis for the consistent organization of information resources is metadata schemas. Traditionally, these outline a series of metadata attributes that represent different aspects of a resource, for example to:

- identify them (e.g. ID, storage address, creator, author),
- describe their content (e.g. application field, level of detail, project area),
- describe their technical properties (e.g. data format, size),
- describe their functional state (e.g. version, revision, work status), and
- retain them for the future (e.g. safety copies, archives, migration).

In cases where individual data objects require very detailed descriptions, including relationships between them within a model, object-oriented meta models may be created and used for the automatic generation of software components (see Tozer 1999).

The most important metadata attribute of an information resource is its identifier. This is a unique descriptor for identifying a resource that is defined by the resource itself or assigned by the management system. In digital building models, all important elements generally have a GUID (Globally Unique IDentifier) or a UUID (Universally Unique IDentifier). These make it possible to manage each element individually, to compare the same element in different model versions and to reference elements in external software systems. For this to work, all systems in a collaborative process must, however, preserve the GUIDs of the central model, and not, for example, regenerate them when exporting into a neutral data format.

Additional consistency between attributes can be achieved through the use of metadata vocabularies. These define a series of possible attribute values, for example through lists, classifications, partonomies or other classification systems.

The first use of metadata in current construction practice is in drawing management. Within a project, a unified coding system, the drawing code, is used to identify

and describe each drawing. The drawing code combines several classification facets that employ a predefined vocabulary, for example for (1) sub-projects, (2) trades (architecture, structural, etc.), (3) forms of presentation (floor plan, section, etc.) and (4) project phase (concept design, design development, etc.) as well as for versions and revisions. As shown in Sect. 14.2.3, such identification codes can also be used to manage digital building models. Metadata vocabularies can follow established standards, for example for general construction classification systems such as OmniClass (2006) and Uniclass2 (2013), cost classification systems such as the German DIN 276 (2008) or element catalogs such as the KKS (2010). For more information, see the discussion in Chap. 5.

14.2.2 Level of Aggregation

A vital aspect for the application of a data management system is the level of aggregation of the information resources. In order to immediately find and edit specific project information, each resource should hold only a limited quantity of information. As the number of resources increases, however, so too does the effort required to manage them. In practice, therefore, a lot of project information is managed in an aggregated form before they are read and used by other software systems. Table 14.1 shows five different levels of aggregation and some examples of corresponding information resources and management systems.

Information resources with a high level of aggregation include, for example, collections of models and documents, such as a CAD file that contains a 3D model along with corresponding 2D drawings and a bill of quantities. The aggregated resources act as a container for different kinds of information, which are now more difficult to access as they must first be retrieved, loaded, interpreted and filtered. Information resources with an intermediate level of aggregation comprise related information from individual work tasks and building systems, for example a section of a building, a floor, or a particular assembly of parts. These are often saved in separate files. Information resources with a low level of aggregation (i.e. a higher level of detail) represent individual logical units within a model or document, such as individual building elements, element properties or text segments. Within a model, these datasets are interconnected and must therefore be managed in a common, coordinated system.

14.2.3 Digital Building Models

The basis for model-based collaboration is the digital building models that are created by the respective project participants using a variety of different software tools. These models represent certain domain-specific aspects of a building and are therefore called *domain models*. In planning phases, domain models typically

Table 14.1 A comparison of information resources with different levels of aggregation

Level of aggregation	Collection, models and documents	Individual model, individual document	Element group, subset of model	Building element	Element property
Example	5D building model CAD project file with model and drawings	3D building model Contract document CAD drawing	Model of the walls of a floor Model of a section of a building 3D marker	Single building element (e.g. a column or room)	Dataset with properties of a building element (e.g. material parameters of a concrete column)
Level of aggregation	High	Intermediate		Low	
Advantages/ Disadvantages	Low number of resources Lower management workload No direct access to detailed information	Medium number of resources Moderate management workload Some access to detailed information		Large number of resources High management workload Direct access to detailed information	
Suitable data management systems	File repository Document management system Internet-based project platform	Document management system Internet-based project platform Product data management system		Product data management system Product model server	

represent specific elements of a building structure or space and their geometric, functional and material properties. In other project phases, these elements can also have conceptual properties, such as deadlines or costs, but may conversely not always hold a 2D or 3D representation of the element.

Over the course of a building project, the project participants create a large number of domain models to design and document the building, its construction and use. Each of these domain models represents a part of the building and its lifecycle and is correspondingly also known as a *partial model*.

For better management, these partial models can be classified according to different aspects. Relevant classification dimensions are in particular the domain, zone, level of detail and project phase.

The *domain* represents the disciplinary perspective and conceptualization of a model. It is primarily defined by the represented technical, functional and economic aspects of a building, the envisaged use of the model and the discipline of the model creator and the software they use. In a project, the classification of domains depends on the kind of building, the project organization of software systems used. The detailed requirements of the domain-specific model content of a particular domain can be defined with the help of Model View Definitions, as described in Chap. 6.

The *zone* of a model specifies the spatial areas that a model encompasses. The classification of zones is in effect a spatial subdivision of a building project, for example into sub-projects, stories, or building sections as is frequently set out in project structure plans. In addition, further detailed compositional structures (partonomies) and topological systems can be used to determine whether a model touches, intersects or contains other models (see Chap.16).

Figure 14.1 illustrates the subdivision of a model into six sub-models with three domains (vertical: architecture, building services, structure) and six logical spatial zones (Overall, east – west, east wing – atrium – west wing) as well as the dividing elements that result from the combination of classification dimensions.

The *level of detail* of a model indicates how precisely the elements of a model represent the specific objects. In building models, the level of detail is initially a

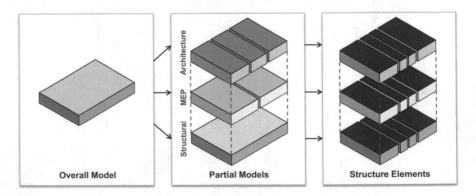

Fig. 14.1 Subdivision of a building into partial models

factor of which geometric parts of a building element are represented, for example, the frame, the door leaf, and the door handle. Alternatively, a geometric element might be simple but include a detailed description of the respective element. Depending on the focus of the classification, this degree of detail is known either as Level of Detail (BS PAS 1192-2:2013) or Level of Development (AIA Document E202 2013) (see Chap. 6).

The *phase* indicates at what time and for what purpose a model was created, and/or which status it currently has. Phase classifications can be based on quite different process structures, for example the overarching project phase and value creation processes, or alternatively the individual work steps and their corresponding processing statuses.

In model management, changes in phases often correspond to changes in the status of the information resources. On the project, statuses must be defined that are reached by requesting, checking, revisioning, filtering, transcoding and linking of a model. At the same time, mechanisms for propagating status changes need to be established that indicate how status changes in individual information resources relay to linked, subordinate and superordinate resources, as well as to resources in adjacent zones and domains.

14.2.4 Information in Model Coordination and Model Management

In addition to digital building models, there are a number of other information resources that arise through the coordination and verification of models and through their evaluation and further use. Figure 14.2 shows an example of a coordination model consisting of several partial models, a 3D marker in the coordination model as well as other accompanying documents and drawings.

A coordination model is a model that collects several partial models and serves as a central resource for model-based collaboration. Coordination models can be created for very different purposes and typically have an own author and lifecycle. The primary aim of a coordination model is to check that separately created partial models are consistent with one another and do not exhibit geometric clashes or other kinds of inter-domain conflicts. For the combined checking of multiple building models, different BIM applications, so-called viewers or model checkers can be used (see Chap. 18). Other application possibilities include, for example, comparing versions, variants and actual versus intended model states as well as to 'locate' certain processes and documents in the overall model.

The results of model checking are likewise important information resources. Typically, a manual or (semi-)automatic checking procedure, e.g. from clash detection, will set 3D markers with comments in a coordination models to flag clashes and uncertainties. In collaborative processes, these quality control checks need to be collated into checklists in order to coordinate their execution and/or clarification. Chapter 6 shows how corresponding 3D markers can be saved, exchanged and managed in a neutral BIM Collaboration Format (BCF).

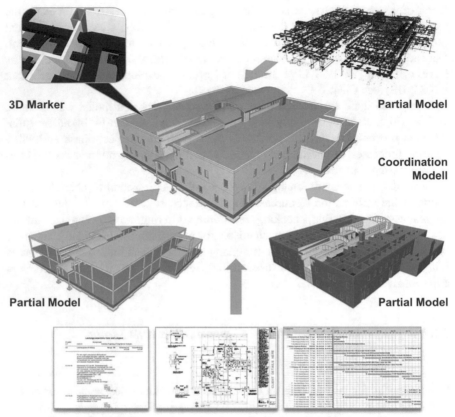

3D Marker

Partial Model

Coordination Modell

Partial Model

Partial Model

Drawings, Application Models of e.g. Scheduls, Bill for Quantities, etc.

Fig. 14.2 The integration of partial models and documents in a coordination model

Alongside such checklists, all documents that relate to the building models represent important information resources. These can be drawings and bills of quantities generated from the building models, and may need verifying and updating with each new version of the model. Or they can be independently created documents and models that are associated with the building model, for example, construction details or delivery schedules that refer to selected model elements. In recent years, research has been undertaken on ways of exchanging and managing combinations of multiple models from 4D and 5D BIM applications as well as corresponding documents with the help of so-called multi models, linked models or linked data techniques (Curry et al. 2013; Scherer and Schapke 2015; Pauwels et al. 2015; Beetz 2009). Please refer to Chap. 10 for an in-depth discussion of this technology.

14.3 The Requirements of Cooperative Data Management

A fundamental function of data management is the efficient provision of all information that the different project participants need. In collaborative work, participants need adequate information in order to agree, coordinate and direct their work towards common objectives. At the same time, the amount of information must be manageable in order to be able to coordinate and control collaborative processes. Those who commission design and planning services must be able to ensure that important information from the respective project participants is created in the desired quality, properly stored, adequately documented in a verifiable form and efficiently distributed to the respective participants.

The requirements for the management of model-based project information depend to a large degree on the project organization, the complexity of the building project and the software systems used. In addition to defining suitable filing structures and coding systems for different project information, rules must be established for editing and saving information. The following five sections provide an overview of different forms of cooperative data management and the technical processes that support this. The application methods and the requirements that each of these have depends in particular on the following aspects:

- *Communication and Cooperation:* how many project participants, in which locations, at what times, from which organizations, with which contractual relationships work together,
- *Concurrency:* when and to what degree does the integrity of information created in parallel need to be ensured,
- *Roles and Rights:* to what degree is project information confidential and only for certain (groups of) participants, to what degree do participants need to have different editing rights and coordination responsibilities and which creation, access and usage rights result from these,
- *Versioning:* in what detail do individual work steps for editing project information and the resulting changes and variants need to be recorded and reliably documented,
- *Approval and Archiving:* how will certain defined planning stages be secured, definitively stored and published for others.

In document management systems, established methods for data management exist that fulfill these functional requirements. These methods deal with drawings, reports and photographs of a project almost exclusively as distinct data containers, and only rarely consider their contents. A key question for the management of model information is therefore how such methods can be applied to other levels of aggregation, for example to manage access rights or track versions of individual elements and element assemblies.

In principle, conventional data management methods can be applied to all levels of aggregation, however, this is very rarely useful in building practice. On the one hand, many methods, such as concurrency control, require very close interaction between software applications and the central data management system. This is

generally only possible when all key project participants work with the same software systems. In building projects, however, a variety of specialist software systems are typically used (e.g. CAD, CAE, ERP) producing and using different forms of documents, drawings, models and other media data.

Moreover, collaborative work on project data results in a large number of dependencies over different levels of aggregation. These need to be taken into account by data management systems to avoid inconsistencies and conflicts. For example, access rights to an element assembly must also determine whether this also confers the right to edit the individual constituent elements, and whether changes made to these also changes the ownership and version of the edited elements, or of the entire element assembly. Many such dependencies can be regulated in detailed, for example through inheritance rules. The high technical complexity required to ensure the conflict-free management of dependencies and the extra work involved and/or the restrictions these entail for users are often disproportionate to the benefits of such comprehensive change control management.

In practice, therefore, one needs to decide what cooperative approaches and data management methods are appropriate for the respective application area. The aim is to find a good balance between a technically simple and user-friendly approach and a data management system that ensures the integrity, reliability and authenticity of all project data at all times.

14.4 Communication and Cooperation

A prerequisite for collaboration is efficient communication between the cooperating partners. The communications medium and the kind of communications influences the form and quality of collaboration.

Depending on the spatial and temporal distribution of the participants, communications can be *synchronous* or *asynchronous* as well as *co-located* or *remote*. The combination of these classifications results in four different communication forms, usually depicted in a time-space matrix as shown in Fig. 14.3 (Johansen 1988).

At the same time, information can be exchanged through *direct* or *indirect* communication (see Fig. 14.4). In direct communication, partners send information and messages to one another directly. In indirect communication, information is exchanged indirectly when working jointly on shared information resources. Shared information resources make it possible to collect relevant communications in a central location so that the solutions chosen and decisions made are transparent and can be understood (McGrath 1984).

In the design of model-based collaboration, also the *information delivery processes* must be examined in order to determine which participants require which information, when and from whom, as well as which information they create and need to provide to which other participants. The objective is to design and adjust work processes and technical interfaces to one another as seamlessly as possible to ensure the continuous and efficient use of information (see also Chaps. 4 and 6).

Fig. 14.3 Time-space matrix of communication forms (After Johansen 1988)

Fig. 14.4 Collaboration (After Schrage 1990)

Compared with other industries with stationary facilities, the project organization of building projects presents particular challenges for process management and process optimization. In each project, a functioning distribution and delivery network needs to be established in a short space of time in which changing project partners can be incorporated into cross-enterprise processes and at the same time have the opportunity to further optimize their own internal business processes (Bøllingtoft et al. 2011). In addition, many of these fragmented processes involve interdisciplinary and iterative planning tasks.

In *cross-enterprise collaboration*, as well as in interdisciplinary planning teams, it is likewise important, aside from sharing information, to consider economic aspects, such as the effective coordination and control of project partners as well as their property and usage rights, the preparation and correct legal documentation of decisions or the balance of group dynamics in interdisciplinary teams. Depending on which of these aspects plays a central role, communications and collaboration can take different forms. The following terms describe these different forms:

- *Communication* describes exchanges of information between two or more human, technical or institutional participants in the form of messages.

- *Interaction* describes reciprocal communicative activities by people who through their actions want to achieve certain effects among other people.
- *Coordination* describes interactions that are necessary to achieve the efficient and effective alignment of the targeted activities of several people.
- *Cooperation* is the working together of several participants on joint material to achieve common aims. Cooperation is typically voluntary and trust-based, which promotes clear communications and effective coordination.
- *Collaboration* describes the cooperation of complementary partners with a high level of trust and reciprocal support. An important objective of collaboration is the creation of collective knowledge in order to develop solutions for complex problems. Collaborative processes are frequently highly creative, and all partners are of equal standing.

14.4.1 Concurrency Control

For data management in model-based collaborative environments, the distributed and synchronous editing of shared information resources presents a particular problem. In practice, several project participants often work concurrently on their respective copies of a building model or document that may have been created by another project participant. Changes made to this copy can lead to technical inconsistencies and disciplinary conflicts in the project information because cooperating partners may make decisions based on different assumptions.

Concurrency control offers a way of avoiding inconsistencies or conflicts when working simultaneously on project information. There are two primary approaches to this: *pessimistic concurrency control* avoids conflicts in advance by allowing only certain changes to be made, while *optimistic concurrency control* identifies conflicts in project information and attempts to resolve them after they have occurred.

Figure 14.5 shows a model of distributed synchronous data processing that offers a good basis for discussing different forms of cooperation and concurrency control. The model divides the process of cooperation into discrete phases. Each phase ends with a coordination point T_i at which the overall dataset should be consistent and free of conflicts. Within each phase, users undertake a series of work steps in order to:

- extract a partial dataset with the information they require for the specific task from the overall dataset (extraction),
- make their respective changes and additions in their local dataset (modification), and
- feed back the changes from their local dataset to the overall dataset and merge this with other, likewise potentially modified, partial datasets (integration).

These three work steps may be undertaken in parallel by several users. At each coordination point at the end of each phase, the overall dataset must be in a conflict-free state.

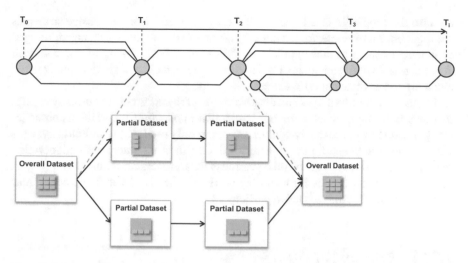

Fig. 14.5 The coordination of individual planning stages through the merging of partial datasets

Using *pessimistic concurrency control* each partial dataset that is extracted is locked in the overall dataset. The lock prevents other users from working on the same information at the same time and is only removed once the partial dataset has been integrated back into the overall dataset. Pessimistic concurrency control is mostly used in documents and product data management systems as well as in model servers. The ability to work on project information concurrently depends largely on the level of aggregation of the information resources and the extent of each lock, i.e. whether an entire model is locked when information is extracted or whether just a single layer, element or property is locked, making it possible for others to work on other parts of the model in the meantime.

Optimistic concurrency control initially assumes that inconsistencies will arise when local partial datasets are worked on in parallel. The resulting conflicts will therefore need resolving when re-integrating the modified datasets into the overall dataset. This approach is called optimistic because the assumption is that only a few conflicts will arise, and that the effort required to resolve them is reasonable. Optimistic concurrency control is commonly used in software development because changes are made to individual lines of source code and information therefore has a low level of aggregation. As such, this method is the basis of many code management and software configuration management systems such as CVS or Git.

Both forms of concurrency control have advantages and disadvantages. The pessimistic approach avoids the occurrence of conflicts arising during concurrent work, but also requires that users wait until the relevant (part of a) model or document is unlocked, which can be lengthy. Depending on the level of aggregation, the management of lock releases can quickly become complex and time-consuming. The optimistic approach offers greater freedom in the editing of data, but the management of partial datasets can become extremely complex, especially when merging partial datasets back into an integrated model. For example, integrating several building models entail comparing not just the respective geometric bodies

but also the properties of all relevant building elements. Comprehensive strategies are required, for example, to transfer geometric modifications to a changed, merged or deleted element to other models while simultaneously taking into account all dependencies with other elements (for example a ceiling slab that rest on the element) and element data (for example its volume).

In practice, the advantages and disadvantages of the different concurrency control methods must be evaluated for the respective application scenario. Approaches using pessimistic concurrency control are commonly used within in-house systems while optimistic concurrency control dominates in cross-enterprise collaboration scenarios. In addition to all of this, seamless data processing requires that project participants establish rules for how they work together, i.e. by defining clear areas of responsibility for the respective participants.

14.4.2 Roles and Rights

The underlying principles of interoperability in data management explained in Chap. 5 refer predominantly to the technical aspects of information modeling. Collaborative approaches to planning and engineering tasks in the construction sector using electronic data requires that we rethink established methods and conventional work practices. With paper-based and document-based forms of collaboration, it is usually clear who is responsible for all facets of information, for example, whoever last stamped or signed the respective planning document (drawing, text, etc.). This is not so straightforward when working on jointly produced and integrated building models, where the kind of ownership, rights and reliability of input need to be considered. For this, project-specific and/or sector-wide agreements have to be reached on how these will be handled.

The authorship of information within one and the same information space (the model) can change from element to element and even from attribute to attribute. Metadata attached to the respective information resource must therefore record who is responsible for which information in each case. The owner of a resource may, for example, be the original creator (e.g. the architect who created the wall element) or alternatively the last person to edit it (e.g. the structural engineer who added reinforcement bars). The ability to edit individual aspects of an element must also be clarified: is the structural engineer allowed, for example, to enter the concrete class as a material attribute of the wall element created by the architect? Or should he create an independent material element and link this to the corresponding wall? Or perhaps create an independent element of his own? The respective rights for reading, writing and deleting can be assigned not just to a specific individual user but also to groups of users, who have different roles, for example all members of a company, a division, all system administrators or the respective project manager. Many common systems allow one to define hierarchical and cascading systems of roles and rights at different levels of aggregation, although this can quickly become more complicated when these overlap (e.g. one user with several roles). As such they must be devised with great care and be regularly monitored. When

collaboratively creating information resources and models, new forms of ownership, rights and reliability must be considered, and corresponding agreements met on who can do what. The resulting legal aspects fur such digital collaborative processes – for example, who assumes liability for what – have not yet been fully resolved.

14.4.3 Versioning

In model-based collaboration, different information resources are added, modified, extended or deleted by various people. Every information resource can therefore exist in different *versions*.

All changes made to an information resource should be identifiable through a clear version identifier, for example a version number. In addition to updating the version identifier, every change should also register the name of the editor and time of the change along with further metadata such as associated comments or the software version used. Consecutive changes to an information resource over time result in a history of changes which can be presented as a version graph. Which versions of a resource need to be saved as an instance that will remain available in future, must be determined for each respective application.

A special form of versioning is revisioning. A *revision* collects together a series of versions of information resources once a certain work stage has been reached. This might the case, for example, when a document has been checked by several people and flagged for release, or when models that have been worked on in parallel have been merged. If an information resource requires additions or corrections before it can be released, a new revision maybe be generated for this purpose. A coordination model can, therefore, be seen as a revision of an overall model. Information resources that belong to a defined revision are usually archived in a non-revisable state and can then made available for release.

A further important aspect of model-supported collaboration is the use of variants or branches. If an existing information resource is worked on by two different people or systems, and the changes result in two possible alternative results, for example of a construction detail, one can call this a variant. Variants can be developed independently in parallel and the results may not always be compatible. Over the course of a project, one variant is usually chosen and carried forward. Variants are also important for comparing, evaluating and discussing different possible solutions. Variants are likewise given specific identifiers. In the version graph, variants are shown as branches, and when a branch is incorporated into the main model, the branch merges back into the main version history. Figure 14.6 presents the relationship between version, revision and variants using a simple version graph.

The granularity of versioning corresponds to the respective level of aggregation of the information resource (see Sect. 14.2.2). As such, a version graph can be created for all kinds of information resources: there are versions, revisions and variants of entire model and document collections, of individual models and documents, of element groups, of elements and also of individual element properties.

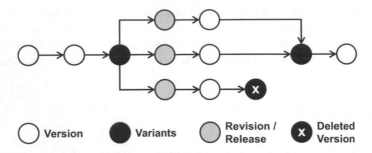

Fig. 14.6 Version graph of an information resource with simple versions (*white*), revision (*dark grey*), variants (*light grey*) and discarded variants (*black with a cross*)

For versioning files, file naming conventions, systems for managing versions of files and directories (e.g. Concurrent Version Systems, CVS, or Subversion, SVN or Git) or document management systems can be used (see Sect. 14.4.2). The simplest approach is to use a file naming scheme. This means the version, revision and variant can be identified through a part of a file's name (e.g. V11_R2_A1 for Version 11, Revision 2 and Alternative 1). Every change is saved as a new file with a new name. The creation of variants using files means that all content must be copied. For building models, this means that the model elements it contains have the same identifiers. This can be useful, for example, when a wall is shifted, and the two variants should be compared. In some cases, however, it can lead to inconsistencies, for example when references are made to model files in another variant. Programs for managing the version of files and directories are generally very good for text files (e.g. Unicode data). When adding a new file, a version number is automatically assigned. Certain stages of progress can be given a revision number. Version management systems also make it possible to track different variants. Such systems are less well suited for binary data as usually each entire variant has to be copied, requiring considerable time as well as storage space. For text-based formats, only the differences between versions and variants need to be saved and transferred. In document management systems, the management of files is usually coupled with the recording of additional metadata in a database. This metadata makes it possible to search for documents using additional information fields. As a rule, these systems do not, however, support variants.

The management of versions of digital building models or partial models is a challenging task. One possibility is to version the entire model file, which for large projects can be several gigabytes in size (a highly aggregated information resource). Most of the time, however, only individual objects within a model change, along with their properties. A selective approach to versioning is, therefore, more advisable, for example at the level of element groups or elements. In most cases, a corresponding database is used that makes it possible to lock, check out and check in individual elements and supports the assignment of specific editing rights. A number of different systems already exist, some of which are proprietary and

some open. With proprietary systems, access to the model requires the use of special software. For distributed collaborative work processes, all relevant users must use this software. Such systems are available from almost all large BIM software vendors. Support for variants are also partially supported, but not all versions of an element are always saved. In mechanical engineering, for example, Product Data Management (PDM) systems are commonly used (see Sect. 14.5.4). Open systems are typically model servers that make it possible to update partial models that may have been constructed or edited using different software tools. These are based on data standards, such as the Industry Foundation Classes (IFC) discussed in Chap. 5. See Sects. 14.5.5 and 14.5.6 for further information on model servers.

14.4.4 Approval and Archiving

Approval is the process in which an agreed (and often also revisioned) information resource is signed by an authorized partner, published and released for use by others. For example, the approval and release of a construction drawing is signed by the architect. Through this signature, the architect indicates that the drawing is the current and valid basis for planning and construction.

For digital information resources, approval can be indicated by a digital signature. When using files from a common data repository (Sect. 14.5.1), the digital signature denotes the author of the document as well as the definitive status, which should then no longer be changed. Subsequent non-authorized changes are immediately identifiable. Document management systems and internet-based project platforms typically also provide means for defining approval and release processes as well as the use of digital signatures (see Sects. 14.5.2 and 14.5.3). If digital building models are used, a release usually takes the form of a coordination model. Individual domain models can, however, also be approved for release. In such cases, these are typically models that can be saved as distinct files and therefore digitally signed. In practice, printed drawing output from digital building models are still often used and then manually signed. In this case, the relevant state of the building model should also be released, and the corresponding state archived. In current product model servers or BIM model servers, release and archiving processes are currently in development (see Sect. 14.5.5). When using such centralized systems, the model should be saved, digitally signed and released in a standardized data format, for example IFC.

The storage of data, also over a long period of time, represents a challenge for both technical systems and their users. It is not only imperative that the data can still be read at a later date, but also that it can be re-used. Rapid technological advances in the field of BIM and its associated software products means that requirements for saving and archiving data are growing. The long period of use of buildings and the long guarantee periods for building works is many times longer than the lifetime of the data and tools that describe them. A significant problem in this respect is the dependency on proprietary (vendor-specific), closed and insufficiently

documented data formats, which has earned the name 'digital amnesia': when products and/or vendors disappear from the market and/or when future versions are no longer compatible with earlier versions of the same software, operating systems or hardware, the data becomes irretrievable. Awareness is growing in the building industry, and in other engineering sectors, of the need for vendor-neutral, self-documenting formats saved in pure text formats with support across numerous sectors, such as STEP or XML (see Chap. 5), as a means of stopping the demise of digital data or at least prolonging its availability. This is particularly relevant for long-term digital archiving for private and public clients who will need to use this data for many years to come.

14.5 Software Systems for Collaborative Work Using BIM Data

The various forms and methods of collaboration discussed above can be implemented today using a variety of different technologies and software tools. In this section, we will discuss the main categories, how they work and what applications they are suitable for.

14.5.1 Common File Repository

In recent years, common file repositories have developed independently of their respective areas of application into a natural means of organizing collaborative work. They are usually used as part of centralized client-server system Architecture as used, for example, within in-house intranets. Simple and traditional implementations can use various protocols to connect to networked drives, FTP servers or Network Attached Storage (NAS) devices. These all require a degree of administration in the setting up of addresses and assignment of rights, and are typically used by users much like external hard drives.

More modern solutions are able to automatically synchronize defined directories and can also incorporate simple mechanisms for versioning, archiving and restoring information resources (e.g. ownCloud, Sharepoint, etc.). Various free and paid services also exist that require no special setup (Dropbox, Google Drive, Microsoft Onedrive, etc.). Here, small firms no longer need to install and administer their own servers, however, they must often agree to sometimes questionable privacy policies that may compromise data privacy and security. A further alternative to server-based solutions are so-called decentralized peer-to-peer networks that synchronize certain files between individual computers (BitTorrent Sync, for example). At present, these are used rarely in practice.

Common to all these simple forms of joint information management is that they offer no specific support for domains, for example the content-based administration of models, drawings and other documents. The most obvious advantage of such systems is their simplicity and ease of use.

14.5.2 Document Management Systems

Document management systems (DMS) have been used in business environments since the 1990s. They offer a central data repository for digital documents and provide various administrative, search and distribution facilities for use in company activities and decision-making processes.

In DMS, the documents are treated as data containers whose content can be used by other kinds of software applications. Figure 14.7 shows the typical components of a DMS. The core element of a DMS is its data management system comprising a file repository for documents and a database for their metadata. The consistent description of the document contents, their formalization, creation and use contexts are defined by predefined metadata schemes and vocabularies. Document management is augmented by a user and rights management facility as well as input and output modules for filing and retrieving the documents. Most DMS provide several modules for the distribution of documents, for example via messages and workflows.

DMS are often used in conjunction with end user or web apps, either directly or via corresponding connectors with other software systems. The parallel editing of documents is generally managed using a pessimistic concurrency control system. Once a document has been opened (i.e. checked out), it is locked, and other users

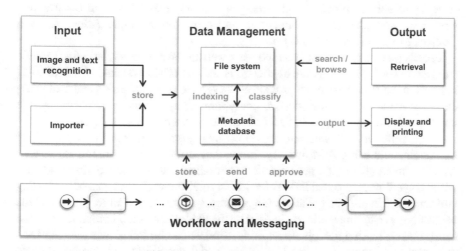

Fig. 14.7 Components of a document management system

can only view it but not edit it. Once any changes have been made and the document is saved, it is checked in as a new version in the DMS and is made available to other users to open and edit along with its versioning history.

DMS are also used in some enterprises to manage BIM data as a means of implementing internal company policies for saving, distribution, release and secure storage of plans and documents for use with BIM models.

14.5.3 Internet-Based Project Platforms

Internet-based project platforms provided a means of centralized information management and the organized filing and distribution of information in cross-enterprise collaboration scenarios. They are also known as collaboration platforms, project spaces or project communication and management systems (PCMS). What makes project platforms appealing is that they are accessible anywhere over the web, flexible enough to be adapted to different application scenarios and that they offer secure data storage and open data connectivity to other software systems.

The basis of any internet-based project platform is a DMS. In contrast to DMS for in-house use, however, they are often managed by external service providers and offered as a Software as a Service (SaaS). While the implementation of a DMS in a company can entail considerable configuration and operation costs, the project platforms are immediately usable systems pre-configured for cross-enterprise collaboration scenarios. Compared with in-house DMS, they do not have as comprehensive workflow options and documents are typically not locked to prevent parallel editing.

Internet-based project platforms are used in many construction projects in order to provide all participants with the necessary planning and controlling information. A series of service providers has emerged with services tailored to construction workflows and plan and document management, for example ASite, Aconex, Conject, McLaren and think project!.

Project platforms are first accessed via a web app in a browser, but often provide connectors for typical software applications such as office systems, ERP and CAD systems. In addition they often provide cloud services for processing and evaluating data, for example text recognition, encryption or reporting, along with mobile applications for capturing field data (e.g. defects, photos, construction progress).

Most collaboration solution providers now also offer special modules for exchanging and using BIM data. Typically, they offer a browser-based 3D viewer, which enables all project participants to visualize and annotate building models without needing any special BIM software. In addition, various means of integrating building models into the collaboration processes are made available. These include centralized versioning (and revisioning) of the models and their combination in the form of coordination models. In addition, models can be linked with 3D markers, drawings and reports in order to process model checklists and conflicts and to monitor dependencies with related document-based communication.

Specialized project platform focused on managing, coordinating and checking building models have also been offered for several years by the larger software vendors (e.g. Autodesk 360 Cloud Services, Nemetschek bim+, GRAPHISOFT BIMcloud) as well as some new specialist providers (e.g. Catenda bimsync). Compared with full-blown BIM solutions, these platform providers allow CAD vendors to work closely with their respective BIM software applications. However, their support for the integration of drawings, documents and project communications is at present only limited.

14.5.4 Product Data Management Systems

Product Data Management systems (PDM systems) are software systems for managing product-related information based on a DMS (Schorr et al. 2011). They are most commonly used in industries with stationary facilities, such as in aerospace or automotive manufacturing, shipbuilding and plant engineering.

In a PDM system, the documents are first organized in a structure that corresponds to the product being constructed. The basis is a compositional structure that describes the product in its individual structural elements, i.e. the component assemblies and their components or sub-assemblies. Documents can be linked to all structural elements and described using additional metadata (document attributes). Figure 14.8 shows an example of the hierarchical organizational structure of a PDM in projects, assemblies, components and documents.

All structural elements are saved in individual files and can be annotated with further feature attributes. Figure 14.9 shows a CAD drawing of a wheel assembly. While the element files describe the geometry of the components, information on the assembly of the individual components is stored in an assembly file. In modern 3D CAD systems for mechanical engineering (MCAD systems) this is a typical way of breaking down all the model information. In principle this modeling method can also be achieved using CAD systems for the building sector (AEC CAD systems) such as Autodesk Revit or Autodesk AutoCAD using external references, or XRefs.

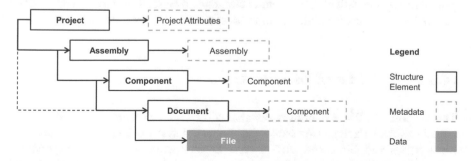

Fig. 14.8 Hierarchical structure of metadata and files in product data management systems

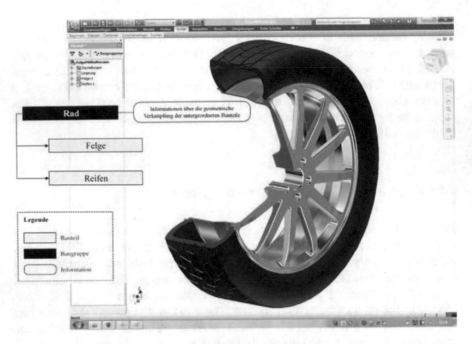

Fig. 14.9 CAD assembly for a wheel comprising the individual components rim and tire

Through inheritance mechanisms, the hierarchical product structure can be used to very efficiently annotate elements and documents with keywords and to regulate access rights. To edit the product information, individual elements and the sub-resources can be locked in a top-down cascade and after checking be approved from the bottom up. To support this work approach in so-called Product Lifecycle Management (PLM) processes, systems for supporting such workflows, so-called workflow engines, are employed that facilitate the controlled development of a product using change requests.

A prerequisite for using a PDM system is the use of CAD systems with which product structures can be defined and contextually visualized. Through their geometric representations, the structural elements, their relationships and respective feature attributes and the attributes of the associated documents can be presented.

14.5.5 Proprietary BIM Servers

The vendors of BIM authoring tools also offer server systems for collaborative model creation. Examples of such vendor-specific systems include the Autodesk Revit Server and Graphisoft BIM Server. These operate with the corresponding software to make partial models available over local (intranet, LAN) or global (Internet, WAN) networks.

The requisite software tools are usually seamlessly integrated into the respective system's authoring tools. Objects can, for example, be edited directly from the user interface of the modeling tool, annotated or locked to prevent further editing. The changes made are saved to the central model on an external server. In ideal cases, the system only saves the differences (so-called deltas) between individual elements, or transfers only attributes. This rapidly improves the editing speed, reduces the data storage requirements and also makes versioning possible.

Other users are then informed of changes made to the model when they open it, or sometimes while they are concurrently working on the model. The greatest limitation of these platforms is that they can only be used with the respective proprietary vendor-specific models which limits or even precludes their availability to other professional disciplines. As with the product models themselves, the network architecture, data exchange protocols and messaging mechanisms are often also vendor-specific and cannot be exchanged with other software applications. For the more comprehensive integration of different software tools and their respective sub-models, product model servers are necessary that are based on vendor-neutral, i.e. standardized product models, data interfaces and communication protocols, as discussed in the next section.

14.5.6 Product Model Servers

Product model servers offer a central management point for product models created by distributed CAD or BIM applications. In contrast to PDM systems, the model data of the elements and their constituent parts are not distributed across several files but are processed in their entirety by the model server and stored in a database (Schorr et al. 2011).

The basis for this database is typically an object-oriented data schema that partially reflects the data format used. To enable the support of different BIM applications, standardized and vendor-neutral product data models, such as the IFC data model, are used, or alternatively generic metadata models such as EXPRESS that also encompass specifications for many other product data standards (see also Chaps. 3 and 5).

To use product model servers, a complete product model must first be created and saved on the server. It is then possible to directly access the individual model elements, the properties and relationships via a corresponding interface. Examples of commercial software packages that can in principle be adapted to work with almost any STEP-based product data model include 'Eurostep Share-A-Space' and the 'Jotne EDM model server', which is commonly used in the processing, automotive and armament industries. Because their architecture is independent of a specific schema, they can in principle be adapted to match any domain-specific model, such as the IFC. This flexibility, however, also entails a high degree of preparatory effort in setting up and using the server. For hierarchical and long-term forms of collaboration and processes such as the development of a new vehicle

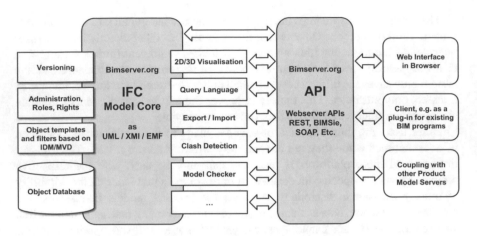

Fig. 14.10 Components of the IFC product model server BIMserver.org

for mass production, tailor-made solutions can be worthwhile. For the specific requirements and workflows of the construction industry, however, domain-specific solutions are required that are adapted to the recurring processes in the sector and to the corresponding data structures but can also be easily adapted to the specific conditions of each respective project.

Figure 14.10 shows the components of the open-source, freely-available product model server bimserver.org (Beetz et al. 2010). The heart of the data management aspect of the platform is a modeling core that can represent the IFC classification scheme and corresponding instances of a concrete model in a vendor-neutral UML model, and can save this in a configurable database. In addition to extensive interfaces for end user applications and a database, the server includes various modules for comparing, validating, filtering, searching, rendering and merging different partial models. These sub-models do not necessarily have to be saved on a single, central server and database instance but can also be switched using vendor-independent protocols (BIM Service interface exchange BIM-Sie, NBIS 2014) between multiple satellite servers in peer-to-peer group constellations. Using such server constellations, for example, individual partial models can be retained and managed by the respective editor and made available, i.e. be 'published' for external project participants. Specific individual applications such as clash detection or model validation based on mvdXML standards (see Chap. 6) can be outsourced as modular services and automatically run each time the model changes.

For the editing of model data, an optimistic cooperation strategy is typically used. Unlike PDM systems, individual elements or documents are not loaded but instead copies of entire partial models are used in order to undertake specific tasks, such as the structural planning. The partial models are not necessarily constructed out of individual assemblies in a product structure but can contain a range of different element data that is not manipulated directly but is required to undertake the respective task.

In addition, because the different project participants work on their partial model for extended periods in parallel (long transactions), the loaded model elements cannot be locked when being worked on. An important task of the model server is therefore to help users identify model changes and conflicts, and in turn to resolve them for integrating the different models (Weise et al. 2004).

Aside from the optimistic concurrency control (see Sect. 14.4.1) with long transactions, model servers can, in principle, support distributed synchronous editing of the models when parallel changes to a model are simultaneously transferred and evaluated. The numerous changes made to individual objects, and their corresponding temporary character and real-time synchronization, can, however, quickly lead to an undesirable flood of changes.

14.6 Summary

The methods and techniques for common data management presented in this chapter are some of the most promising but also most complex aspects of Building Information Modeling. There is no simple answer to which of these forms of organizing collaborative work is best; it depends largely on the application scenario in question (e.g. in-house or cross-enterprise), the service phases, the business culture and technical boundary conditions. Although first approaches are already being implemented in practice, as shown in the case studies in part five of this book, there are still a number of questions and areas currently under investigation in research and development. For example, while *legal aspects* of safety, *guarantee* and *liability* are comparatively easily identified in traditional paper-based work processes, practical solutions and strategies are still being sought in the context of predominantly digital collaboration. Digital signatures and fingerprints, archiving strategies and security concepts with respect to roles and rights need considerable further thought and development. Approaches and procedures from other industrial sectors, for example *Product Lifecycle Management* (PLM) or the *Systems Engineering* approaches used in the aerospace industry, offer many interesting concepts that could potentially play a role in defining the future form of computer-supported collaboration in the construction field. For this, however, these methods must be adapted to the multiple small and diverse kinds of project partners in the construction industry.

Today, project participants still predominantly work on shared data from their local desktop computers and workshops in their respective offices. To a certain extent, this is due to the high graphics processing power required for working with complex three-dimensional models. Different applications such as the management of shared building model data, the dynamic extension of storage space or the purely numeric computations required for simulations could be distributed across several machines or outsourced to external applications. The management of these distributed and outsourced applications is broadly covered by the heading *cloud computing*. In many cases, however, this software (data management, simulation,

etc.) does not need to run on the desktop computer of the user, but can be made available as a networked service (*Software as a Service*). The internet browser will then assume an increasingly important role as a universal graphical user interface.

While there are significant advantages to common data management and processing in the cloud, this is not without some key disadvantages: firstly, cloud service providers must ensure that data belonging to businesses is stored securely and in the long term (e.g. through encryption and archiving) and must be available year-round on the internet. Secondly, many of the cloud applications that run in a web browser, such as those with high graphic processing requirements, are typically not as powerful as the corresponding desktop application. Thirdly, as the number of specific cloud solutions increases, how can project and business data stored on many different servers and services be combined, made available and evaluated?

Technical solutions for the integration of software applications also offer relatively new techniques for the *semantic web* and *linked data* (cf. Chap. 10). Every object and every attribute of a building model can be identified with an URL and stored for linking to one another and later use, with a minimal level of aggregation. The resulting models are directed graphs that are dynamically assembled and can be extended and linked with a range of other information resources, for example sensor date from buildings in the *Internet of Things*. In networked environments, such as for computer-supported collaborative work using building information models, this opens up new kinds of possibilities, which in turn present their own challenges for future research and development.

References

AIA. (2013). *AIA document E202 – 2013, Building information modeling protocol form.* American Institute of Architects, Washington DC. Retrieved from http://www.aia.org/aiaucmp/groups/aia/documents/pdf/aiab099086.pdf (Accessed Nov 2014).

Beetz, J. (2009). *Facilitating distributed collaboration in the AEC/FM sector using semantic web technologies.* Dissertation, Eindhoven University of Technology.

Beetz, J., van Berlo, L., de Laat, R., & van den Helm, P. (2010). Bimserver.org – An open source IFC model server. In *Proceedings of the CIB W78 2010: 27th International Conference. CIB W78*, Cairo (pp. 325–332).

Bøllingtoft, A., Donaldson, L., Huber, G. P., Håkonsson, D. D., & Snow, C. C. (2011). *Collaborative communities of firms: Purpose, process, and design* (Information and organization design series). New York: Springer.

Curry, E., O'Donnell, J., Corry, E., Hasan, S., Keane, M., & O'Riain, S. (2013). Linking building data in the cloud: Integrating cross-domain building data using linked data. *Advanced Engineering Informatics, 27*(2), 206–219.

DIN 276. (2008). *Kosten im Hochbau.* Berlin: Beuth.

Johansen, R. (1988). *Groupware: Computer support for business teams.* New York: Free Press.

KKS. (2010). *KKS Kraftwerk-Kennzeichensystem.* Essen: VGB PowerTech Servic.

McGrath, J. E. (1984). *Groups. Interaction and performance.* Prentice-Hall: Englewood Cliffs.

OmniClass. (2006). *Construction specifications institute (CSI) and construction specifications Canada (CSC).* Alexandria/Berlin: USA Verlag.

PAS 1192-2. (2013). *Specification for information management for the capital/delivery phase of construction projects using building information modelling*. London: The British Standards Institution.

Pauwels, P., Tormä S., Beetz, J., Weise, M., & Liebich, T. (2015). Linked data in architecture and construction. *Automation in Construction, 57*, 175–177.

Scherer, R. J., & Schapke, S.-E. (2015). A distributed multi-model-based management information system for simulation and decision-making on construction projects. *Advanced Engineering Informatics, 25*(4), 582–599. https://doi.org/10.1016/j.aei.2011.08.007

Schorr, M., Borrmann, A., Obergriesser, M., Ji, Y., Günthner, W., Euringer, T., & Rank, E. (2011). Using product data management systems for civil engineering projects – Potentials and obstacles. *ASCE Journal of Computing in Civil Engineering, 25*(6), 430–441. https://doi.org/10.1061/(ASCE)CP.1943-5487.0000135

Schrage, M. (1990). *Shared minds: The new technology of collaboration*. New York: Random House.

Tozer, G. V. (1999). *Metadata management for information control and business success* (Artech House computing library). Boston: Artech House. Retrieved from https://books.google.de/books?id=d9BQAAAAMAAJ

Uniclass2. (2013). *Uniclass2, the classification for the construction industry*. Construction Project Information Committee. Retrieved from http://www.cpic.org.uk/uniclass/ (Accessed Jan 2015).

Weise, M., Katranuschkov, P., & Scherer, R. J. (2004). Managing long transactions in model server based collaboration. In *eWork and eBusiness in Architecture, Engineering and Construction* (pp. 187–194). Leiden: Balkema Publishers.

Chapter 15
Common Data Environment

Cornelius Preidel, André Borrmann ⓘ, Hannah Mattern, Markus König, and Sven-Eric Schapke

Abstract Building Information Modeling, as a model-based approach, has various implications for the information and data management of construction projects. In particular, data exchange during the planning and execution of BIM-based projects creates unique demands for the management of data, since the participants involved exchange different kinds of information at various levels of detail according to their individual requirements, and not just once but repeatedly and back and forth. To address this, procedures for structuring, combining, distributing, managing and archiving digital information must be set up and technically supported within a framework for integral model-based project management. It is widely recognized that for the implementation of BIM-based projects and the related collaborative processes, digital collaboration platforms are highly suitable. The British Publicly Available Specification (PAS) 1192 offers a general framework for the implementation of such central platforms based on a so-called Common Data Environment (CDE). The CDE is defined as a common digital project space that provides distinct access areas for the different project stakeholders combined with clear status definitions and a robust workflow description for sharing and approval processes. This chapter presents the technical aspects of the CDE and introduces selected practical aspects.

C. Preidel (✉) · A. Borrmann
Chair of Computational Modeling and Simulation, Technical University of Munich, München, Germany
e-mail: cornelius.preidel@tum.de; andre.borrmann@tum.de

H. Mattern · M. König
Chair of Computing in Engineering, Ruhr-Universität Bochum, Bochum, Germany
e-mail: hannah.mattern@rub.de; koenig@inf.bi.rub.de

S.-E. Schapke
Think project! GmbH, Munich, Germany
e-mail: sven-eric.schapke@thinkproject.com

© Springer International Publishing AG, part of Springer Nature 2018
A. Borrmann et al. (eds.), *Building Information Modeling*,
https://doi.org/10.1007/978-3-319-92862-3_15

15.1 Introduction

In a BIM-based construction project, several project participants create a digital representation of a building or infrastructure facility using different authoring tools in a collaborative process. During the planning, construction, and operation of a building, the project participants exchange various information from different domains based on agreed procedures. Practical experience has shown that the direct use of a single shared model is not recommended for a number of reasons, not least because this approach does not support accountability which is a problem for legal aspects.

For this reason, various guidelines, such as the Singapore BIM Guide (BCA Singapore 2013) or the British Publicly Available Specification PAS 1192 (PAS 1192-2 2014; PAS 1192-3 2014), implement a collaborative approach based on the principle of domain-specific federated models (Fig. 15.1). This method only gives model authors full access to the domain-specific sub-model for which they are responsible. Each sub-model is an individual aspect of the overall model and is usually called a discipline or domain-specific partial model. According to this federated model approach, each assigned author maintains their domain-specific model exclusively so that the responsibilities for and authorship of building ele-

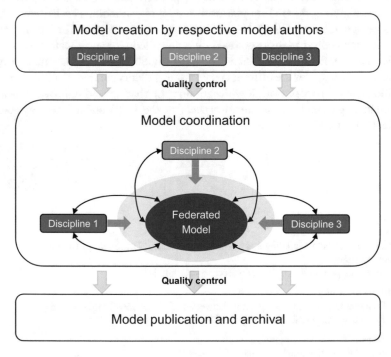

Fig. 15.1 Principle of the federated model approach: Domain-specific sub-models are created independently but coordinated at fixed intervals. (Based on BCA Singapore 2013)

ments, as well as any subsequent changes, are managed unambiguously. However, this results in an enormous number of interfaces and data transition points, which must be coordinated to maintain the consistency and validity of the overall model.

A primary challenge of a BIM-based project is, therefore, to manage the information processing and exchange processes described above during the lifecycle of the construction project. To address this, procedures for structuring, combining, distributing, managing and archiving digital information must be set up and technically supported within a framework for integral model-based project management. It is widely recognized that for the implementation of BIM-based projects and the related collaborative processes, digital collaboration platforms are highly suitable. When implementing such a platform, the following general aspects should be considered:

- **Adequacy:** The objectives, the effort and the benefits of the selected measures and procedures should be proportionate.
- **Neutrality:** The selected procedures and measures should be independent of particular software products so that the companies involved can use their chosen software.
- **Applicability:** The selected procedures and actions should apply to enterprises and projects in various sizes and fields of application.

15.2 Basic Technical Aspects

An essential aspect of the data management of digital construction processes is the centralization of data and information as a basis for all collaborative processes. ISO/DIS 19650-1 (2017) (which is mostly based on the British PAS 1192-2 2014) specifies the characteristics of a technical solution to this requirement: the Common Data Environment (CDE).

ISO 19650 specifies two parts of the BIM-based execution of construction projects: project management and information delivery. Project management describes all process steps necessary to set up a BIM project, including the definition of the Employer's Information Requirements (EIR), and the following tendering and contractual processes, as well as the preparation of the BIM Execution Plan (BEP). Information delivery, in turn, describes all steps that are necessary for model creation and delivery, including the use of a Common Data Environment (CDE). In this chapter, we focus solely on the aspect of information delivery.

The CDE represents a central space for collecting, managing, evaluating and sharing information. All project participants retrieve input data from the CDE and in turn store their output data in it. The common data environment stores all domain-specific partial models and documents which are necessary for the coordination and execution of a project. The primary task is to provide a platform

for information exchange, while at the same time ensuring a consistent data model that meets the required criteria. For this purpose, the data management system enforces procedures and techniques that all stakeholders must adhere to in order to ensure the high quality of data required. Most importantly, the CDE assigns formal states to individual data items and defines quality checking procedures that are undertaken after each state change to properly manage the maturity and reliability of the provided information. The CDE, therefore, serves as the basis for a well-defined way of cooperating among all participating stakeholders.

The centralization of data storage within the CDE reduces the risk of data redundancy and ensures the availability of up-to-date data at any time. Furthermore, the CDE leads to a higher rate of reusability of information, simplifies the aggregation of model information and simultaneously serves as a central archive for documentation. Since this environment is accessible for all the project participants, it should be used as a platform for BIM-based collaborative processes. It should be noted, that the PAS 1192 provides recommendations for the technological as well as management-process based implementation. In this sense, the guideline describes a broad framework for a CDE but does not set detailed requirements so that there is room for interpretations and the technical implementation (Preidel et al. 2016). This setup of a CDE adheres to the aspects described in the introduction: adequacy, neutrality, and applicability.

Despite its broad description, it outlines sufficient information to identify the basic functionalities and elements that a CDE platform must provide. Figure 15.2 shows its typical system architecture presented as a layered structure that describes the minimum requirements for its implementation, which we shall discuss below in detail.

15.2.1 Data Repository

The core part of the entire system is the data repository, which describes the technical space in which all data is physically stored. Since all the information created during the BIM processes over the lifecycle of the building project is stored in the environment, a presumably large amount of data should be considered when establishing a CDE. The volume of data will almost certainly increase in the coming years as storage requirements as well as BIM technologies develop. In principle, there are no specifications that detail where data should be precisely located or which technology is to be used. A central criterion, however, is that data should be accessible at any time from any location for the involved stakeholders. For this reason, technologies that make content easily and directly accessible via the internet (especially cloud systems) should be considered as a technological foundation.

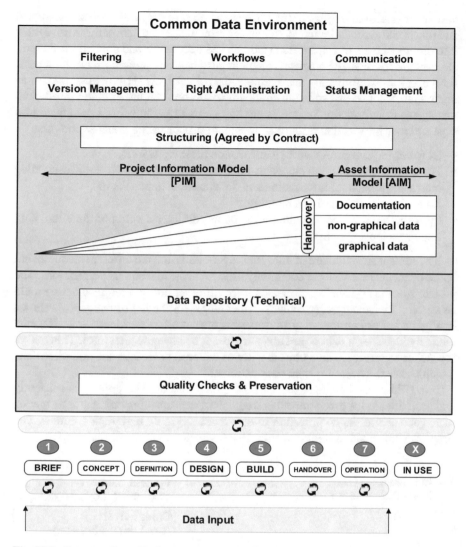

Fig. 15.2 Common Data Environment represented as a layered structure composed of the individual technical elements. (Based on PAS 1192-2 2014)

15.2.2 Data Structuring

In addition to the data repository, the structure of the stored information is an essential part of the CDE. This structure must be agreed on at the beginning of a project and should be updated and reviewed on an ongoing basis – a requirement that is frequently made a contractual obligation. Based on the complex characteristics of a building project and the identifiable resources, BIM data can be structured in

various ways. Commonly used structuring categories might be divided into technical and functional aspects. Technical categories refer to handled data and can be divided into different levels of aggregation (models and documents and collections thereof, element groups or single elements, element attributes and property sets). As a basis for model-based information management, the collected data is structured into information resources so that software applications or users can interpret it. For efficient management, information resources are hierarchically grouped and combined into superordinate information resources. Technical structuring approaches comprise

- Domains (e.g., concrete works, earthworks, finishing works),
- Phases (the temporal development of a building project with a corresponding increasing amount of information and the current planning status),
- Zones (spatial structure of a building),
- Systems (aggregation of building elements fulfilling a common function, e.g., building supply systems).

The content and structure of information required from the different resources are based on metadata which are commonly used to define file naming conventions. The project-specific application of metadata for different information resources should be agreed, if necessary contractually. An example for the use of metadata is shown in Fig. 15.3. Furthermore, any information resource has an identifier (UID) that uniquely identifies a data object and should not be changed afterward. This makes it possible to reference data objects without the need to transfer the complete data, which makes the overall system more efficient.

In a BIM-related context, the selected structure should be applied consistently and according to the given project prerequisites, thus enabling efficient information management and the combination of sub-models despite high data volumes. The Employer Information Requirements (EIR), which define the digital requirements

Fig. 15.3 Example of using metadata (VDI 2552 Blatt 5 2017)

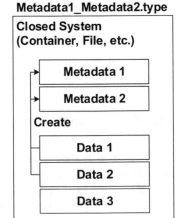

of the client and, in turn, the content of the final Asset Information Model (AIM), offer a degree of basic orientation. A consistent and adequate data structure also supports the automation of processes that need to be performed frequently (e.g., linking and combining sub-models, model quality checking).

The approach and level of detail when structuring project data depends on the project size, type of building, supported BIM application cases as well as the software tools used. Minimizing the effort required to structure information should be a key consideration when defining methods for structuring a project-specific CDE. In the German standard (VDI 2552 Blatt 5 2017), the following approach is proposed to define an applicable data structure:

1. Select and define project-specific BIM use cases
2. Define required information and data structure derived from the combination of BIM use cases
3. Analyze the required data structure with respect to concepts which may derive from software tools and data formats
4. Contractually define the structuring concept (e.g., within the BIM execution plan, modeling guidelines, standard terms, and conditions)
5. Regularly review adherence to the defined data structure

The data structure should correspond to the following prerequisites:

(a) The granularity of data sets and objects must reflect the chosen BIM use cases and support linking external data sets and objects ("Linked Data")
(b) Subsets of data and objects resulting from the BIM use cases can be identified within the entire data pool by characteristic criteria (provision of description methods that are independent of object IDs)
(c) Information in data sets or objects that results from the criteria described in (b) need to be provided in the required format

Classification systems can support the definition of a consistent and standardized data structure. Any classification systems used should be predefined in the BIM Execution Plan (BEP). Guidelines on the use of classification systems are currently under development. An example of using classification systems in the context of databases is shown in Fig. 15.4.

Fig. 15.4 Example of using classification systems in the context of databases

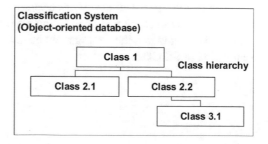

15.2.3 Access Rights Administration

An essential basis for the consistency of information is the allocation and management of property and access rights for the identifiable information resources. These rights control access to data and therefore protect information against unauthorized access. The assigned rights determine the type of access that project participants have to which information resources or which processes they can initiate. The allocation of the rights determines clear responsibilities and prevents errors resulting from unauthorized access. The definition of rights can assign different stakeholders to different roles, which are linked to various combinations of rights. In principle, these functions and the corresponding rights can be defined as required, but it is advisable to keep this hierarchy as close as possible to the organization of the underlying building project.

The granularity of the assigned access rights plays an important role here since these can be linked to different sets of data objects. A right can, therefore, refer only to a single data object, e.g. a single building element, or to complete sub-models, e.g. a construction section. The granularity of assigned rights should be defined according to the application requirements.

15.2.4 Workflows and Information Delivery

BIM-based collaboration requires all project partners to exchange well-defined information between each other at certain times, which are contractually agreed. The exchange should take place exclusively via the CDE so that bilateral exchange without storing information in the CDE is prevented. To ensure each project participant has the required, up-to-date information for the respective processes, the author must enter created model content at agreed times. For this purpose, a corresponding time and performance plan, the Master Information Delivery Plan (MIDP), is required, and often contractually stipulated. The MIDP determines how frequently, and at which degree of detail ("LoD = LoI + LoG") and between which partners information is exchanged. The CDE manages the delivery of new or changed model data and coordinates all work packages. The transfer frequency depends mainly on the intensity of cooperation and coordination of individual or several partners over a given period. The extent of information and frequency with which it is entered into the environment have a significant influence on the technical realization of the CDE.

15.2.5 *Version and Documentation Management*

Each time a change is made to a data entity in the CDE, a new data resource is created with a new version. The content of the modification is, therefore, recognizable by comparing it with the previous version. As a result, any stakeholder can trace the course of changes when required. Since old versions can be accurately restored, old model variants can be recovered. Another important aspect of construction projects is the documentation and archiving of all relevant data. Since any information can also be retrieved later, the CDE serves as a central archive. This stored information is essential both for the subsequent operation phase and for possible legal questions.

15.2.6 *Status Management*

To coordinate cooperation, the status of a registered data object or model can be determined with the help of its planning status (see Fig. 15.5). These states indicate if the corresponding data set can be used for the intended purpose or in which state they currently are. A digital plan status is an intermediate result of a particular planning process, which is stored and, if necessary, made available or released to

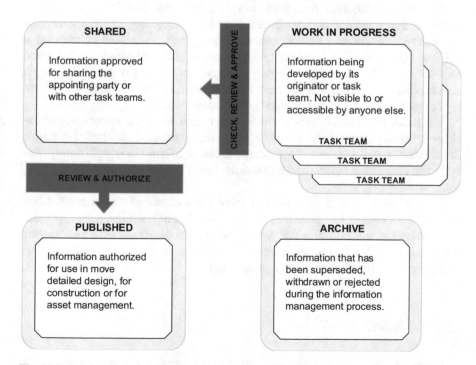

Fig. 15.5 Status management according to ISO/DIS 19650-1 (2017)

other planning participants. For example, a multi-stage digital release process from model states within a planning phase can be characterized by different processing degrees. ISO/DIS 19650-1 (2017) outlines useful definitions to define the current stage of a document or model:

The **work in progress state** is used for information while it is being developed by its originator or task team. Data in this state should not be visible or accessible to any task team apart from its originator.

The **check/review/approve transition** compares the data against the information delivery plan and against the agreed standards, methods and procedures for generating information.

The **shared state** is used for information that has been approved for sharing with the appointing party or with other appropriate appointed parties or task teams. Data in this state should be visible and accessible to them but should not be editable. If editing is required, the data should be returned to the work in progress state.

Information in the shared state should be consulted by all appropriate appointed parties and used to check the coordination, completeness, and accuracy of their own information. The shared state is also used for data that has been approved for sharing with the project client or with the asset owner/operator and are ready for authorization. A separate information state, client shared, might be used for such data in cases where the CDE is distributed over different systems or where there are security considerations.

The **review/authorize transition** state tests all the data in an information exchange for coordination, completeness, and accuracy against the information requirements. If the data or data sets pass these tests, their state is changed to published. Authorization differentiates information (in the published state) that may be relied on for the next stage of project delivery, including more detailed design or construction, or for asset management, from information that might still be subject to change (in the work in progress state or the shared state).

The **published state** is used for information that has been authorized for use, either in the construction of a new project or in the operation of an asset. The project information model at the end of a project or the asset information model during asset operation contains only data and information in the published state or the archived state.

The **archived state** is used to hold a complete record of all superseded data that has been shared and published during the information management process. Data sets in the archived state that were previously in the published state represent information that might previously have been relied on for more detailed design work, for construction or for asset management.

15.2.7 Filtering

A major challenge is to make the stored information accessible to all parties so that the information can quickly be queried and retrieved as required. The

structuring of the information resources allows the filtering of data, which makes the extraction of desired information much easier. Based on the structured information and the contained characteristics of the information, configurable and reusable filter functionalities can be implemented. Filters are often used in the context of workflows to quickly provide an editor with relevant information.

15.2.8 Project Communication

Another important aspect of project management is internal communications between the parties involved. By centralizing all information in the CDE, this can also serve as a central communication platform. A significant advantage is that the information transmitted can be directly linked to information from the model and thus significantly increases the power of expression; redundant communication paths are avoided. For example, the CDE can be used for central issue management using the BIM Collaboration Format (BCF), (BuildingSmart 2016a). In a BCF-based communication process, the project participants create data objects, called topics, which store several attributes such as a type, a description, a current state and many other kinds of information on communications. To connect the topic details with the digital building model, they can be directly linked by storing a particular view position as well as the unique identifiers of affected building elements. In this way, the topic is closely related to the building model and helps other project participants to understand the intended meaning. In principle, this kind of communication replaces the revision cloud as is used in conventional drawing-based processes. This BIM-based communication plays an important role since it supports not only the assignment of tasks and the exchange of information, such as comments but also the documentation of the whole construction process. At this point, the CDE can serve as a central store for these topics, since it also contains the corresponding model data with which the topics are linked. As model and topic data are kept consistent, this is much more robust than systems that exclusively store and manage topics.

15.2.9 Quality Checks and Maintaining Model Quality

While the contents in the environment are always updated or changed, the quality of the domain-specific models, as well as the overall model, must continually be maintained at a high level.

An essential tool for maintaining model quality are projects standards, which are agreed upon at the beginning of the project and by the EIR. Project standards include definitions of how information needs to be structured as well as modeling guidelines. The agreed standards set legally binding requirements for the way data

is stored. The created model information should, therefore, be checked iteratively against these criteria.

For the description of specific data exchange requirements that must be met for particular process steps (BuildingSmart 2016b) developed the Model View Definition Concept (MVD). This concept can also be used to map data integrity rules. These can describe, for example, whether an attribute is assigned a value for a specific value range, which is especially important for additional attributes that are to be used for material properties (units).

Before information is imported as models by the project participants, the quality of the information must be checked. Since the input and output streams of the information are centralized within the CDE, these can be centrally controlled. As a result, models can be individually checked before they enter the environment. Afterwards, they can also be checked for consistency using other models already stored in the environment. The consistency of data implies that stored information is unified and therefore valid as a whole. In the federated model approach, these inconsistencies occur especially when domain-specific models are merged into the coordination model.

An example of an inconsistency is shown in Fig. 15.6. In this example, user A modifies a model object Y, which is only valid in the context of the model object X. If user B tries subsequently to access object Y, an inconsistency arises since the data is no longer valid. In the example, author A deletes the opening, but author B modifies its properties at the same time. If the delete operation is executed prior to the property modification, the data object is no longer valid, resulting in an inconsistency error (Preidel et al. 2016).

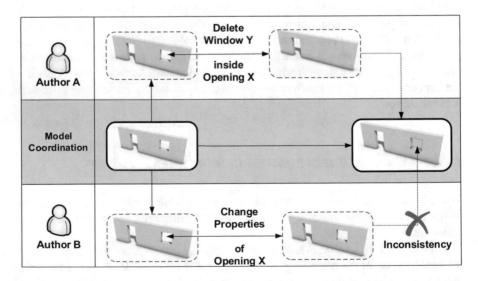

Fig. 15.6 Example of inconsistency in a BIM-based collaboration process

Redundancies occur when the same information is stored in different objects or properties. In the context of collaborative BIM processes, redundancies are often unavoidable or are sometimes even desirable. If redundancies are present or desired, it is important these do not lead to inconsistencies. BIM data management must make clear which redundancies exist, and for what purpose.

15.3 Summary

The BIM method and the accompanying federated model approach present fundamental challenges and require that collaborative processes in the construction industry be adapted. The introduction of the CDE represents a major step towards the digitization of these processes. By centralizing data storage as well as bundling information and data streams, the enormous amount of data stored in models and data objects can be coordinated consistently. At the same time, essential aspects, such as data and model quality, can be considered. The key aspects described above provide an overview of the structure of a CDE and the capabilities it must fulfill. The complexity and dynamic nature of building projects mean that the evolution of BIM-data is a highly dynamic process. When defining the content and functionality of a project-specific CDE, it is necessary to ensure that the chosen system can meet these changing requirements.

References

BCA Singapore. (2013). *Singapore BIM guide* (2nd edn.). Singapore. Retrieved from https://www.corenet.gov.sg/media/586132/Singapore-BIM-Guide_V2.pdf. Accessed 4 Oct 2016.

BuildingSmart. (2016a). *BCF introduction*. Retrieved from http://www.buildingsmart-tech.org/specifications/bcf-releases. Accessed 14 Mar 2016.

BuildingSmart. (2016b). *MVD Documentation*. Retrieved from http://www.buildingsmart-tech.org/specifications/ifc-view-definition. Accessed 13 May 2016.

ISO/DIS 19650-1. (2017). *Organization of information about construction works – Information management using building information modelling – Part 1: Concepts and principles* (1st edn.). Retrieved from https://www.iso.org/standard/68078.html. Accessed 24 June 2017.

PAS 1192-2. (2014). *Specification for information management for the capital/delivery phase of construction projects using building information modelling*. London: British Standards Institution.

PAS 1192-3. (2014). *Specification for information management for the operational phase of assets using building information modelling*. London: British Standards Institution.

Preidel, C., Borrmann, A., Oberender, C.-H., & Tretheway, M. (2016). Seamless integration of common data environment access into BIM authoring applications: The BIM integration framework. In S. Christodoulou (Ed.), *eWork and eBusiness in Architecture, ECPPM 2016 Proceedings of the 11th European Conference on Product and Process Modelling (ECPPM 2016)*, Limassol, 7–9 Sept 2016. CRC Press.

VDI 2552 Blatt 5. (2017). *Building information modeling – Datenmanagement*. Düsseldorf: Beuth.

Chapter 16
BIM Manager

Jan Tulke and René Schumann

Abstract The BIM Manager has emerged as a new role within construction projects. The implementation and consistent application of a BIM-based approach requires certain regulations concerning project-specific application, the technologies selected, processes, responsibilities and specific instructions for the generation and processing of data. In addition, coordination and support are required throughout the life cycle of a project. This task is rather complex and requires knowledge in engineering and IT, and cannot, therefore, be adequately covered by established functions. It is, however, one of the key factors for the success of the implementation and beneficial application of Building Information Modeling within any project. To date, there is no standardized definition of the function of a BIM Manager. This section deals with the rationale on which this new function is based as well as the related responsibilities, tasks and required skills and expertise. In addition, the chapter discusses the integration of the BIM Manager into the project organization.

16.1 BIM Manager: A New Role

Building Information Modeling (BIM) aims at providing all participants in a project with the required information from a joint data stock, where their output is then made available to others for further use. As with traditional functions at the planning and execution level (planning coordinator, project controller, project manager) this requires explicit coordination at the IT level (Rahman et al. 2016). The improved re-use of information along with semi-automation possibilities mean that traditional processes may have to be adjusted. The various parties and discipline specialists

J. Tulke (✉)
planen-bauen 4.0 – Gesellschaft zur Digitalisierung des Planens, Bauens und Betreibens mbH,
Berlin, Germany
e-mail: jan.tulke@planen-bauen40.de

R. Schumann
HOCHTIEF ViCon GmbH, Essen, Germany
e-mail: rene.schumann@hochtief.de

© Springer International Publishing AG, part of Springer Nature 2018 293
A. Borrmann et al. (eds.), *Building Information Modeling*,
https://doi.org/10.1007/978-3-319-92862-3_16

involved in a project employ a variety of established approaches, software tools and data models; BIM is therefore an intricate task that requires not only cross-discipline thinking but also in-depth knowledge of the required information technologies and concepts as well as international or project-specific BIM standards.

The BIM Manager has emerged as a new, independent role that is of utmost importance but cannot be assumed by existing staff in traditional project roles due to its scope and technical complexity (Holzer 2016). The role needs to be neutral and not situated within a respective specialist field in order to ensure an objective analysis of information requirements and the efficient implementation of communication processes across various processes and organizations (Fig. 16.1). Information needs to be structured and provided in a way that meets the requirements of all related processes and can be easily re-used. This requires knowledge of the information requirements of all subsequent processes, their content and structure, which the BIM Manager analyzes at the start of a project on the basis of the respective project's BIM use cases and documents them in the BIM Execution Plan (ICE 2018).

The implementation of BIM should aim wherever possible to use existing software, processes and experience rather than jeopardizing a project's success by making simultaneous, radical changes in all areas. However, a certain amount of change and revised thinking with regard to the structure of information and data will inevitably be required in order to facilitate model-based cooperation across the entire project. The opportunities offered by fully digitized data storage will replace or support certain manual processes by automation. The search for information

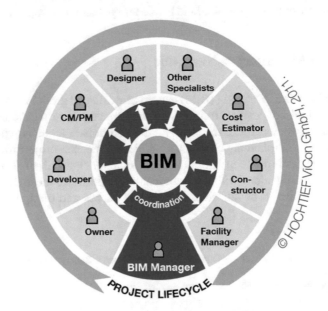

Fig. 16.1 The BIM Manager as a central point of contact and a key coordinator of the implementation and application of BIM throughout all specialist areas. (© HOCHTIEF ViCon, reprinted with permission)

will be fundamentally different, as information is no longer stored in (hardcopy or electronic) documents, but within the model and the databases and electronic archives linked to it. The BIM Manager thus assumes the role of a change manager during the transition period and supports the transformation of established working methods. He therefore plays a pivotal role in the implementation of BIM.

While the additional function of a BIM Manager with its specific requirements might at first seem an additional cost factor, experience has shown that the investment is more than compensated for by the benefits and savings generated through the successful implementation and consistent application of BIM.

16.2 The BIM Manager as a Key to Success

The BIM Manager assumes a pivotal role in the implementation and application of BIM. Without this central role and the coordination across all areas of a project provided by a BIM Manager, the use of BIM generally focuses on the partial application of new BIM technologies within traditional specialist fields. This approach, however, frequently results in isolated implementations that often turn out to have unbridgeable data discontinuities. At the same time, new opportunities and the potential to increase efficiency by re-using data from other parts of the project remain untapped. Consequently, the cost effectiveness is markedly inferior and the potential of the full use of BIM is underestimated.

The implementation of BIM in a project or a company represents a change management process that is not restricted to the use of new *technologies* such as 3D compatible software. At first, the *people* involved in a project must understand the basics and the benefits of the BIM methodology and recognize the core function of BIM, namely to join the traditionally separate perspectives and information structures of the respective specialist fields in one data stock that combines all data in a structured way and is accessible to everyone. This requires the willingness to coordinate with other parties to the project and, if necessary, to adapt own *processes* pertaining to the creation and use of information. Based on existing *policies* or contractual requirements the processes agreed upon must be documented in order to ensure that they can be validated and made available to new employees. In summary, the BIM Manager accompanies, supports and ensures the process of taking the key components, namely people, processes, policies and technologies (see NBS 2018) into consideration and aligning the application of BIM to the project requirements (Fig. 16.2).

Support and coordination aspects over the entire life cycle of a project are essential, as the project participants working under pressure and time constraints will habitually fall back to old, uncoordinated working modes as soon as the slightest problem or insecurity with regard to the use of the new methods and software tools arise. This can result in concurrencies, which ultimately jeopardize the overall success of the BIM implementation. As an immediate and competent partner as well as a controlling instance, the BIM Manager can prevent this from

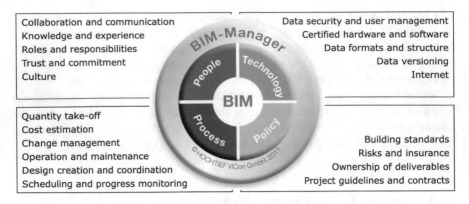

Collaboration and communication	Data security and user management
Knowledge and experience	Certified hardware and software
Roles and responsibilities	Data formats and structure
Trust and commitment	Data versioning
Culture	Internet

Quantity take-off	
Cost estimation	
Change management	Building standards
Operation and maintenance	Risks and insurance
Design creation and coordination	Ownership of deliverables
Scheduling and progress monitoring	Project guidelines and contracts

Fig. 16.2 The four components of the successful implementation and application of BIM. (© HOCHTIEF ViCon, reprinted with permission)

happening. The BIM Manager thus acts as a central point of contact and the driving force behind training, troubleshooting, continuous improvement and the roll-out of a BIM-based approach throughout the project. Ultimately, the BIM Manager ensures that BIM is beneficial to the overall project on behalf of the client. In addition to the technical coordination role, the BIM Manager also aims to achieve the earliest possible Return on Investment (ROI) from the application of BIM.

16.3 Tasks of a BIM Manager

A BIM Manager carries out a variety of tasks pertaining to the project-related development of concepts, implementation, coordination and ongoing support of model-based data communication. The focus on tasks varies along the project timeline.

At the beginning of a project, the BIM Manager and the project team as well as possible BIM staff or external BIM consultants together define and prioritize the BIM use cases. Depending on the type, size and complexity of a building or structure as well as on customer requirements, prior BIM experience and local, software-related and other project conditions, the specific tasks that the BIM model must support are defined. Examples of BIM use cases are the model-based calculation and model-based documentation of the status of acceptance or inspections of building parts. To focus on BIM use cases is important to ensure that all those involved have a clear idea of the application of BIM and to ensure that the content and structure of the model data generated as well as the software used meet the functional requirements. This helps to save unnecessary expense arising from the creation of unusable model data or for the time-consuming reworking of such data. It also helps in designing training programs for specific roles and applications.

The BIM Manager leads and monitors the implementation of all selected BIM use cases, taking interdependencies into due consideration. The following illustrates the range of tasks executed by the BIM Manager:

- Analyze the information, communication and coordination need for each specific BIM use case
- Analyze existing software and determine future software needs
- Define processes for data collection and provision
- Define required content and level of detail for each phase of the project
- Define the data structure and its implementation within the specific concepts of the software in use
- Where relevant, initiate the development of additional functionalities to render the creation and structuring of model data more efficiently
- Define the import and export interfaces to be used as well as their configuration
- Where relevant, initiate the development of additional interfaces or converters or define manual data editing processes
- Define activities to ensure data quality
- Define processes for and intervals of data consolidation and update and, where relevant, initiate the development of automation mechanisms
- Define data coordination processes and the software used for this purpose
- Coordinate a test phase for in-depth testing of processes and software tools
- Cooperate in the development and continuous updating of the BIM execution plan as well as related CAD modeling guidelines and contractual terms for planners, contractors and subcontractors
- Control the set-up and configuration of central software systems, the creation of digital forms, the establishment of workflows and the creation of users and their access rights
- Create automated, project-specific reporting functions on the basis of centrally managed data
- Cooperate in the development of a BIM training and certification program
- Teach BIM methods in the context of dedicated training and ongoing on-site support
- Support or moderate 3D and 4D coordinating meetings
- Report on the status of BIM implementation and application within the project
- Ongoing troubleshooting
- Continuous improvement and expansion of BIM-based work

Through the detailed definition of BIM processes, the software to be used, interfaces, update cycles, model scope and level of detail, model structure and the information to be linked, the BIM Manager reconciles the interests of the parties with regard to cost and benefit in terms of the previously defined BIM targets and use cases and harmonizes cooperation within the project. The BIM Manager defines, controls and supports and thus helps those involved in the project with their use of BIM and pools the knowledge of BIM workflows within the project. The BIM Manager is located between IT infrastructure management and the power users of the respective specialist applications. He actively manages this interface

by either collecting user requirements and translating them into instructions for the configuration and development of IT systems or, alternatively, by restructuring the processes of creating and processing information.

16.4 Competences of a BIM Manager

The profile of a BIM Manager comprises experience in the design of construction planning processes, specific IT knowledge and practical skills in software applications as well as management competencies such as coordination and transfer of knowledge. The requirements are summarized below:

- Architect or civil engineer with experience in the execution of construction projects (planning, planning coordination, BIM management or construction management) and an understanding of processes, information requirements and responsibilities
- 3D IT all-rounder with comprehensive knowledge in the development and use of 3D models, specific data models and data formats as well as state-of-the-art information technologies and, where relevant, programming in order to be able to assess the requirements, feasibility and implementation effort of BIM processes
- Practical experience in the use of relevant IT systems and software packages in order to be able to operate, configure and provide training for such systems (e.g. CAD, scheduling, calculation, estimating, document management, electronic forms, mobile devices, etc.)
- Contextual knowledge of international BIM guidelines, standards and typical employer's tender documents
- Access to IT experts and expert users with specialized knowledge (by means of a personal network or back-office support) for in-depth support in complex issues
- Experience in the development and execution of training and the creation of training material
- Communicative, team player, team leader

16.5 Distinction Between BIM Manager and Other BIM Functions

Depending on the number and volume of BIM use cases, several dedicated BIM functions can be found within a project or company. The sphere of activity of such functions varies, on the one hand, in terms of their organizational relationship to the client or contractor or within an individual company or a project organization encompassing several companies (such as joint ventures) and, on the other hand, in terms of their BIM responsibility with regard to an individual project or for several projects within one organization (such as the so-called BIM Group Manager). The

functions are further distinguished by their location (on site or in the back office), the percentage of work dedicated to BIM and the type of activity (design vs. execution). The following features have emerged for the description of a BIM Manager:

- The BIM responsibility encompasses the entire project organization within one individual project, but is limited to either the client or the contractor side.
- From the outset, all IT requirements are taken into consideration for the entire life cycle of a project, rather than only the current project phase.
- It is a full-time job that involves the coordination and support of BIM processes. It therefore does not involve any additional responsibility for traditional construction or planning processes.
- The range of tasks comprises (where relevant, only to a limited extent) both the conceptual design and the immediate implementation of BIM processes, but does not involve the creation of information in specialist authoring software (e.g. CAD, estimating and scheduling software).
- The BIM Manager is consistently or frequently on site and is integrated into the project team, thus ensuring continuous support.

16.6　The BIM Manager's Place in the Project Organization

Depending on the originator (client, contractor) and the sphere of activity (use cases) of the BIM implementation, the scope and depth at which BIM is integrated into the project organization can vary. However, to ensure smooth integration into the project execution, the BIM Manager must be given sufficient authority to issue instructions. BIM Management is a coordinating task and ideally ranges from planning and execution to handover of as-built documentation to facility and asset management. Since BIM Management embraces all specialist disciplines and project phases, the BIM Manager should be located between the holistic perspective of the client and the level of (construction) project management (Fig. 16.3). If the client is not the driving force behind the use of BIM, BIM Management should be located at project management level. But contents should not be mixed, or only to the extent that BIM provides immediate support to project management by structuring processes and improving the provision of information (Rahman et al. 2016).

Alternatively, especially if projects are executed with partners who have experience in using BIM, BIM Management can also be allocated to technical management as its own specialist field (Fig. 16.4). However, experience has shown that the influence on contractual regulations and project-wide change management that is required during the implementation phase is frequently lost in this case. It might appear advisable to incorporate BIM Management into the Design Team, since that is where the model is developed; however, this option should be disregarded since the function would no longer span all fields of expertise and project phases. As a result, the 3D models designed would not be used or updated over the course of construction.

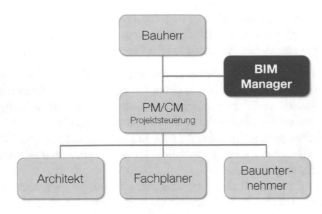

Fig. 16.3 Organisational position of BIM Management between the client and construction project management (PM/CM)

Fig. 16.4 BIM Management as an independent specialist function within the technical management team

In addition to its place in the organizational chart and the position of a BIM Manager, BIM Management assumes further roles within project organization. The further penetration of project organization with BIM related roles are described below. Please note that the designation of roles has not yet been standardized and may vary and assume different meanings in different projects and organizations.

In the development of concepts and strategic decisions, the BIM Manager is supported by a superordinate instance (the BIM Project Manager, BIM Group Manager or, for framework contracts, Framework BIM Manager, BIM Program Manager), which is also the key contact for external partners and thus plays a pivotal role vis-à-vis the client (Fig. 16.5). This function is generally involved in several projects simultaneously and cooperates closely with project management. They are not, however, directly involved in the practical implementation in the respective project.

BIM is also represented in a project on the specialist side by a responsible person for each BIM use case (so-called Lead Representative) and on the hierarchical side by contractually appointed BIM representatives (so-called BIM Coordinators) for each company involved in the project with the authority to take decisions. These functions are often filled in combination with traditional execution or planning roles.

BIM Engineers or BIM Modelers take traditional planning and construction preparation tasks further and are responsible for the practical implementation of each BIM use case in the form of data creation, editing and processing. This

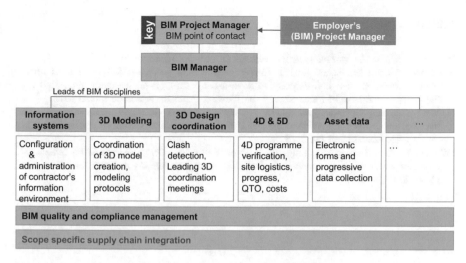

Fig. 16.5 Examples of BIM functions on the contractor side (lead contractor) for a major project

includes, among other things, the extension of 2D planning documents into 3D models, clash detection to support planning coordination and 4D animation as an extension of scheduling. Further tasks include data quality management and the involvement of subsequent parties in the supply chain.

If no suitable staff is available on the project or in the company, in particular during the transitional BIM implementation phase, individual BIM roles can be staffed by external specialist BIM service providers or BIM consultants.

16.7 Summary

The growing importance and interweaving of IT methods with engineering planning and related processes increasingly requires a person explicitly responsible for coordination within the organizational structure of construction projects. In view of the variety of partial processes, different software products and specialist data models, this is a very complex task that requires interdisciplinary knowledge in engineering and information technology. As with other coordination roles, general communicative and management skills are also required.

It remains to be seen how the establishment of BIM Managers as an independent function will develop and become anchored within the construction industry through specific training and career paths. In an alternative scenario, increasing IT skills among those involved in projects and the fact that the BIM approach is fast becoming the state of the art with broader adoption and better standardization, may mean that such coordination tasks can ultimately be covered by existing coordination functions (e.g. architects, project controllers) with a certain level of additional expertise.

References

Holzer, D. (2016). *The BIM manager's handbook* (1st edn.). Chichester: Wiley.

Institution of Civil Engineers. (2018). *Career profile: BIM manager.* Retrieved from https://www.ice.org.uk/careers-and-training/return-to-a-career-in-civil-engineering/which-civil-engineering-role-is-right-for-you/career-profile-bim-manager. Accessed 15 Jan 2018.

National Building Specification. (2018). *What is a BIM manager and what do they do.* Retrieved from https://www.thenbs.com/knowledge/what-is-a-bim-manager-and-what-do-they-do. Accessed 15 Jan 2018.

Rahman, R. A., Alsafouri, S., Tang, P., & Ayer, S. (2016). *Comparing building information modeling skills of project managers and BIM managers based on social media analysis. Procedia Engineering, 145*, 812–819.

Chapter 17
Integrating BIM in Construction Contracts

Klaus Eschenbruch and Jörg L. Bodden

Abstract The use of BIM planning technologies raises a multitude of legal questions. The core task of construction contract law is to regulate the processes required to employ this planning methodology and the rights and responsibilities of the contract parties. Following an initial discussion of the new contract structures in an international context, the authors cover the regulatory aspects of work organization/process details, rights to data, liability, BIM management and remuneration. The authors place emphasis on what they deem to be the key interests deserving consideration in contract design. Solution approaches of standard international contract models (AIA, ConsensusDocs, CIC) are presented and compared. The authors conclude that BIM neither requires a new paradigm in contract types, nor does it necessitate a new liability regime. Details regarding the use of BIM can be governed in BIM-specific contract annexes attached to individual contracts.

17.1 Introduction

Building Information Modeling (BIM) refers to a collaborative working method in which information relevant to planning, erecting and operating a building is captured, managed and exchanged on the basis of digital models. The digital models provide a virtual, three-dimensional planning representation of the project, which can be linked with additional information such as deadlines, costs and qualities. BIM already enjoys widespread international use in realizing construction projects.

BIM puts traditional forms of collaboration and the contract law of planning and construction participants under scrutiny. Experience with BIM application is so new that no unified contract strategy has yet been developed for it. No generally recognized law currently exists for BIM applications. The polymorphism of conceivable BIM applications and the lack of conclusively determined content

K. Eschenbruch (✉) · J. L. Bodden
Kapellmann und Partner Rechtsanwälte, Düsseldorf, Germany
e-mail: klaus.eschenbruch@kapellmann.de; joerg.bodden@kapellmann.de

© Springer International Publishing AG, part of Springer Nature 2018
A. Borrmann et al. (eds.), *Building Information Modeling*,
https://doi.org/10.1007/978-3-319-92862-3_17

in BIM processes have been an obstacle to the emergence of standardized contract solutions until now. This article elaborates on basic principles for contract law in BIM application.

Construction projects bring together previously independent parties in the aim to complete a task over a limited period of time. This requires a reorganization of the roles of the respective stakeholders and their contributions for each new project. The mutual rights and obligations of the project participants are typically defined in contracts. The corresponding definition of consistent project roles and functioning interaction between project participants on the basis of the contract play an essential role in the success of construction projects. The BIM planning method alters the way construction projects are realized. New services must be described, responsibilities must be redefined and new legal issues arising from the incorporation of BIM must be addressed (Abdirad 2015). Sample contract forms often exist that provide meaningful assistance in contract design. The American and British legal systems have produced sample contract clauses governing the use of BIM (McAdam 2010; Olsen and Taylor 2010). Of primary interest here are the supplementary contract conditions of the *American Institute of Architects (AIA)* and *ConsensusDocs* along with the *CIC BIM Protocol* as a supplement to the nec3 contract model (AIA C106 2013; AIA E203 2013; AIA G201 2013; AIA G202 2013; ConsensusDocs 2016; CIC/BIM Protocol 2013). Sample contract clauses can serve as a type of checklist and guideline for the necessary regulatory depth of a contract. They help prevent the parties from overlooking items that require regulation. However, their indiscriminate, schematic application is proscribed, because contract design must always consider the unique, distinctive features of the specific project.

This chapter outlines fundamental construction contract solution approaches. Focus is placed on comprehensive issues that are independent of domestic law when using the BIM planning method.

17.2 Contract Systems

The clearly prevailing contract system for construction projects in most European countries comprises a multitude of separate, individual contracts that the building owner concludes separately in the form of a bilateral contract with the project participants. A further defining characteristic is the involvement of numerous different specialist disciplines in the planning and execution of construction projects. Over a number of centuries (at least in Europe), the combined expertise of a master builder as the primary party equally responsible for planning and execution was divided into different specialist disciplines, which for the most part make independent contributions towards realizing a construction project.

For the most part, significantly stronger collaboration between the various specialist disciplines is a basic premise for the successful implementation of a BIM planning process. Many experts agree that the advantages of BIM, particularly its greater transparency and improved intraproject communication options, can only

truly unfold if this potential is leveraged in the scope of an integrative form of mutual service performance. This recalls the master builder of old, who historically bore the overall responsibility for a construction project. The opinion thus occasionally arises that the potential of BIM is leveraged best in a contract environment that promotes stronger cooperation between project participants by means of a standardized, multi-party contract.

One multi-party contract solution often mentioned in conjunction with BIM is "Integrated Project Delivery", or IPD (Chew and Riley 2013, p. 262). This is a contract system developed in Australia on the basis of "Alliancing", where project participants mutually conclude a contract in which they agree to collaborate extremely closely, share profits and losses within a certain framework, arrange comprehensive, reciprocal indemnity and foster collaboration through common decision-making bodies. Emphasis is placed on encouraging project participants to use contract design to achieve optimum collaboration between the parties (Chao-Duivis 2011, p. 269). Integrating building contractors into the planning process early on is viewed as being particularly advantageous (Chew and Riley 2013, p. 262). Getting building contractors involved in the planning process early on is certainly nothing new. In the Netherlands, for example, it is quite common to involve contractors as early as the planning phase (Chao-Duivis 2011, p. 267). In the US, the *American Institute of Architects* (AIA) strongly advocates the use of IPD (Chew and Riley 2013, p. 262). Corresponding *AIA* contract documents exist that make it possible to realize construction projects with IPD. The contract models provided by *ConsensusDocs* likewise offer multi-party contract solutions.

Multi-party contract systems can help minimize reservations concerning closer collaboration and promote more integrative project realization. However, contract systems such as these also have tremendous disadvantages, which has led to an inability to implement these types of contract models in most European countries to date. Aligning the interests of two contract partners to attain a general consensus during contract negotiations is already challenging enough. Difficulties increase exponentially with the number of contract partners. The fact that not all contract levels are ready to be awarded at the same time adds further substantial complexities. Public private partnership (PPP) projects indicated that there were already considerable difficulties in implementing public procurement rules in contract constructs with a multitude of stakeholders. The most recent requests are for consortia. However, the merger of consortium offers in a public procurement process led to challenging normative questions and often economically inefficient solutions. Moreover, once a multi-party contract has been concluded, it is exceedingly difficult to implement subsequent contract amendments (which require the consent of all contract parties) and they regularly lead to full-scale negotiations of all contract items in which one contract party or the other may see an opportunity to retroactively optimize the contract in its favor. In addition, the stakeholders' vested interests are simply too varied to define them in a single, overall contract that restricts the pursuit of vested interests from the outset (Merrow 2011, p. 293). It is just as difficult to replace individual contractors who do not perform in accordance with the contract.

Multi-party contract systems generally run into difficulties in more complex projects. This is because it is rarely possible to conclude mature planning and construction contracts according to a standardized model practically simultaneously with a multitude of contract stakeholders (Merrow 2011, p. 292). Usually the contracts can only be drafted and negotiated gradually based on the development and planning progress. Although proposals have been made to conclude contracts in stages in which the planning and construction phases are separate from one another, the client would still be bound to one building contractor early on, thereby restricting its negotiating position during the second stage of agreement.

In light of the currently very limited positive experiences with multi-party contract systems in domestic and international practice (Merrow 2011, p. 260 et seq.), it seems expedient to retain the individual contract solution that prevails in Europe. BIM does not require the parties to deviate from this system either. All provisions that apply equally to all project participants to effectively integrate BIM in the project workflows can be documented in BIM-specific, additional contract provisions that then become an integral part of all contracts. Beyond this, it may also be useful to layer bodies of provisions in different contract supplements. It is conceivable to stipulate the purely technical details about BIM (file formats, naming conventions, etc.) in a separate document that is referenced in the supplemental contract provisions. This document may be referred to as a BIM Execution Plan.

ConsensusDocs and *AIA* offer these types of supplemental contract provisions. Moreover, the British *Construction Industry Council* (CIC) collaborated with the *BIM Task Group* in drafting contract conditions. Specifically, these include the following documents:

- ConsensusDocs 301 BIM Addendum, revised 2016,
- AIA Document E203-2013 ("Building Information Modeling and Digital Data Exhibit"), G201-2013 ("Project Digital Data Protocol Form") and G202-2013 ("Project Building Information Modeling Protocol Form"),
- CIC/BIM Protocol, first edition 2013 (if applicable in conjunction with the nec3 contracts for which special application notes exist for linking these with the CIC BIM Protocol).

Consequently, the use of BIM planning processes does not require a new contract system or condition that only multi-party contract systems may be used. BIM technologies can also be implemented with the conventional contract typology, in particular when splitting obligations arising from multiple contracts with various contract parties and different contract hierarchy levels.

17.3 Work Organisation and Process Details

There is currently considerable uncertainty in the marketplace regarding the precise content of the project participants' duties and the details of collaboration when incorporating digital building models. Reliable standards have not yet been

established in the marketplace. This makes it all the more necessary to define this content in a detailed set of provisions. Specifically, it is essential to define:

- How data must be designed (level of detail, information content, file formats, naming conventions, programs/program versions to be used),
- When generated data must be made available (milestones) and when it can be accessed by other project participants (releases),
- Who in what form will maintain a central planning platform and who will provide which software,
- Who is responsible for coordinating the various planning contributions and how this process is designed,
- Which verification and notification obligations apply with respect to preparatory work performed by third parties.

The level of depth with which these regulation issues are specified in supplemental contract conditions or become the object of detailed technical specifications referenced in the basic contract provisions is a question of contract design. *AIA Document E203-2013* is primarily restricted to governing selected basic contract issues and provisions on copyrights and confidentiality. With respect to relevant provisions on technical implementation details, the document refers to "protocols" to be agreed on following contract conclusion (Sects. 3 and 4). Sample texts are also provided for these protocols (*AIA Document G201-2013* and *G202-2013*). The protocol details are arranged following contract conclusion on the grounds that a common understanding on all project details is only possible once all of the project participants have been named.

The *ConsensusDocs 301 BIM Addendum* contains a similar control mechanism. Detailed questions are handed over to the BIM Execution Plan, which the contract parties agree to adopt within 30 days of contract conclusion (Sect. 4.1). Nevertheless, this strategy bears substantial contract risks. It is similar to concluding a construction contract without having formally ratified a corresponding schedule and deadlines. It would appear to be preferable instead to at least agree on the basic requirements regarding the use of BIM technology while arranging the mutual rights and obligations in an annex to the contract that already exists when the contract is signed and that is used as the same underlying basis for all contract stakeholders. BIM protocols should only govern operational implementation and further specification based on how the project progresses, whereby more exact provisions are required to determine whether and to what extent these protocols are suitable for amending provisions in contracts that have already been finalized.

The contract models stipulate that the client must summarize the project-specific requirements on the use of BIM and the objectives to be pursued in what are known as client requests for information before the initial project contract is concluded. These are the binding basis for all subsequent orders. Later the project participants work together to draft a BIM Execution Plan, which designates the workflows by precisely defining the interfaces/liaisons of the various stakeholders and their roles and interactions. Similarly, the *CIC BIM Protocol* requires the parties to outline detailed technical requirements, particularly regarding the information depth of the

digital models, in a Model Production and Delivery Table to be presented at the time of contract conclusion (Sect. 4.1.1 in conjunction with 1.1.10).

17.4 Rights to Data

The exchange of data that BIM both encourages and demands increases the need for contract specifications regarding data handling compared to existing planner and construction contracts, namely with respect to copyright and usage rights to building models, and confidentiality obligations concerning data made available to other project participants. From the building owner's perspective, it is important to ensure unrestricted access to the data models created by the project participants at any time during the construction project life cycle. If the building data is stored on a project platform at another project participant's site, then contract provisions must be effected that ensure access also remains possible if the contractual relationship is terminated prematurely.

Furthermore, data usage could also be restricted by the copyrights of the planning participants if rights of use are not expressly granted in the contract provisions. Copyright protection arises independently regardless of the will of the contract parties. The prerequisite for copyright protection, however, is always that the respective work represents a "personal intellectual creation". This means that building plans are only protected by copyright if they contain a certain level of inherent, independent, artistic content. Therefore, the property planner's planning work is commonly copyright protected, provided its planning does not create standard functional buildings without an artistic signature. Planning contributions made by engineers generally do not reflect intellectual creation because they are defined by their technical content and are integrated in the property planner's planning work in the most functional manner possible. The same applies to planning contributions made by building contractors. Nevertheless, there may be exceptions in certain cases.

To avoid uncertainties regarding the existence of copyrights and the scope of the transferred rights of use, it makes sense to document copyright provisions in contract amendments that are generally binding for all construction participants. The owner's need to later use the transferred building information model in a more comprehensive sense than has been the case with paper plans submitted until now must be taken into account when drafting new copyright clauses. This includes any changes to transferred model data due to changes in use of the building or conversion measures arising in conjunction with changes in planning. Any further use of the data within the scope of facility management should also be secured in the contract.

Moreover, the close collaboration desired as a result of implementing BIM and any associated high levels of data exchange call for clear provisions regarding the confidentiality of data from third parties. Enterprises are skeptical when it comes to integrative planning because they do not want to disclose planning details that they consider operating and trade secrets. This concern is certainly justified.

Digital information can be forwarded and reproduced with much less effort than paper documents. Clear provisions governing data transfer and data security are required in order to relieve enterprises of their concerns regarding the confidential handling of their planning contributions. Rights to forward data should only be granted to the extent necessary in order to fulfill the mutual construction task. Graduated, intracompany access privileges to the building information model may be considered in order to minimize the risk of transfer of data to unauthorized third parties. In addition, contracts should stipulate general data security standards such as encryption, password protection and access controls.

Common international contract models contain copyright clauses that focus primarily on the interests of the contractors. Section 6.3 of the *CIC BIM Protocol* grants the contractor (*"Employer"*) the right to use intellectual property only within the limits of the contractually agreed purpose (*"Permitted Purpose"*) and refers to a narrow definition of this purpose (*Sect. 1.1.12*). At the same time, it also dictates that licenses may be suspended or revoked in the event of non-payment (*Sect. 6.4*). Finally, changes to copyright-protected works (*Material*) are only permitted within narrow limits without the creator's (*Project Team Member's*) consent. (*Sect. 6.5*). *AIA Document E203-2013* contains no such comprehensive copyright clauses. The issue of copyright protection is reserved for a separate agreement, for which the Digital Data Licensing Agreement according to AIA Document C106-2013 is provided. However, both sets of contracts concordantly stipulate that copyright and usage rights may only be granted in the scope absolutely required to realize the project (*Sect. 2.3 E203-2013; Sect. 2.1 C106-2013*). The document clarifies that building model data may only be disclosed to third parties for the sole purpose of fulfilling the contractually agreed planning task or as a result of a binding, legal decree (*Sect. 2.2.1 E203-2013; Sect. 2.3.1 C106-2013*). The *ConsensusDocs 301 BIM Addendum* contains comprehensive language on the subject of copyrights (Sect. 6). Contractors must ensure that the services they provide are not burdened by the rights of third parties and enforce this accordingly (Sect. 6.3). It further clarifies that mutual work processes should not lead to the creation of mutual copyrights (Sect. 6.4.2). What is interesting about this is that these sample clauses also include the revocation of rights of use in the event of a breach of payment obligations. However, they make this legal consequence subject to a decision made by a court or an arbitration tribunal regarding whether the payment demand is justified (*Sect. 6.6.1.2*). These types of provisions are not consistently fit for purpose. There is no reason to revoke the client's rights to the building model solely on account of a payment delay.

17.5 Liability

BIM raises new questions regarding stakeholder liability. It is conceivable for individual planning contributions to be deficient, resulting in an inability to perform services that build on said contributions. It is also possible for planning participants

to perform their own services inadequately because errors in planning in preparatory work were overlooked. It is questionable whether and to what extent stakeholders should be liable for planning contributions. One approach that is gaining ground reasons that work with building information models does not change the responsibilities of the individual stakeholders. Each stakeholder is responsible for its own planning contributions. To the extent that its own performance builds on preparatory work performed by other parties, a stakeholder is only liable for defects resulting from its own works if the preparatory work was not reviewed in the necessary scope and existing defects were not pointed out at the time. In this context, the process details should adequately outline who is responsible for the continuation and usability of the building information model beginning with defined milestones.

Another approach would be to arrange liability limitations to promote collaboration between the project participants. The construction industry is currently characterized by an abundance of energy spent on uncovering errors made in the contributions of other project participants in order to generate notices of hindrance and addenda. In this atmosphere, many stakeholders focus first and foremost on not making mistakes and, when in doubt, sharing too little information rather than too much with project participants. Presumably, this is a toxic atmosphere for realizing an integrative planning approach. Indicative of this condition is that large construction companies that currently consolidate as many services as possible under one roof, thereby avoiding interfaces, appear to have covered the most ground in implementing BIM planning processes. Here, BIM application is limited to internal company operations (also known as *"Closed BIM"*). As previously mentioned, many experts agree that the advantages of BIM can only be leveraged when the use of BIM-ready planning tools is accompanied by a shift in existing planning and construction processes towards closer collaboration between the stakeholders themselves. From this standpoint, agreements regarding liability limitations may contribute to a successful "cultural change". This is why liability limitations are frequently suggested as the basis for the successful implementation of BIM (Lowe and Muncey 2009, p. 5; Circo 2014, p. 916).

However, current planning practice is marked by manifold instances of negligence and errors. The use of BIM planning technology should – if used with new tools such as computer-aided collision avoidance and model checking – enable early detection of planning errors and raise the quality of planning. It can hardly be the objective of any of the stakeholders to facilitate an even greater lack of concern when delivering planning results by reducing the responsibilities of the planning participants, as has been evident in planning project practice to date. On the contrary, the objective of BIM should be to significantly enhance the planning quality of larger projects. The authors see no need to reduce the responsibilities of the project participants for their own planning contributions. Consequently, even when BIM is applied, there is also a tendency in international projects to not accept any compromises with respect to the basic responsibility of the project participants for their own planning contributions, whatever they may be.

A further aspect is the liability for software and data transmission errors. One example of a software error could be inferring budget or scheduling forecasts from

the data model that are incorrectly computed, thereby leading to decisions based on a false understanding of the circumstances. If operating errors can be ruled out and the client has stipulated the use of a specific software program, then the client should be the one to bear this risk. Other provisions may apply if the contractor was permitted to choose which software to use and how to obtain the requested forecasts from it. It is necessary to clarify the scope of the contractor's obligation to perform plausibility checks on automatically calculated forecasts or other values. Moreover, the question of who bears the risk if data is lost or altered during data transmission should also be clarified. A special issue related to data reliability arises when component manufacturers supply prefabricated data models for their products. If planners integrate this prefabricated data in their models, then this can also lead to the transfer of incorrect information. Suppliers will likely be unwilling to accept liability for their catalog data. Consequently, forward-looking contract provisions should also be included to clarify which parties bear what risks.

Applying the *CIC BIM Protocol*, project participants do not accept liability for changes to data during data transfer operations if they observed the agreed data transmission rules *(Sect. 5)*. Furthermore, they are not liable for risks arising from the further processing of their data by other project participants *(Sect. 7.2)*. At the same time, the client's liability for data supplied by another project participant is also excluded *(Sect. 7.3)*. The *AIA* contract models relevant to BIM do not provide any instruction on liability issues. *AIA Document G202-2013* briefly touches on one aspect that is relevant to liability. This document clarifies that project participants can only rely on the level of detail of the data provided by other participants in which the data must be found according to defined project milestones, regardless of an actual advanced level of detail of the existing data *(Sect. 3.1.1)*. The *ConsensusDocs 301 BIM Addendum* stresses that contractors are always fully responsible for their own model contributions *(Sect. 5.1)*. Liability for *consequential damages* resulting from the use of the building model data, however, is waived *(Sect. 5.2)*. Moreover, each project participant *(Party)* is expressly obliged to immediately report identified errors – including those discovered in the planning results of other participants *(Sect. 5.4)*. On the other hand, contractors can generally rely upon the sufficiency of the digital models provided by other participants in meeting the prescribed information requirements *(Sect. 5.5)*. Finally, a liability waiver is envisaged for all damages resulting from the use of building data for any purpose other than that agreed upon in the contract *(Sect. 5.6)*. As far as the risk of software-related defects is concerned, the project participant must be granted the right to consider the consequences of the hindrance *(Sect. 5.9)*.

17.6 BIM Management

Clients must rely on new support services when implementing a BIM planning process due to the changes that result from using BIM. Clients require advice firstly on defining a BIM strategy appropriate for the circumstances of their specific project

and secondly on monitoring and complying with the defined specifications during project progress. Beyond this, someone must be responsible for the technical and administrative management of the building information model and data exchange. While any of the traditional project participants may assume these tasks, it is also conceivable for a specialist BIM Manager to deliver these services. There will likely be no standardized way of handling these tasks. Depending on the project requirements, BIM strategy consultancy tasks will be performed when the project begins, BIM coordination during the course of the project, and the provision of the necessary IT infrastructure by various project participants in bundled or separate form. When procuring BIM management services, it is especially important to separate the area of responsibility from the planning coordination services. For example, architects have been and will likely continue to be responsible for coordinating the content of the various planning contributions.

The *ConsensusDocs 301 BIM Addendum* outlines in detail the need for the client to designate a BIM manager and supplies a detailed list of the services to be performed by said BIM manager *(Sect. 3)*. The sample document contains checkboxes for indicating whether the role should be transferred to the planner, the building contractor or a third party to be designated. Based on this, the BIM manager is responsible for developing and monitoring the BIM Execution Plan; the BIM manager organizes meetings between the stakeholders, thereby facilitating the development process and is above all responsible for the administrative and technical management of the model data. However, the BIM manager does not have any direct influence on the planning process. *AIA Document E203-2013* indicates that the architect is responsible for "Model Management" *(Sect. 4.8.1)*. This likewise encompasses primarily technical and administrative tasks, but also includes content-related activities, such as performing collision checks. The *CIC BIM Protocol* does not contain any provisions regarding the BIM manager. Nevertheless, its introductory remarks make clear that appointing an "information manager" is a prerequisite and refer to the CIC service description for the "information manager" for more information on the scope of the manager's duties ("Outline Scope of Service for the Role of Information Management"). The beginning of the service description clarifies that the duties described therein must be assumed by one of the participants who is already involved in the project. In terms of their content, the activities comprise operating the data platform and organizing data exchange along with monitoring the transmitted data for collisions and complying with modeling guidelines, among other things.

17.7 Summary

The use of BIM planning technologies raises a multitude of legal questions. The core task of construction contract law is to regulate the processes required to employ this planning methodology and the rights and responsibilities of the contract parties.

BIM neither requires a new paradigm in contract types, nor does it necessitate a new liability regime. Therefore, the traditional individual contracts generally used in projects may be retained and expanded to include BIM-specific contract annexes valid for all contract stakeholders, as is the case of liability for the individual project participants for their own service contributions.

The manner in which the participants collaborate, the hardware and software tools used, milestones for model consolidation, tasks of the BIM manager and model checking require specific contract features. Then, in the scope of further project development, a BIM Execution Plan can be used to evolve the basic contract principles based on the project participants' specific efforts in creating the building model.

Copyrights and other data protection rights must be outlined in the contracts. These provisions must fairly balance the interests of the contractor to adequately safeguard its information and the interests of the client to continue using the model data in a robust fashion.

Fit-for-purpose construction contract law may encourage the use of BIM planning technologies. Without the support of construction contracts, Building Information Modeling will likely develop into a risky undertaking for all of the project participants involved.

References

Abdirad, H. (2015). Advancing in building information modeling (BIM) contracting: Trends in the AEC/FM industry. In *Proceedings of the AEI Conference 2015*.

AIA Document C106. (2013). *Digital data licensing agreement*. The American Institute of Architects. Washington, DC.

AIA Document E203. (2013). *Building information modeling and digital data exhibit*. The American Institute of Architects. Washington, DC.

AIA Document G201. (2013). *Project digital data protocol*. The American Institute of Architects. Washington, DC.

AIA Document G202. (2013). *Project BIM protocol*. The American Institute of Architects. Washington, DC.

Chao-Duivis, M. A. B. (2011). Some legal aspects of BIM in establishing a collaborative relationship. *The International Construction Law Review, 2011*, 264.

Chew, A., & Riley, M. (2013). What is going on with BIM? On the way to 6D. *The International Construction Law Review, 2013*, 253.

CIC/BIM Protocol. (2013). *Building information model (BIM) protocol*. Retrieved from www.cic.org.uk

Circo, C. (2014). A case study in collaborative technology and the intentionally relational contract: Building information modeling and construction industry contracts. *Arkansas Law Review, 2014*, 873.

ConsensusDocs. (2016). *ConsensusDocs 301 building information modeling (BIM) Addendum*. Virginia: Arlington.

Lowe, R. H., & Muncey, J. M. (2009). ConsensusDocs 301 BIM Addendum. *Construction Lawyer 29*(1).

McAdam, B. (2010). Building information modelling: The UK legal context. *International Journal of Law in the Built Environment, 2*(3), 246–259. https://doi.org/10.1108/17561451011087337

Merrow, E. (2011). *Industrial megaprojects – Concepts, strategies, and practices for success*. New Jersey: Wiley, Hoboken.

Olsen, D., & Taylor, M. (2010). Building information models as contract documents: Common practice for the U.S. construction industry – A preliminary report. In *18th CIB World Building Congress – W113 Law and Dispute Resolution*, Salford.

Part IV
BIM Use Cases

Chapter 18
BIM-Based Design Coordination

Jan Tulke

Abstract The most important aspect Building Information Modeling contributes to the implementation of engineering design consists in the descriptive interactive visualization of the planned building in 3D, including all the directly related information about product specification, creation, and operation. This creates an in-depth understanding of the construction project and forms the basis for improved coordination between the planners and the parties executing the construction.

In addition to the data model and the new visualization possibilities, the three concepts of clash detection, 4D construction process animation, and model checking have emerged to support and control errors in planning; they offer the benefit of additional automation and detailed coordination compared to conventional planning. This section will now focus on the opportunities, benefits, and required conditions of these three concepts, based on practical experience with the customary software.

18.1 Model Support in Coordination

The coordination of planning plays an important role – especially for major projects – since the various parties involved tend to plan different technical aspects independently and since it is necessary to integrate expert knowledge of the executing companies. Coordination must ensure the timely completion of a fault-free and high-quality integrated design. An integral part of this is to identify conflicts, to define appropriate solution concepts together with the planners, and to follow up on their timely implementation, in particular when it comes to consolidating the different design disciplines.

The complete three-dimensional description of the geometry of all building components – as well as their semantics – and recording the sequence of their construction and/or installation open up new possibilities for planning analysis.

J. Tulke (✉)
planen-bauen 4.0 – Gesellschaft zur Digitalisierung des Planens, Bauens und Betreibens mbH, Berlin, Germany
e-mail: jan.tulke@planen-bauen40.de

© Springer International Publishing AG, part of Springer Nature 2018
A. Borrmann et al. (eds.), *Building Information Modeling*,
https://doi.org/10.1007/978-3-319-92862-3_18

The construction project can be executed digitally and under ideal conditions from the very beginning, allowing to analyze the structure as well as the construction processes in detail. This represents an advantage over traditional planning since it provides a complete representation of the structure's spatial and time requirements, and since the individual plans can be regarded in the context of the overall project. So far, only individual horizontal and vertical sections have been illustrated at certain points in time (construction phases, final status). The transition between these sections and points in time required an individual interpretation and was often ignored. This caused numerous problems at construction sites, as a result of unidentified planning errors. Furthermore, the semantics of construction components are now explicitly included the model, so that stroke widths, colors, shading, and texts no longer need to be interpreted.

In order to systematically use this information for design coordination, the analysis concepts of clash detection, 4D construction process animation, and model checking have been established and will be described in detail below. They serve to ensure the geometric feasibility of the building's final status as well as a logical sequence of the construction processes. Moreover, mutual influencing construction processes (with regard to space and resources) and quality-related planning errors can thus be identified.

Software support provides for multiple added values. In addition to cost savings from automation, a systematic software-based error check on the one hand ensures that conflicts are not simply overlooked. On the other hand, the visualization improves and speeds up the understanding of the respective conflict, enabling the planners to develop a solution faster than before. A reproducible, iterative approach allows for tracking the progress of problem solving between the iterations and, thus, provides performance values pertaining to the planning progress and quality separately for the individual planners. Another effect is that the formalization ensures the quality of error checking, regardless of specific skills or the form of the day of individuals involved. The quality thus remains constant.

18.2 Clash Detection

Clash detection refers to the automated detection of geometric penetrations (conflicts or clashes) of different components in the 3D model. Its purpose is to ensure the geometric feasibility of the structure. Conflicts mainly occur between pipes of different trades of technical building services or arise from uncoordinated wall penetrations (cf. Fig. 18.1). Although planners tend to claim that conflicts do not occur if the plan is of a high quality – i.e. carried out by experienced personnel and with appropriate coordination, thus saving the alleged additional expenditure related to clash detection – practice has shown that numerous (up to several thousands) significant conflicts are identified if clash detection is carried out for buildings and infrastructure projects (depending on their size and complexity). Thanks to the obvious savings potential and the related quick return of investment, clash detection

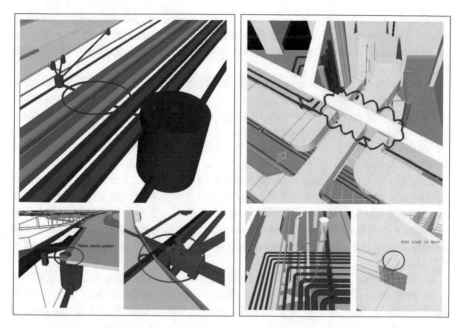

Fig. 18.1 Typical conflicts in infrastructure construction (left) and structural engineering (right). (© HOCHTIEF ViCon, reprinted with permission)

has become one of the most frequently used types of BIM application in the world. Moreover, clash detection has only low requirements regarding model content and structure, and efficient software with various import interfaces for customary CAD programs is commercially available. Therefore, the challenges rather consist in the processing, coordination, and tracking of the solution of the numerous conflicts identified. Ultimately, the actual purpose of clash detection is not the detection of conflicts or planning errors but rather their coordination and solution.

In order to facilitate the structured and trade-oriented processing of the usually high number of conflicts in a coordination meeting with several planners involved, the amount of conflicts identified must be structured in advance. This includes a classification by trade, grouping or pooling of spatially related conflicts, and classification by their location in the floor plans and/or axis grid. This can prevent the loss of spatial orientation in the overall structure during the coordination meeting, and it helps to avoid unnecessary repeated discussions regarding related conflicts – for example, if a pipe crosses a whole strand of other pipes which may appear on different positions in the list of conflicts. Classification by trade also allows to focus on conflicts that are relevant for the planners attending the meeting.

Experience has shown that, during a coordination meeting, the use of an appropriate clash detection software – compared to traditional coordination – can help to speed up the process of resolving conflicts significantly, due to a quicker

and deeper understanding by all parties involved, and help to implement content-related improvements. For comparison and to enhance acceptance, however, the findings should be compared to the corresponding 2D plans, especially in the early implementation stages.

In this context, it has emerged that the technical equipment of conference rooms must also be adjusted to the new methods of operation. A proven approach is to use two large interactive projection boards or screens, on the one hand allowing to show the 3D model and 2D plan next to each other, and – on the other hand – allowing for adding handwritten remarks or sketches with digital pens in order to discuss and document the solution approach (cf. Fig. 18.2).

In addition to the structured discussion of conflicts, other highly important aspects of a planning meeting are to determine and to concurrently document the solution approaches, responsibilities, and revision deadlines. If this is effected by means of a data base that is linked to the clash detection software, the planners can directly access the data in the subsequent decentralized revision of the 3D plan (cf. Fig. 18.3).

If a different solution than the one determined in the coordination meeting proves to be more expedient in the processing, the planner can make an according note in the database so that the information is also made available to the other planners. In

Fig. 18.2 Planning meeting with the 4D model on interactive projection boards at the construction site. (© HOCHTIEF ViCon, reprinted with permission)

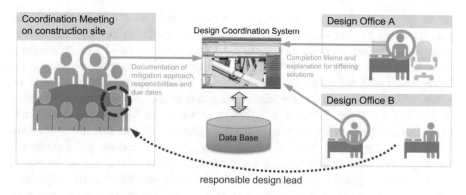

Fig. 18.3 Utilization of clash detection software in coordination meetings and in the revision at the planning office. (© HOCHTIEF ViCon, reprinted with permission)

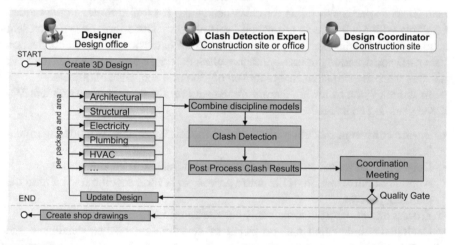

Fig. 18.4 Process and players in the context of iterative planning coordination by means of clash detection. (© HOCHTIEF ViCon, reprinted with permission)

the next clash cycle, it must then be examined whether the conflict has actually been solved or whether the new plan resulted in conflicts once again, for example with other trades.

Because of the different areas of duty, namely sectoral planning, CAD modeling, planning coordination and clash detection, the process of 3D-based planning coordination (as shown in Fig. 18.4) covers various roles and companies within a project. An important key to success is to establish such an iterative regular process with an efficient distribution of tasks without overloading the traditional roles with additional BIM skills. As large-scale projects in particular are typically divided into construction stages or lots which are planned successively, the clash detection should also be carried out step by step, in line with the planning progress.

At the beginning of the project, it is recommended to divide the model into partial models and to define the corresponding clash cycles in line with the regular coordination meetings, in the context of modeling guidelines and a BIM Execution Plan. The uniform creation of the partial models by the respective planners must be regulated with regard to coordinate systems, model structure, level of detail of modeling and color schemes. Particular attention is to be paid to an appropriate level of detail of modeling. While it is sufficient to use simplified placeholder models (so-called space allocation models) in the early planning phases in order to agree on spatial limits for the individual planners, it might become necessary to include the actual position of sprinkler heads and fastenings of pipeline routes into the model in later planning phases. The illustration of small complex objects such as sprinkler heads and ventilation outlets does not need to be true to the original in the model, as this might lead to performance issues in the interactive navigation in the 3D viewer.

In addition to this, it might be advisable to use placeholders for work and maintenance spaces as well as for clearance gauge for traffic routes in the model. Conflicts with such objects are called "soft clashes" since they do not represent actual objects but just spatial requirements. As an extension and/or in connection with a 4D construction process animation, clash detection can also be used to check whether there are collisions due to moved objects or a sequence of objects.

In summary, the following factors are relevant for the success of an efficient 3D-based planning coordination:

- Ensure consistent modeling of all partial models by means of modeling guide-lines
- Determine the sequence of clash cycles for different construction stages
- Appropriate distribution of the entire process to several specific roles within the planning process
- Process and structure automatically detected conflicts
- Central documentation and provision of coordination results, deadlines, and actual solutions

It remains to be said that clash detection can be used similarly in structural engineering and infrastructure construction. The only difference is that the location of existing underground lines can often not be clearly identified in infrastructure construction, even for new built structures. For the rest, the dimensions of identified conflicts and, thus, also the potential costs savings resulting from individual conflicts are mostly larger when it comes to infrastructure construction.

18.3 4D Construction Process Animation

A 4D model is retrieved from the connection of the 3D model with the construction process schedule and indication of visualization parameters such as color, transparency and visualization type (e.g. appear, disappear, temporary) for every scheduled process. The purpose is to visualize the construction processes and the

construction site layout and equipment, which may vary over time. On the one hand, this serves the visual verification of the schedule with regard to completeness and logical sequence – and, on the other hand, its comprehensible communication to all parties involved in the project and to the public for coordination purposes. Especially with regard to complex construction stati, changing traffic routing, spatially limited construction sites and complex structural geometry, the visualization on the basis of the 4D model allows for a quicker and more comprehensive assessment of the planned construction process. This facilitates the coordination among the companies involved, helps to prevent errors by identifying spatial dependencies, and serves to keep the construction site safe (e.g. if the 4D model is used for safety instructions). A successive improvement of the construction process can be achieved by use of a 4D model. The level of detail and the quality of the construction process planning are markedly increased.

For a complete visualization of the construction process, the 3D model of the final structure must however be completed with additional elements such as temporary components, the construction site as such, including construction site equipment (terrain models, storage, traffic and delivery areas, fall arresting devices, important construction machinery, safety facilities and areas etc.) as well as adjacent circulation areas. The schedule must also be completed with the corresponding processes so that these additional 3D objects can be faded in and out in line with the construction schedule. In general, the utilization of a 4D model also requires a schedule that is more detailed in terms of spatial aspects compared to the traditional use of bar charts. This is needed to present construction sections and process sequences in a plausible manner. Scheduling processes which overlap in the bar chart are especially prone to result in illogical presentations. For example, the construction of a ceiling and of the supporting pillars is often planned in a simplified manner by means of two timely overlapping processes, not taking actual construction stages into account (cf. Fig. 18.5). In a 4D model, the pillars and the ceiling they support therefore appear to be constructed simultaneously. This is confusing and does not withstand plausibility checks. If, however, the processes in the schedule are divided into individual concreting phases for the ceiling and related groups of supporting pillars, the construction process is visualized as is: only after the pillars are completed will the ceiling they support be constructed.

In order to achieve an adequate visualization, the granularity of 3D objects and scheduled processes has to be sufficiently detailed and compatible. In many cases, the granularity of the 3D model needs to be retroactively adjusted to the schedule. For example, the 3D model of a ceiling plate usually does not include the concreting phases which are only determined during construction process scheduling, so that the 3D model must be retroactively divided or compiled once again in the CAD software. This results in two issues: Since schedulers do not usually use CAD tools (due to high complexity and high licensing costs), the process iteration cycle between the scheduler and the CAD designer becomes rather complex. At the same time, new CAD objects are created due to the division. In this case, additional information (e.g. component quantities resulting from external calculation) that was initially linked to the original CAD object has to be divided and allocated to the new

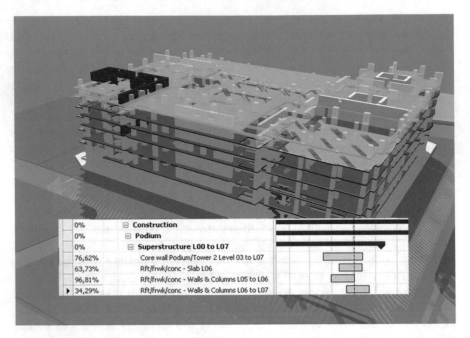

Fig. 18.5 Illogical 4D visualization resulting from insufficiently detailed scheduling and overlapping processes. (© HOCHTIEF ViCon, reprinted with permission)

CAD objects. However, the customary 4D software systems do not yet support the division of objects and re-linkage of information to a sufficient extent.

The time sequence of quantities to be installed or dismantled at the construction site can be derived from the 4D design. The time sequence of quantities is useful for procurement, logistics and accounting, and even for simple construction processes for which a 4D visualization actually only provides limited added value.

The biggest obstacle to the consistent use of 4D models, in addition to the aforementioned requirement of adjusting the model, is the relatively high effort entailed by the creation and updating of the connection between the 3D model and the schedule. As a consequence, the 4D model is most frequently used retroactively for controlling and communicating the completed schedule, rather than as an interactive planning tool. The linking and updating efforts can be reduced if connections are based on rules. Rules are defined on the basis of attributes of the CAD objects and scheduled processes in order to filter the objects to be linked and to automatically link them. While this method generally requires entering the attributes determined by the rules, this will pay off quickly when the schedule is updated the next time.

As an alternative to the traditional bar schedule (Critical Path Method), location based time curves (Line of Balance) are used in infrastructure and structural engineering. Since the distribution of quantities across the location is included in the schedule in a simplified linearized form, the linkage between the schedule and the 3D model can be automatically created for the 4D animation by means of a model-based approach (i.e. upon utilization of the allocation of quantities and CAD objects resulting from the model-based quantity take-off). Because of the linearization, it is however hardly possible to map arbitrary sequences of construction processes in this method.

The practical use of 4D in the project causes further challenges, for example:

- A planning meeting offers a platform to not only use the 4D model for visualization of the initially planned construction process but also to make changes interactively and to directly assess the consequences. Until now, this has been difficult due to the aforementioned efforts related to the adjustment of the CAD model and linkage to the schedule. Moreover, a return installation of the adjusted schedule in the scheduling software is not always supported.
- The synchronous visualization of several schedule variants would enhance the decision-making process. However, the 4D model variants must be created separately in most cases. The reason is that, on the one hand, the 3D model would have to show the common denominator of granularity for all schedule variants, and, on the other hand, the 4D software would have to maintain several (mostly structurally) different schedules with their connections to the 3D model. In most cases, however, a synchronous rendition of 4D model variants in multiple instances of a 4D software is not yet possible.
- In addition to mere date and duration changes, updated schedules often also include structural changes that impact the 4D linkage, i.e. new or deleted processes, processes that were split into partial processes, processes with changed names, descriptions or changed implicit meaning resulting from a rearrangement within the schedule hierarchy. Another example concerns processes related to indicated construction phases or axes, the geometry of which has changed in the meantime although their designation remains the same. These changes are usually neither marked nor communicated in any other manner. Without a coordinated change process, it is very difficult to find these changes in hundreds or thousands of processes in a schedule or to interpret their impacts on the linkage to the 3D model – and this might cause errors that lead to a quick loss of trust in the benefits and effectiveness of 4D models.
- While the data exchange of 3D models and schedules between different authoring programs as such already represents a challenge, no data format has been established for exchanging 4D models among different software packages by now. An exchange by means of Industry Foundation Classes would potentially be technically feasible but is often not supported by customary 4D software.

Despite the difficulties described above, the skillful and coordinated creation and deliberate use of 4D models can create considerable added value for the joint elaboration of the detailed construction process and its communication, and fatal

errors can be detected early and prevented with reasonable efforts. Especially for major or complex projects, the regular use of 4D models is thus expressly recommended. However, adequate integration into processes for the creation of models and schedules as well as for the use in meetings and workshops is to be observed.

18.4 Model Checking

The term Model checking or Code Checking refers to the automated examination of the model on the basis of rules. The geometry, semantics, and linked information of the model are assessed in order to check for compliance with certain planning principles, customer requirements, or building regulations (codes). As a central element, the rules to be checked are to be phrased in such a manner that they can be interpreted by computers. To ensure that these rules do not need to be adjusted to every individual model but can be re-used, a standardized data model which always has the same structure is required to ensure that the required model information can be automatically found at a standardized location. Model checking can be applied in multiple areas, for example to examine country-specific building regulations in the context of building permits, to assess requirements and draft characteristics in the context of architectural competitions, and to control a reasonably growing degree of detail of the model in the transition between the planning phases.

The application of an automated planning check thus requires standardized component descriptions backed by various information on the one hand and sets of rules that can be interpreted by computers on the other hand. The high number of component types and the related information as well as specific regulations and requirements lead to a high degree of complexity and design efforts. Therefore, provision in the form of libraries is desirable. Some component manufacturers and specialized IT providers already provide 3D object libraries for construction components. This not only serves the automated model checking but also the provision of information for procurement and operation. At the same time, checking rules can also be provided by building authorities or institutional clients or used internally for examination purposes in the future. The utilization of the same checking rules by clients, authorities, planners, and general contractors continuously ensures conformity checks throughout the entire planning phase.

Today, the main obstacles are to be seen in the use of different data formats and the non-standardized level of detail of information in models. But already today automatic model checking can be applied very effectively and objectively if the specific use cases and corresponding modeling requirements are carefully defined upfront. This encompasses both, formal as well as content-related data quality. For further information on the subject of automated content-related model checking, please refer to Chap. 22.

18.5 Summary

In order to coordinate the planning across different areas of expertise, including aspects of building execution and operation, the quicker, more precise and more comprehensive understanding as well as the communication of the planned building represent the most obvious advantage of BIM application. This is thanks to the holistic, realistic, and interactive 3D visualization. The concepts of clash detection, 4D construction process animation and model checking also use the model and the inherent information for automatic detection of existing planning errors and/or for expanding the advantages of visualization to the construction process and/or construction site logistics. This can create considerable added value in terms of early fault prevention and improved planning of the building and its construction. However, adequate integration of these methods into the planning and coordination processes is essential, and the required structure of the model data must be ensured. In general, one can say that planning and coordination processes can be automated to a higher degree and that data can be evaluated in a more comprehensive manner, the more the content and structure of the model data are standardized in consideration of the scenarios of utilization across the project and various authors. In the future, this will increasingly cover the alphanumerical data of different technical disciplines linked to the 3D model and, thus, enhance the overall understanding of the planned building, the construction processes, and the related spatial and scheduling dependencies.

The design of the corresponding processes and the definition of content and structure of the required model data do, however, require certain amount of practical experience as well as knowledge in planning and information technology. Thus, it is recommended to involve a BIM Manager (cf. Chap. 16) for drafting and supporting the BIM-based planning coordination to prevent additional expenses which might not generate the expected benefit.

Furthermore, it is expressly pointed out that the opportunities described are only geared to support the engineering planning and/or its coordination in partial areas. Completeness in all technical aspects is not given. Moreover, the responsibility still remains with the individual planners and is not passed on to the automation tools.

Chapter 19
BIM for Structural Engineering

Thomas Fink

Abstract This chapter describes the application of BIM in structural engineering. In this context, the difference between geometric and analytical models is explained. This in-depth discussion covers the application of the method in the various planning phases – including advance planning, permit planning, and construction planning. Finally, potential future developments are discussed.

19.1 Introduction

This chapter seeks to demonstrate how consistently applying a BIM approach to structural engineering projects can prevent the loss of information while increasing the overall design quality. This approach has become known in the industry as "little bim". If, however, methods and tools are used consistently with an eye towards the other participants in the planning and construction process, there are only minor differences between "little bim" and "BIG BIM", since all participants in the process are able to contribute to a common model across the various trades (cf. Chap. 1).

The following descriptions are limited to examples concerning concrete structures, but are equally applicable to any type of construction.

19.2 Geometric and Analytical Model

Structural engineering purposes require two different models which, however, do interact with one another. This can be accomplished either by using a common database or by referencing the corresponding elements with one another.

T. Fink (✉)
SOFiSTiK AG, Oberschleißheim, Germany
e-mail: thomas.fink@sofistik.de

Fig. 19.1 Geometric and analytical model of a two-span slab

The geometric model includes the exact geometry of each individual element, in other words the formwork. A beam consists of a three-dimensional solid body with type, thickness, material, and additional properties that a BIM program can quite easily and reliably display as a view, section, or perspective drawing. The analytical model represents a geometrically simplified model (frequently with reduced dimensions) of an element that forms the basis for stress and deformation calculations in conjunction with the corresponding mechanical models. A beam consists of a system line, cross-section, constraints, and loads (Fig. 19.1). All analysis results refer to the analytical model. Thus, with regard to the structural design phase later on, it is absolutely necessary that the analytical model is linked to the geometry.

This link can be represented with the analytical view of the IFC (see Chap. 5). It is possible to define an analytical model either independently from the geometry or embedded within it.

19.3 Structural Engineering Workflow

The various planning phases with BIM (Fig. 19.2) do not differ from a conventional workflow, except that a modeling step is required at the beginning. This model is refined over time and can be used to generate structural design, construction, and invoicing documents.

19.3.1 Advance Planning, Structural Engineering Drafting

For advanced planning and draft planning, the analytical model must be derived from the geometric model. Whereas in the past an architectural plan would have been imported into a CAD program and used to generate the system lines for structural members, commercial BIM applications now offer greater convenience. For standard elements such as walls, floors, columns, or beams, the analytical model can be generated automatically with intersections of the system lines performed as defined by the user. The most important aspect of this process is that users are

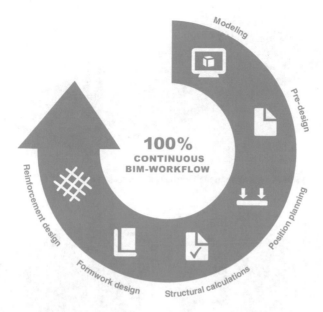

Fig. 19.2 BIM workflow for structural engineering

fully able to make modifications and adapt the system generated by the program according to their preferences without altering the geometric model.

To calculate section sizes and for the subsequent generation of a design, additional inputs such as loads, load cases, action effects, and boundary conditions must be defined. The software suites available on the market differ in this respect. Autodesk Revit, for instance, makes it possible to provide these additional inputs directly within the BIM software, which has the advantage that changes to the geometry are automatically transferred to the analytical system. Other software manufacturers have chosen to only take the geometry from the BIM program and then complete the analytical model in the structural analysis software. In both cases, initial analysis results are obtained very quickly (Fig. 19.3), providing a very good intention for the structural behavior in the respective planning phase.

19.3.2 Permitting Planning

Planning for permits usually involves analyses of both complete systems and partial models. Figure 19.4 shows a physical model of an office building including the structural system (on the left) as well as the finite element system generated from it, including deformations and stress ratios for a wind load (on the right).

In addition to calculations of overall stability and dynamic loads, calculations for individual structural elements must be submitted as well. For the latter, it is of considerable advantage if programs are able to remove these elements from the overall system and to generate the resulting boundary conditions of the subsystem.

Fig. 19.3 Deformation of a two-span slab with equivalent stresses

Fig. 19.4 Structural system of an office building and the finite element mesh generated from it

- Floors are usually calculated as a flat slab. With the data available from the full system, not only fixed or elastic supports can be generated from the supporting elements. It is also possible to, for instance, automatically apply loads resulting from the analysis of the entire system. Of course, a finer FE mesh can be selected for the 2D slab, providing vastly superior precision for the calculation of shear forces. A 2D slab derived from the entire system is depicted in Fig. 19.5.
- In addition to the documentation of overall stability of the entire system, columns must be documented in accordance with the equivalent member method or a second order analysis. This can also be accomplished in a very elegant manner if the data from the full system are accessible.
- Foundation calculations can be performed to obtain the forces from the entire system and also to return the resulting foundation dimensions back to the BIM model.

General arrangements are easy to generate and label based on the geometry.

Fig. 19.5 Floor separated from the full system as a 2D system with analytical model (left) and results (right)

19.3.3 Construction Planning

19.3.3.1 Formwork Drawings

A computer program can easily calculate views, sections, and 3D views from the geometric data model. All the user has to do is to consider which views should be displayed in which manner on the drawing, and to add the appropriate dimension lines and labels.

One major advantage of this method is that, regardless of any modifications to the model, the drawings always reflect the current planning status.

19.3.3.2 Reinforcement Model

The conventional method of working consists of placing the reinforcements into empty formwork drawings (known as rough reinforcement sheets, derived from formwork drawings) according to position, bending shape, dimensions, and quantity. In this case, each piece of steel is usually depicted multiple times, but can only be counted once on the rebar schedule. Before CAD systems were introduced, creating a rebar schedule was a time-consuming process with plenty of opportunities to make errors. In a BIM workflow, each piece of rebar is only placed in the 3D building model once, leading to considerably fewer sources of errors. Users can complete this step manually or utilize specialized software. Since the design results based on the analytical model and the exact geometry are available, newer programs are – to a great extent – also able to independently suggest a required structural reinforcement (Fig. 19.6).

In addition, it is also possible to graphically compare the existing reinforcement with the structurally required reinforcement from the design, thus providing a graphical representation of over-reinforced and under-reinforced areas (Fig. 19.7).

Fig. 19.6 Required reinforcement for a floor and the resulting automatically generated reinforcement layout

Fig. 19.7 Graphical comparison of the required reinforcement (red) and existing reinforcement (blue)

Fig. 19.8 Reinforcement details of a beam generated from a BIM model

19.3.3.3 Reinforcement Drawings

In contrast to the structural member itself, reinforcement drawings only depict rebar as symbols. A 3D rendering of the reinforcement may be nice to look at, specifically for the details, but it is of limited help at the construction site.

Accordingly, one of the main challenges of using BIM for reinforcement detailing is to generate drawings from the reinforcement model that look familiar to what participants in the process are used to seeing (Fig. 19.8). Most importantly, it would be absolutely uncommon to display all individual rebar elements as this would drastically reduce the readability of the drawings. Moreover, in central Europe and many other regions, it is common to depict the labeled rebar shape once again in a separated area on the drawing. These conventions must be respected when automatically deriving drawings from BIM models.

19.4 Summary

Construction planning with BIM methods and tools is now possible for large sections of the construction industry. The software systems already on the market are fit for their purpose and, with the number of users expected to increase, they will soon move past any remaining teething troubles.

A migration may require investments in software and, more significantly, training for those who will work with the new system – yet companies will be able to gain a competitive advantage by doing so. The greatest advantages of a BIM-aided structural engineering process are:

- Time-savings since the geometry does not need to be re-entered for every analysis,
- Fewer errors since the models are consistent with one another,
- Better coordination with others involved in the planning process.

Once a digital building model has been created, there are a number of opportunities to use it for other purposes as well. For instance, computer programs can identify collisions between different elements quite easily. It is exceptionally useful to identify collisions between rebar and MEP components as early as possible, but you have to make sure not to create new problems that did not exist before. Each mesh field with flat meshes would mathematically result in a collision at every single lap splice. To avoid this, every mesh would have to be offset, which is certainly unnecessary in practice.

Another opportunity is to let the computer verify the suitability of combining reinforcements. Instead of deriving complex 2-D drawings from the 3-D model, it seems to be a good option for the future to directly generate a 3D PDF.

This allows the viewer to virtually approach the model from any perspective they choose and to control the visibility of individual elements, with information on the individual reinforcements also available. With the possibility to remove objects from elements to depict them better and to generate exploded drawings like those used in mechanical engineering (such as the one in Fig. 19.9), completely new opportunities are created for conveying information at the construction site. This makes it possible to place assembly instructions in the form of 3D PDFs on tablets or, better yet, smartglasses for access at the construction site.

Fig. 19.9 Exploded drawing of a reinforcement model for a column

Chapter 20
BIM for Energy Analysis

Christoph van Treeck, Reinhard Wimmer, and Tobias Maile

Abstract This chapter addresses BIM in the context of energy demand calculation and building performance simulation. The focus is on different methods to identify the energy demand as well as on building services engineering, including references to the respective standards and calculation bases. We will present data exchange formats that can be used to exchange and to model the energy-related specifications of buildings and its systems and installations – and we will discuss the necessary requirements and definitions regarding the aspects of geometry, zoning, as well as semantics. The chapter also briefly discusses the current state of software-support for HVAC engineering calculations and dimensioning. Furthermore, we focus on the process chain for the use of BIM in the scope of energy demand calculation and simulation, including a brief discussion of the corresponding Model View Definitions of the Industry Foundation Classes. The chapter closes with an outlook on current research and development projects.

20.1 Problem Description and Definition

Energy demand calculation is an integral part of the planning process, not least due to legal requirements. For example, there are energy performance regulations that limit a building's primary energy demand, set requirements regarding the energetic quality of a building's envelope, and define the criteria for mandatory certificates concerning energy demand and consumption. In Europe, for example, it is the Energy Performance of Buildings Directive (EPBD 2010) that serves as a framework directive. As for the aspect of energy demand calculation, we have to differentiate between static and dynamic methods. Although the methods of dynamic building and system performance simulation provide an important set of

C. van Treeck (✉) · R. Wimmer · T. Maile
Institute of Energy Efficiency and Sustainable Building E3D, RWTH Aachen, Aachen, Germany
e-mail: treeck@e3d.rwth-aachen.de

© Springer International Publishing AG, part of Springer Nature 2018 337
A. Borrmann et al. (eds.), *Building Information Modeling*,
https://doi.org/10.1007/978-3-319-92862-3_20

tools to design and optimize complex building energy concepts, they are currently only used in practical applications if special cases require to do so.

However, in the course of the energy turnaround, digital planning methods play a very important role when it comes to evaluating the interaction of systems and components between users, buildings, equipment, and networks on the level of an urban quarter. Without digital methods, it would, for example, not be possible to implement future-oriented methods of model-predictive control or demand-based load management.

On the building level, BIM serves as a method to structure large amounts of data for energy considerations and to manage these sets of data for the entire lifecycle (Chap. 1) (Eastman 2011). Here, the BIM technology can be seen as a future basis for data models, as a working method, and as a tool to create and manage the digital image – or the "energy-related image" of a building. From the perspective of technical building services and HVAC systems, the BIM-approach is of considerable advantage in the scope of planning, plant construction, and operation. For example, to avoid having to re-enter data in time consuming procedures, high-quality data interfaces are able to take over geometric information and system parameters.

20.2 Energy Demand Calculation and Building Services Engineering

Energy demand calculations are used to detect and to optimize the energy flow in complex systems where it is necessary to calculate aspects such as its energy production, energy storage, distribution, and transfer (VDI 2067-10/11 2013; ISO/DIS 52016-1 2015). For this purpose, rough assumptions about the building envelope and the energy reference area have to be made. In many countries, there are energy-saving regulations that have to be observed – in a European context, for example, the EPBD governs mandatory requirements for new buildings, building conversions, and modernization, concerning the aspects of the energetic quality of the building envelope, the system efficiency, and the primary energy demand.

The heat load (EN 12831 2017) and cooling load (ASHRAE 183-2007 RA 2014, VDI 2078 2015), for example, are specified to ensure that the installation components will be able to meet the demand of the users with regard to a thermally comfortable indoor climate. For the technical building services, it is also necessary to consider and combine different HVAC installations – and it is important to attune all installations to each other in a holistic manner, since they operate in different thermal zones that, in turn, have influence on each other (prEN ISO 52000 2015). Many of the standards in the scope of the calculation methods of the EPBD (the German DIN V 18599 2013, for example) are based on static methods.

In addition to the BIM-related geometric point of view, it is – in terms of energy usage – necessary to distinguish boundary conditions, climatic conditions, zones, and service areas. Here, there are similarities between the static and

dynamic methods of creating so-called zonal models. Thus, it might at first seem unreasonable that in the past different methodological approaches were used to develop standards. The development of common data models of normative (static) approaches and (dynamic) simulation methods is still a matter of research and standardization.

20.3 Data Exchange and Software-Support

20.3.1 Formats for the Exchange of Energy-Related Building and Facility Data Using BIM

When it comes to exchanging data in the scope of energy demand calculation and simulation, it must be possible to rely on a sufficient data depth – primarily regarding the definition of the building geometry and the thermal zones, which, on the one hand, represent a container for thermally similar spaces, and, on the other hand, contain respective thermal and energy-relevant parameters such as user profiles. To be able to represent engineering systems, an exchange format has to support objects to describe the building – complete systems, individual components, the hierarchy of the components, their functional and topological relationships and interdependencies, as well as energy-related parameters or characteristics.

In addition to the model of the Industry Foundation Classes (IFC), which is covered in Chap. 5, it is necessary to mention the Green Building eXtensible Markup Language (gbXML) in this context (Roth 2014). gbXML is a data exchange format that was originally developed to exchange data between CAD programs and energy simulation tools. Today, it also serves to exchange data between different energy analysis tools. This XML-based format mostly reflects geometric data, user profiles, weather information, as well as other energy-related data. However, some of the individual parameters that are relevant for building HVAC components are neglected (Dong et al. 2007).

Another exchange format concerning energy demand calculation and simulation is the Simulation Domain Model SimModel or SimXML (O'Donnell et al. 2011), which is also based on XML. This data model is able to represent data of different formats – including IFC and gbXML representations, among others – so it is suitable as an extensive data container for simulations of the HVAC system technology. In comparison with the IFC, it features a simpler data hierarchy, as linked objects were simplified or combined with other objects. Furthermore, a specification level was added, complementing the classes and types of objects with other object subtypes. The format was developed for the task of exchanging data between the simulation core EnergyPlus (DOE 2014) and BIM tools, thus defining a data structure for technical construction components and user profiles (O'Donnell et al. 2011).

Manufacturer-specific building specifications are defined in the context of the international standard ISO 16757 (2015). The format provides manufacturers of

technical components with a uniform template in the form of a product data catalog that represents specific component data of building services elements. It is mainly used to identify manufacturer-specific systems technology and, thus, complements existing information in the IFC model.

As of version 2×4, the IFC are able to represent energy-related building and facility data (BuildingSMART 2014). This includes thermal space boundaries of first and second order that serve to define thermal zones in the scope of energy calculation or simulation, which will be discussed in the following section. Further, different technical building components were added – e.g. boilers and pumps – that serve to exchange object-specific information.

20.3.2 Required Definitions

Basically, a room is a central object of the energy calculation, and construction elements are linked to a room via thermal boundary surfaces (van Treeck and Rank 2007). Thermal boundary surfaces can be calculated in different ways. In a detailed approach in the course of creating a zonal model, the surfaces are defined as an interface between the actual inner surfaces of the components and the volume of the room. For internal components, rooms on the other side are considered as well. Surfaces that are defined in order to calculate heat transfer by transmission between two rooms are known as "2nd Level Space Boundaries" (Rose and Bazjanac 2013). 2nd Level SB are based on so-called 1st Level SB: In the case discussed in the following, the common wall between the heated room and the adjacent rooms is divided into two 2nd level SB and another remaining surface. Based on these definitions, the transmission heat flows of flat components (heat flow in one direction) and thermal bridge effects can be defined clearly and independently from possibly divergent definitions in the architectural or static/structural model. For a definition of the Space Boundary Level, we would like to refer to (Rose and Bazjanac 2013; van Treeck and Rank 2007).

Calculations that are based on the EPBD use a similar but usually simplified definition of surfaces, based on exterior surfaces and averaged surfaces. Figure 20.1 illustrates the differences.

In addition to the geometric description, the physical parameters of the wall structures are needed for the energy calculation as well. Wall structures and material layers are assigned to construction components, and essential physical parameters (e.g. density, thermal conductivity, etc.) are defined for the individual material layers. Thermally similar spaces are combined in zones in order to simplify data entry. For detailed models, this can be done room by room. In addition, data regarding internal loads, usage-specific and technical profiles are required. Apart from details concerning the location and the weather information, further information about the system technology and its control are required to calculate the energy demand.

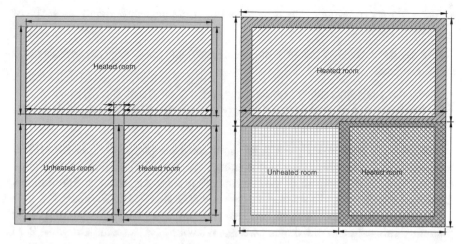

Fig. 20.1 Detailed and simplified definition of boundary surfaces

20.3.3 Software-Support for the Tasks of Dimensioning, Energy Demand Calculation, and Building Simulation

Usually, engineering-specific calculations for the task of dimensioning and sizing are done using static methods that are based on key figures. In an international context, ISO standards play a major role in this regard, serving as a guideline and a means of verification for the engineers. The following is a list of various relevant ISO standards:

- Calculation of internal temperatures of a room in summer without mechanical cooling (ISO 13792 2012)
- Energy performance of buildings (ISO/DIS 52016-1 2015); Calculation of energy use (ISO 13790 2008) and thermal performance of buildings (ISO 13789 2007);
- Design of the system energy performance for heating systems in buildings (ISO 13675 2013)
- Hygrothermal performance of building equipment (ISO 15758 2014)

In the scope of standardization, for example some standards cover the aspect of overheating/heat protection in summer, and dynamic simulation models are already in use for the task of cooling load calculation. The repertoire for the dimensioning of installations includes issues such as:

- the calculation of the heating load (EN 12831 2017); the heating surface layout and the calculation of the pipe network, also regarding hygienic requirements (ductwork lengths, etc.) and the dimensions of the gas pipelines;
- the cooling load calculation for the ventilation, the calculation of volume flow and pressure losses, the planning of air handling and ventilation systems, for example with regard to domestic ventilation;

- water supply planning or the dimensioning of drainage systems in the scope of sanitary planning.

For the tasks of calculating the energy demand and the energy performance, we can distinguish

- methods to calculate the energy demand and
- methods to calculating the overall energy performance (for example, such as DIN V 18599 2013).

Another standard to be mentioned is, as an example, (ANSI/ASHRAE/IES Standard 90.1 2013), which governs the energy standards for buildings in the United States, as well as the methods of the corresponding software products. Additionally, California has introduced a stricter energy standardization (Title 24 2013).

Regarding the software, there are several companies that offer solutions for planning, calculations, and dimensioning. Whether – or to what extent – BIM methods are supported is largely dependent on the respective software vendor, sometimes limited to individual aspects such as collision detection regarding ductwork, pipelines and structure, or means to transfer simple geometric models.

There are building-specific planning and design tools that support exchange with specialist CAD or BIM systems. In most cases, there is support for one (single) common proprietary platform. So far, universal and product-independent data exchange via IFC does not yet play a significant role. Here, data transfer between two products is mostly carried out using gbXML or proprietary interfaces that are integrated into the software platform of the respective CAD/BIM system (possibly by a different vendor). Data management is usually based on an internal proprietary model. However, model checking software sometimes requires the use of IFC models as input for clash detection.

With regard to the software, there are designers and manufacturers that offer dynamic simulation tools that are able to directly access building data via a BIM-interface, using gbXML or IFC. Further, software vendors that focus on the area of technical building services provide support for product-specific manufacturer data regarding technical components (ISO 16757 2015), for the purpose of building technology planning – for example attributes, parameters, characteristics, and 3D representations.

The aspect of product data exchange for building technology data is still a subject of research. Thus, a complex framework was developed in the scope of the IEA EBC Annex 60 project (IEA EBC Annex 60 2016), allowing to analyze BIM data (IFC 4 Add 2) and to facilitate transformations into the object-oriented modeling language Modelica (Remmen et al. 2015; Wetter and van Treeck 2016). Currently, there are no commercial applications that allow to directly transfer data on building technology components from a CAD system to a dynamic simulation model.

Here, it is especially important to distinguish between static and dynamic (numeric) calculation methods. Static methods are not able to capture the complex control behavior of a technical building system or, for example, intelligent interactions between a system and a supply network. However, given the background of

the energy transition and the increasing importance of renewable energy sources and efficient energy systems, this aspect is becoming increasingly important.

20.4 Process Chain: Use of BIM for the Tasks of Energy Demand Calculation and Building Simulation

Several steps have to be undergone to be able to use the BIM methodology for the tasks of energy demand calculation or simulation: The construction of the model is followed by data export, model verification, model conversion, data enrichment, the actual calculation or simulation, the evaluation phase and, finally, an optional data feedback.

Starting with the modeling of the building envelope in a CAD system, the respective pieces of data are exported. Typically, the product model is then checked for errors. An error check is necessary because the calculation of the boundary surfaces is highly dependent on the quality of the geometric model. For example, directives for the BIM-modeling of energy simulations are discussed in Maile et al. (2013). Exemplarily, Fig. 20.2 summarizes the data transfer methodology for the two data formats IFC and gbXML. So far, energy demand calculations are usually based on geometric data alone. For dynamic building simulations, it is possible or even necessary to add further data concerning the description of thermal parameters of rooms, zones, and other system parameters (or installations).

In the gbXML format, it is mainly geometric data that is imported. In addition, it is possible to import thermal data such as internal loads – if supported by the software. In connection with the IFC data format, energy demand programs are usually able to calculate the boundary surfaces independently, since they are based on a simpler definition and, therefore, a simpler calculation (see Fig. 20.1). The boundary surfaces can be stored using the IFC data model to ensure compatibility with simulation programs. Concerning the IFC-model, it is necessary to distinguish between the two latest versions (IFC2×3 and IFC4).

- If IFC2×3 is used, the geometric data to be exchanged is defined in the model view definition (MVD) "Coordination View 2.0" (cf. Chap. 6). The boundary surfaces are governed by the so-called "Space Boundary Add On" (BuildingSMART 2010).
- In IFC4, the "Coordination View" was replaced by two MVDs; a simpler one – the "Reference View" – and a more detailed one, the "Design Transfer View" definition (cf. Chap. 6). Interestingly, the boundaries are not defined in either of the two MVDs. This is to be remediated by the energy simulation MVD which has been undertaken within the IEA EBC Annex 60 project (Pinheiro et al. 2016).

In addition to the purely geometric description, the physical parameters of the components are needed to calculate the energy demand as well. These are defined in the "Concept Design BIM 2010" MVD (CDB 2010). Further, thermal zones

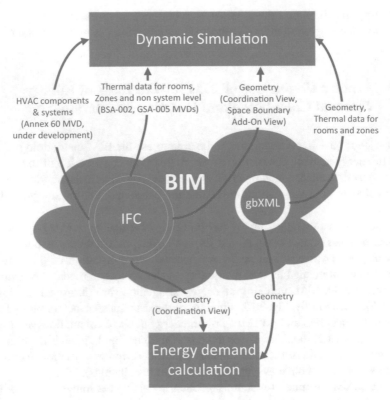

Fig. 20.2 BIM-specific data exchange (IFC and gbXML) following energy demand calculation and building simulation

have to be identified to be able to calculate the thermal characteristics. If the CAD application supports this MVD, physical material parameters and internal loads can be defined in the first step already. Otherwise, this data must be added to the data model before conversion (CDB 2010). HESMOS – another research project in this context – does not feature predefined MVDs, but makes use of corresponding objects and parameters (Liebich et al. 2011). In the scope of the international IEA Annex 60 project, there are now efforts to develop an MVD for IFC4 that integrates the two aforementioned MVDs and also contains other relevant concepts and details concerning systems technology, objects, and parameters (Pinheiro et al. 2016; Wimmer et al. 2014).

If all necessary pieces of data are at hand, it is possible to perform the calculation or the simulation and to evaluate the results from an energy-specific viewpoint. Furthermore, it is possible to re-import some of the resulting data into the data model. This is only reasonable for a small number of parameters, for example for volume flows or calculated heating and cooling loads on the level of a room or a zone. Alternatively, the IFC data model can be used for external referencing. Further, gbXML allows to save the resulting data and supports basic details on components and systems.

20.5 Summary

In summary, the BIM technology is quite beneficial – from the perspective of the technical building services and the HVAC domain in the planning phase as well as during construction and operation. Currently, BIM is only supported by some of the established calculation programs that focus on technical building services or the overall building energy performance in terms of the EPBD. Further, the support is mostly limited to the geometric aspect – and the current development status is still characterized by a high error rate and interpretation problems. Thus, it is still necessary to check the models and to carry out extensive manual corrections. There are individual dynamic building simulation software systems that are able to import data from IFC models, but the building simulation applications still show room for improvement in this regard.

In addition to the application-specific support, it is necessary to consider the imperfect or at least non-matching export functions and results of the different CAD software products. Also, it is in the interest of the respective companies to support proprietary formats. In the scope of energy demand calculation and simulation, successful means to digitally exchange product model data must be based on quality assurance regarding data export, data import, and data modeling.

In the context of IFC, so-called "Model View Definitions" (MVDs) serve to define objects and parameters in a specific use case (see Chap. 6). If both applications support MVD – both for importing and exporting data – the user can be sure that it is possible to transfer data. While more of the existing software applications should include this feature, there are no similar approaches for other data models – such as gbXML – at all.

Currently, there are several international research projects devoted to the goal of defining energy-specific data representation schemes and to unify them. The aforementioned MVDs of IFC2×3 essentially define data on the level of a room or a zone. The European-funded HESMOS project (Liebich et al. 2011) defines parameters at the system level, while details regarding the systems technology on the component level are not considered. Another approach towards additional means to define systems technology components is to be seen in EnEff-BIM, which is funded by the German Federal Ministry of Economics and Technology (BMWi) and carried out in cooperation with EBC Annex 60 of the International Energy-Agency IEA (see, for example, Cao et al. 2014). This project aims at mapping and transferring a BIM to an object-oriented simulation model for buildings and systems. Here, SimModel serves as an intermediate format, while the IFC model is extended and a respective MVD is defined (Pinheiro et al. 2016; Wimmer et al. 2014).

References

ANSI/ASHRAE/IES Standard 90.1. (2013). *Energy standard for buildings except low-rise residential buildings*. ASHRAE.

ASHRAE 183-2007. (RA 2014). *Standard 183–2007 (RA 2014) – Peak cooling and heating load calculations in buildings except low-rise residential buildings* (ANSI Approved/ACCA Co-sponsored). ASHRAE.

BuildingSMART. (2010). *IFC2×3 space boundary implementation guide summary*. Retrieved from http://www.buildingsmart-tech.org/downloads/accompanying-documents/agreements/IFC2x3-space-boundary-implSummary-2010-03-22.pdf/at_download/file

BuildingSMART. (2014). *Industrial foundation class IFC4: Official release*. Retrieved from http://www.buildingsmart-tech.org/ifc/IFC4/final/html/index.htm

Cao, J., Maile, T., O'Donnell, J., Wimmer, R., & van Treeck, C. (2014). Model transformation from SimModel to Modelica for building energy performance simulation. In *Proceedings of BauSIM2014, 5th IBPSA-Germany Conference*, Aachen, 22–24 Sept 2014. ISBN:978-3-00-047160-5.

CDB. (2010). *Concept design BIM 2010*. Retrieved from http://www.blis-project.org/IAI-MVD/MVDs/GSA-005/Overview.pdf

DIN V 18599. (2013). *Energy efficiency of buildings – Calculation of the net, final and primary energy demand for heating, cooling, ventilation, domestic hot water and lighting*. Berlin: Beuth Verlag.

DOE. (2014). *EnergyPlus energy simulation software*. Retrieved from https://energyplus.net/

Dong, B., Lam, K. P., Huang, Y. C., & Dobbs, G. M. (2007). A comparative study of the IFC and gbXML informational infrastructures for data exchange in computational design support environments. In *Building Simulation 2007. 10th Conference of International Building Performance Simulation Association*, Beijing (pp. 1530–1537). Retrieved from http://www.ibpsa.org/proceedings/BS2007/p363_final.pdf

Eastman, C. M. (2011). *BIM handbook: A guide to building information modeling for owners, managers, designers, engineers, and contractors* (2nd ed.). Hoboken: Wiley.

EN 12831. (2017). Energy performance of buildings – Method for calculation of the design heat load. Berlin: Beuth Verlag.

EPBD, European Parliament and Council on Energy Efficiency of Buildings. (2010). In *Directive 2010-31/EU of the European parliament and the council of 19 May 2010 on the energy performance of buildings*. Retrieved from http://eur-lex.europa.eu/LexUriServ/LexUriServ.do?uri=OJ:L:2010:153:0013:0035:EN:PDF

IEA EBC Annex 60. (2016). *IEA EBC Annex 60 project website*. http://www.iea-annex60.org/

ISO 13789. (2007). *Thermal performance of buildings – Transmission and ventilation heat transfer coefficients – Calculation method*. International Organization for Standardization.

ISO 13790. (2008). *Energy performance of buildings – Calculation of energy use for space heating and cooling*. International Organization for Standardization.

ISO 13792. (2012). *Thermal performance of buildings – Calculation of internal temperatures of a room in summer without mechanical cooling – Simplified methods*. International Organization for Standardization.

ISO 13675. (2013). *Heating systems in buildings – Method and design for calculation of the system energy performance – Combustion systems (boilers)*. International Organization for Standardization.

ISO 15758. (2014). *Hygrothermal performance of building equipment and industrial installations – Calculation of water vapour diffusion – Cold pipe insulation systems*. International Organization for Standardization.

ISO 16757-1. (2015). *Data structures for electronic product catalogues for building services – Part 1: Concepts, architecture and model*. London: British Standards Institution.

ISO/DIS 52016-1. (2015). *Energy performance of buildings – Calculation of the energy needs for heating and cooling, internal temperatures and heating and cooling load in a building or building zone – Part 1: Calculation procedures.* International Organization for Standardization.

Liebich, T., Stuhlmacher, K., Katranuschkov, P., Guruz, R., Nisbet, N., Kaiser, J., Hensel, B., Zellner, R., Laine, T., & Geißler, M.-C. (2011). *HESMOS deliverable D2.1: BIM enhancement specification*, ©HESMOS Consortium, Brussels. Retrieved from http://www.hesmos.eu/downloads/20110831_hesmos_wp02_d21_final.pdf

Maile, T., O'Donnell, J., Bazjanac, V., & Rose, C. (2013). BIM – Geometry modelling guidelines for building energy performance simulation. In *Building Simulation 2013. 13th Conference of International Building Performance Simulation Association*, Chambéry (pp. 3242–3249). Retrieved from http://www.ibpsa.org/proceedings/BS2013/p_1510.pdf

O'Donnell, J., See, R., Rose, C., Maile, T., Bazjanac, V., & Haves, P. (2011). SimModel: A domain data model for whole building energy simulation. In *Building Simulation 2011. 12th Conference of International Building Performance Simulation Association*, Sydney (pp. 382–389). Retrieved from http://www.ibpsa.org/proceedings/BS2011/P_1223.pdf

Pinheiro, S., O'Donnell, J., Wimmer, R., Bazjanac, V., Muhic, V., Maile, T., Frisch, J., & van Treeck, C. (2016). *Model view definition for advanced building energy performance simulation.* BauSIM 2016, Dresden.

prEN ISO 52000. (2015). *Energy performance of buildings – Overarching EPB assessment.* Part 1: General framework and procedures (ISO/DIS 52000–1:2015).

Remmen, P., Cao, J., Ebertshäuser, S., Frisch, J., Lauster, M., Maile, T., O'Donnell, J., Pinheiro, S., Rädler, J., Streblow, R., Thorade, M., Wimmer, R., Mueller, D., Nytsch-Geusen, C., & van Treeck, C. (2015). An open framework for integrated BIM-based building performance simulation using Modelica. In *Building Simulation 2015. 14th Conference of International Building Performance Simulation Association*, Hyderabad (pp. 379–386). Retrieved from www.ibpsa.org/proceedings/bausimPapers/2014/p1143_final.pdf

Rose, C. M., & Bazjanac, V. (2013). An algorithm to generate space boundaries for building energy simulation. *Engineering with Computers, 4*, 1–10.

Roth, S. (2014). *Open green building XML schema: A building information modeling solution for our green world.* Retrieved from http://gbxml.org/

Title 24. (2013). *Energy calculations and compliance reports for all California projects.* Retrieved from http://www.energy.ca.gov/title24/

van Treeck, C., & Rank, E. (2007). Dimensional reduction of 3D building models using graph theory and its application in building energy simulation. *Engineering with Computers, 23*, 109–122. https://doi.org/10.1007/s00366-006-0053-7

VDI 2067 Blatt 10 und 11. (2013). *Economic efficiency of building installations: Energy demand for heating, cooling, humidification and dehumidification.* Düsseldorf: Verein Deutscher Ingenieure.

VDI 2078. (2015). *Calculation of thermal loads and room temperatures (design cooling load and annual simulation).* Düsseldorf: Verein Deutscher Ingenieure.

Wetter, M., & van Treek, C. (2016). *IEA EBC Annex 60 – Final report.*

Wimmer, R., Maile, T., O'Donnell, J., Cao, J., & van Treeck, C. (2014). Data-requirements specification to support BIM-based HVAC-definitions in Modelica. In *Proceedings of BauSIM2014, 5th IBPSA-Germany Conference*, 22–24 Sept 2014, Aachen. ISBN:978-3-00-047160-5.

Chapter 21
BIM for Construction Safety and Health

Jochen Teizer and Jürgen Melzner

Abstract Large to small organizations throughout the entire construction supply chain continue to be challenged by the high number of injuries and illnesses. Although the five C's (culture, competency, communication, controls, and contractors) have been focusing on compliance, good practices, and best in class strategies, even industry leaders experience marginal improvements in occupational health and safety (OHS) for many years. BIM for construction safety and health identifies three major focus areas to aid in the development of a strategic – as opposed to tactical – response: (a) OHS by design, (b) pro-active hazard detection and prevention at the workplace, and (c) education, training, and feedback leveraging state-of-the-art processes and technology. This chapter explains the motivation for developing a strategic roadmap towards the use of BIM in OHS. It highlights meaningful predictive, quantitative, and qualitative measures to identify, correlate, and eliminate hazards before workers get injured or other incidents cause collateral damage. Using selected case study applications, the potential of BIM in practical implementation as well as the social implications on conducting a rigorous safety culture and climate in a construction business and its entire supply chain is shown.

21.1 Introduction

Although the construction industry has been seeing some dramatic shift towards adapting and developing modern information and communication technologies for the past decade, its occupational safety and health performance worldwide remains very poor. Statistics show that in many countries the construction sectors experience one of the highest accident rates. Among the 60,000 construction workplace

J. Teizer (✉)
RAPIDS Construction Safety and Technology Laboratory, Ettlingen, Germany
e-mail: jochen@teizer.com

J. Melzner
W. Markgraf GmbH & Co KG Construction Company, Bayreuth, Germany
e-mail: juergen.melzner@markgraf-bau.de

© Springer International Publishing AG, part of Springer Nature 2018
A. Borrmann et al. (eds.), *Building Information Modeling*,
https://doi.org/10.1007/978-3-319-92862-3_21

deaths worldwide, falls remain a major concern as they contribute to very serious injuries or even fatalities on construction projects. Despite stricter work conditions, environments and labor requirements, standards and rules for adequate protection change too slowly to have a significant impact. Regulations also may vary vastly by the location of a project. Increasingly international operating organizations that must deliver ever larger and more complex projects are in need of simple tools that allow ubiquitous understanding and planning of safety and health regardless in which country they operate in. The problem with construction safety and health therefore can be examined by responding with methods and tools that advance best practices in place and make use of technological innovations. These also must empower a new generation of technology-savvy engineers in design and planning offices and leaders in all operational fields of construction and facility management.

Due to the large number and severe consequences of construction workers falling from heights, this chapter focuses on fall-related incidents only. The next two sections introduce the most noteworthy fall-related accident statistics of Germany and the United States and the current practices that are being employed to prevent such accidents from happening. The section following thereafter introduces research on an intelligent safety-rule checking platform using Building Information Modeling (BIM). Lessons learned from real use cases demonstrate the feasibility of the selected approach. The final section discusses the constraints and provides an outlook of further work necessary to advance the developed approach for field readiness.

21.2 Accident Statistics and Root Causes

Construction offers some of the most dangerous workplaces and has historically seen one of the highest work-related injury and fatality rates. Compared to other industry sectors in Germany for the past two decades, the German construction industry reported most of the accidents. In Germany, a reportable case is an accident during occupation or commuting which is either fatal or leads to an incapacity to work for more than three days. When relating the accident rate in construction to the amount of full-time employees, construction in Germany has 55.49 reportable accidents based on 1,000 full-time workers. Though the accident rate in the German construction industry decreased over the past two decades, more than 100,000 reportable work accidents are still witnessed annually.

In the US, for example, the construction industry continues to rank among the most dangerous industries to work for (Hinze and Teizer 2011). 751 construction workers died in 2010 alone, while these numbers are equal to a fatal work injury rate of 9.5 workers per 100,000 full-time equivalent workers (U.S. Department of

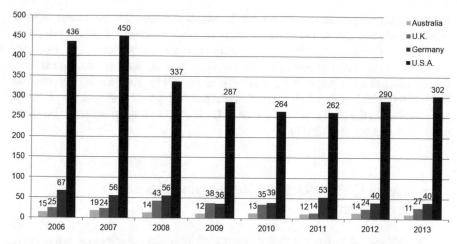

Fig. 21.1 Overall number of construction fatalities and reported fall-related fatalities in the United States, Germany, Australia and the UK. (© J. Teizer, reprinted with permission)

Labor 2011). A comparative overview of statistics related to fatal falls is highlighted in Fig. 21.1. These numbers do not account for the circumstance of the construction economy being cyclical (between 2008 and 2012 was a downturn in construction activity). They also do not adjust for the different sizes of the economies.

Falling from height is one of the most common causes leading to fatalities in construction. Existing research conducted revealed that inadequate or inappropriate use of fall protection equipment and inoperative safety equipment contributed to more than 30% of all fall accidents (Huang and Hinze 2003). According to Bunn et al. (2007), falls also incurred the highest workers' compensation and hospitalization costs in construction. The average absent days for construction workers suffering from falls from heights was 44 days (Gillen et al. 1997). The root causes for such poor accident statistics in the construction industry can be, according to Hinze and Teizer (2011): physical tasks are very demanding, the work environment is complex and constantly changing, best operating techniques are not always available when needed, a company's organizational structure and commitment to safety and health is imperfect, and allows human error. While close to 26,000 German construction workers retire early from their work life due to musculoskeletal injuries, the building industry sees a significant shortage of qualified labor. Hence, severe accidents limit the quality of a person's and probably a family's life but also limit a country's competitiveness and lower its productivity.

Many safety and health related organizations, owners and contractors, and other stakeholders in a construction project have well understood the consequences that are caused by injuries and fatal falls. Their first mission since then has been to provide safe working conditions. One of its goals is to pursue appropriate safety design and planning. As many researchers already pointed out, awareness of safety during design and planning phases can improve the safety standard throughout the entire construction phase and beyond (Gambatese and Hinze 1999; Frijters and

Swuste 2008; Hinze and Wiegand 1992). Much research has also been done to improve safety in construction by focusing on improvements of safety awareness or technical developments for on-site safety (Garrett and Teizer 2009). However, it is evident that more attention should be paid to safety as it is used in the early design and planning stage of a project (Qi et al. 2011). As Building Information Modeling (BIM) has already been proven as a promising tool to support construction management in the earlier project phases, BIM has yet to impact construction safety and health (Zhang et al. 2013).

21.3 Legal Obligations and Responsibilities Differ by Country

As an example the United States' Occupational Safety and Health Administration (OSHA), sets forth minimum guidelines to protect the health and safety of those working in the construction industry and other occupational fields. OSHA's regulation 1926.16 defines that (1) the prime contractor is generally responsible for work site safety, and (2) each subcontractor remains responsible for keeping their workers safe. A similar law exists in Germany (§4 BaustellV). Dividing up the roles in construction safety can cause problems, for example, a prime contractor that often provides general safety equipment and coordinates work site safety may not be aware that subcontractors perform unsafe work at height on a project. Communication of essential hazard-related information and needed safety equipment can be an issue and often has led to issues on projects.

Under German law, a health and safety coordinator should be present if a contractor cannot perceive the tasks him- or herself. Typical reasons for a contractor to hire a safety coordinator are lack of expertise or a small project. The relationship is illustrated in detail in Fig. 21.2. In Germany mainly the "Employers' Liability Insurance Association for Construction" (in short "BG Bau") is responsible for maintaining and controlling safety in the construction industry. It publishes regulations to set safety objectives as well as defines industry and process-specific rules. Such rules include fall protection regulations. These rules are legally binding.

Although the involvement of a safety and health coordinator adds up to about 0.3–1.0% to the total construction budget, savings can be expected by lowering construction interferences, accident and loss rates/costs, providing better coordination, and sharing of construction equipment. Furthermore, the implementation of a coordinator on a project does not exempt the contractor from the responsibility for maintaining safe construction sites. The safety and health coordinator has to

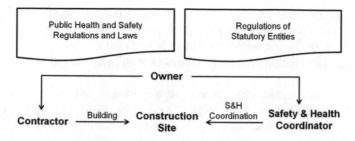

Fig. 21.2 Safety relationship between German regulative entities and contractors. (© Taylor & Francis, reprinted with permission)

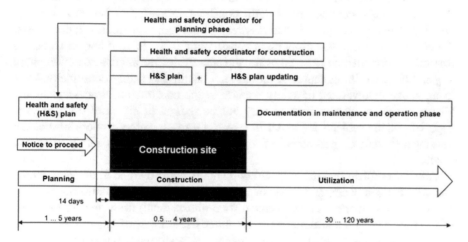

Fig. 21.3 Responsibilities of a German safety and health coordinator in project development. (© Taylor & Francis, reprinted with permission)

actively participate in design and construction planning. Figure 21.3 shows the responsibilities of the safety and health coordinator during the project development. During design he/she has to elaborate the safety and health plan and communicate the protective measures to the contractor and planners. Further, he/she has to coordinate safety and health issues during construction.

21.4 Problems in the State-of-the-Art Safety Planning

Safety planning in the construction industry is complicated due to the dynamic nature of the construction environment and active involvement of various stakeholders. Construction is typically seen as a one-of-a-kind business. Each project is built "for the first time" and only very few building types are constructed repeatedly. Consequently, construction planning has to start again with the start of a new

project or phase. Traditionally, safety planning in construction is separated from the other planning phases. Frequently experienced issues arise when (1) decisions of the architectural/engineering design and layout planning team are made without considering safety factors, and (2) the project layout keeps changing throughout the project.

A further well known characteristic of the construction industry is the large number of trades involved in a project. An architect/engineer might as well be responsible for the preliminary design and construction documentation. However, the contractor remains responsible for construction site safety (Gambatese et al. 2009). The current state of many construction businesses shows that contractors participate relatively late or very little in the design or planning process. Therefore, the time between contract award until construction starts is often too short for detailed safety planning. This defers safety planning into the construction phase. Another often proclaimed problem in construction is the lack of human resources for construction planning as well as for site supervision during the execution phase (Egan 1998).The introduction of an external health and safety coordinator leads to an active involvement of safety experts in the construction process planning. However, the safety coordinators may not be present at all times on a project; especially if the projects are small in size. As a result, safety responsibilities are delegated to staff or personnel that might not be familiar with safety rules and regulations.

Another problem that exists in safety planning is the method to detect potential hazards that put workers at risk or in dangerous work environments. Manual observation and marked up and printed (two-dimensional) drawings are only two of the very common traditional practices that exist to interpret existing health and safety hazards. As seen on projects, safety risk analysis is based on long-time experience of personnel, observations of progress at site, tasks actually performed, and looking at drawings. Such analysis is often referred to Job Hazard Analysis (JHA) but is ultimately conducted in detail a few days before the work is actually performed.

It has been widely acknowledged that safety planning in construction needs improvement. It is in the nature of the construction business that quality planning and work preparation is directly linked to the knowledge of the executing and experienced personnel. Therefore, knowledge-based decision support tools can help humans to improve the quality of planning. An example is to assist a safety planner or engineer with tools that detect hazards, shifting the focus of the engineer on problem solving rather than problem finding. As an important note, humans should always be involved in the decision making process, in particular when it comes to safety. Therefore, the proposed framework brings together human experience, best practices, and legal requirements in a knowledge-base and applies BIM to safety.

21.5 Integrating BIM in the Safety Planning Process

As explained before, safety planning can be a tedious and time-consuming task that currently relies on many manual tasks. For large structures, for example, a high-rise building, such tasks are repetitive in nature. Floor plans that may look the same can consist of different drawings and the sections that are shown might be in several different building plans. As site conditions also change frequently, it is inadequate to analyze the construction project concerning safety issues only based on information/drawings that represent the final, built status. It therefore very essential to take project schedules and modifications into account. All such information is already an integrated part of BIM.

An experienced issue in safety hazard detection is the understanding of spatio-temporal relationship of work space and time. Many decision makers have yet to adapt using the full potential of three-dimensional (3D) and time-based visualization/simulation (4D) of information models. Education and training in handling BIM technology for experienced personnel is lacking as a new generation of BIM technology-savvy engineers is still growing. Thus it takes the spatial imagination of a safety engineer to study the coherent structure of a building. Such manual hazard analysis is generally time-consuming and can be an error-prone procedure. Since it is worthwhile to avoid a hazard at the design stage rather than waiting for controlling the hazard or simply protecting the workers during the construction stage (Manuele 2003), Ku and Mills (2010) discussed in their research the need for design-for-safety tools. One potential solution to fill the gap is to provide (manual) tools that assist a safety engineer in the task of modeling protective safety equipment in BIM (Sulankivi et al. 2013). BIM-based cost estimating, risk management, clash detection and 4D visualization have become established features to support construction management (Hartmann et al. 2012). Many other advantages are witnessed by using BIM for project planning. Even safety applications in BIM were suggested (Zhou et al. 2012). While digital building models are widely used in the AEC industries in design and construction, further investigation needs to been done for safety planning.

The limitations of current applications for safe design and planning of construction work ask for change towards: (1) hazards will be semi- and automatically detected near real-time to keep up with the dynamic construction progress, (2) existing software will assist humans to fit safety equipment to the identified hazards in a digital model, and (3) hazards, work space conflicts and prevention methods will be visualized in 4D (3D plus schedule) and communicated in form of multilingual work instructions and procedural instructions to all project stakeholders and process levels.

21.6 Safety and BIM in the Project Lifecycle

Safety, which overlaps with all project phases, is a generally accepted goal. The piecemeal strategy of separating the information flow of construction hazard prevention through concepts that are only shared among design personnel, construction workers, and operations and maintenance personnel is not benefiting safety on a project. While recent years have been showing an increased interest for automation in construction, novel concepts also emerge for the planning of preventive safety and health protection systems. BIM in conjunction with the use of mobile field devices, for example, has already shown a positive influence on project outcomes.

However, many of these concepts have not found entry in construction yet. Safe-BIM is a novel concept that leverages existent safety-relevant data and implements it in existing processes over a project's lifecycle (Fig. 21.4). It gives project stakeholders foremost early access and control over some of the following important tasks in construction safety:

- *Owner/clients:* standardizing its safety program(s); selection of construction companies, subcontractors, producers and suppliers on the basis of good safety records; investing in modern safety methods; early involvement and intervention at any time in order to avoid pre-known hazards.
- *Construction industry associations:* availability of up-to-date data, including statistics; creation of proactive policies; rule compliance; lower insurance premiums.
- *Construction companies:* effective employment protection methods that are actually implemented and controlled on construction sites; application of modern information and communication methods; monetary benefits.

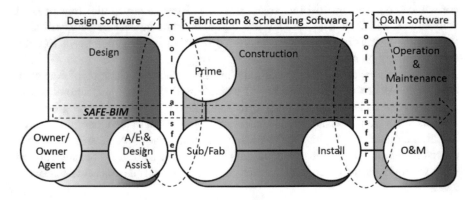

Fig. 21.4 Safe-BIM project lifecycle. (© J. Teizer, reprinted with permission)

- *Architects, engineers, facility manager:* influence of design guidelines on safe project execution and maintenance; make available and share safety expert knowledge in the entire project lifecycle; early coordination of owner, contractor, and facility manager.
- *Suppliers:* delivering safe and reliable products in the safety supply chain.

21.7 Safety Rule Checking in BIM

Existing safety rules, guidelines, and best practices can be used in conjunction with existing three-dimensional (3D) design and schedule information (4D) to formulate an automated safety rule checking system. The goal is to automatically identify hazards and eliminate these conditions before construction starts. While construction is underway, safety rule checking can be performed continuously. In addition, decision makers on a project are able to identify the locations of the hazards in a virtual 3D space and can, interactively or automatically, provide solutions and visualization of protective systems to mitigate the identified hazards.

Such a platform developed by Zhang et al. (2013) can function as a tool for providing easily accessible and understandable visualization of up-to-date progress on construction and safety over time. The indication of safety measures also provides the right quantities that helps understand the investment in safety. Based on the contractual arrangement, safety managers can start planning already at the front end of a project, while they can plan for safety conveniently throughout the construction phase.

The rule checking process is similar to spell checking. It enables all project stakeholders with early detection and proactive elimination of dangers, potentially well before a project enters the construction phase. Safety rule checking in BIM strengthens therefore existing Prevention through Design (PtD) concepts and enables personnel to interact with the workforce via jobsite hazard analysis report cards and visualization. Latter can finally leverage its full potential and provide personalized safety education and training specific to project- and schedule-related work environments, worker qualifications and age groups. Rule checking consists of the following procedures (Fig. 21.5):

1. *Rule interpretation:* The interpretation of safety rules from safety regulation or best practices (e.g., BG Bau or OSHA) is a logic-based mapping from human language to machine readable form. The name, type, and other properties in the rule can be analyzed and extracted from the written rule.
2. *Building model preparation:* A building model must be well constructed to include required objects, attributes, and relations used to carry out the rule checking. In addition, since the need of fall prevention equipment depends on the status of the construction work, a 4D model including the installation schedule/order of building assemblies is required.

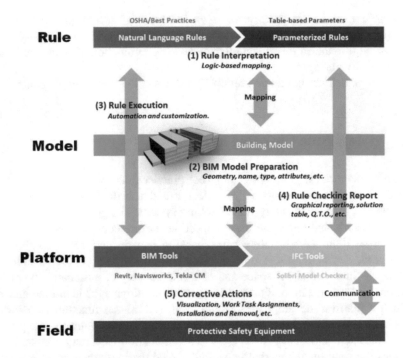

Fig. 21.5 Safety rule checking in BIM (Zhang et al. 2013). (© Elsevier, reprinted with permission)

3. *Rule execution:* The rule execution phase brings together the translated rule sets with prepared building model. The rule may apply to thousands of condition cases, requiring combinatorial tracking. The rule execution has two steps: (a) automatically check the model to identify unsafe conditions, and (b) identify and apply candidate solution actions to correct the unsafe condition. This last step can be variously controlled, manual intervention for each condition, to completely automatically resolve through the application of rules to determine the best correction.

4. *Rule checking reporting:* The checking results can be reported in multiple forms: (a) visualization of applied safety protective equipment in the model, and (b) Excel-based reports of unsafe conditions and the corrective actions taken. In addition, quantity-take-off information for resource leveling of safety equipment and importing the generated information into project schedules is also possible. The report can then be integrated into Job Hazard Analysis (JHA) processes as shown by Zhang et al. (2015b).

5. *Safety correction:* The primary corrective actions that will take place on construction sites are to schedule and track logistical movements of protective safety material. Based on the rule checking reports, an exemplary implementation in the field would report via a commercial BIM software platform and assign work tasks for the installation and removal of safety equipment on a building floor.

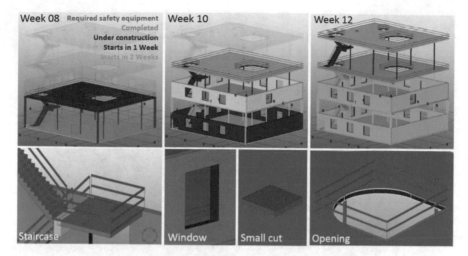

Fig. 21.6 Safety rule checking automatically detects and models required fall prevention methods for slab edges, cuts, and openings. (© J. Teizer, reprinted with permission)

Once the building information model has been well constructed and the connections between the model objects and the schedule have been established, digital rules related to fall hazards, for example, are applied for detecting each one of the hazards. As the results show in Fig. 21.6, the building model visualizes and links required safety equipment and ties it to a construction schedule. This information can be used in weekly project meetings and allows human decision makers to implement or modify the solution, if needed.

21.8 Real World Applications of Safety Rule Checking in BIM

Building information modeling (BIM) has been taking on a greater role in the industry, moving beyond clash detection and coordination to a valued resource in the field for real-time jobsite safety monitoring. Field tests of the safety rule checking had the goal to validate the approach. The case studies extended BIM to include several important issues (see some selected examples in Fig. 21.7):

- a graphical software user interface that allows humans to steer the process of the rule checking, for example, by defining the rules and overriding automated results,
- Job Hazard Analysis (JHA) report cards based on a safety ontology visualize the hazards and provide multi-lingual instructions to work crews in the field work or for education and/or training courses,

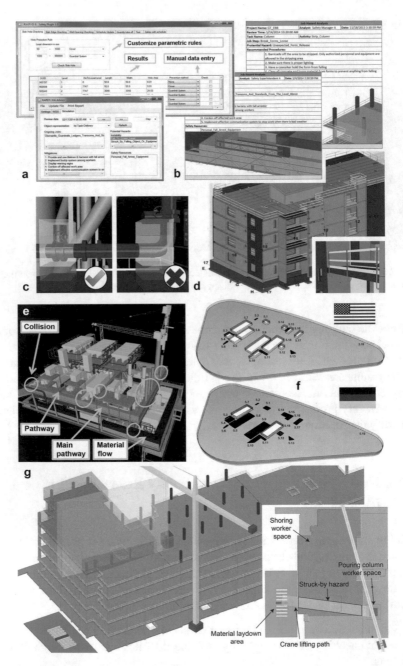

Fig. 21.7 Safety rule checking in BIM: (**a**) Software user interface, (**b**) Job Hazard Analysis (JHA), (**c**) ergonomics, (**d**) safety equipment, (**e**) access and obstructions, (**f**) comparison of international fall prevention regulations, and (**g**) simulation of logistics, swing and work spaces. (Zhang et al. 2013, 2015a,b; Melzner et al. 2013; Kim et al. 2014; Wang et al. 2015). (© Elsevier, reprinted with permission)

- checking for ergonomically correct positions of valve and turning wheel heights in a downstream oil refinery to prevent workers from having long term illnesses,
- detection of fall-related hazards such as openings and leading edges for a multi-story apartment building along with modeling and scheduling the installation and removal of safety equipment as part of the building sequence (4D),
- clash detection of physical installations and obstructed walking spaces in an off-shore oil platform,
- comparison of the rule checking results for an identical building floor based on two different international fall prevention regulations, and
- 4D work packaging and site layout sequence planning that detects and adjusts crane load paths over pedestrian work crew spaces.

These results demonstrate that the developed rule checking approach was successfully integrated into best of class safety engineering and management systems. For the use case fall protection, it has become possible to inform construction safety engineers and managers by reporting where, when, what, and why safety measures are needed.

21.9 Return on Investment

The results from a survey among 263 planning and construction firms in the US highlight the benefits from very good safety programs: (1) smaller number of accidents, (2) improved reputation, and (3) increased yield or return (McGraw Hill 2013). The survey also showed that the bigger the firm the higher the investment in innovation including safety was. The study stressed more advantages which are connected to applying excellent labor safety programs:

- 50% of all surveyed companies reported a decrease in the overall construction time,
- 73% of all observed projects reached cost savings of at least 1%, while 24% of all projects with a very good safety program saved more than 5% of the project costs, and
- 73% of projects improved their profits by more than 1%, while 20% of all projects reached an improvement of more than 5%.

Participating companies mentioned further benefits: (a) reputation, (b) improvement in the acquisition of new projects, and (c) reached an overall higher quality in the execution of project. These and more results to the survey are illustrated in Fig. 21.8.

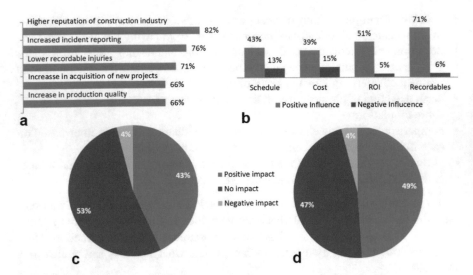

Fig. 21.8 (**a**) Advantages of an excellent safety program (% of firms that reported a positive impact), (**b**) financial advantages observed by applying an excellent safety program, (**c**) reported impact of BIM on work site safety and health, and (**d**) impact of prefabrication and modularization on safety and health. (After McGraw Hill 2013)

21.10 The Future Role of BIM in Safety and Health Planning

Only a few research activities worldwide are focusing on the use of BIM for construction safety and health. Integration in commercial BIM products are far from reach. Particular issues seem to hinder the integration of Safe-BIM in commercial applications:

- *Quality of models, norms and standards:* Although BIM sees widespread uses in construction, most applications focus on planning. Most models today lack standardization, use proprietary formats, have low detail, and are not kept up to date during the construction phase.
- *Investment vs. costs:* Since the construction industry is a lagging industry, general thoughts on the return on investment may favor current over transformative approaches. Investment in safety though might require regulative steps.
- *Lean supply chains:* In order for processes related BIM to work effectively in con-junction with construction safety and health applications, all stakeholders need to buy in. Safe-BIM becomes efficient, if the owner commits resources to it, planners design out hazards at the front end, and contractors, subcontractors as well as safety equipment suppliers advance workflow management by collaborating on an effective supply chain that mitigates project risk.
- *Lagging vs. leading indicators:* The goal to predict and proactively eliminate hazards before injuries and fatalities occur needs to be set.

- *Knowledgeable workforce:* The existing workforce is not skilled to execute transformative processes. A technology-savvy workforce that is familiar with BIM, mobile and sensing technologies has to be educated and trained before a widespread application among all stakeholders becomes feasible.
- *Variability of methods and technology on processes:* The application of safety rule checking, for example, might work well for parametric rules. Though intelligent concepts must be developed for other safety and health topics, such as risk originating from human factors.
- *Explore related domains:* While safety is an important topic, the impact it has on lean production and productivity should be explored. Probably, lean and injury-free work environments need to explore the benefits that real-time remote data sensing and intelligent data processing provide (Cheng and Teizer 2010, 2014; Teizer et al. 2013; Wang et al. 2015; Golovina et al. 2016).

21.11 Summary

Despite existing rules and regulations, safety remains a significant problem in construction. Proposed is an innovative BIM-based platform that allows practitioners to check, among others, for fall-related hazards in building construction. The novel method of detection and prevention these hazards early on in BIM and before construction starts has been successfully implemented in several case studies. The developed computational algorithm are able to detect the location of potential fall hazards in concrete slabs and leading edges, and provide installation guidelines (e.g., bill of quantities, construction schedules) of the corresponding fall protection equipment that solve the identified hazards virtually in a BIM. Furthermore, the results show the effectiveness of the proposed approach in visualizing the fall hazards for work site specific education and training.

Although the automatically generated fall prevention plan and job hazard analysis reports must always be checked by a safety specialist, it allows adjustment if other safety guidelines or best practices need to be followed. Future work might be directed towards commercialization efforts as well as transformation of existing safety industry best practices. As BIM-based safety planning might become part of the standard building construction planning process, early involvement can also increase the safety understanding and communication among all project stakeholders. Requirements for using a formal standardized process and the generation of high quality models that are frequently updated while construction is underway must be set before the developed approach may yield acceptable rates of return.

References

Bunn, T., Slavova, S., & Bathke, A. (2007). Data linkage of inpatient hospitalization and workers' claims data sets to characterize occupational falls. *Journal of the Kentucky Medical Association, 105*(7), 313–320.

Cheng, T., & Teizer, J. (2010). Real-time data collection and visualization technology in construction. In *Proceedings Construction Research Congress*, Banff, Calgary (pp. 339–348).

Cheng, T., & Teizer, J. (2014). Modeling tower crane operator visibility to minimize the risk of limited situational awareness. *Computing in Civil Engineering, 28*(3), 04014004.

Egan, J. (1998). *Rethinking construction*. Construction Task Force Report for Department of the Environment, Transport and the Regions, HMSO, London.

Frijters, A. C. P., & Swuste, P. H. J. J. (2008). Safety assessment in design and preparation phase. *Safety Science, 46*(2), 272–281.

Gambatese, J., & Hinze, J. (1999). Addressing construction worker safety in the design phase: Designing for construction worker safety. *Automation in Construction, 8*(6), 643–649.

Gambatese, J. A., Behm, M., & Rajendran, S. (2009). Design's role in construction accident causality and prevention: Perspectives from an expert panel. *Safety Science, 46*(4), 675–691.

Garrett, J. W., & Teizer, J. (2009). Human factors analysis classification system relating to human error awareness taxonomy in construction safety. *ASCE Journal of Construction Engineering and Management, 135*(8), 754–763.

Gillen, M., Faucett, J. A., Beaumont, J. J., & McLoughlin, E. (1997). Injury severity associated with nonfatal construction falls. *American Journal of Industrial Medicine, 32*(6), 647–655.

Golovina, O., Teizer, J., & Pradhananga, N. (2016). Heat map generation for predictive safety planning: Preventing struck-by and near miss interactions between workers-on-foot and construction equipment. *Automation in Construction, 71*, 99–115.

Hartmann, T., van Meerveld, H., Vossebeld, N., & Adriaanse, A. (2012). Aligning building information model tools and construction management methods. *Automation in Construction, 22*, 605–613.

Hinze, J. W., & Teizer, J. (2011). Visibility-related fatalities related to construction equipment. *Journal of Safety Science, 49*(5), 709–718.

Hinze, J. W., & Wiegand, F. (1992). Role of designers in construction worker safety. *Journal of Construction Engineering and Management, 118*(4), 677–684.

Huang, X., & Hinze, J. (2003). Analysis of construction worker fall accidents. *Journal of Construction Engineering, and Management, 129*(3), 262–271.

Kim, K., & Teizer, J. (2014). Automatic design and planning of scaffolding systems using building information modeling. *Advanced Engineering Informatics, 28*, 66–80.

Ku, K., & Mills, T. (2010). Research needs for building information modeling for construction safety. In *International Proceedings of Associated Schools of Construction 45nd Annual Conference*, Boston.

Manuele, F. A. (2003). *On the practice of safety*. Hoboken: Wiley-Interscience.

McGraw Hill Construction. (2013). *Safety management in the construction industry: Identifying risks and reducing accidents to improve site productivity and project ROI*, SmartMarket Report, New York.

Melzner, J., Zhang, S., Teizer, J., & Bargstädt, H.-J. (2013). A case study on automated safety compliance checking to assist fall protection design and planning in building information models. *Journal of Construction Management and Economics, 31*(6), 661–674.

Qi, J., Issa, R. R., Hinze, J., & Olbina, S. (2011). Integration of safety in design through the use of building information modeling. In *Proceedings of the 2011 ASCE International Work-shop on Computing in, Civil Engineering*, 19–22 June, Miami (pp. 698–705).

Sulankivi, K., Zhang, S., Teizer, J., Eastman, C. M., Kiviniemi, M., Romo, I., & Granholm, L. (2013). Utilization of BIM-based automated safety checking in construction planning. In *Proceedings of the 19th International CIB World Building Congress*, Brisbane Australia (pp. 5–9).

Teizer, J., Cheng, T., & Fang, Y. (2013). Location tracking and data visualization technology to advance construction Ironworkers' education and training in safety and productivity. *Automation in Construction, 35*, 53–68.

U.S. Department of Labor, Bureau of Labor Statistics. (2011). *Census of fatal occupational injuries.* Retrieved from http://www.bls.gov/iif/oshcfoi1.htm (Accessed Jan 2018).

Wang, J., Zhang, S., & Teizer, J. (2015). Geotechnical and safety protective equipment planning using range point cloud data and rule checking in building information modeling. *Automation in Construction, 49*, 250–261.

Zhang, S., Teizer, J., Lee, J.-K., Eastman, C., & Venugopal, M. (2013). Building information modeling (BIM) and safety: Automatic safety checking of construction models and schedules. *Automation in Construction, 29*, 183–195.

Zhang, S., Sulankivi, K., Kiviniemi, M., Romo, I., Eastman, C. M., & Teizer, J. (2015a). BIM-based fall hazard identification and prevention in construction safety planning. *Journal of Safety Science, 72*, 31–45.

Zhang, S., Boukamp, F., & Teizer, J. (2015b). Ontology-based semantic modeling of construction safety knowledge: Towards automated safety planning for job hazard analysis (JHA). *Automation in Construction, 52*, 29–41.

Zhou, W., Whyte, J., & Sacks, R. (2012). Construction safety and digital design: A review. *Automation in Construction, 22*, 102–111.

Chapter 22
BIM-Based Code Compliance Checking

Cornelius Preidel and André Borrmann (iD)

Abstract In the construction industry, a large number of codes and guidelines define technical specifications and standardized requirements to ensure a building's structural stability, accessibility, and energy efficiency, among others. Today, checking the compliance with the applicable guidelines is an iterative, manual process which is based to a large extent on 2D drawings. In consequence, this process is cumbersome, time-consuming and error-prone. With the increasing adoption of digital methods in the construction industry, most importantly Building Information Modeling (BIM), new technologies are available to improve and partially automate this process. In a BIM-based construction project, digital models that include 3D geometric as well as semantic information comprehensively describe the building to be erected across the different involved disciplines. This rich information provides an excellent basis for automating the code compliance checking process. With Automated Code Compliance Checking, not only a higher degree of compliance with the different regulations can be achieved, but also a significant reduction of effort is possible. The chapter first discusses the major challenges of Automated Code Compliance Checking. Subsequently, representative available software solutions are presented and current research activities are discussed. Finally, an outlook for the development of code compliance checking in the construction industry is given.

22.1 Introduction

In the construction industry, a large number of codes and guidelines define technical specifications and standardized requirements to ensure a building's structural stability, accessibility, and energy efficiency, among others. There is a large variety of regulations covering different life-cycle phases and disciplines within a construction project. Depending on the respective international, national or regional legislation,

C. Preidel (✉) · A. Borrmann
Chair of Computational Modeling and Simulation, Technical University of Munich, München, Germany
e-mail: cornelius.preidel@tum.de; andre.borrmann@tum.de

© Springer International Publishing AG, part of Springer Nature 2018
A. Borrmann et al. (eds.), *Building Information Modeling*,
https://doi.org/10.1007/978-3-319-92862-3_22

367

The access route for pedestrians / wheelchair users shall not be steeper than 1:20. For distances of less than 3 metres, it may be steeper, but not more than 1:12. The access route shall have clear width of a minimum of 1,8 m and obstacles shall be placed so that they do not reduce that width. Maximum cross fall shall be 2 %. The access route shall have a horizontal landing at the start and end of the incline, plus a horizontal landing for every 0,6 m of incline. The landing shall be a minimum of 1,6 m deep. Minimum clear height shall be 2,25 m for the full width of the defined walking zone of the entire access route including crossing points.

Fig. 22.1 Selection of usual representation styles of requirements within guidelines left – Extract of a guideline for accessibility, Norwegian Standard NS 11001-1 (2009) right – Restrictions for the placement of openings in exterior walls for fire safety, UK Fire Code Part B4 (U. K. Building Regulations 2007)

the regulations must not only be followed by the architects and planning consultants in the course their design activities, but also be checked by the building authority officers when granting the building permission (Hjelseth 2015).

In general, a code or guideline describes a certain discipline-related application context and requests the compliance with a number constraints. These conditions and constraints can be represented in different ways, ranging from running text over graphical representations to parameter tables. In Fig. 22.1, a selection of different ways for representing conditions and requirements is depicted. So far, the checking of the building design for compliance with the guidelines is an iterative and largely manual process, characterized by high effort, costs and error-rates. In the conventional procedure, 2D drawings are checked manually by the building authority for their compliance with the applicable guidelines and codes. Whenever a change in the building design comes into effect, the checks for the affected elements have to be repeated. In consequence, the manual checking process demands not only an advanced level of knowledge and experience regarding the appropriate guidelines but also a high degree of skill and care of the responsible planner.

With the introduction of digital methods, in particular *Building Information Modeling (BIM)*, and the development of data standards for digital models in the construction industry (e.g., IFC), new tools become available which provide a very suitable basis for improving and optimizing of this process (Nisbet et al. 2009; Hjelseth 2015). During the different phases of a BIM-based construction project, models are created by the various stakeholders resulting in a comprehensive digital representation of the building. It is straight-forward to use the available high-level

information for a semi or even full automation of the checking processes, resulting in Automated Code Compliance Checking.

22.2 Challenges of Automated Code Compliance Checking

In order to discuss the major challenges of Automated Code Compliance Checking the common structure and basic components of the process will be presented first. Eastman et al. (2009b) divide the overall process into four components: Translation of the Rules in a Machine-Readable Language, Preparation of the Building Model Data, Execution of the Checking Process and, finally, the Preparation and Representation of the Checking Results. The resulting structure is shown in Fig. 22.2.

The translation of the contents of the codes and guidelines into a machine-readable language represents the starting point and is therefore the core task of an Automated Code Compliance Checking. Two essentially different approaches can be distinguished here:

The significantly easier way of translation is based on the direct transfer of the checking process in hard-coded program routines or methods. This means that the digitization of the contents of a code or guideline focuses on the definition of machine-readable algorithms, which are usually hidden from the user. Therefore, the readability of the translated rules for the user is limited and an involvement of a user in the encoding process is disregarded. As a result, the execution of the checking process is a hidden procedure, in which the user does not have an insight. Also, extensions and modifications are only possible by incorporating the software vendor. Such a process, which makes only the ingoing and outgoing information visible, but not the processing procedure itself, is called the *Black-Box* method (see Fig. 22.3) according to the general system theory (Von Bertalanffy 1972). The major advantage of this method is the comparatively low error rate of the overall process because of the closedness and the direct access to the internal data structures of the code checking system.

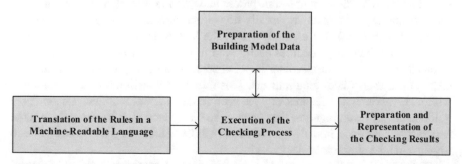

Fig. 22.2 Common Structure of an Automated Code Compliance Checking, inspired by Eastman et al. (2009b)

Fig. 22.3 Schematic
Representation of a
Black-Box and
White-Box-Method

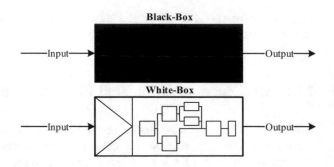

In contrast to these hidden procedures, *White-Box* methods make the internal
processing steps visible and therefore comprehensible for the user. To achieve this
transparency, the contents of the translated guideline or code must be readable not
only by the machine but also by the user. The rules must be translated based on a
code representation system (a language), which is a system of symbols and rules.
These elements can be used for the sufficient description of objects, methods and
relationships. So the major target is not only to cover all kinds of information
a code or guideline could contain, but also to enable the user to understand and
retrace information at any time and follow the progress step of the checking
procedure. Although the development and implementation of such a system requires
significantly more effort compared to the closed checking approach, it has major
advantages for the execution of a checking task.

The transparency solves one of the major problems within the automation of
processes: Despite the growing degree of digitization and automation in the con-
struction industry, the planning engineers or the regulatory authorities, respectively,
remain in charge of the outcome of each process step. This responsibility cannot be
handed over to a machine or software application due to legal restrictions. Results
of an automated process need to be treated with caution and in case of doubt must
be checked manually. It is common practice in the *AEC* industry to check results
periodically, e.g., by a manual calculation or comparison with rules of thumb. Such
checks for plausibility must also be enabled within an automated framework for
code checking, but this requires transparent and observable single processing steps.
Since planning consultants are usually non-programmers, these checks cannot be
combined with *Black-Box* methods due to the lack of transparency. According to
Gross (1996), hidden procedures easily lead to a lack of trust of the results. The
White-Box approach, on the other hand, represents an acceptable compromise in
order to fulfill the major requirements. This raises the question if a full automation
without involvement or feedback by the user makes sense at all. Since semantics in
guidelines may be ambiguous, they need to be interpreted by a human, who has the
necessary experience, knowledge and responsibility. Accordingly, it is advisable to
implement a semi-automated approach.

After translating the contents of a guideline into a machine-readable language,
an interpreting instance has to execute the directives. This processing is closely
related to the contents of the building information model, since information must

Fig. 22.4 Geometric representation of model subsets for different purposes; Left: Fire Escape Routing; Middle: Accessibility & Circulation; Right: Fire-Safety related building components; inspired by Solihin & Eastman (2015)

be accessed, retrieved or derived. The accuracy, correctness and consistency of the building model is a basic prerequisite for the following checking process and therefore a basic condition in order to produce resilient results (Kulusjärvi 2012). Although there is a continuous development of non-proprietary and open data standards, especially the IFC standard, Beetz et al. (2009) point out that a complete correctness of the data standard can only be achieved by providing a formal rigid data structure. Therefore, the generally valid formulation of a checking process for a specific data standard is quite difficult and can only be realized by a preprocessing step, which checks and prepares the data model. The correctness of building model information is outlined in the following Sect. 22.3.

Since a rule usually applies only to a certain subset of data, it is recommended to create and prepare this subset before the rule is checked (Solihin & Eastman 2015). In Fig. 22.4 different subsets and derivations of a model for different purposes are shown.

At this point, there is a high demand to implement solutions which enable quality and consistency checks for preparing the models for the subsequent Code Compliance Checking.

As a last step, the results of a checking process must be reported so that the responsible person can understand the intended meaning of the detected problem to be able to initiate the correct post-process, i.e. solve the detected noncompliance. Therefore, the detected problems should be presented as a written report or, better, digitally communicated to the responsible person, e.g. using the *BIM Collaboration Format (BCF)* (buildingSMART 2016a) (see Chap. 14).

22.3 Formal and Content-Related Correctness of Building Models

As described in Sect. 22.2 the results of a checking process are highly dependent on the correctness and availability of the information in the underlying BIM model. Since a process cannot produce correct results based on incorrect information, this

correctness of the digital building model is an essential prerequisite for following code checking processes. The necessity of corresponding checking processes were introduced by various BIM guidelines, such as the *Singapore BIM Guideline* (BCA Singapore 2013), *COBIM* (Kulusjärvi 2012) or the PAS 1192-2 (2013). According to these guidelines all kind of models have to pass quality gates at certain milestones (e.g., when they are exchanged or submitted) in order to preserve the overall quality.

Although the overall correctness of a model is often subsumed under the general term data quality, it can be divided in two parts: the formal part and the content-related correctness of a BIM model.

First of all, the information provided by a BIM model must fulfill formal criteria, which means that the information follows defined "grammar rules." Usually these rules are defined by the syntax of the data model, e.g., IFC, which is used for the representation of information. These requirements can be extended by further project-wide requirements, which the project participants contractually agree on in the beginning of a building project. Such requirements can contain individual constraints which information should fulfill in order that all the stakeholders have a unified interpretation of the contents of a BIM model, such that the information is interpreted in the same way. Templates for project-wide requirements can be found in several guidelines, such as in the *GSA BIM Guide* (GSA 2007). Usually these requirements are written down in modeling requirements and provided as part of the *BIM Execution Plan*. Since formal criteria are straight-forward rules (e.g., checking the availability or the data type of certain attributes), these conditions are easy to check. Unlike the formal criteria, the content-related criteria are significantly more complicated to check, since they require the interpretation of the information. Content-related checks include, e.g., the compliance with reasonable boundaries and the consistency of the provided information.

Next to the correctness of single BIM models, the validity of multiple composed models must also be taken into account. According to the *Federated Model Approach*, each stakeholder, who is responsible for discipline-specific model contents according to the requirement specifications, has to submit a BIM model when reaching specific milestones (BCA Singapore 2013). These submitted models result in a composed overall model, which finally describes a comprehensive description of the building to be constructed. Required information for model checking often refers to different discipline models and so not only the quality of a single model, but the quality of the overall model must be taken into account. This applies particularly to intersecting building components, redundant or contradictory information.

22.4 Selected Software Products

In the past decades, a number of commercial software tools for Automated Code Compliance Checking have been introduced. A selection of these products is depicted in the chronological diagram in Fig. 22.5 next to some of the research approaches which will be discussed in Sect. 22.5. The number of available

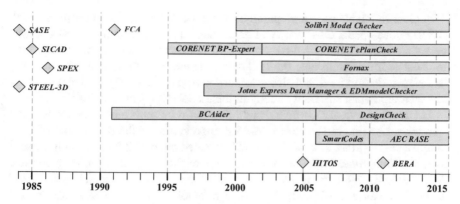

Fig. 22.5 Chronology of selected research approaches as well as commercial products, which focus on the Automated Code Compliance Checking, inspired by Dimyadi and Amor (2013)

approaches shows the continuously growing significance of this application area during the last years.

In the following subsections, selected software solutions and applications for Automated Code Compliance Checking will be discussed.

22.4.1 CORENET

In 1995 the *Building Construction Authority (BCA)* in Singapore started the platform *CORENET* as a first representative of a common national submission platform. The basic intention of this platform is to collect all kinds of information related to a construction project and optimize the processes with the help of digital methods and tools. One of these tools is the application *CORENET BP-Expert*, which aims to check the compliance of digital 2D-based drawings with regulations regarding accessibility and fire safety. In 1998 *CORENET* was enabled to work with the IFC standard and therefore extended by 3D compliance checking. The current version of the tool was first published in 2002 as *CORENET e-Plan Check* and provides a code compliance checking feature of a digital building model regarding a large extent of the Singaporean regulations in terms of building control, accessibility, fire safety as well as environmental healthcare (Dimyadi and Amor 2013).

The checking processes within *CORENET* are based on hard-coded routines and therefore the algorithms, process steps and methods are not transparent for the user. The overall process is structured into three basic phases. In a first step, the model information is checked for availability of the information in the required form to be processed. Subsequently, in a second step, the model is searched for the missing information in underlying information layers. If the missing information cannot be found here, it is created in a last step with the help of information derivation (Eastman et al. 2009b).

In order to enable such a preparation of the BIM model, the company *novaCI-TYNETS* developed a *C++* library of hard-coded methods, called *FORNAX*. These methods contain routines which are able to represent semantic objects and map this kind of information onto the IFC data schema. With these methods, not only data preparation routines, but also code checking processes may be defined. These defined routines can be stored directly in the model (Eastman et al. 2009b).

The development of *CORENET* and *FORNAX* represents one of the earliest, but even nowadays one of the most advanced approaches for the automation of code compliance checking. In 2008 *CORENET* covered almost 92% of the Singaporean Guideline *Integrated Building Plan* and 77% of the *Integrated Building Service*. The *CORENET* platform is used by approximately 2500 companies in the AEC sector (Eastman et al. 2009b). The basic principle of the *FORNAX* objects and methods provided also the basis for several other approaches aimed at the digital representation of code checking processes, such as discussed by Xu, Solihin and Huang (2001).

22.4.2 Jotne Express Data Manager

Besides the developments in Singapore, in 1998 the Norwegian technology company Jotne EPM Technology (2016) published the collaboration platform *Express Data Manager (EDM)*. This platform is built upon an object-oriented database, which makes direct use of the EXPRESS data modeling language (ISO 10303–11) – the basis of the IFC data model. The platform is intended to manage product model data of various engineering domains but is especially focused on the AEC industry.

The data modeling language *EXPRESS* is used within the *EDM* to achieve a high degree of flexibility for the handling of the information in the data models, since it enables the user to perform queries and derivations of information. *EXPRESS* is a part of the *Standard for the exchange of product model data* (STEP, ISO 10303) and provides EDM platform compatibility with a large number of different data model formats (cf. Chap. 5). Since this data model language is also the base for the IFC data modeling, EDM is particularly compatible with this format. For the conversion of the data, EDM provides an integrated conversion tool, the *EDMmodelConverter*. EDM is often used as a basis for the development of import/export routines of third-party applications (Wix and Espedokken 2004).

For model checking, *EDM* provides the *EDMmodelChecker* tool which can be used for the definition and formulation of rules. Rules and guidelines must be translated into *EXPRESS* checking routines and can be applied afterwards on BIM models. Since the formulation of these processes with the data modeling language demands significant programming skills, it is only of limited suitability for non-programmers, such as architects or engineers.

22.4.3 BIM Assure

BIM Assure is an online platform for model checking and was released by the company *Invicara* in 2016. This platform is one of the first representatives of an online checking system, but marks a general trend in the construction industry toward increasing adoption of cloud-based systems. Currently, several software vendors develop solutions for managing building models in a Common Data Environment (CDE) according to the British specification PAS 1192-2 (2013). Since model checking is an important step of the CDE process, which affects all discipline models and must be performed frequently, a cloud-based solution seems to be a reasonable approach.

The *BIM Assure* platform retrieves the required model information via an add-in plugin for Autodesk Revit, which means that it currently works only for Revit models. Apart from a basic project and user management, *BIM Assure* also provides checking functionalities as a main feature. As a first step, all retrieved information from the Revit model is "normalized", which means that the information is categorized according to a library maintained by *Invicara*. Elements, which could not be detected, and therefore not categorized, can be adjusted manually by a custom mapping. For the actual checking, the user can compose a specific checking process by choosing analysis templates, which can be adjusted by a number of parameters. Detected non-geometric problems, e.g., wrong attributes, can be immediately fixed within the BIM Assure environment.

Even if *BIM Assure* does not provide as rich functionalities as comparable desktop applications so far, the software represents a first commercial approach for taking the model checking process to the cloud. Since the information of the BIM model as well as the definition of the check routines are stored online, the execution of the rules can be conducted without specific local hard- or software. The execution of the checks can even be carried out automatically and become part of an automated workflow.

22.4.4 Solibri Model Checker

The *Solibri Model Checker (SMC)* is a software system for BIM-based model quality and code checking, which was published by the Finnish company Solibri (2016) in 2000. All processes within this application are based on information contained in IFC models, which themselves are mapped onto an internal data model. Although the IFC format is standardized, the available BIM authoring tools often export IFC data in a slightly individual way. Therefore, SMC's data mapping is based on hard-coded routines adjusted to the individual export mechanisms of the authoring tools. In this manner, SMC is able to read and correctly interpret IFC files exported from a wide range of BIM authoring tools.

In order to harmonize and bring the data of different discipline models and authoring tools together, the SMC makes extensive use of a classification approach. A classification represents a categorization of building components based on specific information found in the data model. With this classification mechanism, information from different building models can not only be filtered but also prepared for the following checking process.

The core of the SMC's code compliance checking routines is the Ruleset Manager, which provides a basic library of 42 single rule templates. Such a rule template represents a hard-coded standard checking procedure, which can be adjusted by a limited number of given parameters. These rule templates can be composed or adjusted by the user regarding his individual requirements. In order to exchange and share such defined rules, the rule composition can be stored as rule sets. As an example, the interface for adjusting a rule for checking intersections between defined architectural building components is shown in Fig. 22.6.

However, since the composition of such rules demands not only deep knowledge regarding the rules themselves but also expertise in data modeling and IFC structures, this feature is mostly used by expert users and not the planning consultants themselves. Large parts of the user interface of SMC are based on a line-by-line composition of requirements and adjustments, which can be very complicated for non-expert users. Therefore, most of the users currently use the predefined rules provided by SMC and focus on basic architectural checks, such as the completeness of information or the intersection of building components (Fig. 22.7). More specific rulesets like COBie compliance, ADA/ABA accessibility or fire escape routing are available as fee-based extensions.

Since SMC focuses on the quality check of building model information, it is not applicable for modifying and writing IFC data. However, results of checking routines may be exported and published as PDF or BCF reports.

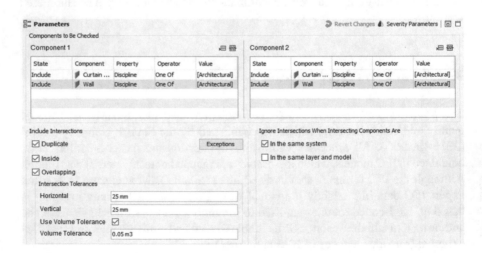

Fig. 22.6 Interface for adjusting a rule template in the SMC (Solibri 2016)

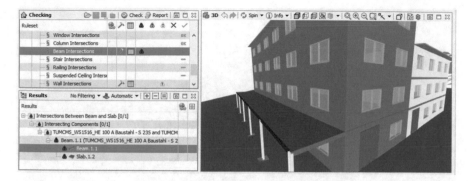

Fig. 22.7 User interface of the Solibri Model Checker (Solibri 2016)

For specific applications, *Solibri* provides an Application Programming Interface (API), which can be used for the composition as well as definition of rules, but is not publicly available. Based on this API and in close cooperation with the Georgia Institute of Technology, the *Design Assessment Tool* was developed, which can be used for checking requirements by the U.S. General Services Administration for courthouses. These requirements are defined by the U.S. Courts Design Guide, a guideline that includes spacing, safety, environmental as well as building service requirements (Eastman 2009a).

22.5 Current Research

Given the high potential benefits of automated code compliance checking on the one hand, and the numerous challenges involved on the other hand, code checking is an intensively investigated research subject (Navari 2018). Among the most challenging issues is the transformation of human-readable text into computer-interpretable code. A significant number of current research projects follow the white-box approach by defining a proprietary computer language that is close to the domain concepts and comparatively easy to use and thus allows domain experts to manually encode the regulations into a computer-processable representation.

A representative of these research approaches is the *SMARTCodes* project, which was initiated in 2006 by the *International Code Council (ICC)*. The *SMARTCodes* represent in principle a data exchange protocol used for standardizing and unifying common elements of a regulation. The defined elements are supposed to be provided in a library. Although the developments within this research project were discontinued by the ICC in 2010 due to lack of funding, the approach was continuously investigated by the companies AEC3 and DigitalAlchemy (Dimyadi and Amor 2013).

For the formalization of guidelines, the *SMARTCodes* uses the *RASE* syntax. With this tool, all elements of a regulation rule can be categorized into the four

<R>Standard NS 11001-1, Clause: 5.2 Dimensioning an <a>access route to a building

<R> The <a>access route for <s>pedestrians</s> <s>wheelchair users</s> shall <r>not be steeper than 1:20 </r>. <E>For <a>distances of less than 3 metres, it may be steeper, but <r>not more than 1:12</r>.</E> </R>
<R>The <a>access route shall have <r>clear width of a minimum of 1,8 m</r> and <r>obstacles shall be placed so that they do not reduce that width </r>.<r>Maximum cross fall shall be 2 %.</r> </R>
<R>The <a>access route shall have <r>a horizontal landing at the start and end of the in-cline<r>, plus <r>a horizontal landing for every 0,6 m of incline</r>. <r>The landing shall be a minimum of 1,6 m deep.</r> </R>
<R> <r>Minimum clear height shall be 2,25 m </r>for the full width of the defined walking zone of the entire <a>access route including crossing points. </R> </R>

Fig. 22.8 Formalization of the Norwegian code NS 11001–1:2009 according to the RASE syntax (Hjelseth and Nisbet 2011)

different classes *Requirement, Applicability, Select and Exceptions*. In this way, even complex contents of codes and guidelines may be formalized and divided into these basic components. The result of this categorization can be illustrated and marked within the regulations' running text (Hjelseth and Nisbet 2011). It must be noted, however, that this markup procedure can only be seen as a preprocessing step as the result cannot be directly interpreted by the computer. An exemplary application of the markup language on a regulatory text is shown in Fig. 22.8.

Another language-based approach is the *Building Environment Rule and Analysis (BERA) Language* (Lee 2011). It provides a much more powerful tool than RASE, as it is able to provide not only a descriptive categorization but an algorithmic implementation of regulatory rules. On the one hand, BERA is supposed to meet the high requirements regarding the handling of building model data and, on the other hand, to enable the formulation of rules and guidelines. The design of *BERA* is inspired by popular languages known from data base management and handling. A special feature of *BERA* is the relatively easy readability by humans and the direct access to the contents of a building information model.

To automate the translation of human-readable regulations into computer code, a number of research projects have investigated the application of natural-language processing (NLP) (Zhang and El-Gohary 2015; Salama and El-Gohary 2016; Zhang and El-Gohary 2016; Uhm et al. 2015; Lee et al. 2016). Although the results seem to be promising, it is important to note that comparatively straight-forward and well-defined regulations have been used for the conducted cases studies.

An approach which aims for an increased involvement of the domain experts in the translation process is the development of a *Visual Programming Language (VPL)* for Code Checking. The basic idea of this approach is that a checking procedure can be represented as a visual, graph-based flow of information. For the definition of this graphical representation, a *VPL* uses visual instead of textual elements, so that also non-programmers like engineers and architects can understand the intended meaning. In this way, the visualization of the process is used as a visual assistance

and supporting system for the user, who is able to adjust the checking procedure according to his requirements (Preidel and Borrmann 2015, 2016).

An entirely different approach is to enable the machine-readability of codes and guidelines in general. This requires that all guideline documents maintained by the various international, national and regional boards must be rewritten, so that they are readable for humans as well as machines. Usually today's codes and guidelines are not written with the intention to be translated into a machine-readable language. Although there are no specific approaches for the guidelines in the construction industry, there are available mechanisms to enable such a two-way readability, e.g. the programming language *Inform* (Graham 2005). Though the benefits of a formally defined and computer-processable regulations are clear, this shift will require extensive resources and it will thus take a number of years until such solutions are conceivable.

To cover the various approaches undertaken so far, buildingSMART (2016b) has initiated the *Regulatory Room*, which aims to provide a platform for an open discussion for regulators, researchers, developers as well as end users. In this way, the platform strives for an open BIM-based approach, which will lead to common mechanisms, templates or definitions supporting building regulations.

22.6 Summary

In the AEC domain, there exists a large number of regulations and guidelines which must be fulfilled by the building design. Today, the checking process is conducted mostly manually in a laborious and error-prone process. BIM provides an excellent basis for automating Code Compliance Checking as the digital building model provides in principle the required geometric and semantic information. In many cases, however, a pre-processing of the BIM model is required, as information needed for checking some regulations (e.g. excavation routes) are not directly provided by the model and must be computed or derived beforehand. The bigger challenge, however, lies in the transformation of the regulatory texts, which are written to be understood by humans, into computer-processable formats. In many cases, contextual expert knowledge is required to a large extent in order to interpret a rule correctly. Very often, today's regulations contain soft or even ambiguous expressions that require the careful interpretation of a regulatory expert. In consequence, approaches for a full automation of code compliance are still in an early research stage. More promising solutions rely on a semi-automated translation of the rules under the guidance and supervision of a domain expert.

From a general perspective, it is important to distinguish white-box solutions, which implement an open, transparent approach for rule representation based on an accessible rule repository, from black-box solutions, which typically rely on hidden hard-coded implementations of specific regulations. Whereas white-box solutions are open to verification, modification and extension by domain experts, black-

box solutions are currently more powerful as they can make direct use of internal algorithms and data structures of the code checking system.

The software solutions discussed in Sect. 22.4 show that most of the commercial tools focus on black-box approaches. They are able to perform basic model checks regarding element classifications, attribute provision and collision detection, but can also provide advanced code compliance checking for specific national or international regulations in the domains of fire safety, accessibility or escape routing, for example. However, these solutions only provide limited room for customization and flexibility for the user, i.e. domain experts are typically not able to alter the rule implementation or create new ones. In consequence, both planning consultants and construction authorities are forced to use the predefined sets of rules available. Nevertheless, the currently available solutions document the enormous potential of Automated Code Compliance Checking, which reduce the effort of the checking processes significantly.

References

BCA Singapore. (2013). *Singapore BIM Guide – Version 2*. Singapore: Building and Construction Authority Singapore.

Beetz, J., van Leeuwen, J., & de Vries, B. (2009). IfcOWL: A case of transforming EXPRESS schemas into ontologies. *Artificial Intelligence for Engineering Design, Analysis and Manufacturing, 23*, 89–101.

buildingSMART. (2016a). *BCF Introduction*. Retrieved from http://www.buildingsmart-tech.org/specifications/bcf-releases. Accessed 13 May 2016.

buildingSMART. (2016b). *Regulatory Room*. Retrieved from http://buildingsmart.org/standards/standards-organization/rooms/regulatory-room/. Accessed 25 Aug 2016.

Dimyadi, J., & Amor, R. (2013). Automated building code compliance checking – Where is it at? In *Proceedings of CIB WBC 2013* (pp. 172–185).

Eastman, C. (2009). Automated assessment of early concept designs. *Architectural Design, 79*, 52–57.

Eastman, C., Lee, J., Jeong, Y., & Lee, J. (2009). Automatic rule-based checking of building designs. *Automation in Construction, 18*(8), 1011–1033.

Graham, N. (2005). *Natural language, semantic analysis and interactive fiction*. Oxford: St Anne's College.

Gross, M. D. (1996). Why can't CAD be more like Lego? CKB, a program for building construction kits. *Automation in Construction, 5*, 285–300.

GSA. (2007). BIM guide for spatial program validation GSA BIM guide series 02. Retrieved from http://www.gsa.gov/bim/. Accessed 26 Aug 2016.

Hjelseth, E. (2015). *Public BIM-based model checking solutions: Lessons learned from Singapore and Norway* (Vol. 149, pp. 421–436). Retrieved from http://library.witpress.com/viewpaper.asp?pcode=BIM15-035-1. Accessed 07 Jan 2018.

Hjelseth, E., & Nisbet, N. (2011). Capturing normative constraints by use of the semantic mark-up RASE methodology. In *Proceedings of the 28th International Conference of CIB W78* (pp. 26–28).

Invicara. (2016). *BIM Assure*. Retrieved from http://bimassure.com/. Accessed 24 Aug 2016.

Jotne EPM Technology. (2016). *About Jotne IT*. Retrieved from http://www.epmtech.jotne.com/about-jotne-it. Accessed 26 Aug 2016.

Kulusjärvi, H. (2012). *Common BIM Requirements (COBIM) – Part 6 Quality Assurance.* Retrieved from http://www.en.buildingsmart.kotisivukone.com/

Lee, J. K. (2011). *Building Environment Rule and Analysis (BERA) Language.* Ph.D., Georgia Institute of Technology.

Lee, H., Lee, J. K., Park, S., & Kim, I. (2016). Translating building legislation into a computer-executable format for evaluating building permit requirements. *Automation in Construction, 71,* 49–61.

Nawari, N. O. (2018). *Building information modeling: Automated code checking and compliance processes.* Boca Raton: CRC Press.

Nisbet, N., Wix, J., & Conover, D. (2009). The future of virtual construction and regulation checking. In P. S. Brandon & T. Kocatürk (Ed.), *Virtual futures for design, construction & procurement.* Oxford: Blackwell Publishing Ltd.

NS 11001-1. (2009). *Universal design of building works – Part 1: Buildings open to the public.* Oslo: Norwegian Standards.

PAS 1192-2. (2013). *Specification for information management for the capital/delivery phase of construction projects using building information modelling.* London: British Standards Institution.

Preidel, C., & Borrmann, A. (2015). *Automated code compliance checking based on a visual language and building information modeling.* Oulu: ISARC.

Preidel, C., & Borrmann, A. (2016). Integrating relational algebra into a visual code checking language for information retrieval from building information models. In *Proceedings of the International Conference on Computing in Civil and Building Engineering (ICCCBE),* Osaka.

Salama, D. M., & El-Gohary, N. M. (2016). Semantic text classification for supporting automated compliance checking in construction. *Journal of Computing in Civil Engineering, 30*(1), 04014106.

Solibri. (2016). *Solibri Model Checker.* Retrieved from http://www.solibri.com/solibri-model-checker-v9-1-available-today/. Accessed 08 Mar 2016.

Solihin, W., & Eastman, C. (2015). Classification of rules for automated BIM rule checking development. *Automation in Construction, 53,* 69–82.

U. K. Building Regulations. (2007). *UK Fire Code Part B4: Fire safety.* Newcastle upon Tyne: NBS, Part of the RIBA Enterprises Ltd.

Uhm, M., Lee, G., Park, Y., Kim, S., Jung, J., & Lee, J. K. (2015). Requirements for computational rule checking of requests for proposals (RFPs) for building designs in South Korea. *Advanced Engineering Informatics, 29*(3), 602–615.

Von Bertalanffy, L. (1972). The history and status of general systems theory. *Academy of Management Journal, 15,* 407–426.

Wix, J., & Espedokken, K. (2004). *Building code and code checking developments in the UK and Norway.* Singapore: Vendor ITM User (VIU) Presentations. 2 Nov 2004.

Xu, R. (2001). *Code checking and visualization of an architecture design.* Austin: IEEE Visualization.

Zhang, J., & El-Gohary, N. M. (2015). Automated information transformation for automated regulatory compliance checking in construction. *Journal of Computing in Civil Engineering, 29*(4), B4015001.

Zhang, J., & El-Gohary, N. M. (2016). Semantic NLP-based information extraction from construction regulatory documents for automated compliance checking. *Journal of Computing in Civil Engineering, 30*(2), 04015014–04015014.

Chapter 23
BIM-Based Quantity Take-Off

Hannah Mattern, Markus Scheffer, and Markus König

Abstract Estimating represents an important aspect of the building process that can benefit from computable building information. Quantity take-offs (QTO) are usually performed at different stages of the project and with different purposes (e.g., for cost estimates and auditing). The conventional approach to perform a QTO represents a time-consuming and error-prone process. Relevant building information needs to be extracted from drawings and unstructured documents, which might be outdated or inconsistent. This chapter focuses on the requirements to support BIM-based QTO. Crucial aspects comprise defining a clear project structure as well as establishing a transparent information management. To organize building-related information, the application of a project-specific Work Breakdown Structure (WBS) is proposed. The structure and content of the generated models needs to adhere to the WBS. In this context, geometric and alphanumeric information at various Levels of Detail (LoD) need to be included. Based on these prerequisites, a workflow for an automated generation of QTO is presented.

23.1 Introduction

Pricing and cost estimation for construction projects is still a challenging task for any engineering or construction (AEC) company, since construction projects are always unique. However, in a globalized market with strong business competition detailed knowledge about project costing is now more important than ever. Nowadays, construction projects of large-scale are mostly realized by numerous companies, each organized in several geographically dispersed project teams. For this reason, the cost-estimation process during the design and construction phase is continuously interrupted and inaccurate. Cost estimation in the construction industry is generally done by performing a quantity take-off (QTO) based on the

H. Mattern (✉) · M. Scheffer · M. König
Chair of Computing in Engineering, Ruhr-Universität Bochum, Bochum, Germany
e-mail: hannah.mattern@rub.de; markus.scheffer@rub.de; koenig@inf.bi.rub.de

© Springer International Publishing AG, part of Springer Nature 2018
A. Borrmann et al. (eds.), *Building Information Modeling*,
https://doi.org/10.1007/978-3-319-92862-3_23

available information within the current project phase. Estimators review blueprints and additional requirements to calculate the quantities of the construction work. These quantities are the basis to create the pricing and, subsequent, the bill of quantities (BOQ). Regarding the generally disrupted flow of information and common changes of the design within the early project phases, it becomes clear that the manual generation of QTOs is a time-consuming and inefficient task.

The idea of realizing a close collaboration between different project teams by using BIM-methods significantly supports the QTO estimation. The continuously updated data model and a semi-automatic QTO lead to a straightforward cost estimation throughout the complete project life cycle, a more accurate cost management and consequently to successfully finished projects within the budget (Abanda et al. 2017). Focusing on early design stages, BIM-based QTO provides a quick and intuitive exploration of early stage design (Cheung et al. 2012).

This chapter provides an overview on performing BIM-based QTO. Section 23.2 contains a description on structuring a building project to enable QTO. Section 23.3 gives an overview on modeling guidelines to achieve a consistent quantification despite numerous project participants, while in Sect. 23.4 requirements concerning data modeling are presented. A possible workflow of performing BIM-based QTO at different project stages is presented in Sect. 23.5.

23.2 Work Breakdown Structure

The automation of cost estimation processes in the construction industry requires a structured information management supporting the identification of necessary information for a special use case and to make sure that this information is always available and up-to-date. Especially at early planning stages, a so-called "Work Breakdown Structure" (WBS) helps to organize the design and construction of a project despite limited information. In case the entire project team adheres to this agreed-upon structure, conflicts, errors and omissions can be avoided. WBS is widely used in the AEC industry and can be divided into different classification systems which offer a structured organization of measurements. Current classification systems include MasterFormat, OmniClass, Uniformat and Uniformat II, UniClass and CEEC.

Choosing an adequate WBS is necessary and significantly affects the requirements on models and data structures of the project (see Sects. 23.3 and 23.4). Classification systems can be grouped into three general approaches: physical space, material based or element based. Performing a QTO should always be based on the structure of the WBS and thus, the model structure should match with the WBS. That means, for example, when using a classification system with a physical space approach, single elements of the BIM model must be merged into suitable packages (e.g., space or room elements) in order to get the quantities for the corresponding items of the WBS. In Fig. 23.1, excerpts of the Uniformat II WBS are shown in three levels of detail. To identify the quantities of foundations in a project, the quantities of

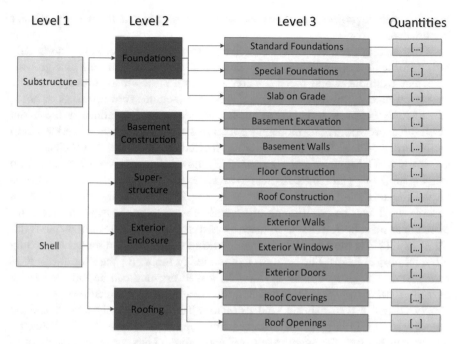

Fig. 23.1 Work Breakdown Structure for shell work according to the Uniformat II classification (Charette and Marshall 1999)

all sub-items have to be available and up-to-date. Currently, performing a QTO with respect to the WBS is done manually and intermittently over the project progress. For that, all required information (e.g., measurements, materials or building/room designations) must be collected by the estimators reviewing blueprints and project documentation. For a detailed WBS, manual quantity estimation is time consuming, in case of design changes difficult to update and prone to failure due to possible outdated or inconsistent documentation.

23.3 Modeling Guidelines for QTO

Using BIM greatly reduces the time and effort to perform a QTO. However, to support a semi-automatic QTO the model must fulfill requirements which have to be considered during the modeling process and updated with ongoing project progress. Frequently, the structure of the BIM model or the implemented level of information do not exactly tally these requirements. This can be due to an unstructured information management or because of an increasing level of information during the modeling process. This consequently leads to difficulties for the estimators locating all necessary quantities. Thus, the question of what information needs to be included

in which specific project phase and how this information is structured is of particular importance.

When setting up a construction project, during the early project phases only little information is available or the existing information can still change over time. For example, while the gross area of a roof structure is already available within the model, information saying if this area includes roof openings or not is still missing. To prevent that, strict modeling rules must be defined in the initial phase of a project. These modeling guidelines must contain information about model structure, e.g., floor structure or room structure, to enable a sufficient semi-automatic QTO. Monteiro and Martins (2013) show further problems resulting from missing modeling guidelines. In order to avoid possible overlaps of single elements during the modeling process as shown in Fig. 23.2, modeling guidelines must describe in detail the partitioning of several substructures. Possible intersections of elements must be detected in advance by performing clash detection methods (cf. Chap. 18). This is most important when working with a merged model created by different project teams. Further, different modeling tools give the user alternatives in modeling the geometry. As an example, a wall opening can be modeled either by special *Wall Opening Tools* defining the opening as a geometric object or by simply editing a wall using a void extrusion. The latter is only favorable if no model-based QTO is planned. However, only openings represented in geometric objects can be used for quantity take-off estimation. Thus, opening objects must contain information about their entity relationship, e.g., related fill and opening elements. For example, to calculate the window reveal size of a building, all opening elements filled by window elements must be filtered. Ongoing, the geometry of the wall elements related to the filtered opening elements can be used to calculate the window reveal size.

Fig. 23.2 Different options of column modeling, based on Yun and Kim (2013)

23.4 Data Modeling for QTO

Following an object oriented parametric modeling approach, a BIM model can be seen as assemblage of different elements composing a building. The geometric description of these elements is mainly based on surfaces which are composed of triangular meshes. Consequently, spatial quantities such as length, area and volume can be directly derived from the model. However, a quantity take-off cannot be generated from geometric information exclusively. As a consequence, properties such as material, discipline or position (interior/exterior) of single elements need to be evaluated during the QTO process. These parameters are expressed by alpha-numeric values which are assigned to the respective objects. However, performing a QTO which is exclusively based on physical building elements is not always feasible. In case single wall layers are not modeled explicitly, the wall covering may be derived from the specific function of a room. For this reason, virtual objects such as rooms, spaces and zones need to be considered to create a precise QTO. Opening elements and their geometric properties as well as their relationship to building elements are also required. For example, the total area of a wall does not necessarily comply with the amount of plastered surface as shown in Fig. 23.3. Depending on applicable quantification rules, openings might be excluded from the calculation in case their total area exceeds a predefined level.

Due to their decisive influence on project management and cost, quantity take-offs may be performed at various project stages. In the most desirable case, the modeled data corresponds to the chosen Work Breakdown Structure (WBS) of the project. Under this condition, elements of the WBS can be directly linked to building objects. If the QTO is performed in a traditional manner, the mapping process between 2D-drawings and the WBS becomes more complicated with increasing level of detail. Following the BIM methodology, this time-consuming and error-prone procedure can be replaced. The majority of BIM-based QTO applications

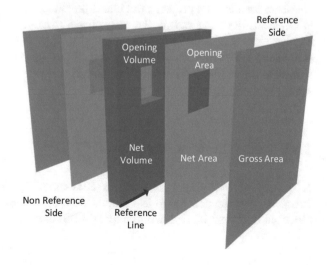

Fig. 23.3 Area and volume definition of a wall with opening elements

Fig. 23.4 Visualization of building spaces and room functions

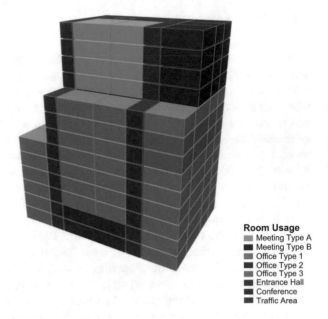

Room Usage
- Meeting Type A
- Meeting Type B
- Office Type 1
- Office Type 2
- Office Type 3
- Entrance Hall
- Conference
- Traffic Area

offer rule-based matching processes that serve to automate the mapping process between the model and WBS. At early planning stages, the prevailing model is generally characterized by a low level of detail. Consequently, estimation methods using available information become necessary which are commonly based on key figures and parameters. For example, the function of a room as shown in Fig. 23.4, might be an indicator for estimating the number of required exit doors.

The information provided in the BIM model can help to determine these key figures more precisely. In contrast to the traditional QTO approach, BIM enables a fast and easy access to very large data volumes. Furthermore, a BIM-based collaboration between project participants helps to guarantee creating a QTO which is based on the most recent planning phase. Changes introduced by other team members are considered automatically and thus, possible effects on the QTO are considered with minimum effort. On top of that, due to the central model-based data structure, information loss or omission is prevented resulting in decreased time spent on extracting relevant information.

23.5 Work Flow of BIM-Based QTO

A general workflow of performing a BIM-based QTO is shown in Fig. 23.5. Irrespective of the current project phase, the QTO is based on the prevailing BIM model and the work breakdown structure (WBS) of the project. Generating a QTO is

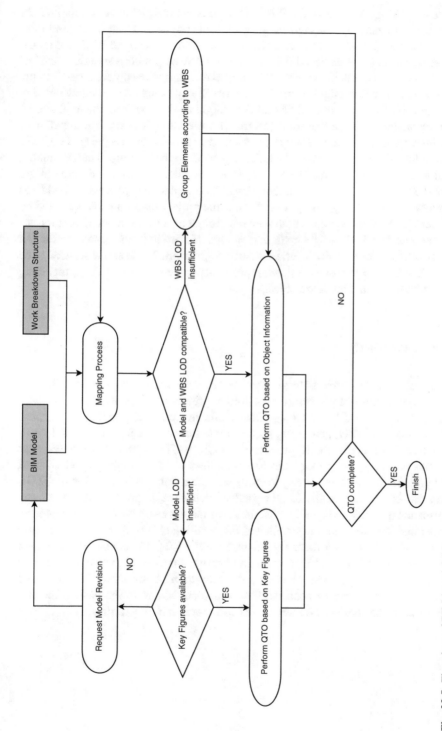

Fig. 23.5 Flowchart of BIM-based QTO

based on linking elements of the WBS to the corresponding objects within the BIM model. Most desirably, the applied software tool supports an automated and rule-based mapping process. However, a direct connection between the WBS and model elements can only be achieved if both are provided with a corresponding level of detail (LoD). In case the LoD of the BIM model does not allow object-based linking, available information might be used to determine key figures which allow creating a rough QTO (e.g., the amount of wall tiles might be derived from the total area of sanitary facilities). If the prevailing information does not allow the determination of key figures, the estimator needs to request a model revision. In case the applied WBS is provided with a comparably low LoD, objects need to be grouped before linking them to the elements of the WBS (e.g., exterior walls, windows and doors might be assigned to the "shell" of the building). As the planning process of buildings progresses continuously, disciplines of the same project might be characterized by different LoDs. Consequently, both scenarios might occur within one QTO process. Furthermore, the WBS might contain elements that are not represented within the model as this would require an unnecessarily high effort. These elements need to be added to the QTO manually following project-specific regulations (e.g., modeling site equipment as a parametric object).

23.6 Summary

In general, a QTO forms the basis for several processes in construction. Furthermore, the procedure is performed by different project participants. Thus, information derived from a QTO has a significant influence on total project performance. If performed manually, generating a QTO represents a time-consuming and error-prone task. For this reason, the process of creating a QTO is regarded as a desirable use case of automation in the construction industry. The emerging application of BIM provides a fundamental step towards such an automated generation of QTOs. Due to the central and model-based organization of data, improvements concerning information quantity and quality as well as information availability can be achieved. Furthermore, quality and transparency of the resulting QTO can be increased while at the same time, an easy reuse and adaption of the QTO to changes in the project design is enabled. Table 23.1 provides an overview on these aspects in comparison to the traditional approach. However, it needs to be considered that the listed improvements can only be achieved if stakeholders adhere to the basic principles of BIM which structure the definition, exchange and handling of data.

Table 23.1 Traditional QTO vs. BIM-based QTO

Aspect	Traditional QTO	BIM-based QTO
Information quality	Risk of working with outdated or inconsistent documents; 2D-drawings may contain errors	BIM-based collaboration helps to work with models that adhere to the current planning phase; Possibility to perform collision checks before conducting QTO
Information quantity	Depends on available documents	Model contains available information which corresponds to current planning phase
Information availability	Manual (time-consuming, error-prone)	Easy and fast due to central model-based organization
Quality of QTO	Manual measurements may contain errors	Errors caused by wrong measurements are avoided
Transparency of QTO	Manual mapping between drawings and WBS may result in decreased transparency; Complex situations require human interpretation of drawings (subjective)	Visualization options offer greater transparency
Reuse of QTO	Depends on data format of QTO (MS Excel, data bases, etc.)	Direct link to 4D- or 5D-analysis; Reuse for organizing material orders
Flexibility concerning changes in design	Need to revise QTO manually	Effective revision of QTO; Possibility to compare design alternatives with little effort

References

Abanda, F. H., Kamsu-Foguem, B., & Tah, J. H. M. (2017). Bim – New rules of measurement ontology for construction cost estimation. *Engineering Science and Technology, an International Journal, 20*(2), 443–459. Retrieved from http://www.sciencedirect.com/science/article/pii/S2215098616309156

Charette, R. P., & Marshall, H. E. (1999). *UNIFORMAT II elemental classification for building specifications, cost estimating, and cost analysis.* Gaithersburg: National Institute of Standards and Technology.

Cheung, F. K. T., Rihan, J., Tah, J., Duce, D., & Kurul, E. (2012). Early stage multi-level cost estimation for schematic BIM models. *Automation in Construction, 27*, 67–77. Retrieved from http://www.sciencedirect.com/science/article/pii/S0926580512000817

Monteiro, A., & Martins, J. P. (2013). A survey on modeling guidelines for quantity takeoff-oriented BIM-based design. *Automation in Construction, 35*, 238–253. Retrieved from http://www.sciencedirect.com/science/article/pii/S0926580513000721

Yun, S., & Kim, S. (2013). Basic research on BIM-based quantity take-off guidelines. *Architectural Research 15*(2), 103–109.

Chapter 24
Building Surveying for As-Built Modeling

Jörg Blankenbach

Abstract Building surveying is an important element for as-built documentation as well as for planning and construction in existing contexts. In connection with BIM, however, building surveying faces new challenges. In the past, the results of surveying were typically two-dimensional CAD drawings depicting floor plans, sections, and views. BIM, in contrast, relies on digital three-dimensional building models based on an object-oriented modeling paradigm including semantics, descriptive data, and relationships of building elements. This holistic building modeling approach also impacts the surveying workflow for building measurement as well as the data processing. Nevertheless, the basis for building measurement are geodetic surveying techniques with single-point methods (manual surveying, tacheometry) or aerial measurement methods (photogrammetry, laser scanning) in combination with appropriate surveying software. Also, new developments in context of spatial data capturing (UAVs, multi sensor and mobile mapping systems) rely on these basic methods.

24.1 Introduction

Building measurement or, in general terms, building surveying, is a crucial factor for the creation of geometrically accurate building models. The aim of building surveying is to capture the current three-dimensional geometric conditions of existing buildings and to document them – nowadays almost always digitally – in drawings, plans, and models. The results typically consist of floor plans, sections,

Assisted by Dr.-Ing. R. Schwermann, RWTH Aachen as well as MSc. S. Siebert (Aibotix GmbH) (Sect. 24.5.4).

J. Blankenbach (✉)
Geodätisches Institut und Lehrstuhl für Bauinformatik & Geoinformationssysteme, RWTH Aachen, Aachen, Germany
e-mail: blankenbach@gia.rwth-aachen.de

393

views and possibly detail drawings, providing building experts such as architects, civil engineers, building technicians, architectural historians etc. familiar views of the existing building, even without an on-site visit. Building surveying is often complemented by a building specification, with which data relevant to the structures is documented in the form of alphanumerical data (attribute data). The building survey is completed by research into aspects relating to building history, which might be helpful for the interpretation of results. For BIM, building surveying does not involve fundamentally different methods than are used for classical surveying of buildings, since the geometry determination is a key basis for BIM. However, BIM takes a holistic approach to the documentation of building structures, which affects the surveying workflow as well as the processing and modeling of the data. For the processing and utilization in BIM, the as-built situation has to be depicted on the basis of a standardized data model, which takes both geometric and semantic properties into account (see also Chaps. 2 and 3). While the geometric elements points, lines, areas, and volumes have, to date, been of central importance to keep the data collection process in order, from a surveying point of view, they are now being replaced by objects with a large number of attributes, of which the geometry is only one of many. Object creation is now the focus of an object-oriented workflow that forms the basis for the modeling of buildings or structures with redundancy-free data storage and consistent data retention in the event of revision. For the surveying task, this means that the individual processes are far more integrated in the data collection process than in the past. In this context, established products such as floor plans, sections, views, and component lists are derived in a subsequent step directly from the BIM software.

In practice, there are often plans and drawings dating from when a building was planned and built. In principle, these plans and drawings can be used as the initial source of data for the geometric description, for example by extracting dimensions which are then incorporated into the preparation of a digital CAD inventory. The digitization process can be performed particularly effectively if the plan template is scanned first and then integrated as a raster image for on-screen digitization, since the person performing the digitization can see the old plan throughout the vectorization process. However, in principle, anyone who uses existing as-built drawings for building measurement should be aware that the actual situation may be significantly different. It is not uncommon for the builders to deviate from the plans even during the building process, or there may be undocumented changes and alterations to the building.

Thus, there is no alternative to accurate geometry determination by surveying. The development of high-performance measurement instruments in combination with computers (a PC, laptop, or tablet) connected by cable or by WiFi and of method-specific software has resulted in different methods to survey buildings in practice. Even though there exists a variety of products in the market, the following techniques represent the basic methods:

1. Manual (electronic) surveying
2. Tacheometry

3. Photogrammetry
4. Laser scanning

These methods are described below in this chapter. What all of them have in common is the fact that they require a (mathematical) coordinate system that provides the overall reference framework for the geometric documentation of the various parts of the structure.

24.2 Coordinate System

The geometry of buildings and structures can be described universally and consistently using mathematical coordinates. A building survey thus begins with the definition of a suitable coordinate system, which is the reference framework (reference system) for all of the surveying and documentation processes. In most instances, a local (Cartesian) coordinate system is defined, the alignment of which should ideally follow the building's main axes. If, for example, the coordinate axes are parallel or orthogonal to the principal axis of the building, this makes many subsequent modeling operations easier. In addition to the position coordinates (X, Y), the height H is often used as a third coordinate (Z) in order to be able to perform a completely three-dimensional building measurement and documentation.

For small and medium-sized buildings (e.g. typical office buildings) the use of national territorial coordinates (e.g. UTM) as a spatial reference system (or geodetic reference system) has been less widely used in practice to date because the alignment relative to the building is generally purely arbitrary. The parametric geometry modeling by BIM also favors the use of a local Cartesian coordinate system in relation to the structure for surveying and primary modeling. Due to the designation of BIM as a central and consistent building database, however, there should be a connection to the official spatial reference system used for planning. If geospatial data is used in the context of BIM, it is even mandatory to draw on a spatial reference system. When using spatial reference systems, one should be aware of their characteristics and parameters, e.g. possible distortions when using projection coordinates (e.g. UTM) (see e.g. Uren and Price 2010). However, by introducing identical points in both systems (national territorial system, local system), it is nevertheless possible to perform a conversion between them by coordinate transformation.

For large buildings (e.g. railway or road constructions), however, one should be aware that due to the large extension of the construction some effects (e.g. earth curvature and height) have to be considered for the surveying (see e.g. Uren and Price 2010), and thus using the data for BIM modeling. Moreover, for road and railway documentation usually also geospatial data (e.g. terrain models) is used and thus the consideration of spatial reference systems is essential.

The implementation of the coordinate system on location is performed by marking reference points (fixed points, FPs), which are either to be measured in

advance or simultaneously in the course of surveying the building – and which need to be coordinated in the spatial reference system. The FPs are used both as locations for the surveying instruments and as tie points or control points for the stationing and orientation processes. Their positions must be chosen in such a way that the measurements can be performed without any problems and, at the same time, that long-term validity is given, where possible. The reference points and connection points are placed both outside the building, i.e. generally in the surrounding terrain, as well as inside on floors, walls, and possibly also on ceilings. The reveals in the openings in the masonry (doors, windows etc.) are favorable locations for the densification of the network of reference points indoors, since they are clearly visible from two directions.

Figure 24.1 shows a schematic example of a network of reference points for the building survey. The survey starts with the outdoor points, which form a ring around the building. Based on this, further reference points are transferred into the building, forming the basis for further densification. If there are several floors, the same principle applies by analogy for each one of them. The geodetic determination of reference points is performed according to conventional single-point methods such as traversing or arc intersection.

The measurement of distance and direction networks followed by network adjustment requires the largest amount of work, but it also provides the most precise coordinates, while errors are most likely to be able to be detected. The best instrument position for conducting the measurement of the decisive structural points often only becomes evident in the course of performing the survey. These points do

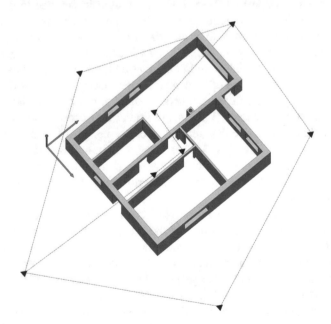

Fig. 24.1 Example of a reference point network for surveying a building

not, as a rule, include the marking. The position determination is normally carried out by frcc stationing. For further details on the method of point determination described above, please refer to appropriate geodetic literature (e.g. McCormac et al. 2013).

24.3 Manual Surveying

Manual electronic surveying is based on the combination of electro-optical distance measurements, mobile computers, and specialized software. It differs from the conventional manual measurement used in the past in terms of the instrumentation and the process, which was characterized by the use of a measuring tape/folding rule, plumb line, optical square, and ranging-poles/rods – as well as the orthogonal method in connection with tying into a baseline, as the predominant method of surveying. Modern manual surveying typically involves laser distance meters operated by a single person for measuring distances. Here, the points to be measured are examined using a visible laser beam. The measurements are transferred straight to the surveyor's portable computer (tablet, laptop) via an interface, using a cable or Blue-tooth, and are then processed by means of the surveying software. The surveying software can either be a stand-alone software or an add-on in a CAD software. If the latter is the case, the operator can make use of the extensive CAD functionality for graphical representation of the survey results, which have numerous additional specialized surveying functions to increase the effectiveness of the process.

Measurements are only taken of – primarily horizontal, vertical, and diagonal – distances. That is why this method can even be used without specialist knowledge of surveying. In methodological terms, manual electronic surveying involves, first of all, the task of subdividing the building into the existing units of space as base elements, the geometric properties of which are acquired independently of each other. As a first step, each room is thus surveyed individually, as an independent cell. For the overall dimensioning of a rectangular standard room on the floor plan, it is thus sufficient, at least in most cases, to measure three horizontal distances for the length, width, and diagonals, with the latter generally being used to check for orthogonality (see also Fig. 24.2). On the basis of this, the openings in the masonry – i.e. primarily windows and doors, as well as recesses, openings and protrusions – are determined by performing more distance measurements and are then included in the drawing using the surveying software. If a three-dimensional survey is required, the third dimension is obtained by measuring the relevant vertical distances in the third dimension analogously.

There is no direct connection to the reference system, as is the case for the other survey methods (tacheometry, photogrammetry, and laser scanning). This means that the units of space, which are initially determined independently and are in themselves fully defined geometrically, are aggregated to form a whole, so that eventually the building is completely represented in its geometric arrangement. This

Fig. 24.2 Manual electronic surveying: Measurement of space-determining distances (lengths, widths, and diagonals)

is usually done on the basis of the shared wall openings (windows and doors) and the measured wall or reveals depths, by which the individual space units are joined in the correct position. For this operation, the software provides the appropriate functions, assisting the user in creating a hierarchical structure of rooms, room groups, floors, and the complete building.

Modern measurement systems take a different approach; they subdivide the workflow described above into two steps: rough structuring and fine dimensioning. In principle, rough structuring involves sketching out the rooms on the basis of estimated dimensions, from which the space units and the building structure are only roughly geometrically defined. This step is accompanied by defining constraints such as parallelisms and orthogonalities, so that the structural building design with all relationships is already implicitly given. In the second step, this is then followed by fine dimensioning, which involves including the distance measurements so that the space units (which were so far only roughly sketched out) are gradually given their precise dimensions. As a result, the rough sketch is transformed step by step into the final, geometrically accurate model of the building.

Depending on the software, the digital model of the building may, in its simplest form, be created as a wire frame model, based essentially on basic CAD elements such as lines and arcs. For 3D building modeling, there are systems in which surface or volume models are created directly or indirectly and, where applicable, using parametric dimensioning. It is then very easy to make corrections to the geometry by modifying the parameters. Some measuring systems also have functions that are directly or indirectly aimed at BIM, such as object-oriented structure formation or an interface for simultaneous recording of non-geometric data, for example by providing dialog boxes to enter the attribute information. Manual surveying is ideally suited for this step of the process, since it enables the user to work on-site and as near as possible to the building.

The greatest disadvantage of manual surveying is the relatively poor absolute accuracy, although the adjacency accuracy for each space unit, if considered by itself, is sufficient. Due to the simple aggregation of the rooms using doors and windows, without true integration of a superordinate reference system, points between the beginning and end of the building only achieve decimeter accuracy. In the scope of building surveying, manual surveying should therefore only be used as a supplementary method.

24.4 Tacheometry

Tacheometry is of great importance for building surveying. Generally, modern tacheometers or total stations with an electro-optical distance measurement system are used. Measurements are either performed using reflector prisms which are placed at the points to be measured, either directly or eccentrically, or – the technological state-of-the-art for some years now – by measuring the structural points without reflectors. As is the case with a hand-held laser distance meter, this may be done using a visible laser beam. The achievable accuracy of the electro-optical distance measurement is within the millimeter range. However, in case of reflectorless measurement, some aspects influencing the accuracy (e.g. the reflectivity of the object surface, the incident angle) have to be considered. Particular attention has to be paid to the reflected signal when measuring corners and edges, as partial reflections may distort the distance measurement. Further details about the electro-optical distance measurement technique can be found in the technical literature (e.g. Uren and Price 2010).

The introduction of reflectorless measuring has led to a considerable simplification of building surveying, as the actual measuring is sped up and as it is no longer necessary to have a second person hold the prism. The primary measuring elements are horizontal direction (Hz), vertical angle (V), and slope distance (s), i.e. 3D polar coordinates, with which the points are determined in three dimensions. Conversion of the primary measurements into equivalent parameters such as the horizontal distance (e), height difference (dH) or local Cartesian coordinates can even be performed in the total station. The measurements are generally stored on a memory card or transferred online via cable or Bluetooth to a portable computer with appropriate surveying software. Surveying software for tacheometry essentially has functions that are similar to those used for manual electronic surveying (cf. Sect. 24.3), but have (additional) interfaces for tacheometers. Modern total stations also have a wide range of embedded software programs that usually include calculation processes for surveying (arc intersection, free stationing, centering etc.).

The positions used for the total station while carrying out the survey are either the previously determined reference points or the method of free stationing (see. Fig. 24.3). The arbitrarily chosen instrument positions are selected on-site, in such a way that the surveying of the building points can be carried out flexibly and efficiently. To enable the coordinate determination of the instrument position, which

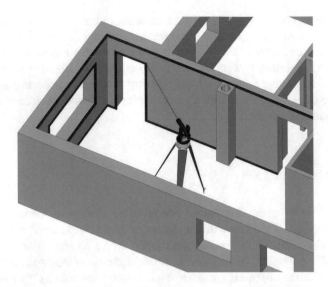

Fig. 24.3 Tacheometric surveying of an interior space from a free location

is not necessarily marked, point measurements of at least two reference points are needed. Positioning and survey measurements are generally performed together. This is accompanied by a continuous densification of the control framework on the basis of additional points on the floor or the walls, which are temporarily indicated by reflecting marks. In most cases, one setup is required per room.

From a methodological point of view, the summary below serves to distinguish the different approaches to tacheometry (Uren and Price 2010):

(a) Acquisition of 3D structure edges
 This involves directly aiming at and measuring all of the corners and edges that define the geometry of the rooms. The surveying software then generates the corresponding three-dimensional lines and arcs by connecting the measuring points to represent the building structure, resulting in a 3D CAD wireframe model of the surveyed building. The standard two-dimensional architectural drawings – such as floor plans, sections, and views – then need to be derived from these wireframe model drawings in an additional processing step.

(b) Direct acquisition of sections
 If the number and position of the floor plans and sections is clear from the outset, it is possible to perform direct acquisition in cutting planes. For this, all of the points that define the geometry of the floor plan or the vertical section are measured. Meanwhile, the surveying software continuously projects the 3D points in the predefined cutting plane. Frequently recurring elements on floor plans, such as windows and doors, can be acquired very effectively with the appropriate specific functions of the (CAD) software. This immediately results in a 2D drawing.

(c) 3D modeling

The third method is most important for use in BIM applications. Like in method (a), the points that define the geometry of the building are measured. The point coordinates are used to derive three-dimensional surface and solid elements, which ultimately represent the building model. If boundary edges or corners cannot be aimed at directly, indirect measurements are carried out on the wall and ceiling surfaces, and the results are then used to create the section. With BIM, it is possible to perform object recognition and additional enhancement with attribute information simultaneously during the geometry acquisition process. The acquisition software then has to have the corresponding dialogue interfaces.

In practice, total station measurements are often combined with manual surveying, in particular if, for instance, simple linear distances are sufficient due to parallelism or right angle conditions, as is the case for recesses or protrusions.

24.5 Photogrammetry

Classical photogrammetry, i.e. surveying on the basis of photographs, is often used for architectural surveying in outdoor areas, for example to examine a building's outer shell. For indoors, the classical method is often too cumbersome, as the number of geometric parameters to be determined is disproportionate to the amount of work required. An exception to this is the task of surveying large buildings like churches or concert halls with voluminous interiors or listed buildings with a high density of details. The time taken on-site to perform photogrammetry is relatively modest, as the actual surveying work takes place in the office instead.

We basically distinguish between three different photogrammetric surveying methods: single image photogrammetry, multi-image photogrammetry, and stereo photogrammetry.

24.5.1 Single Image Photogrammetry

Single image photogrammetry involves the evaluation of a single image, which is usually a digital procedure nowadays. The original image, which like all photographs adheres to the laws of central projection, exhibits projective distortion, as a result of which object edges that are actually parallel appear to be more or less convergent in the image. For the evaluation, the digital image is rectified, i.e. the image is converted so that the object edges are made parallel again. This is normally done using at least four photogrammetry control points per image, which first need to be determined geodetically. The actual evaluation work is done on the distortion-corrected image, for which on-screen digitization has proven to be effective. This is done with the distortion-corrected photograph in the background so

that the operator can trace all of the relevant edges. If the photogrammetric software is integral part of a CAD system – such as the digital analysis software PHIDIAS (see Fig. 24.5), which is integrated into the CAD environment MicroStation, for example – the evaluation and drawing work is made easier by the system's own CAD functions (copy, mirror, etc.). The overlap of the drawing and the photograph (superimposition) helps to verify the graphical evaluation to ensure that it is complete and correct.

Using single image photogrammetry, it is essentially only possible to measure 2D objects such as flat building facades, as the photographic image is, in principle, created in the (two-dimensional) plane of the camera sensor. As a result, one dimension is lost, meaning that single image photogrammetry is thus limited to planar objects. The only exception to this is if the object surface is a consistent developable surface (cylinder, truncated cones) such as a tower structure, in which case the evaluation can also be performed on the basis of just a single image, as long as the orientation data for the image is available. For further details on this method, please refer to the literature (e.g. Luhmann et al. 2014).

24.5.2 Multi-image Photogrammetry

For multi-image photogrammetry, several photographs of the object – with an overlap between 30% and 90% – are taken freehand from different positions, resulting in a set of images (Fig. 24.4). Each object point to be measured should occur in at least two of the images, as this forms the basis for three-dimensional point determination. A prerequisite for multi-image photogrammetry is that the image orientation is carried out beforehand. For this, the situation is reconstructed mathematically, i.e. the task is to determine the positions, the angle and the rotation of the camera or of the images at which the photograph was taken (orientation data). The orientation calculation is typically performed by bundle adjustment, with the camera data (camera constant, coordinates of the principal point, distortion parameters) generally being determined simultaneously. The data is integrated into the local coordinate system of the building survey using the control points, which are determined geodetically. For further details on image orientation, please refer to the literature (e.g. Luhmann et al. 2014).

The image evaluation is based on the 3D triangulation method. The point to be fixed is measured in two or more images monoscopically, i.e. it is localized in each image successively. In combination with the orientation data, it is possible to reconstruct the corresponding spatial rays and put them together to obtain a section. This results in the 3D coordinates of the object points, from which it is then possible, for example, to form the lines that represent the corresponding object contours. The evaluation results are generally saved as a three-dimensional CAD drawing.

Nowadays, software is used to support several tasks in image processing. For instance, the aforementioned digital photogrammetric analysis software PHIDIAS provides all of the procedures required for multi-image photogrammetry (Fig. 24.5).

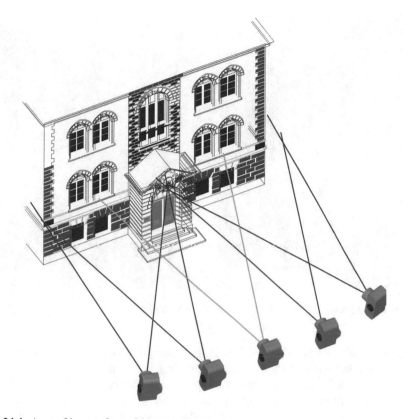

Fig. 24.4 A set of images for multi-image photogrammetry

The result of the evaluation is generally a 3D wireframe-model drawing, which is overlapped on screen, congruently with the oriented images in the background. As a result, visual inspection is possible at all times during the evaluation process. As is the case for single image evaluation, a kind of on-screen digitization is performed, except that now the measurement is three-dimensional. Alternatively, it is also possible to perform the 3D modeling with area and solid elements immediately, instead of building a wireframe model. If a BIM application is installed as well (e.g. AECOsim Building Designer), it is possible to combine the photogrammetric geometry acquisition with the preparation for BIM applications in PHIDIAS.

24.5.3 Stereo Photogrammetry

Stereo photogrammetry only plays a minor role in building surveying, as it is quite demanding, both in terms of personnel and equipment. This method exploits the human ability to view scenes spatially, i.e. stereoscopically. In combination with

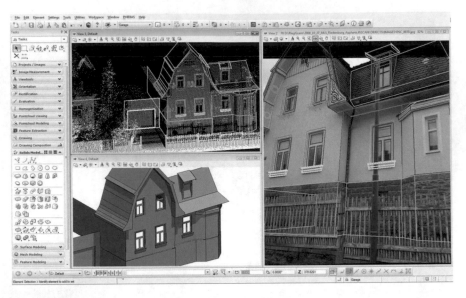

Fig. 24.5 The photogrammetric evaluation system PHIDIAS

a floating mark that is also spatial, it is thus also possible to measure contourless objects photogrammetrically, e.g. a domed ceiling in a church.

For stereo evaluation, two photographs are taken in the so-called normal case. Normal case means that both of the viewpoints are parallel and perpendicular (normal) to the base. This can either be done with one camera, successively, or with two cameras simultaneously. The base, meaning the distance between the two camera locations, should be chosen in such a way that the images overlap by about 50% to 60%. In practice, the normal case conditions must at least be approximately adhered to.

For the image evaluation, the operator's eyes need to view the photographs of the stereo image pair separately, in order to recreate the real-life situation. Image separation can be achieved optically using a stereoscope or – as is most common with digital photographs nowadays – using shutter glasses that operate according to the active shutter principle, with the images displayed alternately on the screen at a frequency of at least 100 Hz, while the left and right lenses of the glasses alternate between being translucent and opaque at the same frequency. By synchronizing the alternating images, the photographs are separated and, if the frequency is high enough, the observer sees the scene depicted spatially, in three dimensions.

For stereo analysis, the operator has a spatial measurement cursor, which he can move around and place anywhere in the stereo space, as desired. This 3D cursor can, for instance, be placed on the surface of the object under the visual control of the observer, in order to implicitly record the three-dimensional coordinates of the point localized. This process can be continued to trace the surfaces along the three-dimensional curves, somewhat like contour lines on a map.

Stereo photogrammetry has the advantage that it can also be used to survey objects without discrete contours, such as sculptures, in three dimensions. In aerial image analysis, special digital stereo evaluation stations are used, which are designed for continuous operation. In principle, these sophisticated but expensive devices can be used for building measurement and surveying, but it is rather uncommon. The PHIDIAS software (Fig. 24.5) also supports stereo evaluation, using shutter glasses for image separation.

24.5.4 UAV Photogrammetry

Developments in computer vision and digital image data processing in recent years have made it possible to create point clouds (Structure from Motion, SfM) automatically, on the basis of a large number of strongly overlapping images using dense image matching methods (Fig. 24.6). This method can be used for geospatial data acquisition with unmanned aerial vehicles (UAVs) that are equipped with cameras to take aerial images which are then used to create surface models and orthoimages. Aerial image photogrammetry – which has to date largely relied on manned aircraft – is a possibility to reach totally new dimensions of flexibility, efficiency, and accuracy by combining the existing methods with UAVs. Several evaluations of the use of UAVs have already been conducted (e.g. Gini et al. 2013; Nauman et al. 2013; Siebert and Teizer 2014). Unmanned aerial vehicles can be

Fig. 24.6 A point cloud of UAV images with shooting positions (red)

Fig. 24.7 Aibot UAV with
camera (Source: Aibotix)

distinguished between vertical take-off rotary wing aircraft and horizontal take-off fixed-wing aircraft, each in different weight classes. When it comes to rotary wing aircraft, multicopter systems (Fig. 24.7) should be mentioned especially, as they are characterized by a high degree of flexibility and stability, with a relatively simple operating concept and rapid deployability. Horizontal take-off fixed-wing aircraft generally offer a long range and low sensitivity to wind. Another group of UAVs are blimps (zeppelins), which have a high load carrying capacity and long range.

The major challenge regarding a use of UAVs, aside from legal issues and the integration in the aviation infrastructure, is to integrate the method into the existing data processing workflows. Due to the similar features (point clouds), there are many positive synergy effects with terrestrial laser scanning (Chap. 24.6). In the scope of BIM, UAVs can, in particular, complement terrestrial data acquisition (e.g. terrestrial laser scanning), in order to provide data from areas that are insufficiently covered by terrestrial methods (e.g. roof areas).

24.6 Terrestrial Laser Scanning

Terrestrial laser scanners are gaining increasing importance in building surveying, especially in the context of BIM (Scan-to-BIM), even though the instrumentation required is comparatively complex and costly. For simple structures (e.g. buildings with rectangular rooms) laser scanning is – like photogrammetry – often too complex for indoor application, as it generates vast amounts of data that are disproportionate to the really relevant geometric information. For more demanding structures like buildings with more complex room structures, technical building systems, industrial plants, historic buildings, churches etc., laser scanning is, on the other hand, an efficient method of data acquisition due to the areal scanning. A benefit of laser scanning in contrast to the single-point surveying techniques (e.g. tacheometry) is the direct 3D capturing of the whole scene, resulting in a point cloud with a high spatial resolution. In general, automated evaluation of point clouds has high potential for development, so that interior surveying using laser scanners is set to become increasingly attractive in future.

In operation, a laser beam scans systematically, horizontally and vertically across the measurement range in predetermined angle steps (Fig. 24.8). Which room segments can be scanned in a single pass depends on the design of the scanner (camera, panoramic or hybrid scanner, (see e.g. Vosselman and Maas 2010)). At the

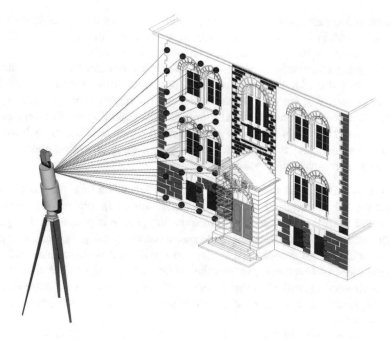

Fig. 24.8 Terrestrial laser scanning

same time, like when using the reflectorless tachymeter, the distance to the object point is measured on the basis of the returning signal, so that 3D polar coordinates (two angles and a slope distance) are recorded continuously and then converted into the equivalent Cartesian 3D coordinates. This results in one 3D point cloud per scan. The distance measurement is based either on the time-of-flight method or the wave analyzing method (phase comparison procedure). The latter permits scanning speeds with measurement frequencies of over a million points per second. However, the range is limited to some deca- or hectometers, but this is generally sufficient for building surveys. The time-of-flight method allows by now also for measurement frequencies of up to approx. 1,000,000 points/sec, but it can measure over distances of several kilometers. In addition to the geometric measurements, many scanners can also register the intensity of the reflected measurement signal. The accuracy of the single distance measurements by a laser scanner is between 2 and 5 mm. However, quite similar to reflectorless tacheometry, the accuracy is influenced by further aspects, especially the angle of incidence as well as the reflectivity and roughness of the object surface. For building measurement, these influences often result in a non-homogenous accuracy (and precision) of the point cloud.

In principle, the scanner locations can be, chosen freely, and it is not necessary to set up the instrument using control points. At each position, the scanner generates a point cloud that is initially coordinated in the local sensor coordinate system, which is generally not leveled. For further processing, the individual point clouds are transferred into a common coordinate system, which is referred to as registration.

The registration can either be done using highly reflective targets (reflective tape, balls, or cylinders), extractable features in the point clouds (such as corners, edges, or plane sections) or using the point clouds themselves (ICP algorithms). From a mathematical point of view, spatial similarity transformation is performed between the point clouds on the basis of common fitting elements. The laser scanners generally come with suitable software for registration (provided by the manufacturer), which differ in terms of their handling and degree of automation.

The information on the structural geometry and structure is indirectly located in the 3D point clouds. As is the case for tacheometry, we differentiate between three basic methods for evaluating point clouds:

- Direct acquisition in cross-sections: This involves cutting the point cloud, normally with horizontal or vertical planes, which in practice are wider or narrower corridors in which the corresponding profile is portrayed. The profile path can then be traced manually or (semi-)automatically. When doing so, it must be taken into account that the scanned points are scattered and tend to be spread more or less randomly over the surface of the object. The advantage of the cross-section method is that it results directly in standard 2D architectural drawings, such as floor plans and vertical sections, and that this method is very straightforward.

- Contour-based acquisition: This involves measuring the building structure from the point clouds in the form of corners, edges, and planes, resulting in a three-dimensional wireframe model. Since the scanner's measuring points are generally not located directly on the corners and edges, indirect evaluation methods need to be used. For example, an object edge is obtained by the intersection of adjacent planes. Since these procedures are averaged over a large number of measurements, often in combination with filtering and smoothing processes, the geometric accuracy of the contour elements derived is very high.

- 3D modeling: This evaluation method is the most important for BIM, since it creates the necessary prerequisites for holistic object representation with structure formation and attribution. The geometric shape of the structure is modeled on the basis of the point clouds in the form of surfaces, cuboids, cylinders, cones and other primitives, by fitting these elements into the point cloud using special fitting algorithms. This process is usually done semi-automatically, i.e. the points for the fitting process are selected manually by the operator and then fitted by the software (e.g. PHIDIAS). Some software products also support object creation for BIM. Full automation of this task is the subject of current research, although it is already successful now, at least in part. 3D modeling from point clouds generally achieves a very high degree of accuracy, as the geometry is determined on the basis of a large number of measuring points.

Laser scanners are specialized measuring instruments, with measuring rates of up to 1 million points per second or more. Recent developments are now tending towards fitting total stations with scanning functions and integrated cameras for image capture. In addition to the traditional angle and distance measurements, it is then possible to perform simple scans using the same instrument, possibly in

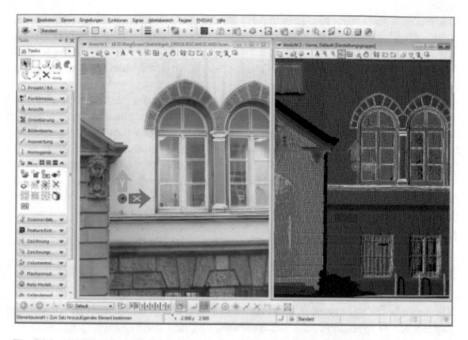

Fig. 24.9 PHIDIAS – combined evaluation of photographs and point clouds

combination with color photographs, although the measuring frequency in scanning mode is only 1000 Hz max. at present, which restricts the applications of this technology to supplementing other measurement methods. In future, however, we anticipate that the measuring sensors for tacheometry, photogrammetry, and laser scanning – to the benefit of building surveying – will merge into a single universal instrument.

24.6.1 Laser Scanning in Combination with Photogrammetry

The measuring methods of laser scanning and photogrammetry can complement one another very well and offset the disadvantages of the other method. The weaknesses in terms of the measuring depth accuracy that affect photogrammetry as a direct result of the process do not affect laser scanning. On the other hand, the photogrammetric pictures have a higher resolution on the surface of an object, meaning that the detail detectability is significantly higher than can be achieved by laser scanning.

The PHIDIAS software, for example, exploits this, combining the oriented photographs with the three-dimensional point clouds for geometry acquisition, see Fig. 24.9. This allows the point clouds to be portrayed in the correct position and congruently over the oriented images. The operator can therefor view both at the

same time – and is thus also able to carry out measurements in both simultaneously. In the simplest case, the evaluator measures a specific three-dimensional point with the mouse: localization is performed visually, primarily on the basis of the image, while the determination of the 3D coordinates on the other hand takes place in the point cloud (monoplotting).

Also, it is possible to constantly switch between the measurements that are only performed in the point cloud or only in the photographs and the combined measurements, either using the standard drawing functions provided by the CAD system, or special tools such as the (semi) automatic determination of ducts. It is possible to acquire the geometry of the building in the form of wireframe, surface, or volume models. The images and point clouds are overlayed with the graphical outcome by superimposition, so that the evaluator can constantly check the progress and correctness of the evaluation.

24.7 Summary

The basic building surveying methods presented are proven methods of surveying, in particular for geometry acquisition of buildings, either using single-point methods (manual surveying, tacheometry) or areal sensors (photogrammetry, laser scanning). BIM, however, poses new demands to building measurement. Whereas surveying was previously required to provide the measurements of existing buildings or new buildings, primarily in the form of as planned/actual comparisons, dimensional plans, or as digital CAD drawings (e.g. for CAFM) in the past, BIM requires a digital building model with volume object-oriented modeling, including its semantics and relationships as well as other descriptive characteristics. Some current surveying software programs already support the creation of BIM data, e.g. by offering the possibility of creating building elements or by extended functionality for the creation of building models from point clouds.

Nevertheless, there is great potential for optimization and automation in building measurement for BIM in terms of the entire workflow, from the stage of data acquisition on-site to data (post) processing and to data provision. Using the single-point methods, surveying constitutes a considerable time factor due to the model discretization on site. More efficient computer-aided measuring technology can help to minimize the amount of effort required for measurement and to acquire all of the information needed for BIM on-site (e.g. structure formation with geometry, semantics, and possibly attribute data). Using the mass data methods (in particular laser scanning), most of the work involved lies in the data post-processing. The challenge here lies in minimizing the amount of manual data processing – which is often immense – by the use of smart software processes (e.g. improved geometric structural analysis, derivation of the semantics). Also for the most recent measurement systems for building surveying, e.g. mobile mapping systems or UAVs, which are based on the presented fundamental methods, a higher automated data processing is essential.

Moreover, there are further challenges in building surveying like the true-to-deformation survey for BIM especially in terms of modeling. Using point clouds and as-planned models, today this can only be achieved by comparing the model against the point cloud (Scan-vs-BIM). However, the topic of "BIM" has arrived both in geodesy and in surveying practice, meaning that it is safe to assume that the methods and workflows of building measurement will adapt BIM much better in future.

References

Gini, R., Pagliari, D., Passoni, D., Pinto, L., Sona, G., & Dosso, P. (2013). UAV photogrammetry: Block triangulation comparisons. *ISPRS, XL-1/W2*, 157–162.

Luhmann, T., Robson, S., Kyle, S., & Boehm, J. (2014). *Close-range photogrammetry and 3D-imaging* (2nd ed.). Berlin/Boston: Walter de Gruyter.

McCormac, J., Sarasua, W., & Davis, W. (2013). *Surveying.* (6th ed.). Hoboken. Wiley.

Naumann, M., Geist, M., Bill, R., Niemeyer, F., & Grenzdörffer, G. (2013). Accuracy comparison of digital surface models created by unmanned aerial systems imagery and terrestrial lasers scanner. *ISPRS, XL-1/W2*, 281–286.

Siebert, S., & Teizer, J. (2014). Mobile 3D mapping for surveying earthwork projects using an unmanned aerial vehicle (UAV) system. *Automation in Construction, 41*, 1–14.

Uren, J., & Price, B. (2010). *Surveying for engineers* (5th ed.). London: Palgrave Macmillan.

Vosselman, G., & Maas, H.-G. (2010). *Airborne and terrestrial laser scanning*. Dunbeath: Whittles Publishing.

Chapter 25
BIM in Industrial Prefabrication for Construction

Marcus Schreyer and Christoph Pflug

Abstract Building Information Modeling offers enormous potential for increasing the productivity of design, production and quality management processes in the field of industrial prefabrication. To this end, construction software for production models needs to fulfill a series of additional requirements compared with typical planning-oriented CAD systems. Automated production systems require extremely precise geometric data, which requires the use of parametrical modeling techniques and support for common data exchange interfaces for production machinery used in the industry.

25.1 Industrial Production in the Building Sector

Compared with other technical sectors, building construction is predominantly associated with the production of individual entities made using trade skills and craftsmanship. Productivity levels in the building industry, compared with those in other sectors, have stagnated over the past twenty years (Fig. 25.1) due, it is presumed, to the low degree of automation and corresponding higher level of craftsmanship and improvisation. This in turn leads to greater cost uncertainties and lower profit margins in the building industry. The attempt to reduce labor costs by using less qualified, temporary workmen has brought little improvement and also affected the resulting quality of the end result. To meet the need for greater cost-efficiency and quality, the building sector, like other industrial sectors, will need to improve the degree of automation in data processing and production processes.

Today, the construction industry uses industrial production methods primarily for the prefabrication of construction element in static production facilities. Steel manufacturing employs automated methods for the thermal cutting, welding, boring and marking of sheet steel and steel profiles. These systems are controlled using

M. Schreyer (✉) · C. Pflug
Max Bögl Group, Sengenthal, Germany
e-mail: mschreyer@max-boegl.de; cpflug@max-boegl.de

© Springer International Publishing AG, part of Springer Nature 2018 413
A. Borrmann et al. (eds.), *Building Information Modeling*,
https://doi.org/10.1007/978-3-319-92862-3_25

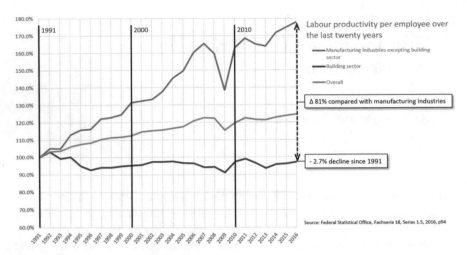

Fig. 25.1 The productivity of the building sector compared with other manufacturing industries

numerical control (NC) data, for which object-oriented 3D interface standards have been developed by national associations, for example the CIS/2 CIMSteel Integration Standards (Eastman and Wang 2004; Reed 2002).

In the prefabrication sector, industrial standards have also been established for the digital control of production machinery based on object-oriented 3D models. For example, reinforcement objects from digital models are passed on for further processing by bending machines and mesh welding robots using open standards. In carousel production, a multi-stage production process for mass production in which the production item passes a series of workstations in succession that are interlinked by a controlling computer, the Unitechnik CAM[1] (Computer-Aided Manufacturing) interface has become the industry standard. In timber and formwork construction, control standards have existed since the mid-1980s (for example those developed by the company Hundegger) for the automated computer numerical control (CNC) of machinery and trimming machines (Willmann et al. 2016).

Complex compound building systems, such as building elevation panels or component assemblies for technical installations are made in multi-step production processes in which multiple different assembly lines need to be coordinated. The design must therefore consider not only the technical requirements but also the logistics of production and transportation, for example the maximum size, position of mounting points and future maintenance needs. To help the designer manage these different complexities, production-oriented CAD programs use parametric design approaches, such as those discussed in Sect. 25.3. The key to successful automation in modern-day building construction lies not in making products more uniform but in the machine-readable parametric description of said products. This

[1] https://www.en.unitechnik.com/

makes it possible to reconcile the hitherto incompatible requirements of design flexibility and highly-automated production processes.

25.2 Production Models for Digital Production Methods

25.2.1 CAD-CAM Process Schema

To digitally transfer control instructions to CNC machine tools, data from a CAD model must be processed using Computer-Aided Manufacturing software. CAM systems initially create system-independent NC control code. An additional software component, a post-processor, is required to adapt these instructions to the respective machine tool.

CAM systems offer several advantages over the previous method of directly programming NC instructions. CNC machines can remain productive while the instructions are being created in the CAM system, and can be organized in a central pre-production group. All machine programming can also be undertaken within the same development environment, simplifying data exchange between the different production facilities and saving costs.

The computer-aided manufacturing process comprises several successive stages, which can vary depending on the respective production process. The basis is a 3D model of the workpiece, which describes all aspects of the resulting element in detail, complete with mounting markings. If the element is to be made from a billet – a raw, unmachined part – this is also modeled and transferred to the CAM system (see Fig. 25.2).

In the CAM module, the individual steps of the production process are defined along with the respective production methods. Dialog boxes make it possible to define technical parameters for the construction process such as the spindle speed

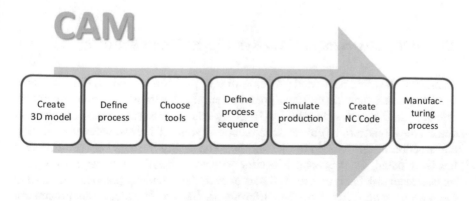

Fig. 25.2 The stages of a CAM process

or tool feed. The CAM software then automatically computes the tool path and succession of work steps to produce the required geometry from the billet taking into account the different working parameters. The sequence of these steps forms the basis for simulating the NC process in a virtual environment, which traces the tool path, shows the tool being moved and the resulting geometry of the object as it changes over time during the milling process.

After successful completion of the simulation – i.e. without collisions between tools, the item being processed and the clamping mechanism – the CAM system generates system-independent control code and passes it on for post-processing to create the specific NC code for the tooling machine.

25.2.2 Requirements for Production Models

Prefabricated building elements are rarely made of a single, homogeneous material. Typically, they comprise multiple individual elements assembled into a component, which in turn may consist of core and extension sections. Manufacturing oriented modeling programs can describe the logic of the assembly of these multi-part components. The same applies for the precise mathematic description of all the points on the surfaces of free-form geometries. For better performance, most CAD programs employ a simplified representation of the 3D geometry of curved elements that approximate the actual curved form. Such simplifications are not, however, appropriate for machine tools, and may cause tolerances to be exceeded or result in visible kinks in the surfaces or edges of the final element. For manufacturing purposes, production models must also contain all necessary details, all individual elements, their connections, along with any reinforcement within to make it possible to derive assembly plans. At the same time, all attributes for its later assembly must also be included in the model, such as its position or serial number, its surface quality along with any marker objects.

25.3 Object-Oriented CAD Systems in Manufacturing

To address the aforementioned particularities of production models, CAD systems need additional functionality that goes beyond the capabilities of most planning-oriented CAD systems. In addition to being able to precisely model all element details, they must also be able to simultaneously show all the elements of a building construction in relationship to one another. The ability to scale between different levels of detail, from general overview to precise details, is a demanding data management task but is an essential part of everyday modeling practice. To manage the various requirements of the different production, logistical and procedural processes, object-oriented CAD systems make it possible to enter parametric building element catalogs for elements such as those shown in Figs. 25.3 and 25.4.

Fig. 25.3 Simulation of the milling process of the contact surface of a steel compression pad

Instead of manually constructing standardized building elements, the geometry of variable-sized elements is described by a series of complex boundary conditions, which are defined as parameters. The actual resulting geometry of the building element can be varied by adjusting the respective parameters (see Fig. 25.4).

The creation of such parametric building element libraries is the key to improving the speed of construction processes, however creating them requires detailed technical knowledge and good experience of construction. As they become more detailed, production models can grow to a size of several hundred thousand objects, each of which has several object properties, such as their material composition or position number. In a conventional list format, these are hard to check for errors. An alternative approach is to color-code building elements based on rules so that it is possible to graphically verify the building element parameters: deviations or missing details are easier to spot and correct in large data sets.

Despite the availability of all these digital interfaces, plans are still currently required in the prefabrication industry. Using the model-based approach, the model is first constructed and the plan drawings are then derived from the model. Because of the comparatively long lead time required before the first plan drawings can be produced, software systems need to offer ways of making the process efficient in order to be competitive in current market conditions. Object-oriented functions such as automatic part recognition, automatic object positioning, and the output of

Fig. 25.4 Parametric definition of the corner of a prefabricated frame element. © Max Bögl, reprinted with permission

complex (item) lists helps the constructor to create documentation directly from the model data. Other process optimizations resulting from CAD system interfaces include the ability to digitally compute CNC instruction sets for production, to output directly to structural analysis software and to functions for transport logistics and construction and assembly planning.

25.4 Further Aspects of Industrial Prefabrication

In future, we can expect to see developments in the optimization of fabrication processes from other sectors influence the prefabrication of building elements. Aspects such as computer-aided product lifecycle management, quality management and additive manufacturing techniques such as "3D printing", are technologies that are already being employed by innovative companies in the prefabrication and steel construction industries and will in future become standard methods for industrial prefabrication in the building sector.

25.4.1 Product Lifecycle Management (PLM) Systems

PLM software systems are used in large manufacturing facilities to network the processes and systems over the entire product lifecycle of a building element, from its design, preparation for use and quality management through to its use and final recycling.

In technical terms, virtual product data – typically a geometric model, along with associated documents and metadata – is stored in the central database of the PLM system. By storing the data in a centralized system, as opposed to the current separate storage of these entities, it is easier to interlink product data, to manage design variants along with their documents and to conduct work processes entirely digitally (Schorr et al. 2011). Ideally, data only needs to be entered once into the system for it to serve as a basis for numerous automated analysis, verification and reporting functions. PLM systems provide better process integration, making the task of managing the data easier for the user. As such, constructors can concentrate more on those parts of the process that require their value-adding input.

25.4.2 Computer-Aided Quality (CAQ) Management

The inclusion of quality management information in digital models is termed Computer-Aided Quality (CAQ) Management.

The ongoing automation of manufacturing stations and the equipping of machinery with sensors means that key values can measured directly in the production process and attributed to the respective building elements. By networking individual production stations with one another, it becomes possible to create increasingly autonomous production lines. CAQ as a component of cyber-physical systems is a key concept of Industry 4.0 (Rajkumar et al. 2010; Lee et al. 2015; Hermann et al. 2016).

25.4.3 Additive Manufacturing (AM) Techniques

So-called "3D printing" is an additive manufacturing technique that makes it possible to create complex and individual building elements directly from CAD system data without the need for specific tools. The technique employs the layer-for-layer application of a formless substrate made of metal alloy, plastics or ceramics that is melted or polymerized point by point to create a solid object from the CAD data. While this method has been used for some time in the field of rapid prototyping, current research, for example at the University of Southern California in Los Angeles, is aiming to use this technology to produce prefabricated building elements, or even entire serially-produced buildings, using a technique called "Contour Crafting" (Khoshnevis 2004; Zhang and Khoshnevis 2013).

25.5 Summary

The use of Building Information Modeling offers enormous potential for improving the productivity of design, production and quality management processes in the field of industrial prefabrication. This potential does not come about on its own but requires detailed consideration of the technology and the conditions and organizational structures under which it is used. Construction software for production models will need to be extended to offer functionality not adequately provided by current planning-oriented CAD systems. A further complication is that, in the coming years at least, users of new model-oriented approaches will nevertheless still also need to provide conventional plan drawings using these new BIM tools and systems. Design offices and production companies will face considerable challenges when automating their processes using BIM, as such changes will not happen quickly, but will entail a more controlled process of wide-ranging changes to processes as a whole. If we fail to embrace the potential that digitization and Building Information Modeling offers for all production and lifecycle phases, we risk no longer being able to satisfy the demand for high-quality but affordable building constructions and may no longer be able to offer staff secure and attractive workplaces.

References

Eastman, C., & Wang, F. (2004). Comparison of steel detailing neutral format (SDNF) and CIMsteel version 2 (CIS/2). *Structures congress*. Nashville: American Society of Civil Engineers (ASCE).

Hermann, M., Pentek, T., & Otto, B. (2016). Design principles for industrie 4.0 scenarios. In *Proceedings of the 49th Hawaii International Conference on System Sciences (HICSS)*.

Khoshnevis, B. (2004). Automated construction by contour crafting-related robotics and information technologies. *Automation in Construction, 13*(1), 5–19.

Lee, J., Bagheri, B., & Kao, H.-A. (2015). A cyber-physical systems architecture for industry 4.0-based manufacturing systems. *Manufacturing Letters 3*, 18–23.

Rajkumar, R. R., Lee, I., Sha, L., & Stankovic, J. (2010). Cyber-physical systems: The next computing revolution. In *Proceedings of the 47th ACM Design Automation Conference*.

Reed, K. A. (2002). The role of the CIMsteel integration standards in automating the erection and surveying of constructional steelwork. In *Proceedings of the 19th International Symposium on Automation and Robotics in Construction (ISARC)* (pp. 15–20).

Schorr, M., Borrmann, A., Obergriesser, M., & Ji, Y. (2011). Employing product data management systems in civil engineering projects: Functionality analysis and assessment. *Journal of Computing in Civil Engineering, 25*(6), 430–441.

Willmann, J., Knauss, M., Bonwetsch, T., Apolinarska, A. A., Gramazio, F., & Kohler, M. (2016). Robotic timber construction – expanding additive fabrication to new dimensions. *Automation in Construction, 61*, 16–23.

Zhang, J., & Khoshnevis, B. (2013). Optimal machine operation planning for construction by contour crafting. *Automation in Construction, 29*, 50–67.

Chapter 26
BIM for 3D Printing in Construction

Jochen Teizer, Alexander Blickle, Tobias King, Olaf Leitzbach,
Daniel Guenther, Hannah Mattern, and Markus König

Abstract Three-dimensional printing – often known as additive manufacturing
or the layered production of 3D objects – has been the focus of attention in the
media at present and a subject that arouses great expectations in the construction
industry. While the topic is rapidly emerging, 3D printing has the potential of
simplifying key processes in the facility lifecycle, for example, by following design
to production principles and reducing waste while increasing the quality of the final
product. A pivotal piece in the success of 3D printing in construction is the Building
Information Modeling (BIM) method. Since BIM already serves as a rich source
of geometric information for commercially-existing, large scale, and automated 3D
printing machines, 3D printing robots co-existing with human workers on construc-
tion sites will eventually need scheduling and assembly sequence information as
well to maintain safety and productivity. As suitable 3D printing techniques and
materials are still parts of wider research efforts, applications by early adopters in
the construction industry demonstrate how 3D printing may benefit and at some
point in the future complement existing construction methods like prefabrication or
modularization.

J. Teizer (✉)
RAPIDS Construction Safety and Technology Laboratory, Ettlingen, Germany
e-mail: jochen@teizer.de

A. Blickle
Ed. Züblin AG, Stuttgart, Germany
e-mail: alexander.blickle@zueblin.de

T. King · D. Guenther
voxeljet AG, Friedberg, Germany
e-mail: tobias.king@voxeljet.de; daniel.guenther@voxeljet.de

O. Leitzbach
MEVA Schalungs-Systeme GmbH, Haiterbach, Germany
e-mail: lb@meva.de

H. Mattern · M. König
Chair of Computing in Engineering, Ruhr-Universität Bochum, Bochum, Germany
e-mail: hannah.mattern@rub.de; koenig@inf.bi.rub.de

© Springer International Publishing AG, part of Springer Nature 2018
A. Borrmann et al. (eds.), *Building Information Modeling*,
https://doi.org/10.1007/978-3-319-92862-3_26

26.1 Introduction

Three-dimensional (3D) printing, also known as additive manufacturing, has recently been a focus of attention in the media – and the subject has raised great expectations. In many industrial sectors, 3D printing, which is often seen as superior to conventional methods, has become an established technology for the fabrication of 3D objects. The layered production of scaled prototypes and smaller series typically involves automated computer controlled systems that rely on a-priori designed digital 3D models. The existing principles of modeling, printing, and finishing are based on various materials – such as different kinds of paper, polymers, or metal materials – which are cut, melted, or softened in order to be printed into shape.

The Building Information Modeling (BIM) method extends the traditional 3D modeling, as it offers the seamless integration and management of many previously defined processes of design, planning, construction, as well as operation and maintenance, including scheduling (4D), cost estimation, and progress tracking (5D). Together, they provide the necessary basis for commercially available or to-be-developed 3D printing strategies for construction.

While the advantages and limitations of the 3D printing processes require a careful review for its final application, the construction industry itself has successfully adopted several industrial applications – for example where consecutive layers of concrete are combined into a desired structure or form. One of the key challenges of construction, however, is the need for large scale 3D printing of complex geometric shapes in the scope of projects where construction time, cost, and quality are the predominant and determining success criteria. While complexity and scale of the planned structure can usually be managed at finer detail during the architectural design process, the final fabrication of large scale geometric shapes often fails because of constructability issues.

This article introduces conventional construction methods for large-scale and complex geometric structures using purpose built automated and robotic 3D printing machines. It therefore contributes the missing link between demanding architectural design and design to production techniques that otherwise could only be built at large cost. Commonly known advantages and limitations of existing 3D printing processes, including modeling, printing, and finishing principles are reviewed, and the novelty of using Building Information Modeling (BIM) for 3D printing is presented. Further, the significance of resolution, speed, and quality of materials in 3D printing are explained, and exemplary results of implementing a complex formwork in a major capital construction project are shown. Preliminary benefits and limitations from the perspective of a construction company explain what it takes to advance 3D printing to a field-ready construction method. Finally, an outlook investigates how BIM can leverage its potential for 3D printing.

26.2 Background on 3D Printing

One of the roots of additive manufacturing lies in a MIT patent by Sachs et al. (1993). It describes "a process for making a component comprising the steps of (1) depositing a layer of a powder material in a confined region; (2) applying a further material to one or more selected regions of said layer of powder material which will cause said layer of powder material to become bonded [..]; (3) repeating steps (1) and (2) [..]; (4) removing unbounded powder material [..]".

As a digital means of fabrication, 3D printing offers many advantages. Computer control of the manufacturing sequence allows for latitude and shorter production times, often just a matter of days from design to the finished object. Analogue forms of production, in contrast, frequently involve a lot of stages and take much longer. 3D printing is found in many realms of work – in mechanical engineering, in metal pouring, medical technology, research and development, design and education. In architecture, the technology reveals its advantages especially in the creation of 3D building models. Construction companies, however, have yet to develop a strong business case to be able to implement the technology and its overlaying processes in practice.

26.2.1 Principles of 3D Printing

The fundamental principle of 3D printing is based on using a computer to reduce a three-dimensional volume to a series of 2D layers. What are initially virtual layers are then built up into a real object, for which the individual layers are produced successively; for example, by means of laser rays. The process is generative or additive. The principle is implemented by machines in a number of different forms.

26.2.1.1 Stereolithography (SLA)

Stereolitography (SLA), for example, is based on a process in which a platform is repeatedly lowered into a bath of synthetic resin (Fig. 26.1). The very thin layers formed in this way are hardened by exposure to ultraviolet (UV) laser rays. Projecting parts have to be supported, and, after hardening, the resin is smoothed. This step is repeated until the construction object is complete. The elements themselves are strong and transparent and have a good resolution. Usually, polymerhybrid resins are used in this method. In part, they contain ceramic additives and are as strong as 2k cast resins. The largest machines have a capacity of up to two cubic meters. This process is, therefore, especially suited to create architectural models.

Fig. 26.1 Diagrammatic
depiction of the
Stereolithography 3D printing
system. (© Voxeljet AG,
reprinted with permission)

Fig. 26.2 Selective Laser
Sintering (SLS). (© Voxeljet
AG, reprinted with
permission)

26.2.1.2 Selective Laser Sintering (SLS)

Another process is Selective Laser Sintering (SLS). A thin layer of powder is poured onto a platform which is moved inside a steel container or "box" (Fig. 26.2). The material is shaped in a series of layers that are fused together by means of a laser ray.

The individual steps are repeated until the building component is complete as a powder block. After the units have cooled, they are cleaned of loose powder. Overall, the SLS process can lead to a high degree of resolution and to excellent strength. The surface quality – often an important criterion for a construction company to get its work approved and paid – will depend on the material used. Usually, particles of medium grain (ca. $50\,\mu m$) are used, creating a porous, but not coarse, finish. It is possible to process metals, such as aluminum, rust-free steel, and titanium, as well as plastics – polyamide mainly. With regard to the thermomanagement of the machines, elements not much larger than an eighth of a cubic meter in size are produced.

Fig. 26.3 Fused deposition
modeling (FDM). (© Voxeljet
AG, reprinted with
permission)

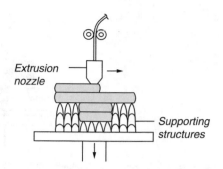

Fig. 26.3 Fused deposition
modeling (FDM). (© Voxeljet
AG, reprinted with
permission)

26.2.1.3 Fused Deposition Modeling (FDM)

Fused deposition modeling (FDM) is a process by which plastifiable building material is extruded through a usually heated nozzle (Fig. 26.3). The latter is moved in relation to the construction platform.

The shape of the element is defined in outline, and the enclosed area is then filled. Different kinds of material can be used with this method – such as plastic, wax, concrete paste or ceramic paste. A variation of this system is known as "contour crafting" (Khoshnevis 2004), whereby an adjustable outer rim prevents the material from flowing out unimpeded. The rim consists of parallel slabs or strips that can be turned around the nozzle. In this way, for example, rapid-hardening vertical concrete wall elements can be formed (Khoshnevis et al. 2006). This process only allows for a low resolution. For bigger volumes, very large nozzles are required (Guenther 2015). Although the method is suitable to bring about spaces of more than $10 \, \text{m}^3$, a major limitation is still to be seen in the precision – as the structures are formed by huge (and, most likely, free-swinging) nozzles. According to construction industry experts, the accuracy of the final surface, for example of concrete walls, has to be within millimeters in order to be accepted by a client.

26.2.1.4 Powder Bed and Inkjet Head 3D Printing

3D printing with inkjets is closely related to surface printing on paper. In contrast to the techniques described earlier, inkjet print heads, usually with several thousand nozzles, are not drawn along a contour line, but across the construction area (Fig. 26.4). As is common in additive manufacturing processes, the part to be printed is built up from many thin cross sections of the 3D model.

The liquid is hardened after leaving the head – for example in a polymerization process stimulated by a hardener that was previously mixed into the powder. In non-powder-based applications, the supporting structure and the construction element are printed with different materials – similar to FDM techniques. In powder-based processes, various ground materials can be applied over a large area while the print head selectively prints binder onto the surface where the parts are to be produced,

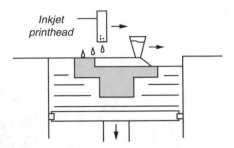

Fig. 26.4 3D printing with inkjets. (© Voxeljet AG, reprinted with permission)

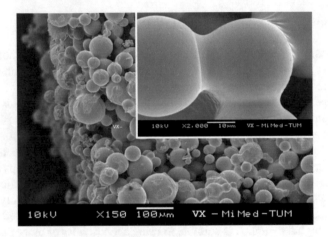

Fig. 26.5 Binding mixture of particle materials (Lim et al. 2011)

thus solidifying the respective area. The process is repeated until the object is complete. Powder-based methods are limited by the grain size of the material, which cannot be reduced at will. The strength of these products is generally low, but it can be increased subsequently by incorporating 2K synthetic resin. The spatial volume of the largest production machine at present is $8\,m^3$ (Guenther 2015). An example for a PolyPor system with binder-based acrylics (a mixture of binder monomers and chemical activator in the powder Teizer et al. 2012) is shown in Fig. 26.5.

26.2.2 Cost of 3D Printing

The overall costs of 3D printing include the machines, materials, and labor. The latter is mainly related to the extraction stage. SLA and SLS are the most expensive 3D printing processes to date, with costs of more than € 30,000 per m^3. Powder-based 3D printing with sand costs about € 3,000 per m^3, and the FDM process, depending on the type of material, costs less than € 2,000 per m^3.

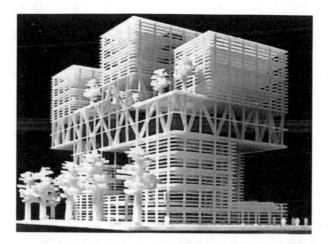

Fig. 26.6 Color-printed building model. (© Rietveld Architects, New York, reprinted with permission)

Pending the application, 3D printing as a design-to-production process reduces the overall cost (about 30% less compared to conventional computer numerical control (CNC) machining). Although the use of sustainable material resources for efficient production is still under research, 3D printing has potential to significantly reduce waste that typically occurs on construction sites.

26.2.3 Direct and Indirect Use of 3D Printing

A distinction is made between the direct use of 3D printed units and the indirect manufacturing of elements by means of 3D printed tools. Many architects, for example, already employ models of buildings created with 3D printing machines for presentation purposes. A special feature of powder-based 3D printing is the use of color (Fig. 26.6). Obstacles to a wider application in the design process are the high costs and the necessary effort to prepare and use the respective data.

26.2.4 Techniques in Construction Applications

Several individual cases exist where engineers applied 3D printing in practice. Some of them will be briefly highlighted here. A manufacturing technique known as the "D-shape process" – developed by the Italian engineer Enrico Dini and first presented in 2009 – used an inorganic liquid solidifying agent that is poured into the powder mix. Figure 26.7 shows part of a large pavilion that was created in this manner.

Fig. 26.7 A 3D-printed architectural object made from powder mixture with inorganic solidifying agent. (© Voxeljet AG, reprinted with permission)

Fig. 26.8 House assembled from printed basic elements, manufactured by Winsun. (© Voxeljet AG, reprinted with permission)

The Chinese company Winsun is developing entire buildings by means of 3D printing. With a technique similar to contour crafting, wall elements are manufactured based on extruded prismatic bodies; i.e. there is no change in their cross-sectional form over their full height. Due to the rather simple form of such elements, they can be assembled using conventional hoisting techniques. They then form constructional components that can be used in buildings – currently ranging from single-family houses (Fig. 26.8) to multi-story (5) housing blocks.

As an alternative to direct production, indirect processes use forms that were originally designed as tools. For example, sand forms are already being printed in large numbers for applications with cast metal. They can also be used for mineral castings and concrete. As with metal castings, the mold is usually unfit for use after a single pouring, but the advantage of this system is the possibility to insert reinforcement in the mold prior to casting. Figure 26.9 shows a concrete column

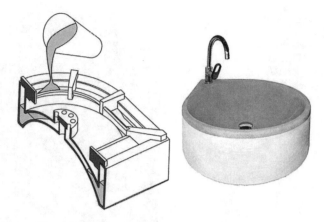

Fig. 26.9 Cast-concrete washbasin: diagrammatic depiction of the casting process in 3D printed form (left); finished washbasin with tap fitting (right). (© Voxeljet AG, reprinted with permission)

form for a washbasin cast in two halves. Similar processes have been used to produce sculptures using ultra-high-performance concrete (UHPC) or free-form facade elements.

26.2.5 Ongoing Research Activities

A lot of current research is focused on the materials used. Efforts are being made to exploit the properties of UHPC in powder-based 3D printing techniques. Investigations (Guenther 2015) have led, for example, to a cement-based material that, after final treatment, possesses a closed, weatherproof surface with great fire resistance. An example of a screen wall with dimensions of roughly 5×2 m is shown in Fig. 26.10. Its strength, however, is not comparable with normal concrete, which is why it is not suitable for load-bearing elements.

Many investigations are also concerned with integrating other construction elements in what are essentially monolithic components such as reinforcements, conduits and cables. The 3D Print Canal House project in the Netherlands is another example. It investigates the use of printing techniques in the field of architecture. In this project, a large FDM machine was installed in a container. The setup is operated close to the construction site (see Fig. 26.11), using a synthetic material (which is, externally, also known "bio-plastic"). After being printed, the elements can be assembled directly. Alternatively, hollow forms filled with concrete can be used for load-bearing purposes.

A further example of printing entire houses is the work of the group 3M-FutureLab, led by Peter Ebner. An extremely compact "micro-home", developed as a student project, was printed out to full scale as a demonstration object. It was

Fig. 26.10 Directly printed building component consisting of cement-bonded material; design: Wieland Schmidt. (© Voxeljet AG, reprinted with permission)

Fig. 26.11 Fused deposition modeling process: 3D Print Canal House; DUS architects, Amsterdam. (© Voxeljet AG, reprinted with permission)

produced in two half-shells as a sand model (Fig. 26.12). This home is supposed to offer just about enough space to live – with a floor space of only a few square meters and a height of approximately 3 m.

In mechanical engineering, 3D printing techniques are well established. In construction, however, 3D printing is not yet very common, despite all the potential societal benefits. Currently, the largest construction components are made using extrusion methods, but their monolithic character makes it difficult to incorporate other components such as reinforcement, insulation, and building systems technology. With the use of sintering techniques, it is possible to produce entire building elements, but high costs often prevent a wider application.

Since transformation processes regarding well-established best practices in the industry can – and usually do – take a long time, the respective changes in the construction industry will not take place immediately, but gradually. New approaches that are likely to enrich existing construction methods, such as pouring

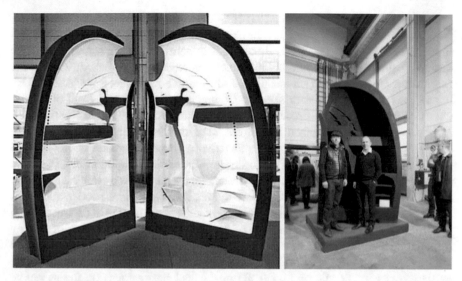

Fig. 26.12 "Micro-home" printed as a sand model; design: Peter Ebner and 3M Future Lab. (© Voxeljet AG, reprinted with permission)

concrete into 3D printed forms, offer an alternative to conventional formwork. Soon, they might become established techniques. The many different techniques and materials used in 3D printing demonstrate that there is a great potential for its use in construction and that the method offers a new scope for design. For these reasons, a new research project was initiated to investigate 3D printing in construction in greater detail.

26.3 Methods

26.3.1 Interdisciplinary Team Building for Setting Goals and Work Steps

The case study that is presented involved the companies Ed. Züblin AG (a large construction company that belongs to STRABAG SE), voxeljet AG (a manufacturer of 3D printing machines and supplier of large scale 3D print elements), and MEVA Formwork Systems (expertise in formwork systems). They teamed up to investigate the understanding and potential of 3D printing in the construction of complex-shaped geometric concrete elements. Ed. Züblin AG's research and development team took a leading role in the project. The Chair of Computing in Civil Engineering at the Ruhr-University Bochum added further expertise in BIM, automation, and robotics.

After aligning the project team and setting the goals, the following main work tasks were agreed upon and executed. First, in order to improve some of the existing

processes of design, planning, and the actual work, they had to be analyzed in great detail with regard to their potential return on investment (ROI). Building information modeling (BIM) processes were about to be integrated, i.e. the use of digital 3D design techniques that 3D printing machines can read and automatically use in the fabrication process. Based on techniques of Additive Manufacturing (AM), BIM-layered data are converted to specific Computerized Numerical Control (CNC) codes, enabling large scale processes for Rapid Manufacturing (Buswell et al. 2008) and fully-automated manufacturing of complex building components (Ding et al. 2014). Second, the team took time to analyze the aspect of market potential and to ensure technical feasibility. The third phase focused on digital design based on existing architectural drawings. Tests on smaller scale (reason: small investment and risk) were conducted to demonstrate the feasibility of the respective approach. Meanwhile, the team determined a suitable test site for the final field trial, according to the criteria defined at the beginning of the project (i.e. answering one of the key research questions, about where 3D printing makes most sense – economically as well as from the viewpoints of construction methods and quality). Repeating the earlier process of creating a digital 3D design put heavy focus on the aspect of potential constructability. Second to last, the elements were printed and prepared for the final field trial. The steps can be summarized:

1. Understanding conventional and desired construction processes
2. Survey of market potential and technical feasibility
3. Digital design processes and BIM design generation
4. Test printing of small scale 3D prototypes
5. Selecting a test site and finalizing the digital design
6. 3D printing of elements including the infiltration of the surface with resin for hardening
7. Final large-scale implementation and tests in a realistic construction project
8. Critical review of results and needs statement for future research and development in automation and robotics for 3D printing

Some tasks, due to their nature, overlapped with others and were scheduled to take place simultaneously. Since 3D printing has yet to become a standardized construction method, all elements included in the preliminary tests and the final field trial were not supposed to be part of the final structure. They were solely built for testing purposes, to be archived or destroyed soon afterwards. Due to the nature of being a research project, some of the work steps are still in progress.

26.3.2 Automated 3D Printing Technology and Process in a Factory Setting

This project used the voxeljet AG VX4000 3D printing machine (Fig. 26.13) to produce the sand molds for the elements. The machine's space requirement is 25×12 m and a height of 4.5 m. As a standalone factory, it is one of the largest

Fig. 26.13 3D printing machine VX 4000. (© Voxeljet AG, reprinted with permission)

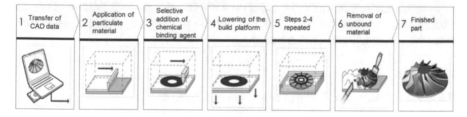

Fig. 26.14 Powder-based 3D printing process. (© Voxeljet AG, reprinted with permission)

industrial facilities of its kind. Fabricating one piece at a time in a safe work environment, it produces elements of up to 8 m^3 (4,000 × 2,000 × 1,000 mm), based on a fully automated layer building process. Depending on size and shape, 3D prints can take several dozen hours (15 mm/h build speed at 600 dpi print resolution), while most pieces weigh a few hundred kilograms or more. The process selected for 3D printing is explained in Fig. 26.14.

The voxeljet 3D printing process offers two plastic materials based on Poly(methyl methacrylate) PMMA (a.k.a. acrylic glass) particles bound by different resins. The PolyPor B binder is ideal for parts that are true to detail and which require a high degree of edge sharpness, resolution, and green compact strength. The PolyPor C binder, on the other hand, lends itself to simplified burn-out processes in investment casting and for architectural models.

The sand types with different granulations are selected individually for each order, depending on the geometry and application purpose. The grain size that is used will determine the surface finish of the cast result. Small grain size might be required for high surface finishing quality, like it is sometimes required for

architectural concrete. The most commonly used sand is made of quartz and is available in the granulations 0.14, 0.19, and 0.25 mm. Another possibility is the more temperature-resistant Kerphalite sand, which is suited for especially complex geometries and internal cores for steel casting (Guenther 2015).

The standard for data exchange is the Standard Tesselation Language (STL). STL uses oriented surfaces that are represented by triangles and allows to identify sectional planes that run through all triangles. In 3D printing. It is sufficient to save cut lines only (2 points per line), which makes data exchange efficient. The creation of the jetting dataset is based on: real-time conditions while printing (allowing some flexibility), movement data, and printing data. Occasionally, it is necessary to replenish the print head and powder reservoir, and to edit the data.

26.4 Experiments and Results

Two experiments were performed: printing (1) small scale 3D elements for early feedback on the design, including material tests and (2) large scale 3D elements to determine constructability, including reusability of formwork system elements. First, however, the wider business scope for 3D printing on a large scale capital-intensive construction project is introduced.

26.4.1 "Stuttgart 21" Main Central Station

The requirements that were set for 3D printing originated from a realistic construction project, called "Stuttgart 21". The heyday of railway stations in the nineteenth century saw great halls for train terminals in many European cities. Typically, stations were erected outside the historic city center, which soon grew around them, turning the tracks into a hindrance to urban development. This is especially true for the city of Stuttgart in southwest Germany. The existing station is a terminus and difficult to connect to the growing European high-speed rail network. New tunnels and an underground station are being built. The most striking features of the new subterranean station will be its brightness and visual openness, which combines aesthetic with security advantages. It will have an attractive special white and light-weight concrete structure subjected only to compressive loads with minimal construction thickness. The thickness of the optimized shell structure, i.e. of the complex parabolic concrete columns, was reduced to one hundredth of the span, thanks to which it is possible to use significantly less material for construction than usual (Figs. 26.15 and 26.16).

These reasons required the reuse of formwork and the prefabrication of modular components which facilitate efficient construction (Lim et al. 2011; Oesterle et al. 2012). Thus, the project is especially attractive for exploring the potential of 3D printing.

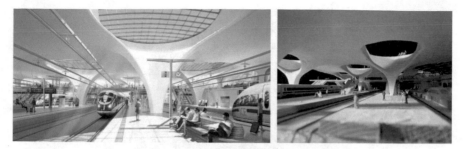

Fig. 26.15 left: "Stuttgart 21" main station with parabolic concrete column, and **right**: design based on an idea by Frei Otto. (© ingenhoven architects, Düsseldorf, reprinted with permission)

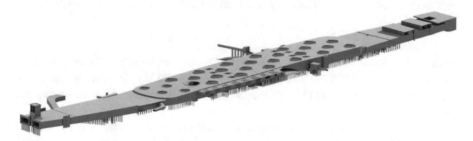

Fig. 26.16 Isometric view on main station model. (© Ed. Züblin AG, reprinted with permission)

26.4.2 Small Scale Testing

The research method was intended to build up on experiments with small-scale test models. A simplified 3D model of the column was generated in available BIM software packages, and divided into two sand mold segments. Later, they were joined together to serve as a formwork system. Aside from developing the general 3D printing process for formwork purposes (Fig. 26.14), the experiment allowed to gather practical experience with handling and hardening the sand mold with epoxy resin, pouring the concrete into the molds, and removing the formwork. Specimens using various binder fillings were 3D printed for standardized material tests (Fig. 26.17). The mechanical properties of the 3D printed specimens exhibited as much as ten times the compressive and tensile strengths of regular concrete. The success of generating the final structure of a small scale parabolic concrete column can be seen in the center of Fig. 26.18.

26.4.3 Large Scale Testing

The large scale test involved detailed element and formwork design as well as construability planning (see one segment in Fig. 26.19) of one parabolic concrete

Fig. 26.17 Compression test of an epoxy-infiltrated specimen. (© Ed. Züblin AG, reprinted with permission)

column in the main station. Due to the size of the concrete model, none of the supporting scaffolding parts were modeled before the 3D printing process. Otherwise, the construction site personnel had to rely entirely on BIM during the construction process.

The elements were further arranged and optimized for efficient 3D printing in the VX4000 (Fig. 26.20). The expected total weight of all four elements was about 840 kg. The 3D printing lasted about 1 day. The next task was to harden the material with epoxy resin, which also took about one day of work (Fig. 26.21). The final task was to erect the 3D printed formwork elements and to pour a layer of concrete. This has yet to be done at the construction site, but has been tested in indoor laboratory-like settings with smaller 3D printed elements already (Fig. 26.22). As the resulting concrete structure shows, the desired complex geometric shape was successfully built. Structural and further quality performance tests, which have been done for the small scale experiment, have still to be conducted to meet the client's demands and any regulative requirements. In future work, it will also be necessary to investigate efficient methods to carry out the entire procedure for all the concrete column elements. The robustness of the 3D-printed formwork elements indicates, after dismantling them from the initial concrete column segment, repetitive use of the 3D-printed formwork elements.

26.5 The Role of BIM and Robots in the 3D Printing Process

Despite the rapid establishment of prefabrication and modularization in construction, most construction projects are of a unique nature – thus requiring an assembly process that is largely based on manual work. Because construction projects tend to involve a diverse range of building components produced by numerous competing manufacturers, the existing BIM knowledge functions well as a basis to develop new approaches that are aimed at a more frequent use of automated fabrication

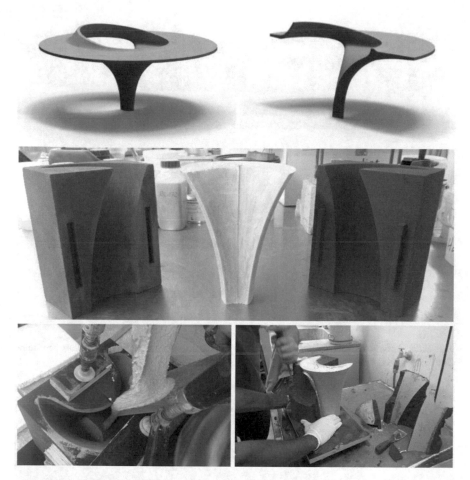

Fig. 26.18 Conceptual 3D model of the parabolic concrete column (top left and cross-sectional cut top right side), printed sand molds (middle image on the left and right side), pouring concrete and removing formwork (bottom image left and right side, respectively) and finished element (center of the middle image). (© Ed. Züblin AG, reprinted with permission)

processes in construction. Thanks to the digital building models – specifically the design, planning, and construction processes, which are all relevant to 3D printing – can be improved significantly.

While 3D printing is an emerging field in construction, the specific application of BIM for 3D printing, i.e. as a data source, is still in its infancy. BIM represents a comprehensive data source by providing a high amount of precise information. A digital model's individual components are characterized by rich semantics that can be applied and extended for various construction planning and analyzing tasks (Bruckmann et al. 2016). BIM connects building component catalogs with digital models by using semantic technologies that were tested for the prefabrication

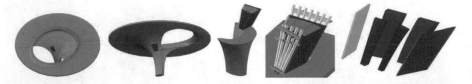

Fig. 26.19 Detailed model, detailed formwork model and extracted formwork elements due for 3D printing. (© MEVA Schalungs-Systeme GmbH, reprinted with permission)

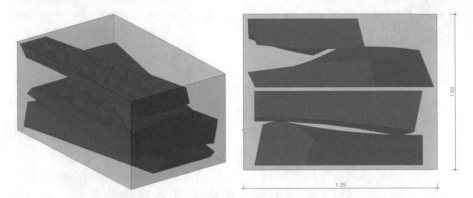

Fig. 26.20 Efficient 3D printing: isometric and front views. (© MEVA Schalungs-Systeme GmbH, reprinted with permission)

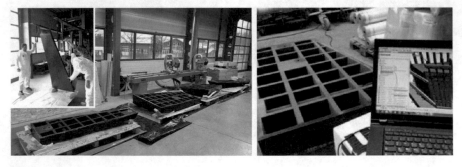

Fig. 26.21 Manual application of epoxy resin on the surfaces of the 3D-printed formwork elements. (© Ed. Züblin AG, reprinted with permission)

and automated production of single building elements, for example on concrete components (Costa and Madrazo 2015).

In construction practice, BIM is already extensively used during project planning and execution. Typical application cases include clash detection and the scheduling of work sequences. Further and more advanced application examples of BIM are the simulation and control of detailed construction site logistics processes, for example BIM-supported site layout planning (Schwabe et al. 2016).

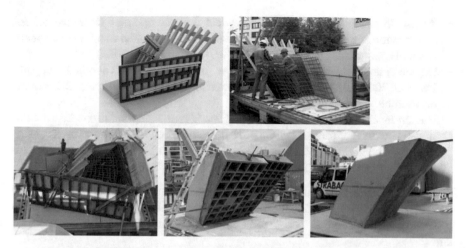

Fig. 26.22 Design-to-production process for a parabolic concrete column segment. (Strabag 2016, reprinted with permission)

BIM, in applications closer to 3D printing, serves as a key element for transparent information delivery in prefabrication and modularization (Buswell et al. 2008). In a variety of projects, BIM solves constructability issues (McGraw Hill 2011), for example by involving manufacturers at an early project stage (Ding et al. 2014), and enables enterprise resource planners (ERP) to link object-related information among modular construction manufacturing (MCM), and permits lean construction stakeholders (Babič et al. 2010) to control optimized material flow (Moghadam et al. 2012).

26.5.1 General Requirements for 3D Printing

While printing concrete is often mentioned in connection with the term '3D printing', there are possible applications for automation and robotics in other areas as well – and throughout the lifecycle of a project. For example, off-site pre-fabrication of original building components or replicas is typically done in a factory-type setting using stationary 3D printing machines. Commercial 3D printing applications for small to medium sized components, for example scaled mock-ups, exist already. On-site 3D printing while construction is underway by using large-scale robots is still under research. There are several general requirements that have to be met before 3D printing can be applied to construction, for example:

- Existence of 3D printing standards (i.e., structural integrity of automatically assembled building components)

- Precise information in digital 4D models (i.e., component reference values, construction site layout, available work space for automated machines or robots, assembly sequence) (Kumar and Cheng 2015; Wang et al. 2015)
- Degree of automation and simulation (i.e., the guidance of a robot's travel paths Lee et al. 2009, 2012) needs to be optimized to yield a highly efficient 3D printing or assembly operation.
- Human-machine interaction demanding intelligent safety solutions i.e., a collision-free work environment might be realized based on real-time location sensing (RTLS) (Cheng et al. 2012; Zang et al. 2015; Golovina et al. 2016) wearable proactive alert technology (Teizer and Kahlmann 2008; Teizer et al. 2010).

Since the annual consumption of concrete in Germany is about 46 million cubic meters, several additional requirements exist before automated 3D printing of concrete can become a widespread application in construction – on-site or off-site:

- Material delivery and placement to produce fast-hardening concrete at large volumes and at economical cost
- Layering of material and the formation of "cold joints" (by layered extrusion)
- Control and measurement of phase transition
- Implementation of reinforcement (fiber orientation)
- Design of print heads delivering high surface finishing quality
- Large scaling of robots meant for outdoor applications (i.e. based on wire robots)

26.5.2 3D Printing with Robots

When examining the typical processes of construction projects, the size of a building lot makes the application of 3D printing robots demanding. A challenge is that existing standard industrial robots hardly cover workspaces of more than five meters in radius. Their considerable weight and their sensitivity to outdoor environments are other major limitations. Tasks that demand high skill levels even from humans, for example bricklaying of irregular shaped walls, might require extensive measures to recalibrate the robot or to customize it in order to perform complex movements.

These are only some of the reasons why many automation approaches that were theorized as early as in the 1950s (Landsberger et al. 1985) failed later, most of them during the first wave of automation attempts in the 1990s (Bruckmann et al. 2016). High manufacturing costs turned out to be a major drawback, which is why such methods could not be successful on a broader level. Currently, there are ongoing projects focusing on novel approaches for brick laying based on serial robot manipulators equipped with a wide range of pose sensors, which, for example, use a manipulator arm to place objects at any desired position on test construction sites (Bruckmann et al. 2016).

The following passage focuses on some of the requirements for 3D printing with robots. Due to its advantages over manipulated robots, a fully-tensioned

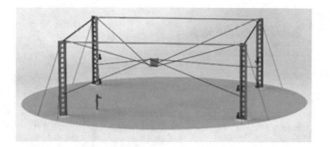

Fig. 26.23 Fully-tensed wire robot (Bruckmann et al. 2016)

wire robot (Fig. 26.23) will serve as an example. Wire robots consist of a set of counteracting cables that are needed to suspend the payload. This allows to actively vary the tension in the system and move the payload. If one cable increases the tension, the others can react with an appropriate force and establish the force equilibrium again. Additionally, this allows to fully constrain the payload and to suppress vibrations effectively. As this method also involves cables below the moving platform, collisions with humans or objects (e.g., parts of the structure that have already been built) might still be an issue. As an option, sliding pulleys on rails can help to avoid this issue (Bruckmann et al. 2016).

For building site layouts that are complex, it is necessary to take special care when customizing the wire robot according to an optimized building sequence:

- Very large workspace: Since it is quite simple to coil up cables of several dozen meters, wire robot can be designed to cover an entire building lot. Simulations could include optimizing storage position and size – thus leading to a reduction in project schedule and costs.
- Simple and inexpensive mechanical elements: Only winches, pulleys, and cables are needed. These elements are traditional and widely used on building lots.
- Easy to install: A wire robot needs a supporting cuboid frame which can be easily erected on site.
- Lightweight and fast: Since a wire robot has nearly no mass except from the payload (about 100 kg including payload Bruckmann et al. 2012), it can move very fast as long as human safety is not affected. Large volumes of concrete are not moved as a whole, but in several smaller batches at fast rates. For large dimensions, the frame may be constructed by lattice girders.
- Material characteristics: Robots can easily pick and place prefabricated materials, e.g. steel or bricks. This is not so easily possible especially with material that is self-compacting or self-assembling. Concrete is an example of interest to 3D printing. The ability to predict the development of strength of fresh cementitious materials (Fig. 26.24) is important for several reasons such as formwork pressure and the building rate in extrusion systems (Wangler et al. 2016).
- Precision: A wire robot is a combination of computerized cranes that act in a synchronized manner, keeping the appropriate cable lengths and cable tensions

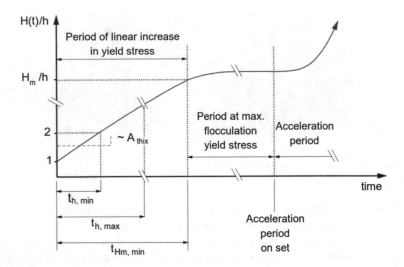

Fig. 26.24 Element height vs. time for digital concrete processes. For concrete processes, the initial strength correlates to a yield stress limited by the flocculation processes. Hydration at the beginning of the acceleration process is necessary for higher element height and faster vertical building rates (Wangler et al. 2016)

to precisely move materials to the desired position. A precise execution of the planned tasks helps to ensure high product quality. The achievable level of working precision needs to be investigated (i.e., the influence of external factors including forces, elasticities, and inertia) which might result in higher demands concerning robot platform stiffness.

- Flexibility: A wire robot can carry multiple tools (i.e., extruding concrete using specialized nozzles, picking and placing of door lintel, sawing lumber) to meet the demands of setting concrete like contour crafting or placing pre-fabricate or modularized elements.
- Navigation: The planning of the assembly process is based on a catalog of automated processes. BIM represents a valuable source of information for building geometry and material, while the construction schedule provides further information on the installation sequence (Fig. 26.25). A common data format for the task of exporting moving paths to the control system of the wire robot needs still to be developed.
- Input data from BIM: When using the neutral IFC format to exchange building information, there are no restrictions regarding the applied modeling software. The site layout plan modeled in BIM restricts the maximum size of a robot. The model delivers information concerning building geometry and material type.
- Construction and supply chain methods: It is necessary to consider wire robot (de-)mobilization efforts and their effects on conventionally performed assembly

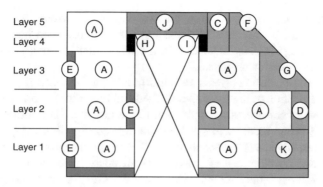

Fig. 26.25 Wall installation plan with layers based on KS-PLUS Wandsystem GmbH (2016)

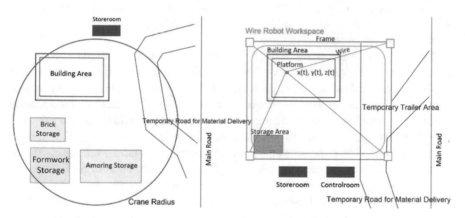

Fig. 26.26 Exemplary building site equipment (without and with wire robot) (Mattern et al. 2016)

processes and the supply chain. Figure 26.26 shows, for example, two fictitious and simplified site layout plans – conventional and automated with a 3D printing robot.

26.6 Summary

Despite the high potential to improve the productivity, quality, safety, and also the potential impact on reducing costs, automated technologies are not widely spread in the construction sector. This chapter presented a review of the existing methodologies and practices in 3D printing. Special attention was paid to the use of BIM for the automated printing of 3D objects and, furthermore, on developing a concept that uses robots for 3D printing on construction sites. In this context, building information models may serve as input data to define collision-free motion

profiles which can be exported to the robot control system. An investigation resulting in a needs statement revealed how each domain can benefit from one another by leveraging the information that BIM inherently provides to control the planning and production processes.

Additive manufacturing offers new opportunities in the production and in particular in the fabrication of highly individualized and repetitive modules. It is likely to impact the entire construction supply chain. The fact that 3D printing is currently quite present in the media will surely encourage construction companies to start exploring alternative construction methods. Therefore, the current interest to invest in research and development is growing, albeit many issues remain that demand intelligent solutions. Many of them relate to structural engineering and quality issues (i.e. material properties, placement, implementation of reinforcement, hydration control, formation of cold joints, impact on durability and surface finishes) and some, of which many are of high relevance to construction companies, relate to placement and constructability issues.

The presented case study on 3D printing portrayed the realistic scenario of a construction company that investigates alternative construction methods. The application of small-scale and large-scale 3D printing for complex shaped concrete formwork elements served as an example to outline a successful development procedure – which is to be considered as part of a transformation process.

3D printing of concrete, as one example for digital fabrication, still requires intense collaboration of architects, structural engineers, materials scientists, roboticists, and construction specialists, among others. If construction organizations are to make investments in the near future, standardized 3D printing processes will have to impact the bottom line: cost, time, quality, and safety. For the technology itself, it will be important to rely on open data formats, process-oriented design and constructability planning, and flexible material characteristics that yield highest quality work and reduce existing waste as noted also in Oesterle et al. (2012), Teizer et al. (2016) and Wangler et al. (2016).

References

Babič, N. Č., Podbreznik, P., & Rebolj, D. (2010). Integrating resource production and construction using BIM. *Automation in Construction, 19*(5), 539–543.

Bruckmann, T., Lalom, W., Nguyen, K., & Salah, B. (2012). Development of a storage retrieval machine for high racks using a wire robot. In *Proceedings of the ASME International Design Engineering Technical Conferences and Computers and Information in Engineering Conference* (pp. 771–780).

Bruckmann, T., Mattern, H., Spengler, A., Reichert, C., Malkwitzc, A., & Knig, M. (2016). Automated construction of masonry buildings using cable-driven parallel robots. In *Proceedings of the 33rd International Symposium on Automation and Robotics in Construction*, Auburn (pp. 332–340).

Buswell, R. A., Thorpe, A., Soar, R. C., & Gibb, A. (2008). Design, data and process issues for mega-scale rapid manufacturing machines used for construction. *Automation in Construction, 17*(8), 923–929.

Cheng, T., Mantripragada, U., Teizer, J., & Vela, P. A. (2012). Automated trajectory and path planning analysis based on ultra wideband data. *ASCE Journal of Computing in Civil Engineering, Reston, Virginia, 26*, 151–160.

Costa, G., & Madrazo, L. (2015). Connecting building component catalogues with BIM models using semantic technologies. *Automation in Construction, 57*, 239–248.

Ding, L., Wei, R., & Che, H. (2014). Development of a BIM-based automated construction system. *Procedia Engineering, 85*, 123–131.

Guenther D. (2015). 3D printing – The state of the technology and the future of this process. *Detail – Technology* (pp. 596–600).

Golovina, O., Teizer, J., & Pradhananga, N. (2016). Heat map generation for predictive safety planning: preventing struck-by and near miss interactions between workers-on-foot and construction equipment. *Automation in Construction, Elsevier, 71*, 99–115.

Khoshnevis, B. (2004). Automated construction by contour crafting-related robotics and information technologies. *Automation in Construction, 12*, 5–19.

Khoshnevis, B., Hwang, D., Yao, K., & Yeh, Z. (2006). Mega-scale fabrication by contour crafting. *Industrial and Systems Engineering, 1*, 301–320.

Kumar, S. S., & Cheng, J. C. (2015). A BIM-based automated site layout planning framework for congested construction sites. *Automation in Construction, 59*, 24–37.

KS-PLUS Wandsystem GmbH. (2016). *Maßgeschneiderte Lösungen aus Kalksandstein*. Retrieved from http://www.ks-plus.de/5_1771_KS_PLUS_gesamt.pdf. Accessed Jan 2017.

Lee, G., Kim, H.-H., Lee, C.-J., Ham, S.-I., Yun, S.-H., Cho, H., Kim, B. K., Kim, G. T., & Kim, K. (2009). A laser-technology-based lifting-path tracking system for a robotic tower crane. *Automation in Construction, 18*(7), 865–874.

Lee, G., Cho, J., Ham, S., Lee, T., Lee, G., Yun, S.-H., & Yang, H.-J. (2012). A BIM- and sensor-based tower crane navigation system for blind lifts. *Automation in Construction, 26*, 1–10.

Landsberger, S. E., & Sheridan, T. B. (1985). A new design for parallel link manipulator. In *Proceedings Systems Man and Cybernetics Conference* (pp. 812–814).

Lim, S., Buswell, R., Le, T., Austin, S., Gibb, A., & Thorpe, T. (2011). Developments in construction-scale additive manufacturing processes. *Automation in Construction, 21*, 262–268.

Mattern, H., Bruckmann, T., Spengler, A., & Knig, M. (2016). Simulation of automated construction using wire robots. In *Proceedings of the 2016 Winter Simulation Conference*, Washington, DC.

McGraw-Hill Construction. (2011). Prefabrication and Modularization: Increasing Productivity in the Construction Industry. SmartMarket report.

Moghadam, M., Al-Hussein, M., & Umut, K. (2012). Automation of modular design and construction through an integrated BIM/lean model. *Gerontechnology, 11*(2).

Oesterle, S., Vansteenkiste, A., & Mirjan, A. (2012). Zero waste free-form formwork. In *ICFF 2012* (pp. 258–267).

Sachs, E. M., Haggerty, J. S., Cima, M. J., & Williams P. A. (1993). *Three-dimensional printing techniques*, United States Patent, No. 5,204,055, Date of Patent, 20 Apr 1993.

Schwabe, K., Knig, M., & Teizer, J. (2016). BIM applications of rule-based checking in construction site layout planning tasks. In *Proceedings of the 33rd International Symposium on Automation and Robotics in Construction*, Auburn University.

Strabag. (2016). *Research, development and innovation 2015/2016*. Strabag AG.

Teizer, J., & Kahlmann, T. (2008). Range imaging as an emerging optical 3D measurement technology. *Transportation Research Record: Journal of the Transportation Research Board, Washington, DC, 2040* (pp. 19–29).

Teizer, J., Allread, B. S., Fullerton, C. E., & Hinze, J. (2010). Autonomous pro-active real-time construction worker and equipment operator proximity safety alert system. *Automation in Construction, 19*(5), 630–640.

Teizer, J., Venugopal, M., Teizer, W., & Felkl, J. (2012). Nanotechnology and its impact on construction: Bridging the gap between researchers and industry professionals. *Construction Engineering and Management, 138*(5), 594–604.

Teizer, J., Blickle, A., King, T., Leitzbach, O., & Guenther, D. (2016). Large scale 3D printing of complex geometric shapes in construction. In *Proceedings of the 33rd International Symposium on Automation and Robotics in Construction*, Auburn (pp. 948–956).

Wang, J., Zhang, X., Shou, W., Wang, X., Xu, B., Kim, M. J., & Wu, P. (2015). A BIM-based approach for automated tower crane layout planning. *Automation in Construction, 59*, 168–178.

Wangler, T., Lloret, E., Reiter, L., Hack, N., Gramazio, F., Kohler, M., Bernhard, M., Dillenburger, B., Buchli, J., Roussel, N., & Flatt, R. (2016). Digital concrete: Opportunities and challenges. *RILEM Technical Letters, 1*, 67–75.

Zhang, S., Teizer, J., Pradhananga, N., & Eastman, C. (2015). Workforce location tracking to model, visualize and analyze workspace requirements in building information models for construction safety planning. *Automation in Construction, 60*, 74–86.

Chapter 27
BIM-Based Production Systems

Jan Tulke and René Schumann

Abstract The term "production system" is mainly used in connection with the industry of stationary production. It describes the overall system of controlling and monitoring the manufacturing of goods. Companies generally use internal software systems for their own, specific requirements. Such production systems and the related software systems cannot be transferred to construction projects since the conditions of such projects are very specific and varied; production systems are thus hardly ever used in the building sector. The BIM-based approach, which is finding its way into the construction industry, spans various fields of expertise, is geared towards cooperation and standardization and to an in-depth implementation of digitized data processing; it is therefore well positioned to overcome existing obstacles. Restrictive elements (fragmentation, temporary production facilities, unique product) can now be eliminated through the introduction of a BIM-based production system; project control can thus be improved, simplified, and rendered more efficient. At the same time, the method of operation is standardized throughout the entire project. This approach constitutes a fundamental change to project control in the construction industry, which will shift its focus from people to information in future.

This chapter deals with the purpose and conditions of the implementation of a BIM-based production system in construction projects. The relevant information and the modular structure of such systems are described in detail on the basis of practical experience gained in the implementation in various projects.

J. Tulke (✉)
planen-bauen 4.0 – Gesellschaft zur Digitalisierung des Planens, Bauens und Betreibens mbH, Berlin, Germany
e-mail: jan.tulke@planen-bauen40.de

R. Schumann
HOCHTIEF ViCon GmbH, Essen, Germany
e-mail: rene.schumann@hochtief.de

447

27.1 Production Systems in the Building Sector

A production system comprises strategies, concepts, and methods to achieve previously defined targets in the production of goods. It mainly determines the way production is planned and controlled. The principles and components of production systems are generally adapted to the respective corporate strategy, the type of goods produced, and the specific conditions. Targets are mostly defined with a view to the traditional, correlative dimensions of time, quality, and cost. An additional target, flexibility, is given particular significance, as it allows for short-term reactions to changes in production (e.g. due to customer requirements, incidents, circumstances, etc.).

The term "production system" is mostly used in stationary industries and is not common in the construction industry; however, a lot of efforts are being undertaken to transfer Lean management principles (i.e. principles extracted from the automotive industry and derived from an analysis of certain successful production systems) into the building sector.

However, the conditions in the construction industry are fundamentally different from those in stationary industries, and the respective production systems cannot simply be transferred. The only exception to this fact are the areas of pre-fabrication and pre-assembled components (cf. Chap. 25), which play a subordinate role in overall construction volumes. One of the key features of the construction industry is project-driven work, and production is not based on a stationary facility but on a construction site – a temporary production site to create a unique building, in consideration of the local requirements and meteorological effects. In addition, the production team, in particular for major projects executed by joint ventures, is composed of a number of specialized (sub)contractors, each with their own corporate strategies and corporate cultures, and familiar with different methods of operation and production, at least on a low level. The temporary production team at the temporary production site can therefore only establish a temporary production system which is based, in an ideal case, on best practice experience gained by those involved in the project or, less ideally, on the lowest common denominator and an incompatible patchwork structure. The development of a temporary production system at a construction site, taking into consideration the non-hierarchical structures of contractual interfaces and, thus, limited transparency, represents one of the main challenges successful construction project management is facing today. An additional factor is the strong position of the clients, who (in contrast to the party ordering an industrial product) frequently contribute their own requirements concerning the partners to be included in the production team, the inspection and approval processes, or – often until the late stages of the production phase – changes to the building (product) itself.

While the factors listed above have so far impeded the establishment of production systems in the construction industry, Building Information Modeling (BIM), a method that is in the process of establishing itself on a global scale, offers an opportunity to overcome these obstacles and to focus on the implementation of a

standardized, integrated production system for construction projects that is geared towards the individual building (product) and integration of all parties involved. BIM first constructs a building virtually in 3D, including all its complex production processes, doing away with the traditional fragmented 2D plans and incompatible, unrelated information that require individual, mental (and thus subjective and frequently incorrect) interpretation. The BIM-based approach provides for detailed planning of the building and thus facilitates the coordination of production concepts and methods in detail, in particular in the case of incidents that require a reaction. BIM enables the development and flexible adjustment of a production system that is geared towards the unique product of a building and its specific circumstances. The visual transparency of a jointly used integrated model[1] serves to easily integrate the knowledge and expertise of all parties involved, and it helps to communicate impacts due to client requirements. Opportunities aside, it remains to be said that the factors described above are rather individual and, thus, require a certain adjustment or development process at the beginning of a construction project, which is not duly taken into account these days. The pre-project work is frequently limited to work preparation and scheduling. For instance, the production of individual parts, the delivery to and within the construction site, storage yard management and detailed resources management are often not given sufficient attention and detail, contrary to stationary industries. However, if the concepts and supporting software tools are sufficiently flexible, they should be transferable to buildings or to similar types of construction projects (e.g. office buildings, tunnels, bridges, etc.).

27.2 Software Systems Supporting Production Systems

Stationary industry uses so-called production planning and scheduling software systems (PPS software) for the operative implementation, i.e. planning, approval, control, monitoring, and documentation of the production of goods. These systems serve the practical implementation of theoretical concepts and methods of company-specific production systems within a factory's production operation. In addition to actually planning the respective work, the resources required, procurement, etc., they are used to provide planning data to all parties involved in a central and transparent manner, to approve individual steps in the production, to continuously gather actual production data, and to follow up on and archive decisions in the context of production control.

This approach is aimed at replacing a variety of specialized individual software solutions that can only be handled by trained experts with a harmonized system available to all parties involved in the production, thus providing information and software functionalities centrally and for specific functions. Furthermore, the

[1]This is regardless of whether the jointly used data base is very detailed or whether only a consolidated extract of separate specialist models intended for joint coordination is being used.

systems ensure and functionally support compliance with the principles of the corporate production system.

Currently, the construction industry does not use such cross-sectional software systems to support production operation. This is due to the fact that production teams are often temporary – involving several companies, each with its own (incompatible) software program – and due to the restrictions posed to communication by security-protected corporate networks. However, certain applications, such as document and drawing management, are already using software products that are specialized in web-based cooperation across several companies. This is also to be expected for the implementation of BIM-based production systems and is promoted by the increased international push for open data standards (IFC, COBie). As has been stated above, the level of detail of such systems results in a higher need for configuration and adaptation to the specific project than is the case with customary standard software products today. This is an effort that the software companies will no longer be able to undertake alone. Instead, BIM Managers (cf. Chap. 16) are expected to configure, adjust, and maintain the software systems in line with the requirements of the respective project's production system. As a result, the system needs to be modular and suitable for flexible configuration (both on a functional level and with regard to role-specific level of detail) so as to prevent the need to develop new software products for each project.

At the same time, having such a software system will implicitly determine the fundamental principles of a production system for each project, rendering the project success less dependent on the personal approaches of those involved in the project. It will therefore also be referred to as a software system to establish a production system.

27.3 Data Communication on the Project

The flow of data to communicate project-related information can basically be divided into three steps (cf. Fig. 27.1), with the first two (data editing and data utilization) to be executed by a software environment that supports a production system.

The first step consists of the mostly decentral *data generation* by specialized authoring software products that support a special application or process – and it only provides the functions and separate dedicated data models that are relevant for that particular purpose. The data is generally available in proprietary format. However, it has the highest level of detail available. Examples of data generation include the creation of planning documents (e.g. 3D models, drawings, documents), accompanying project documentation (e.g. as-built documentation, quality checks, deficiencies, progress reports), project communication (e.g. change requests, scheduling conflicts) and ongoing collection of data and images (e.g. photos, sensor data).

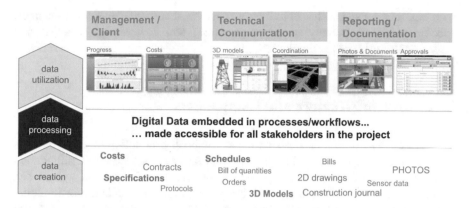

Fig. 27.1 Data editing as a vital step between data generation and data utilization. (© HOCHTIEF ViCon, reprinted with permission)

The second and most important step is *data processing*. It aims at processing the data created in data generation by means of validation, approval, aggregation, and evaluation processes for further use, and to pass it on to subsequent software systems or parties to the project. BIM also includes in this step the cross-sectional linkage of data, where data from various fields of expertise and processes is interlinked and integrated into the overall model; this allows for a holistic analysis of dependencies and interconnections. However, in view of its complexity and the large volumes of data to be delivered decentrally at the same time, this step should be largely automated. Since data ought to be up to date at any time and a manual approach is prone to errors, automation lends itself as the best option. A largely automated process requires, on the one hand, an initial, cross-sectional, strict structuring of data. On the other hand, it is required to have lossless data interfaces or conversions for the exchange of the partial data sets that are required for coordination and their relevant structures. Typical tasks for a BIM Manager are the setting up of the automation processes, the structuring of data, and the definition and configuration of data interfaces (cf. Chap. 16).

Data utilization is the third step. Suitable tools are provided that allow none experts to easily analyze data from various fields or to extract data for use in their own special field. This includes the (automated,) regular creation of various reports. In general, users of data have very different requirements. For instance, project management mainly needs a high level of aggregation of selected information. At the same time, in-depth information should be available to analyze certain aspects. What information is relevant and what level of aggregation is required thus depends on the individual project. Multidisciplinary technical processing, in contrast, often requires special partial information that should be retrieved quickly. The data queries made in this context are manifold and cannot be satisfied by pre-configured queries, lists, or charts. Instead, such queries require highly flexible but easy-to-use filter and visualization functionalities.

It can thus be stated that both highly specialized software products to support specific processes (mainly in data generation) and general data analysis and visualization software are required.

27.4 System Structure and Components

The introduction of software systems that establish production systems on construction projects has shown that (if a modular structure and flexible configuration of individual applications were given) the structure of the overall system can be identical, regardless of the particular project and type of building (building construction, infrastructure, offshore). Depending on requirements, only different additional modules were included, and existing generic functionalities of individual systems were configured to fit the respective case of application. The structure and the main modules (cf. Fig. 27.2) of such systems are described below. Please note that, while the processes supported by the system may vary from project to project (depending on various factors, such as type of building, project volume, specialist software used, contractual terms, etc.), the software used for the cooperation always remains the same.

27.4.1 Software Provision and Data Storage

Since the system is intended to be accessible to all parties involved in the project in various companies, both the data and the software functionalities must be provided centrally. This is to ensure, on the one hand, that the data is always

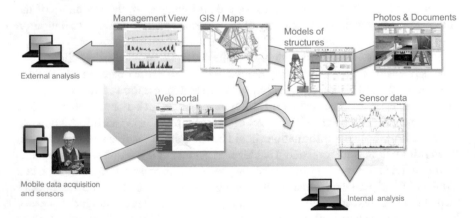

Fig. 27.2 General structure of the software implementation of a BIM-based production system. (© HOCHTIEF ViCon, reprinted with permission)

up to date, and, on the other hand, that limitations in terms of installation and security on the user computers can be bypassed. Not all relevant application systems (especially 3D Viewer) provide the required capacities, programming and configuration options online; therefore, terminal server-based virtualization systems (such as Citrix XenApp) and corresponding 3D graphics hardware support have proved a viable option. They are used via the browser or special apps, and they offer the possibility to centrally configure and operate standard desktop applications on the terminal server for all users. A close look at recent developments in the fields of HTML5, WebGL, and web-based scripting and communication standards allows for the assumption that it will be possible in future to consistently implement a software system that establishes a production system purely on the basis of web technologies. However, the complexity is increased in this case – due to different browser programs and versions in use, as well as the various configurations and security restrictions. Data is stored on data base and file servers that are accessed from the terminal server. Model servers can be connected as well.

27.4.2 Web Portal

A web portal is the access point to the overall system. It provides function-related user administration, up-to-date information and work flow notification for the user, and it serves as the hub from which other functional models and partial projects of the overall project structure branch off.

27.4.3 Document Management

The document management system provides traditional functionalities such as plan approval work flows, document, map and image viewers and annotation, version control, conversion, archiving, and classification and search options. Management of read and write authorizations is function-based down to document level. The system also provides functionalities to fill out and manage electronic forms and to evaluate and transfer the contained information to third-party systems. In order to flexibly adapt the system to the respective project's requirements, the structure of archives must be hierarchical, and it must be possible to configure the navigation surface and the work flows in use as required, as offered by Microsoft SharePoint and others. Additional applications on the client side might be helpful to enhance the effective work (bulk upload, provision of meta data, check of file name conventions, etc.) with thousands of documents and the related e-mail correspondence.

27.4.4 Mobile Devices

In future, mobile devices (mainly tablets) will be used consistently on construction sites. They serve to provide information in the form of locally stored drawings, 3D models, and documents or to directly access the project network or document management system online. The possibility of collecting data by means of digital forms is also gaining importance. Blank forms are created centrally and provided on the mobile devices, in line with specific functions. The forms are completed on the mobile devices and immediately submitted to the subsequent processing and approval work flow. Automated data editing may extract individual pieces of information and use them for further evaluation (e.g. in the 3D or GIS Viewer) or integrate them into the respective data model (cf. Fig. 27.3). The structured storage and archiving of completed forms in the document management system in an uneditable format is also automated. If no mobile internet connection is available, the completed forms are first stored locally on the mobile device, to be sent off at a later time. Compared to paper-based forms, electronic forms not only offer the benefits of immediate electronic storage and automated processing of data, but they can also integrate additional functionalities such as the allocation to the centrally maintained project structure by way of drop-down menus, take photos by means of the integrated camera, can locate the creation of forms via GPS, read bar and QR codes by means of the integrated camera or a scanner that is connected to the mobile device either with or without cable. Experience has shown that the use of electronic forms on mobile devices increases efficiency enormously, and it improves the structure of data storage significantly.

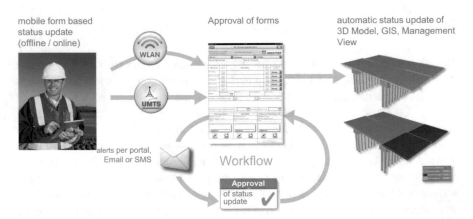

Fig. 27.3 Mobile data collection by means of digital forms, including controlled data processing and transfer to the BIM model. (© HOCHTIEF ViCon, reprinted with permission)

27.4.5 3D BIM Viewer

The core of each BIM-based production system is the collective work on the integrated 3D model, which, on the one hand, serves as a three-dimensional table of contents for all information linked to it – and, on the other hand, it helps to understand contexts in alphanumerical data (cf. Fig. 27.4). Thus, the 3D Viewer is a central tool within a software system that establishes a production system; however, it can only use its potential to the full if, in addition to the 3D illustration, bidirectionally linked views of the alphanumeric data stock and the relevant documents are also provided. Only then can 3D objects be interactively selected, and the related data can be filtered in other specialist data models (e.g. scheduling processes or volumes in the bill of quantities). At the same time, the results of the filter in the alphanumeric data stock can be synchronized with the 3D view, for instance in order to visualize the locations where selected components included

Quantities and qualities

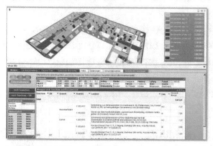

All objects of the 3D model are interactively linked with the bill of quantities.

Room book and door list

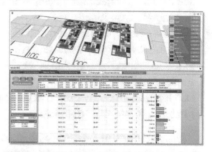

The 3D model connects the room book, door list and other project-specific information.

Acceptances and defect logging

Acceptances and defects are recorded using mobile devices. The information is directly available online for the project management.

Photo documentation

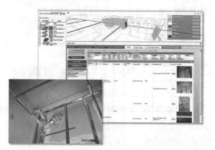

Photos for the documentation of quality, installation conditions or construction progress are directly linked to location and time of the photo, the trade etc.

Fig. 27.4 Integrated analysis of 3D model, alphanumeric data, photos, and documents. (© HOCHTIEF ViCon, reprinted with permission)

in a supply list are to be incorporated. Both mechanisms are equally available. Depending on the task, the spatial relation, or the structure of the initial information, one mechanism might be preferred over the other. (Multiple) combination of both mechanisms is a powerful tool to find and visualize relevant data for complex issues in a targeted manner.

Several mechanisms that are, in part, different from customary viewer functionalities used in other industries have been proven useful for visualization. These are, among others:

- exploded view, used in building construction to show all floors of a building next to each other at the push of a button, thus allowing for a comparison of adjacent floors
- 4D animation to visualize planned and actual construction processes
- visualization of linked data by dynamic color schemes in 3D (e.g. for information on material or status)
- 3D pinheads to precisely locate information and documents
- passive transparent objects that are only used for spatial orientation and cannot be selected (e.g. adjacent objects, or in case of analysis of sensor systems embedded in concrete components)
- simple section planes that can be aligned parallel to the component surfaces
- rule-based viewpoints whose settings (visual field, color scheme, passive objects, exploded view, section planes, visibility of objects, etc.) can be updated with each model update
- cooperation aided by annotations from various users to the same model (e.g. on the basis of the BCF data format)

The development process with regard to the tailoring of functionalities of 3D viewers to the needs of the construction industry is certainly far from completed. A further challenge with regard to performance, transparency and simple navigation in large (infrastructure or urban district development) projects is represented by the branch structure of partial models with various levels of detail within the BIM model or between GIS and BIM models.

27.4.6 Geographic Information System (GIS)

The interactive map views of geographic information systems are used to process surveying data and information that (as is the case in infrastructure projects) is distributed across a large area. Geographical, geological, and topological maps (e.g. indicating the location of natural reserves, noise protection areas, etc.) air view photos, weather data, cadastral data, information on existing infrastructure lines, etc. (which can be acquired from authorities, utility companies, or commercial providers) can be superimposed on the building plans. GIS systems not only provide information on existing structures, planning, and the environment for mere information purposes; they also document information generated in the course of

a project and link it to either a flexible or a permanent location (e.g. locations where photos are taken, where sensors or cameras are installed, where accidents happened, soil probing locations, well locations of dewatering systems, and the tracking of locations and routes of construction machines, vehicles, and vessels). This aims at documenting the construction process and the management of logistics. GIS systems record where components are installed (e.g. by means of acceptance forms on mobile devices) and can thus generate maps of the existing structure at the end of the project.

Although GIS is increasingly based on 3D data and 3D geometry, 2D map illustration is still predominant, in particular in GIS applications that are geared towards web-based cooperation. Similarly to BIM, GIS objects can be allocated optional attributes and connected documents. While the underlying technological concepts are distinctly different, GIS and BIM can still be expected to merge in future.

27.4.7 Management Dashboard and Reporting

The provision of management information is mainly about an easily created, but detailed and substantiated overall statement on the current status of the project with regard to time and cost aspects. Although regular document-based reports are still the standard, interactive dashboards with drill-down functionalities have – compared to static documents – proved to be better suited for day-to-day project management and for the task of keeping the various parties involved in the project up to date with different information requirements at different levels of detail. Today, reports are mainly used to document past events.

In the past, management reports were mostly generated manually; a software system that establishes a production system aims at largely automated reporting and the provision of continuously updated dashboards. The layout, content, and calculation system of status reports and dashboards are defined by the project management upon setting up the system. Its implementation should be based on software systems that can flexibly cover the varying requirements of different projects, ideally only by configuration (cf. Fig. 27.5).

27.4.8 Schedule

Traditionally, schedules are the most important element of project control. In the data section of the 3D Viewer, scheduling processes can be illustrated with start and end dates in chart format, similar to other alphanumerical data; however, bar charts and location based time diagrams have established themselves for visualization of sequences and dependencies (relations between predecessor and successor) as well as project progress. Sophisticated software programs that offer additional

Performance and costs

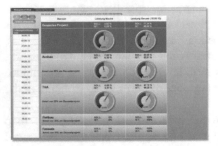

Detailed data is condensed into higher-level key figures.

Deadlines

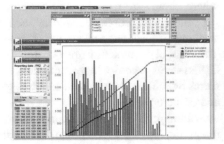

Individual evaluation criteria illustrate the deadline situation of the project. The early recognition of deficits enables compensation measures to be carried out.

Quality

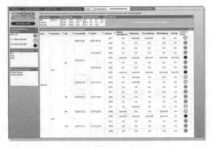

Planned and achieved quality objectives at a glance.

Client reporting

Each client has individual requirements for reports. Structured reports can be automatically derived from the available data.

Fig. 27.5 Individually tailored interactive dashboards and automatically generated reports. (© HOCHTIEF ViCon, reprinted with permission)

functionalities for resource planning and cooperation across the entire project (and spanning various companies) are readily available. These software systems are, however, only operated by preparation or scheduling specialists, and the schedule thus produced is provided to the project team in the form of (digital) hardcopies. This approach does not offer filter and search options, and it runs the risk of using obsolete documents. The following requirements have thus emerged as targets for the subsequent provision, update, and visualization of scheduling information:

- central provision in an easy-to-handle interactive format, using familiar illustrations
- support of decentral integration of detailed schedules and progress reports (e.g. by way of mobile devices) by various parties involved in the project
- integration into possibly automated 4D visualization

Although parts of this can already be found in customary software products today, no integrated solution has been developed.

27.4.9 Further Modules

Depending on the project requirements, it might be expedient or required to integrate further specialized modules into the overall system. Some examples are listed below:

- machine monitoring (e.g. tunneling machines or earthmoving machines)
- monitoring and data processing of sensor systems in the context of settlement measurement or structural health monitoring
- defect management system
- clash detection or model checker

Irrespective of the software used, additional modules can be easily provided within the overall system from a technical perspective (cf. Sect. 27.4.1). If the modules are integrated at a lower level, additional value to central access can be generated by exchange of information with other modules. However, this depends on the integration options provided by the respective software program.

27.5 Application in a Construction Project

27.5.1 Users and Project Stages

Software systems that establish a production system can be used by everyone involved in the project, i.e. planners, contractors, suppliers, and the client. The type of use can be divided into two scenarios:

- purely internal use, within a general contractor's company or a bidding consortium or joint venture (similar to stationary industry)
- use on behalf of and involving the client

While introducing BIM on an international scale, it was found that is especially the public clients who are increasingly asking their contractors to use such systems or to provide them to those involved in their projects for use. This is driven by the intention to improve planning and coordination processes and to ensure the quality of building data generated in the course of the project with regard to asset and facility management.

Regardless of how the software is used, it is recommended to use such systems at an early stage, i.e. during the early planning or bidding phase (possible with gradually increasing functionality). The resulting integrated information model is

thus able to store the knowledge gained as well as decisions made during these project stages as comprehensive and comprehensible as possible. The customary disruption at the time of handover from the planning and bidding teams to the construction team can thus be prevented. Introducing such systems will become more difficult as the project progresses, as processes will have been established and data that has been generated independently will have to be integrated retroactively.

If the data available at the end of a project is structured and integrated, it is relatively easy to hand over information to subsequent systems for the operation of a building in the desired format.

27.5.2 *Implementation in the Project*

The implementation of BIM or a BIM-based production system and its related software environment in a construction project requires a detailed implementation concept, since the system is rather new and complex. Such a concept must include:

- *Contractual provisions* with regard to structured data generation (modeling guidelines, file and object name conventions, use of classification systems) and a project structure that encompasses all fields of expertise (product and work breakdown structure) as well as the obligation to use the overall software system provided.
- The definition and documentation of processes, responsibilities, and technical implementation in the context of a continuously updated *BIM execution plan*. With regard to the project-specific need for adjustment, it is generally recommended to carry out a setup, testing and configuration phase during which the system can be defined in a constructive manner by the main users. Suitable integration of the entire supply chain must be taken into consideration. The insights gained during the test phase are immediately fed into the BIM execution plan and help prevent problems concerning cooperation and the use of data right from the start.
- *Dedicated BIM staff* and BIM contacts for each project partner must be stipulated in the project organizational chart (cf. Chap. 16).
- *BIM training programs* for project members and assistance by the BIM Manager provide comprehensive support.
- Establishment of a continuous *quality management* that reviews data with regard to formal and structural accuracy as well as conformity – based on defined processes concerning chronology and level of detail.

27.5.3 Summary

The authors have already implemented systems for project-wide use – at a scope similar to that described herein and with both usage scenarios – on the basis of commercially available software. The benefit generated was multiple and can be summed up as follows:

- increased productivity through automated data processing and editing – as well as the prevention of double entries
- improved availability of information through centrally accessible and up-to-date data
- increased data quality through encompassing structuring and linkage
- interactive data base that can be filtered at various dimensions and offers visualization in 3D and 2D
- prevention of jumps in media and loss of know-how between project stages
- guided processes render the production process independent of personal experience, skill and preferred modes of operations by individuals.

The authors are convinced that the total benefit is so considerable that such systems will be used on all major construction projects in the medium term. This will result in the further development of software packages that can be used in a modular manner as described herein. As a consequence, production systems will be based on the plug & play concept and become attractive to small and medium-sized projects thanks to a low need for configuration.

Chapter 28
BIM-Based Progress Monitoring

Alexander Braun, Sebastian Tuttas, Uwe Stilla, and André Borrmann (iD)

Abstract On-site progress monitoring is essential for keeping track of the ongoing work on construction sites. Currently, this task is a manual, time-consuming activity. BIM-based progress monitoring facilitates the automated comparison of the actual state of construction with the planned state for the early detection of deviations in the construction process. In this chapter, we discuss an approach where the actual state of the construction site is captured using photogrammetric surveys. From these recordings, dense point clouds are generated by the fusion of disparity maps created with semi-global-matching (SGM). These are matched against the target state provided by a 4D Building Information Model. For matching the point cloud and the model, the distances between individual points of the cloud and a component's surface are aggregated using a regular cell grid. For each cell, the degree of coverage is determined. Based on this, a confidence value is computed which serves as a basis for detecting the existence of a respective component. Additionally, process- and dependency-relations provided by the BIM model are taken into account to further enhance the detection process.

28.1 Introduction

Large construction projects require a variety of manufacturing companies from different trades on site (e.g. masonry, concrete and metal work, HVAC). An important goal for the main contractor is to keep track of accomplished tasks by subcontractors, and the general time schedule. In construction, process supervision

A. Braun (✉) · A. Borrmann
Chair of Computational Modeling and Simulation, Technical University of Munich, München, Germany
e-mail: alex.braun@tum.de; andre.borrmann@tum.de

S. Tuttas · U. Stilla
Department of Photogrammetry and Remote Sensing, Technical University of Munich, Munich, Germany
e-mail: sebastian.tuttas@tum.de; stilla@tum.de

© Springer International Publishing AG, part of Springer Nature 2018
A. Borrmann et al. (eds.), *Building Information Modeling*,
https://doi.org/10.1007/978-3-319-92862-3_28

and monitoring is still a mostly analog and manual task. To prove that all work has been rendered as defined per contract, all performed tasks have to be monitored and documented. The demand for comprehensive and detailed monitoring techniques rises for large construction sites where the entire construction area becomes too large to monitor by hand and the number of subcontractors rises. Main contractors that control their subcontractors' work need to maintain an overview of the current construction state. Regulatory issues add to the requirement to keep track of the current status on site.

The ongoing digitization and the establishment of Building Information Modeling (BIM) technologies in the planning of construction projects can facilitate the use of digital methods in the built environment. In an ideal implementation of the BIM concept, all semantic data on materials, construction methods, and even the process schedule are connected, making it is possible to make statements about the cost and estimated project finalization. Possible deviations from the schedule can be detected and the following tasks rearranged accordingly.

A Building Information Model is a rich source of information for performing automated progress monitoring. It describes the as-planned building shape in terms of 3D geometry and combines it with the as-planned construction schedule. The resulting 4D model contains all relevant information for the complete construction process. Accordingly, the planned state at any given point in time can be derived and compared with the actual construction state. Any process deviation can be detected by identifying missing or additional building components.

For capturing the actual state of the construction project in an automated manner, different methods can be applied, among them laser scanning and photogrammetric methods. Both methods generate point clouds that hold the coordinates of points on the surface of the building elements but also of all objects occluding the building. A sample of a point cloud, generated in one of the case studies rendered during the duration of this research can be seen in Fig. 28.1.

The main steps of the proposed monitoring approach are depicted in Fig. 28.2. The minimum information that a BIM needs to provide is the 3D geometry and the process information (construction start and end date) for all building elements. From this, the target state at a certain time step t is extracted. Subsequently, the target state is compared to the actual state, which in the approach presented here is captured using photogrammetric techniques. Finally, any recognized deviations are used to update the schedule of the remaining construction process.

28.2 State of the Art

Several methods for BIM-based progress monitoring have been developed in recent years (Omar and Nehdi 2016). Basic methods start by including technical advancements like email and tablet computers into the monitoring process. These methods still require manual work, but already contribute to the shift towards a

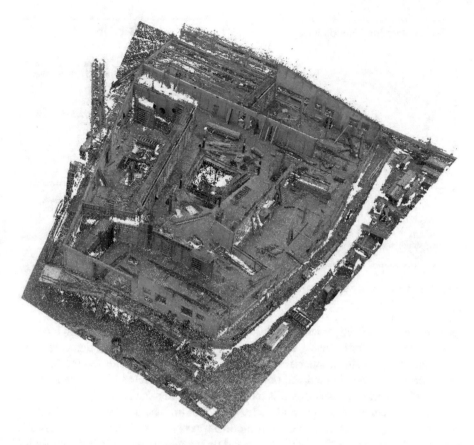

Fig. 28.1 Point cloud generated during the observation of the construction progress of a sample construction site. (© A. Braun, reprinted with permission)

digital process. More advanced methods try to track individual building components with radio-frequency identification (RFID) tags or similar methods (e.g. QR codes).

Current state of the art methods propose using vision-based methods for more reliable element identification. These methods either make direct use of photographs or videos taken on site as input for image recognition techniques, or apply laser scanners or photogrammetric methods to create point clouds that hold point-based 3D information and additionally color information.

In Bosché and Haas (2008) and Bosché (2012), a system for as-built as-planned comparisons based on laser scanning data is presented. The generated point clouds are co-registered with the model using an adapted Iterative-ClosestPoint-Algorithm (ICP). Within this system, the as-planned model is converted to a point cloud by simulating the points using the known positions of the laser scanner. For verification, they use the percentage of simulated points, which can be verified by the real laser scan. Turkan (2012) and Turkan et al. (2011) use and extend this system for

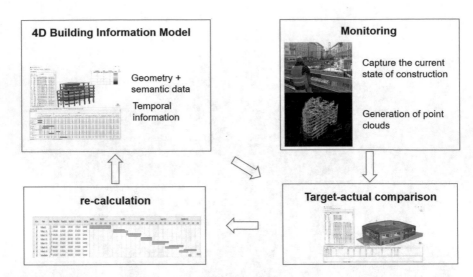

Fig. 28.2 Concept for automated progress monitoring. (© A. Braun, reprinted with permission)

progress tracking using schedule information, for estimating the progress in terms of earned value and for detecting secondary objects. Kim et al. (2013b) detect specific component types using a supervised classification based on Lalonde features derived from the as-built point cloud. An object is regarded as detected if the type matches the type in the model. As above, this method requires that the model is sampled into a point representation. Zhang and Arditi (2013) introduce a measure for deciding four cases (object not in place, point cloud represents a full object or a partially completed object or a different object) based on the relationship of points within the boundaries of the object and the boundaries of the shrunk object. The authors test their approach in a very simplified artificial environment, which is significantly less challenging than the processing of data acquired on real construction sites.

In comparison with laser scanning, the use of photo or video cameras as acquisition devices has the disadvantage that geometric accuracy is not as good. However, cameras have the advantage that they can be used in a more flexible manner and their costs are much lower. This leads to the need for other processing strategies when image data is used. Rankohi and Waugh (2014) give an overview and comparison of image-based approaches for monitoring construction progress. Ibrahim et al. (2009) use a single camera approach and compare images taken over a certain period and rasterize them. The change between two time-frames is detected using a spatial-temporal derivative filter. This approach is not directly bound to the geometry of a BIM and therefore cannot identify additional construction elements on site. Kim et al. (2013a) use a fixed camera and image processing techniques for the detection of new construction elements and the update of the construction schedule. Since many fixed cameras would be necessary to cover a whole construction site, more approaches rely on images from hand-held cameras covering the whole construction site (Kropp et al. 2018).

For finding the correct scale of the point cloud, stereo-camera systems can be used, as done in Son and Kim (2010) and Brilakis et al. (2011a,b). Rashidi et al. (2015) propose using a colored cube of known size as a target, which can be automatically measured to determine the scale. In Golparvar-Fard et al. (2011a) image-based approaches are compared with laser-scanning results. The artificial test data is strongly simplified and the real data experiments are limited to a very small part of a construction site. Only relative accuracy measures are given since no scale was introduced to the photogrammetry measurements. Golparvar-Fard et al. (2011b, 2015) use unstructured images of a construction site to create a point cloud. The orientation of the images is computed using a Structure-from-Motion process (SFM). Subsequently, dense point clouds are calculated. For the comparison of as-planned and as-built, the scene is discretized into a voxel grid. The construction progress is determined in a probabilistic approach, in which the parameters for threshold for detection are determined by supervised learning. This framework makes it possible to take occlusions into account. This approach relies on the discretization of space as a voxel grid to the size of a few centimeters. In contrast, the approach presented in this chapter is based on calculating the deviation between a point cloud and the building model directly and introduces a scoring function for the verification process.

28.3 Concept

The presented approach for BIM-based progress monitoring is depicted in Fig. 28.1. On the one hand, a building information model is needed that not only holds geometric and semantic information, but also temporal data (process schedules). This BIM represents the as-planned state of the construction site. On the other hand, monitoring using UAVs or similar camera-based systems is required for the generation of as-built point clouds by photogrammetric means for the representation of the as-built status.

During the design and planning phase, the building model and the process schedule is modelled and combined in a 4D model. During construction, the site is continuously monitored by capturing images of the as-built state. These are processed to create point clouds, which are compared to the as-planned building model (as-builtas-planned comparison).

28.4 Data Acquisition and Point Cloud Generation

The generation of the point cloud consists of four steps: data acquisition, orientation of the images, image matching and co-registration.

In the following, different strategies for image acquisition on construction sites are introduced.

28.4.1 Handheld Camera

A circuit of the construction site with a camera acquires sufficient images to map the building: For the creation of the dense point cloud, images are taken in an approximated stereo geometry, and there should be enough overlap to ensure every object point is visible in at least three images. Additionally, images have to be acquired looking forward and backward to support the image orientation process, e.g. Structure-from-Motion (SfM). Additional images may be required to support the co-registration process, either for the co-registration of point clouds from subsequent acquisition data or of the model and point cloud. Images acquired for documentation by other project members can also be used for the reconstruction process.

Golparvar-Fard et al. (2011b) state that images acquired for documentation tasks are sufficient for an as-built reconstruction. In turn, images made for the purpose of reconstruction may be sufficient for documentation tasks. Only a single camera is necessary for acquisition, and no further equipment is required, making this acquisition method very affordable.

The acquisition geometry has to be adopted to the current state of construction. During the construction of basement elements, images have to be taken around the excavation looking downward. As the building construction increases in height the images are acquired from an appropriate distance to the building's façade. When a certain height is reached the use of upright format images (with decreased baseline) or the acquisition of a second row of images might be necessary. The stronger the camera is inclined upwards, the worse the conditions for rectification and stereo-matching. If the façade is not completely flat, but has, for example, protruding elements, the occlusions due to lower building parts will increase. Additionally, temporary objects, like scaffolding, can increase occlusions. In such cases, the problem gets worse for upward looking views.

Another source of occlusion, which is mainly relevant for the ground floor, is building site facilities (e.g., construction trailer, site fence), stored material (e.g., prefabricated construction products) or vehicles for delivery purposes (e.g., transit truck mixer). Depending on the surrounding of the construction site it may be possible to acquire images from elevated positions, e.g., from adjacent buildings, to reduce the amount of unseen surfaces. Additionally, platforms in the mast of the crane can be used as acquisition position. In this case, the baseline for stereo images is limited to the width of the mast (typically 1 m) or the distance between two platforms (typical values are 2.5, 5 or 10 m, depending on the combination of tower sections) at different heights.

In the worst case, where a construction site is completely occluded, this acquisition technique cannot be used.

28.4.2 UAV

In the context of this chapter, UAV acquisition refers to the acquisition using a UAV system with a total weight of less than 5 kg that also adheres to the regulations for UAV flights in many countries, which are among others:

- maximum flight height of 100 m
- Free line of sight to the UAV in all cases
- No flights over streets
- No flights over crowds

The construction is acquired in nadir view at two different flight heights, which have to be adopted to the current construction state (typically the height of the building). The upper flight (e.g., above the cranes) is mainly intended for stabilizing the orientation process. Additionally, oblique view images are acquired during a flight around the construction site.

For UAV acquisition, the aircraft itself, a camera, and a remote control as well as a trained pilot are all necessary. The costs for a professional UAV including appropriate configuration can be in the range of several €1000. Additionally, there may be costs for software for flight planning.

Generally, all areas, which are not inside the building, are visible for the UAV. But there are also restrictions. A certain safety distance has to be kept to the building itself, nearby buildings, and the cranes. Inner city construction sites are often surrounded by busy roads, which limits the usage of an UAV or even makes it impossible.

28.4.3 Crane Camera

Acquisition of construction site images using crane-mounted cameras is based on the fact that cranes can usually reach all areas of a construction site, i.e., the footprint of the booms cover the whole area. Images of the whole construction site can be acquired this way. Areas where no construction activity takes place are also covered, e.g., areas used for unloading construction material. These areas can be use to mount control points. To ensure complete coverage and sufficient image overlap for 3D reconstruction, several cameras have to be mounted on the boom. Cameras mounted on the boom are always located in the same plane. Because of this, cameras should be calibrated before they are mounted on the crane, since the structure on the ground may also be, at least approximately, a flat plane.

The required components for crane cameras are described based on the cameras used in the experiments in this chapter. A camera is composed of a watertight box which contains a single board computer for the control of the camera and intermediate storage of the images, the camera itself, and a mobile communication unit for data transfer. The acquired images are saved on internal storage and

subsequently transferred to a server via a mobile internet connection. For the power supply, a cable is run up the center of the crane. Additionally a network cable is required for data transfer and camera control. For top slewing cranes (with crane cabs) there is power supply at the top of the crane, i.e., there is also a power supply available for the cameras. For (small) bottom slewing cranes it may be necessary to provide a power supply for the cameras from the bottom.

As stated, the crane usually reaches the complete active area. To receive images of the whole construction site the crane has to make a full circle, stopping at set angle increment to make the acquisition. This requires that the steering of the crane and the camera control is synchronized. Another acquisition procedure (which is used in the experiments here) makes the camera expose at a certain frequency (e.g., 20 sec) within a certain time (e.g., 2 h) and the movements resulting from construction activity is used to provide sufficient coverage. In this case, complete coverage cannot be ensured, but at least it is very likely to cover the entire active area. In this case, an overhead of acquired images may result that needs to be discarded to avoid unnecessary processing time.

With both procedures, it can transpire that the hook trolley obstructs the camera's view and therefore occludes the scene.

28.4.4 Conclusion

By way of conclusion, all methods have valid fields of application. However, UAVs tend to be the most productive way to perform an overall acquisition of a complex construction site with various levels and grades of complexity with regard to its geometry.

28.5 As-Planned vs. As-Built Comparison

The as-planned vs. as-built comparison can be divided into several stages. This includes the direct verification of building components based on the point cloud, and the indirect inference of the existence of components by analyzing the model and the precedence relationships to make statements about occluded objects.

For the verification process, which in the first step is based only on geometric conditions, a triangle mesh representation of the model is used. Every triangle is treated individually. It is split into two-dimensional raster cells of size x_r as shown in Fig. 28.3. For each raster cell, an independent decision is made to determine whether the as-built points confirm the existence of this part of the triangle surface using the measure M. For the calculation of this measure, the points within a distance δd before and behind the surface are extracted from the as-built point cloud. The measure M is based on the orthogonal distance d from a point to the surface of the

Fig. 28.3 Rasterization of a triangulated geometry for verification of relevant points. (© S. Tuttas, reprinted with permission)

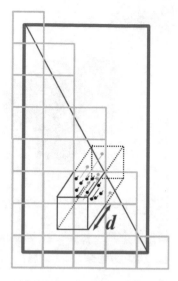

building part, taking into account the number of points extracted for each raster cell and the accuracy of the points σ_d and is calculated as follows:

$$M = \frac{1}{\sigma_d} * \sum_i \frac{1}{d_i * \sigma_{d_i}} \qquad (28.1)$$

In order to visualize the results from the as-planned vs. as-built comparison, a 4D BIM viewer has been developed that incorporates all data from different observations and can also display point cloud data and corresponding images (see Fig. 28.4).

28.5.1 Enhancing Detection Rates

One of the main reasons for failed detections are occlusions. During construction, large amounts of temporary structures, such as scaffolding, construction tools, and construction machinery obstruct the view on the element surfaces. Limited acquisition positions further reduce the visibility of surfaces and impact on the overall quality of the generated point clouds. As introduced in Huhnt (2005), technological dependencies can help formalize the schedule sequence. A precedence relationship graph (PRG) can hold this information and help to identify the described occluded elements (Braun et al. 2015a). The graph (see Fig. 28.5) visualizes the dependencies and shows that all following walls depend on the slab beneath them. These objects can be denoted as checkpoint components. They play a crucial role for helping to identify objects from the point clouds that cannot be confirmed sufficiently accurately using the as-built point cloud.

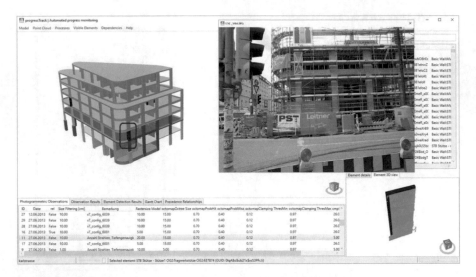

Fig. 28.4 As-planned vs. as-built comparison visualized using a corresponding point cloud (bottom right) and source image with re-projected geometry (top right). (© A. Braun, reprinted with permission)

Fig. 28.5 Precedence Relationship Graph (PRG) that holds all technological dependencies for a specific construction site. (© A. Braun, reprinted with permission)

Another reason for weak detection rates lies in the difficulty of identifying building elements currently under construction. As such elements count towards the overall progress of construction, they cannot be ignored and play a crucial role

in defining the exact state of the current process. The most challenging situations are construction methods or elements in which the temporary geometry differs greatly from the final element geometry. This applies, for example, to reinforcement bars or formwork. On the one hand, formwork may obstruct the view of the element, making it impossible to detect. On the other, the plane surface of formwork for a slab may be detected as the surface of the slab itself and thus lead to false positives. Due to these challenges, further enhancements to the comparison and detection algorithms are needed.

As depicted in Fig. 28.6, vision-based algorithms can help to identify elements that are visible from certain points of view. In order to enhance detection rates, visual renderings based on all camera positions were generated. Based on this additional information, the detection rates can be verified and final conclusions regarding the detection rates are more precise.

Fig. 28.6 Reconstructed 4D geometry based on estimated camera positions for the detection of visible elements. (© A. Braun, reprinted with permission)

Fig. 28.7 Results from the as-planned vs. as-built comparison of an observation incorporated with the corresponding process data. Green elements were built ahead of schedule, red elements behind schedule. (© A. Braun, reprinted with permission)

28.5.2 Process Comparison

After successfully detecting built and not-built elements for each individual observation time, the gathered results can be combined with the corresponding process schedule of the construction site (4D BIM). The detected elements (as-built) of an observation are compared against the expected elements (as-planned) at the same timestamp t. Based on the schedule, predictions can be made on whether the construction progress is ahead or behind schedule (see Fig. 28.7). This information can then be used by schedule planners to adjust the schedule accordingly.

28.6 Case Studies

A set of comprehensive cases studies of real construction sites document in detail the detection rates achieved (Braun et al. 2014, 2015b; Tuttas et al. 2014, 2016). These were performed on five construction sites, in which the complete construction progress was monitored. The figures used in this chapter are drawn from these case studies.

28.7 Summary

This chapter discusses general approaches to BIM-based progress monitoring. It presents a detailed overview of a concept for the photogrammetric creation of point clouds for construction progress monitoring, and for the procedure for as-planned vs. as-built comparison based on the 3D geometry. In addition, potential ways of improving these results by augmenting them with additional information from the BIM and accompanying process data have been discussed.

To determine the actual state, a dense point cloud is calculated using images from a calibrated camera. To determine the scale, control points are used, which requires manual intervention during orientation. The evaluation measure introduced for component verification detects built elements correctly but misses a larger number of them due to occlusion, noisy points or insufficient input data. There is, therefore, a need to extend this geometric analysis with additional information and visibility constraints.

BIM-based progress monitoring is currently the subject of considerable research and development. Recent advancements show that progress monitoring based on UAVs and point clouds is becoming more reliable and demand for such methods is increasing in the construction industry. Automated progress monitoring facilitates the need to keep track of construction progress. However, not all elements can be detected with current methods. The concepts presented here assist in enhancing detection rates and support greater automation in the scope of BIM-based progress monitoring.

References

Bosché, F. (2012). Plane-based registration of construction laser scans with 3D/4D building models. *Advanced Engineering Informatics, 26*(1), 90–102.

Bosché, F., & Haas, C. T. (2008). Automated retrieval of project three-dimensional CAD objects in range point clouds to support automated dimensional QA/QC. *Information Technologies in Construction, 13*, 71–85.

Braun, A., Tuttas, S., Stilla, U., & Borrmann, A. (2014). Towards automated construction progress monitoring using BIM-based point cloud processing. In *eWork and eBusiness in Architecture, Engineering and Construction: ECPPM 2014.*

Braun, A., Tuttas, S., Borrmann, A., & Stilla, U. (2015a). A concept for automated construction progress monitoring using BIM-based geometric constraints and photogrammetric point clouds. *Information Technologies in Construction, 20*, 68–79.

Braun, A., Tuttas, S., Borrmann, A., & Stilla, U. (2015b). Automated progress monitoring based on photogrammetric point clouds and precedence relationship graphs. In *Proceedings of the 32nd International Symposium on Automation and Robotics in Construction and Mining* (pp. 274–280).

Brilakis, I., Fathi, H., & Rashidi, A. (2011a) Progressive 3D reconstruction of infrastructure with videogrammetry. *Automation in Construction, 20*(7), pp. 884–895.

Brilakis, I., German, S., & Zhu, Z. (2011b). Visual pattern recognition models for remote sensing of civil infrastructure. *Journal of Computing in Civil Engineering, 25*(5), 388–393.

Golparvar-Fard, M., Peña-Mora, F., & Savarese, S. (2011a). Integrated sequential as-built and as-planned representation with tools in support of decision-making tasks in the AEC/FM industry. *Journal of Construction Engineering and Management, 137*(12), 1099–1116.

Golparvar-Fard, M., Peña-Mora, F., & Savarese, S. (2011b). Monitoring changes of 3D building elements from unordered photo collections. In *2011 IEEE International Conference on Computer Vision Workshops (ICCV Workshops)* (pp. 249–256).

Golparvar-Fard, M., Peña Mora, F., & Savarese, S. (2015). Automated progress monitoring using unordered daily construction photographs and IFC based building information models. *Journal of Computing in Civil Engineering, 29*(1), 04014025.

Huhnt, W. (2005). Generating sequences of construction tasks. In *CIB-W78's 22nd International Conference on Information Technology in Construction*, Dresden

Ibrahim, Y., Lukins, T., Zhang, X., Trucco, E., & Kaka, A. P. (2009). Towards automated progress assessment of workpackage components in construction projects using computer vision. *Advanced Engineering Informatics, 23*(1), 93–103.

Kim, C., Son, H., & Kim, C. (2013a). Automated construction progress measurement using a 4D building information model and 3D data. *Automation in Construction, 31*, 75–82.

Kim, C., Son, H., & Kim, C. (2013b). Fully automated registration of 3D data to a 3D CAD model for project progress monitoring. *Automation in Construction, 35*, 587–594.

Kropp, C., Koch, C., & König, M. (2018). Interior construction state recognition with 4D BIM registered image sequences. *Automation in Construction, 86*, 11–32.

Omar, T., & Nehdi, M. L. (2016). Data acquisition technologies for construction progress tracking. *Automation in Construction, 70*, 143–155.

Rankohi, S., & Waugh, L. (2014). Image-based modeling approaches for projects status comparison. In *CSCE 2014 General Conference (Rankohi 2013)* (pp. 1–10). Retrieved from http://lasso.its.unb.ca/publications/Sara_Rankohi_Lloyd_Waugh_CSCE_2014_Generalconference.pdf

Rashidi, A., Brilakis, I., & Vela, P. (2015). Generating absolute-scale point cloud data of built infrastructure scenes using a monocular camera setting. *Journal of Computing in Civil Engineering, 29*(6), 04014089.

Son, H., & Kim, C. (2010). 3D structural component recognition and modeling method using color and 3D data for construction progress monitoring. *Automation in Construction, 19*(7), 844–854.

Turkan, Y. (2012). *Automated Construction Progress Tracking Using 3D Sensing Technologies*. Dissertation, University of Waterloo. Retrieved from https://uwspace.uwaterloo.ca/handle/10012/6628

Turkan, Y., Bosché, F., Haas, C. T., & Haas, R. (2011). Automated progress tracking of erection of concrete structures. In *Annual Conference of the Canadian Society for Civil Engineering* (pp. 2746–2756). Retrieved from http://web.sbe.hw.ac.uk/fbosche/publications/conference/Turkan-2011-CSCE.pdf

Tuttas, S., Braun, A., Borrmann, A., & Stilla, U. (2014). Comparison of photogrammetric point clouds with BIM building elements for construction progress monitoring. In *The International Archives of the Photogrammetry, Remote Sensing and Spatial Information Sciences* (Vol. XL-3).

Tuttas, S., Braun, A., Borrmann, A., & Stilla, U. (2016). Evaluation of acquisition strategies for image-based construction site monitoring. In *The International Archives of the Photogrammetry, Remote Sensing and Spatial Information Sciences*. Prague, ISPRS Congress.

Zhang, C., & Arditi, D. (2013). Automated progress control using laser scanning technology. *Automation in Construction, 36*, 108–116.

Chapter 29
BIM in the Operation of Buildings

Klaus Aengenvoort and Markus Krämer

Abstract BIM does not only facilitate the design and construction of buildings, but also and especially the operation of these buildings. This chapter argues that the BIM-based operation of buildings can be divided into six work stages: (1) requirements management; (2) preparation for commissioning; (3) commissioning; (4) ongoing operation; (5) change of owner/operator; and (6) data acquisition for existing buildings. During these stages, a structured set of data relevant to the operation of the building(s) is constantly updated. These data sets facilitate multiple use cases occurring during the operation phase, e.g. the operation, inspection and maintenance of technical equipment. The data relevant to the operational phase can either be obtained by the handover of design and construction data or by the collection of data for existing buildings or buildings where the BIM method was not used prior to operation.

29.1 Introduction

The preceding chapters have dealt with how BIM methods can be used in the design and construction phases to create and maintain coordinated and consistent building information models. Here, BIM provides a platform for participants to coordinate their respective processes.

This principle can be taken further to allow BIM methods to be used in managing the operation of buildings (Shepherd 2015). Relevant selected data models of the building created during the design and construction phase can be carried over to the operation phase for further use.

K. Aengenvoort (✉)
eTASK Immobilien Software GmbH, Cologne, Germany
e-mail: klaus.aengenvoort@etask.de

M. Krämer
Faculty of Technology and Life, HTW Berlin, Berlin, Germany
e-mail: markus.kraemer@htw-berlin.de

© Springer International Publishing AG, part of Springer Nature 2018 477
A. Borrmann et al. (eds.), *Building Information Modeling*,
https://doi.org/10.1007/978-3-319-92862-3_29

Of key relevance here is the benefit that updating data over the building's lifetime can offer, and this is of central concern in the development and use of BIM tools for facility management and building operation. To determine the benefit of BIM for stakeholders in the operation phase – for example, property owners, users, property managers, facility managers or technical services – one must first identify their respective processes, roles and business models. BIM systems for operators link together these roles in a digitally integrated process.

To highlight the advantages of using BIM during all phases of the building's life cycle, Patrick MacLeamy of HOK Network coined the acronym BOOM – Building Operation Optimization Model – which he describes as follows: for every dollar that is invested in a building's design, around 20 dollars are invested in its construction (BAM – Building Assembly Model) and 60 dollars are spent on its operation (BOOM) over a period of 50 years. By simulating the BOOM phase before commissioning, it is potentially possible to make vast savings in the later energy consumption and running costs of the building. The point at which it is most economical to optimize the operating costs over the life cycle of a building is during the BIM and BAM phases. For this, one needs to use data from the BIM and BAM phases to simulate the BOOM phase. Any additional expenditure this entails during the BIM phase is offset by later savings in the BOOM phase (cf. HOK Network 2010).[1]

Using BIM for operating buildings extends current document-based exchanges of information by offering a well defined structured way, keeping all information of building elements and its linkages among each other intact, based on the building data model. Structured data about a building can then be linked seamlessly to process-based information.

Standards and IT systems for implementing BIM methods are now available for all phases of the life cycle of a building (design, construction and operation).[2] If a BIM model has been created during the construction phase, relevant data from the model can be extracted and integrated into the Asset Information Model (AIM) for use in the operation phase. The data can then be maintained on an ongoing basis and passed over to future users or owners of the building at a later stage of the building. BIM can also be used for operation in those cases where no BIM model was developed during construction (see Sect. 29.3.6).

The extraction of data relevant to the operation phase involves reducing the overall volume of data to that which is necessary for the operation phase, making it simpler to manage the data over the entire lifecycle of the property. Where BIM processes are only introduced in the operation phase, an initial investment of effort is inevitable. For this to pay off, the benefits must outweigh the cost or effort of setting

[1]Also see Roper and Payant (2014), section six "Operations and Maintenance" for a detailed discussion of the relative share of operational and maintenance services in the life cycle of a building.

[2]ISO (TC 59/SC 13), CEN (TC 442) and several national standardization initiatives (e.g. DIN (NA 005-01-39), VDI (2552)).

up the BIM model. Benefits primarily include time-savings for recurring processes, such as:

- simplified *tendering of facility services* through the automated calculation of quantities from the building information model,
- legally compliant *description of rental areas* by avoiding discrepancies in floor area calculations,
- reliable assessment of a *building's condition* as a product of maintained property records,
- fast and reliable *localization* of building elements and equipment in the context of installation circumstances,
- legally compliant *operation of the building* through the collaborative undertaking of inspection, maintenance and repair processes.

29.2 Property Portfolios

A newly completed building is frequently added to a portfolio of properties containing a large number of buildings. The respective building information model is then incorporated into a larger portfolio data model (cf. Fig. 29.1).

Fig. 29.1 The BIM for a new building is incorporated as part of a portfolio of properties

Portfolios of properties are typically held by the following kinds of organizations:

- *Public authorities* manage portfolios of civic buildings including schools, childcare facilities, public buildings such as council offices, and in many cases also social housing schemes.
- *Industrial corporations* manage portfolios of their industrial facilities, for example production plants, warehouses, offices and research laboratories.
- *Transport companies* manage portfolios of traffic infrastructure facilities, offices, sales and ticket offices, and technical workshops.
- *Financial or media companies* manage portfolios of office buildings, broadcasting stations and film production sites.
- *Commercial companies* manage portfolios of warehouses, office buildings and sales outlets.
- *Fund management companies* manage portfolios of property assets of different kinds, depending on their investment focus.

Many of these operators manage and operate different kinds of building structures in a single portfolio. In addition, many portfolios contain properties distributed over a wide area, e.g., across a company site, a city or across a region, the entire country, continent or even all over the world.

In order to be able to query information across several properties within a portfolio, the building information models within a portfolio should be structured similarly. For example, an operator may wish to retrieve information on all the elevators within a geographic region. With the help of BIM-based Asset Information Management Systems, these kinds of queries can be carried out using BIM-based CAFM systems.

29.3 Work Stages During the Operation Phase

The BIM method divides the operation phase of a building into six work stages. The following diagram shows the succession of work stages in the context of the design, construction and operation phases of a new building.

The model in Fig. 29.2 shows the typical cycle of work stages for new buildings in a portfolio of properties used by the operating companies. There are various organizational variants of this process, some of which are discussed in more detail in the following sections. Compared with BIM in the operation phase of existing buildings, the approach to use BIM for new buildings differs in one significant respect. Figure 29.3 shows the use of BIM for the operation of existing buildings.

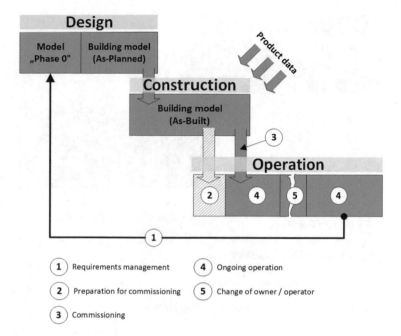

Fig. 29.2 Typical cycle of work stages for BIM in the design, construction and operation phases of new buildings

The "building model (as-built)" shown in Fig. 29.3 differs significantly from the "building model (as-built)" in Fig. 29.2. The data model for the operation phase requires fewer details than the corresponding building information model for a new building (see Sect. 29.3.6). In the following section, we discuss each of the six work stages along with concrete examples of BIM applications.

29.3.1 Requirements Management

During the management of a property portfolio, the operator gains experience through ongoing communications with its users (e.g., tenants). If the portfolio is managed using digital methods (e.g., using CAFM), this experience can serve as a basis for the structured evaluation of needs and requirements for new buildings.[3]

[3] For a detailed discussion of the cooperation between operation and design/construction see Roper and Payant (2014), section five "The Design-Build Cycle". Also see Kumar (2015), p.5 for the importance of cooperation between all groups relevant in the life cycle of a property.

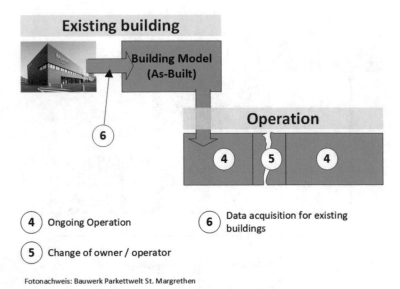

Fig. 29.3 BIM phases in the operation of an existing building

- *Example – Office Building:* The design for a new office building to replace a current office facility uses information on the current floor area requirements for different kinds of floor qualities.
- *Example – Shopping Mall:* The design for a new shopping mall in a city draws on information from a portfolio of shopping malls, including the experience of shopping malls in other cities or comparable projects.

The assessment of needs and requirements can draw on experience already gained and on operating data, or be created anew, for example when determining the needs for a kind of building not already in the operator's portfolio. In both cases, the number and types of rooms, the functions, as well as any necessary fittings, furnishings and equipment can be stored in a structured and user-friendly form in a BIM system by the client. To begin with, a series of room templates are created into which the requirements for number, size and room fittings are entered.

The building's user (or representative of the users) can then check these directly in the model against statutory requirements. Should the user's list of needs exceed the available budget, or conflict with agreed rules, the user (or representative) is asked to revise their list of needs to align with the boundary conditions. This results in a structured and documented exchange between the users and the planners. Potential conflicting points can therefore be identified and resolved before any design work is undertaken.

The finished agreed requirements then serve as a basis for the architects' initial design. Its creation can be supported by the presentation of the schedule of rooms in the form of visual, model-based spatial representations.

The result of the requirement management work stage can likewise serve as a basis for the project brief when inviting tenders for design services. Moreover, the architects' design and detail planning can be validated against the requirements at any time by comparing them (without the need for manual work) against the requirements model. Only once the comparison is satisfactory can the next stage of detailed design work begin. A clear list of necessary fittings and equipment for each individual room likewise serves as a basis for later design and planning work. Changes made during the design or construction phase can constantly be traced back and checked against the original model.

29.3.2 Preparation for Commissioning

Once the prospective building has been designed based on the BIM-based management of requirements, the construction phase begins. Parallel to this, the operator begins making preparations for commissioning the building. At the beginning of this phase, the operator of the building transfers all relevant data from the building information model. Ideally, this is a copy of the model from the early construction stage that already incorporates key initial decisions for constructing the building. The provision of a model based on the detail planning is likewise useful at this point. The time at which such a commissioning model must be delivered depends on the time required to prepare for commissioning. The building information model is transferred into a BIM-based CAFM system, so that it can serve as the basis for the following applications:

- *Model-based planning and simulation of floor space usage* by the respective departments, persons and equipment.
- *Cost estimation and inviting tenders for technical services management* such as the inspection, maintenance and operation of technical services.
- *Cost estimation and inviting tenders for cleaning services* such as maintenance cleaning and window cleaning.
- *Purchasing of fittings and furnishings* such as furniture, permanent fittings, hospital equipment, laboratory equipment, etc.
- *Instruction of staff* in future processes for running the building and the available equipment and relevant work processes,
- *Booking of meeting rooms, lecture halls or workplaces* for planning the use and occupation of rooms before the end users take up occupancy,
- *Planning removals and budgets* for moving from the previous premises to the new building

29.3.3 Commissioning

The work stage of building commissioning is characterized by the transfer of responsibilities for the building's operation from the client to the operator. From the day of handover, the operator is obliged to undertake all activities necessary to fulfill all the statutory obligations of an operator. In addition, operators must provide records that prove the fulfillment of their obligations as an operator. The operator must determine what these obligations are and organize and implement the necessary measures themselves. For this, they require the following information:

- *Location of the property*, for example, the address of the building.
- *Applicable regulations* at the location of the property, for example EU regulations, national laws, local state legislation as well as any additional stipulations by the local municipality and any project-specific conditions.
- *The list of built elements in the property (as built)* in order to determine the relevant legislative frameworks that apply for them.
- *Specific manufacturer's instructions* to ensure that built elements continue to function safely and correctly in accordance with the regulations.

Based on this, the operator can determine all activities necessary to fulfill their statutory obligations, and to plan, implement and document them accordingly. A BIM-based building data model can contain a list of all the actually used elements and is therefore an ideal basis for supporting the IT-based management of the necessary tasks.

As such, the efficient transfer of data plays an important role, also for fulfilling legal obligations. The transfer of data is regulated in the Employer's Information Requirements (EIR). A template for the necessary data for operating a building is given in VDI 6039. In addition, laws and regulations that govern the operator's responsibilities provide sufficient information on the specification of information requirements of the model.

After the handover of all relevant data, the digital building data model is integrated into the portfolio data model and is from this point onwards used as the digital twin of the building. Thus, the digital twin functions as the basis for all structure-related operational processes. The Digital Twin is seamlessly integrated into the IT-system landscape[4] and can therefore be used by a variety of users (cf. Fig. 29.4).

Using BIM methods, all participants can exchange data based on standardized data formats and classifications, ensuring the loss-free transfer of data without the need for additional agreements. In addition, the use of BIM-based standards also makes it possible to validate the completeness and consistency of the transferred data. The receiving party can, therefore, easily verify whether the sender has provided all the necessary data in accordance with the contract.

[4]So called Common Data Environment (CDE).

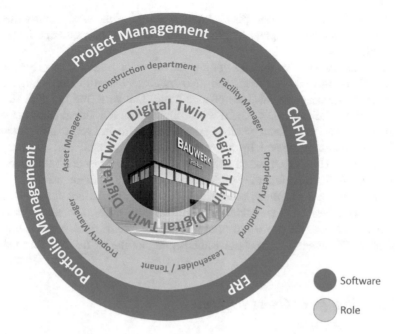

Fig. 29.4 Integration of the Digital Twin into the IT system landscape

29.3.4 Ongoing Operation

During the ongoing operation of the building, the building data models used for commissioning can also be used for supporting other BIM use cases. Additionally, the aforementioned BIM cases can continue to be used in sections of the property (e.g. for requirements management in case of a partial usage). The ongoing operation of a building is characterized by processes that recur over a long period of time (sometimes up to 50 years and more). The following application areas can be supported by BIM methods during the ongoing operation of a building:

- *Fulfilling operator obligations* to ensure that all statutory requirements are fulfilled over the duration of the building's operation phase.
- *Security management* for defining security zones on site and the surveillance and visualization of their access by authorized persons.
- *Operation, inspection and maintenance* of technical plant facilities with supporting technologies such as Virtual Reality (VR) and Augmented Reality/Mixed Reality (AR).
- Integration of *building control and sensor systems* to visualize sensor and measured data in a 3D building model, and for the automated transfer of operating instruction data from the Asset Information Model to control systems and sensors,

- Creation of workplace concepts for optimal design of the work environment for employees in office or plant buildings on the basis of current experiences and regulations,
- *Space management* for making optimal use of floor areas in the property. The sizes of contiguous floor areas and their respective qualities to a large extent determine the usage/rental price of a building. Unlike a traditional CAD plan, a BIM-based building data model is intelligent. The individual elements of the model are not "just" lines or other graphic elements but are existing elements of a building represented by a combination of graphical and alphanumeric information. This object-based definition can be used to add "intelligence" in terms of automated calculation of floor area prices for different uses.
- *Spare parts and inventory management* in order to budget for replacement parts/disposables by undertaking a proactive cost evaluation and to plan for wear and tear and the procurement of replacement items, including planning the logistics of their actual repair/replacement, and monitoring their actual condition.

29.3.5 Change of Owner/Operator

During the operation phase of a building's life cycle, a property can change hands several times. The frequency with which this happens depends on the type of building and the value creation strategy of the owner.

As there are often breaks in the chain of ownership for certain classes of assets, and likewise in responsibilities and fields of work of the various individuals involved – asset and property manager, tenant, building manager as well as specialists and contractors – the data produced in the construction phase of a property, despite the best effort made to transfer them, can only rarely be used effectively by a subsequent owner.

To ensure that a new owner or operator can seamlessly continue to operate the building in accordance with the statutory requirements, they need precise information about the acquired property. This information should be provided, at the latest, at the moment of handover. For the new owner, it is beneficial to receive these information in the form of a digital data model, and ideally in a format based on open standards (e.g. ISO 16739; COBie; OSCRE). The new owners can then incorporate this model into their portfolio of properties and can organize the continued statutory-compliant operation of the building with the least manual effort.[5]

The availability of information is checked in detail prior to signing the purchase agreement. Providing these information in the form of a digital data model prior to signing the agreement makes it possible for the prospective purchaser to calculate

[5]The issue of operator's responsibility is ommissioned in most publications on BIM. Pramod Reddy (2012), however, makes a case for using BIM and other IT-based systems for both facility management and facility maintenance (see pp. 10–12 and pp. 35–37). Also see Teichholz (2013).

their purchase offer in detail and to automatically determine the subsequent costs for acquisition and operation of the property, minimizing transaction risks. The following information is relevant to a prospective purchaser in the calculation of a purchase offer:

- *Financial model of the property* including information on clients, loans, economic entities, plots, buildings, areas/rentable units, rent agreements, conditions, reports and projects.[6]
- *Technical model of the property* including information on its layout, structure, maintenance condition including a detailed surface model, and all building elements and documents (see ISO 16757-1:2015-09).
- *Historical operation model* with selected information on work carried out by the previous owner and any necessary documentation/proofs that need to be passed to the new owner.

To ensure the correct transfer of these information, the purchaser and seller contractually agree fixed information exchange requirements based on the processes set out in open standards (Open BIM). Alternatively, the contract partners may agree on their own information exchange requirements based on proprietary data (Closed BIM) or a combination of open and proprietary data (Open + Closed BIM).

29.3.6 Data Acquisition for Existing Buildings

One of the greatest obstacles for the use of BIM methods for the operation phase of buildings arises from the fact that digital data models (suitable for use with BIM methods) are only rarely available for existing buildings. Furthermore, to be useful in the operation phase, such digital building data models must also represent the actual state of the building, i.e., contain "as-built" information. A digital building data model can be created from the following information:

- *Conversion of existing information into a consolidated building data model.* Existing disparate documents, (2D-)CAD drawings, Excel lists and database-based information are converted and incorporated into a simple building data model, that replaces them for all further operations management purposes. The information contained in the building data model does not exceed the quantity of information contained in the original documents.
- *New survey of the property, or parts or elements thereof, using digital surveying techniques* can be used for the (semi-)automated creation of a building data model.

[6]For further detail see the Guideline of Real Estate Data Exchange, published by the Society of Property Researchers, Germany (2016) and the Open Standards Consortium for Real Estate.

A combination of both methods is also possible. In such cases, any existing information is converted for use in a building data model, and is later augmented and updated using digital surveying techniques. Those digital surveying techniques, e.g. terrestrial 3D laser scanning, usage of surveying drones using photogrammetric applications usually leads to 3D point cloud data, which have to be post processed for BIM usage. The following approaches are suitable for capturing and processing data on existing buildings for use in the operation phase:

- *Transformation of a 3D point cloud (or clouds) into parametric building element objects* (Scan2BIM). The information in a point cloud acquired using an automatic scanning system can be used to instantly create parametric BIM objects manually, or be processed with the help of semi-automated detection methods. Therefore, the point cloud is automatically converted into a surface model and from this into native BIM objects, such as walls, ceilings, columns, according to their context. Today, extended algorithms provide further support to transform other objects such as ducts and cable runs, as well as some plant objects.
- *Direct use of point cloud information for obtaining factual information for management purposes* (Scan2CAFM). The idea is to identify simple objects in the point cloud (for example, fittings, etc.) and, where relevant, their dimensions for direct use in a CAFM system without prior creation of BIM objects. While the detection of the dimensions of rooms and surfaces is relatively straightforward, the identification of plant installations, for example by scanning machine detail plates, is often not possible as the currently available scan resolution is not fine enough. Some scanners employ a combined approach using point clouds and photos.

These two approaches for evaluating point clouds can also be used in combination to reduce the effort of modeling for the initial BIM model. The individually-created point cloud segments (for example for a room or a specific element with its neighboring objects) are made available via a database (Scan2Dataset). For certain operational processes, the point cloud data may be sufficient and may not need transforming into BIM objects.

Modern systems have made the creation of point clouds using a 3D laser scanner fairly straightforward and time-efficient. For standard-conform data capture (building surveys) of the kind most FM services undertake for new buildings (contracts), they are, however, typically still too expensive. If the demands on precision are lower (which is quite often the case for FM purposes), the aforementioned surveying techniques based on photogrammetry are a good alternative. For the optimal use of the scan data, all three scan scenarios can be combined.

It can be useful to provide a database-driven integration platform that makes it possible to query both existing digital building data models as well as CAFM databases as well as keyword-coded point cloud segments. For this, semantic web technologies provide powerful features (see Chap. 10 and Krämer et al. 2017).

To efficiently employ BIM in the aforementioned work stages and the respective BIM applications, the use of integrated software systems is recommended. The following section discusses the basic systems.

29.4 Software Systems for the Operation of Buildings

IT support of the operation of buildings can be achieved by using Asset Information Management (AIM) systems. Different categories of systems have been developed for different kinds of properties:

- *CAFM software systems* are used primarily for the operation of buildings
- *Road and highway management software* is used to manage roads
- *Proprietary solutions* exist for managing a range of other building types, for example tunnels, canals, railways and bridges

A number of standards and IT systems exist on the market that are already used to apply BIM methods to the operation of buildings. One of these is CAFM-Connect, an IFC specification devised by the CAFM Ring.[7] CAFM-Connect is a view (a MVD) of the IFC specification that has been developed for transferring data from the construction phase to the operation phase as well as for facilitating interoperability among CAFM systems in the operation phase. It supports the reliable and direct (i.e. intervention-free) exchange of rooms, building elements and documents for individual buildings or entire building portfolios based on the open IFC standard (ISO 16739:2016). CAFM-Connect facilitates the structured transfer of all elements and documents in an ifcXML file.

In an international context, COBie is used as a data exchange format for transferring data on an individual building from the construction into the operation phase (see Eastman et al. 2011, Chap. 3.4.3). COBie is an English-language standard developed by the US Army and is based on a database format comprised of interlinked spreadsheets which can be read and edited using spreadsheet programs such as Microsoft Excel.

There are three kinds of CAFM systems that support BIM data:

1. CAFM systems that transfer building data models from the as-built phase into traditional 2D CAD drawings at the beginning of the process and then continue to update these over the life cycle of the building. In this case, two separate building models exist during the life cycle: the native BIM model which can be edited using appropriate modeling software (ArchiCAD, Allplan, Revit) and separate CAFM/CAD plans.

[7]www.cafm-connect.org

2. CAFM systems that offer a proprietary interface to specific modeling software systems.
3. CAFM systems that offer an open, bidirectional IFC interface to any IFC-compatible modeling software system.

In addition, the available CAFM systems offer differing degrees of support for BIM methods, for example:

- Transfer of building data models in IFC format for seamless transfer into all IFC-based modeling tools, for example Graphisoft Archicad, Autodesk Revit or Nemetschek Allplan.
- Import and updating of graphical and alphanumeric information from building data models into operating data and processes.
- Bidirectional connection between the building data model and the operating data and processes, for example to ensure information is fed back into the building data model for future use.
- Dynamic display of linked information in geometric models that is not part of the building data model, for example maintenance information, documents and deadlines, etc.
- Dynamic coloring of the building data model based on process information and other linked datasets.
- Connection of building data models to SAP, DATEV or other accounting and Enterprise Resource Planning (ERP) systems.
- Transfer and maintenance of inventory information on products, for example the installation and replacement of building elements, based on standardized data models (e.g., CAFM-Connect or COBie).
- Connection of building data models to dynamically changing workflows, for example for maintenance, service tickets, room reservations or contractor services and review appointments.
- Connection of building data models to control systems and sensor software systems.

29.5 Summary

Working with BIM building data models in CAFM offers the best of two worlds. One the one hand, models can be created and maintained using the most professional tools available on the market. On the other, the process and data-based approach of CAFM systems provides an optimal basis for using and keeping model data up to date over an extended period of time, ensuring their ongoing usability and value in future.

References

Eastman, C., Teichholz, P., Sacks, R., & Liston, K. (2011). *BIM handbook – A guide to building information modeling for owners, managers, designers, engineers and contractors*. New Jersey: Wiley.

HOK Network. (2010). The future of the building industry (5/5): BIM, BAM, BOOM. Retrieved from https://www.youtube.com/watch?v=5IgdcCemevI. Accessed Nov 2017.

ISO 16757-1. (2015). *Data structures for electronic product catalogues for building services – Part 1: Concepts, architecture and model*. Geneva, Switzerland: International Organization for Standardization.

ISO 16739. (2016). *Industry Foundation Classes (IFC) for data sharing in the constriction and facility management industries*. Geneva, Switzerland: International Organization for Standardization.

Krämer, M., Besenyöi, Z., & Lindner, F. (2017). 3D laser scanning. Approaches and business models for implementing BIM in facility management. In *Tagungsband INservFM* (pp. 679–691). Auerbach/Vogtland: Verlag Wissenschaftliche Scripten.

Kumar, B. (2015). *A practical guide to adopting BIM in construction projects*. Dunbeath: Whittles Publishing.

Pramod Reddy, K. (2012). *BIM for building owners and developers – Making a business case for using BIM on projects*. New Jersey: Wiley.

Roper, K. O., & Payant, R. (2014). *The facility management handbook* (4th ed.). New York: AMACOM.

Shepherd, D. (2015). *BIM management handbook*. Newcastle upon Tyne: RIBA Publishing.

Society of Property Researchers, Germany. (2016). *Guideline of real estate data exchange*. Wiesbaden: Society of Property Researchers.

Teichholz, P. (2013). *BIM for facility managers*. New York: Wiley.

VDI 6039. (2011). *Facility-management – Managing of building commissioning – Methods and procedures for building-services installations*. Düsseldorf, Verein Deutscher Ingenieure (VDI).

Part V
Industrial Practice

Chapter 30
BIM at HOCHTIEF Solutions

René Schumann and Jan Tulke

Abstract Since 2003, HOCHTIEF has been systematically developing Building Information Modeling (BIM) in the framework of the innovative ViCon concept (short for *Virtual Design and Construction*). HOCHTIEF uses BIM during the tender, planning, and construction phases of major projects. The traditional working processes are adapted towards the new BIM methodology in a sequential and iterative manner. Based on national and international developments, there will hardly be any projects in the near future not relying on BIM.

30.1 BIM History Within HOCHTIEF Solutions

Virtual construction as such was initially processed in a structured manner within the scope of HOCHTIEF AG's Corporate Development. In 2003, HOCHTIEF launched a new innovative initiative called ViCon for Virtual Design and Construction. As an internal competence center, ViCon bundled all expertise regarding BIM. The initiative thereby executed a large number of pilot projects, all aimed at gaining experience with commercially available software applications and on accumulating know-how on the implementation and use of BIM in the corporate divisions. HOCHTIEF subsidiaries Turner in the USA and Thiess in Australia also participated in the projects. HOCHTIEF mainly focused on measuring and substantiating the added value generated by BIM. A relatively easy way to determine the value of innovations is to charge the operative units for innovative BIM products and

R. Schumann (✉)
HOCHTIEF ViCon GmbH, Essen, Germany
e-mail: rene.schumann@hochtief.de

J. Tulke
planen-bauen 4.0 – Gesellschaft zur Digitalisierung des Planens, Bauens und Betreibens mbH, Berlin, Germany
e-mail: jan.tulke@planen-bauen40.de

© Springer International Publishing AG, part of Springer Nature 2018
A. Borrmann et al. (eds.), *Building Information Modeling*,
https://doi.org/10.1007/978-3-319-92862-3_30

services. If a BIM product is requested and paid for, it has proven its added value. It was mainly due to this basic concept that in 2007, the HOCHTIEF ViCon GmbH was founded in order to offer worldwide professional BIM services, both internally and externally. As a subsidiary of HOCHTIEF Engineering GmbH, it nowadays provides 80% of its services to third parties. This sustainable and open approach to the continuous development of BIM is based on the simple belief that an extensive topic such as BIM cannot be accomplished by one company alone, but must be addressed in a joint effort by all those involved in the construction industry.

30.2 From 2D to BIM

Building Information Modeling has been the strategic focus of the HOCHTIEF divisions since 2003. HOCHTIEF Solutions in Europe and MENA (Middle East and North Africa) have adopted BIM during tender, planning, and construction phases of major projects. The traditional working processes are adapted towards the new BIM methodology in a sequential and iterative manner. However, many software tools are not sufficiently advanced, and some new processes have not yet been defined. Therefore, it is expedient to implement BIM step by step within partial processes that have proven to be effective. ViCon supports the in-house implementation of BIM at HOCHTIEF Solutions with experienced BIM Managers and BIM-based production systems such as OBIS (Online Building Information System), ORIS (Online Rail, Road & Bridge Information System), and OWIS (Online Onshore Offshore Windpark Information System) (cf. Chap. 27).

The staff is trained in the four main areas: processes, people, policies, and technologies (cf. Chap. 16) – either directly on projects or within BIM workshops, where specialist teams define and establish new BIM-based processes. Then, test projects are carried out to substantiate the expected benefit and document the added value.

Some examples for the versatile use cases for BIM at HOCHTIEF Solutions are listed below:

In high-rise buildings, model-based quantity take-off is applied for shell constructions and fitouts. 4D models (3D + time) support construction sites by simulating the construction progress by means of complex geometries, and 4D models are useful in the scope of large and/or complex projects, in order to better understand correlations at the construction site and to plan construction site logistics. For highly complex building services, 3D MEP clash detection is performed on major projects. For this purpose, ViCon developed a special software program, the DCS – *Design Coordination System*, (cf. Fig. 30.1). Based on Autodesk Navisworks, the tool serves to investigate and eliminate detected clashes.

During tender negotiations with clients, for technical clarification and sampling of rooms, 360° visualization, 3D PDF illustrations, and technical movie sequences are used for support. Many projects use the 3D BIS (Building Information System) software, which allows to evaluate and review numerical and graphical data for a

Fig. 30.1 3D DCS (Design Coordination System) to eliminate geometric clashes. (© HOCHTIEF ViCon, reprinted with permission)

variety of construction management purposes (cf. Fig. 30.2). The 3D BIS software was especially developed for the construction industry and is based on desiteMD (by ceapoint) and other tools.

In addition to the scope used for high-rise building construction, civil engineering also benefits from GIS (Geographic Information Systems), in particular for line construction or large-scale projects such as wind farms. The use of mobile devices helps to submit locally collected data (performance, status photos, approvals, etc.) via the production system directly to the central data base. In the scope of many major national and international projects, clients expect the creation of an individual "BIM Execution Plan", which systematically describes all steps of executing the BIM methodology in the course of the project – as well as a final information transfer at the beginning of the building's operative phase.

As the implementation of BIM is of strategic importance for HOCHTIEF Solutions, this task is executed according to a business plan constructed by ViCon. The implementation and standardization of BIM is a pivotal element of a long-term goal achievement for increased efficiency and risk management at HOCHTIEF Solutions AG. BIM use cases were given particular importance, and their value added is recorded and assessed individually. The business plan moreover comprises aspects such as future software roadmaps, the use of neutral exchange formats, and employee training. The implementation is carried out following a set schedule. The

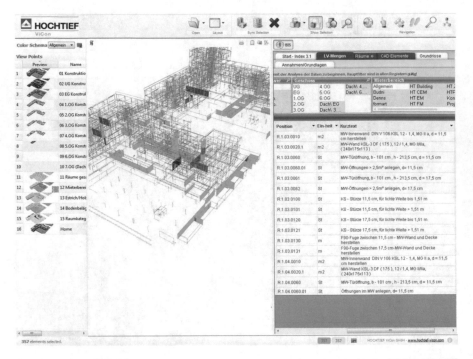

Fig. 30.2 3D Building Information System to support construction management. (© HOCHTIEF ViCon, reprinted with permission)

process of operative BIM implementation at HOCHTIEF in Europe has begun, and BIM is going to be introduced into the daily workflow step by step.

30.3 Examples of Completed and Ongoing Projects

30.3.1 Barwa Commercial Avenue, Qatar

Superlatives in the Gulf region: 400,000 m³ of concrete, 920,000 m² of gross floor area, 18,500 rooms, 16,000 doors, 1,990,000 m² of formwork and approx. 280,000 CAD elements. These gigantic figures outline the Barwa Commercial Avenue Project in Doha (Qatar) (cf. Fig. 30.3). The construction of a 8.5 km shopping mall confronted architects and structural engineers with unknown logistic challenges.

During the planning phase, HOCHTIEF ViCon created an intelligent 3D model, on the basis of which a rough cost estimate was calculated. The 3D model was also used to monitor subcontractor performance and to report construction progress to the client.

Fig. 30.3 View of one of five types of buildings. (© HOCHTIEF ViCon, reprinted with permission)

During the execution phase, the 3D model was regularly adjusted to the current execution plan in order to generate data for calculation, billing and performance reports. The Planning Department of HOCHTIEF Solutions Middle East created performance reports on site, using their hand-held devices. The accurate distribution of masses to each individual room as indicated by the model, provided up-to-date perspectives of construction progress and helped to settle subcontractor invoices.

On the basis of the information linked to the 3D model, 2,100 construction target plans were created, providing information on the quality and fitout of the respective rooms. The construction target plans were used to define performance standards in subcontractor agreements and were added to the contracts with tenants and users of the building.

All data created were fed into the 3D Building Information System. Construction managers were thus able to quickly and flexibly search for and filter project-related data. The system links the 3D model to all kinds of information in a central data base. In addition to the building topology, the 3D BIS also contained 2D drawings, deadlines, spatial information, construction target plans and further information.

The 3D Building Information System provided reliable monitoring of schedules as well as structured documentation of construction processes, and it formed the basis of logistic planning, material planning, and reliable settlement of subcontractor invoices. The construction work was largely completed in September 2012, and the project has meanwhile been handed over as scheduled (cf. Fig. 30.4).

Key figures of the 3D model:

- Planning phase: 2,700 h spent on modeling and 1,100 h spent on quality control and model correction
- Execution phase: on average 2 employees deployed for updates of model and quality management
- Bill of quantities comprised 2,200 items
- 8,120 scheduling positions were linked to 280,000 CAD elements

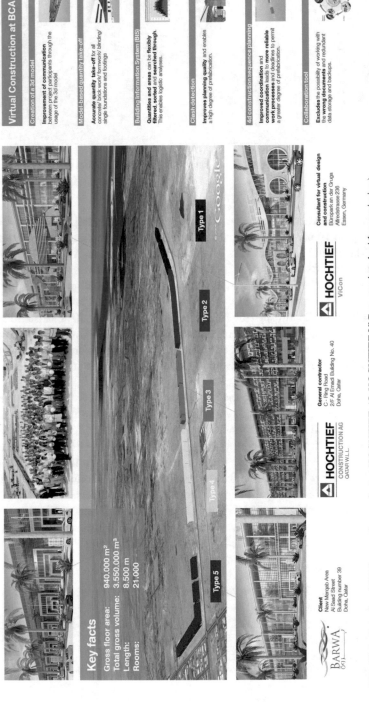

Fig. 30.4 Completed BIM execution project at HOCHTIEF. (© HOCHTIEF ViCon, reprinted with permission)

- 7,000 architect plans and 2,000 location plans in 2D were processed throughout the entire duration of the project
- More than 30 people worked with 3D BIS on the construction site.

30.3.2 Elbe Philharmonic Hall, Hamburg

Another major project supported by HOCHTIEF ViCon is the Elbe Philharmonic Hall in Hamburg. Its complexity and modern site configuration can hardly be matched. Virtual models and meeting rooms with interactive touchscreen displays, the so called iRooms, belong to the standard site equipment. The BIM Project Manager and the BIM Manager support the HOCHTIEF Project Management in transforming the architects' ambitious ideas into tangible reality.

The Elbe Philharmonic Hall is a particularly complex building, consisting of a dense network of tubes and pipelines and of steel and concrete. Technical building systems presented a particular challenge to the planners. Therefore, HOCHTIEF opted for BIM and model-based planning from the very beginning in order to coordinate the shell construction and the eight different trades involved; from heating and sanitary installations to ventilation. "On the seventh floor alone, we detected 861 clashes," reports the construction manager in charge of technical building services.

The construction manager in charge of technical building services gives a virtual presentation on two large boards in the iRoom, turning the Elbe Philharmonic Hall upside down and showing it from a bird's-eye view just seconds later. "The building services could probably work as a standalone solution." From the distance, only a colorful mix of tubes and cables is recognizable as the shape of the Elbe Philharmonic Hall (cf. Fig. 30.5). Zooming in on the sixth floor, he points out a location at which the plan showes two overlapping tubes. Further, he mentions that more than 8,000 of such clashes were detected in the entire building project.

The construction manager in charge of the technical building services assumes that only about one third of clashes would have been detected if the individual trades had been individually monitored on the basis of 2D plans. This would have cost significantly more time. The remaining two thirds would probably not have been discovered until the construction phase, and this would have resulted in a further loss of time and material. The entire technical building services team now examines every floor on the screen in the consolidated 3D technical building services model – and is by several weeks ahead of construction "to give the other trades time to react".

During weekly meetings in the iRoom, the participants discuss which planner is responsible for which issue and when it needs to be solved. Translated into practice, this means: If a ventilation pipe touches the sprinkler system, one of the planners will have to move the pipe up or down. That way, the construction team will not have to deal with this clash at a later stage (cf. Fig. 30.6). The new procedure helps those in charge to prevent defects in advance, without having to eliminate them later. This is how the BIM Project Manager puts it: "It is our target to detect errors in the

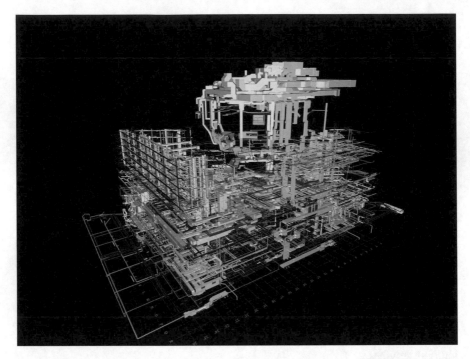

Fig. 30.5 Consolidated 3D model, comprising eight different technical building service plans. (© HOCHTIEF ViCon, reprinted with permission)

digital model rather than on the construction site. Each discrepancy that has to be eliminated at a later time costs time and money."

However, not every clash that occurs in the 3D model is relevant. Therefore, Julian Janßen inspects and assesses every single one. All stakeholders can access the model and his comments. "We also create 4D models for the Elbe Philharmonic Hall," says the BIM Manager. The fourth dimension is time.

"Of course, we have built other complex structures without BIM," says the HOCHTIEF Manager in charge of the overall project. He adds that the construction of the Elbe Philharmonic Hall on the site of the former docks poses particular challenges, since the surface of 6,000 square meters is relatively small for such a complicated structure, which involves large quantities of concrete and steel as well as rather complex technical building services. He concludes that BIM helps the construction company to stay on top of things and to work precisely to the lowest level of detail.

30.3.2.1 Building Statics Do Not Allow for Adding Openings at a Later Time

In this particular, it is not an option to add openings at a later time, since all surfaces and walls are precisely calculated and many walls are made of prestressed concrete

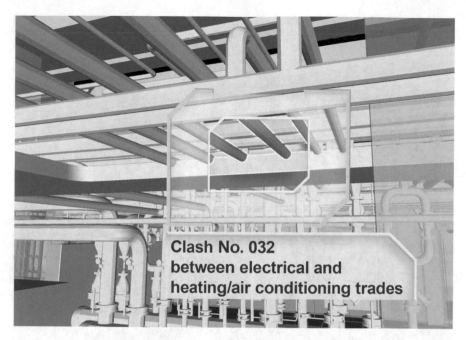

Clash No. 032
between electrical and
heating/air conditioning trades

Fig. 30.6 Clashes between technical building services. (© HOCHTIEF ViCon, reprinted with permission)

to begin with, followed by installing the ventilation system. Then, the inner ceiling of the hall is constructed in shotcrete. A HOCHTIEF Project Manager who is in charge of the two concert halls, among others, doubts that this cultural monument could have been built without BIM. "The model gives us a level of security in planning and execution that we would otherwise not have," she says.

People entering the construction site of the Elbe Philharmonic Hall can see the Small Concert Hall from the 13th floor. It must be completely soundproof against the adjacent foyer and hotel areas; therefore, a cavity will be created between two walls, which will be used for technical building services.

The construction manager in charge of construction process planning explains: "Originally, we had planned to build the lower part of the ceiling, the building services and the outer shell one after the other. The model showed that this would create spatial issues." Therefore, a section of the outer ceiling will be constructed in prestressed concrete to begin with, followed by installing-first, then the ventilation system. Then, will be installed, and then the inner ceiling of the hall will be constructed in shotcrete. "This enables us to continue working on the hotel areas at the same time," explains the engineer. In order to visualize construction management contexts, the 3D models are linked to the latest schedule. The digital 4D model (3D + time) will then be compared against the actual situation on site (cf. Fig. 30.7).

Fig. 30.7 Comparison of 4D model with actual status. (© HOCHTIEF ViCon, reprinted with permission)

30.3.2.2 From Areas to Structures

While HOCHTIEF ViCon creates partial models and coordinates their consolidation – together with the specialist planners in an overall model, the responsibility for project planning remains with the general planner. "We perceive ourselves as the conductors of digital data flows between the parties, and we try to link data and models in an efficient manner that allows to reuse them as frequently as possible," explains the BIM Project Manager.

The Swiss architects of the Elbe Philharmonic Hall created 20 different 3D area models for the Big Concert Hall alone. ViCon has created 3D volume models from the 3D area models and merged them into one 3D model. The aim is to determine the precise distance between the inner and outer shells of the concert hall and thus the space available for technical building services. In this regard, it is a convenient option for all stakeholders to work with a 3D model (cf. Fig. 30.8).

BIM allows to analyze, capture and realize even multi-faceted structures such as the Elbe Philharmonic Hall even if only for their technical complexity.

Fig. 30.8 3D volume model of the inner shell of the concert hall. (© HOCHTIEF ViCon, reprinted with permission)

30.4 BIM Benefits

HOCHTIEF has recognized the benefits that BIM offers. BIM benefits are as varied as the scope of activities HOCHTIEF engages in.

BIM benefits in a nutshell:

- Improved communication among all parties involved
- Prevention of duplicate entries/data discontinuities caused by various stakeholders
- Structured instead of unstructured data enables partly automated process execution
- Improved data topicality and quality
- Processes can be standardized
- Process quality and speed can be measured
- Productivity can be increased enormously throughout the entire value chain

Specific planning advantages:

- Changes are made directly in the 3D model, which prevents mistakes in 2D planning (floor plan, view, section, detail, other types of 2D plans)
- Planning contents are standardized
- Automated 3D model check (geometry and attributes)
- Improved planning quality, e.g. thanks to clash checks
- Involvement and understanding of all planning stakeholders is improved

- The client/user/operator of the building renders his requirements more precisely and has a better understanding of the planning

Specific building execution advantages:

- Error prevention – building digitally first
- Construction processes are optimized by construction process simulation
- Required volumes are calculated more precisely
- Mobile data collection during construction
- Improved information management
- Improved decision and change management
- Transparent calculation and monitoring of costs

Client/user/operator benefits:

- Transparent planning and construction processes thanks to 3D support
- Decisions are managed more effectively with regard to time and content (minimized risks)
- Information contributed by various parties is consolidated – overall improvement of the level of detail
- Faster, more precise and detailed visualization opportunities for PR purposes
- Various options for simulation of operation
- Improved handover and commissioning thanks to virtual test runs

30.5 Summary

Based on national and international developments, there will hardly be any projects in the near future not relying on BIM. The conventional 2D planning process will gradually be replaced by the 3D modeling process in the next few years. Project execution "on the basis of 3D models" is becoming standard during the construction phase.

The BIM Manager will be established as an important participant in building projects (cf. Chap. 16), focusing on the management of "digital data flow" within projects. It is his responsibility to ensure that clients will receive information and data early enough to make timely decisions and in agreement with the project's quality requirements. Both professional and non-professional planning and construction clients will be enabled to understand the "product" being built and to contribute actively to its design. BIM will be required by public and private clients.

National and international BIM standards will form the basis on which digital information in connection with planning, construction and operation of buildings is created, processed and documented.

BIM production systems (cf. Chap. 27) will be the standard required by clients for major projects or will be provided by those involved in planning or construction. This Common Data Environment will serve as a pool from which all parties can draw all required information for their particular purpose at the time of

execution. Similarly, partial results or the construction progress of a building will be documented and stored in the BIM production system. Reports on planning and construction progress as well as the development of schedules and costs will be graphically illustrated in a partially automated process. Quality control will be comprehensively documented, using mobile devices.

In future, the main focus will be on the interface between the actual and the digital world. Digital information will be transferred into the real world on construction sites, e.g. by importing 3D model information into measuring devices (BIM-to-Field). As-built information will be transferred back into the model and compared against the digital world, e.g. via sensors or laser scanning technologies (Field-to-BIM). Augmented reality applications will support work on the construction site, as soon as positioning aspects within the buildings have been satisfactorily resolved at a technical level.

The construction industry – meaning all companies involved in the construction process, from planning to manufacturing – will contribute to increased productivity and generate more efficiency on the basis of uniform BIM standards and partially automated processes.

Future buildings will be influenced considerably by their future users and, therefore, determined by their individual demeanor.

Chapter 31
Arup's Digital Future: The Path to BIM

Ilka May, Christopher Pynn, and Paul Hill

Abstract For Arup, BIM represents a new paradigm for an integrated approach to design. The push towards BIM in the architecture, engineering and construction industry represents a digital alignment with Arup's existing 'Total Architecture' philosophy. Arup has always been at the forefront of new technologies, such as CAD, 3D Design, and project collaboration. The chapter provides details on Arup's drivers, strategy and the five key activity areas under the implementation program: Governance and leadership, People and skills, Marketing and communication, Processes, Technology.

31.1 Introduction to Arup

Arup is an independent firm of designers, planners, engineers, consultants and technical specialists, working across every aspect of the built environment. Together we help our clients to solve their most complex challenges – turning exciting ideas into tangible reality as we strive to shape a better world.

Many of Arup's projects leave a legacy to subsequent generations: a legacy that outlasts any one individual. With 10,000 projects going on at any one time, Arup is doing the best possible job for current and future generations. Putting sustainability at the heart of its work is one of the ways in which Arup exerts a positive influence on the wider world. Put simply, Arup people are driven to find a better way.

I. May (✉)
LocLab Consulting, Darmstadt, Germany
e-mail: ilka.may@loclab-consulting.com

C. Pynn
Arup, East Melbourne, VIC, Australia
e-mail: chris.pynn@arup.com

P. Hill
Arup, London, UK
e-mail: paul.hill@arup.com

© Springer International Publishing AG, part of Springer Nature 2018
A. Borrmann et al. (eds.), *Building Information Modeling*,
https://doi.org/10.1007/978-3-319-92862-3_31

Arup's independent ownership structure gives conviction a place in its decision-making, alongside the needs of clients and commercial imperatives. The result is clear-sighted, thoughtful decisions about its priorities as a business and as a member of society.

Arup influences many people's lives through its projects. Shaping a sustainable future – particularly through the urban environment – will be one of the greatest challenges in the twenty-first century. Arup is rising to the challenge: investing in research, innovating and creating better solutions for its clients and the wider world.

> ... our lives are inextricably mixed up with those of our fellow human beings, and that there can be no real happiness in isolation... **Ove Arup, 1970**

31.2 Arup's Global BIM Strategy: Phase 1

Arup's global BIM strategy and implementation plan were developed in early 2013 and implemented by a dedicated task force between August 2013 and March 2015. The strategic plan set out the foundation, structure and processes needed to enable a valuable adoption of BIM, whilst setting longer term objectives that will shape Arup's digital future over the next 10 years.

The strategy defines the expected minimum use of BIM for all Arup (buildings and infrastructure) design projects. The strategy will ensure that BIM is planned and implemented successfully.

Arup's approach to the implementation of BIM within the firm affects many things, from winning to delivering work. A consistent global strategy to our internal approach is therefore vital. To establish shared clarity of meaning, we have settled on a common and concise definition of what we mean by 'BIM' at Arup:

> BIM is a descriptive term for a digitally enhanced collaborative design process across the built environment. It is characterized by the creation and use of geometrically & spatially coordinated 3D 'objects', enhanced by associated computable data. The data is typically interrogated in a 3D environment, and is manipulated to describe a project in many ways.

Phase 1 Targets

Arup's strategy defines the organizational change and training we need in order to achieve a rapid adoption of BIM across every area of the firm. The strategy is centered on two main objectives:

- Oversee a consistent level of BIM adoption across all three practices on all projects
- Provide the foundation and structure for the next 5 years around digital technology in engineering

Phase 1 centres on using BIM to improve the quality and level of productivity in what we do, while expanding our capabilities at the same time. However, to achieve

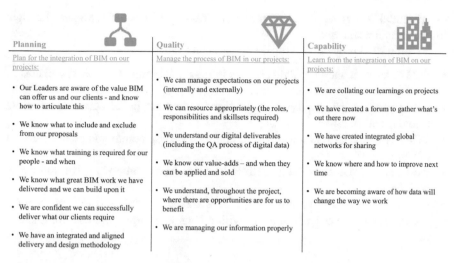

Planning	Quality	Capability
Plan for the integration of BIM on our projects:	Manage the process of BIM in our projects:	Learn from the integration of BIM on our projects:
• Our Leaders are aware of the value BIM can offer us and our clients - and know how to articulate this	• We can manage expectations on our projects (internally and externally)	• We are collating our learnings on projects
• We know what to include and exclude from our proposals	• We can resource appropriately (the roles, responsibilities and skillsets required)	• We have created a forum to gather what's out there now
• We know what training is required for our people - and when	• We understand our digital deliverables (including the QA process of digital data)	• We have created integrated global networks for sharing
• We know what great BIM work we have delivered and we can build upon it	• We know our value-adds – and when they can be applied and sold	• We know where and how to improve next time
• We are confident we can successfully deliver what our clients require	• We understand, throughout the project, where there are opportunities are for us to benefit	• We are becoming aware of how data will change the way we work
• We have an integrated and aligned delivery and design methodology	• We are managing our information properly	

Fig. 31.1 Phase 1 targets. (© Arup, reprinted with permission)

a basic and consistent level of BIM use on our projects, we first need to set some minimum standards and protocols.

Phase 1 comprises five minimum requirements, and have been required of all design projects since April 2015. These targets relate to our people's knowledge and skills, while clarifying responsibilities and deliverables for Arup (Fig. 31.1).

1. Complete a BIM Data Review (pre and post project win)
2. Produce a BIM Execution Plan (BEP)
3. Implement the process for managing data – 'Common Data Environment' (CDE)
4. Implement a Virtual Design Review (VDR) process
5. Verify our design through open industry data standards (IFC, COBie etc)

31.2.1 Drivers for BIM in Arup

Arup has always been at the forefront of new technologies, such as CAD, 3D Design, and project collaboration. At its most comprehensive, BIM represents a new paradigm for an integrated approach to design. Although BIM is not new, in the last 2 years influential industry and government bodies have brought us closer to the tipping point where BIM becomes the norm.

This suits Arup. The current push towards BIM in the architecture, engineering and construction industry represents a digital alignment with Arup's existing 'Total Architecture' philosophy. Clients are rapidly becoming more receptive to it. BIM's strong parallels with our Arup's longstanding collaborative and creative ethos has

the potential to put us ahead of our competitors, but only if we have the right implementation strategy.

Existing BIM projects at Arup demonstrate its value:

- BIM saves us money – testing choices in the model rather than on-site makes us more efficient
- BIM improves the quality of our designs – they are better coordinated, more rigorous and creative
- BIM improves our relationship with clients – we can communicate the value of our approach
- BIM reduces our risks – our deliverables are more comprehensive and better coordinated
- BIM builds longer-term value – the BIM model can be used into operational phases, extending our relationship with clients and improving our commercial potential

31.2.2 Aim of the BIM Strategy

To succeed we need to establish a shared approach. This means structured data and a consistent use of technology across all regions and practices, for clients across the world. Our people need to be able to clearly and effectively communicate the benefits of our BIM-first strategy to clients.

This consistency of approach will result in:

- Minimised repetition of tasks through better interoperability and automation
- Fewer wasteful activities from bid stage to project delivery
- Designers and engineers able to focus on their core tasks, leading to more creativity innovation and outstanding projects
- Maintaining/regaining our reputation for innovation, which is vital for winning work

31.2.3 Mission Statement

At Arup, we use BIM wherever it will add value. BIM will be our default method for producing all design work. BIM enables our teams to take an integrated lifecycle approach to the management of data for clients. We want to be the recognized market leader in identifying and applying BIM in the built environment, creating maximum value for clients across the lifecycle of their assets.

As a platform for digital collaboration, BIM represents the next stage of Arup's "Total Architecture" culture. In BIM we hear echoes of our founder Ove Arup's maxim that, 'all relevant design decisions have been considered together and have been integrated into a whole'. BIM is about new opportunities. As an approach

it liberates us to offer clients a range of valuable additional services, allowing us to expand beyond our traditional core disciplines. We will identify project-specific differentiators linking the Arup brand to the needs of its projects and clients.

We will use marketing, client education, and networking to position Arup as the digital leader in the built environment. We will discuss BIM with our clients to understand how their business would benefit from the approach, from design to ongoing operation. We will evangelize the benefits of BIM to our clients, by quantifying and sharing the benefits in effective case studies. Our people will be given the responsibility and training to communicate our approach to BIM to clients.

BIM is the future. As such its use is now a mandatory business requirement instructed by Arup's board. We will accept reduced profitability on some early demonstration projects until the techniques have bedded in. The firm will also support its people through this transition. We will invest in new tools, new techniques, new training, and new people as needed, through a coordinated implementation process.

31.2.4 Implementing BIM: The Risks

In its ability to unify and model the work of every discipline contributing to a given project, BIM both highlights a team's strengths and at the same time exposes and amplifies any weaknesses in project management or decision-making.

BIM means a new way of working for everyone. At the end of 2013, the Arup team does not yet have wide experience of full lifecycle BIM, particularly on large-scale infrastructure projects. BIM is not yet 'business as usual'. A mistaken belief persists that BIM means extra work for no extra fee, or is just an additional CAD technology that is not applicable to design. Education efforts will be needed, and misconceptions must be challenged.

We need to commit fully. BIM's benefits only occur when it is fully integrated into the project process. Incomplete implementation of BIM will just create additional administration and management activities, duplication and overload of data and information, undermining trust in the approach and sow confusion amongst Arup team members.

The implementation of new processes and tools will obviously need to be managed very carefully and thoroughly in a transparent and consistent way. However, in a highly competitive market, the 'do nothing' option is the real risk to our business.

31.3 Managing the Transition

Top-down demands for change have never been part of Arup's culture. This partly explains why, despite its use on some exemplar projects, the overall pace of change

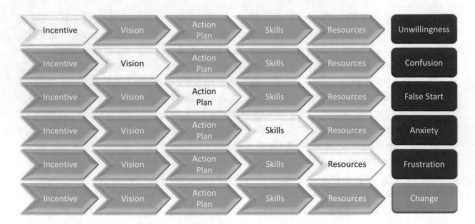

Fig. 31.2 Change Management Approach adopted by the Global BIM Strategy. (© Arup, reprinted with permission)

has been too slow and adoption patchy, although we have been aware of the need to embrace BIM for over a decade. In 2013 the Arup Group Board therefore decided that the firm needed to adopt BIM across the entire business, including all Practices and Regions. The aim over the following 12 months was to effect a step change in the adoption of BIM across all of Arup's operating groups.

Changing the workflows, procedures and use of technology for more than 14,000 staff is a massive undertaking. People respond differently to change, and the team worked closely with change management experts in order to craft a plan that would have a chance of success. The team adopted the following change management theory, which became the backbone of the implementation program: *We need an incentive to get started, the vision to know where we are going, we need the action plan that tells us how to achieve it, the skills and the resources to do it – only then will we succeed* (cf. Fig. 31.2).

31.3.1 Incentives

Given the urgency and the scale of the task, but mindful of Arup's traditional ground-up culture, it was recognized that a hybrid, push-and-pull approach was more likely to succeed (cf. Fig. 31.3).

The pull factor is Arup leadership's full support for its BIM implementation strategy, its official mandate for a defined level of initial BIM maturity on all new design projects from 2015 onwards.

The push element was more difficult to achieve. It comprises various motivations, encouragements and support tailored to the different roles and responsibilities across the Arup business and the regions (also see Strategy Implementation section).

 You will be measured how you are getting on

You will be rewarded for good BIM work on projects
You will be left behind if you sit back and wait

Remain creative and bottom up – but aligned

We are setting targets and we define what is needed

We are creating an infrastructure of standards, guidance and training

We are removing blockers to adoption

We are leading and we are steering

Fig. 31.3 Our push-and-pull approach. (© Arup, reprinted with permission)

Communicating BIM – Arup's various 'elevator pitches'

The following 'elevator pitches' explain the benefits of BIM to different members of staff, relevant to their different roles and responsibilities:

As a leader, I worry about:

- Staying innovative
- Remaining profitable (and more efficient)
- Delivering best value projects to our clients
- Creating repeat business

Elevator pitch: *We have reached the point where it's not "if the industry will adopt BIM" it's more "when the industry will adopt BIM". By supporting this change and developing this capability, we will be competitively responding to the most significant transformation in our industry for a generation. We know our competitors are doing the same, so if we don't act now, we will be playing catch-up.*

As a project manager, I worry about:

- Competition from contractors
- Losing projects
- Quality and risk management
- Access to information
- Remaining in control
- Re-inventing the wheel – waste and duplication on my project

Elevator pitch: *BIM offers you the tools to be able to plan and execute the exchange and delivery of information throughout the project, with less risk to both time and cost. Surely that's got to be a better way of working? However, if you don't support this change, you will continue to be frustrated with the late delivery of information, lacking enough or the right resources, and managing countless RFI's throughout construction.*

As an architects/engineers/designers/analysts, I worry about:

- Data reliability
- Efficiency in my work
- Responsibility and liability
- Whether I have the right skills and access to tools

Elevator pitch: *BIM makes complex design collaboration easy. It ensures you possess exactly the information you need in order to produce, when you need to produce it and to the required level of detail. You will also be able to see what other people are responsible for and when they're going to do it. When they've completed their work, you'll know exactly where to find it, if it's the latest version or not, and more importantly, what you can use it for. Any additional time spent on BIM processes and procedures is insignificant compared to the time you save from not having to hunt down or deal with poor information. Surely that's got to be a better way of working?*

31.3.2 Action Plan

We have developed an action plan that captures our incremental goals, as well as setting longer-term objectives:

Activity area 1: Governance and leadership
Action: Arup's usual 'ground-up', evolutionary approach to change won't be able to deliver the required level of BIM adoption quickly and consistently enough. Therefore we need directors at board/executive level to be accountable for BIM capability development. They will be supported by a network of BIM coordinators and champions, who have a defined remit of action and necessary funding.

Activity area 2: Align the people
Action: Roles, tools and processes are going to change, but we can adapt to change with appropriate training and education. We will lower the introductory costs of BIM on new projects/groups/offices and provide the appropriate supporting procedures, technology and tools. BIM must be embraced by all and recognized as the new way of working.

Activity area 3: Align the processes
Action: BIM changes the way we work, improving how we carry out design, calculations and reporting. But more importantly, BIM changes how we manage data and information on every project in the future. Therefore we have to review and adapt existing standards and procedures in Arup – including Arup Operating Procedures, existing BIM strategies, templates and best practice guides, taking differing regional and discipline requirements into account.

Activity area 4: Align the technology
Action: We need to become more aware of digital technology's ability to reshape our industry and get better at anticipating the challenges and opportunities it presents.

Activity area 5: Marketing, change management and communications
Action: Questions about BIM capability are increasingly becoming part of the bidding process for new projects. We need to present a global face of BIM within Arup. Starting with Arup.com right through to project sheets, capability statements, presentations and other marketing material.

Activity area 6: Research and development
Action: BIM and digitalisation are key tools and platforms for innovation and collaboration. They should therefore play a prominent active part in our research agenda.

Activity area 7: Business development and project support
Action: BIM's potential is often oversold and under-delivered by our competitors. By contrast we welcome the opportunity to explore how BIM can help individual clients on their projects. Arup uses BIM to deliver incredible, unique and bespoke data-rich outcomes.

31.3.3 Skills

Strategy is one thing. Having the skills to achieve change is another. We've started with education, informing our engineers, technicians and leaders about the processes and value of BIM. This ensures that every project team has a base level of understanding about issues such as data management and exchange, process mapping and interoperability, but the overarching goal at this point is that more of us fully embrace the value and opportunity that BIM presents. We've also established that to encourage interest and adoption of BIM you must keep discussion of it relevant to people's individual perspective.

BIM training modules have been rolled out to help train Arup leaders in the foundations of BIM. The BIM for Leaders program was successfully rolled out across the globe over a two year period with over 50 of all grade 7s, 8s and 9s having attended a session.

The next key target group were project managers and five modules were developed to explain the technical implementation of BIM on a project.

Table 31.1 Expected investment areas

Area	What	Estimated Costs
Governance	The regional SRO should be able to provide the required amount of time for both influence and direction.	An allowance of time equivalent to 2 days per month
Governance	The 5 regional BIM implementation coordinators should be non-billable during an initial 8 months transition period and focus on managing the transition. They should aim for 50% billability after that period.	5 staff funded centrally or through the regions for 8 months as the initial investment, probably followed by more central support for key roles that enable and support projects and regions.
Governance	Nominated sub-regional BIM implementation Managers should be able to spend up to 2 days per week non-billable for winning work and project delivery without adding to the costs of the project	Depending on number of nominated sub-regional BIM mentors, funded by sub-regions in accordance with their needs
Technology	Funding requirements for licenses, customization, development and hardware will be specified after the requirements reviews.	
Process	The review and appropriate revision of processes will be a key activity of the regional BIM implementation coordinators during the initial 8 months transition period; therefore the costs are already covered under governance.	
People	There will be an increased need for staff training across all levels. More details will be available after the skills assessment.	

31.3.4 Resources

We recognized that the desired step change in BIM capability and capacity globally would require time and money. People with the right skill sets had to be identified and freed up from their day jobs for defined periods of time, with support from their line managers.

The expected investment areas in the Global Strategy in 2012 were as shown in Table 31.1

31.3.5 Measuring Success: The BIM Maturity Measure

To measure success you first need a baseline. Arup's strategy developed used a survey to establish an initial baseline. This established existing use and understanding of BIM at the firm. But the more important measure would be how to understand future progress made in the implementation of BIM.

The Arup BIM Maturity Measure, (fondly referred to as the 'dipstick') makes an overall assessment of a project's BIM maturity looking at overall implementation at both a wider project level and an internal level (Azzouz and Hill 2016).

At the project level BIM implementation is often a response to the stated requirements of our client. But it's equally important to recognize the value that Arup derives internally by adopting BIM even when the client isn't pushing for it, such as greater efficiency, less repetitive work and less waste. Our BIM Maturity measure captures both these viewpoints and is able to assess Arup's BIM score as well as a measure for client and contractor involvement.

The Arup BIM Maturity Measure is backed by the Arup Group Board and now each region has to report a measure of BIM implementation through the management board twice a year. This has again elevated the importance of BIM across the business and started to align it to the firm's commercial performance, revealing the emerging patterns of adoption and use.

31.4 Implementation Activities

The following section describes activities started or undertaken during the strategy implementation phase between August 2013 and April 2015.

The sections reflect the Action Plan described in Sect. 31.3.2 and provide further details and examples.

31.4.1 Activity Area 1: Governance and Leadership

A global implementation task force has been created to coordinate activity. The remit of the task force was to:

1. Create the supporting framework to support and facilitate a coordinated and accelerated BIM adoption in Arup through

 - funding and activity priorities
 - avoidance of duplication
 - identification of gaps in BIM related activities

2. Set things in motion and provide 'top down' guidance
3. Support 'ground-up' BIM related activities in the regions
4. Support BIM's transition to 'business as usual'

 Each of the six task force members had a dual responsibility:

1. Ownership of one activity area under the implementation program
2. Lead coordinator for one of the Arup regions

31.4.1.1 Tasks and Objectives

The tasks under the governance activity area were identified as follows:

- Ownership and responsibilities
- Organisational structure
- Global coordination
- Regional delivery
- Funding and control mechanism
- Stakeholder engagement

31.4.1.2 Activity Example: Global Benchmarking Heat Map

We had three questions: "What level of awareness of BIM is there at Arup? How is it already being used? And do our people have the relevant technical skills?"

In May 2014, Tristram Carfrae, Deputy Chairman, invited all of Arup to participate in the first Global BIM Awareness Survey so that we could identify gaps and focus our effort and investment.

The survey was issued to all members via email, meeting a dual purpose in raising awareness of 'BIM', our strategy and the task force at the same time as garnering responses.

The survey addressed three themes:

1. BIM awareness – what is BIM? Is there an understanding how BIM is applicable to the individual – and an understanding of the benefits and challenges?
2. Use of BIM on projects – what experience of BIM? Are we engaged in BIM project pre-planning/bidding, quality control, BIM lifecycle applications, technologies and terminology?
3. Arup BIM Strategy – what awareness and support? What understanding is there of 'Phase 1', targets and regional implementation.

The results made clear where the task force needed to increase their efforts and which activities should be prioritized.

31.4.2 Activity Area 2: People and Skills

31.4.2.1 Tasks and Objectives

The task under the people and skills activity area are:

- Creating awareness
- Ensuring we have the right skills
- Increasing our capability

Fig. 31.4 Example of BIM global learning path (Information Management Grades 5-6). (© Arup, reprinted with permission)

BIM training

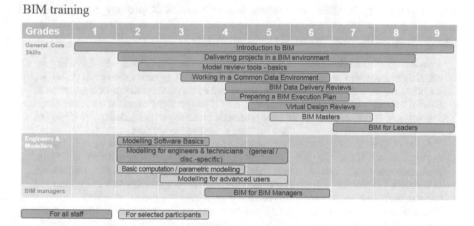

Fig. 31.5 Europe Region BIM Learning Path. (© Arup, reprinted with permission)

We designed a BIM global learning path in order to provide a professionally developed suite of inter-related and globally relevant training courses dealing with BIM practice and protocol. The aim was to set an industry leading standard for consistent BIM delivery across Arup. The learning path and associated BIM training is available through Moodle, Arup University's learning portal (Figs. 31.4 and 31.5).

BIM is a series of data-centric processes, where information (and data) play a central role in the delivery of a project. Success depends on the effective sharing of robust data and requires both technical (information modeling) and information management skills. Broadly speaking, information modeling is used to create and manipulate the model, and information management is used to specify what the model should contain and govern how it is shared:

Information Modeling = the process that produces the "thing"
Information Model = the "thing" that is produced
Information Management = making sure everyone knows what, when and
 how the "thing" is produced

The learning path below shows our expectations for each level in a specific area or category. These are then linked to courses in Moodle where you can increase your knowledge and skills within that area or category.

Even though the BIM task force was trying to achieve a greater level of consistency in Arup globally, regional adaptations were still possible in order to take account of geographic differences in culture, skills, BIM maturity and technology.

31.4.2.2 Activity Example: BIM for Leaders

The first training module for leaders was aimed at improving awareness and understanding of BIM's opportunities but also the risks it poses. The following introductory text is from the Arup learning portal:

> Arup has adopted a Global BIM Strategy approved by our Group Board. BIM is acknowledged as best practice and endorsed as industry standard by governments around the world, including those in the UK, Norway, Singapore and Finland. The international adoption of BIM will not only change the way we design, it will change every aspect of the construction industry and for all involved. If we want to remain at the top of our industry and retain our reputation as amongst the world's best designers, we need to act now.
>
> The aim of the BIM for Leaders training program is to make you aware of what BIM is to Arup, what it is not, why it is important to the future of Arup, how it will affect your profession, your role within Arup and your teams, and how Arup intends to move forward. In addition, the program will equip you with the knowledge to discuss BIM, its impact and benefits, with your teams – and with your contacts, clients and peers.
>
> The BIM for Leaders course will help you become familiar with what the BIM process should look like and how teams and workflows should be structured in order to get the most benefit from BIM. It will also equip you with the information you will need to be able to take BIM out to our clients. We will outline the services we can offer, how they will benefit the client and how you can articulate this value to clients. We will provide an overview of the support and content available to you to win work.

31.4.3 Activity Area 3: Marketing and Communication

31.4.3.1 Tasks and Objectives

Communicating our objectives concerning BIM, explaining how it will impact our work and what people need to do at a group, project and personal level.

The marketing and communication tasks are:

Internal communications	External communications
• Knowledge sharing	• Public face
• Stakeholder engagement	• Conferences and publications
• Coordination	• Marketing material
• Bid support	

We developed a communications plan summarizing the key objectives, messages, measures, channels, stakeholders and deadlines for both internal and external audiences. This became the backbone of the overall implementation program.

31.4.3.2 Activity Example: Marketing and Communication

Establishing a common level of understanding among 14,000 people located across the world is not an easy task. However, the global task force took advantage of the firm's communications channels to provide information and updates about BIM, as well as to gather feedback. The global strategy presentation was delivered 48 Arup offices globally within 6 months by the task force members. In addition to that, regular updates were provided to all staff on Ovanet, the Arup intranet.

31.4.4 Activity Area 4: Processes

The digital technology revolution will usher in a step-change improvement in our design processes. Existing practices are built around a fragmented and often strictly siloed design approach, with little incentive or opportunity for open collaboration between disciplines and organizations. For BIM to improve our processes, they first need to be mapped and then optimized, focusing not just on time, resource and deliverables, but also the flow of information that joins everything together (Fig. 31.6).

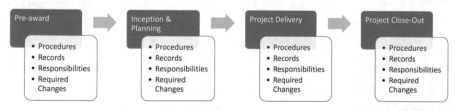

Fig. 31.6 Arup Management System (AMS) process changes. (© Arup, reprinted with permission)

31.4.4.1 Tasks and Objectives

To make BIM 'business as usual' clearly required a change to many of the existing Arup processes embedded within the Arup Management System (AMS). This was a delicate task as the task force had to ensure that our ISO 90001 and other business-critical certificates were not put at risk. The processes affected cover all areas of project delivery:

The key tasks under the process activity area were broken down into the following categories:

- Operating procedures (AMS)
- Staged approach (Phase 1)
- Defined targets and milestones
- Measures
- Technical procedures ("How to" – Guides)

31.4.4.2 Activity Example Processes: The Arup *BIM Maturity Measure*

As mentioned in Sect. 31.3.5, the Arup BIM Maturity Measure allows us to assess how well a project has used BIM. We believe this tool has wider value and we are making the BIM Maturity Measure available for the rest of our industry to use. This will help demystify BIM, reduce 'BIMwash' and encourage its use across our industry.

It was launched on 2nd December 2014 at Autodesk University 2014 and is available on the Arup website to download along with some guidance material.

We wanted a tool that would:

- Allows comparisons across all projects quickly
- Help identify trends or training needs
- Be quick to fill out

Each project is rated by its team against project-wide and discipline-specific criteria and the results emailed to the BIM team. The tool takes about 10 min to complete, though a first-timer may take 20 min of reading to digest and understand all the choices. The results for each section and the overall rating will be displayed on the cover sheet.

Features of the tool (Fig. 31.7):

Project information:	*Tracks:*
• directly filled in from the Arup project database	• Project stage
	• Disciplines scored
	• Extranet/CDE used

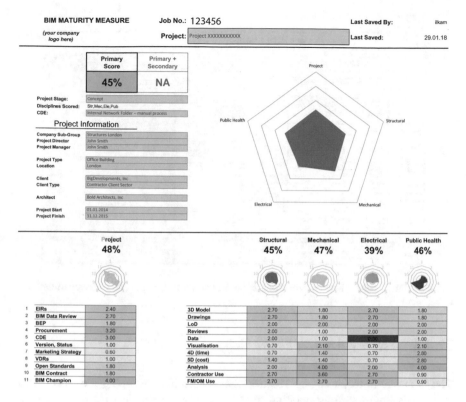

Fig. 31.7 Arup BIM Measurement Tool Cover Sheet. (© Arup, reprinted with permission)

Scores:

- Primary BIM Disciplines, based on Project Information and up to 4 "Primary Disciplines" (e.g. Structural, Rail, Highways, Mechanical, etc.)
- Up to 21 "Secondary Disciplines", e.g. Lighting, Acoustics, Geotechnics, etc.

For project management (see Fig. 31.8), the tool comprises:

- 11 questions
- 6 possible responses
- Suggested Target

- Score 0–5
- Weighting applied
- Overall Percentage

Arup uses the tool to regularly measure and monitor thousands of projects across the world. This provides with an incredibly valuable and growing basis of project information for commercial, quality and capability analysis.

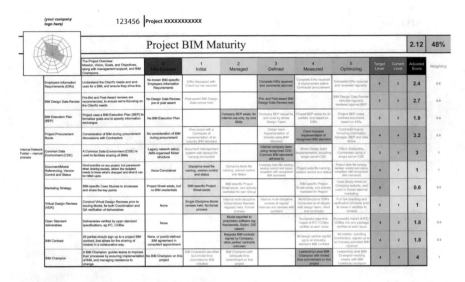

Fig. 31.8 Arup BIM Measurement Tool project management page. (© Arup, reprinted with permission)

31.4.5 Activity Area 5: Technology

The information technology revolution that is currently sweeping the construction industry is finally putting the kind of tools in place to enable BIM to become the norm. Previously specialist tools such as 3D and parametric modeling applications, multi-disciplinary optimization tools, advanced simulation environments and digital collaboration tools are now commonplace, expanding people's skills and raising expectations. Familiarity with all of these has prepared us to adopt BIM.

31.4.5.1 Tasks and Objectives

Rapid adoption of BIM requires that we define and proactively deploy the appropriate technology. Our technology roadmap comprises:

- Clear governance and prioritization of resources and activities
- Coordinated investment
- Focus on ease, speed and stability of access to data
- Focus on engineering technology, supported by business systems
- Focus on open industry standards, not proprietary solutions

 It covers the following aspect of IT at Arup:

- Consistent IT infrastructure and hardware
- Virtual design review spaces in all offices

- Global software costs/splits
- Roles and responsibilities
- Technical support
- Development of knowledge management content
- Strategic software procurement

31.4.5.2 Activity Example: Technology

A series of technology enablement plans were published to support the BIM implementation task force. These plans covered:

Information Management	Infrastructure	End User Devices	Software
• Information architecture	• Globally consistent infrastructure	• Desktops and laptops	• Design tool integration
• GIS/geo-data integration	• Visualization	• Mobility	• Design tool enhancement
• Data ware-housing	• Cloud		• Software licensing
• 'Big data'	• Networking		

31.4.6 Activity Area 6: Research and Development

In the twenty-first century, competitive advantage is all about developing insights that can produce valuable innovation. To achieve this, Arup invests in research that leads to better, more sustainable solutions to the issues our clients face. Our remit is wide, tackling everything from city masterplanning and transport strategy, to circular economy initiatives and innovative responses to climate change. Research is fundamental to our pursuit of technical excellence and integral to the way we do business. With the support of a dedicated research team, Arup delivers ideas that are ready to be put in practice.

31.4.6.1 Tasks and Objectives

The tasks identified under the BIM implementation program for research and development were

- Development of a BIM-roadmap for research and development
- Clear governance and prioritisation for internal investment
- Coordinated investment through the Arup internal investment mechanism
- Focus on return on investment (RoI)

- Alignment with the overall Arup Strategy regarding strategic businesses and markets
- Focus on developing innovation – otherwise it is training!

31.4.6.2 Activity Example: Research and Development

Each year, Arup reinvests a share of its profits in research as part of the firm's pursuit of technical excellence. Some of our research projects are conducted by specialists within Arup; others are collaborations with academic institutions or partnerships with industry. "Invest in Arup (IiA)" is the Arup internal mechanism for coordinating and monitoring innovation and research activities in order to harness the value from the creative minds in Arup. There are currently 639 live R&D projects tagged with the key word "BIM" (November 2016).

One example of an Investment in Arup project is ProjectOVE. ProjectOVE brings building information modeling (BIM) technology to life, using virtual design tools to create a fully functioning building that replicates the human body (Fig. 31.9). The project was the brainchild of Andrew Duncan, a mechanical, electrical and plumbing (MEP) BIM Manager, and Casey Rutland, BIM specialist and Associate Director at Arup Associates. Their team worked around the clock for seven weeks to make ProjectOVE a reality.

Fig. 31.9 ProjectOVE video clip is available on https:// www.youtube.com/watch?v= wjYszL9mDXc. (© Arup, reprinted with permission)

What started as an internal research and development project became a tool for the whole industry to learn from – the most exciting development yet in BIM technology.

Have you ever thought that the ducts and pipes of a building are a lot like the veins and nerves of a human body? This innocent observation sparked an idea that has grown into one of the industry's most talked about innovations: ProjectOVE.

Our team used BIM to design a 170 m tall, 35-storey building in the shape of a real human body, replicating its inner workings as accurately as possible.

The team wanted to create a multidisciplinary model comprising architecture, structure and MEP, correlating as closely as possible to the human anatomy. They replicated five major human body systems:

- Respiratory: mechanical ductwork
- Circulatory: mechanical pipework
- Nervous: electrical
- Skeletal: structure
- Intergumentary: architecture

Originally conceived for internal research and development, Project Ove has exceeded everyone's expectations and has demonstrated the inspiring possibilities of modern, digitally-enabled engineering.

The team estimate that the processes they created using six different software packages saved up to 3 hours of manual calculation time for every structural and MEP change. The model has also proved a captivating tool in schools, inspiring the next generation of architects and engineers.

31.4.7 Activity Area 7: Business Development and Project Support

31.4.7.1 Tasks and Objectives

Business development and project support tasks included (Fig. 31.10):

- Reducing waste and set-up time for projects
- Reducing risk
- Knowledge sharing through learning by doing
- Built on solid foundation and lessons learnt
- Focus on project delivery

Fig. 31.10 Interactive PDF of Arup realBIM Award case studies. (© Arup, reprinted with permission)

31.4.7.2 Activity Example: Business Development and Project Support

realBIM is the Arup awards program for staff and projects, launched in July 2014, engaged with Building Information Modeling (BIM). All staff involved in a project which made best use of BIM processes and/or technologies were invited to enter into the awards program. Arup's knowledge sharing culture encourages members of staff to engage in skills networks and forums to share best practice and lessons they've learned, for the benefit of their colleagues and their clients. The global BIM task force decided to launch an internal awards program for "BIM projects" for a number of reasons:

1. To make people aware that what they were already doing could be called BIM
2. To celebrate, reward and share innovation
3. To provide practical case studies that can be utilized to support bids as references through the Arup projects database.

Each quarter, category and special award winners were selected by an international and multi-disciplinary judging panel. The quarterly heat winners then progressed to the 2014-15 annual awards and were offered the opportunity to showcase their work at the Digital Environments Skills Network Global Forum 2015-16. All award winning entries were prepared as a case study and included in Arup's annual BIM best practice review.

31.5 Hand-Back to the Business

In March 2015, at the conclusion of the work of the global BIM task force, the individual elements of the BIM implementation program were handed back to the existing operating units and services in Arup, so that they could become 'business as usual'.

The elements are:

- The Arup management system for quality assurance of all business-relevant processes,
- The skills networks and their forums for discipline-specific skills development and knowledge sharing,
- Arup University for rolling-out the BIM global learning path
- Investment in Arup for innovation and research coordination
- CITX for all IT and technology aspects
- The Arup businesses to promote BIM capability
- The Arup groups to deliver BIM projects
- The dedicated BIM champions to identify and close skills gaps within a region or country
- Global Marketing for continuous marketing support
- All staff to take ownership and responsibility over their own career development and using all the support that Arup provides to ensure that their skills will still be needed tomorrow.

31.6 How Are We Doing?

Two years on, how much progress have we made?

Results so far are very promising, and probably higher than we had originally anticipated. As an overall average we have a high level of BIM implementation across all regions but as you would expect there are pockets where results could be better. What it says is that we are tracking well ahead but there is still work to do.

We are finding projects in all regions that are achieving the 5 goals of the Phase 1 strategy and scoring well in excess of 80% as a result; this show shows a strong trend to having highly successful projects with respect to true BIM implementation. Furthermore we are seeing that the projects and groups that are scoring highest are also the groups who are performing well commercially. This again bucks a major perception that BIM does not provide Value.

Progress then, but still plenty of work to do.

31.6.1 Maturity Measurement

Between its launch in December 2014 and April 2016 use of Arup's BIM Maturity Measurement tool was strongly recommended, but remained optional. In that initial period over 300 projects were measured. Early in 2016 the Arup Group Board decided its use should now become a standard component of project delivery and that all relevant projects should be assessed. It is now being included in the Arup Management System.

The first global measurement of Arup's BIM Maturity for the year to April 2016 assessed 881 projects and produced aggregated scores for Groups and Regions supported by Group and Discipline reports.

31.6.1.1 Analysis and Insight

Over a thousand live projects are now regularly measured and monitored. The results allow easy comparison of projects delivered by Groups and Disciplines. They are allowing us to identify areas of strength and weakness, which projects are demonstrating best practice and areas where BIM use is still immature.

It's also now clear that 'BIM Champions' are key to success. At project, Group and Region level, projects with higher levels of support from a BIM Champion tend, on average, to score higher. Whilst this wasn't unexpected it is encouraging to have it confirmed.

The data is now clear. Every Arup Region is using BIM to produce exceptional projects, a positive practice that is gradually spreading to all groups and teams. These metrics serve as a benchmark against which to increase our rate of change. So each Group and Region is setting and monitoring improvement targets and using this process to raise standards and understanding across the firm.

It is also used as a project management tool at project inception and during delivery to communicate what BIM is, what good looks like and to set project goals and expectations.

31.6.1.2 Further Developments

We have received positive feedback about the Arup BIM Maturity Measurement tool and received useful suggestions for its improvement. Though it already provides credible insights into a project we are keen to improve both its usefulness and reach. So we have worked to clarify the wording of the maturity criteria and to fill gaps in existing worksheets. We have also extended the tool to cover additional disciplines, recently adding a GIS/spatial data worksheet.

We are also planning to migrate the tool from its current form inside MS Excel to become an online form and database. This will improve its ease of use, reliability and flexibility.

31.6.1.3 Encouraging BIM Across the Industry

Since December 2014 we have made the BIM Maturity Measure available for download from the Arup website, accompanied by comprehensive guidance material.

In the ensuing two years it's been downloaded and used by many different companies and organizations. The tools is also being actively promoted by the ICE, BIM4SME and buildingSMART International and has been configured for use by Atkins, another leading engineering consultancy.

31.7 Arup's Global BIM Strategy: Phase 2

We're about to start the next phase of this transition: the digital transformation of our entire business. This means taking everything we have done very well for many years in traditional, 'analogue' ways, and transferring these activities to the data driven realm. This evolution will affect everyone and involve programming tasks, database development, investment in cloud computing, employment of data scientists and oh yes engineers, we mustn't forget the engineers!

This transformation is no small undertaking and will take some years to achieve. But the journey has begun and we are already seeing transformations in our ability to deliver structural engineering through the use cloud computing and storage. Digitization will take us well beyond the foundations laid in Phase 1 of our BIM strategy, and allow us to start using the data we are creating and capturing in brilliant and ambitious new ways.

By running a fully digital business we will be able to make better decisions, produce better engineering, and create better outcomes for the communities we serve.

31.8 Summary

Arup's global BIM strategy and implementation plan were developed in early 2013 and implemented by a dedicated task force between August 2013 and March 2015. The strategy sets out the foundation, structure and processes needed to enable a valuable adoption of BIM, whilst setting longer term objectives that will shape Arup's digital future over the next 10 years. The implementation plan was centered on a phased adoption of new processes and technology aimed at improving the quality and level of productivity, while expanding capabilities at the same time.

Reference

Azzouz, A., & Hill, P. (2016). Hunting for perfection: How Arup measures BIM maturity on projects worldwide. *Construction Research and Innovation* 8(2), 49–54. https://doi.org/10.1080/20450249.2017.1334909

Chapter 32
BIM at OBERMEYER Planen + Beraten

Martin Egger, Markus Hochmuth, Nazereh Nejatbakhsh, and Sabine Steinert

Abstract For a general planner such as OBERMEYER the application of BIM assumes a pivotal role. The focus on computer-aided planning already commenced shortly after the foundation of the company over 60 years ago. Today, the company is committed to establishing generally valid BIM standards and guidelines, e.g., as leading member of buildingSMART Germany or as co-author of the German BIM manual published in 2013. Three sample projects on the current planning front illustrate how BIM can be implemented in practice: the planning of the 2nd principal rapid transit line in Munich, the Auenbach viaduct pilot project and the planning of Al Ain hospital in the United Arab Emirates.

32.1 Technical Background and History

The general planner Obermeyer has been backing computer-aided planning for almost 50 years. BIM is considered the central working method at Obermeyer, being further developed and advanced by specialized organizational units within the company. The aim is to intensify the integration of all specialist planning in one model. To this end BIM methods are employed for the planning of both buildings and transport infrastructure.

To promote the use of BIM throughout Germany and establish generally accepted sets of rules in practice, Obermeyer is increasingly engaged in determining standards and guidelines. For over 10 years the company has, for example, been a leading member of the association buildingSMART Germany. Its foremost objective is the development of integrative planning processes. The end-to-end data access which this involves permits building processes which are interdisciplinary,

M. Egger (✉) · M. Hochmuth · S. Steinert
OBERMEYER Planen + Beraten GmbH, Munich, Germany
e-mail: BIM@opb.de

N. Nejatbakhsh
Ingenieurbüro Grassl GmbH, Munich, Germany

© Springer International Publishing AG, part of Springer Nature 2018
A. Borrmann et al. (eds.), *Building Information Modeling*,
https://doi.org/10.1007/978-3-319-92862-3_32

sustainable and cost-efficient. Furthermore, Obermeyer has coauthored the first German BIM manual on behalf of the Federal Institute for Research on Building, Urban Affairs and Spatial Development.

To honour the company founder Dr. Leonhard Obermeyer and his continuous commitment to the employment of state-of-the-art computer technologies in construction planning, Technical University of Munich (TUM) founded the Leonhard Obermeyer Center (LOC) in 2013. The LOC combines the research undertaken by five different chairs with the aim of uniting standardized building models with geographic information systems in a single system and making these available for planning tasks in various degrees of detailing. OBERMEYER not only supports the LOC, but the university's research and teaching in general, by accompanying master theses prepared by students and affording them the opportunity to combine learning and practice.

The application of BIM methods and their linkage with Geographic Information Systems (GIS) constitute an operational and strategic corporate objective within the ambit of overall planning integration.

Internally the emphasis is placed on an early consideration of design alternatives and 3D coordination across trades. These are two decisive aspects which already depict the effects of individual specialist planning inputs in the initial project phases and are able to make these aspects comprehensible for all project participants. Using these BIM applications, makes it possible to derive possible solutions and to correct erroneous definitions in short time. In the case of complex schemes, especially a holistic consideration of all mutually interdependent parameters is of utmost importance. Obermeyer's long-term objective is to concentrate and analyze these diverse data from different sources, so as to be able to create a comprehensive basis for decision-making even at an early stage. The stronger linkage with GIS and remote sensing data permits a timely adjustment to modified planning conditions.

With over 500 different software applications in use at Obermeyer, it is a question of analyzing their strengths in the planning process and testing their interoperability with other software solutions, in order to permit integrative processes on an interdisciplinary basis and guarantee a consistent data flow. The aim is to combine the strengths of the various software packages in an optimal manner, so as to benefit from synergy effects as much as possible and make their interaction visible and accessible to all project participants in each phase.

32.2 The Importance of BIM from a Company Perspective

Management plays a decisive part in the introduction of BIM in the company. Its task is, among others, to drive and facilitate the development of the company and hence also the introduction of BIM. In the words of Christopher Grimble, Managing Director of the Corporate Division Buildings at OBERMEYER Planen + Beraten GmbH:

Whether owner, planner, contractor or product manufacturer – BIM will shape construction and our way of executing projects like no other change before. A rigorous and lasting adaptation in the company is therefore of overriding importance.

The OBERMEYER Corporate Group's Strategy 2020 follows the model of the modern master builder. BIM can make a significant contribution to ensuring the desired quality and avoiding the vagaries of the planning engineer's joint and several liability.

As general planner OBERMEYER aspires to an intensive exchange between the individual specialist engineers and a good interdisciplinary integration. The potential for project success lies in the cooperation between the various departments. Traditionally, office standards such as well-organized CAD standards or project kick-off documents already create a high level of coordination and guarantee an optimum planning quality for the clients. By means of BIM it is now possible to raise the interdisciplinary integration and coordination to a new level.

Planning in a model increases the transparency and improves the coordination between the trades. For example, discussions not only within the project team, but also with the client are held with the help of three-dimensional models. Consequently, it is not necessary to view countless and, above all, technically oriented plans which in many cases the owner does not understand. Rather, the design status is recognizable at a glance and the effect of the construction measure can be clearly communicated. In addition, by means of virtual clash detection it is possible to measure the quality of the coordination and document this accordingly.

32.3 BIM Development

The continually growing complexity of planning projects calls for a dynamic planning process which ensures a timely adjustment to modified planning conditions. This is all the more important whenever in national, and especially international, projects interdisciplinary teams are working on the same project at various locations with heterogeneous data.

Because of ever-shorter planning timescales new methods and data sources for design and construction are being increasingly tested and employed besides the classical planning instruments. OBERMEYER also puts emphasis on the use of modern technologies in the acquisition of the basic data for planning. These include remote sensing data, such as digital aerial and satellite images, as well as digital surface and terrain models from optical data or laser scanning.

The challenge lies in the fact that these heterogeneous basic data have to be exchanged without any loss between the various software packages used by the remote sensing/GIS specialists (e.g., ERDAS, ArcGIS) and those of the planners in the sectors transport infrastructure, urban development and environment (e.g., AutoCAD). The individual strengths of the various software packages in the

planning process have to be optimally combined, too. Only these synergy effects guarantee efficient working and hence a competitive advantage.

The OBERMEYER project "High Plateau Railway Lines, Algeria" may serve as an example for the employment of an image processing system which visually depicts the most up-to-date socio-economic data on the project area for the planner.

Especially in the scope of the study of variants commonly required in transport infrastructure designs and master planning, the use of a GIS-based 3D planning tool achieves an optimization of the processing and decision flow.

A substantial part of the research carried out was thus the approach of combining BIM route planning in ProVI with the opportunities provided by the geo-information system ArcGIS. Alterations to the route design performed in BIM and CAD systems are displayed in parallel in the GIS system and immediately evaluated. In doing so, current GIS data are used to set up a simulation framework for the design process.

In projects with large volumes of data and information, in particular, this therefore exploits the potential of accelerating the decision-making process and optimizing the planning process in an early phase of the project like route selection or visualization of variants. Augmented by additional information-concerning costs, operation or energy efficiency, further assumptions and predictions become possible and can be visualized in different ways – in a model, in a diagrammatic form, etc. This yields decision-making aids which allow to quickly take account of all aspects of general planning and can depict complex interrelationships for decisions in a simple way (Fig. 32.1).

32.4 Project Examples

32.4.1 Second Principal Rapid Transit Line in Munich, Germany

Shortly after the first principal rapid transit line in Munich was opened in 1972, there were already deliberations and plans to construct another tunnel under Munich for a second principal rapid transit line. Although the line, with about 950 trains per workday, ranks as one of the most frequented double-track lines in Germany, the Bavarian state government did not adopt the resolution to advance the extension of the second line until just after the turn of the millennium (Fig. 32.2).

Since these deliberations commenced in 2001 OBERMEYER Planen + Beraten has been involved in the designs with a tunnel variant conceived together with the company DE Consult. OBERMEYER as general planner finally received the order for all service phases from the basic investigation through to the approval planning (status 2014) and also performed the overall coordination of all specialist planners involved.

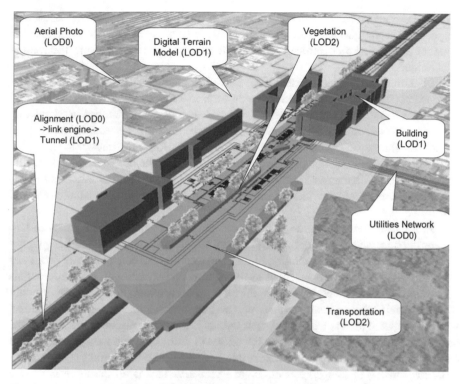

Fig. 32.1 Example of the resulting interoperability between submodels in inhomogeneous LoDs. (© N. Nejatbakhsh, reprinted with permission)

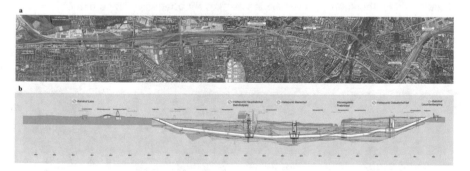

Fig. 32.2 (**a, b**) Location and elevation plan for the second principal rapid transit line (red) in Munich with the planned stations Hauptbahnhof, Marienhof and Ostbahnhof. (© OBERMEYER Planen + Beraten, reprinted with permission)

The second principal rapid transit line runs through the inner city in parallel with the existing principal line over a total length of about 10 km, about 8 km of which are underground. Three underground stations (Hauptbahnhof, Marienhof and Ostbahnhof) are planned in this area at a depth of 40 m (Hauptbahnhof). The

Hauptbahnhof and Marienhof stations are to be constructed under top-down cut-and-cover technique. On account of the sensitivity of these areas to vibrations the tunnel is not to be constructed with a tunneling machine, but using the mining technique.

Ever since the project started, importance has been attached to the detailed 3D-based modeling of the new construction and, in substantial parts, of the existing facilities, too. In particular, account had to be taken of the difficulties in connecting the new Hauptbahnhof underground station with the existing station building via a central staircase. The new construction of a station in a downtown location, the platform level being about 40 m below ground, requires the preparation of a roughly 45 m deep pit with a ground area of roughly 50 × 60 m using the diaphragm wall/cut-and-cover construction method in order not to obstruct rail traffic in Munich Central Train Station.

In the further course of the planning the simple 3D model was transformed into a comprehensive BIM model for the carcass which not only considers the quantity surveying, but also the scheduling of the construction. All relevant work processes and information were represented in the model. Constructional and static details were modeled and incorporated into the respective structural analysis software with standardized interfaces and defined information content. In doing so, bidirectional interfaces were at first deliberately left out, as it is not yet possible to maintain the documentation and tracking of modifications in a uniform and transparent manner (Fig. 32.3). A promising approach in this context is the bcf format (BIM collaboration format) developed by buildingSMART e.V. This is all the more important whenever interdisciplinary cooperation is involved. Here OBERMEYER is pursuing the submodel approach, where each planner is responsible for the components he creates. Thus, the submodel for the structure only contains component objects and information necessary for this discipline (Fig. 32.4). The individual submodels were coordinated by means of clash detection checks with Navisworks.

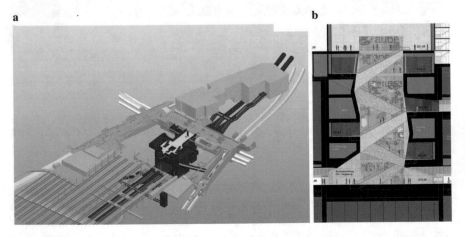

Fig. 32.3 (a, b) 3D model of Hauptbahnhof station (red), depiction of connection with existing facilities. (© OBERMEYER Planen + Beraten, reprinted with permission)

a b

Fig. 32.4 Depiction of construction process at start shaft (**a**) and central staircase (**b**). (© OBER-MEYER Planen + Beraten, reprinted with permission)

32.4.2 BIM Pilot Project Auenbach Viaduct, Germany

Innovative design methods in bridge construction: Auenbach viaduct was chosen by the German Federal Ministry of Transport and Digital Infrastructure (BMVI) as the first of four pilot projects for the implementation of design and construction processes with the aid of the Building Information Modeling (BIM) method.

In the course of the preliminary design phase this project's existing designs were to be subjected to an extended economic feasibility study. The structure leads the Federal Highway B 107 across the Auenbach valley, a service road and several tracks on the Dresden-Werdau railway line. Originally, the structure was intended to span the entire valley with a total length of about 273 m. During the overall optimization of the alignment in position and elevation the structure was separated into two single structures-two prestressed concrete girder bridges with lengths of 142 and 32 m and span lengths between 2 and 35 m – linked by an intermediate embankment (Fig. 32.5). The project is currently in the early design phase.

Throughout this project, the use of BIM in early design phases is being investigated. The main BIM goals are

- improvement of organization, communication and interface coordination by consistent, interdisciplinary and model-driven planning;
- improvement of planning quality through integrated work on basis of a common BIM;
- improvement of risk management through greater transparency throughout planning;
- improvement of change management leading to a higher adherence of schedule and cost during construction and
- higher quality of project information through flexible visualization.

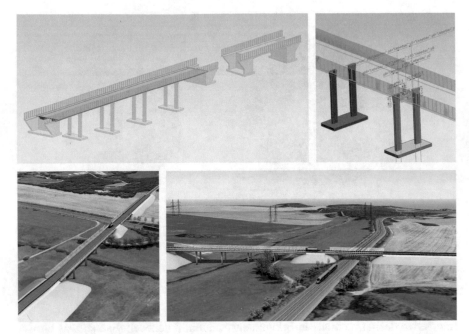

Fig. 32.5 Models and visualizations of the Auenbach viaduct pilot project. (© OBERMEYER Planen + Beraten, reprinted with permission)

In the frame of the pilot project a coordinated, complete model was prepared. The aim was to integrate all the project planning models for engineering structures as well as the models of the specialist planners for traffic facilities, subsoil and environment in accordance with the design status in each case. The design of the road and railway alignments is realized by means of the Obermeyer software ProVI. The model of the bridge structures and the soil model are designed using Siemens NX. The results of this service phase were provided for the further BIM processes as an object-based, coordinated 3D complete model. By means of a model-based time schedule it was then possible to perform a complex analysis of the model data (e.g., quantities, costs, deadlines, collision detection, etc.) and carry out optimizations. Subsequently, the BIMs are used for quantity take-off and the simulation of the construction works.

The additional combination with alignment and GIS data in these phases furnishes a flexible and robust basis upon which to create a holistic evaluation of planning concepts. With the application of a parameterized, object-oriented complete model it is possible to realize an integral process chain across the whole planning and implementation period as well as across the entire life cycle.

For mutual information exchange, BIMs and drawings are exchanged between the stakeholders via the data platform DOXIS following the basic principles of a Common Data Environment (cf. Chap. 15 and Fig. 32.6).

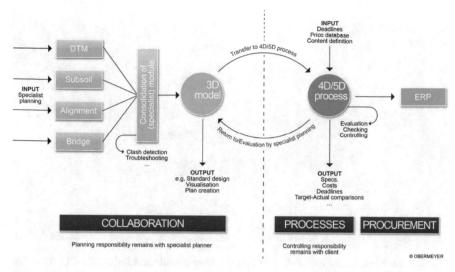

Fig. 32.6 Project-specific workflow. (© OBERMEYER Planen + Beraten, reprinted with permission)

The objective of the intended continuation of the pilot project is the automated, model-based elaboration of the final design and tender for the structure.

With the digitization of construction the design and implementation process is undergoing a fundamental methodological transformation. From the standpoint of the owner DEGES and the project planner OBERMEYER the effects expected as a result of establishing the BIM method should be investigated, checked and assessed.

32.4.3 Al Ain Hospital, Abu Dhabi, United Arab Emirates

Planning of the Al Ain hospital in the Emirate of Abu Dhabi commenced in 2008 (Fig. 32.7). The remit was to develop a replacement construction for an existing hospital during regular operation. What emerged was a concept for a clinic campus with a total of five medical buildings, two technical supply buildings and a mosque. As general planner OBERMEYER was responsible for all service phases including a feasibility study. Moreover, OBERMEYER is commissioned with the supervision of the project, which is currently under construction. Completion is scheduled for 2018.

Due to the size and complexity of the construction task as well as the very short prescribed planning period, the OBERMEYER architects and engineers had decided to plan the project using the BIM method.

The gross floor area of about 330,000 m^2, in particular, posed a great challenge for the model-based processing, but also for the software available at the time.

a b

Fig. 32.7 (**a, b**) Visualization of Al Ain hospital from outside and inside. (© OBERMEYER Planen + Beraten, reprinted with permission)

To begin with – parallel with the conceptual development – various tests were carried out in all trades in order to determine the best strategy for each discipline. Accordingly, the architecture, interior design, structural design and medical engineering were entirely modeled in the first step. The building services engineering was initially still planned in 2D, based on the data from the BIM models or various simulations. To this end, the planners created simplified mass models with which to simulate, among others, the flow behavior of the air masses in the central hall, the natural lighting, the influence of the position of the sun at various times of the day and year and the deformation behavior of the facade (wind tunnel test). The results were processed in the corresponding building services and building physics systemic observations, then integrated into the design, e.g., of the ventilation, the artificial lighting or the form of the atrium roof and hall facade.

This work was performed at various locations in Germany as well as in Argentina and the United Arab Emirates. Altogether 150 employees took part in the design of all the trades. The data were accordingly structured into submodels by trades and geometrically by building sections. This called for a joint approach for managing the model and updating the respective interconnected files.

The submodels "lay" at the location involved in the processing and were regularly exchanged before being merged into one overall model (Fig. 32.8).

The 2D planning documents required at the end of each service phase were likewise managed in separate models and created there out of the combined overall model. The overall model embraced a total of 99 submodels, which together corresponded to a file size of about 8 GB.

To take the extensive coordination with the end users at the start of the project into account, and to achieve a standardization of identical room types, the normal modeling tool for the complex medical engineering was supplemented

Fig. 32.8 Overall model and individual models of Al Ain hospital. (© OBERMEYER Planen + Beraten, reprinted with permission)

by an external database. This was capable of automatically transferring certain information bidirectionally from the model into the database and vice-versa.

In this way the standardized room equipment was coordinated with the user and installed in parallel with the design and the progressive development of the architecture and equipment models. The data model was synchronized as required and enriched with the necessary object information or whole objects.

Because of the size and complexity of the project, many approaches regarding BIM were developed and implemented in the course of planning the Al Ain hospital. For this, OBERMEYER was awarded the Autodesk BIM Award for Innovative Solutions in 2010.

Later on, at the instigation of the owner, the building services engineering was also prepared by means of BIM. The main intention was to coordinate all the technical disciplines among themselves so as to commence the construction phase with a design as clash-free as possible. For this purpose the building services engineering trades were successively tested with themselves and the load-bearing elements of the architecture in cyclical clash detection checks and readjusted after each cycle (Fig. 32.9). A key factor in maintaining an overview of a project of this size and – because of this building type's high concentration of installations – complexity lay in determining the "clash detection" parameters. The main task consisted in the clash-free coordination of the trunk lines and determination of the corresponding openings. In this way, it was possible to minimize potential delays during the implementation phase and reduce the subsequent need for coordination.

Despite various technical hurdles the BIM method served to improve the planning of this complex project, but above all it made it more speedily manageable than traditional planning methods.

As the project progressed, moreover, the client came to appreciate the added value of a well-coordinated design, including the investigation of variants, and the potentials for simplifying the user coordination efforts. Accordingly, at the instiga-

a b

Fig. 32.9 3D model of Al Ain hospital structured by trades (**a**) and excerpt from the 3D model (**b**). (© OBERMEYER Planen + Beraten, reprinted with permission)

Fig. 32.10 Photo of building site, taken in February 2018. (© Musanada, Abu Dhabi, reprinted with permission)

tion of the owner, the general contractor was required to prepare his construction documentation in BIM too. Further, a jointly used BIM studio was established to assist all participants on the building site. The general contractor's models hence permit problems to be discussed and jointly solved. Last but not least the progress of the building activity is permanently documented, controlled and cross-checked with the construction schedule (Fig. 32.10).

32.5 Summary

The number of BIM projects at OBERMEYER is constantly increasing. New projects of all sizes are examined at the outset. If they are BIM compatible, targets are set and implemented in the course of the project. Projects tendered in phases or obsolete CAD guidelines are currently the greatest hindrance to opting in favour of BIM. BIM can be optimally employed whenever a large amount of information is available. OBERMEYER also tries to work with BIM on small projects and at the start of projects. But this mode of operation is not obligatory. It is often determined jointly by the project team and the overall planning integration competence area on a project-specific basis.

The advantages of the BIM working method are primarily for the owner, who ideally uses the enhanced quality of information throughout the entire life cycle. Major general planners like OBERMEYER trust in a long-term efficiency gains. On the basis of a heterogeneous software landscape the procedure must first be developed, standardized, exercised and constantly optimized. The opportunities for further optimization are then manifold. Project execution libraries will continue to steadily expand. More use will be made of server solutions in future too. OBER-MEYER's leading role in pioneering the successful development and application of BIM planning will benefit most from the national efforts to promote BIM and the growing acceptance of BIM in Germany. Our clients and partners stand to gain from this.

Chapter 33
BIM at Hilti

Matthias Ebneter and Nils Krönert

Abstract As a global manufacturer, Hilti is much affected from Building Informa-
tion Modeling (BIM). Based on a detailed analysis, BIM has changed the offering of
Hilti to its customers on various levels. Hilti has developed software and services for
the different project stages to provide a holistic support for the clients. The software
tools aim for a direct integration of the customer workflow. They help to conduct the
regular use cases in a fast and efficient way. The services complement the offering
to cover special requirements of the projects. Hilti is already integrated in the design
phase to find the optimized solution for the fastening and protection requirements.

33.1 Introduction and General Approach

Building Information Modeling (BIM) and digitization is transforming construc-
tion projects around the world and has implications for all the different parties
involved in construction projects. The successful adoption of BIM methods requires
the participation of them all. Since its beginnings in North America, BIM have
been adopted in almost all regions of the world. BIM standardization initiatives,
for example by the ISO and CEN, have since followed.

As a global manufacturer, Hilti is very aware of the different degrees of BIM
adoption around the world and is increasingly asked by customers to support BIM
methods. The trend towards more detailed planning has effected a shift in decision-
making from the jobsite to the design stage, but to make decisions at an earlier stage,
architects and planners require information about products from manufacturers.

In response to this development, Hilti undertook an in-depth analysis and
identified four key pillars of improvement:

1. *Know-How/competence:* At present, only a few experts have sufficient
 knowledge and capabilities to properly implement information management in

M. Ebneter (✉) · N. Krönert
Hilti AG, Schaan, Liechtenstein
e-mail: matthias.ebneter@hilti.com; nils.kroenert@hilti.com

construction projects. For successful adoption, however, almost all the stakeholders involved in a project need to understand the BIM approach and its benefits. This competency gap applies not just to construction projects but also to many other companies. Very often, only a handful of people are proficient in BIM methods. It is, therefore, important to establish an overall strategy for knowledge exchange.

2. *Construction process:* Current conventional construction processes often impede the adoption of integrated planning and execution processes. One major obstacle in this respect is the contractual situation. Construction processes must, therefore, adapt to facilitate better BIM integration.

3. *Software compatibility and exchange standards:* Due to the diverse and fragmented nature of the construction market, different parties employ different software products when working on the same construction project. For BIM processes to be successful, the correct exchange of information is crucial. At present, this means either an open BIM solution using open formats such as IFC, or the stipulation that all parties must use the same software system. In both cases, manufacturers must examine how best to integrate their product information.

4. *Simple solutions:* Very often the people involved lack the time or possibility to utilize complex software systems. On site, in particular, simple solutions are needed which are intuitive and do not require long explanations.

Based on these four pillars, Hilti developed their own strategy as a manufacturer, as part of its aim to provide complete project-life-cycle support for its customers (cf. Fig. 33.1):

- **Hilti BIM Solution – Design:** What manufacturer information should be included in the Building Information Model, and how? How can manufacturers support design tools by providing integrated solutions?

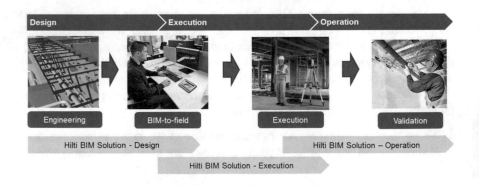

Fig. 33.1 Hilti project life-cycle concept. (© Hilti, reprinted with permission)

- **Hilti BIM Solution – Execution:** How can BIM data from the design phase be transferred to the jobsite?
- **Hilti BIM Solution – Operation:** Which information from the as-built situation is relevant and how can it be gathered and incorporated into the model for later use in operation and maintenance?

33.2 Hilti BIM Solution: Design

Hilti offers a variety of different software tools to simplify the work process and optimize the design. Currently more than 15 different tools in the field of "Fastening & Protection" are available, covering the product portfolio of anchoring, support installation, direct fastening and fire stops. The software tools implement different parts of the BIM approach. Here we examine four key tools to illustrate how they are integrated into the BIM workflow.

33.2.1 PROFIS Anchor

PROFIS Anchor enables the designer to calculate and decide which type of anchor is suitable for a given concrete connection. The program offers full design flexibility and also covers most of the relevant construction standards (ETAG, CEN-TS, ACI 318-11, ACI 318-08 and more). In addition, the tool also incorporates Hilti's expertise in research and development, offering solutions for areas not currently covered by international standards (e.g. seismic or exhaustion resistant applications).

The tool allows the designer to calculate the anchor and also provides direct import to popular design or calculation tools such as Tekla or Dlubal. This simplifies data transfer, minimizes possible errors and increases the quality of the design.

33.2.2 PROFIS Installation

PROFIS Installation (cf. Fig. 33.2) assists the planner in designing and calculating complex 3D installation support systems. Using a simple, modular design, it guides the user through predefined use cases, while also permitting full adaptability and design flexibility. All important technical data is available in different reports including shop or assembly drawings. In addition, the software also provides direct export to BIM/CAD software packages such as Revit, AutoCAD or Vectorworks with all necessary information. IFC export is available to support open BIM systems.

Including this information in a BIM-model means that the system can also support pre-fabrication. All the required drawings are available and a detailed analysis of the cost is also possible. PROFIS Installation provides a complete package of products, software and services to enhance the MEP design.

Fig. 33.2 PROFIS Installation. (© Hilti, reprinted with permission)

Fig. 33.3 BIM/CAD-Library. (© Hilti, reprinted with permission)

33.2.3 Hilti BIM/CAD-Library

Alongside these software packages, Hilti also provides a complete library of all its design relevant products. This allows the designer to specify the right amount of detail within the design by utilizing actual and not generic products, which is particularly important for products which are cast in concrete.

The BIM/CAD-Library (cf. Fig. 33.3) includes a variety of products from the anchor, installation and firestop portfolio, which can be exported to almost all the main BIM software packages. In 2014, Hilti was also the first such manufacturer in the world to introduce IFC export capability.

33.2.4 Hilti Button for Firestop

The development of the Hilti Button for Firestop (cf. Fig. 33.4) introduces a new area of design automatization that works with existing design software. Based on the designer's BIM models, the tool analyzes and proposes the required fire stops. It even provides the ability to automatically place these products into the BIM model. This automatization offers the designer a fast and simple solution to ensure a buildable design based on the respective regulations.

Fig. 33.4 Hilti Button for Firestop. (© Hilti, reprinted with permission)

33.3 Hilti BIM Solution: Execution

Modern measuring technology offers a variety of means of transferring design information to the jobsite. The Hilti Robotic Total Station in conjunction with "Hilti Point Creator" software offers a complete solution for the execution phase. The relevant measuring points are defined using the software and transferred to the Robotic Total Station (cf. Fig. 33.5). If the design employs Hilti products taken from the libraries, the measuring points are included in the library data, and are transferred along with additional attributes (such as drill diameter) to the Total Station. After the Robotic Total Station is positioned in the building, the station will indicate the position of the objects with a laser beam so that the workers know exactly where to drill which hole on site. This reduces possible errors on site.

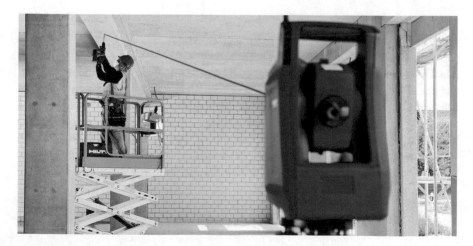

Fig. 33.5 Hilti Robotic Total Station. (© Hilti, reprinted with permission)

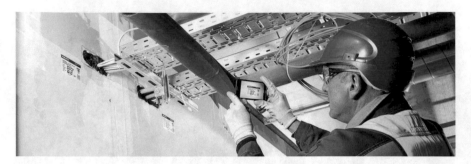

Fig. 33.6 Firestop documentation manager. (© Hilti, reprinted with permission)

33.4 Hilti BIM Solution: Operation

The third aspect of Hilti's BIM strategy is the documentation of installed products. This is important to ensure that the installation took place correctly and in accordance with the design, as well as for archival purposes. How can this information be brought into the operation of the building?

An example is the firestop-documentation manager (CFS-DM). The CFS-DM (cf. Fig. 33.6) makes it possible to document correct work during the installation process. All installed fire stop products are tagged with a QR-code and can be photographed with a mobile device. The information is stored in a cloud solution and is accessible through all stages of the project. The report contains not only the on-site information but also the required approvals and additional documents which are integrated automatically into the system. This tool has convinced not only the designer and installer but also the owners and authorities because it provides a complete solution for all fire stop related documentation.

33.5 Summary

The Hilti BIM strategy provides a project-life-cycle orientated approach for the customer. Its holistic implementation ensures consistent information flow throughout the project. Hilti's BIM tools are, however, not just for the customer but also offer a variety of BIM services at all stages, from design consultation in the early planning phases to jobsite instructions or prefabrication details based on BIM information as well as supporting the inspection of the installed products. With these tools and services, Hilti provides comprehensive BIM support for the construction process.

Chapter 34
BIM at STRABAG

Konstantinos Kessoudis, Jochen Teizer, Frank Schley, Alexander Blickle ,
Lynn Hiel, Nikolas Früh, Martin Biesinger, Martin Wachinger, Arnim Marx,
Alexander Paulitsch, Benjamin Hahn, and Jan Lodewijks

Abstract Modern construction projects can be designed, built and operated more
efficiently and to a higher quality when knowledge is shared quickly and transpar-
ently. With BIM.5D®, STRABAG SE has been advancing the vision of a "digital
construction site" since the late 1990s. The "5D" stands for the 3D model + time
(4D) + process data (5D), thus adding all relevant process information to the
product-oriented building information model. BIM.5D® involves the client and all
project participants from the start of a project and facilitates the interdisciplinary
gathering and analysis of data to generate valuable information. One of the many
benefits BIM.5D® offers is the transfer of knowledge that increases the quality
and the efficiency of the final product. Since project data is digitally captured,
combined, and linked over the entire lifecycle of a construction project, the result
is a comprehensible, transparent and resilient information network for everyone
involved in a project.

K. Kessoudis (✉) · F. Schley · L. Hiel · M. Biesinger · M. Wachinger · A. Marx · A. Paulitsch ·
B. Hahn · J. Lodewijks
STRABAG SE, Züblin, Stuttgart, Germany
e-mail: konstantinos.kessoudis@zueblin.de

A. Blickle
Dassault Systèmes Deutschland GmbH, Stuttgart, Germany
e-mail: alexander.blickle@3ds.com

N. Früh
Institut für Tragkonstruktionen und konstruktives Entwerfen, Universität Stuttgart / Frueh
Engineering, Stuttgart, Germany
e-mail: nikolas@frueh.co

J. Teizer
RAPIDS Construction Safety and Technology Laboratory, Ettlingen, Germany
e-mail: jochen@teizer.com

© Springer International Publishing AG, part of Springer Nature 2018 555
A. Borrmann et al. (eds.), *Building Information Modeling*,
https://doi.org/10.1007/978-3-319-92862-3_34

34.1 Overview

STRABAG SE is one of the largest construction companies in Europe. In addition to its home markets Austria and Germany, the company is active in all countries in Eastern and South-East Europe, in selected markets in Western Europe, on the Arabian Peninsula, as well as in Canada, Chile, India, and many more countries. STRABAG is a European-based technology group for construction services, and one of the most financially strong and innovative companies in the market. STRABAG covers all life-cycle phases of the construction process and creates added value for its clients by integrating the most diverse services and assuming responsibility for them: By linking people, materials and machinery at the right place and at the right time, it coordinates the realization of complex construction projects – on schedule, at the highest quality and at the best price. STRABAG's 73,000 employees contribute in more than 700 locations worldwide to a yearly output volume of more than € 14 billion. STRABAG works in a wide range of fields, including residential construction, commercial and industrial facilities, public buildings, the production of prefabricated elements, civil engineering, bridges, power plants, environmental technology, railway structures, roads, earthworks, waterways, landscape architecture and development, paving, large-area works, sports and recreational facilities, protective structures, sewer systems, production of construction materials, ground engineering, tunneling, real estate development, infrastructure development, operation, maintenance and marketing of private-public-partnership projects, and property and facility services.

The Group's Central Technical Division (ZT) is its technical planning unit. More than 960 ZT employees support the Group's operative units in their construction process management, civil engineering and tunneling, structural engineering, and turnkey construction works. ZT, therefore, accompanies the entire construction process: from the acquisition phase, to tender bid processing, to execution planning, through to specialist construction management. In order to strengthen the Group's technical competitiveness for the future, ZT pursues all avenues of specialist and interdisciplinary innovation. Furthermore, ZT is also responsible for the Group's registration and management of patents and trademarks. The basis for an efficient planning and construction process is the maintenance and further development of tools such as software for planning, estimation, and construction site management. The ZT is also the central source of know-how for BIM.5D® within the Group, and it strives to advance these fields for the entire Group.

Many young engineers start their career in the ZT before later assuming responsibility for one of the Group's many construction sites. This enables university graduates to obtain an overview of the full range of fields of activity and, therefore, to later quickly implement what they have learned. In addition to the practical training of young professionals, the ZT also offers specialist in-house training within individual fields of work to all Group employees. The division's contribution to the Group's outreach and public relations activities includes lectures and presentations at national and international conferences and workshops, as well as publications

in technical journals, and participation in professional committees. Many of these activities relate to the topic of Building Information Modeling (BIM) and a wider range of technical innovations.

34.2 Motivation for BIM

The Gross Domestic Product (GDP) of the European construction industry is worth about € 12,000 billion or roughly 10% of the entire GDP of its countries (FIEC 2014). The importance of the construction industry for Europe's power and wealth has not, however, given rise to any significant productivity improvements. Such advances are typically based on strategic, long-term, and continuous innovation, and the improvement of transformative research and best practices. In fact, public confidence in the construction sector is faltering and the past few decades have shown that the construction industry trails behind other major industry sectors in terms of efficiency, safety, and other key performance criteria. According to analysts, countries that wish to maintain or advance their GDP must be willing to challenge prevailing approaches. One of the key challenges among the many stakeholders involved in a construction project's lifecycle is the suboptimal flow of information between the individual phases. The different stakeholders often establish their own information standards and systems, but this disrupts knowledge transfer between the design, planning, building and production/operation phases.

The process of managing the entire construction lifecycle from design, through planning and building, to operation and maintenance is called Product Lifecycle Management (PLM). In the same way that PLM has been a reason for major progress in the automotive sector (see Fig. 34.1), construction has benefited from the use of three-dimensional (3D) Computer-Aided Design (CAD) systems and equivalents. Although such efforts have dramatically improved workflows within

Fig. 34.1 Client-based CAD application in the automotive industry sector (SDZ 2014)

organizations, standardized working approaches for coordinating the work of different departments and with other organizations was lacking. A logical next step towards PLM in construction is to enable better collaboration and information exchange between the different participants involved in a project. Construction processes must focus on increasing data flow based on key performance indicators (KPI) (i.e., cost, schedule, quality, risk) in the recurring process of sharing information. In order to achieve general improvements over the entire lifecycle, this has to happen from the owner to the architect to the design team to the construction manager, and from the contractor to the suppliers, vendors, and subcontractor, to different operators, and ultimately back to the owners.

To address this issue, the construction sector is increasingly adopting Building Information Modeling (BIM) methods to maintain a central repository of information to support the business process of design, planning, constructing, operating and maintaining a building or infrastructure asset. BIM fundamentally changes the prevailing Architecture, Engineer, and Contractor (AEC) process and workflow by the way information is generated, reviewed, coordinated, shared, and finally applied. To implement the BIM method successfully, the construction industry has to change its work practices as a whole. This is a major challenge, because the industry itself, as well as governmental organizations and local authorities, have yet to establish rules, regulations, and best practices to follow. Another issue is that many construction organizations have a traditionally risk-averse approach to change. While most construction companies prefer continuous renewal strategies, changes to processes and structures in their organizations is incremental rather than discontinuous. This makes it possible to define the requirements for internal and external processes, interoperable software platforms, data exchange interfaces, and standards. The implementation of commercially-available software or sensing hardware products in the field of BIM requires customization to perfectly fit an organization's internal processes. This, in turn, becomes a good reason to distinguish an organization's portfolio and expertise from others.

34.3 BIM.5D® Development and Applications

Efficient construction requires efficient tools and lean processes. ZT has responded to this challenge by introducing the term BIM.5D® and developing a corresponding BIM.5D® roadmap. The aim within STRABAG is to implement a model-based workflow that integrates all of the project stakeholders involved using a standardized approach. The roadmap ensures that all project phases are covered and that all trades are effectively integrated. The BIM.5D® group within ZT continuously introduces the necessary working methods, tools, and templates for STRABAG. Its strategic BIM.5D® tasks focus on:

- Central organization, development, coordination, and maintenance of agreed methods and templates across STRABAG,

- Development of requirements for software and hardware partner companies,
- Service support in all available BIM.5D® applications, and
- Transfer of BIM.5D® knowledge, consultation and training in all of STRABAG's subdivisions and operational units.

34.3.1 Definitions

BIM facilitates efficient project design, construction planning, building, and operation and maintenance based on the standardized representation and sharing of digital information among authorized project stakeholders. At STRABAG, the term BIM.5D® is defined as follows (see Fig. 34.2):

- 3D model: Coordination of trades and visualization of construction design, planning, execution and production phases.
- 4D model: Linking the geometry (3D model) with a project timeline based on the dependencies of processes on resources (people, equipment, and material).
- 5D model: Integration of all relevant process information in a model-centric repository (i.e., from automated quantity and cost estimation to digital fabrication).

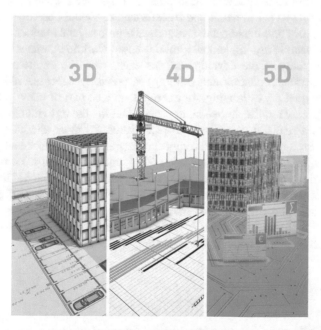

Fig. 34.2 From 3D modeling, quantity estimation, project scheduling, detailed construction planning, work task simulation, to process control. (© Ed. Züblin AG, reprinted with permission)

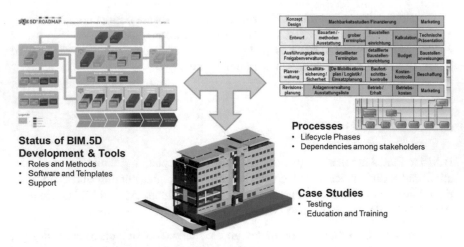

Fig. 34.3 BIM.5D® roadmap. (© Ed. Züblin AG, reprinted with permission)

34.3.2 Roadmap

To accomplish these tasks, a roadmap was developed for a standardized approach
to implementing BIM within a large construction organization. STRABAG's
BIM.5D® roadmap is structured in three main parts (see Fig. 34.3). First, existing
processes are reviewed in detail and transformed to model-based workflows. This
reveals interfaces and dependencies among the process stakeholders that must be
addressed to seamlessly implement a model-based workflow among the processes.
Second, the status of the development for each trade (i.e., software, templates,
working practices, education and training) is precisely coordinated and tracked.
Model-based quantity estimating, for example, may be part of many processes and
subsequently may require an overall approach that fits the individual needs of each
trade. Third, a realistic case study project (called Z3 after one of STRABAG's
buildings in Stuttgart, Germany) exemplifies in great depth all necessary processes
and working templates among the trades. Z3's modeling detail is commonly used
in the education and training of internal and external project stakeholders. It allows
users to familiarize themselves with STRABAG processes, working templates,
BIM.5D® development status for specific trades, and which pilot projects have
successfully implemented the BIM.5D® applications. Some of these applications
are explained in greater detail in the following sections.

34.3.3 Use Cases

The BIM.5D® group provides specific services and support within STRABAG.
It organizes and coordinates strategic BIM.5D® development and ensures the

Useful BIM Applications throughout the Building Lifecycle

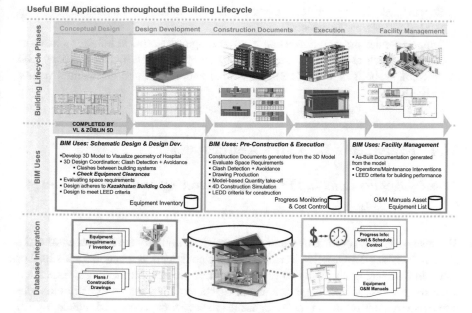

Fig. 34.4 Exemplary BIM.5D® use case over a building project's lifecycle. (© Ed. Züblin AG, reprinted with permission)

practicability of the tools that meet the requirements of STRABAG's operative units. Figure 34.4 illustrates exemplary use cases over the project lifecycle of a building:

- Supply all templates for the software programs linked to the BIM.5D® process in accordance with the requirements of the STRABAG Trade Code (STC), for example, for structural works, finishing, and shell works.
- Develop templates for other trades in building construction and civil engineering, as well as infrastructure work domains.
- Support model-based collision checking and trades coordination.
- Support model-based scheduling by connecting the schedule provided (ASTA Power Project/MS Project/Primavera) with the 3D models of the building and site installations.
- Determine quantities for model-based cost estimation and control in RIB iTWO software.
- Set up model-based production design and work preparation, for example, to support formwork production design and create the required 3D design of support structures and temporary structures in cooperation with the construction planning team.
- Provide BIM.5D® modeling capacity based on 2D design drawings or the client's information.
- Provide BIM.5D® project management by coordinating internal and external BIM.5D® design.

- Support tasks in prequalification and proof of technical skills by already existing BIM.5D® reference projects.
- Support tender presentation using a wide range of technical solutions in visualization, such as 3D PDF, photos, photo composition, films, stereoscopy (3D cinema), as-built models from laser scans, and virtual and augmented reality (VR/AR).

34.4 Examples of BIM.5D® Applications

34.4.1 Applications in the Design, Planning and Construction Phases

3D-design, design coordination and collision detection are the fundamental tasks of many existing BIM applications. Visualizing construction schedules adds further value in convincing an owner to proceed with a project. Furthermore, a detailed analysis of construction sequences ahead of construction assists construction site personnel in identifying and resolving issues to save time, costs, and reduce overall project risk. One of STRABAG's BIM.5D® projects is BLOX. BLOX includes the construction of a six-story tall multi-purpose building on a former industrial site in Copenhagen's harbor area. The architect and project team shared a total of 21 detailed information models, i.e., structural steel, reinforcement, precast concrete elements, construction site layout planning, construction sequencing, temporary aids (e.g., climbing formwork and scaffolding), building façade, and mechanical engineering and plumbing (e.g., HVAC, photovoltaic panels). Engineers representing the various trades teamed up with STRABAG's BIM.5D® group (BIM lead, BIM manager, BIM coordinator) and the construction site team to develop a successful construction schedule. Some of the successful BIM.5D® applications that were executed during the planning and construction phases are illustrated in Figs. 34.5, 34.6, 34.7, and 34.8.

Fig. 34.5 Project visualization (left) and structural steel model (right). (© Ed. Züblin AG, reprinted with permission)

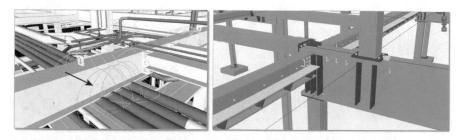

Fig. 34.6 Clash detection reports (left) and detailed construction model (right). (© Ed. Züblin AG, reprinted with permission)

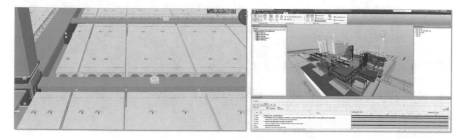

Fig. 34.7 Precast concrete elements (left) and construction schedule (right). (© Ed. Züblin AG, reprinted with permission)

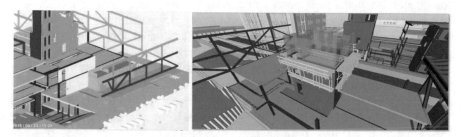

Fig. 34.8 Pre-assembly location and spaces (left) and climbing formwork (right). (© Ed. Züblin AG, reprinted with permission)

34.4.2 Object-Oriented Foundation and Infrastructure Modeling

For many years the availability of commercially-available software platforms has led to the successful use of BIM in building construction projects. Applications in related areas such as foundation engineering or infrastructure have been rare and have yet to become more widespread. The BIM-based design and planning of geotechnical works, for example, involves the modeling of the interactions between building, deep excavation, and geotechnical elements. Details of interest are concrete slabs, pillars, and earthwork layers.

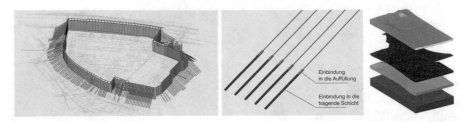

Fig. 34.9 Geotechnical engineering (e.g., deep foundation and soil layers). (© Ed. Züblin AG, reprinted with permission)

Fig. 34.10 Highway infrastructure modeling (e.g., road layers and noise barrier wall). (© Ed. Züblin AG, reprinted with permission)

Although commercial CAD software is not always able to model all elements, such dependencies must be represented in the 3D-model. In addition, best practices for quality assurance must ensure that even related tasks, such as the services that surveyors provide, can be easily and rapidly integrated. Interactive tools for users in the office and in the field then enable 3D visualization, quantity and cost estimating, scheduling, controlling, logistics coordination, and billing. A project model consisting of geotechnical as well as building components is therefore modeled using pre-designed 3D elements from catalogs. These catalogs consist of building component types made out of variable parameters (see Figs. 34.9 and 34.10). The further a project progresses in the timescale, the more detailed the final building model gets. Information on the geometry, materials, costs, building sequence, survey data, ground type and more eventually become parameters of the model. This facilitates a standardized, automated way of drawing a parametrized 3D visualization, performing quantity estimations, offering design and construction coordination, and issuing quality checks (Koch et al. 2017).

In addition, time savings result when editing or changing a model. To foster BIM.5D® development across the Group, the model-based approach is being implemented in bridge design efforts. A bridge design was created using an open source graphical programming environment that allows the extension of BIM with the data and logic an engineer would typically apply manually. Using such automation makes it possible to create a model that represents complex geometric shapes and offers tools for estimating quantities during the tendering phase (see Fig. 34.11).

A further application the Group has been focusing on is the application of BIM.5D® in mechanized tunneling. This domain has yet to explore suitable

Fig. 34.11 Bridge modeling using graphical programming environment. (© Ed. Züblin AG, reprinted with permission)

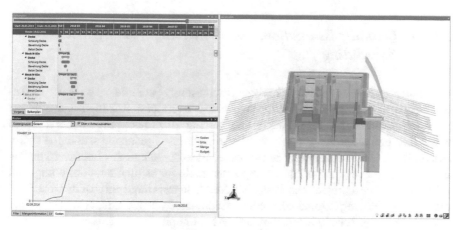

Fig. 34.12 Task driven cost control using BIM.5D® model (Klar and Grundhoff 2016). (Reprinted with permission)

methods to demonstrate the benefits of using BIM in practice. STRABAG is part of one of the first scientifically evaluated BIM.5D® pilot projects in Germany focusing on mechanized tunneling. BIM.5D® best practices are being applied and tested on a 4.2 km long tunneling project in Rastatt, Germany. Although the construction of the project's tunnel has just started, several BIM benefits can already be observed, for example, drawing benefits from visualization of a project's complexity, immersive 3D navigation for users, interactive communication among all stakeholders, public outreach, detailed modeling of the entire tunnel, realistic 4D scheduling, accurate quantity and cost estimation, and the testing and application of field reporting methods for early risk detection and mitigation (see Figs. 34.12 and 34.13).

Fig. 34.13 Field communication and progress reporting to control risk, from Klar and Grundhoff (2016). (Reprinted with permission)

34.4.3 Quantity Estimation, Cost Calculation, Construction Scheduling

Construction processes have become increasingly complex as many stakeholders participate in a project through many interfaces. Effective and efficient communication is therefore a major goal among all project participants to avoid waste (i.e., defined as the potential for deviating from as-planned vs. as-is). A major reason for a successful project is the model-based application of software during the tender and construction phases. Accurate tools for estimating, controlling, and billing determine a project's success. STRABAG invests large parts of its BIM.5D® efforts in developing automated, model-based quantity estimation, cost calculation, and construction scheduling techniques. An example that is extensively used to educate and train STRABAG's own BIM experts is shown in Fig. 34.14. The model contains models for all building trades, for example, geotechnical works, structural works, interior finishing, mechanical engineering and plumbing, façade design, and more. They are tied to legal and tendering procedures, subcontractor procurement and management, and construction best practices.

34.4.4 From Digital Planning to Automated Production

The rapid growth of people in urban areas creates strong demand for mobility. In addition, an aging society requires the development of intelligent, but individualized solutions that ensure high quality living. Renewable energies, as one example, contribute to a new standard of living (see Fig. 34.15). E-bikes and car sharing are two of the most recent trends in urban living. However, very few loading stations exist to charge or securely store these vehicles. STRABAG's "Z-BOX" project sets out to address this problem. BIM.5D®, as an integral part of a team effort across all trade disciplines, has been part of this project since the beginning (3D design and construction of a prototype) right up to the successful pilot implementation using automated 'design to production' fabrication techniques.

Fig. 34.14 BIM.5D®-based quantity and cost estimation (Z3 building of STRABAG's Ed. Züblin AG in Stuttgart, Germany). (© Ed. Züblin AG, reprinted with permission)

Fig. 34.15 Seamless application of BIM.5D® in all project phases: from early design to parametric modeling, semi-automated production, and assembly of modular construction elements. (© Ed. Züblin AG, reprinted with permission)

34.4.5 As-Built Documentation and Facility Management

STRABAG's "Record Modeling" application uses 3D point clouds from laser scanners or unmanned aerial vehicles (UAVs) to model the as-built geometry of existing buildings or infrastructure assets (see Fig. 34.16). It adds high precision details (error-free quality, parametric, object-oriented information) to a model that owners need for the cost-efficient operation and maintenance phase of their facilities. The "Construction Operations Building Information Exchange (COBie)" schema integrates data parameters into the model that is then used in facility management applications in the form of IFC and Excel tables.

Fig. 34.16 From laser point clouds to BIM.5D® model (LOD 400). (© Ed. Züblin AG, reprinted with permission)

34.5 Summary

STRABAG has developed and implemented a comprehensive 5D BIM strategy which covers all relevant stages in the design and construction of built facilities. BIM.5D® involves the client and all project participants from the start of a project and facilitates the interdisciplinary gathering and analysis of data to generate valuable information. Since project data is digitally captured, combined, and linked over the entire lifecycle of a construction project, the result is a comprehensible, transparent and resilient information network for everyone involved in a project.

References

European Construction Industry Federation. (2014). http://www.fiec.eu. Accessed 10 Jan 2014.
Klar, S. B., & Grundhoff, T. (2016). BIM-Pilotprojekt Tunnel Rastatt – Erfahrungswerte aus der Planung mit digitalen Arbeitsmethoden (Engl.: BIM pilot project Tunnel Rastatt – Report on experiences using digital construction planning techniques). *Eisenbahntechnische Rundschau* (4), 30–36. http://www.eurailpress.de/archiv/tunnel-rastatt
Koch, C., Vonthron, A., & König, M. (2017). A tunnel information modelling framework to support management, simulations and visualisations in mechanised tunnelling projects. *Automation in Construction, 83*, 78–90.
SDZ SimulationsDienstleistungsZentrum GmbH. (2014). http://www.sdz.de (with permission to use).

Part VI
Summary and Outlook

Chapter 35
Conclusions and Outlook

André Borrmann (ID), **Markus König, Christian Koch, and Jakob Beetz**

Abstract This chapter illustrates the current status of the implementation of Building Information Modeling and addresses questions that still need to be answered. In addition, there is an outlook on expected developments in the near and distant future. In particular, the potentials of autonomous construction methods are discussed.

This book shows very clearly that the concept of Building Information Modeling has already reached a high level of maturity. Today, there are not only powerful software tools available for generating and processing digital building models. The Industry Foundation Classes offer a neutral data format that enables a high-quality data exchange across the boundaries of individual software manufacturers. The Information Delivery Manual further provides a standardized method for describing data exchange processes and specifying model content. Finally, various technical approaches are available to assist the model-supported cooperation of participating planners in a meaningful manner.

This implies that the most important prerequisites for the successful implementation of the BIM vision have already been met from a conceptual and technical point of view. This becomes evident through the large number of practical contributions

A. Borrmann (✉)
Chair of Computational Modeling and Simulation, Technical University of Munich, München, Germany
e-mail: andre.borrmann@tum.de

M. König
Chair of Computing in Engineering, Ruhr-Universität Bochum, Bochum, Germany
e-mail: koenig@inf.bi.rub.de

C. Koch
Chair of Intelligent Technical Design, Bauhaus-Universität Weimar, Weimar, Germany
e-mail: c.koch@uni-weimar.de

J. Beetz
Chair of Design Computation, RWTH Aachen University, Aachen, Germany
e-mail: beetz@caad.arch.rwth-aachen.de

© Springer International Publishing AG, part of Springer Nature 2018
A. Borrmann et al. (eds.), *Building Information Modeling*,
https://doi.org/10.1007/978-3-319-92862-3_35

that describe how BIM can actually be used productively in various areas. However, it should not be dismissed that currently only Little BIM approaches are often being used, that is, individual BIM applications are employed and data exchange is mainly carried out via proprietary interfaces. This is mainly due to technical problems, which have not yet been fully solved, including the not always error-free import and export of IFC data. These problems, however, are not fundamental and are going to be solved in the near future.

From a purely technological point of view, there is nothing to prevent the comprehensive use of the BIM methodology. The remaining open questions are mainly of legal or organizational manner. For example, the use of the BIM methodology places a shift of the required planning effort into earlier planning phases, which necessitates an adjustment of the corresponding compensation structures. Furthermore, the legally compliant use of the model across individual planning phases and questions concerning the commitment of model contents must be clarified.

In view of the enormous efficiency gains that can be achieved with the use of BIM, along with the great success achieved with the introduction of BIM-supported work in the USA, the UK, the Scandinavian countries and elsewhere, the success of model-based planning, construction and operation will continue steadily. The examples of the BIM initiative of the United Kingdom and elsewhere show that an "impulse from the top" can play a significant role in the modernization of the construction industry.

In any case, it can be said that the building industry is undergoing a major change. The broad introduction of digital technologies will change the construction industry to an even greater extent than was the case when switching from the drawing board to the use of CAD. Properly deployed, BIM ensures that all stakeholders are freed from inconsequential and error-prone tasks and can concentrate on the essentials of their respective planning, building and operating activities. The result will be error-free procedures and higher-quality results, that is, projects can be realized within given time and cost constraints.

With the nationwide implementation of BIM Level 2, already being practiced in many countries, the technological development of model-based work is far from being fully developed. For the realization of BIM Level 3, a number of important problems have to be solved, in particular, how cloud technologies can be used in a reliable and secure manner to make digital building models available across the boundaries of individual companies.

For the successful implementation of the BIM methodology in companies, the education and training of architects, engineers, craftsmen and operators is of great importance. Only through well-trained staff can such a change be made meaningful and adapted to existing conditions. Knowledge of certain methodological foundations, such as object-oriented modeling, process modeling, geometric modeling and intensive cooperation, are essential. It is only through knowledge of these concepts that the problems of working with digital construction models can be solved. A typical example is the use of wrong structural component types in a construction model. For example, even though the geometry, including color and texture, can represent a specific concrete support, if the wrong structural component type (for

example masonry wall) is assigned, subsequent applications can lead to incorrect results. Such semantic errors are very difficult to identify and can have far-reaching consequences.

The BIM method also creates new occupational fields, which must be considered in education and training programs. The BIM manager, for example, should have substantial knowledge in the field of applied computer science. Many universities around the world are already devoted to BIM education, however this has not yet taken place as comprehensively as desirable. Since the efficient implementation of BIM involves everyone in a construction project, even craftsmen or facility managers should be trained accordingly. To this end, preliminary training measures are urgently required for a successful and comprehensive BIM introduction. Such skills will certainly be even more important when BIM Level 3 is to be introduced.

Even beyond BIM Level 3, the development of technologies for digital building will raise several interesting challenges. Current research projects deal, for example, with the fact that even very early phases of the conceptual building design can benefit from model-based work and how prevailing uncertainty can be dealt with. Other initiatives focus on how the high-quality information of a building model can be used during the construction process to improve coordination details and logistics management. Further projects deal with how the BIM methodology can be applied within the infrastructure sector so that in the future also bridges, tunnels and alignments can be completely planned, built and operated on a digital basis.

In the UK, the BIM2050 initiative has been launched to develop visions of digitized construction and built environment in the year 2050. In its 2014 report, quite futuristic (by today's standards) approaches are discussed, ranging from self-assembly, industrial 3D printing, autonomous building erection robots to self-healing materials. Most of these approaches are related to Artificial Intelligence (AI), a very ubiquitous topic that is currently being discussed in all areas of society, economy and academia. AI methods are being employed in several sub-domains and application areas, for example, Internet of Things, Big Data, Robotics, Machine Learning and Computer Vision.

Linking the technology of Internet of Things with construction delivers smart and intelligent buildings that are equipped with a network of different sensors and devices, such as cameras, access control, lighting, smart meters, etc., to assist sustainable building automation and control. The vision is to integrate building models with actual sensor data to simulate the building behavior in real-time and control the building, for example, with regard to energy efficiency. When looking at the use of robotics in the construction industry, first research projects on bricklaying robots and large-scale 3D printing have already shown promising results. At the same time, drones (Unmanned Aerial Vehicles – UAVs), use different sensors, actuators and intelligent software to fly autonomously and collect high-quality images of existing buildings or construction sites. Using machine learning and computer vision algorithms, these images can be used to automatically create 3D as-built models, monitor the construction progress on site, and identify and assess damages for maintenance purposes.

It is clear that such visions are needed to further strengthen the innovative power of the construction industry. Just a few years ago, Building Information Modeling was still a vision, the realization of which seemed to lie in the distant future.

Glossary

3D model Three-dimensional model of a built facility with geometric, physical and functional properties (3D BIM).

3D point cloud A set of three-dimensional data points in space not (yet) organized into a spatial structure. Typically the product of laser scanning or photogrammetry.

3D city model Virtual three-dimensional model of an urban area with categorized information on geometry, location and appearance of all buildings and sections of terrain.

3D viewer Software for the interactive display of three-dimensional building information. Unlike an editor, a viewer does not provide a way to edit the data.

4D construction process animation Time-dependent visualization of the construction process based on a 4D Building Information Model (4D BIM).

4D model A three-dimensional model extended to include scheduling and/or duration information (time). Serves as a basis for creating a 4D construction process animation (4D BIM).

5D model A four-dimensional model extended to include additional information on costs or cost estimates. Serves as a basis for the temporal presentation of building costs over the course of a building project (5D BIM).

Aggregation A special means of association for modeling relationships between components and larger objects of unequal classes. The object is an entire item (the aggregate) and the aggregated objects are part of the item.

As-built model Digital model of a building (BIM) that, in contrast to the as-designed or as-planned model, documents the actual condition of the building "as it was actually built".

As-designed model (as-planned model) Digital model of a building (BIM) that, in contrast to the as-built model, documents the condition of the building "as it was intended to be built".

Automated code compliance checking Automatic checking of norms and guidelines. See also Model Checking.

© Springer International Publishing AG, part of Springer Nature 2018
A. Borrmann et al. (eds.), *Building Information Modeling*,
https://doi.org/10.1007/978-3-319-92862-3

BIG BIM The consequent use of a digital building model between all participants over all phases of the life cycle of a building using extensive Internet platforms and database solutions.

Bill of Quantities (BoQ), also Specification A tabular list of the individual work stages required to complete a particular construction task/service.

BIM Collaboration Format (BCF) An open XML-based data format for supporting workflow communication in BIM processes, for example for communicating conflicts and modifications.

BIM Execution Plan (BEP) A strategy for every BIM project that defines the extent of BIM implementation, its effect on processes, the composition of the team for the modeling and the appropriate Level of Development (LOD) for each phase of the project lifecycle.

Boundary Representation (B-Rep) A typical method for explicitly describing the three-dimensional boundary of a body or solid in a digital form using nodes, edges, surfaces and bodies.

Building Information Model A digital model of a building with all its geometric, physical and functional properties.

Building Information Modeling (BIM) Methods and tools for the continuous digital support of the planning, construction and operation phases of the lifecycle of built facility based on a digital building model.

buildingSMART International, independent, not-for-profit organization of companies, educational institutions and private individuals from all sectors of construction with the aim of make project development more effective and more continuous using efficient methods of integrated information processing.

Business Process Model Notation (BPMN) A standardized graphical specification language for modeling business processes and workflows.

City Geography Markup Language (CityGML) An open, standardized, non-proprietary format published by OpenGIS for the persistent and multi-disciplinary exchange of virtual 3D city models.

Class (type, family) An object-oriented data concept for typing and describing the structure and behavior of similar objects.

Collision detection/clash detection A procedure for detecting collisions/clashes (usually geometric) between objects of a model, for example an air duct and a wall.

Common Data Environment (CDE) A single source of information, used to collect, organize, manage and disseminate all relevant project documentation among multi-disciplinary project team members.

Computer-Aided Design (CAD) Computer-aided design of products based on 2D and 3D geometric models. In the past also known as Computer-Aided Drafting, which primarily applies to digital design based on 2D plans.

Computer-Aided Manufacturing (CAM) Computer-aided manufacturing of products, traditionally using numerically controlled milling machines, more recently using 3D printing techniques.

Construction Operations Building Information Exchange (COBie) A specification describing processes and information requirements for streamlining the

handover of specific building data from the design and construction phases to the facility's operation and maintenance (FM).

Constructive Solid Geometry (CSG) Classic procedure for the implicit, procedural description of bodies based on basic geometric solids (e.g. cube, cylinder, pyramids) and boolean operations (union, subtract, intersect, difference).

Data exchange Process of data export from a software program and subsequent data import into another software program using a data exchange format.

Data exchange format Specification describing how data exchanged between programs should be saved, loaded and edited, for example IFC.

Employer's Information Requirements (EIR) Define the information to be delivered, and the standards and processes to be adopted by the supplier for the development of the project and the operation of the built asset.

Exchange Requirements (ER) Part of the IDM method. Tabular catalog of requirements for data or information exchange.

EXPRESS A declarative data modeling language specified in the STEP standard part 11, with which object-oriented data models can be defined. EXPRESS is used to specify the IFC data model.

Facility Management (FM) Set of measures used to manage and optimize operation of land parcels, buildings, facilities and services.

Geographic Information System (GIS) An information system for capturing, editing, organizing, analyzing and presenting spatial data, including the necessary hardware, software, data and applications.

Geometric modeling A methodology for describing the geometry and topology of products.

Green Building XML (gbXML) XML-based data format for the exchange of building-related geometric data, use profiles and weather data between different CAD, BIM and energy simulation tools.

Industry Foundation Classes (IFC) A vendor-independent open, standardized and object-oriented data format for exchanging Building Information Models (BIM).

Information Delivery Manual (IDM) Methods for capturing and specifying data exchange processes and flows of information in the lifecycle of a building. Comprised of roles and tasks, process maps, exchange requirements and model view definitions.

Interoperability (Software interoperability) Compatibility of software systems with respect to the lossless exchange of data.

Level of Detail (LOD) Describes the different levels of detail when displaying virtual worlds. This concept is also used in the definition of 2D city models (for example CityGML).

Level of Development (LOD) A concept describing the degree of elaboration of a building information model in order to determine the reliability and limitations of the information stored within a model according to a specific project stage. LOD comprises Level of Information (LOI) and Level of Geometry (LOG).

Level of Geometry (LOG) As part of the LOD concept, LOG describes the level of detail of graphical or geometrical information within a model according to a specific stage of the project.

Level of Information (LOI) As part of the LOD concept, LOI describes the level of detail of non-graphical information within a model according to a specific stage of the project.

Linked Data Structured information that can be shared, interconnected and queried over networks using open standards. The reuse of common data models, vocabularies and semantics enhances interoperability between heterogeneous information systems.

little bim The use of a specific BIM software system by an individual specialist planner for his or her own discipline-specific needs to create a digital building model and derive plans without the intention of passing the data on to other software.

Model Checking A procedure for the automated, rule-based verification of a Building Information Model against a particular specification, for example norms, directives or client requirements.

Model View Definition (MVD) Part of the IDM method. Specification of a subset of a model or schema (for example the IFC) needed to satisfy the Exchange Requirements for a particular task (for example determining energy demand).

Non-uniform Rational Basis-Splines (NURBS) Parametric freeform curve of any degree based on B-splines with additional weighting factors that can exactly express regular conic sections (circles, ellipses, hyperbolas).

Object-oriented Modeling Method for the structured description of data or information on the basis of objects and their inter-relationships.

Ontology General meaning: study of the nature of being. In the context of BIM: An ordering system. A formally organizxed collection of concepts/categories in digital form, typically formulated verbally of graphically.

Open Geospatial Consortium (OGC) An international association for the specification of spatial information processing (especially geodata) based on common standards for the purpose of interoperability (OpenGIS).

Process Maps (PM) Part of the IDM method. Standardized process diagrams for selected sub-processes of the planning, construction and use of buildings/building constructions.

Product Lifecycle Management (PLM) A concept from mechanical engineering for the seamless integration of all information arising over the lifecycle of a product.

Process Modeling Methods and concepts for describing processes and workflows (planning, communication, data exchange, business, controlling, construction, and operating processes).

Quantity Take-Off (QTO) Also known as quantity surveying. The determination or calculation of quantities of a particular construction task/service, usually in accordance with a particular norm (e.g. VOB).

Semantics In the context of BIM: The meaning of a sequence of characters, symbols, data or information, usually related to non-geometrical information.

Index

Printed in the United States
By Bookmasters